Sixth Edition

INSIDE TODAY'S HOME

Cover: In the Telegraph Hill, San Francisco, townhouse of David Weingarten, heroic neoclassical sculptures representing Architecture and Sculpture lead from the entryway into a dining and kitchen area. The blue and silver walls of the entry recall the shimmering bay outside. David Weingarten and Lucia Howard, ACE Architects. (*Photograph: David Livingston*)

INSIDE TODAY'S HOME

LuAnn Nissen

University of Nevada, Reno

the late

Ray Faulkner

Stanford University

Sarah Faulkner

HARCOURT BRACE COLLEGE PUBLISHERS

Fort Worth Philadelphia San Diego New York Orlando Austin San Antonio
Toronto Montreal London Sydney Tokyo

PUBLISHER Ted Buchholz

ACQUISITIONS EDITOR Barbara Rosenberg

DEVELOPMENTAL EDITOR Terri House

PROJECT EDITOR John Mark Hobbs

PRODUCTION MANAGER Cynthia Young

ART DIRECTORS John Ritland, Nick Welch

PICTURE DEVELOPMENT EDITOR Peggy Cooper

Copyright © 1994, 1986, 1975, 1968, 1960 by Holt, Rinehart and Winston, Inc. Copyright 1954 by Holt, Rinehart and Winston, Inc. Copyright renewed 1988 by Sarah K. Faulkner, James K. Faulkner, John W. Faulkner, Patrick K. Faulkner, and William W. Faulkner.

All rights reserved. No part of this publication may be reproduced or transmitted in any form or by any means, electronic or mechanical, including photocopy, recording, or any information storage and retrieval system, without permission in writing from the publisher.

Requests for permission to make copies of any part of the work should be mailed to the Permissions Department, Harcourt Brace & Company, 6277 Sea Harbor Drive, Orlando, FL 32887-6777.

Address for Editorial Correspondence: Harcourt Brace College Publishers, 301 Commerce Street, Suite 3700, Fort Worth, TX 76102

Address for Orders:
Harcourt Brace & Company, 6277 Sea Harbor Drive, Orlando, FL 32887 1-800-782-4479, or (in Florida) 1-800-433-0001

ISBN: 0-03-055492-6

Printed in the United States of America

3 4 5 6 7 8 9 0 1 2 0 4 8 9 8 7 6 5 4 3 2 1

CONTENTS IN BRIEF

Dedication		v
Preface		vi
PART ON	E: Introduction	;
Chapter 1. In	nterior Design Practice and Process	2
	Historical Overview	19
PART TW	O: Foundations of Design	5 1
Chapter 3. D	Design Judgment	52
Chapter 4. E	llements: Space, Form, Line, Texture	67
	lements: Light and Color	90
Chapter 6. D	Design Principles	115
PART TH	REE: Designing Residential Spaces	139
	Iuman Factors and Special Needs	140
	lanning and Design Development ocial Zones	169 206
	Vork and Support Areas	232
_	rivate Spaces	256
Chapter 12. Fl	loor Plan Selection	281
PART FOU	JR: Construction and Materials	297
Chapter 13. En	nvironmental Issues	298
	echnical Requirements	325
	Vood and Masonry	346
	eramics, Glass, Metals, and Plastics	382
Chapter 17. To	extiles	406
PART FIV	E: Interior Components and Treatments	433
	Valls and Ceilings oors and Stairways	434
	Vindows and Doors	470 499
	ghting	532
	ırniture	568
	ecessories	598
PART SIX:	Professionalism in Interior Design Practice	621
Chapter 24. Bu	isiness Matters and Professional Issues	622
Appendixes		635
Glossary		651
Index		661

For my mother and father, who encouraged my lifelong pursuit of knowledge; For my husband, who supports and inspires all my endeavors; And, finally, to my students, whose continued success makes my lifework in education worthwhile.

LUANN NISSEN

PREFACE

During the long and successful life of *Inside Today's Home*, there have been many changes in the theory and practice of interior design. This book has kept abreast of changing trends and technologies with each new edition, so little remains today from the earliest editions. What endures is an abiding dedication to a straightforward approach to the design of living spaces. What has been added is a focus on the increasingly important professional aspects of interior design.

The Sixth Edition of *Inside Today's Home* presents a comprehensive introduction to the professional dimensions of interior design: the philosophical and historical foundations of the profession; the design process and the timeless elements and principles by which design is judged; the human factors and behavioral bases that determine functional success; the elements, materials, and components of which interiors consist; the environmental and regulatory considerations that influence choices; and the issues that affect professional practice. The field of interior design has grown increasingly technical and complex, with greater attention to regulation for the health, safety, and welfare of the public. In consequence, the body of knowledge required for the preparation of the professional interior designer has evolved to become more responsive to human needs, ecological issues, and technological developments. Responsible interior designers today must pursue, with technical knowledge and creative skill, a wholistic approach to improving the quality of life in the built environment.

This textbook is a survey of the various aspects and building blocks of interior design. It provides the basic principles involved in designing residential spaces and a solid foundation of professional study for a career in interior design. It may also serve the interests of anyone who wishes to create as useful, comfortable, and attractive a living environment as possible; and it can be used as a source of information, a reference, in the professional designer's library.

The newly organized Sixth Edition is designed to more closely reflect the sequence of topics instructors may present in an introductory course. It begins with an introduction to the profession of interior design and its historical background, then moves on to the fundamentals of design. This is followed by the more detailed, technical aspects of design, construction, and materials. Chapters then progress through interior components and surface treatments to the final details of accessorizing a space. The book then comes full circle with a return to issues of professionalism and the future of interior design. The text is arranged in parts addressing each of these topics, each part consisting of related chapters. However, instructors who wish to organize their course in a different sequence may rearrange chapters or use some for subsequent additional courses.

An expanded table of contents includes major topic headings for each chapter, and highlighted outlines at the beginning of each chapter assist instructors and readers by providing an overview. Within chapters, headings break the text into easily readable segments while bold-faced and italicized terms emphasize impor-

tant vocabulary and new concepts. Tables and charts summarize and explain important concepts and provide quick references. Numerous carefully chosen new illustrations and line drawings clarify and reinforce the text, providing specific contextual examples. Readers are encouraged to research additional information from a variety of sources listed at the end of each chapter. Several appendixes provide quick reference to graphic symbols (which may be used as templates for projects), styles of carpet and window treatments, a detailed drapery measurement problem, types of lighting fixtures, and recommended lamp positions and shade heights for various activities. Finally, an expanded glossary of terms assists readers in developing a professional vocabulary by defining bold-faced and italicized terms from the text.

Part One, "Introduction," defines the profession of interior design, introduces the design process as a systematic step-by-step method of problem solving, and prepares students for the profession by discussing possible career paths, including areas of specialization. A historical overview of the nineteenth and twentieth centuries provides an introduction to style, a perspective on the development of the profession and how specialized areas of design originated, and acquaints the reader with some of the first significant women in the field.

Part Two, "Foundations of Design," begins with a discussion of design judgment, developing awareness of the complex factors that determine the appropriateness and success of a finished design and providing a basis for objective analysis and decision-making. Chapters on the classic elements and principles of design provide a broad foundation of design fundamentals, balancing theory with practical examples and applying information from other fields such as psychology and physiology to interior design. Information is included on sensory perception, ordering systems, spatial illusion, and the link between color and light.

Part Three, "Designing Residential Spaces," emphasizes human factors, design that meets client needs and values over the lifespan, and functional and flexible (as well as aesthetic) design of social, work, and private spaces within the home in addition to safety and architectural barriers that affect the quality of life. The research and development phases of the design process (programming, concept development, design drawings, specifications, and schedules) are presented in detail. A comparison of types of floor plans and housing forms is presented, with objective criteria analyzing and evaluating the suitability of a plan for its intended users. An addition to the Sixth Edition, linking theory to practice, is the inclusion of three case studies that provide insight into the working methods used by practicing professional designers to meet real-life client needs.

Part Four, "Construction and Materials," aims to develop an appreciation for the global impact of design decisions and the responsibility of the designer in choosing materials and making informed decisions. Environmental concerns such as energy conservation, indoor air quality, toxicity of materials, endangered species, and preservation are discussed. The fundamental functions and applications of technical systems, including HVAC, plumbing, electrical, acoustical, safety, security, and communication requirements, are presented to enable knowledgeable interaction with other building and design professionals (architects, engineers, electricians, plumbers, etc.). In addition, Part Four develops an understanding of the characteristics, capabilities, limitations, forms, finishes, and ornamentation of the materials utilized in design and construction. A glossary of fabrics at the end of Chapter 17 provides a quick reference to appropriate textile uses.

Part Five, "Interior Components and Treatments," explores a variety of materials, treatments, and methods of construction and application for interiors, including walls, ceilings, floors, stairways, windows, and doors. Lighting, furniture, and accessories are also presented by type and function with information on

selection, placement, and effect. Terminology and application are emphasized; methods of measuring and estimating are also provided.

Part Six, "Professionalism in Interior Design Practice," returns to a discussion of interior design as a business and profession. It prepares students for the profession and other interested readers for working with members of the profession by providing information on preparation and qualification, professional organizations, ethics, licensing, and future directions.

No project of this size and duration can be completed without the encouragement, assistance, and prodding of many people. I would like to express my deep gratitude to all those who have borne with me during this arduous task and my sincere appreciation to those who have aided in conceiving, nurturing, and finally giving birth to another edition.

Many individuals on the staff at Harcourt Brace College Publishers have helped shepherd this revision through to completion. Former editors Janet Wilhite and Kathryn Lang initiated communication with a number of interior design educators to determine current needs of students and instructors in interior design classrooms. From these helpful suggestions, a reorganization plan and the focus of the new edition were determined. Then Barbara Rosenberg and Terri House saw the project through various drafts to the final manuscript. Peggy Cooper searched for the many illustrations, secured permissions, and gathered details to enable me to write informative captions. Mark Hobbs guided the book through the actual editing, design, and production processes with patience and sensitivity to graphic quality, and Cynthia Young managed interactions with compositor and printer. John Ritland provided the initial graphic format and color palette, which was then executed by Nick Welch, who also designed the cover and frontmatter.

I would like to thank those interior design educators who took the time to provide thorough, constructive evaluations and useful recommendations in their reviews of the manuscript as it progressed: Cigdem T. Akkurt, Iowa State University; Barbara Daher, Chabot College; Ann Erickson, University of Minnesota; Lisa Highley, Southwest Missouri State University; Wally Jonason, California College of Arts and Crafts; Jane Kucko, Texas Christian University; Alvalyn Lundgren, Learning Tree University; Paul Petrie, Virginia Commonwealth University; Carla Rogers, Latter-Day Saints Business College; and Lisa Kinch Waxman, Florida State University.

My thanks also to the interior designers and architects whose work so ably illustrates the content of the text and to the photographers, the quality of whose work contributes immeasurably to the book. In particular, I appreciate the contributions of Peter Aaron, Ed Asmus, Morley Baer, Richard Bryant, Karen Bussolini, Frederick Charles, Mark Darley, Scott Frances, Hewitt/Garrison, Jay Graham, Mick Hales, Hedrich-Blessing, John T. Hill, Timothy Hursley, Howard N. Kaplan, David Livingston, John F. Martin, Peter Mauss, Norman McGrath, Derry Moore, Philip R. Molten, Maurice J. Nespor, Peter Paige, Robert Perron, Tim Street-Porter, Steve Simmons, Ted Spiegel, Ezra Stoller, Paul Warchol, Matt Wargo, and Alan Weintraub.

Finally, my special appreciation to my husband, Howard Goodman, for his continual support, patience, encouragement, and applause, which gives me the inspiration to continue.

C on T E N T S

\mathbf{P}_{A}	ART ONE: Introduction	1		Art Deco: 1925–1940	36
CONTRACTOR				Modern Design	37
				Furnishings and Interiors	38
1	Interior Design Practice and Process	2		Domestic Architecture	42
	Definition of the Professional Interior			Post-Modern Design and the	
	Designer	4		Preservation Movement	45
	Interior Design Careers	7		References for Further Reading	47
	The Design Process	9			
	Problem Statement	11			
	Programming	11	_		
	Preliminary Schematic Design and			ART TWO: Foundations	
	Concept Development	16	of	f Design	51
	Presentation	16			
	Final Design Development and				
	Documentation	17	3	Design Judgment	52
	Implementation: Construction and			Determinants of Design	53
	Installation	17		Function	53
	Evaluation	17		Materials	55
	References for Further Reading	18		Technology	58
				Style	60
2	Historical Overview	19		Types of Design	62
	Progressive Trends in the Nineteenth			Structural Design	62
	Century	20		Decorative Design	64
	The Arts and Crafts Movement:			Discrimination	66
	1860–1900	20		References for Further Reading	66
	Currents Outside the Mainstream	23			
	Art Nouveau: 1890–1905	24	4	Elements: Space, Form, Line,	
	Elsie de Wolfe, America's First			Texture	67
	Professional Decorator	28		Space	67
	Frank Lloyd Wright	29		Sensory Perception	68
	Design for the Machine Age: 1900–1930	31		Ordering Systems	69
	De Stijl: 1917–1931	32		Spatial Illusion	70
	The Bauhaus: 1919–1933	32		Form and Shape	73
	Mies van der Rohe	33		Rectilinear Forms	75
	Le Corbusier	34		Angular Forms	77
				-	

	Curved Forms	78	\mathbf{P}_{I}	ART THREE: Designing	
	Line	82		esidential Spaces	139
	Texture	83	***************************************		
	Ornament and Pattern	85			
	References for Further Reading	89	7	Human Factors and Special Needs	140
				Physiological Requirements	141
5	Elements: Light and Color	90		Behavioral Basis of Design	141
3	Light	91		Ergonomics	141
	Color Theory	92		Cultural Influences	142
	Hue	93		Psychological and Social Needs	144
	Value	95		Safety and Architectural Barriers	152
	Intensity	98		Stairs	152
	Color Systems	99		Bathrooms	154
	Munsell	99		Kitchens	155
	Ostwald	101		Throughout the Home	155
		101		Special Needs Populations	158
	Planning Color Harmonies	102		Children	158
	Monochromatic			The Elderly	159
	Achromatic	104		The Disabled	162
	Analogous	104		Case Study: A Universal Kitchen Design	
	Complementary	104		for the Low-Vision Elderly	163
	Double Complementary	104		References for Further Reading	167
	Split Complementary	106			
	Triad	106	8	Planning and Design Development	169
	Tetrad	106		Programming	170
	Factors to Consider in Selecting Colors	106		Client Profile	170
	Effects of Hue, Value, and Intensity	108		Functional Goals	177
	Economies with Color	112		Equipment Needs	177
	References for Further Reading	113		Space Requirements	178
				Character	178
6	Design Principles	115		Site and Orientation	179
	Balance	115		Cost Estimates and Budget	183
	Symmetrical Balance	117		Analysis	184
	Asymmetrical Balance	118		Concept Development	191
	Radial Balance	120		Ideation	191
	Rhythm	121		Schematics	191
	Repetition	121		Concept Statement	193
	Progression	122		Design Drawings	193
	Transition	124		Plans	193
	Contrast	124		Sections, Elevations, and Details	195
	Emphasis	125		Axonometric Views and Perspectives	197
	Scale and Proportion	128		Specifications and Schedules	198
	Harmony	132		Case Study: Remodel from Second	170
	Unity	135		Home ("Ski Cabin" Townhome) to	
		136		Primary Residence	202
	Variety References for Further Reading	136		References for Further Reading	202
	Keterences for Further Keading	130		References for rundler Reading	400

CONTENTS xiii

9	Social Zones	206	12 Floor	Plan Selection	281
	Activities and Spaces	207	Types	s of Plans	281
	Greeting Guests	207	Close	ed Plans	282
	Conversation	208	Oper	n Plans	283
	Reading	212	Hori	zontal and Vertical Plans	284
	Quiet Games	213	Housi	ng Forms	289
	Audio-Visual Entertainment	214		tifamily Housing	289
	Active Indoor Entertainment	218		ched Housing	289
	Outdoor Entertainment	220		le-Family Detached Housing	291
	Children's Activities	221	Evalua	-	291
	Dining	222	Refere	ences for Further Reading	295
	Planning Social Spaces	228		8	
	Location	228			
	Room Shapes and Sizes	230			
	References for Further Reading	231	PART F	OUR: Construction	
	reaction for a drawer frequency				
	Ť		and Mat	terials	297
10	Work and Support Areas	232			
	Kitchens	232		onmental Issues	298
	Anthropometrics	234	_	y Conservation and Efficiency	300
	Work Centers	236		ervation Measures	300
	Storage Space	242		iinable Energy Resources	310
	Designing the Kitchen	243		· Air Pollution	315
	Utility Spaces	249		Building Syndrome	315
	Laundry Facilities	249		th Consequences	315
	Sewing Areas	251	Preser		317
	Workshops and Garden Rooms	252		ration/Adaptive Reuse/	
	General Storage	253		emodeling	317
	References for Further Reading	255		ingered Species	322
	reserves for 1 arener recuams		Globa	Impact of Design Decisions	322
			Refere	nces for Further Reading	323
11	Private Spaces	256	14 Techr	nical Requirements	325
	Sleeping and Dressing	257	HVAC	_	325
	Size of Sleeping Area	260	Heat	ing	326
	Number, Location, and Layout of			ilation	331
	Bedrooms	261	Air	Conditioning	333
	Storage	262	Plumb		334
	Individual Needs	263	Electr	2	337
	Hygiene	266	Acoust		338
	Location, Layout, and Details	268		and Security	343
	Guest Accommodations	274		Safety	343
	Home Office and Studio Space	276		e Security	343
	Case Study: The Home Office	279		nunications	344
	References for Further Reading	280		nces for Further Reading	345

15	Wood and Masonry	346	Sheer		426
	Wood	346	Lightweig	ht	427
	Forms	349	Medium V	Weight	428
	Ornamentation	359	Heavy W	eight	430
	Finishes	366	References	for Further Reading	431
	Masonry	368			
	Block Materials	370			
	Moldable Materials	378	PART FIVI	E. Interior	
	References for Further Reading	381		ts and Treatments	433
16	Ceramics, Glass, Metals, and				
	Plastics	382	18 Walls and	Ceilings	434
	Ceramics	382	Walls		434
	Clay Bodies	383	Design		436
	Form in Ceramics	384	Constructi	ion	440
	Ornamentation	385	Materials	and Surfacings	441
	Glass	387	Fireplaces		458
	Form in Glass	388	Location		459
	Ornamentation	390	Appearan	ce	460
	Architectural Glass	391	Materials		461
	Mirrors	393	Wood-Bu	rning Stoves	462
	Fiberglass	395	Ceilings		463
	Metals	395	Design		463
	Form and Ornament in Metal	396	Materials		467
	Plastics	399	Color and	Texture	468
	Families of Plastics	400	References	for Further Reading	469
	Environmental Problems	402			
	Form and Ornament in Plastics	403	19 Floors and	d Stairways	470
	References for Further Reading	405	Floors	•	471
			Finish Flo	ooring Materials	472
17	Textiles	406	Selection		492
	Fibers	407	Stairways		494
	Natural Fibers	409	Design an	nd Construction	495
	Man-Made Fibers	412	References	for Further Reading	498
	Fiber Blends	413			
	Yarns	414	20 Windows	and Doors	499
	Fabric Construction	415	Windows		499
	Weaving	415	Types		500
	Knitting	417	2.1	ed Location	501
	Other Constructions	418	0	eral Composition	506
	Finishing the Fabric	420	Window V		507
	Functional Finishes	420	Window T		511
	Color Application	421	Exterior		511
	Decorative Finishes and Enrichment	423	Interior		512
	Glossary of Fabrics and Their Uses	426	Doors		526

CONTENTS XV

	Types	527	Functional Accessories	603
	Functional Aspects	528	Decorative Accessories	606
	Design	530	Plants and Flowers	606
	References for Further Reading	530	Art	609
	The second secon	220	Crafts	613
21	Lighting	532	Mass-Produced Accessories	615
	Natural Light	533	Location and Background for	013
	Artificial Lighting	536	Accessories	615
	Sources	537	References for Further Reading	619
	Types and Uses	541	references for Further reading	017
	Technical Factors	545		
	Psychological Aspects of Light	551	PART SIX: Professionalism	
	Lighting Fixtures	552	in Interior Design Practice	621
	Economic Aspects	560	in interior Design Tractice	021
	Lighting Specific Areas and Activities	560		
	References for Further Reading	566	24 Business Matters and Professional	
	8		Issues	622
22	Furniture	568		625
	Selecting Furniture	569	Preparation for the Profession Professional Organizations	629
	Utility and Economy	570	NCIDQ Examination	630
	Beauty and Character	573	Ethics	630
	Furniture Types	574	Licensing	631
	Built-In and Modular	574	Future of the Profession	631
	Beds	577	References for Further Reading	633
	Seating	577	References for Further Reading	033
	Tables and Desks	581		
	Storage Units	584	Appendix A: Designer Symbols	635
	Outdoor Furniture	586	Appendix B: Carpet Pile Styles and Selection	
	Materials and Construction	588	Guide	640
	Wood	589	Appendix C: Interior Window Treatments	641
	Metal	591	Appendix D: Example of Measuring for	
	Synthetics	592	Draperies	645
	Upholstered Furniture	593	Appendix E: Luminaires	646
	-	597	Appendix F: Optimum Lamp Positions and	
	References for Further Reading	39/	Lampshade Heights	650
23	Accessories	598	Glossary	651
	Background Enrichment	602	Index	661

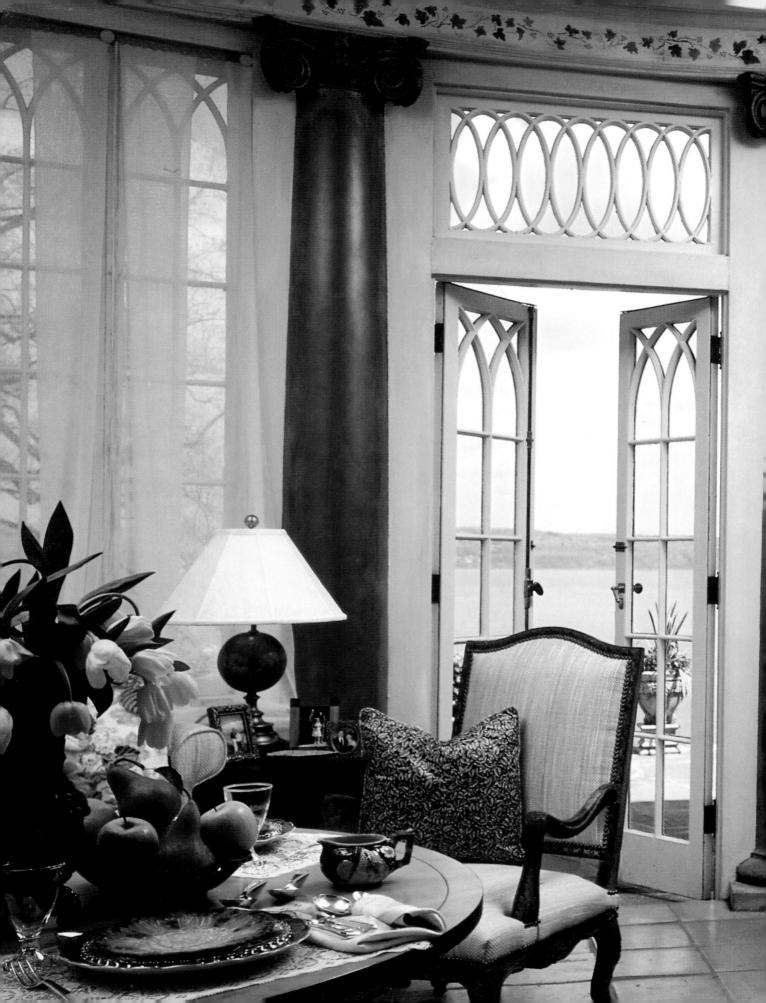

PART ONE

Introduction

Interior Design Practice and Process

DEFINITION OF THE PROFESSIONAL INTERIOR DESIGNER

INTERIOR DESIGN CAREERS

THE DESIGN PROCESS

Problem Statement

Programming

Preliminary Schematic Design and Concept Development

Presentation

Final Design Development and Documentation

Implementation: Construction and Installation

Evaluation

The need to beautify our surroundings, the desire for comfort and convenience, the expression of individuality, and the inventive solution to problems are as old as humankind. On an individual basis, interior design and decoration have been practiced throughout history. Before structures were built, natural cave shelters were arranged and decorated to meet functional and aesthetic needs. Interior spaces have always been arranged by their occupants and/or completed as part of the building process.

Designing for others, as a profession, began in America with the society decorators of the late nineteenth century, led by Elsie de Wolfe. The title *interior decorator* was used by these "ladies of good taste" who assembled residential interiors in reproductions of various traditional styles for their wealthy clients. Their focus was on decorative surfaces and ornament, color and texture, movable elements such as furniture and accessories, and easily installed fixed details such as moldings and paneling.

A more architecturally oriented practice also developed, with emphasis on planning space, functional design, structure, and the technical aspects of an interior such as acoustics and lighting. *Interior designers*, as these practitioners came to be called (*interior architects* in Europe), were associated with the Modern movement in architecture, with new materials, technologies, and innovations. Their concern was with the way interiors functioned while the decorators emphasized the way they looked.

These two disparate approaches to practicing interior design continued well into the twentieth century. In the years following World War II, growing pros-

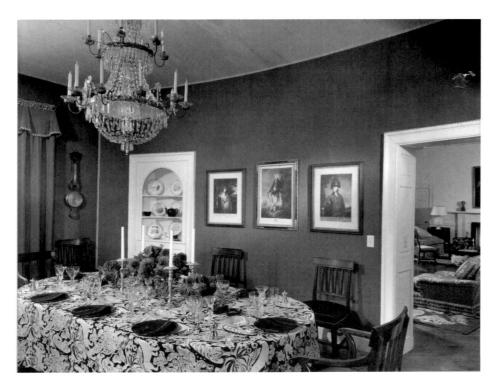

- **1.1** (left) The interior of a Pebble Beach, California, house, designed by Frances Elkins in 1952, reflects historicism in the tradition of Elsie de Wolfe. Bold red walls are accented by black and white in the English dining room while the living room, partially seen through the open doorway, is serene in green and white. *(Photograph: Julius Shulman)*
- 1.2 (below) Frank Lloyd Wright's Taliesin West, built in the Arizona desert, exemplifies the functional design of interior spaces, with all the elements fully integrated for harmony. In Wright's open plans, activity areas are defined by furniture placement rather than by walls. (Photograph: Ezra Stoller, © ESTO)

perity, the building and population boom, commercial development, the burgeoning middle class, and the adaptation of war technology to the production of more affordable goods brought an increased demand for design services by the general public. With it came the growth of the profession and the birth of specializations such as commercial space planning and industrial design.

In recent years, the distinction between interior decorating and interior design has lessened, with renewed interest in architectural historicism and broader public acceptance of Modern design. To professional interior designers today, decorating is just one aspect of their responsibilities, which also include problem definition and analysis; space planning; selecting and specifying the details of all interior furnishings and finishes; and coordinating installation. These activities

1.3 One of the many interior design career specializations, kitchen design, requires detailed knowledge of many technical requirements, including cabinetry, construction, appliance technology, properties of various materials, ergonomics, and human factors. (Source: Interior Graphic and Design Standards, by S.C. Reznikoft)

UNIT KITCHEN

Available in the following lengths: 72", 84", 87"

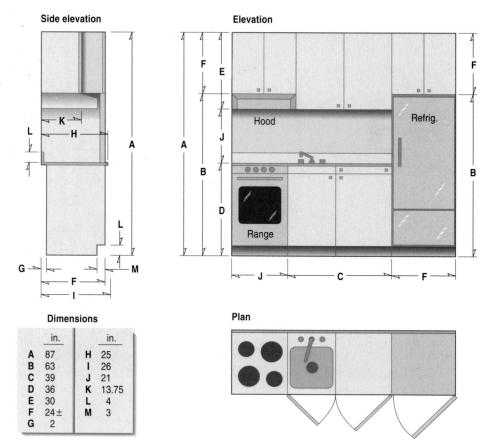

require skill and vast technical knowledge of construction, codes, zoning laws, fire regulations, product technology, and product sources.¹

The relatively new discipline of interior design is still developing. Evolving requirements, regulations, complex technologies, and new materials and processes have led to ever-increasing specialization. Preparing for professional practice to-day requires both knowledge and practice in order to combine the functional, technical, and economic aspects of design with human, aesthetic, and psychological considerations. As in medicine, law, or other professions, the general public has begun to recognize that complex tasks are most effectively handled by experts with a high level of specialized skill. Today, interior designers serve the needs of people of all income levels, creating environments that function well for living, working, learning, relaxing, and all other activities.

DEFINITION OF THE PROFESSIONAL INTERIOR DESIGNER

There have been many changes in the interior design profession, broadening the scope of the industry, increasing career opportunities, and constantly striving for higher professional standards.

The extent of the profession's growth is reflected in the definition of the interior designer, developed and endorsed by the major professional organizations of North America to which its practitioners belong.

The professional interior designer is qualified by education, experience, and examination to enhance the function and quality of interior spaces. For the purposes of improving quality of life, increasing productivity, and protecting the health, safety, and welfare of the public, the professional interior designer

- analyzes the client's needs, goals, and life and safety requirements;
- formulates preliminary design concepts that are appropriate, functional, and aesthetic;
- develops and presents final design recommendations through appropriate presentation media;
- prepares working drawings and specifications for non-load-bearing interior construction, materials, finishes, space planning, furnishings, fixtures, and equipment:
- collaborates with professional services or other licensed practitioners in the technical areas of mechanical, electrical, and load-bearing design as required for regulatory approval;
- prepares and administers bids and contract documents as the client's agent;
- reviews and evaluates design solutions during implementation and upon completion.

As noted above, the activities of an interior designer are limited where loadbearing structural design and some technical systems are involved. These aspects of building design and construction may be legally limited to registered or licensed

1.4 The office of interior designers Rhoda Russota, ASID, and Rosalyn Cama, ASID, in Branford, CT, reflects a professional business atmosphere. Their office is located on the ground floor of their townhouse condominium residence. (Photograph: Karen Bussolini)

architects and engineers who are specifically trained and tested in these technical areas. Professional interior designers are educated to know when they must seek specialized assistance and to understand these complex matters well enough to communicate effectively with consultants or team members from architecture or engineering firms. In some locations, only licensed architects or engineers are allowed to file plans with building departments. This legal restriction assures the public that responsibility for compliance with all regulations established to protect their safety rests with qualified professionals. Some firms employ all three groups of professionals—architects, engineers, and interior designers—to work together as a team on projects. In other cases, specialists are consulted for their expertise as necessary.

Interior designers are currently pursuing registration/licensing for promoting their profession, defining their areas of expertise, ensuring professional competence in practitioners, and protecting the health, safety, and welfare of the public in the environments they create. (Licensing, qualification, testing, and other professional issues are further discussed in Chapter 24.)

TABLE 1.1

Professional Interior Design Practice

I.	RESIDENTIA	AL DESIGN		
	Specializations:	Remodeling Kitchen Design Bath/Spa Design Lighting Vacation Homes Restoration	Special Clie	ents: Elderly Disabled Children
II.	CONTRACT	DESIGN		
	Specializations:	Office	Examples:	Business, law, medical, financial, travel
		Hospitality		Hotel/resort, convention center, restaurant, club, casino, fitness/recreation facility
		Health Care		Hospital, hospice, clinic, geriatric center, retirement home, nursing home, medical/dental facility, mental institution
		Retail		Shop, department store, shopping center/mall, showroom
		Institutional		Education, government, correctional facility
		Public Building		Museum/gallery, library, theater/concert hall, auditorium/arena, church/temple, court, city hall/state capital, legislature
		Industrial Facilities		Manufacturing plant, factory workshop/laboratory, power plant, exhibition design
				(continued)

INTERIOR DESIGN CAREERS

Innumerable career opportunities are available in the general field of interior design, and it is possible to enter the field by many avenues. Although it is not necessary to specialize in a particular aspect of the profession, the mounting quantity of detailed information regarding the built environment has led to a proliferation of specialized career paths. Individual interests and abilities can be matched with the many areas of specialization.

There are three principal areas of professional practice: residential design, non-residential or contract design, and product design. Each may be further divided into specific fields of concentration. Table 1.1 provides a list of many of the specializations in each category as well as the many related careers that draw on a design education or that focus on a specialized aspect of interior design.

TABLE 1.1 (continued)

Transportation

Automobile, airplane, ship/boat/yacht, submarine, bus, mobile home, spacecraft, station/terminal, ticket office, highway rest stop

Tenant Improvement

Retail space, office space

Restoration/Preservation or

Adaptive Reuse

Model Home

III. PRODUCT DESIGN

Specializations: Furniture

Textiles
Lighting
Wall Covering

Floor Covering Storage Systems Window Treatments Fixtures/Appliances Cabinetry Hardware Accessories

IV. ADDITIONAL AREAS OF SPECIALIZATION

Programmer Historic Preservationist/

Space Planner Restoration Specialist

Draftsperson/CAD
Operator

"Green" Designer
(Environmentally safe

interiors)

Specifier Universal Design Specialist

Purchasing Agent Manufacturer's Representative

Renderer Graphic Designer
Project Manager Set Designer

Facilities Manager Visual Merchandiser
Marketing Director (Display Artist)

Resource Librarian Buyer

Consultant: Teacher/Professor/Lecturer

Color Consultant
Lighting Consultant
Journalist/Writer

Corporate Designer Interior Photographer or Stylist

Certified Kitchen Designer Real Estate Developer

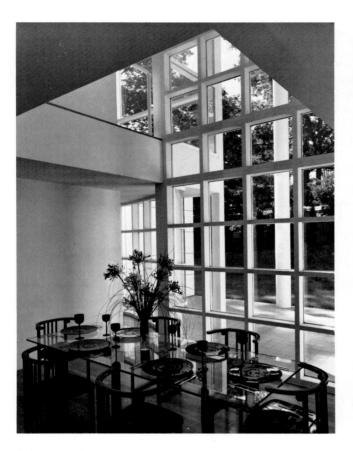

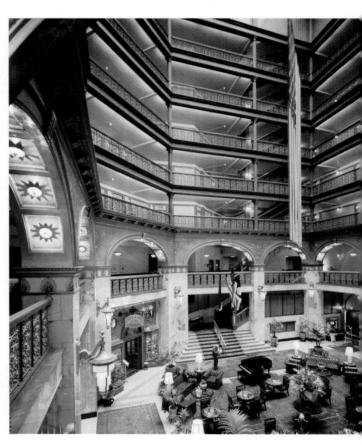

1.5 (left) A dining room designed by Richard Meier reveals the owners' desire for a bright and airy setting for social discourse. (*Photograph: Ezra Stoller, © ESTO*)

1.6 (right) The 100-year old Brown Palace Hotel in Denver, Colorado, was restored in 1986. In hospitality design, access and public safety are critically important and the designer must meet many regulations in addition to creating an aesthetically pleasing and, in this case, historically accurate interior. Samuel K. Morgan, Jr., interior designer; Frank Edbrooke, architect. (Photograph: Tim Street-Porter)

Residential designers apply their expertise to the design of homes whether new construction or remodels, custom or tract or manufactured homes, full-time or vacation houses, single-family detached or multiple unit structures, fixed in place or mobile, owned or leased. The focus of the designer's practice, like the focus of this text, is private residential space. Specialties may include kitchen design, bath and spa design, restoration, remodeling, lighting, or even design for particular groups of people such as the elderly, the disabled, or children. The client is the individual (or group) who will occupy the space as end-user and often works closely with the designer to achieve a very personal living environment.

Contract design encompasses nearly every type of interior that is non-residential. The term contract design was adopted originally because all the necessary components of the interior were acquired by contract rather than at retail. The public spaces dealt with in contract design require cognizance of building codes, safety regulations, and accessibility standards as well as application of a great deal of technical knowledge. The designer is responsible for protecting the health, safety, and welfare of the public that utilizes facilities ranging from places of work, recreation, or medical care to places of incarceration. The materials and furnishings a designer selects for public facilities, and their methods of installation, must not endanger anyone in normal use or contribute to risk of injury in case of fire or other emergency. Public spaces must also be designed to be accessible and usable by the physically disabled. The contract designer is liable for compliance with these legally mandated protections. Due to the widely varied technical expertise involved in the design of, for example, hospitals versus casinos, there are many opportunities to specialize in a specific type of contract interior design. An elabo-

ration of the branches of contract design, as well as many of the specific spaces to be designed, is included in Table 1.1.

The client for these large contract projects is usually not the end-user, or at least, not the only occupant. S/he may be the developer, the proprietor, or a group of people such as a board of directors who may speak for themselves or represent a group of others. In any case, the designer must satisfy both the client and the public who will ultimately use the facility.

The third division of interior design practice is often overlooked as a separate but natural part of design. It is **product design**—the creation and development of the multitude of products that are manufactured and sold, ranging from textiles and furniture pieces to light fixtures and door knobs. For design problems, designers often create one-of-a-kind solutions that could be produced for much broader distribution. The product designer joins creative skills with knowledge of materials and manufacturing processes or skill at hand crafting. Designers from a variety of backgrounds may specialize in creating a wide range of products—appliances, hardware, commercial or trade exhibits, and even vehicles. When products are industrially manufactured, the designers are called *industrial designers*.

THE DESIGN PROCESS

Designing successful interior spaces requires analysis and decision making, discrimination, and sensitive evaluation of the needs of the client. Function and aesthetics must be balanced like an equation. As in any problem-solving activity, the planning, creating, and organizing of interior space to perform the functions desired comfortably can be approached by segmenting and working through one step at a time. Following each problem through a systematic **design process** assures that details are not overlooked in an attempt to jump to a quick and superficial solution. Small projects may not require every step in the design process to the same extent as larger, more complex interiors; however, even the simplest of

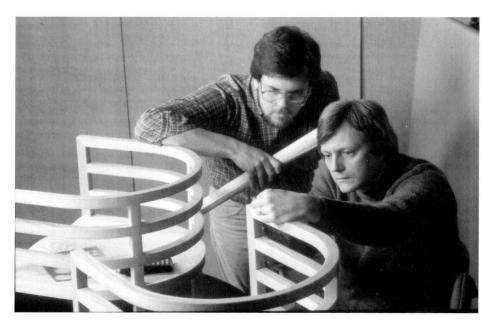

1.7 Designers often engage in product design as a solution to a design need for a particular project. Many such products are then manufactured for broader distribution. Designers may also choose product design as a career path. Shown here in design and development is a maple chair designed by Richard Meier in 1982. (Photograph: Gary Gladstone/TIB)

projects will benefit from a systematic approach to solving the design problem. Each project should proceed methodically through a number of steps in logical sequence:

- **Problem Statement**: a clear identification and definition of the project to be undertaken.
- **Programming** and writing the program document for client approval: the collection, organization, analysis, and composition of relevant information and goals regarding the problem.
- Preliminary Schematic Design and Concept Development: further graphic investigations of spatial and activity relationships, circulation patterns, and other aspects such as siting and orientation, which begin to generate a creative synthesis of ideas or concepts in both sketch and written form. The written concept statement addresses the dominant ideas and approach behind a design solution, the cause that brings about the final effect, and the methods that produce the result. It does not state what the solution, effect, or result will be, but rather offers a brief description of the dominant characteristic of what will be attempted. Conceptualizing is envisioning a synthesis of plan and program into physical form.
- **Presentation**: (a) selection of one or a few alternative proposals complete with preliminary drawings, proposed colors, furnishings, and materials, and (b) an estimated budget to present to the client for feedback, revision, and approval before proceeding.
- Final Design Development and Documentation: development and documentation of the approved design proposal, with final design and construction drawings and written specifications for furnishings and materials to be used.
- **Implementation**: execution and installation of the project, including selecting a contractor, scheduling and on-site observation for the coordination of construction and finishing, ordering/purchasing/installing furnishings and materials, and resolving any remaining problems itemized on a *punch list*.
- Evaluation: review of the design problem to assess degree of success in its solution. Follow-up evaluation can and should involve critique by both the designer him/herself and the occupant/client. Post-occupancy evaluation (POE) may take the form of a questionnaire to users of the space, a walk-through inspection with the client, or more informal verbal feedback. Evaluation or critique may also be invited from peers or others in allied professions and may be conducted at repeated intervals to determine if the project is meeting its goals, thus providing opportunity for adjustments and re-evaluation.

Orderly working methods and the ability to manage the project itself are the signs of a professional designer; they assure the client of both efficiency and thoroughness. Often the designer develops a **critical path** time frame for the project, mapping out the duration of each activity, sometimes with actual beginning and ending dates, in consecutive and overlapping order. In many cases, the client, particularly a non-residential or commercial client, will have a fixed date on which to take occupancy of a space. The designer must then work backward from that date to plan enough time for each step of the design process. If the project is not completed on schedule, the client may lose valuable revenue and will certainly be displeased. A designer may be penalized if work is not completed by a predetermined date specified in the contract with the client. The penalty may be monetary or contractual: termination of the contract or agreement to complete the design work. Even without a predetermined date of completion, clients will expect to be given some idea of a realistic time frame for their projects. The designer also benefits from a plan of action by which to measure progress.

PROBLEM STATEMENT

Initially, the design problem should be briefly stated by identifying the client, the location of the project, and the purpose of the space and extent of design work in very general terms. At this stage, little detail has yet been researched. The *design statement* simply identifies the project to be completed.

PROGRAMMING

The real work of understanding the full extent of the design problem begins with the process of *programming*—the compilation and organization of data on every aspect of the project. This is the research phase of the process, during which the designer asks questions and conducts interviews of the client and often additional end-users as we'l. All the facts, criteria, objectives, and constraints of the project must be identified in relation to the people who will inhabit the space, its location and orientation, and the resources available for it. This crucial preliminary statement of the design objectives and requirements forms the *program*, which is essential to ensure that the client and designer have a clear understanding of both the design problem and the client's and designer's goals for its solution.

An overview of the underlying purpose of programming is presented here to provide an understanding of its importance as the basis of a successful design solution. (The details and components of programming and planning will be taken up in Chapter 8.) A solution must develop from an analysis of the design problem—the program, compiled and written by the designer, then reviewed and approved by the client before design development begins. The ultimate goals of planning a satisfying living space are *character*, *utility*, *beauty*, and *economy*, just as it may be said that the *cube* is the building block of design. Thorough and accurate programming provides the foundation on which the CUBE rests.

1.8 A *critical path* graphically illustrates the sequence of activities necessary for the completion of a project and the time frame for each step. (Courtesy Gensler and Associates)

Typical Timeline for a Corporate Interior

Project Schedule	1993	1993 September October November December										1994		
Phase	Septemb	September					November			Decembe	er	January		
Lease Review														
Preliminary Space Plan														
Final Space Plan														
Preliminary Design														
Design Development														
Lighting Consultant														
Construction Documents														
Engineering M/E/S														
Construction Bid														
Bid Negotiation														
Permit														
Construction														
Computer/Telesystems Installation														
Construction Punch List														
Furniture Specification														
Furniture Bid/Order														
Carpet Installation														
Workstation Installation														
Furniture and Files Installation									-					
Library Shelves Installation														
Condensed File System Installation														
Move-in														

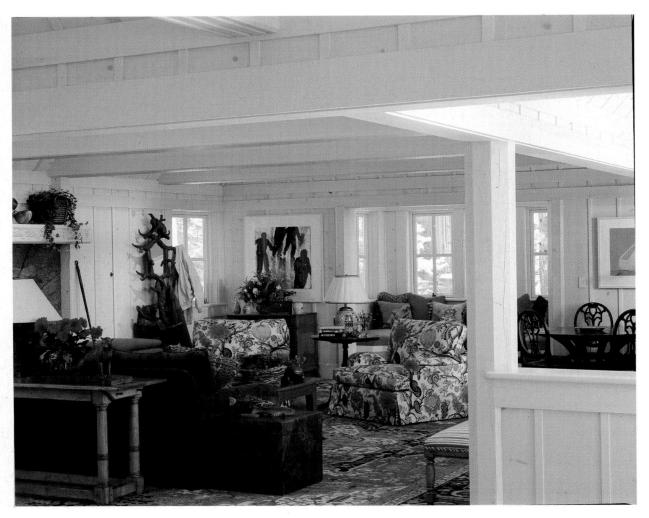

1.9 An antique hall tree, Oriental rug, chintz fabric, and white-washed fir paneling express character and individuality in this Lake Tahoe vacation home in the Sierra Nevada Mountains. Kirk Hillman, architect; Alice Wiley and Kendall Potts, interior designers. (Photograph: David Livingston)

CHARACTER Character differentiates one home from another; it is the result of the expression of style and the individual personality of each household member. It can occur only when the members are involved in the design process, and it sometimes takes time to develop fully—after the home has been lived in for a while. An accurate and detailed *client profile* will form the basis of the designer's successful development of an interior that reflects the client's individuality. A client profile is developed after interviewing members of the household to collect information about each individual's habits, interests, values, psychological needs, interactions, and preferences, as well as to record demographic data such as age, sex, stage in the life cycle, and type of household: single-parent family, nuclear family, childless couple, aggregate family, elderly, singles, etc.

Even when a particular *style* of design such as Georgian or Minimalism is adopted, the home should still reflect the unique personality of its residents rather than merely reveal a faithful recreation of the various components of the style. Style in this sense refers to the distinctive manner of design, construction, and execution that expresses a cultural period, a particular location, or a point of view. Individual style is a harmonious reflection of the way a person lives and the choices s/he makes, and it can evolve only from personal input to the design process. It develops most convincingly from fundamental lifestyles, not from acquiring the

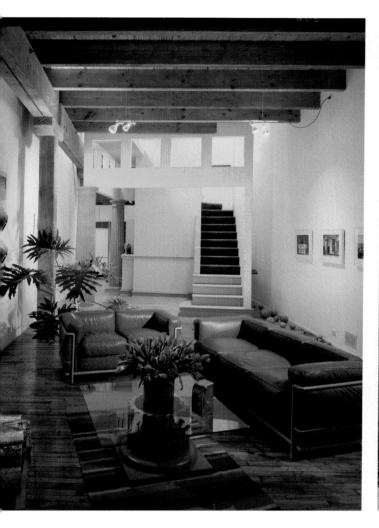

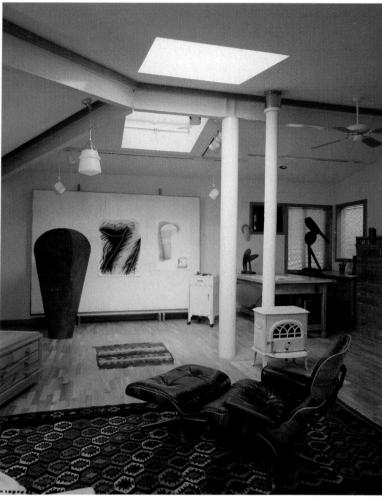

latest fashion. No one wants a home with the generalized aura of a hotel room. Thus, character is that unique individuality of design that gives a space warmth and keeps it fresh in appeal.

UTILITY Functional or utilitarian needs are those that are required to satisfy the people for whom the space is designed—their intended use, lifestyle, desires, and limitations, both immediate and into the future. Everyone wants spaces and furnishings that "work" effectively, that serve the purposes for which they are intended. The client profile serves as a tool for the designer to collect information about the functional needs to be addressed. The most beautiful interior is not successful if it does not function effectively for the people who must use it. (Human factors and special needs to be considered are presented in greater depth in Chapter 7.)

In addition, functional needs include the use and quantity of space for various activities, relationships between uses and spaces (*adjacencies*), site considerations, orientation, equipment and mechanical necessities, and applicable codes and regulations. Each of these factors is considered in later chapters.

BEAUTY Aesthetic considerations involve the client's regard for beauty, style, and individuality. It is said that beauty lies in the eye of the beholder, meaning

1.10 (left) An old Chicago factory has been transformed into an unconventional living space. A reference to classical tradition is seen in the old wood columns found in a salvage yard but cut down to size to support the tower. Part of one column supports the glass table top. Kenneth Schroeder, architect. (Photograph: © Peter Aaron/ESTO)

1.11(right) An artist's studio has many functional requirements, including light, ventilation, and plenty of space. Gerald Walburg's adaptive reuse of a building zoned for heavy commercial use in Sacramento, California, complete with a metal fabrication workshop downstairs, fulfills these needs successfully. (Photograph: Ed Asmus)

1.12 A reflection of the architectural heritage of the old Southwest, this modern adobe house is well suited to the high-desert landscape of Nevada. Maurice J. Nespor & Associates, architects; Diana Cunningham, interior designer. (Photograph: Maurice Nespor)

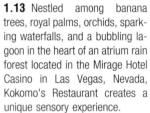

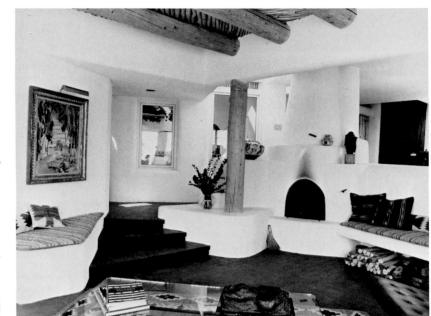

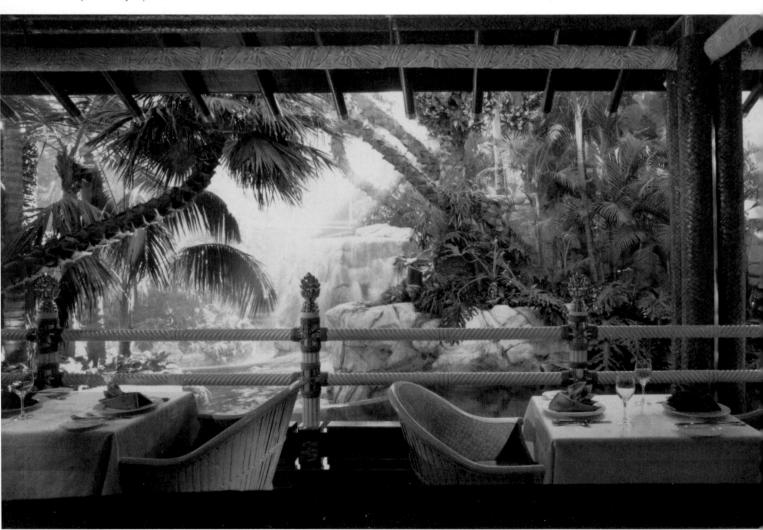

that it is subject to highly individual interpretation, with perhaps the precision of machine-made objects appealing to one person while the variations found in natural or handcrafted articles attract another. Ideas about beauty are also conditioned by time and culture; a glance at photographs from another time or place reveals its diversity. However, the qualities of a design that please the senses and lift the spirit are generally achieved through the application of design principles and elements. In this, the designer guides and, if necessary, educates the client to produce a result that "fits" aesthetically, culturally, and functionally and is experienced as pleasing—satisfying the innate need for sensory stimulation. Efforts of humans to beautify their surroundings are evident in the earliest archeological sites. Both the process and the result bring pleasure. The home is often the only environment that allows the freedom to explore and express a uniquely individual idea of beauty. Part Two presents design foundations to assist the beginning designer and student in the application of the elements and principles of design that will serve as a guide to evaluate choices and achieve beauty.

ECONOMY Finally, economic factors are of critical importance in determining the feasibility, extent, and quality of the project to be completed. Many economic considerations affect the final design. The program must detail not only the amount and kind of funding available for new acquisitions and construction but also an inventory of existing possessions to be retained and a consideration of the initial cost of materials balanced against long-term maintenance and replacement. Needs must be distinguished from wants in order to set design priorities, and the program must represent agreement on what can be achieved with the funding available. There are many methods of limiting building costs during the initial design and planning. Economies of plan shape, building materials, and individual components can easily be incorporated into the design. Flexibility of design to meet changing future needs also makes good economic sense.

Economy refers to the management of human, material, monetary, and natural resources. Ecological and environmental issues (which affect costs) should also be addressed by the responsible designer. Site considerations, orientation, insulation, and the use of plentiful, renewable, recyclable, or safely biodegradable materials should all be given due thought. (These issues are discussed more fully in later chapters.)

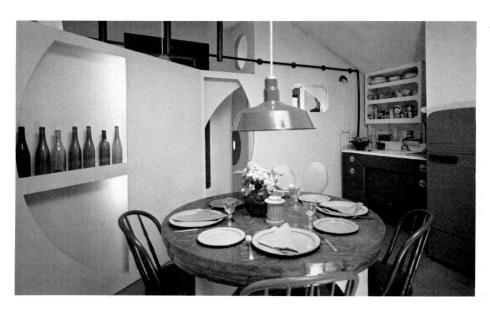

1.14 Recycled materials belie their age in a contemporary New Haven, Connecticut, apartment designed by Andrus Burr and Peter Rose. The old table top rests on a new base of heavy plywood, chairs get a fresh coat of bright paint, and empty wine bottles without labels serve as accessories. (Photograph: John T. Hill)

Character, utility, beauty, and economy are as closely related as the warp and filling of a textile. One cannot be completely dissociated from the others and retain full significance. On the other hand, it is difficult to consider all four factors simultaneously. In choosing certain items, such as rugs or chairs, function and economy might take precedence. Once these objectives have been satisfied, beauty and character can be considered. In selecting accessories, however, beauty and character will probably be the first consideration. Each goal must be balanced with the other goals to achieve the objective of good design.

During programming, the designer researches, organizes, and records all pertinent data that will determine the final design solution. The success of the design depends on the quality of the program; adequate time must be spent to develop a comprehensive and accurate assessment of all needs and considerations. The program and existing plan, if any, are first analyzed and then synthesized to guide further design development. The information is categorized and studied for similarities, interrelationships, and patterns that will help clarify various aspects. Space adjacencies, traffic flow, and activity relationships are depicted with *bubble diagrams*, charts, and *matrixes* (see Figures 8.21, 8.22, and 8.23). Analysis of program data, schematics, concept development, and design drawings are further detailed in Chapter 8, with only a brief introductory description here.

PRELIMINARY SCHEMATIC DESIGN AND CONCEPT DEVELOPMENT

A solution to the design problem is now sought. Solutions are conceived graphically and verbally. Initial ideation may begin with *brainstorming*, allowing a free flow of ideas unfettered by critical judgment. This type of preliminary activity encourages creativity and idealism in the resolution of program requirements. Numerous ideas are generated, one often stemming from another.

Quick sketches or *schematic drawings* are made to visualize ideas, space allocations, relationships, and important details that meet the program requirements. They are continuations of the bubble diagrams used in analysis, with greater refinement of proportion and the addition of character so that they begin to suggest how the space will feel (see Figure 8.24). Schematics are drawn in order to study the design problem from a variety of perspectives and seek the solution. The designer should develop as many ideas schematically as time will allow (see Chapter 8). Simultaneously, the designer formulates *concepts* about how the problem can be solved and states the principal ideas in a *concept statement*. Typically, as the problem is thought through, self-critique begins to limit the number of workable concepts and channel them in a few specific directions that can be further developed and refined. When finalized, the concept statement will become the continuous thread or dominant theme that is woven throughout the design.

PRESENTATION

One or more design concepts may become the focus of a *proposal* presented to the client. The proposal may be comprised of a preliminary floor plan (evolved from the schematics) showing furniture arrangement, color board with materials and finishes, an estimated budget, and additional sketches or a perspective drawing or full rendering, or even a model, slides, videotape, or computer-simulated walk through the space, depending upon the extent of the project (see Figures 8.26–8.31). Creative ability must be combined with technical, scientific, and humanistic knowledge to address all program objectives. At this point, the client may approve or alter the design, or reject it.

FINAL DESIGN DEVELOPMENT AND DOCUMENTATION

When a design concept has been agreed upon, the project moves on to greater documentation with the development of *construction drawings* and *specifications*. Final working drawings include plans, elevations, sections, and details along with all drawing notes necessary for the construction of the design. Specifications list and clearly describe all items to be acquired, and *schedules* (for paint, trim, wall coverings, doors, or windows) detail type and placement of each color, material, or style (see Figures 8.32 and 8.33). Every detail must be documented as a record of the life of the project. The design should be checked to verify that all program objectives have been met, a continuous evaluation measure.

When approved, construction drawings, specifications, and a time frame for completion of the project become a part of the written agreement or *contract* to provide design services entered into with the client.

IMPLEMENTATION: CONSTRUCTION AND INSTALLATION

Next the designer begins the realization of the design. If necessary, *bids* are sought for various aspects of the project. All purchases are made, orders are placed, and when received, goods are inspected and marked as to project and placement. Damaged goods are repaired or reordered. Another *critical path* or schedule of events is developed to coordinate work to be done in proper sequence and to ensure completion of the job on time. Carpenters, plumbers, electricians, sheetrockers, painters, tile and carpet layers, paperhangers, and drapery installers must be choreographed so as not to interfere with one another.

The designer must visit the project site regularly during the execution of the design to check on quality of workmanship as it progresses, give additional guidance to subcontractors, and resolve any problems that occur. A *punch list* is made of all details that must be finalized with the contractor or subcontractors. Finally, when all construction is complete, movable furnishings are installed, again with the designer coordinating and observing, and accessories are placed. The details that complete the job are often as important to the project's success as the overall design once the client begins to experience and utilize the space.

EVALUATION

The responsible designer follows up on the completed job to measure the success of the design solution. To determine how effectively the design functions and meets the goals of its users, the designer should evaluate the project at intervals of approximately six months, one year, and two years. This measure of user satisfaction or user-environment fit (ergofit) provides the designer with an opportunity to make adjustments or revisions as needed to improve the project and to increase professional knowledge for future projects. Whether conducted formally or informally, the post-occupancy evaluation (POE) is an important final step in the design process, focusing on the people who subjectively use and experience the space rather than on the designer who objectively planned it. Feedback is of vital importance for the designer's continued professional growth and development. Without evaluation, the designer lacks a measure of truly meaningful success in meeting human needs in the environmental context.

Career opportunities in interior design have multiplied as the profession has become more diverse, complex, and technical during this century. The scope of services has been both (a) broadened to reflect this increasing diversity and (b)

more explicitly defined by professional groups to describe what a professional interior designer is qualified to do. At the same time, design education and practice has developed a methodology for the process of design to make its complexities more manageable and to reflect a professional and responsible approach to problem solving.

NOTE TO THE TEXT

 "Interior Design as a Profession" (Richmond, Va.: Interior Design Educators Council, 1982).

REFERENCES FOR FURTHER READING

ADA Compliance Guidebook: A Checklist for Your Building. Washington, D.C.: Building Owners and Managers Association (BOMA) International, 1992.

Altman, Irwin. The Environment and Social Behavior: Privacy, Personal Space, Territory, Crowding. Monterey, Calif.: Brooks/Cole Publishing Company, 1973.

Ballast, David K. Interior Design Reference Manual. Belmont, Calif.: Professional Publications, Inc., 1992.

Hall, Edward T. The Hidden Dimension. New York: Doubleday, 1966.

Hartwigsen, Gail Lynn. Design Concepts: A Basic Guidebook. Boston: Allyn and Bacon, 1980, unit 1.

Kilmer, Rosemary and W. Otie Kilmer. *Designing Interiors*. Fort Worth: Harcourt Brace Jovanovich College Publishers, 1992.

Knackstedt, Mary V. The Interior Design Business Handbook. New York: Whitney Library of Design, 1988.

Koberg, Don and Jim Bagnall. *The Revised All New Universal Traveler*. Los Altos, Calif.: William Kaufmann, Inc., 1981.

Kriebel, Teresa M., Craig Birdsong, and Donald J. Sherman. Defining Interior Design Programming. *Journal of Interior Design Education and Research* 17(1):29–36, 1991.

Nielson, Karla J. and David A. Taylor. *Interiors: An Introduction*. Dubuque, Iowa: Wm. C. Brown Publishers, 1990.

Panero, Julius and Martin Zelnick. Human Dimension and Interior Space: A Source Book of Design Reference Standards. New York: Whitney Library of Design, 1979.

Pile, John F. *Interior Design*. Englewood Cliffs, N.J.: Prentice-Hall, Inc.; New York: Harry N. Abrams, Inc., 1988.

Piotrowski, Christine. *Professional Practice for Interior Designers*. New York: Van Nostrand Reinhold, 1989.

Pryweller, Joseph. Living History: The Challenge of Resurrecting Older Interiors. *The ASID Report*, May/June 1992, pp. 10-11.

Rapoport, Amos. House Form and Culture. Englewood Cliffs, N.J.: Prentice-Hall, 1969.

Siegel, Harry with Alan Siegel. A Guide to Business Principles and Practices for Interior Designers, new rev. ed. New York: Whitney Library of Design, 1982.

Sommer, Robert. Personal Space: The Behavioral Basis of Design. Englewood Cliffs, N.J.: Prentice-Hall, 1969.

Tate, Allen. *The Making of Interiors: An Introduction*. New York: Harper & Row, Publishers, 1987, Chapter 6.

Tate, Allen and C. Ray Smith. *Interior Design in the 20th Century*. New York: Harper & Row, Publishers, 1986, Chapter 6.

Veitch, Ronald M., Dianne R. Jackman and Mary K. Dixon. *Professional Practice: A Hand-book for Interior Designers*. Winnipeg: Peguis Publishers, 1990.

Wakita, Osamu A. and Richard M. Linde. *The Professional Practice of Architectural Working Drawings*. New York: John Wiley & Sons, 1984.

Historical Overview

PROGRESSIVE TRENDS IN THE NINETEENTH CENTURY

The Arts and Crafts Movement: 1860-1900

Currents Outside the Mainstream

ART NOUVEAU: 1890-1905

ELSIE DE WOLFE, AMERICA'S FIRST PROFESSIONAL DECORATOR

FRANK LLOYD WRIGHT

DESIGN FOR THE MACHINE AGE: 1900-1930

De Stijl: 1917–1931

The Bauhaus: 1919-1933

Miës van der Rohe

Le Corbusier

Art Deco: 1925-1940

MODERN DESIGN

Furnishings and Interiors

Domestic Architecture

POST-MODERN DESIGN AND THE PRESERVATION MOVEMENT

The appearance of today's homes reflects an evolution in architecture and design that began in the late nineteenth century, reached a critical turning point in the early twentieth, and has been refined and elaborated on since.

During these two centuries, Western civilization underwent a transformation more rapid and comprehensive than any that had occurred in its previous history. Scientific discoveries and the theories of evolution and relativity challenged fundamental concepts of humanity and the universe. Conflicts between classes, nations, and ideologies culminated in the Russian Revolution and two world wars. Perhaps the most important factor was the Industrial Revolution which, in creating vast new sources of wealth and power, destroyed the old order of society, shifted international relations, and profoundly affected the lives of people everywhere. Transportation by railroad, steamship, automobile, and airplane, as well as communication by telegraph, telephone, radio, and the visual media brought individuals throughout the world into closer contact with each other, important events, and commercial products. In prosperous nations, improved material conditions changed living patterns and social structure, and the middle class became the predominant consumers of the products of industry.

The arts of the home naturally reflected these fundamental changes in culture and society. The domestic styles of the late nineteenth and twentieth centuries exhibit a broad variety of aims and achievements that cannot easily be summarized. In general, however, both architecture and furnishings gradually abandoned the imitation of past styles. Along with this development, both areas of design evolved a new formal language that took full advantage of the materials and methods introduced by industry. The aesthetic principle that the form of any object should express its function, materials, and process of construction became predominant, but this did not prevent architects and designers from creating distinct personal styles.

Perhaps the single most important innovation in house design during this period was the rejection of the enclosed box in favor of the fluid interpenetration of spaces expressed in the open plan. The strength of new materials, such as iron, steel, and concrete, facilitated the distinction between structural support and the devices used to separate interior spaces, while allowing an ever-increasing expanse of glass. The development of electric lighting dispelled darkness indoors and central heating eliminated the need to contain heat in closed-off rooms in the last half of the twentieth century. Increased awareness of finite energy sources and our fragile environment have further altered interior design.

PROGRESSIVE TRENDS IN THE NINETEENTH CENTURY

The beginning stages of the Modern movement took the form of a conscious revolt against popular taste, as expressed in the poor quality and stylistic confusion found in household objects mass produced for commercial distribution. This reaction began in England, where early and rapid industrial progress had affected the crafts sooner than elsewhere. As early as the 1840s John Ruskin (1819–1900), popularizer of the Middle Ages and the undisputed arbiter of Victorian taste, condemned machine-made ornaments and the use of one material to simulate another as immoral "deceits." Similar sentiments were expressed by A. W. N. Pugin (1812–1852), who wrote in *Contrasts* (1836) that "the great test of beauty is the fitness of the design for the purpose for which it was intended."

THE ARTS AND CRAFTS MOVEMENT: 1860-1900

Like Ruskin and Pugin, **William Morris** (1834–1896) identified art with morality, rejected modern civilization, and looked to the Middle Ages as a model for society and art. Ruskin and Morris both held that machine production destroyed the "joy in work" that had led medieval craftsmen to create objects of true beauty. Condemning both industry and the capitalistic system, Morris advocated a thorough reform of both art and society on a Utopian medieval model. Household furnishings, he argued, should offer honesty of construction and genuineness of materials rather than stylistic imitation, applied details, and illusionistic effects.

Morris went beyond his predecessors, however, by putting his theories to the test of reality. In 1861 he established a firm, later renamed Morris & Co., that produced textiles, wallpaper, and furnishings. Morris was aided by a number of artists and craftsmen in the design and execution of the firm's products.

The results of this collaboration appear in a room created in 1867. Architect Philip Webb designed the walls and ceiling with their painted and molded-plas-

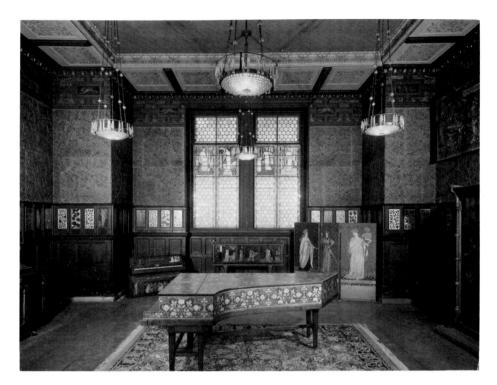

2.1 William Morris and Philip Webb designed the Green Room in 1867 as a refreshment area for the South Kensington (now Victoria & Albert) Museum in London. The interior contains furnishings designed and decorated by Morris, Webb, and others. (Victoria & Albert Museum, London. Crown Copyright)

ter decorations, while painter Edward Burne-Jones provided stained-glass windows and the small painted panels in the wainscoting. Morris himself designed the carpet and, with his wife, painted the folding screen with figures from a tale by Chaucer. Morris & Co. produced all the furnishings, including a grand piano and several massively proportioned cabinets whose sturdy construction and hand-painted, elegantly stylized decorations clearly identify each piece as the unique product of individual craftsmanship.

Morris dedicated much of his later life to the promulgation of his ideas in books and lectures, as well as through the example of his own pattern designs and the production of his firm. Unfortunately, the firm's handcrafted wares were inevitably more expensive than the debased products of industry and therefore failed to effect the broad reform on all levels of society that Morris had hoped to achieve. Nevertheless, he attracted a wide following among artists, architects, and critics, including Charles Locke Eastlake (1836–1906), whose *Hints on Household Taste* (1868) was especially influential in America. A number of guilds and associations were formed in the 1880s to consolidate the efforts of like-minded designers and attract public interest in their work. The Arts and Crafts Exhibition Society, founded in London in 1888, gave its name to the entire reform movement.

The general trend during the later nineteenth century, however, brought furnishings and interiors away from the heavy, rather medieval forms of Morris's circle toward lighter, simpler shapes with fewer historic references. A major factor in this development was the liberating influence of Japanese art, which became widely known, especially in the 1880s, through illustrated travel books and imported prints, scrolls, and pottery. Japanese homes typically contained no furniture as we know it, but their uncluttered spaciousness and refined detailing seemed like a breath of fresh air next to the dense clutter of the Victorian drawing room. The elegant linear patterns of Japanese prints contributed to the flatter, more stylized decorations applied to the later examples of Arts and Crafts furniture.

2.2 An oak writing desk with a pierced copper hinge (1896) illustrates the work of Charles F. A. Voysey, whose simple, light designs were widely copied by commercial firms of the day. (Victoria & Albert Museum, London. Crown Copyright)

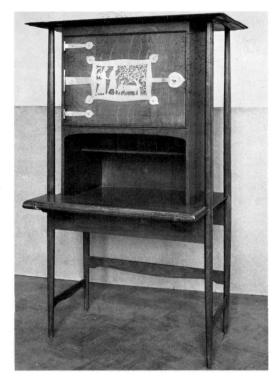

Charles F. A. Voysey (1857–1941) claims distinction as the most important of Morris's immediate successors. The houses he designed in the 1890s featured bright, uncluttered interiors, and his designs for wallpaper and textiles were the best of the day. Japanese influence contributed to the fresh, airy quality of Voysey's furniture. Voysey disliked ostentation, but the elegant flat patterns of his hinges and plaques revealed a unique talent for linear design.

In Vienna, **Josef Hoffmann** (1870–1956) and **Koloman Moser** (1868–1918) founded the *Wiener Werkstätte*, joining the reform movement in the production of handcrafted functional objects as total works of art. Although the theories and achievements of the Arts and Crafts movement had a profound effect on the Continent by the turn of the century, their earliest and most fruitful influence was in the United States.

Henry Hobson Richardson (1838–1886) developed a personal style of architecture using rough blocks of stone in thick courses, round arches, and towers

2.3 The staircase from the R. T. Paine house in Waltham, Massachusetts, was built between 1884 and 1886 by H. H. Richardson. (*Photograph: Wayne Andrews*)

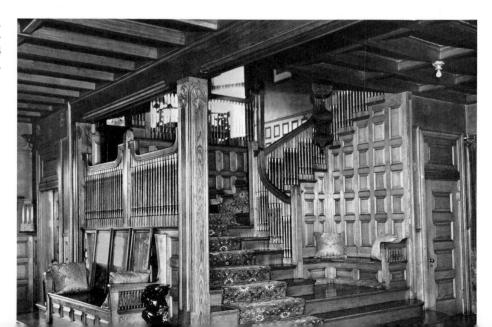

recalling the Romanesque churches of medieval Europe. His houses featured exteriors of local stone or weathered wooden shingles that harmonized with the natural setting. The size and placement of windows accommodated internal need rather than external regularity, and interiors followed an asymmetrical plan with a free flow of space around the entrance hall and stairway. His interiors reveal an emphasis on the warm attraction of expertly crafted woodwork. His interpenetration of spaces, as well as built-in furniture, anticipates the work of Frank Lloyd Wright.

The reform movement in America gained widespread popularity among the middle classes through the designs and publications of **Gustav Stickley** (1848–1942). After a trip to the European Continent and England, where he met Voysey, Stickley returned to New York and introduced a line of "Craftsman" furniture whose severely rectilinear construction of thick pieces of wood, usually oak, emphasized honest joinery, simplicity, and massive solidity. This popular type of furniture, called **Mission Style**, was very compatible with Frank Lloyd Wright's Prairie houses and the furnishings he designed for them (see pp. 29–31). From 1901 until 1916, Stickley published *The Craftsman*, a magazine that served as the forum of progressive design and gave its name to the American reform movement.

In California, the brothers **Greene and Greene** designed bungalow homes that reflected the Craftsman tradition. Like Voysey and Wright, who was their contemporary, they were also influenced by Japanese art and architecture.

CURRENTS OUTSIDE THE MAINSTREAM

Even while Ruskin and Morris assailed the decline of quality in the household arts, at least two independent developments were taking place that in some degree fulfilled the ideals of the Arts and Crafts movement.

SHAKER HOMES The **Shakers**, a radical offshoot of the Quakers, came from England to the United States in the second half of the eighteenth century in order to pursue a communal, religious lifestyle. A strict but cheerful work ethic, a

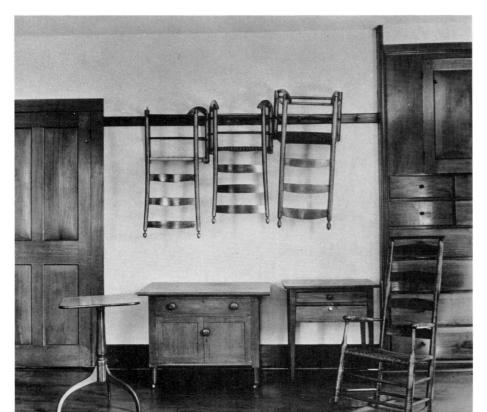

2.4 A desk designed by Gustav Stickley circa 1901 shows the restraint and forthrightness he advocated. (*The Brooklyn Museum. H. Randolph Lever Fund*)

2.5 Austere simplicity and fine workmanship characterize a Shaker interior of the late 19th century in Hancock, Massachusetts. Ladderback rocking chairs recall the furniture of the early Colonial period. (Shaker Museum, Old Chatham, N.Y. Photograph: William Winter)

passion for cleanliness and order, and a compulsion for efficiency all contributed to an austere approach to design. Shaker homes were characteristically clean and uncluttered—especially through the use of built-in cabinets and strips of pegs, on which not only coats but also chairs and other pieces of furniture were hung when not in use. Shakers frowned on the luxury of superficial embellishments, preferring economy of means and fitness of purpose as the standards of design. Furniture designs were those of the eighteenth century, modified and pared down to their essentials to achieve maximum efficiency and lightness. Every piece was fabricated with utmost care by craftsmen who saw their task as a religious exercise.

The Shaker experience bears a surprising resemblance to Morris's Utopian vision of communal handicraft villages, and yet the results were very different—and in fact more modern in appearance than the solid furniture and densely patterned interiors created by Morris and Webb. The functional but personal quality of Shaker homes continues to inspire the design of contemporary interiors (Figure 2.6).

MICHAEL THONET In his zeal to correct the vulgarities of most furnishings produced by industry, Morris condemned the entire system. Yet during his lifetime the principles of honest construction and genuine materials (if not handcraftsmanship) had already been reconciled with mass production in the elegantly functional designs of Michael Thonet (1796–1871), the inventor of the bentwood chair. Born in a small town on the Rhine, Thonet moved to Vienna hoping to make cabinets for great palaces. Instead, in the 1830s he invented a process for steaming and bending solid lengths of beechwood into gently curved shapes. The result was a type of sturdy, lightweight, and inexpensive furniture whose unprecedented popularity brought it to cafes, ice-cream parlors, and homes of all social and economic levels throughout Europe and the United States. Thonet's bentwood chairs were lightweight, making them easy to transport, and designed for easy assembly with just a few screws, making them the first mass-produced, easily packaged products to be shipped "knocked-down" for assembly at their destination. Slightly modified versions are still in production and are used for both commercial and residential interiors the world over. Thonet's rockers (see Figure 3.8) fared less well with modern functionalists, who objected to the swirling arabesques that now seem wonderfully suited to the chair's swaying motion. Thonet's firm and others have produced numerous variations on all of the originals, but these nineteenth-century designs have stood up remarkably well and still grace many contemporary homes.

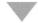

ART NOUVEAU: 1890-1905

The first truly original style since the French Rococo (1715–1774), **Art Nouveau** appeared almost simultaneously throughout Europe during the 1890s. Although it formed a transition between the nineteenth and twentieth centuries, the "Style 1900" bore little resemblance to the work that preceded or followed its brief popularity.

The explicit aim of Art Nouveau was to create a totally new formal language from which all traces of the past had been eliminated. The characteristic motif became the sinuous line, ending in a whiplash curve like the bud of a plant. Abstract but not geometric, the stylized forms expressed the process of natural growth without depending on literal representation.

All of these features appear in the *Tassel House* in Brussels, designed by the Belgian architect **Victor Horta** (1861–1947) and built between 1892 and 1893.

2.6 A contemporary bedroom reflects the pared down design of Shaker tradition. (Courtesy Ethan Allen Interiors)

Although probably influenced by Japanese prints and certain forward-looking English textile and book designs, Horta essentially created the style, in fully developed form, in a single building. In the stair hall, a slender iron column sprouting leaflike tendrils supports arched ceiling beams pierced by openwork. Sinuous, meandering ribbons in asymmetrical patterns appear everywhere: painted on walls, inlaid in floor mosaics, and molded in the iron handrail. Until now, iron had never been so frankly exposed except in bridges and engineering works. In Horta's hands, Art Nouveau combined industrial materials with handcrafted uniqueness, and functional expression with rampant decoration.

Art Nouveau was primarily a style of interior decoration that its leading practitioners extended to everything in the house, including furniture, fixtures, lamps, and doorknobs. **Hector Guimard** (1867–1942), the leading Art Nouveau architect of France, even designed special nailheads as part of a totally unified environment. Long, sinuous lines interrupted by bulbous knots flow over Guimard's furniture, creating a dynamic unity out of deliberately asymmetrical designs.

Unaware of developments in Brussels and Paris, Antonio Gaudí (1852–1926) independently evolved a similar style of greater power and individuality in Spain. Gaudí's style is more plastic and sculptural than the linear elegance of his French and Belgian contemporaries. The swelling masses of Gaudí's exteriors seem to be in constant motion, pulling interior spaces askew and leaving strange kidney-shaped, round-cornered windows that seem hollowed out by the wind. The same fluid shapes reappear in furnishings and fixtures, but not always for purely aesthetic reasons: the saddle-seated chairs of the *Casa Battlo* are molded for human comfort, and the "ears" projecting from the chairbacks provide convenient, if quite unnecessary, handles for moving them about.

The most prophetic exponent of Art Nouveau (and the only major one in Britain) was **Charles Rennie Macintosh** (1868–1928), a Scots architect whose early interiors in Glasgow in the 1890s paralleled the work of Horta. With Macintosh, however, the delicate swirls of linear pattern are held in place by a framework of slender verticals and a few tempering horizontals, resulting in light, airy

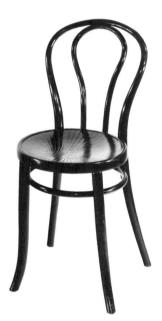

2.7 Michael Thonet first mass-produced this version of the "Vienna" Café Chair in 1876. A single section of bent wood forms the back and rear legs. With minor variations, it is still in production today. (Side chair; steam-bent solid beechwood, veneer seat, 33½ X 14½ X 15½"; seat height 18¼". Manufacturer: Gebrüder Thonet, Vienna, Austria. Collection, The Museum of Modern Art, New York. Purchase.)

- 2.8 (left) A profusion of dynamic curvilinear patterns overwhelms the stairhall of the Hōtel Tassel in Brussels, Belgium (1893), designed by Victor Horta. The earliest Art Nouveau building was also the first private residence to make use of iron, both as a structural material and as ornamentation. (Tassel House. Stair Case. Photograph courtesy, The Museum of Modern Art, New York.)
- **2.9** (right) An angled cupboard of triangular section (1904–1907) illustrates Hector Guimard's talent for asymmetrical designs united by flowing, continuous lines. The pearwood cupboard formed part of Guimard's total design of a house for Léon Nozal in Paris. (Musée des Arts Decoratifs, Paris)

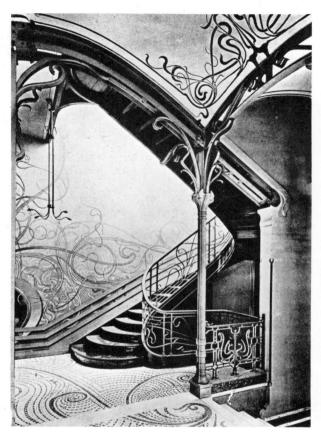

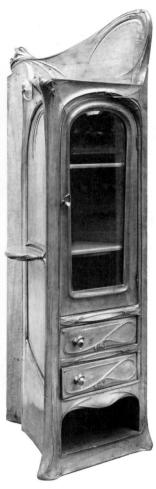

2.10 Bulging, sinuous forms abound in the dining room and furnishings of the Casa Battló, built in Barcelona from 1904 to 1906 by the Catalan architect Antonio Gaudi. *(Photograph: MAS)*

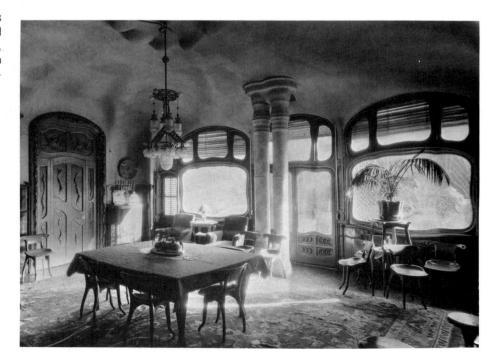

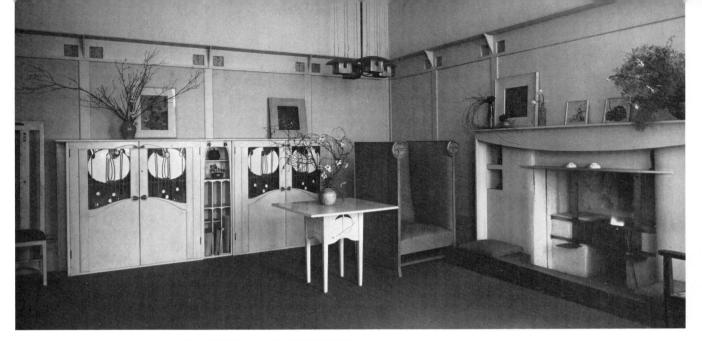

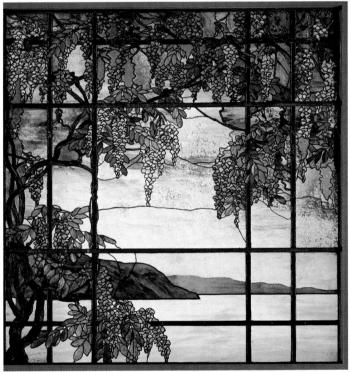

2.11 Charles Rennie Macintosh collaborated with his wife in designing the drawing room of their Glasgow apartment in 1900. The light, airy quality and rectilinear discipline of the interior recalls the work of Voysey (see Figure 2.2) and distinguishes Scottish Art Nouveau from the Continental movement. (Photograph: T & R Annan & Sons. Ltd.)

2.12 Louis Comfort Tiffany designed his own interpretation of Art Nouveau in stained glass windows such as "View of Oyster Bay" for the William Skinner House in New York. (From the Charles Hosmer Morse Museum of American Art Collection, Winter Park, Fla. Courtesy Charles Hosmer Morse Foundation. The Metropolitan Museum of Art.)

interiors with surfaces enlivened by evocative accents. His furniture was often builtin, but even his free-standing chairs defined spatial volumes through their tall, straight backs and lean, rectilinear shapes.

Art Nouveau had only two major practitioners in the United States. One was Louis Sullivan (1856–1924), the pioneer Chicago architect who developed a lush, florid brand of stylized naturalism in the ornament he applied to commercial structures. The other was Louis Comfort Tiffany (1848–1933). A leading designer and manufacturer of decorative art in metal and glass, Tiffany combined vibrant colors and asymmetrical decorative patterns in the lush trees and flowers of his lampshades and stained-glass windows, but he is equally well known for his exquisite Favrile glassware whose graceful, tapering shapes, translucent colors, and swirling forms seemed to arise naturally from the glass-blowing process.

ELSIE DE WOLFE, AMERICA'S FIRST PROFESSIONAL DECORATOR

In 1890, the publication of an article entitled "Interior Decoration as a Profession for Women," by Candace Wheeler, helped establish the career now known as interior design. Elsie de Wolfe (1865–1950) declared herself the first professional decorator in America at the turn of the century. Neither a craftsman nor a tradesman/supplier, de Wolfe was a supervising designer who made aesthetic and intellectual judgments independent of the artist, fabricator, or collector. Hence, she established herself as a professional in the practice of interior design.

Beginning with her own home in New York City in 1898, de Wolfe transformed typical Victorian interiors of American homes—dark and heavy and chaotic with clutter—into simple, elegant, light and airy rooms with eighteenth-century French Neoclassic furnishings and comfortable English country chintzes. She removed the confusion of pattern upon pattern and objects avidly collected and displayed as well as the oppressive dark colors, replacing them with simple plain surfaces and unified patterns, light colors (white, ivory, and beige), mirrors, and glass.

De Wolfe established her authority on decorating, broadened her influence, and publicized the light, comfortable Neoclassic style that was her trademark through a series of lectures in 1910, published articles during the next two years, and, finally, a book in 1913, *The House in Good Taste*. Thus the foundation of the interior design profession was laid.

American schools began offering courses in interior decoration early in the twentieth century and the profession began to expand. In 1913, Nancy McClelland (1876–1959) opened the first decorating department in Wanamaker's de-

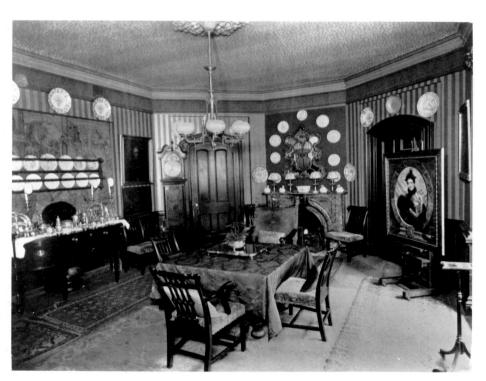

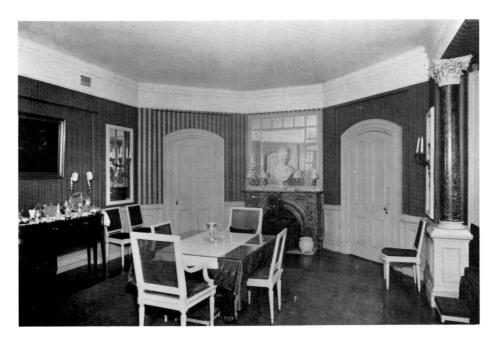

2.13b Two years later, in 1898, she redecorated the same room in the lighter and brighter style that she espoused, and started interior design on a new pathway. (Photograph: Byron, from the Byron Collection, Museum of the City of New York)

partment store in New York. Eleanor McMillen advanced the profession further when she opened McMillen Inc. in 1924, the first professional interior decorating firm in America. She first attended business and secretarial school to enable her to manage her business professionally. Using a company name, McMillen Inc., rather than her personal name, was a first.

Although each had his or her own personal stylistic preferences, in the tradition of Elsie de Wolfe, most American decorators espoused the re-creation of period rooms, first of European origin, then Colonial American and eclectic mixes. This academic Beaux-Arts formula of historicism continued in residential decorating for the first half of the century, long after the Modern design movement had reached the United States in architecture and industrial design, and has since been rediscovered in reaction to Modern design.

FRANK LLOYD WRIGHT

The series of houses built by Frank Lloyd Wright (1867–1959) during the first decade of the twentieth century represents the culmination of the Craftsman movement as well as the beginning of modern home design. Wright's *Prairie houses*, as he called them, incorporated many features of Richardson's and contemporary craftsman-style homes—opening one room off another, for example, and the use of unpretentious materials, as well as covered verandas placed around the house—but he expanded, refined, and integrated these elements into a coherent, powerful style. Interior and exterior formed a single entity in the Prairie house, with which Wright hoped to express the freedom of movement and wide open spaces of the American Midwest.

Trained in Chicago under Louis Sullivan, Wright developed the theory that architecture should be *organic*, that a building should "grow" from the inside out, as determined by function, materials, and site. Thus the fireplace, traditionally the focus of family life, became the central feature around which interior spaces were

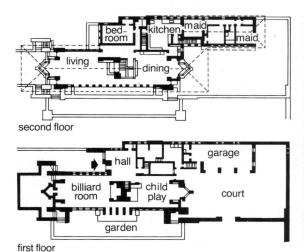

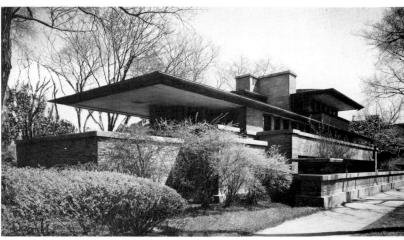

2.14 (left) The plan of the Robie house, Chicago, built by Frank Lloyd Wright in 1909, seems to grow outward from the centrally placed fireplace.

2.15 (right) The exterior of the Robie house expresses the centrality of the hearth inside. The broad, sweeping horizontals and interlocking masses and voids epitomize the "Prairie" style of Wright's early career. (Photograph: Hedrich-Blessing. Courtesy Chicago Historical Society)

planned informally to allow free circulation within the house and between the interior and the outdoors. Unexpected light sources and variations in ceiling height—reaching two stories at least once in most of Wright's houses—gave each area a distinct atmosphere without interrupting the continuous flow of space. Voids and solid elements interacted to create a dynamic sense of movement throughout the interior. In addition to skylights and clerestories (often partially concealed), windows appeared in continuous horizontal bands held firmly in place between the ceiling and a common sill. Contrasting materials, the accentuation of structural features, and geometric detailing provided a decorative scheme fully integrated with the architecture. Much of the furniture was built-in, but Wright specially designed even the free-standing pieces of each house.

Wright's position as the bridge between the nineteenth-century reform movement and the twentieth-century acceptance of industrial technology was best expressed by the architect himself in the title of a lecture he delivered in 1901: "The Art and Craft of the Machine." "The machine is here to stay," Wright told his audience. "There is no more important work before the architect now than to use this normal tool of civilization to the best advantage." Unlike the Bauhaus leaders

2.16 In Taliesin East (1925) in Spring Green, Wisconsin, designed by Frank Lloyd Wright, each surface that encloses the living room is clearly defined by its material, shape, and direction, but all are interwoven into a complex flow of space. (*Photograph: Ken Hedrich, Hedrich-Blessing. Courtesy Chicago Historical Society.*)

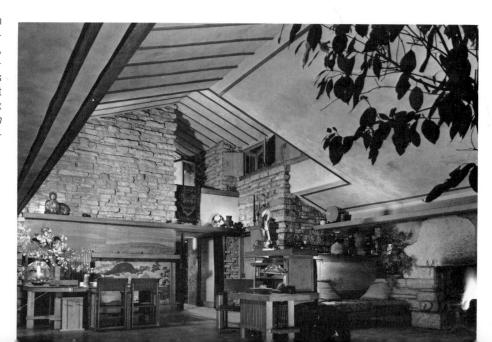

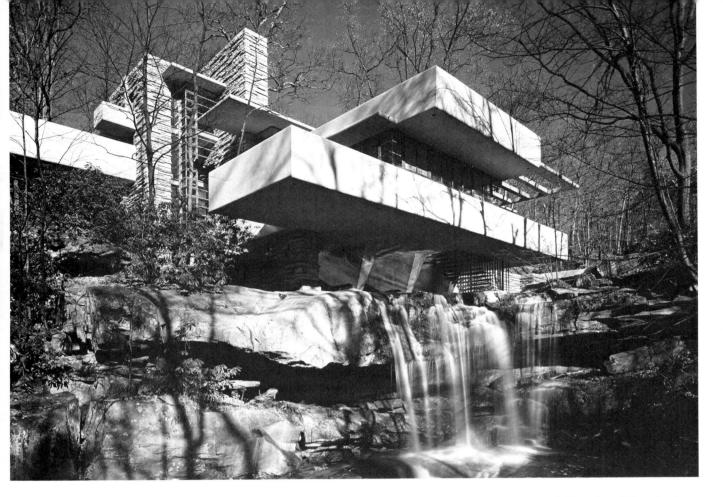

of the 1920s and 1930s (see pp. 32–34), however, Wright never *celebrated* the machine. Throughout his long career, which continued with great vitality and new innovations until his death in 1959, Wright maintained a romantic love of nature. Even when responding to the Bauhaus-born International Style, he continued to exploit the varied colors and textures of natural materials and to integrate his houses with the contours of their natural settings. His *Falling Water*, built on the banks of a rushing stream, admirably fits his definition of a good building as "one that makes the landscape more beautiful than it was before."

Wright was too individualistic to become a teacher in the usual sense, but he trained many capable assistants who continued his principles in careers of their own, particularly in California and the Midwest. Followers and imitators spread the master's influence far and wide—and sometimes rather thin, as in the "ranch-style" homes built by developers in the 1950s and 1960s. Many aspects of the Prairie houses passed into general currency during this period.

2.17 Falling Water, the home built for Edgar J. Kaufmann in Bear Run, Pennsylvania, was designed by Frank Lloyd Wright in 1936. Cantilevered concrete balconies and thick, rough walls in local stone paraphrase the landscape below and around the house. (Photograph: Bill Hedrich, Hedrich-Blessing. Courtesy Chicago Historical Society.)

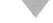

DESIGN FOR THE MACHINE AGE: 1900-1930

The maturity of modern architecture in the 1920s grew directly from the functionalist trend that emerged in Europe, partly in reaction to Art Nouveau, during the early years of the twentieth century. This trend began in 1907 in Dresden with the formation of the *Deutscher Werkbund* which combined modern materials and machine production with the Arts and Crafts standards of workmanship, a major step toward the **Modern** movement. In Austria, Viennese architect Adolph Loos (1870–1933) succinctly expressed his attitude toward decoration in the title of his

essay "Ornament and Crime" (1908). Other architects in France and Germany pioneered in the structural and expressive use of reinforced concrete, steel, and glass, creating several exteriors free of historic reminiscences.

DE STIJL: 1917-1931

A decisive contribution to Modern design issued from a group of Dutch artists and architects associated with the magazine *De Stijl* (Style), founded in 1917. Promising a "radical renewal of art," the painters of the group, which included Piet Mondrian, developed a totally nonrepresentational mode, restricting the elements of painting to an abstract arrangement of lines and geometric shapes on a flat surface, using only black, white, and the primary colors of red, blue, and yellow.

Gerrit Rietveld (1888–1964), a furniture designer turned architect, translated these principles into three-dimensional form as early as 1917 in his *Red-Blue Chair*. The chair's rectilinear structure, flat planes of wood, and simple joinery recall the furniture of Macintosh and Wright, but the emphasis here is very different. Paint and varnish conceal the natural grain of the wooden members, whose sharp edges suggest a machine aesthetic rather than the individual craftsmanship that actually produced the chair. Intersecting elements almost always continue beyond the point of intersection, as if they could be extended infinitely into the surrounding space. The slanting planes of the seat and back seem to be the only concession to human comfort. Yet for all its freshness and absolute renunciation of past modes, the Red-Blue Chair remains an overinvolved exercise—a rigid demonstration of an aesthetic doctrine. It was left to the Bauhaus to create a modern mode of design flexible enough to meet the needs of a complex technological society.

THE BAUHAUS: 1919-1933

Certainly the single most influential force in shaping all of Modern architecture was the **Bauhaus**, the German state school of design. **Walter Gropius** (1883–1969) founded the school in Weimar in 1919 and later moved it to a new building complex of his own design in Dessau.

Initially devoted to arts and crafts in the tradition of the English reform movement, the Bauhaus curriculum was soon revised to place an emphasis on working with the machine in the design of buildings, furniture, textiles, and household articles. The chief aesthetic principle was to simplify the design of any object, so that no unnecessary elements would distract from the pure statement of function, material, and the process of industrial fabrication. For more than half a century the Bauhaus education influenced design.

Attracting to its faculty artists, architects, craftsmen, industrial designers, and leaders of industry, the Bauhaus remained the center of European innovation until the Nazi regime forced its closing in 1933. After two generations of reform and debate, "Arts and Crafts" at last gave way to the "new unity" of art and technology. The Modern movement spread to America and gained wide acceptance in business and industry through the 1950s.

One of the earliest expressions of design for industry appeared in the invention of chairs made of tubular steel by the Hungarian architect-designer **Marcel Breuer** (1902–1981). Breuer's tubular armchair of 1927–1928 reflects its inspiration in the handlebars of a bicycle as much as in the formal precedents of De Stijl, but its wholehearted exploitation of resilient, lightweight steel marks a pivotal moment in the history of design. Canvas or leather straps stretched across the metal tubes provide seat, back, and armrests; the wide stance of the chair ensures a stability surprising in a piece so easy to move. Chromium plating creates a gleaming, smooth surface that celebrates the precision of industrial production.

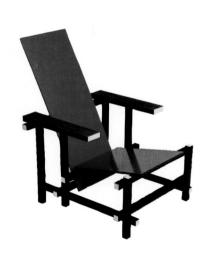

2.18 Gerrit Rietveld, of the De Stijl group in Holland, created the Red-Blue Chair in 1917 as a deliberate break with traditional furniture design. (Stedelijk Museum, Amsterdam.)

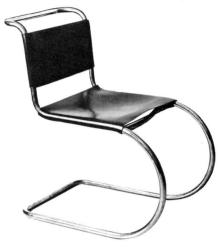

Breuer also designed a much simpler Machine-Age stool—an inverted **U** in tubular steel surmounted by stretched canvas or a block of wood—which was mass-produced in 1926 for Gropius's new Bauhaus buildings in Dessau. In the next year, another Bauhaus member, **Ludwig Miës van der Rohe** (see below) adopted Breuer's use of tubular steel in the first "cantilever chair," in which a single, continuous length of steel was arched upward from the floor to provide resilient support in a simple, graceful design. The excessive springiness of Miës's chair had to be corrected in later versions, however, and the leather or woven-cane seat and back could not be attached by machine. Breuer's more practical version of the cantilever chair, the *Cesca*, appeared in 1928 (see Figure 3.12). The rectilinear **S** shape of the tubular support offered less bounce and did not encumber the sitter's legs, while the separate attachment of seat and back allowed efficient mass production and clearly expressed a distinction between the parts. The lightness, clarity, and comfort of Breuer's chairs have ensured their continuing popularity.

MIËS VAN DER ROHE

The most innovative German architect of the 1920s was Ludwig Miës van der Rohe (1886–1969), who served as director of the Bauhaus from 1930 to 1933. More than any other individual, Miës crystallized the machine-oriented aesthetic of the Bauhaus and spread its ideals throughout Europe and America in what came to be recognized as the **International Style.** As early as 1919, Miës designed a project for a thirty-story skyscraper with floors cantilevered from a central core and enclosed entirely in glass—a scheme boldly forecasting buildings of the 1950s.

Miës van der Rohe's famous statement that "less is more" epitomized the architect's working method of reducing an object to its essentials and then refining the design through fastidious attention to every detail. Thus the expression of structure became the focus of Miës's architecture, with steel columns, slablike roofs, and nonsupporting walls all clearly distinguished and arranged on a rectangular grid plan.

Miës's early masterpiece was the *German Pavilion* designed for an exhibition in Barcelona (1929), which he adapted as a model house shown in Berlin in 1931. Under a low, flat roof resting on thin steel columns, free-standing walls divide the interior space into loosely defined areas. Those walls, parallel and perpendicular to each other, extend onto the flat site in an abstract arrangement recalling the compositions of De Stijl. The open plan also recalls Wright, but Miës strove to

- **2.19** (left) The first tubular steel chair was designed in late 1927 or early 1928 by Marcel Breuer, then the 23-year-old master of the Bauhaus furniture workshop. Breuer's tubular armchair remains one of the most popular furnishings of contemporary homes. (Armchair, Model B3. Chromeplated tubular steel, canvas, 28½ X 30½ X 27¾". Manufacturer: Standard-Möbel, Germany. Collection, The Museum of Modern Art, New York. Gift of Herbert Bayer.)
- 2.20 (right) Slow, graceful curves and wide proportions characterize the earliest cantilever chair, designed by Ludwig Miës van der Rohe in 1927. The forthright clarity and refined elegance of the design are paralleled in Miës's buildings. (Side chair. Chromeplated tubular steel and leather, 31½ X 19½ X 25½"; seat height 17¾". Manufacturer: Berliner Metallgewerbe Joseph Muller, Germany. Collection, The Museum of Modern Art, New York. Gift of Edgar Kaufmann, Jr.)

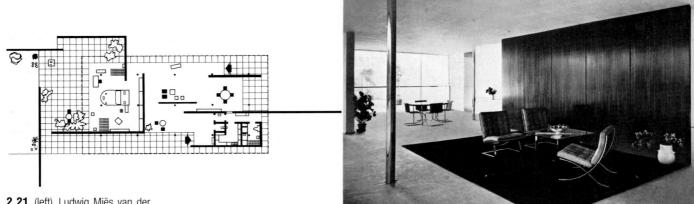

2.21 (left) Ludwig Miës van der Rohe summed up his architectural principle in a model home erected for the Berlin Building Exhibition held under his direction in 1931. The plan is extremely open but zoned for different activities. (Plan. Ink on illustration board, 30 X 40". Collection, Miës van der Rohe Archive, The Museum of Modern Art, New York. Gift of Ludwig Miës van der Rohe.)

2.22 (right) Inside the Exhibition House, living and dining areas are discreetly defined within the continuous flow of open space. The furniture, all designed by Miës, includes a *Barcelona* chair (1929), a low glass-top table, two *Tugendhat* chairs (1929) similar to the *Barcelona*, and four cantilever chairs (1926) grouped around a circular dining table. (Photograph courtesy, Miës van der Rohe Archive, The Museum of Modern Art, New York.)

give his interiors a sense of static, classical repose rather than dynamic contrasts. The structure was meant to recede from view, to act as the neutral enclosure of a strictly ordered volume. Steel construction allowed supporting posts to be widely separated so that interior spaces became broad, uncluttered, and infinitely adjustable. Wide, expansive windows, reaching to the logical boundaries of floor and ceiling, divided interior from exterior space with minimal emphasis. Living functions were sparsely defined by a single wall or a strategically placed carpet.

Miës designed every detail of his houses, including all the chairs and tables visible in Figure 2.22. In the foreground is his *Barcelona* chair, produced for the 1929 Barcelona pavilion. Perfectly square in plan, the chair's large scale reflects the ample proportions of Miës himself, but the gentle curves of its X-shaped supports are a perfect expression of luxurious comfort. No other chair designed since the Empire period of the 1800s rivals the Barcelona's monumental dignity, and it continues to hold a place of honor in today's homes.

LE CORBUSIER

Charles Edouard Jeanneret-Gris (1888–1965), commonly known as Le Corbusier or by the nickname Corbu, had the benefit of broad exposure to the work of many early twentieth-century masters. Although never a member of the Bauhaus, Le Corbusier participated directly in the creation of the International Style during the 1920s through the Art Moderne movement in France which also endorsed Machine-Age Modernism. Corbu possessed Gropius's and Miës's vision of the architect as a designer for all of society, as well as their concern for incorporating industrial technology in a new architecture. Moreover, he brought a painter's sense of abstract visual form to the creation of a monumental style of building.

In 1919 and 1920, contemporary with Miës's projects for glass skyscrapers, Le Corbusier developed a program for domestic architecture in what he called the *Citrohan* house, a prototype single-family dwelling planned as part of an urban settlement. The prototype had several specifications, including a two-story living area, lit by a tall "window-wall" and backed by a lower room under a balcony. This use of vertical space has returned to prominence in many contemporary homes.

Except for this feature, the salient characteristics of the Citrohan prototype appeared in the masterpiece of Corbu's early career, the *Villa Savoye*, built between 1929 and 1930 in the Paris suburb of Poissy. Constructed of reinforced concrete, the house is raised off the ground on stilts or *pilotis*, freeing the ground for circu-

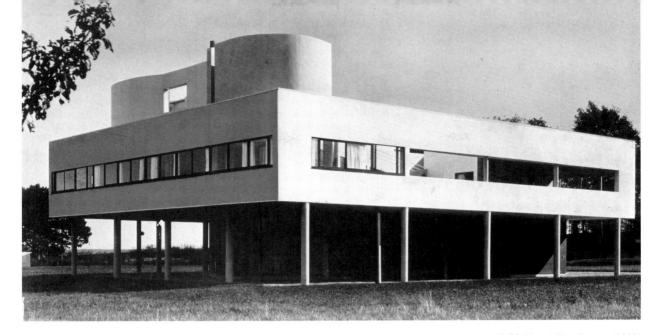

lation (Corbu explained) while a roof garden "recaptures" the open space covered by the structure. Frame construction frees the enclosing walls to be treated as geometric shapes dominated by long, horizontal "ribbon" windows. The wide spacing of concrete structural supports also allows for an open plan in the interior, here treated with living areas grouped around a sunken patio.

Le Corbusier called the modern house a "machine for living in." Equally opposed to Wright's romantic integration of house and landscape and Miës's rationalist ideal of neutral, reticulated space, he saw architecture as a heroic statement—an assertion of human will on the indifference of nature.

Le Corbusier's interiors were like hollow cubes, enclosed by geometric solids and sometimes enlivened by pastel colors and protruding sculptural shapes. He furnished several interiors with the aid of his brother, Pierre Jeanneret, and furniture designer cousin, Charlotte Perriand. Together they designed the elegant built-in storage walls and three very different chairs installed in a remodeled home (Figure 2.24). The *Basculant* armchair (right) and form-fitting chaise longue (left) both had tension springs to provide resiliency, while the *Grand Comfort* cube chair (rear) consisted entirely of stuffed leather pillows contained in a steel cage. Though less rational and more expensive than the chairs of Breuer and Miës (particularly

2.23 The Villa Savoye (1929-1930) in Poissey-sur-Seine, near Paris. France. illustrates Le Corbusier's "heroic" approach to architecture. Raised by a dozen pilotis above the ground-level garage and fover, the main part of the house is on one level, enclosed on three sides around an open patio. A ramp leads from the patio to a rooftop garden, which is partially protected by a curving windscreen. (Le Corbusier and Jean-Pierre. Photograph neret. courtesy, The Museum of Modern Art. New York.)

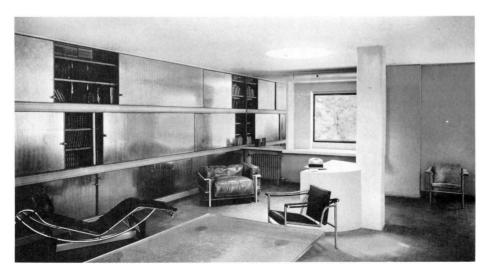

2.24 The interior of the living room in an old home (Church House) in Ville d'Avray, France, was remodeled in 1928–1929 by Le Corbusier and Pierre Jeanneret. Le Courbusier and Charlotte Perriand together designed the chairs, glass-top table, and built-in storage wall. (Photograph courtesy, The Museum of Modern Art, New York)

2.25 Rough textures and vigorous sculptural forms energize the interior of the Maison Jaoul, designed by Le Corbusier in 1952 and built at Neuilly, outside Paris, between 1954 and 1957. Changing ceiling heights and vaults of unequal width dramatize the interior space; below, a long shelf is cantilevered from the wall and extended across the windows. (Photograph: Lucien Hervé)

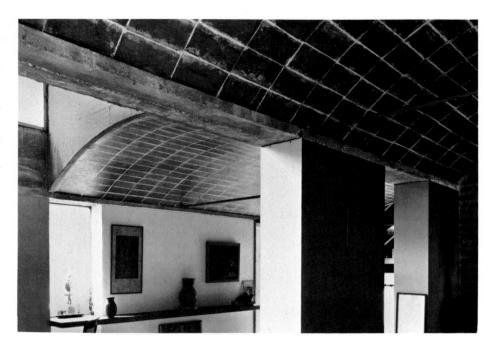

when upholstered in black and white ponyskin), this sophisticated Machine-Age furniture remains perfectly at home in the most contemporary surroundings (see Figure 1.10).

Beginning in the 1930s, Le Corbusier turned away from the taut, white, planar surfaces of the Villa Savoye toward a more sculptural conception of architectural form, with an increasing interest in the plastic moldability and rough textures of exposed reinforced concrete. Although primarily concerned with city planning and large-scale projects, Corbu built a few smaller houses, in which vigorously shaped spaces and masses were enlivened by contrasting surfaces of concrete, brick, tile, and stone. Yet he did not abandon his original "heroic" approach in favor of a Wrightian integration with nature. Le Corbusier's exteriors emphasized the weight and mass of concrete in thick, heavy rectangles, protruding geometric shapes, and a balanced contrast between solids and voids that turned buildings into giant abstract sculptures.

Le Corbusier's sculptural manipulation of reinforced concrete represented an essential departure from the International Style of his earlier years, and this new approach was soon taken up by other architects.

ART DECO: 1925-1940

The popularization of modern trends in design took the form of the **Art Deco** style of the later 1920s and 1930s. Named after the *Exposition Internationale des Arts Décoratifs*, held in Paris in 1925, Art Deco quickly reached the general public through the efforts of department stores in Europe and America. On the whole, this "modernistic" style applied new materials and geometric decorations to traditional classical forms more acceptable to popular taste than the austere designs of the Bauhaus. Shiny metals, exotic and glossy lacquered woods, polished stone, glass, and some of the newly invented plastics were used in various, usually contrasting combinations. Geometric shapes, especially the triangle, appeared in dynamic patterns, including zigzags, thunderbolts, electrical currents, and sunbursts. Essentially a symbolic style, Art Deco celebrated mechanistic progress in much the same

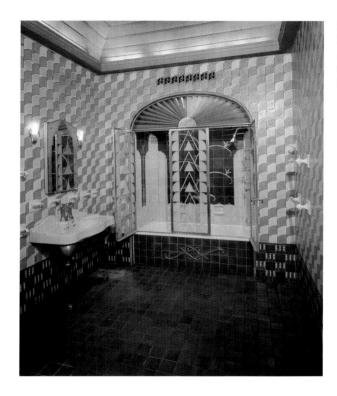

2.26 Ceramic tile, glass, and gold plate create a dazzling display of Art Deco modernism in an executive office suite bathroom, designed by Jacques Delamarre, in the Chanin Building, New York (1929). A sunburst appears above the shower doors, which present a dynamic pattern of triangles, quadrants, and semicircles. (*Photograph: Angelo Hornak*)

way that Art Nouveau had expressed organic growth. Although responsible for several stunning creations, the style lacked the theoretical foundation that allowed Bauhaus and later designers to integrate function, materials, and process in designs of more lasting value.

During the 1930s, "airflow" patterns and "streamlining," suggesting the speed and power of modern machines, covered not only automobiles but everything from skyscrapers to easy chairs. In America, the profession of **industrial design** had developed in the 1920s and, closely related to their work for the transportation industry (trains, ocean liners, airplanes, and automobiles), industrial designers are credited with developing the **Streamline Style**.

The spread of "modernistic or streamline styling" coincided with the introduction of planned obsolescence in the design of automobiles and home appliances. Art Deco has often been rediscovered, most recently during the 1960s and early 1970s when the influence of the past began to be recognized again and historicism was adapted to current design. Interest has been revived in designs by Eileen Gray (1879–1976), an Irish-born designer whose work reflected the exoticism of French Art Deco combined with the Machine Age Modernist trend of the 1930s. She was one of the first women to gain attention at a time when design was dominated by men.

MODERN DESIGN

The achievements of the early twentieth century were gradually refined, expanded, and popularized during the period after 1930. Despite the persistence of revivalistic modes, industrial materials, simple forms without applied ornament, and direct functional expression without reference to historicism became standard

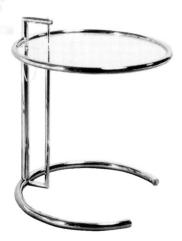

2.27 Eileen Gray's tubular steel and glass table illustrates the adoption of Machine Age Modernism in its parallel lines and sleek modern materials. (Courtesy Images of America)

features of architecture and household furnishings. Nevertheless, as modern concepts of design gained wider currency, the Bauhaus approach was moderated and made more flexible. Thus, in both architecture and furnishings, less geometrical shapes and more traditional materials such as wood and brick became accepted alongside the polished chrome and machinelike severity of the 1920s. The development of plastics provided new materials whose potentials were at first slow to be exploited, then widely used, and are still being explored today.

FURNISHINGS AND INTERIORS

Renewed interest in wood and in less rectilinear shapes characterized furniture design after 1930. The persistence of strong craft traditions and the late arrival of industrialization contributed to the high quality of Scandinavian furniture, which became extremely popular throughout the world during the thirties, forties, and fifties. From the outset, first-rate designers collaborated with industry to create mass-produced **Scandinavian Modern** furniture of almost handcrafted quality. Finnish architect **Alvar Aalto** (1898–1976) combined simplicity and lightness with the natural grain and color of laminated birch in a series of chairs and stacking stools designed from 1933. Native design traditions inspired new variations by a number of other designers in Denmark and Sweden such as Finn Juhl, Hans Wegner, and Karl Bruno Mathsson.

The polished metal frames and geometric forms of the Bauhaus lost their supremacy in other countries, too. Even Marcel Breuer turned to form-fitting bent plywood in a chair he designed in 1935.

American furniture design rose to prominence through the work of **Charles Eames** (1907–1978) and **Eero Saarinen** (1910–1961), who collaborated on a prizewinning chair design of 1940 in which back, seat, and arms formed a single, multicurved shell of bent plywood. Though produced only in a modified version, this prototype formed the basis for the later work of each individual. Eames's side chair of 1946 combined the best qualities of industrial and natural materials. Metal rods provide a strong, lightweight support, while seat and back are molded for human comfort in walnut plywood. Rubber disks joining the two elements add resilience. A similar combination of materials, together with thick upholstery, appeared in Eames's 1956 lounge chair and ottoman (see Figure 22.15).

2.28 (left) Alvar Aalto's lounge chair of laminated birch and webbing possesses the lyric simplicity that characterized his designs. (Courtesy ICF Inc. Photograph: Peter Paige.)

2.29 (right) Many of the characteristics of wood—such as tensile strength, slight resilience, and ability to be shaped and molded—are superbly demonstrated in this chair designed by Charles Eames in 1946. (Side Chair. Model DCM. Molded walnut plywood, steel rod, rubber shockmounts, 29½ X 20½ X 21½". Manufacturer: Herman Miller Furniture Company, Zeeland, Michigan. Collection, The Museum of Modern Art, New York. Gift of the manufacturer.)

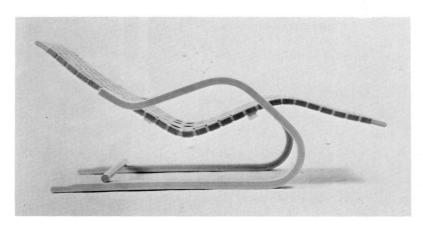

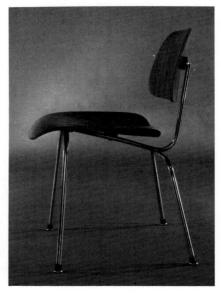

Saarinen developed his and Eames's original scheme into a set of single-pedestal tables and chairs, in which the seat, back, and arms all formed part of a unified, curving shape of molded plastic. As we have seen elsewhere, the almost infinite flexibility of plastic has made this material a major focus of contemporary design innovation. Plastic, fiberglass, and foam have been responsible for a number of new furniture designs since the late 1950s, ranging from Arne Jacobsen's *Egg* and *Swan* chairs, to Eero Aarnio's *Gyro* chair, to the *Sacco* or bean-bag chair by Gatti, Paolini, and Teodoro, and soft structural foam furniture without rigid frames.

During the 1940s, the Knoll Furniture Company and the Herman Miller Company were founded and began to produce Modern furniture. The Knoll Planning Unit, headed by Florence Knoll, teamed with the architectural firm of Skidmore, Owings & Merrill (SOM) in the new field of **corporate office design** which boomed in the 1950s and 1960s when development of a "corporate image" became important. This identity was reflected in functional interiors that came to be known as the corporate style. The Herman Miller Company produced Charles Eames's furniture designs as well as those of Isamu Noguchi and George Nelson while Knoll Associates, as it was renamed, produced designs by Eero Saarinen, Florence Knoll, Miës van der Rohe, Marcel Breuer, and Harry Bertoia, and, more recently, Richard Meier, Ettore Sottsass, and Robert Venturi.

Through the 1950s and 1960s, many prominent designers, such as Billy Baldwin (1903–1984) and Angelo Donghia (1935–1985), continued to pursue a variety of romantic and nostalgic revivals and historical combinations in the decorator

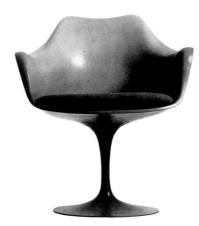

2.30 A graceful continuity of line enhances the single-pedestal chair designed in 1958 by Eero Saarinen, an American born in Finland. Seat, back, and arms, made of molded plastic reinforced with fiberglass, rest on a base of cast aluminum. (Courtesy The Knoll Group)

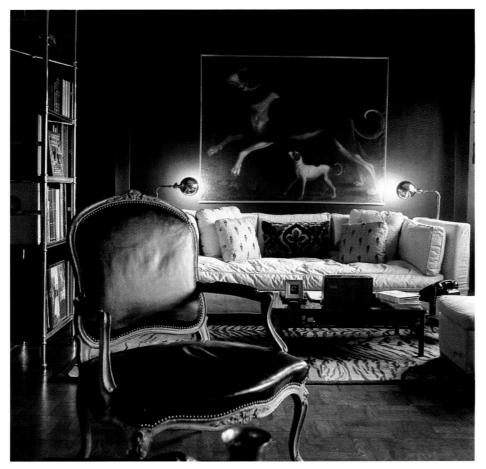

2.31 The late Billy Baldwin designed this eclectic apartment interior for himself, combining his signature dark walls with white upholstery, a tubular brass bookcase, Chinese table, and traditional French provincial chair. (*Photograph: Horst*)

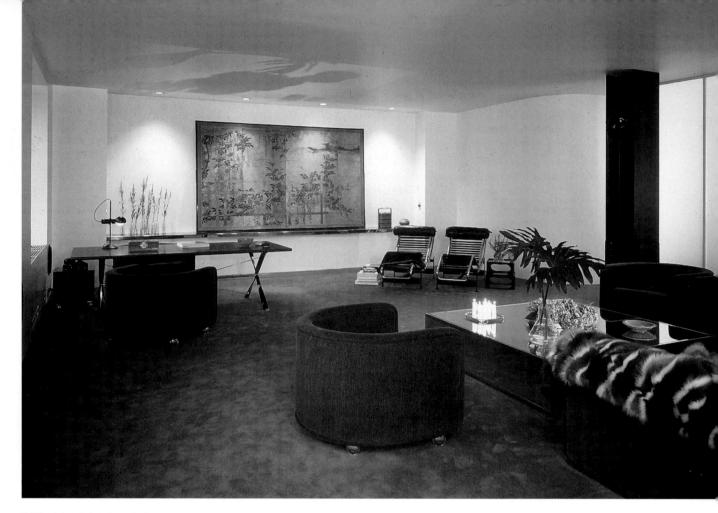

2.32 (above) Interior designer Ward Bennett has placed furnishings sparingly in this apartment, each carefully juxtaposed in space like objects in a museum. The smooth geometric forms of Machine Age furnishings and plain surfaces contrast with the natural textures of plants and animal hide. (Photograph: © Norman McGrath)

2.33 (right) An example of the industrial utilitarian aesthetic, this Los Angeles home employs exposed concrete and steel in a spacious bathroom. The stainless steel bath was custom built by Simon Maltably. Brian Murphy, architect/designer. (Photograph: Tim Street-Porter)

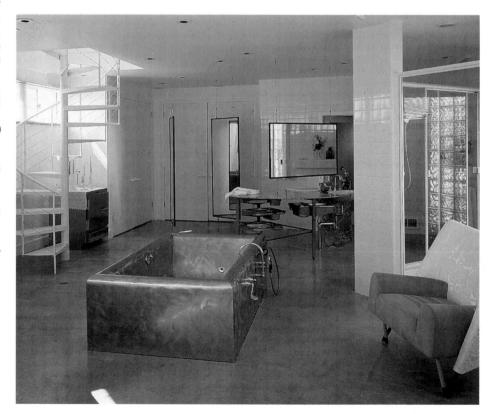

tradition of the early Elsie de Wolfe style. In California some designers worked toward a regional **vernacular style** featuring an informal lifestyle, natural textures, and eclecticism. Other designers, including Edward Wormley who designed for the Dunbar Furniture Company, were transitional, producing **Contemporary** furniture which mixed traditional forms with Modern design to appeal to the public taste. Still others, such as Joseph Paul D'Urso (b. 1943) and Ward Bennett (b. 1917), were leading a trend toward the simple sparseness of **Minimalism** which became popular in the mid-1960s and 1970s as a refinement of the International Style.

With the advent of the home office and the **High-Tech** electronic influence, anthropometrically designed office and industrial furnishings found their way into the home in the 1970s industrial utilitarian aesthetic. A **craft revival** also came about in the 1970s as a reaction to technology and industrialism. The new artist-craftsman explored original forms in both new and traditional materials. Highly original Italian designers influenced furniture design from the 1950s through the 1970s with sophisticated new materials and technology, continuing into the 1980s with the uninhibited color and pattern of **Memphis** furniture. And finally, designers began to think about conservation of natural resources and environmental quality after the energy crisis of the early 1970s. Social responsibility also began to emerge in design through increased awareness and sensitivity regarding people with physical disabilities.

This diversity of directions led to a new design pluralism in the 1970s and 1980s and on into the 1990s. John Saladino (b. 1939) has exemplified pluralism and eclecticism in design with refined interiors that orchestrate a mix of colors, textures, materials, and periods, ranging from Machine Age Modern, historical and country vernacular, to his own upholstered furniture designs.

2.34 Wendell Castle designed and crafted this innovative "drop leaf" table from mahogany. His work often emphasizes the beauty and grain of different woods. (Photograph: Michael Galatis)

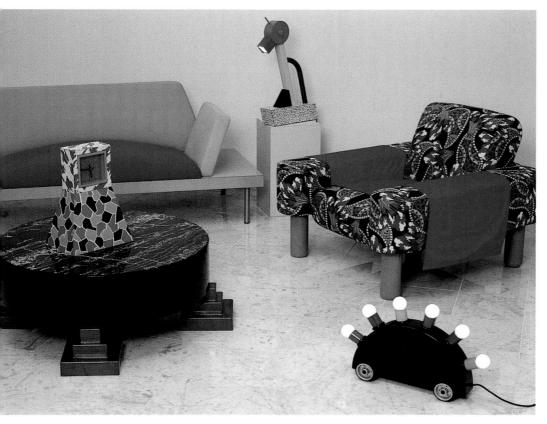

2.35 Memphis designers Ettore Sottsass (table and lamp on pedestal), George J. Sowden (chair and clock), Marco Zanini (sofa), and Martin Bedin (lamp on floor) give their ideas free rein, joyously exploiting the decorative possibilities of color and pattern. (Photograph: Brian Coats)

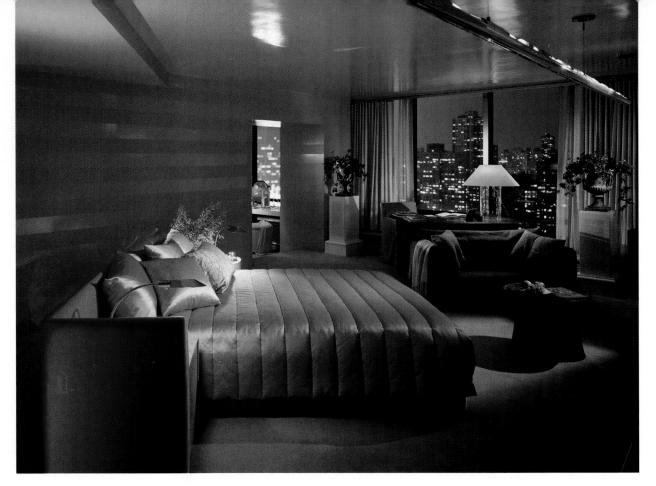

2.36 A highrise duplex apartment in Manhattan, New York, remodeled by John Saladino combines an 18th century Italian walnut writing table, a Thai ceremonial bronze drum, 19th century iron urns, sleekly modern brass bedside lamps, a heavy satin bed covering, and alternating bands of matte and reflective gloss paint with his own soft furniture designs for a richly sensuous, yet refined, effect. His interiors successfully merge modern, traditional, and country vernacular furnishings with an air of elegant simplicity. (Photograph: Peter Aaron, ESTO)

Another new area of emphasis, "green" or environmentally safe design, has recently evolved from the continued depletion of natural resources and the discovery of numerous health threats emanating from "sick buildings" filled with toxic indoor air pollution from building materials or situations within them. (This topic will be discussed further in Chapter 13.)

DOMESTIC ARCHITECTURE

The closing of the Bauhaus in 1933 marked the end of the "classic" or definitive phase of the International Style. Of its creators, Corbu developed along different lines, while the former leaders of the Bauhaus were dispersed and temporarily cut off from major commissions. In the late 1930s, Miës, Gropius, and Breuer came to the United States where they assumed academic positions and resumed their active careers. This artistic emigration from Germany accelerated the diffusion of the International Style throughout the world and contributed to the shift in architectural leadership from Europe to the New World after World War II. By the 1950s, transparent cubes of lightweight steel and glass could be found everywhere from Tokyo to Rio de Janeiro.

At the same time, the adoption of the new mode by increasing numbers of architects naturally led to greater diversity. The almost dogmatic unity of the 1920s gave way increasingly to personal and regional variations. And just as Wright and his followers responded to the European achievement, the International Style came to admit textured surfaces, natural materials, and greater variety in planning. This trend can be seen in the work of **Richard Neutra** (1892–1970), a Vienna-born architect who had worked briefly with Wright before establishing a practice in California. Neutra's houses of the 1940s exhibit the lean steel-frame construction, glass walls, and geometric composition of the International Style, but they also

feature the warm textures of wood and brick and an open, informal integration with the immediate landscape. Similar combinations appeared in the buildings of Alvar Aalto and Marcel Breuer.

The sleek technological emphasis of the 1920s by no means disappeared, however. From 1940 until his death in 1969, Miës van der Rohe simplified and refined his basic concern with the metal frame and neutral, reticulated volumes. Perhaps the ultimate expression of his principles in domestic architecture was the "Glass House" designed in 1949 by Miës's foremost disciple, **Philip Johnson** (b. 1906). Except for an enclosed circular bathroom, the house is entirely surrounded by glass walls that all but eliminate the distinction between interior space and the carefully landscaped setting. Reduced to barest essentials, the structure has an obvious, self-evident quality that belies its originality.

The functionalism of the 1920s was also evident in exposed structural systems such as HVAC (heating, ventilation, and air conditioning) ducts, sprinkler conduits, lighting cables, pipes, and so forth, often painted for decorative as well as informative purposes. Perhaps the ultimate in frank expression of such functional elements is the Centre Georges Pompidou in Paris by Renzo Piano and Richard Rogers (see Figure 2.40). Materials and equipment originally intended for industrial or commercial uses were applied to High-Tech residences by the 1970s Minimalist designers (see Figure 2.32).

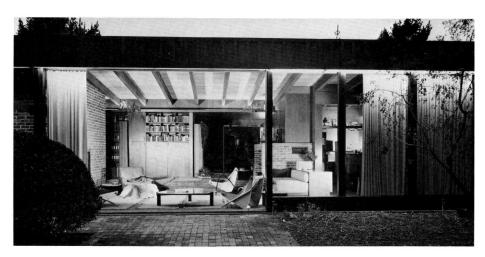

2.37 (left) The J. B. Nesbitt house, built in 1942 in Brentwood, California, illustrates the mature work of the Austrian-American architect Richard Neutra. A wall of plate glass slides open to unite the living area with a paved outdoor terrace. (*Photograph: Julius Shulman*)

- **2.38** (above) Philip Johnson's "Glass House" of 1949 represents the epitome of his preferences for strict regularity and openness.
- **2.39** (left bottom) In living area of the "Glass House", precision of placement and detail contrast with the natural forms seen through glass walls on all four sides. (*Photograph: Ezra Stoller, © ESTO*)

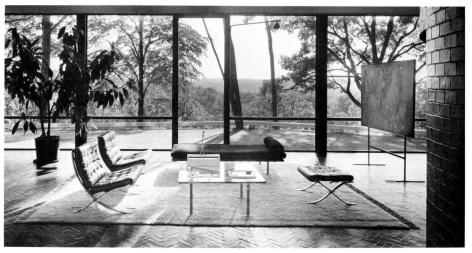

2.40 The Georges Pompidou National Center for Art and Culture in Paris (1977) exposes ductwork, escalators, and elevators outside its glass walls supported by structural steel in an inside-out emphasis on functional technology. Bright color lends a decorative quality. Renzo Piano and Richard Rogers, architects. (Photograph: Hidalgo/TIB)

2.41 Post-Modernism brought a return of Graeco-Roman classical elements, adding color, ornament, and irreverent humor to humanize the environment. The opening lines of Chaucer's Canterbury Tales form a hand-lettered border around this home library/study in San Francisco which features a pedimented bird's eye maple bookcase with a center unit encased in industrial wire glass and a 1920's French chair. Designed by Arnelle Kase for Barbara Scavullo Design. (Photograph: David Livingston)

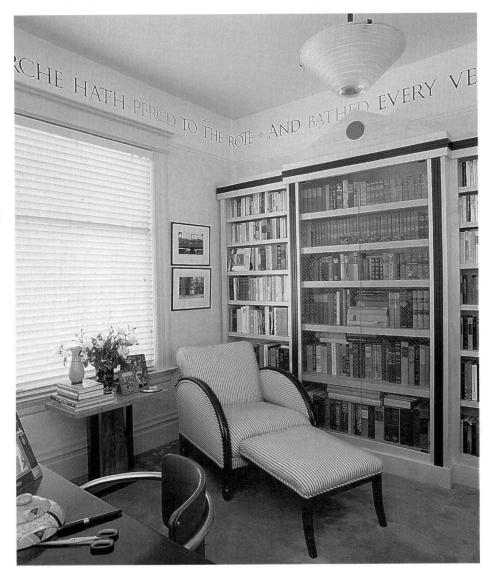

POST-MODERN DESIGN AND THE PRESERVATION MOVEMENT

A reaction to the Modern movement in architecture and interior design became apparent in the 1960s, continuing and gathering momentum into the 1970s when it's irreverent eclecticism was named **Post-Modernism**. It sought to re-establish ornament and historic tradition in contemporary design, to reflect the rich heritage of the past in creative new forms and colors that would evoke a more intimate response and reflect users' needs and involvement in a more humanized environment. Leading proponents included **Robert Venturi**, **Charles Moore**, **Philip Johnson**, **Robert A. M. Stern**, and **Michael Graves**. Historical references were primarily classical in derivation: pediments, columns, and moldings used to ornament both exteriors and interiors. **Richard Meier** and **Charles Gwathmey** were historically inspired by Le Corbusier and the white architecture of the 1920s. There is an ironic humor in Post–Modern design in contrast to the seriousness of functional Modern design and the blandness of corporate design.

Related to Post-Modernism, regional vernacular styles have also evolved, resulting in more eclectic interpretations of traditional styles, materials, and building types. The new traditional houses, like their antecedents, are usually designed in response to site and climate, but they stand out from rather than blend organically into the contextual landscape.

2.42 Chairs reminiscent of the Queen Anne style but in a modern idiom suited to industrial processes were designed by Robert Venturi in the early 1980s. (Courtesy The Knoll Group)

Historic interest was also revived in the **preservation movement** which grew during the 1960s in response to urban renewal efforts to eliminate slums and demolish old sections of American cities. The preservationists revived interest in old buildings, advocating their restoration and adaptive reuse as well as the recycling of various components. A historical restoration of the White House was partially completed by Mrs. Henry "Sister" Parish II in the early 1960s. Many historic buildings, and even whole neighborhoods, have been restored and given new life as "old town" shopping centers and urban residential units. Preservation, recycling, and conservation of energy and natural resources will remain among the foremost concerns for designers through the next decades.

In 1950 the history of modern architecture and design was seen in terms of a unitary progression, beginning with the reforming struggle of William Morris and culminating in the final mastery of technology in the machine style of the Bauhaus—whose enlightened gospel, the International Style, gradually reached to the farthest corners of the earth. Today's perspective is less doctrinaire. In a sense, we live in a new age of eclecticism, but the sources are not only the historic modes of a remote past; inspiration lies also in the immediate heritage of the postindustrial era.

Thus we find that the various phases of the Modern period are all accessible to contemporary restatement, without the need for pointlessly literal imitation. The Arts and Crafts tradition lives on in the individual workmanship of hand-crafted furniture and many accessories and in the general emphasis on personality in the home environment. Distant echoes of Art Nouveau and Art Deco rever-

2.43 In their own home, a house built in 1922, architects Denise Scott Brown and Robert Venturi retained much of the original Arts and Crafts interior, adding eclectic furnishings and design features, such as the stenciled walls. (Photograph: @ Paul Warchol)

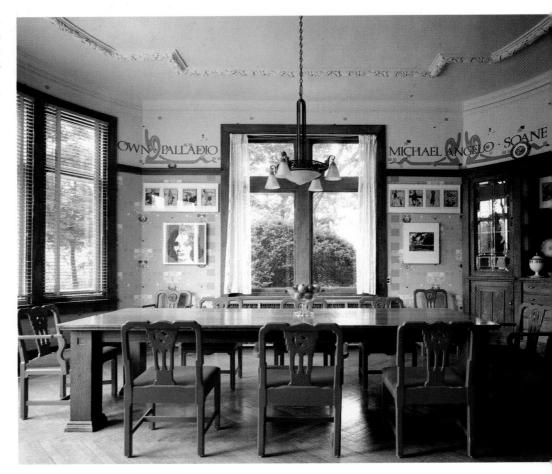

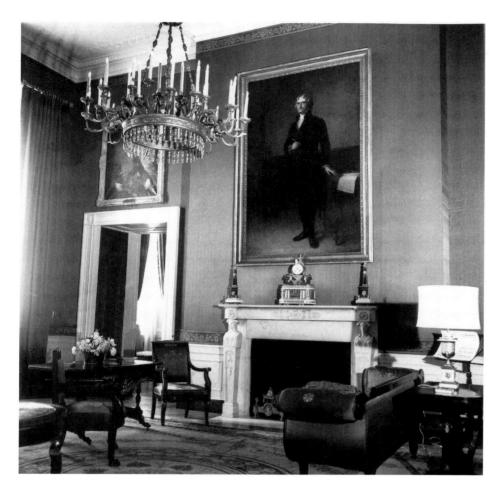

2.44 Mrs. Henry Parish II envisioned the White House exhibiting fine late-eighteenth- and early-nineteenth-century American furnishings and interiors, indicative of the period when the mansion was built. The Red Room contains American Empire furnishings. (Photograph: William Warnecke/CBS)

berate in some of the more imaginative furniture designs. The International Style maintains its universal adaptability, economy, and elegance. The lesson of Frank Lloyd Wright is particularly relevant today, when ecological arguments bolster those of aesthetics for an integration of house and landscape. Both the smooth, white surfaces of Le Corbusier's early work and the sculptural plasticity of his later style reappear in contemporary homes.

The current period thus provides not a single development of quickly outdated fashions but rather a rich and varied range of choices. Interiors as well as architecture may be wholly traditional or modern, or a personal integration of old and new. No one approach can be accepted without question or without rethinking its suitability to the present day. Yet an awareness of the modern heritage enriches our experience and enables us to respond more effectively to contemporary life.

REFERENCES FOR FURTHER READING

Abercrombie, Stanley. The 70s Recap: Highlighting Events of the Decade. *AIA Journal*, January 1980, pp. 38–50.

American Architecture of the 1980s. Washington, D. C.: American Institute of Architects Press, 1990.

Andersen, Timothy J., et al., (eds.) *California Design 1910*. Salt Lake City: Peregrine Smith Books, 1980.

Architectural Record. Record Houses of 19--. New York: McGraw-Hill, annual.

Ball, Victoria Kloss. Architecture and Interior Design: Europe and America from the Colonial Era to Today. New York: Wiley, 1980.

Battersby, Martin et al., (illus.). The History of Furniture. New York: Morrow, 1976.

Bayley, Stephen, Philippe Garner and Deyan Sudjic. Twentieth-Century Style and Design. New York: Van Nostrand Reinhold Company, 1986.

Bethany, Marilyn. The Regional-Style Farmhouse. *The New York Times Magazine*, June 28, 1981, pp. 44–47.

Blake, Peter. Frank Lloyd Wright. Baltimore: Penguin, 1964.

Blake, Peter. Miës van der Rohe. Baltimore: Penguin, 1964.

Brown, Erica. Sixty Years of Interior Design: The World of McMillen. New York: Viking Press, 1982.

Brown, Robert K. and Iris Weinstein. Art Deco International. New York: Quick Fox, 1978. Clark, Robert Judson (ed.). Arts and Crafts Movement in America 1876–1916. Princeton, N.J.: Princeton University Press, 1972.

Davern, Jeanne M. A Conversation with Paul Rudolph. Architectural Record, March 1982, pp. 90–97.

Dean, Barry. Architectural Ornamentation. *Residential Interiors*, September-October 1979, pp. 88–93.

Emery, Marc. Furniture by Architects. New York: Harry N. Abrams, 1988.

Fehrman, Cherie and Kenneth R. Fehrman. *Postwar Interior Design: 1945–1960.* New York: Van Nostrand Reinhold, 1987.

Fitch, James Marsten. Walter Gropius. New York: Braziller, 1960.

Fitzgerald, Oscar P. Three Centuries of American Furniture. Englewood Cliffs, N.J.: Prentice-Hall, 1982.

Foley, Mary Mix. The American House. New York: Harper Colophon Books, 1980.

Giovannini, Joseph. Regional Styles Enter the Architectural Mainstream. New York Times, September 22, 1983, pp. C1, C6.

Glancey, Jonathan and Richard Bryant. The New Moderns. New York: Crown Publishers, Inc., 1990.

Habegger, Jeryll and Joseph H. Osman. Sourcebook of Modern Furniture. New York: Van Nostrand Reinhold, 1989.

Habitat VI: Contemporary Furniture. New York: Universe, 1978.

Harling, Robert (ed.). Modern Furniture and Decoration. New York: Viking, 1971.

Hatje, Gerd and Elke Kaspar (eds.). New Furniture 10. New York: Praeger, 1971.

Hennessey, James and Victor Papanek. *Nomadic Furniture*. New York: Random House, 1973. Hennessey, James and Victor Papanek. *Nomadic Furniture* 2. New York: Random House,

1974. Hitchcock, Henry Russell, et al. *Architecture: Nineteenth and Twentieth Centuries*, 2nd ed. Baltimore: Penguin, 1963.

Hitchcock, Henry Russell and Philip Johnson. *International Style*. New York: Norton, 1966 reprint.

Jencks, Charles. Le Corbusier and the Tragic View of Architecture. Cambridge, Mass.: Harvard University Press, 1974.

Jencks, Charles. The Language of Post-Modern Architecture. New York: Rizzoli, 1977.

Johnson, Philip and Mark Wigley. Deconstructivist Architecture. New York: The Museum of Modern Art, 1988.

Klotz, Heinrich. The History of Postmodern Architecture. Cambridge, Mass.: The MIT Press, 1988.

Koch, Robert. Louis C. Tiffany, Rebel in Glass. New York: Crown, 1964.

Madsen, S. T. Art Nouveau. New York: McGraw-Hill, 1967.

Makinson, Randell L. Greene & Greene Furniture and Related Designs I, II. Salt Lake City: Peregrine Smith Books, 1979.

Mang, Karl. History of Modern Furniture. New York: Harry N. Abrams, 1979.

McCoy, Esther. Richard Neutra. New York: Braziller, 1960.

Modern Chairs, 1918–1970. London: Whitechapel Art Gallery, Victoria and Albert Museum, 1970.

Peel, Lucy, Polly Pavell and Alexander Garrett. *An Introduction to 20th-Century Architecture*. Secaucus, N.J.: Chartwell Books, 1989.

Pehnt, Wolfgang (ed.). Encyclopedia of Modern Architecture. New York: Abrams, 1964.

Pevsner, Nikolaus. *The Sources of Modern Architecture and Design*. New York: Thames and Hudson, Inc., 1985.

Pfeiffer, Bruce Brooks. Frank Lloyd Wright Drawings. New York: Harry N. Abrams, 1990. Pile, John F. Modern Furniture. New York: Wiley, 1978.

Pool, Mary Jane and Caroline Seebohm (eds.). 20th Century Decorating, Architecture & Gardens: 80 Years of Ideas & Pleasure from House & Garden. New York: Holt, Rinehart and Winston, 1980.

Scully, Vincent J., Jr. Modern Architecture, rev. ed. New York: Braziller, 1974.

Smith, C. Ray. Interior Design in 20th-Century America: A History. New York: Harper & Row, 1987.

Sparke, Penny, Felice Hodges, Emma Dent Coad, and Anne Stone. *Design Source Book*. Secaucus, NJ: Chartwell Books, Inc., 1986.

Stern, Robert A. M. New Directions in American Architecture. New York: Braziller, 1969, 1974.

Stickley, Gustav. Craftsman Homes. New York: Craftsman, 1909.

Straub, Calvin C. The Man-Made Environment: An Introduction to World Architecture and Design. Dubuque, IA: Kendall/Hunt Publishing Company, 1983.

Tate, Allen and C. Ray Smith. *Interior Design in the 20th Century*. New York: Harper & Row, 1986.

The Architecture of Skidmore, Owings & Merrill, 1950–1962. New York: Frederick A. Praeger, 1963.

Thompson, P. (ed.). Work of William Morris. London: Heinemann, 1967.

Venturi, Robert. Complexity and Contradiction in Architecture. New York: The Museum of Modern Art, 1966.

Wheeler, Karen and Peter Arnell (eds.). *Michael Graves: Buildings and Projects*, 1966–1981. New York: Rizzoli, 1983.

Whiton, Sherrill. *Interior Design and Decoration*, 4th ed. Philadelphia: Lippincott, 1974, pp. 374–415.

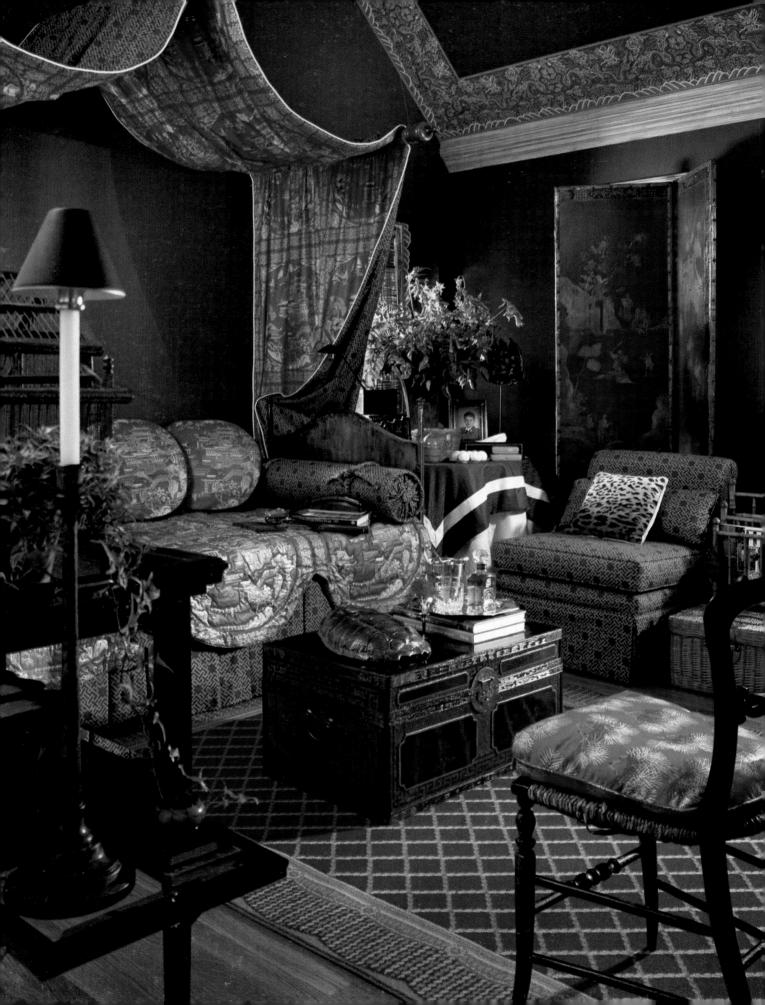

PART TWO

Foundations of Design

Design Judgment

DETERMINANTS OF DESIGN

Function Materials Technology Style

TYPES OF DESIGN

Structural Design Decorative Design

DISCRIMINATION

Design is the selection and organization of materials and forms to fulfill a particular function. It has been with us since the first primitive hunter shaped a stone or twig to make a more effective weapon. In its simplest form, this process of toolmaking embodies all the basic concepts that still apply to the design of very complicated objects today: the hunter saw a need, sought the material that would best answer that need, considered how to shape and adapt the material, and worked out the process of forming the material to achieve a particular goal. Carrying this idea one step further, we should point out that the *second* hunter who saw the first's design and admired and imitated it was not designing but in fact merely copying—unless the second weapon incorporated an improvement of the first.

No more can the beaver's dam, the spider's web, or the bird's nest be considered the products of design, for these creatures are following instincts and learned patterns of behavior. Design is an intrinsically *conscious* process, the deliberate act of forming materials to fit a certain utilitarian or aesthetic function. Still, the marvelous structures built by animals do refer to one of our most fundamental ideas of design—the so-called grand design of nature. From the tiniest unique snowflake to the mightiest mountain range, we find our world beautiful, satisfying, appropriate: in short, well-designed. But beyond these isolated elements, it is the interrelationship of all the various earth's components that we call nature's design. Every living thing has its place in the food chain because of what it eats if it is an animal, what it absorbs if it is a plant, and what it is eaten by or what it gives off to enable others to live. A rock is a rock, but at the same time it may be part of a mountain that catches rain clouds and helps dump the water out of them onto

the thirsty land. A rock eventually breaks down into sand to form a totally different landscape with a different function. One of the most serious concerns of our time revolves around the ways in which human beings, in the name of progress, have interfered with this natural design, perhaps paving the way for a total breakdown in its harmony.

In recent years we have become increasingly aware that manufactured things, as well as natural ones, have a part in this overall design. A chair is a chair, but it is also a former tree or hide or chunk of metal or collection of chemicals. When it has ceased to function as a chair, it must go somewhere—up in smoke, into some other product, or to the top of an ever-more-immense pile at the dump. Design becomes a very serious business indeed when we realize that its application to any object—from the largest building to the tiniest electronic component—is bound to affect other objects and structures, the people who use them, and possibly the environment as a whole. A chair made of wood demands that a tree be cut down; one upholstered in leather or fur exacts the life of an animal. Whether the tree will be replaced by planned reforestation, whether the animal's species will remain stable are factors the designer should keep in mind. Many designers who feel a strong social responsibility to mankind do not specify endangered products. On the other hand, a chair with plastic components may be ultimately responsible for causing health problems in workers at the plastics factory.

As far as disposal is concerned, it may be difficult for the designer involved in creating something beautiful to anticipate its eventual destruction. But most objects wear out sooner or later, and the combined refuse of more than 200 million people in the United States alone makes for a staggering problem. Intelligent design takes into account the entire spectrum—the source of materials, the shaping of materials, and the return of materials to the environment.

DETERMINANTS OF DESIGN

Several factors inevitably influence and determine design: the **function** an object is to serve, the **material** or materials from which it will be made, the **technology** or method of production to be employed, and changing ideas of **style** and appropriateness. These four aspects of design establish the fundamental basis from which to evaluate design quality.

FUNCTION

We might consider the "purest" form of design the creation of something that has never existed before, so that we have no preconceived ideas about how it should look. However, relatively few designers have the opportunity to create something totally new. Most design is actually redesign, or improvement of designs that already exist. If a manufacturer presents a new line of tables and advertises them as a radically new design, this is true only up to a point, because tables have been with us for many thousands of years and serve the same basic purposes now that they did centuries ago. Furthermore, it is hoped that a new design means improved function, for we place very high value on things that work efficiently. The company that makes kitchen appliances may change their appearance every year, altering them physically if not functionally, to conform with prevailing tastes. But in advertising a new product, they will take pains to point out its improved features—additional jobs it can perform, ease of cleaning, quietness, speed, and so on.

Only since the Industrial Revolution have designers systematically investigated the role of function in planning objects and whole systems. Mass production of thousands or even millions of identical objects gives both the opportunity and the incentive to evaluate their effectiveness. Functional performance is the first test of design quality for interiors as well as individual objects.

Deliberate, scientific investigations of function have played a major role in shaping the contemporary home, and, as addressed in Chapter 10, no part of the home has been more thoroughly researched than the kitchen. Time-motion studies, studies of work patterns and the flow of activities all relate function to design. Today's researchers utilize highly sophisticated methods, but the concept of *ergonomics*, the interface between people and their environments, applied to planning for the home is by no means new.

In the mid-nineteenth century the inefficiency of most American homes spurred Catherine Beecher, with her sister Harriet Beecher Stowe, to undertake a personal study of the ways in which function could be related to design. Although certainly not an advocate of the women's movement as we know it today, Beecher was concerned with the idea of liberating women within the home in terms of economy of labor, money, health, and comfort. Her designs stressed function—in the kitchen, for example, cabinets and surfaces built for specific purposes and storage near the point of use. Beecher designed a movable storage screen that could be placed in a large room to subdivide it for different activities at different times: a true multipurpose space. Surprisingly for that era, she gave serious attention to the quality of air inside the home. The Franklin stove, which was efficient in providing heat, had come into popular use, replacing the much less effective open fireplaces that gulped large quantities of air to keep the fires going. But the Franklin stove created less turnover of air in the room, keeping it warmer but also keeping stale air inside. To counteract this, Beecher designed house plans that provided good circulation (see Figure 3.1). She also advocated the inclusion of more bathrooms in the home and compartmentalized them for flexible use. All in all, Beecher's designs were predicated on function rather than style and emphasized a trend toward specific applications.

If we compare Catherine Beecher's ideal kitchen work area (Figure 3.2) with the contemporary mix center shown in Figure 10.12, we find many similarities. It should not surprise us that the two kitchens, separated by more than a century, have so many points in common, for basic food-preparation techniques have changed little. What should surprise us is the fact that so few kitchens incorporate planning of this nature. The task of the designer is to formulate ideas that answer the needs of function; the task of the consumer is to demand them.

Much has been made of the credo *form follows function*, announced in the nineteenth century by American sculptor Horatio Greenough and first applied to architecture and interior design by Louis Sullivan. This means simply that the form

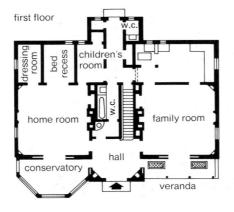

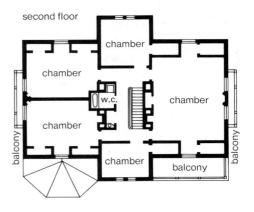

3.1 Revolutionary in its provision for closets, bathrooms, and ventilation, this house plan, from the Beechers' *The American Woman's Home* (1869), has the multiroom comfort and graciousness we associate with the 19th century.

3.2 Deliberate, methodical planning went into the design of this kitchen work area published by Catherine Beecher and Harriet Beecher Stowe in *The American Woman's Home* (1869). It provides space for all the staple foodstuffs and working surfaces a cook of that era would need, while keeping an array of tools and cooking implements close at hand.

of an object or space should be a straightforward reflection of its intended use, that it should *look* like what it *does*. Yet function can never be an absolute determinant of form, since any given end use might be satisfied perfectly well by two or four or a dozen different forms. Leafing through the pages of this book alone we might easily find twenty or thirty different chairs that fulfill the function of offering comfortable seating, but their forms seem to have little in common.

MATERIALS

Possibly the single most important influence on interiors and their furnishings in the last few decades has been that of Italian designers. Their contributions have been twofold: the bold, imaginative use of new synthetics, both hard and soft; and the investigation of totally innovative forms that are flexible in use, made possible by these plastics. Chairs and sofas exist not as discrete objects but as parts of modular seating arrangements capable of being assembled, combined, rearranged, repositioned, even reshaped as needs and whims dictate. The familiar seat, back, and

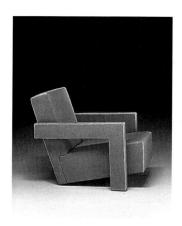

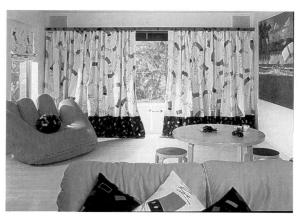

- **3.3a** (left) The *Utrecht* armchair, designed in 1935 by Gerrit T. Rietveld and brought back into production in 1988, clearly expresses its function through straightforward form. (Courtesy Atelier International/Cassina)
- **3.3b** (right) *Joe*, a huge stuffed leather baseball glove, designed in 1971 by De Pas, D'Urbino, and Lomazzi, was inspired by American pop art and culture. Its humorous form does not reflect its function as a sofa, used effectively in this Tiburon, California, game room remodeled to suit the needs of two boys. Sharon Campbell, ASID, interior designer. *(Photograph: John F. Martin)*

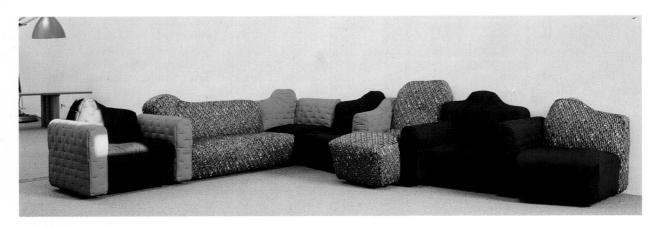

3.4 Cannaregio modular seating consists of ten different upholstered units that can be used individually or linked together as straight or angled combinations ad infinitum. Each piece has its own unique individual form, volume, and dimensions, reflecting our desire for diversity according to designer Gaetano Pesce. (Courtesy Cassina S.p.A.)

four legs of a chair may disappear entirely into an amorphous or geometric shape that assumes contours only when someone sits in it.

Designers have exploited the universe of plastics in two directions. Rigid plastic chairs and tables may be light in scale and weight, assuming shapes not possible with the more conventional wood, but they are remarkably strong. On the other hand, soft plastics, such as polyurethane foam, have brought back the bulky look in furniture, because it is now possible to have solidity without weight. The success of Italian designs rests on the fact that their creators had the insight to go beyond traditional forms, techniques, and conventions to explore the possibilities for design in materials that had never before existed.

Materials can both limit and inspire the designer—limit because no material should be forced into shapes contrary to its nature; inspire because an understanding of the particular qualities inherent in a material can free the designer to innovate. *Integrity* in the use of materials is an important aspect of good design. It means an honest use and true expression of the intrinsic qualities of the substances

- **3.5** Verner Panton's stacking side chair, designed in 1959–60, is molded in one piece of plastic. Its contours are specifically engineered to accept the seated human form. (Manufactured 1967. Rigid polyurethane foam, lacquer finish, 32 5/8 X 191/4 X 231/2". Manufacturer: Vitra-Fehlbaum GmbH, Weil-am Rhine, Germany. Collection, The Museum of Modern Art, New York. Gift of Herman Miller AG.
- **3.6** This replica of a side chair designed by Gerrit Rietveld in 1934 shows the natural grain and the joinings typical of wood. [Chair (Zig-Zag). Wood, 29 X 14 ½ X 16"; seat height: 17". Manufacturer: Mr. G. A. Van der Groenekan, The Netherlands. Collection, The Museum of Modern Art, New York. Gift of Phyllis B. Lambert.]

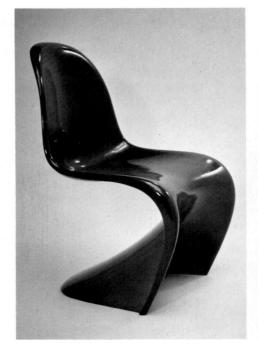

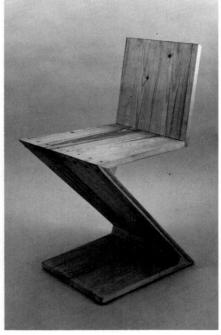

used. Plastics, so effectively used by Italian designers, have been used too often in imitation of other materials with totally different qualities. Vinyls and melamines simulate textiles, leather, clay, marble, and wood for use as wall and floor coverings, upholstery, and countertops. Although such simulations may offer greater durability and ease of maintenance, they lack the warmth, feel, and smell of the real thing and designers may be missing the opportunity to explore and develop the unique qualities of plastics (see Chapter 16).

The two chairs shown in Figures 3.5 and 3.6 illustrate this point. Both are simple, armless units essentially Z-shape in outline; both depend on cantilever construction, and both are surprisingly comfortable. However, the first, a 1959–1960 design by Verner Panton, is a smooth, sinuous expression of the flowing qualities of plastic. It has no joints, nor does it require them, for the molded plastic, shaped imaginatively for balance, is sufficiently strong to hold the sitter's weight. Gerrit Rietveld's side chair, designed in 1934, is an angular assembly of flat wood boards, joined in three places and reinforced at the joints. With appropriate construction, wood possesses adequate tensile strength to resist breaking, yet this chair actually is somewhat resilient.

While Rietveld's chair would seem to be an unusually honest and straightforward use of wood, designers of the twentieth century have not restricted themselves to the board-and-plank forms we often associate with the material. By laminating together many small pieces of cherry wood, Wendell Castle created a chopping block that suggests—without directly imitating—the form of a live tree (Figure 3.7). Its celebration of grain patterns and whorls highlights the most attractive quality of wood.

The classic example of curvilinear design in wood is the bentwood chair, developed in response to new methods of steaming wood that were introduced in the late nineteenth century (see Chapter 2). Although some might argue that bending wood into such curvilinear forms is not "natural", the bentwood rocking chair, with caned back and seat, has enjoyed enormous popularity (Figure 3.8). This in turn has inspired contemporary designers to create related forms in metal—a

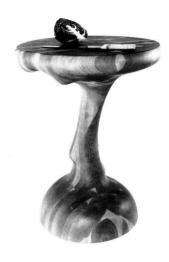

3.7 The laminated wood furniture of Wendell Castle, with its sinuous organic forms, refers back to the natural growths from which the material originated. (*Photograph: John Griebsch*)

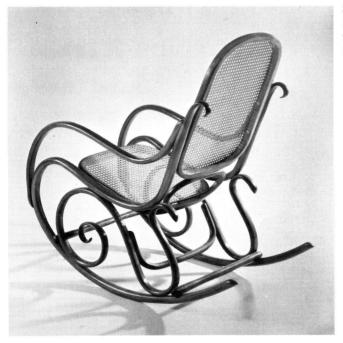

3.8 A process for steaming and bending wood, developed by Michael Thonet in the 19th century, made possible the creation of the bentwood rocker, whose function seems appropriately mirrored in its medley of swirling curves. (Courtesy Thonet Industries, Inc.)

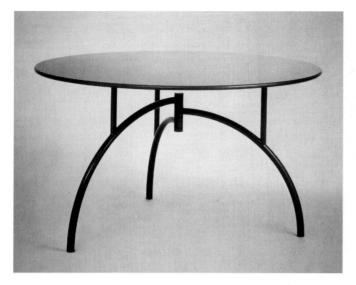

3.9a & b Philippe Starck's *Tippy Jackson* folding table exploits the possibilities of slender, curving steel in its three-legged design. *(Courtesy Aleph, Italy)*

material also capable of assuming thin, curving lines (Figure 3.9). Along with plastic, metal is very much a material of the present; although many people still prefer furniture made of wood or other organic substances, metal and plastics seem particularly in touch with the industrial age. The materials selected for any object must be suitable and appropriate to the intended use. (Various materials and their characteristics, qualities, and forming methods will be examined more fully in Part Four.)

TECHNOLOGY

When a weaver sits down at the loom to create a tapestry, there is almost no limit to the design possibilities. A contemporary hand-woven art fabric might be two-or three-dimensional, have many colors and textures, and involve an array of yarns. But if the same weaver were to design an upholstery textile for commercial production, very different rules would apply. No doubt there would be a restriction on the number of yarns and colors used, and the complexity of pattern would depend on the sophistication of the looms involved. Whether a designer is limited or challenged by such restrictions will depend on his or her imagination.

A number of contemporary designers have met the challenge brilliantly. Jack Lenor Larsen was among the first to refuse inhibition, demanding that the designs come first and the technology be developed to cope with those designs. The result has been a series of unique, sumptuous textiles that dispel the image of boring mass design.

Often the best of modern design results from a combination of machine and hand processes, as is true for the steel-wire furniture created by Warren Platner (Figure 3.11). A specially tailored mold system that involves some hand work in shaping the wires allows the Platner furniture to be made as one piece, with frame and supports an integral unit. The smooth flow of these weblike forms contrasts with older furniture styles in which separate parts had to be joined with nails, pegs, bolts, and glue. Thus, the design and the method of construction are practically inseparable.

The designer who creates a single object may not be so concerned about its method of production, for if one system doesn't work, there is always time to find another. But the vast majority of objects designed today are intended for mass production, and this raises all sorts of new questions. It was only in the mid-eigh-

3.10 Susan Lyons, design director of DesignTex, worked with the unique visions of various architects to produce the *Portfolio Collection* of contract textile designs. Aldo Rossi's spontaneous and romantic watercolor and pencil sketches produced these unusual designs: top, "Marco Polo"; bottom, "Italian Garden".

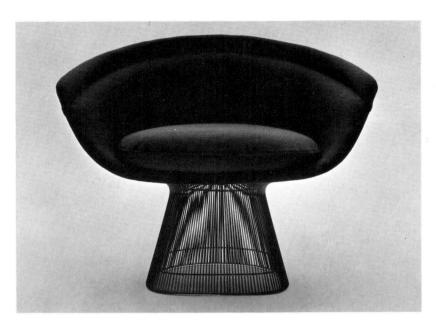

3.11 A complicated mold system had to be devised to permit the mass production of Warren Platner's steel-wire furniture. The one-piece frame construction results in an unusually graceful curving shape. (Courtesy, The Knoll Group)

teenth century, when it became feasible to manufacture many identical objects, that people began to analyze the nature, goals, and principles of design.

The Industrial Revolution had an enormous impact on the methods by which objects were produced, but it also profoundly affected their design. Machinery made it possible for the first time to turn out large quantities of goods at relatively low cost. In so doing, however, it dramatically changed the relationships between designer and object, consumer and object, and eventually the whole precarious balance among producer, consumer, object, and environment.

Before machines took over the business of manufacture, most articles—from spoons to houses—were designed and made either by the people who wanted them or by craftsmen in the community who were thoroughly familiar with the available raw materials and how they could be fashioned, how the objects would be used, and often how successful they proved to be in meeting the original needs. If a particular item did not serve in the way it was intended, it could be taken directly back to the maker, who might then be inspired to alter the design. Industrialization changed this situation drastically.

If, in preindustrial society, design responded to felt needs—the lack of something inspiring its creation—the reverse situation prevails today. Large manufacturers competing with one another produce vast quantities of items for which they must then generate a desire among consumers, and preferably a "need." The typical household did not "need" an electric can opener until it became aware that electric can openers existed. Particularly active in this field are makers of large appliances, which usually have a working life of from ten to twenty years. To encourage the consumer to discard an appliance before it ceases to operate, manufacturers annually introduce "improvements"—some of them truly useful, some at best whimsical. More often than not, design asks "What will the public buy?" rather than "What does the public need?"

Fortunately for the course of mass design, there always have been those who sought to maintain high standards within the framework of machine technology. The most organized and deliberate movement of this type occurred in the Bauhaus, a school of design active in Germany during the 1920s and early 1930s (see Chapter 2). The Bauhaus had as its guiding principle the establishment of standards of

3.12 A side chair designed by Marcel Breuer in 1928 is a modern classic of machine production. ("Cesca" side chair, Model-B32. Chrome-plated tubular steel, wood, and cane, 32 X 18 X 213/6"; seat height: 181/6". Manufacturer: Gebrüder Thonet, Germany. Collection, The Museum of Modern Art, New York. Gift of Herbert Bayer.)

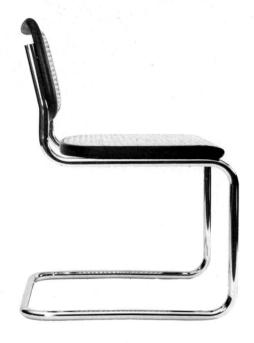

excellence in design and workmanship that would be compatible with mass production. Many of the designs formulated under its auspices, such as the side chair created by Marcel Breuer (Figure 3.12), have remained modern classics and are still in production today.

STYLE

It is extremely difficult to separate materials and technology from style because they are so interdependent. If the technological processes necessary for working with metals and plastics did not exist, there could be no style or characteristic manner of design and construction for metal and plastic objects. With this in mind, we can say generally that styles, or prevailing modes, and tastes and aesthetic preferences regarding beauty do fluctuate over time and between cultures. For example, the fashion in Europe and the United States during the nineteenth century was for opulence, profusion of ornament, and a kind of heavy solidity in design. In the twentieth century most people have come to prefer cleaner lines, less applied decoration, and an overall impression of lightness. To see these principles operating, we need only compare the bedroom from the 1870s with a bedroom from the 1990s, both reflections of their time and culture (Figures 3.13 and 3.14).

The Victorian bedroom, viewed in its original cultural context, was the product of a society that held in high esteem the possession of material goods. The home existed as an expression of self-importance and self-worth. Therefore, the reasoning went, the more objects it contained, and the more heavily decorated those objects were, the higher would be the owners' apparent position on the social scale. A contributing factor to this value system was the new availability of consumer goods made possible by the advancing machine age. Upward mobility and possession of objects became synonymous. Thus, the Victorian bedroom contains heavy, ponderous furniture with pseudo-classical decorations and other enrichment over virtually ever square inch.

To a certain extent, many of us still use our homes as the visible yardstick of material wealth and social status, but if this is true, then our aesthetic criteria have changed. The bedroom in Figure 3.14 is simplified, light and airy compared to the Victorian version. Clean-lined and built-in furniture blends into the architecture and provides an ample amount of storage whose unobtrusive character would have been out of place in a Victorian home. The twentieth century does not place

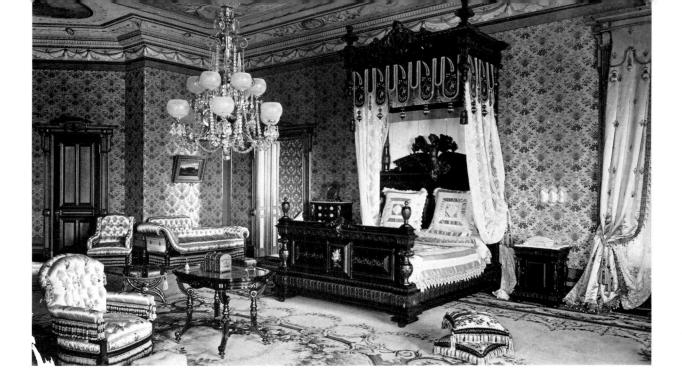

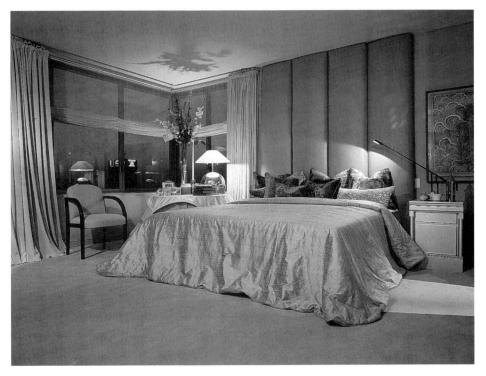

3.13 A high-Victorian bedroom from the Leland Stanford house in San Francisco was furnished for comfort, solidity, and richness in 1878. (Photograph: Eadweard Muybridge; print made from a negative in the Stanford University Archives)

3.14 The master bedroom in a condominium at the Rittenhouse Hotel and Condo in Philadelphia, Pennsylvania, has a built-in upholstered headboard that forms ceiling-high columns, performing a subtle dual function. The room is unified and made more spacious looking by achromatic gray color throughout. Window treatments admit plenty of light. Textural contrast and detail are minimized. Don Reiff, architect; Cynthia Frishberg, interior designer. *(Photograph: Matt Wargo)*

a high premium on clutter, so a different lifestyle demands different expression in designs.

Numerous other examples could be given to show how aesthetic views have changed over the centuries and vary among societies, and how design in architecture, furnishings, and all kinds of objects has followed those trends. It is important to remember, however, that style is a cumulative process. It would not be impossible to find a room generally in the character of the Victorian bedchamber today, but the bedroom shown in Figure 3.14 could not have existed in the 1870s. This fact depends partly on the absence of built-in furniture and some

present-day materials and fabrication techniques in the nineteenth century, but it also relates to questions of taste, for the contemporary room would have seemed eccentric or even shocking a hundred years ago. As fashions change, many people change with them, but there will always be those who appreciate the beauties of yesterday. As designers, we must strive to develop the ability to recognize and appreciate fine design wherever it is found, and to apply a conscious effort in making good choices that reflect sound aesthetic judgment.

We have come a long way from the shaping of a primitive tool to the design of whole environments or even of extraterrestrial structures. In traveling this distance, we have begun to understand the implications of design. The hunter making a new tool seemed to affect only himself. Today we know that the creation of any object may have repercussions throughout the design continuum. The responsibility is enormous, and it remains to be seen how designers of the future will meet that challenge.

TYPES OF DESIGN

Understanding structure and decoration as basic ingredients of design will further assist in discerning design quality. Objects can be either structural or decorative in the purpose they serve, or their design can be judged for its form and/or ornament. Materials and production methods play a central role in determining both structural and decorative design.

STRUCTURAL DESIGN

The design of any object is an integral part of its structure. Size, shape, materials chosen, and methods of construction determine how the structure is formed. Good

3.15 An ergonomically designed computer work station may reduce the likelihood of developing physical problems such as muscle strain to the neck and arms. This diagram illustrates guidelines for choosing and adjusting a desk and chair, positioning the keyboard and display, and adjusting room lighting. (Courtesy Apple Computer, Inc.)

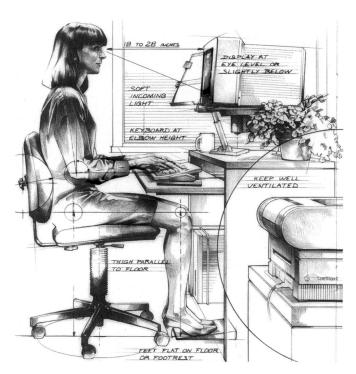

structural design is revealed in the unembellished form itself through an honest use of appropriate materials and a frank assemblage of necessary parts. An additional attribute is good proportion; the relationship among parts of the object should be pleasing, of appropriate size and shape for the purpose it serves. *Ergonomic design* takes human scale, posture, and movement into consideration to produce objects and spaces well-proportioned to their users. The field of ergonomics has emphasized the importance of good structural design, particularly in the workplace where poorly designed equipment, furnishings, and spaces can adversely affect productivity and well-being.

Structural design is of critical importance in the built environment where issues of public health and safety are of concern; but, even in the home, where comfort and relaxation may be primary goals, form and structure of furnishings determines their suitability to purpose. A chair is only comfortable if its structure fits the user's body dimensions, offers support and stability, and can be moved easily or not as its use requires.

In many objects, materials and design are truly inseparable from structure. In the fiber arts, the weaving together of various materials constitutes the structure. In a flight of stairs, the design of risers and treads of uniform dimensions *is* the structure. An object may also be either structural or decorative in the purpose it serves: the stairway exists to serve a specific function while the creation of the fiber artist is ornamental. Often, structure and decoration are inextricably related. For example, the hand rail for a stairway, a necessary part of its structure, may be highly ornate in appearance, with elaborately shaped supports (see Figure 2.8).

Finally, our perception of the structural design of large spaces such as rooms and buildings is largely *kinetic*, related to motion and the time it takes to experience the space by moving through it. Size, shape, materials, and structure are ex-

3.16 Marianne Strengell's handwoven off-white casement fabric of linen, fiberglass, rayon, and goat hair contrasts thick and thin, tightly and loosely spun yarns in a seemingly spontaneous construction. (Photograph: Ferdinand Boesch)

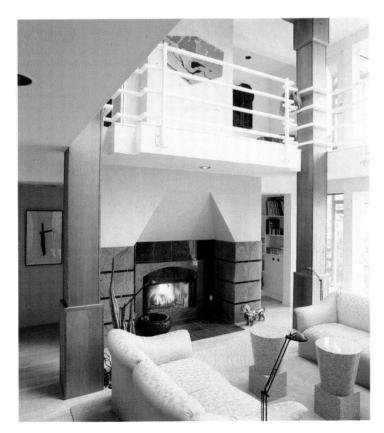

3.17 Architect David Weingarten's own condominium residence in the Telegraph Hill district of San Francisco features a redwood-columned two-story gallery which provides enticing glimpses of spaces above and beyond that beckon and encourage experiencing by moving from area to area, level to level. Ace Architects. *(Photograph: Alan Weintraub)*

perienced as our position changes within the space. The purpose of interior design is to compose space and create an environment for human activity. The structure of that space will, to a large degree, determine the success of a building. The concepts of time and motion are inseparable from the experience of space and vital to the design of interiors (Figure 3.17).

DECORATIVE DESIGN

When color, line, texture, and pattern are selected and applied to an object or surface to adorn or embellish it, the result is decorative design. Some objects are purely structural, with decorative design added, as when a chair leg is carved with an acanthus leaf or reeding. Other objects are inherently decorative, as a porcelain figurine or work of art.

Decorative design commonly refers to the added ornamentation applied to an object to give greater sensory appeal—to make it more beautiful. Many processes can be used, based on the material to which the decoration is applied. (Methods of ornamentation appropriate to various materials will be presented in Part Four.) Sources of inspiration for decorative design include nature, the human figure, geometry, abstract shapes, and even technology and man-made objects. (Classification of design motifs/patterns will be addressed more fully in Chapter 4.)

3.19 (top right) A footed bowl created for Georg Jensen in 1918 is still being reproduced because its contrast of form and ornament is unusually harmonious. (Courtesy Georg Jensen, Inc.)

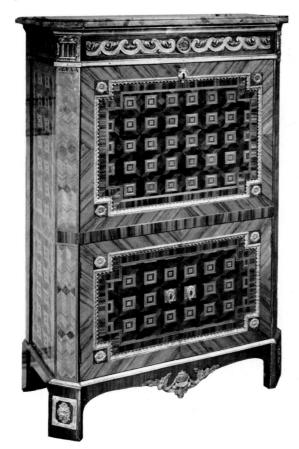

3.20 (lower right) A reproduction of a chair designed by Josef Hoffmann in 1911 employs highly contrasting piping to emphasize its form. (Courtesy ICF Inc. Photograph: Peter Paige.)

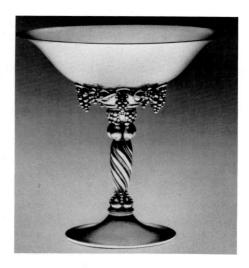

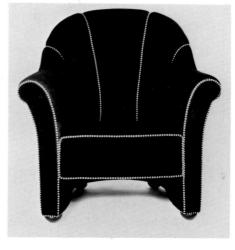

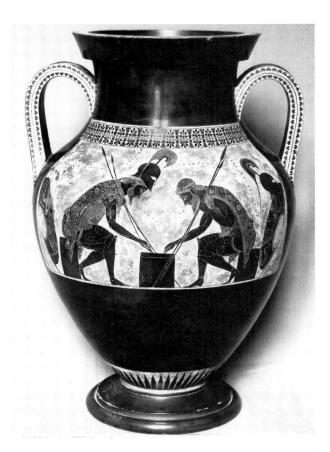

3.21 Many Greek vases exemplify the use of good proportion, in both their overall shape and their ornamentation. *(Courtesy Alinari/Art Resource)*

To be successful, decorative design must meet the following criteria: suitability, appropriateness, placement, and proportion.

- 1. Ornamentation must be suitable for the purpose of the item, complementing its function and keeping it evident. If, for example, the decorative design covering an object obscured its intended purpose, it would be unsuitable because it interfered with its use and function. Decorative design should also be suitable to the character or style of the object it adorns. Different times, places, cultures, and technologies have produced characteristic styles of ornament. Opulent Baroque ornamentation would be unsuitable for a sleek modern object.
- 2. Applied design should be appropriate to the materials from which the article is made and should accent its shape and form. The decoration should enhance the structural design and not interfere with function. Applied ornament should not make an object difficult to hold or operate; it should be harmonious with the materials of construction and the kind of use the object will receive. A sturdy, durable park bench requires a different sort of ornamentation in a different material than an elegant chaise longue.
- 3. Embellishment should be placed to emphasize structural points such as the rim of a cup or plate, or the knee of a cabriole leg. Decorative design can actually assist an object in performing its function by accenting important edges, handles, or other points that aid in its use.
- **4.** Decoration should be proportioned in size and amount to the object it adorns. Ornament should be similar in scale to the size of the object and the amount of surface decoration should be proportionate to the size of the object. Ideally, the amount should relate to the Greek proportions of 3:5, 4:7, 5:8, and so on, with unadorned area proportionate to areas of adornment.

DISCRIMINATION

The development of design discrimination or judgment takes place over time with continual learning and experience. Just as there is no single prescribed rule for good design, there is no formula that ensures the acquisition of good aesthetic judgment. Exposure to as much variety of design as possible and study of the basic elements and principles, application, and theory of design are necessary to develop appreciation, sensitivity, and discrimination.

A thorough knowledge of design is essential to every process of selection that makes up the complex task of interior design. An interior designer works with spaces whose architectural features have often already been defined and built by others, manipulating them to communicate an idea and satisfy the goals of the design concept and program. Sometimes the end-users have no direct communication with the designer; most of the materials and furnishings that complete the interior are manufactured by others with no knowledge of their end use; and the finished design may continue in use for years, changing users and requirements many times. Under these circumstances, an interior designer's knowledge of design is as important to the discriminating selection of products as it is to the creation of an effective and aesthetic design. Time must be taken to research thoroughly the needs of the client, the products available, and the functions of the space, and to make careful choices that will function harmoniously in meeting the design program objectives.

We learn to make discerning choices by continually evaluating everything until we are able to recognize and appreciate good design even when it is not what we might choose for ourselves. Good design expresses a time and place, possesses character appropriate to its use, and communicates its purpose and intent clearly.

REFERENCES FOR FURTHER READING

Bevlin, Marjorie Elliott. *Design Through Discovery*, 5th ed. New York: Holt, Rinehart and Winston, Inc., 1989.

Cheatham, Frank R., Jane Hart Cheatham, and Sheryl A. Haler. *Design Concepts and Applications*. Englewood Cliffs, N.J.: Prentice-Hall, 1983.

Friedmann, Arnold, John F. Pile, and Forrest Nilson. *Interior Design: An Introduction to Architectural Interiors*, 3rd ed. New York: Elsevier Science Publishing Co., 1982.

Hartwigsen, Gail Lynn. Design Concepts: A Basic Guidebook. Boston: Allyn and Bacon, 1980.Pile, John F. Interior Design. Englewood Cliffs, N.J.: Prentice-Hall, Inc., New York: Harry N. Abrams, Inc., 1988.

Thiel, Philip. Visual Awareness and Design. Seattle: University of Washington Press, 1981. Zelanski, Paul and Mary Pat Fisher. Design: Principles and Problems. New York: Holt, Rinehart and Winston, 1984.

Elements: Space, Form, Line, Texture

SPACE

Sensory Perception Ordering Systems Spatial Illusion

FORM AND SHAPE Rectilinear Forms Angular Forms Curved Forms

LINE

TEXTURE

Ornament and Pattern

Writers use words, mathematicians numbers, and musicians sounds to express their verbal, mathematical, and musical ideas. Literature is, of course, a refined coalescence of language preserved in durable form; but mathematics and music each have their own "languages" composed of symbols, words, and concepts that are as readily comprehensible to initiates as the letters of the alphabet would be to the layman.

In design, expression is achieved through organizing the tangible components of **space**, **form and shape**, **line**, **texture**, **light**, and **color**. The last two of these, being highly specialized, form the subjects of separate chapters. These basic elements or tools, along with the principles which guide their application, comprise the visual vocabulary of design which communicates emotional and intellectual meaning. Both the emotional response and a deeper intellectual communication are essential in the applied arts.

SPACE

Space is one of the most essential elements in interior design. Simply by erecting walls we have enclosed a space, defined it, and articulated it. Painters often experience a kind of "block" when confronted with a pristine canvas, writers when facing a blank sheet of paper in the typewriter. The first mark on canvas, the first letter struck represents an enormous commitment and the establishment of all sorts

of relationships. So it is with space, but to an infinitely greater degree. We deal with the mechanism of articulating space thousands of times during the day without realizing it. In placing an object on a surface, we are not filling a void but carving out sections of space around the object. Before a structure is built, the space it will occupy exists as a continuous, diffuse entity; the construction of walls and a roof isolates two segments of space—that inside the structure and that outside.

Space suggests the possibility of change, of freedom to move physically, visually, or psychologically until we collide with or are diverted by a barrier. The element of *time* also plays an important role in our perception of interior space, for unless the space is very small, we cannot perceive it all at once, but must move through bit by bit, gradually accumulating impressions, until a sense of the whole has been assembled. Walking through a sensitively designed spatial volume, we participate in its expansion and contraction as naturally as we breathe. Space becomes a space-time continuum, because it changes constantly as we move.

As we travel through space our eyes, our bodies, and our spirits explore its constantly changing contours—that which is open and that which is closed. Everyone recognizes the sense of exhilaration felt upon emerging from a forest into a meadow or walking across an open plaza in a city. Architects and city planners always have understood the drama implicit in passing from a constricted space to an expansive one. Entrance to the great urban plazas—the Piazza San Marco in Venice, the Zocalo in Mexico City, St. Peter's Square in Rome—typically is gained through narrow, congested streets, thus magnifying the element of surprise and delight upon reaching the square. Frank Lloyd Wright utilized the same concept very effectively for passageways that opened into spacious rooms in the homes he designed.

Splendid as these open spaces are, most people feel a psychological need to return periodically to sheltered spaces that enclose and protect. We respond to the spaces that envelop and include us, and we adapt to them. In doing so, we share their triumphs or failures. The merging of open and closed spaces represents one of the hallmarks of modern architecture. Instead of sequences of boxed rooms, cut off from view of one another, we find spaces that flow together, expanding and contracting as the need arises, providing sensory variety.

SENSORY PERCEPTION

We perceive space through a variety of sensory receptors: the eyes, ears, nose, skin, and muscles. As previously mentioned, the **visual** experience of space as distant, expansive, close, or restricted is integrated with the **kinesthetic** experience, the physical act of moving around and through space. For Americans, the ability to move about freely without bumping into something bears a direct correlation to the perception of space. If something or someone is always in the way, space is perceived as unsatisfactorily designed and frustratingly cramped. For people from other cultures, spatial experiences and sensations are often quite different, but generally, what can be done in a space determines how it is experienced. (For more information regarding cultural differences, see Chapter 7.)

The **auditory** sense of space is affected by the reverberation of sound, whether sound is reflected (bounced) or absorbed. The acoustics of a space help to determine success in supporting functions within it. Auditory interference can make it difficult to communicate or to concentrate on a task. Based on cultural conditioning, some people are more able than others to selectively screen out unwanted auditory information. When an individual is unable to screen interfering noise, thick walls and sound-absorbing materials must be used to compensate or the space may be perceived as too small and crowded.

The **olfactory** experience also differs widely by cultural background. Americans tend to mask or suppress most odors as much as possible to the extent that much of the richness of experience is lost. To the sensitive nose, a room can present an array of olfactory sensations emanating from woods, leather, textiles, foods, other people, even an open window. Smell is also linked much more strongly to memory than either vision or sound. A familiar odor can bring back a flood of memories or even identify a place. It can also help determine location in relation to other objects or people. While it is customary to bathe another person in one's breath in Arab cultures, an American generally feels uncomfortable in a public place if forced into a position close enough to smell another person. Obviously, this results in a perception of inadequate space.

Finally, the skin is the sensory receptor in the perception of **thermal** and **tactile** space. Extremely sensitive, the surface of the skin both emits and detects radiant heat. When body heat from others can be felt, the experience of space is affected, increasing feelings of crowdedness. Heat radiating from a thermal storage surface such as brick or tile, or air currents stirring near a window, can also provide clues to location within a space. Visually impaired persons are particularly sensitive to both thermal and auditory information.

Tactile sensations are inextricably tied to visual experiences. Children touch everything as they learn. As they grow older, they are taught to be more visually oriented. The memory of the tactile experience influences how textures and spaces are subsequently seen. Yet, the actual sense of touch also remains important in keeping people related to the world. It is the most personally experienced sensation and establishes an intimate relationship between the person and object or surface being touched or between people. The texture of materials and furnishings selected affect the experience of interior space, inviting personal involvement or deterring interaction. The sense of space is closely related to the sense of self which interacts closely with the environment.

ORDERING SYSTEMS

The organization of space for various uses is the essence of architectural and interior design. When the designer faces the initial challenge of creating and defining an enclosure, there are several logical methods that can be used to develop space plans. These organizational concepts can also aid in analyzing the system used to arrange spaces in existing structures. Although spatial arrangement is largely a matter of required adjacencies, sizes, and functions, any given space problem can be solved in a variety of ways. There are four basic ordering systems that form the basis of space planning for individual rooms or large projects: linear, axial, radial, and grid configurations (see Figures 4.1– 4.4).

Linear systems arrange spaces, rooms, or objects along a single line, usually a circulation path, which may be straight, curved, or a series of segments at angles to one another. Spaces or rooms (or furnishings) along the traffic route may vary in shape or size but maintain their relationship to the connecting path. Rooms on either side of a hallway are placed in a linear arrangement.

When there are two or more major linear arrangements at angles to each other, like intersecting streets, the spatial configuration is **axial.** The axes may be at any angle to each other and often have important terminal spaces at their ends. Major rooms at the ends of one circulation corridor and a primary entrance at the end of another axis are examples. An axis itself may also be an important element in the design.

Radial arrangements have a central nucleus with spaces and circulation routes extending outward from it. Rooms may be grouped around a central courtyard or

4.1 LINEAR ARRANGEMENT with direct or common link

4.2 RADIAL ARRANGEMENT has a common center

4.3 AXIAL ARRANGEMENT from central space or corridor

4.4 GRID ARRANGEMENT repetitive system of units

4.1–4.4 The four basic ordering systems for space planning. **4.1** A *linear* organization links spaces along a line. **4.2** A *radial* configuration has a central nucleus with spaces grouped around it or extending from it. **4.3** An *axial* arrangement encompasses linear structures that intersect or terminate in important spaces. **4.4** A *grid* system establishes repetitive modules between two sets of parallel lines at an axis to each other.

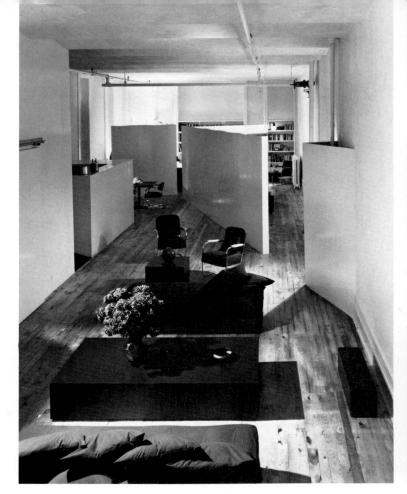

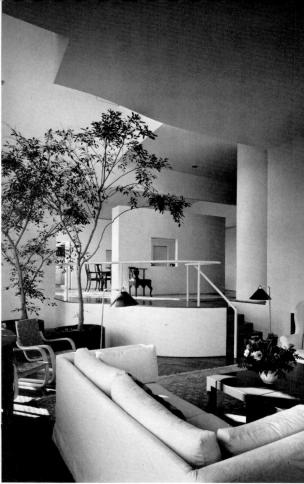

4.5 In a renovated loft, walls set on the diagonal reveal tantalizing glimpses of the spaces beyond and visually enlarge the space. Kevin Walz, designer. (Photograph: Peter Aaron ⊚ ESTO)

4.6 An open plan seems to expand space, allowing at least partial view of adjacent spaces. Henry Smith-Miller, architect. (Photograph: © Norman McGrath)

entry foyer or corridors may radiate from such a central space. Radial systems are often quite formal arrangements with emphasis placed on the central space, but they may be more irregular, loosely-formed configurations as well. In commercial spaces, building codes may require that the corridors end with exits unless they do not exceed the maximum dead-end length.

A **grid** organizes repeated units of space, usually defined by circulation routes. Tables in a restaurant with spaces between for movement provide a typical example of a grid pattern. The grid system can be varied in size and angle of intersection of the two sets of lines (circulation paths) to define and emphasize a special area, but it can also be very confusing and monotonous if used too much or in inappropriate settings.

Each of these arrangements can be modified to create many variations. They are presented only as a starting point to planning space.

SPATIAL ILLUSION

The two most obvious and common space problems in homes are a lack of space and an excess of it. Both conditions tend to indicate an unwise *use* of the available space rather than an unmanageable number of cubic feet. The knowledgeable designer modulates spaces, using the other elements of design—line, form, light, color, texture—to achieve a sense of spaciousness or intimacy. It is this impression of *apparent* space that affects us so dynamically and that turns spatial problems into "ideal" living environments. There are many ways to articulate space physically, visually, and even audibly.

Small spaces may be so designed deliberately and even have their smallness emphasized when coziness and intimacy are desired; however, when small spaces are confining and uncomfortable, they can be made to appear larger. To increase apparent spaciousness:

- Allow the eye (and the body, if possible) to travel freely beyond the immediate space through uncluttered openings into adjacent spaces or outdoors by using open plans, large openings between rooms, diagonal sight lines to spaces beyond, and expansive, uncovered windows (Figures 4.5 and 4.6).
- Place large pieces of furniture near and parallel to walls so that they do not interrupt the open space, dividing it into even smaller segments.
- Use small-scale furniture, textures, and patterns.
- Keep furnishings and accessories few in number.
- Leave some empty, silent space in the room—between furniture or on walls.
- Expose as much floor area as possible by choosing furniture that sits up off the floor (on legs or hung from walls) rather than furniture with bases that sit directly on the floor, and by using transparent glass or plastic pieces.
- Use mirrors and *trompe l'œil* (three-dimensional "deceive the eye") effects to create the illusion of depth.
- Unify the space as much as possible, using wall-to-wall floor coverings and the same floor covering throughout the house, floor-to-ceiling window treatments; and colors, textures, and patterns that blend rather than contrast.
- Select light, cool colors that seem to expand space.
- Light the perimeter of the room, the ceiling, and/or possibly the underside of heavy pieces of furniture such as beds or sofas to make them appear to float above the floor.

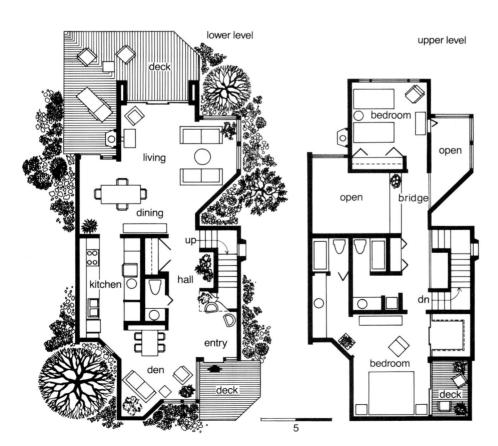

4.7 A plan illustrates the way in which just a few irregularities in outline contribute to the flexible space within. A minimum of furnishings, with open spaces between, also contributes spaciousness. John Sampieri, architect.

4.8 For a single client who entertains frequently, Marcello Pozzi maximized space in a turn-of-thecentury apartment in Milan, Italy, by demolishing walls that enclosed spaces and restructuring the space within, defined by a transparent glass enclosure that separates space without isolating the occupant. (Photograph: Alberto Tagliabue)

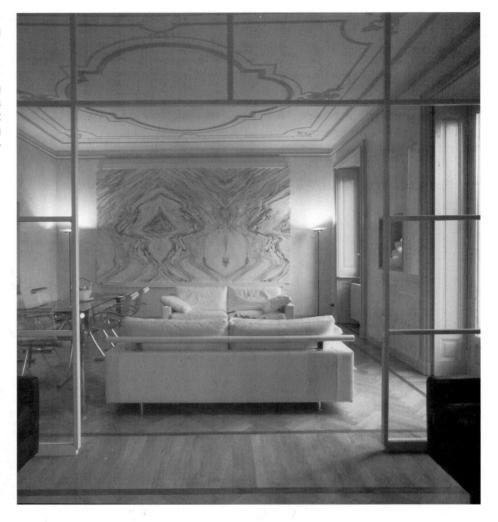

When space lacks definition, seeming to have neither beginning nor end, it may be made to appear more secure and intimate. To create this spatial perception:

- Subdivide the space physically and visually, placing furnishings perpendicular to walls to act as room dividers.
- Choose furnishings of varied height to obstruct extended views.
- Group furniture in clearly defined areas of activity.
- Select large-scale furniture and perhaps more pieces that sit on solid or skirted bases, obscuring floor area.
- Break up the expansive area of walls and floors with contrasting colors, textures, and patterns.
- Contract space or improve its proportions with warm, dark colors.
- Create distinct, cohesive spatial units with controlled natural lighting and sensitive placement of artificial lighting.
- Use soft (not hard), rough textures to absorb sound and further feelings of privacy and intimacy.

Space is among the most important elements of home design. Unless it is thoughtfully planned, nothing else will ever seem quite right. Yet almost any space, if sensitively handled, can be made effective, livable, aesthetically pleasing, even dramatic.

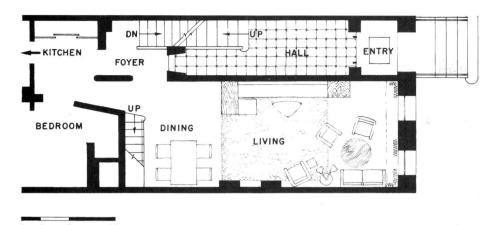

4.9 (left) A New York City brownstone house remodeled by Joseph Aronson for his own family illustrates the subdivision of open space by the use and placement of furnishings. (below, left) A view of the interior reveals how the long narrow space is visually altered by three separate activity areas. (*Photograph: F. S. Lincoln*)

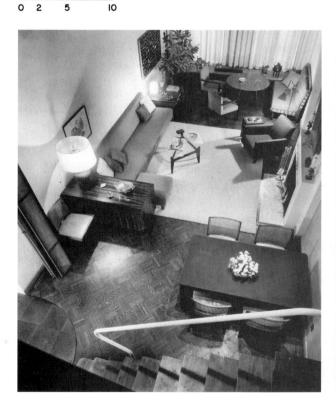

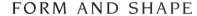

Form and **shape** are two terms often used interchangeably, both as nouns and as verbs; indeed, we have so used them in this book. But in the purest descriptive sense, subtle differences do distinguish them. **Shape**, the simpler of the two, refers to the measurable, identifiable contours of an object, generally expressed in relation to its outlines. We speak of a square shape, a round shape, a triangular shape. *Area* refers to the two-dimensional extent of a shape, such as the floor area of a house or the wall area of a room. A much more inclusive term, **form** takes account of shape but may also encompass substance (solid or liquid form), three-dimensional volume or mass, internal structure, and even the idea implicit in shape.

4.10 In the courtyard of the California Palace of the Legion of Honor in San Francisco, California, sharp contrasts of light and dark, texture, and materials increase the intimacy of the space. *The Thinker*, cast bronze sculpture by Auguste Rodin. *(Photograph: Philip L. Molten)*

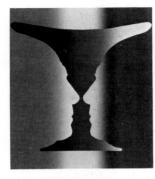

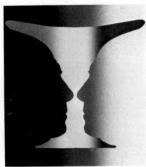

4.11 This classic visual device reverses constantly, depending on how we focus our eyes. At one glance it is a white vase on a black background; at another it shows two profiles facing each other. Such tools help broaden our concepts of the relationship between space and form. *Cups 4 Picasso*, 1972 lithograph by Jasper Johns. *(Leo Castelli Gallery, New York)*

Shape is best understood in relation to space, as the classic positive-negative reversal silhouette (Figure 4.11) illustrates. Looking at the drawing one way, we see the positive shape of a stemmed goblet with a negative space on either side; when we allow the drawing to reverse, we see the shapes of two human profiles with space between them. If we permit our perceptions to expand, we can apply the same kinds of interrelationships to the home. The act of putting a chair into an empty room affects both the form and the space. When a second chair is added to the room, *both* forms and the space will be affected. The objects with which we fill our homes are not isolated, self-contained items but forms that relate to each other and to the spaces they articulate.

Except for purposes of analysis, form and space are inseparable because form gives space whatever dimension it has and space reveals, even determines, form. Usually form seems more constant and permanent than space; form gives space three-dimensional structure and establishes boundaries while space implies the possibility of change and the infinity of space-time.

Well-designed objects for the home also relate to *buman* form. Ergonomics has had a positive impact on the design of both furnishings and spaces, particularly for work activities. Those objects and spaces that accommodate the human form most readily produce the most comfort and satisfaction in use.

Additional aspects of form may be illustrated with three chairs (Figures 4.12–4.14). In the first, we perceive form as *mass*, which fills space solidly. In the second group of chairs, it is *shape* that catches the eye, a wondrous assortment of contours that are reminiscent of earlier designs. The third chair calls attention to its form by concentrating on *structure*, the continuous swirl of the supporting frame. Modern architecture and furnishings are often characterized by their frank expression of structural design, exposing materials and methods of construction as inseparable from design. Good structural design relies on simplicity, function, integrity, and good proportion.

Despite the infinite diversity of shapes and forms in our world, all can basically be categorized as **rectilinear**, **angled**, or **curved**. In their purest expression, these shapes become the geometric figures of square, triangle, and circle or, in solid form, cube, pyramid, and sphere. The circle often occurs in nature, the triangle occasionally, the square or rectangle rarely. Yet so perfect are these shapes,

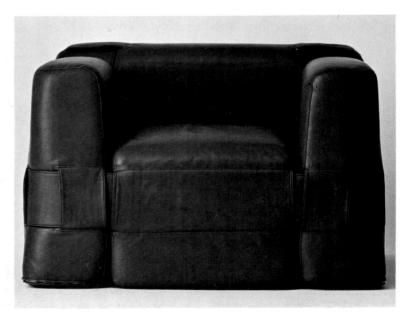

4.12 An easy chair designed by Mario Bellini illustrates the use of *mass* to achieve a desired effect, in this case comfort. (Courtesy Atelier International, Ltd.)

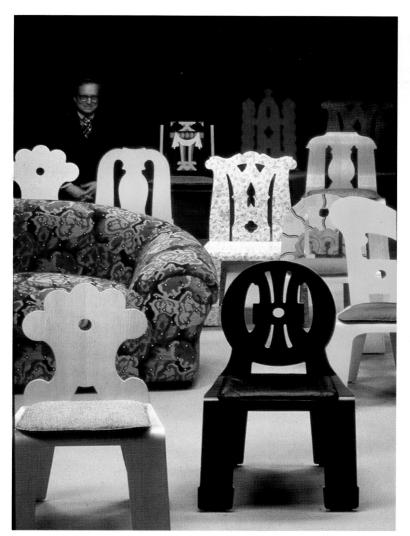

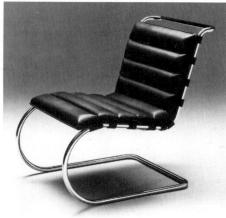

4.13 The cut-out shapes of these Robert Venturi chairs capture the essence of Chippendale, Queen Anne, Empire, Art Deco, and other historical styles. (Courtesy The Knoll Group)

4.14 Miës van der Rohe's *MR lounge chair*, designed in 1931, is constructed with a polished steel frame and saddle leather straps supporting leather-covered foam upholstery. *(Courtesy The Knoll Group)*

so satisfying in their completeness, that they serve as the basis for every kind of design, from massive buildings and the layout of whole cities down through the smallest implement. Today designers are applying geometric shapes and forms to domestic architecture in new ways. Dramatic angles, unexpected planes, sculptured space, and architectural cutouts characterize some of the most innovative designs for interiors (Figure 4.15). Where previously the circle, the triangle, and the square represented stability and repose, today's geometry provides an exciting freedom and a whole new concept for shaping internal space.

Not every shape, of course, is identifiable as a pure circle, square, or triangle; but every shape contains one or more of these elements, so we can discuss objects in terms of the predominant shapes and investigate the ways in which these shapes can be combined.

RECTILINEAR FORMS

That **rectangularity** is typical of the larger spaces and forms in today's homes is evident in all but a few of the illustrations in this book. It prevails not only in entire houses and rooms but in such furniture as beds, tables, storage units, and television sets, plus many sofas, chairs, and benches, even putting in an appearance in

4.15 Notre-Dame-du-Haut, in Ronchamp, France, designed by Le Corbusier in 1950–1955 admits glowing light into the chapel through a variety of openings which pierce the sturdy walls. (From The New Churches of Europe by G. E. Kidder Smith)

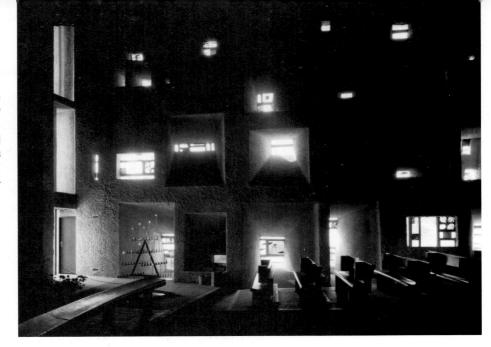

smaller artifacts and textiles. Among the reasons for this widespread acceptance, we might note that rectangles

- are easily handled on designers' drafting boards, by carpenters and masons on the building site, and by machines in factories,
- fit together snugly—an important factor when multitudinous elements coming from many sources are assembled on the job and when space is becoming increasingly expensive,
- have a stable, secure relationship of exact 90-degree angles, which gives a sense of definiteness and certainty, and
- establish an apparent unity and rhythm when repeated.

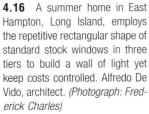

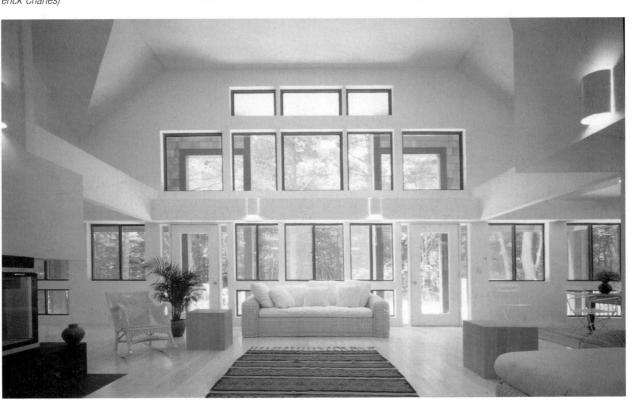

The qualities of clarity, stability, and certainty that combine to make rectilinear forms popular can also bring a harsh, boxlike monotony that many people deplore. When handled imaginatively, however, the right angle has a pure, strong, absolute character—its own quality of beauty. When the rectangle or square is placed on the diagonal, it ceases to be restful and becomes a dynamic element. In sum, then, rectilinear shapes can create very different effects and call forth a variety of emotional responses from the people who see them, depending upon size, placement, color, and orientation.

ANGULAR FORMS

Triangles and **pyramids** differ from rectangles in their pointed, dynamic character. Among the most common angular elements in contemporary homes are the sloping rooflines that introduce a note of variety and surprise to the basic room cube. The reception area in Figure 4.18 has sharply angled walls, their form echoed in the triangular stepped platform and reception desk jutting into the space. While remaining stable, this room takes on life and spirit with the inclusion of dramatic angles.

From a structural point of view, triangles are among the most stable forms known, since their shape cannot be altered without breaking or bending one or more sides. Still, they express greater flexibility than rectangles, because the

4.17 From the Kutch district of India, this Harijan patchwork quilt demonstrates the energetic effect of diagonal lines and shapes. (Fowler Museum of Cultural History, UCLA [Gift of Mr. & Mrs. Richard B. Rogers])

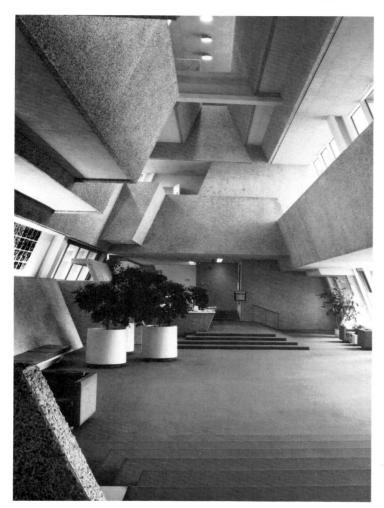

4.18 Concrete aggregate and glass combine to form the dynamic pyramid-like interior of the Burroughs, Wellcome & Co. building in Research Triangle Park, North Carolina, designed by Paul Rudolph in 1974–1975. (Photograph: Greg Plachito)

- **4.19** (right) Unlike most chairs of this type, the Kirkpatrick folding chair is handsome both open and in profile—and comfortable as well. (Courtesy C. I. Designs)
- **4.20** (far right) Triangles and diamond shapes, arranged in a linear pattern, create an active yet stable design element in a textile ("Navajo Stripe") from Brunschwig & Fils. Chris O'Connell, designer.

angles can be varied to suit the need. For example, the triangles formed by the legs of standard folding chairs can, with a flick of the wrist, be transformed from stable support to space-saving linearity. Used with discretion and in large size, as in the ceiling or gable end of a pitched-roof house, triangles are secure yet dynamic. Small repeated triangles or diamond shapes in textiles, tiles, or wall coverings add briskness to interiors, while a three-sided table between two chairs sets up a congenial relationship. Diagonals generally increase apparent size; a diagonal line through a space, whether structural or visual, is longer than the lines which enclose a rectangular room. Also, because angular forms imply motion and are relatively uncommon, they usually attract and hold attention beyond what their actual dimensions would otherwise suggest.

CURVED FORMS

Curves bring together the lively combination of continuity and constant change. They remind us sympathetically of flowers, trees, clouds, and our own bodies. Until recently, large curvilinear elements, such as circular rooms, domed or vaulted ceilings, and curved stairways, have been rare in contemporary houses, but there is increasing interest in their possibilities.

Circles and spheres have a unique complex of qualities:

- They are nature's most conservative and economical forms, since they not only
 enclose the greatest area or volume with the least amount of surface but also
 strongly resist breakage and other damage.
- Although as rigidly defined geometrically as squares or cubes, they do not seem so static, probably because we are subconsciously reminded that balls and wheels roll easily.
- They have an unequaled unity, for every point on the edge or surface is equidistant from the center—a natural focal point, especially when accented.

Inside our homes, circles and spheres are most noticeable in plates, bowls and vases, lampshades and pillows, and in a few tables, chairs, and stools. They also form the basic motif in many textiles, wallpapers, and floor coverings. Curvilinear forms seem particularly appropriate for fabrics, especially those meant to be hung, for the sinuous curves only enhance the quality of draping (Figure 4.23).

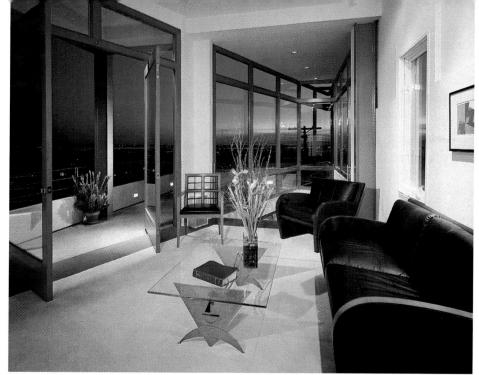

4.21 The dramatic diagonal line of a glass wall in this San Diego, California, hillside home not only extends apparent space to its apex but also captures a spectacular view of the downtown city lights. Brad Burke, Studio E Architects. (Photograph: Hewitt/Garrison)

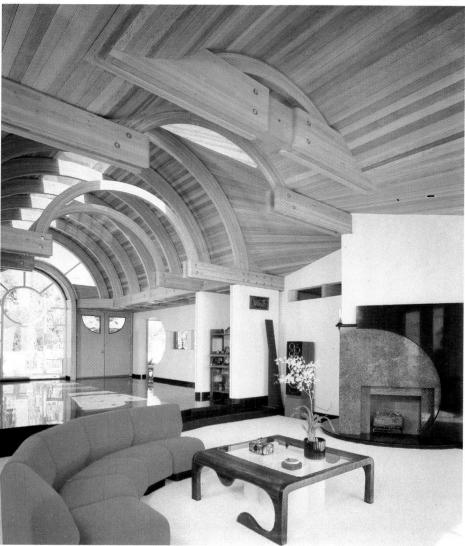

- **4.22** Architect C. W. Kim has featured numerous curved forms in his own home on a hilltop in La Jolla, California. An Oriental/parabolic arch dominates the ceiling from front to back and is echoed in an arched window, curving sofa, and the sweeping arc of granite over the fireplace. (Photograph: Hewitt/Garrison)
- **4.23** When choosing fabrics, consider how a pattern will look when draped. The stylized flower pattern "Allegro," by Gloria Vanderbilt, is shown hung in folds and stretched flat. (Courtesy James Seeman Studios, Inc.)

4.24 A table desk by Modern Living has inverted cones of polished metal for legs, a sharp contrast to the traditional wood top. Law offices designed by Nancy Jones and Walter Thomas, ISD + Al. (*Photograph: Hedrich Blessing*)

4.25 A variety of forms—rectangular, diagonal, and curvacious—combine to create a light-filled, view-oriented four-room permanent retreat on the Connecticut River for a retired couple. Jefferson B. Riley, AIA, Centerbrook, architect. (Photograph: Norman McGrath)

Cones and cylinders, too, are curvilinear forms, but they entail a definite, directional movement not found in circles or spheres. While cones and cylinders resemble each other, there is an important difference: Cones, like pyramids, reach toward a climactic terminal peak, whereas cylinders, like rectangles, could continue forever. This makes cones more emphatic and directs attention to a focal point. Both forms please us, because they relate to our own arms and legs. They frequently serve as the vertical supports of furniture, as lamp bases and shades, candle-holders, and vases. Furniture legs of wood or metal often take the form of truncated cones, tapering toward the top or bottom for visual lightness and grace.

Rarely do we find a home composed entirely of rectangles, triangles, or circles. Instead, most interiors reveal a combination of forms chosen to balance and counterpoint one another. The essence of combining forms lies not in seeing how many one can include but in making them work together to present a pleasing juxtaposition for overall unity (Figures 4.25–4.27).

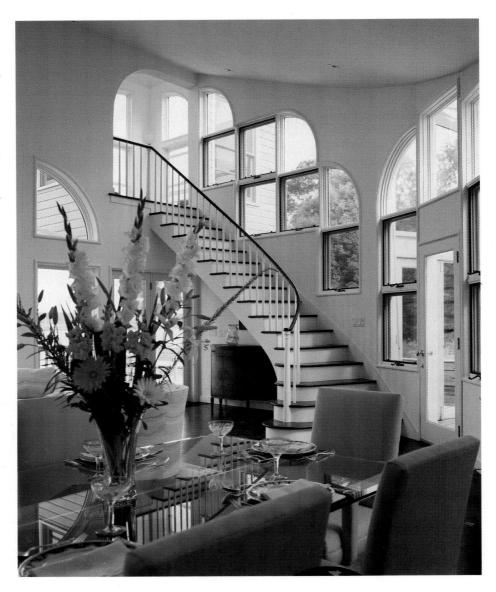

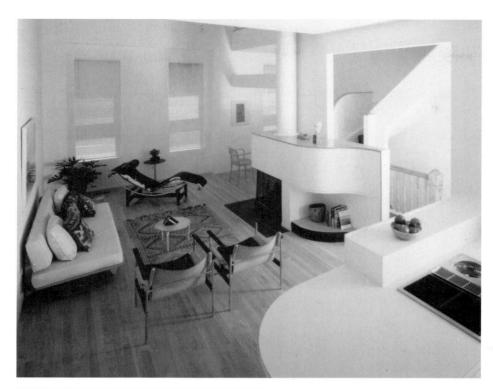

4.26 The basic rectangularity of this three-story Chicago, Illinois, remodeled Victorian house is pleasantly disrupted by a pianoshaped fireplace and the arc of the kitchen peninsula, the stair wall, and the Le Corbusier chaise longue. Sidney Weinberg, architect/designer. (Photograph: Howard N. Kaplan)

4.27 Architect Robert Graves juxtaposes straight and curved geometric forms in unexpected ways in a townhouse library. (Photograph: Peter Aaron © ESTO)

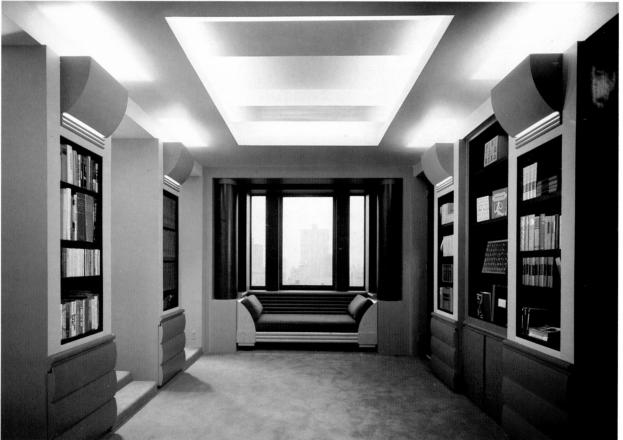

4.28 In "Gossamer," a leno-weave fabric of long silky wool fibers, the lines produced by the yarns between the woven areas form a major design element. (Courtesy Jack Lenor Larsen, Inc.)

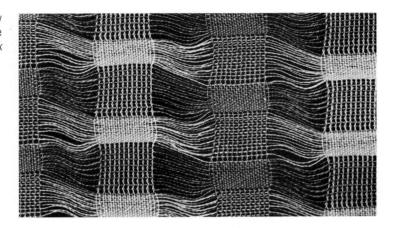

LINE

Theoretically, a line has only one dimension, since by definition it is the extension of a point; but in practice lines can be thick or thin, giving the additional qualities of being bold or sketchy, while maintaining the basic characteristic of length. In interior design, the word *line* is frequently used to describe the outline of a shape or space (where edges occur, planes meet, or there is a change in color, texture, or material), or the dominant direction, as when the "lines" of furniture or houses are said to be pleasing. Line is often described as lending attributes of masculinity or femininity, tight precision or free-flowing looseness, depending upon the length, width, direction, angularity, or degree of curvature.

Among the most expressive qualities of line is its direction. In studying the ways in which direction affects our feelings and our movements, psychologists and artists have come to such generalizations as the following:

- **Vertical lines** imply a stabilized resistance to gravity and seem to lend dignity and formality to spaces. If high enough, they evoke feelings of aspiration and ascendancy.
- Horizontals tend to be restful, relaxing, and informal, especially when long. Short and interrupted horizontals become a series of dashes.
- **Diagonals** are comparatively more active in that they suggest movement and dynamism. Long diagonals extend space.
- Big upward curves are uplifting and inspiring.
- Horizontal curves connote gentleness and relaxed movement.
- Large downward curves, seldom seen in homes, express a range of feelings, including seriousness and sadness. They may, however, bring a welcome sense of solidity and attachment to the earth.
- Small curves suggest playfulness and humor.

But line has a more concrete meaning when it serves to ornament or accentuate a form. Textiles make a natural exponent of line, since the warp and filling yarns are themselves lines. When closely woven, textiles absorb the lines, but an openwork fabric such as the one illustrated in Figure 4.28 gives ample evidence of its linear structure.

Lines can act either to emphasize or to deemphasize shapes, thereby changing the apparent proportions of objects and rooms. Figure 4.29 depicts two rectangles of equal dimensions, one divided with vertical lines, the other with

4.29 Dividing a shape into segments and reinforcing parallel contours in first the horizontal direction (a), then the vertical (b), can result in quite different effects.

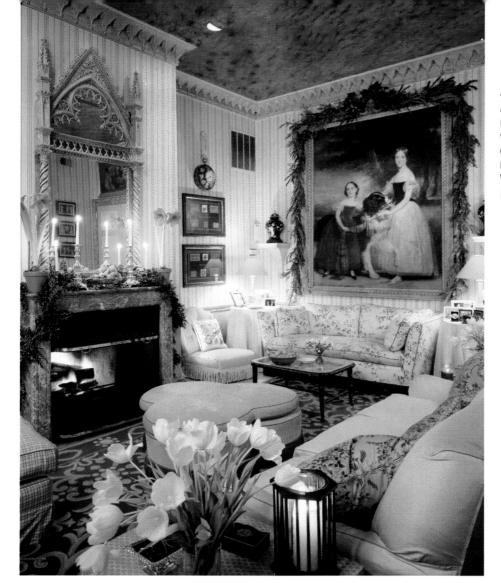

4.30 English interior designer Anthony P. Browne mixes Gothic revival vertical and diagonal lines with warm, rich hues and the low, continuous horizontal line of furnishings in his own Georgetown, Washington, D.C., apartment. (Photograph: Mick Hales)

horizontal lines. The horizontal lines reinforce the horizontal direction of the rectangle, seeming to further extend its length, while the perpendicular lines counteract it, producing a more vertical effect.

As interpreted for interior design, these generalizations recommend that verticals be emphasized—high ceilings, tall doors and windows, upright furniture placement—for a feeling of loftiness and cool assurance; horizontals—low ceilings, broad openings, stretched-out furniture—for an impression of informal comfort; diagonals—sloping ceilings, oblique walls or furniture placement—for an environment that speaks of activity. Usually, several or all of these lines are brought together at differing levels of dominance and subordination so that the total effect seems varied yet unified.

TEXTURE

Referring to the surface qualities of materials, **texture** describes how they feel when we touch them. A distinction is often made between actual or **tactile** textures, in which the actual three-dimensional surface qualities can be felt, as in bricks and woolen tweeds or hammered metal, and **visual** textures (sometimes called **illusionary** or **simulated**), in which a material reveals a textural pattern under a

- **4.31** "Pythagory," a knotted linen "jar" by Patti Lechman has a *tactile* ribbed texture that produces a strong pattern of light and dark. (Courtesy International Linen Promotion Commission)
- **4.32** The spontaneous flowering of a sky-blue crystalline glaze on a cream background resulted in a somewhat rough *visual* but actually quite smooth *tactile* texture on a covered jar by Jack H. Feltman. (The Fine Arts Museums of San Francisco [gift of the artist])

smooth surface. The texture results from a translation of one sensory experience—touch—into another—vision—by means of variations in light and dark that are perceived as highlights and shadows created by hills and valleys on a surface. Past experience in actually touching a wide variety of surfaces helps us interpret visual textures.

The effectiveness of a texture is a matter of relationships among forms, colors, and other textures present. A decidedly tactile texture will be more obvious when contrasted against a uniform surface than it will against a rough one. In interior design, texture plays an extremely important role in creating interest and variety as well as providing needed sensory stimulation.

Texture affects us in a number of ways. First, it makes a physical impression of everything we touch. Upholstery fabrics, for example, if coarse and harsh, can actually be irritating; if too sleek, they look and feel slippery and cold. The most popular fabrics tend to be neither excessively rough nor smooth. Second, texture influences light reflection and thus the appearance of color. Very smooth materials—polished metal, glass, or satin—reflect light brilliantly, attracting attention

4.33 Lighting creates a play on textures—ranging from smooth silk upholstery to bouclé drapery, sisal rug, walls finished with pearlized automotive paint, carved reproduction Zen tables, and live plants—in this Sacramento, California, remodeled English Tudor-style home. Paulette Trainor, interior designer. *(Photograph: Cathy Kelly)*

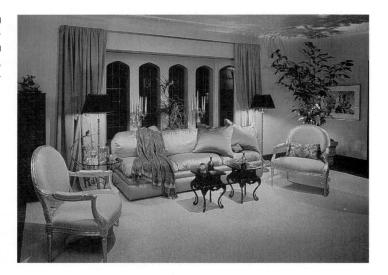

and making their colors appear clear and strong. Moderately rough surfaces absorb light unevenly, hence their colors look less bright. Very rough surfaces set up vigorous patterns of light and dark, as can be seen especially in plants. Texture can be further emphasized or minimized by the light that falls on it. Strong light falling at a grazing angle dramatizes natural highlights and shadows; uniform "wall-washing" light minimizes texture; diffuse light tempers harshness. (See Chapter 21 for further explanation of the effects of light.) Third, texture affects sound quality. Hard, smooth surfaces reverberate and magnify sound while soft, porous textures absorb it. Fourth, texture is a factor in household maintenance. The shiny surfaces of brightly polished metal or glass are easy to clean but show everything foreign; rougher surfaces, such as bricks or rugs with deep pile, call less attention to foreign matter but are harder to clean; and smooth surfaces with visual textures combine most of the good qualities of both. Finally, texture is a source of both beauty and character. When organized and used repetitively in home design, texture becomes an ornamental as well as a structural pattern.

ORNAMENT AND PATTERN

Ornament, a broader term than texture, relates to the decorative qualities visible on the surface of things. An object or surface may be adorned with a single ornament to add beauty, such as a piece of jewelry or a tassel hung from a door handle, or the materials used in its construction may be formed in such a way as to lend texture or sheen, or it may be covered with designs or patterns which provide interest or add emphasis. Texture can thus serve as a kind of ornament, and ornament and pattern usually provide some texture. Every surface has a texture

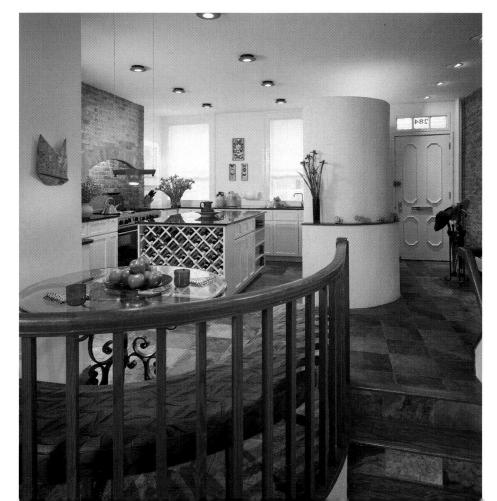

4.34 The *inherent* individual character of African slate, old brick, black granite, textured plaster, polished wood, and wrought iron provide a rich, natural aesthetic mix in a brownstone townhome renovation in Greenwich Village, New York, by Heather Faulding, Faulding Associates. (Photograph: Frederick Charles)

that affects us physically and aesthetically. When texture is consciously manipulated to beautify an object, we call it ornament or pattern.

We can distinguish two major types of ornament: inherent and applied. **Inherent** ornament comes from the intrinsic character of materials, the way in which they are fabricated, or the sensitivity with which an object and each of its parts are shaped. It encompasses the natural beauty of wood grain or the innate qualities of silk or linen; textures and patterns originating in the weaving process or in the laying of a brick floor; the deliberate design and shaping of objects beyond utilitarian or structural demands so that they provide visual and tactile pleasure. Inherent ornament is the texture of the material that is intrinsic to the object it enriches; it seems natural and fundamental. Usually it is less subject to physical deterioration, such as breakage or fading, and is less likely to go out of fashion than is applied ornament.

Applied ornament refers to that added to an object after it is structurally complete, such as patterns printed on fabric or wall covering, carved moldings on walls, or designs etched on glass. As a kind of applied ornament, **pattern** is derived from the repetition of a design unit, called a *motif*, as a thematic element. Motifs can generally be categorized as **naturalistic** or realistic reproductions of natural subjects; **stylized** or conventional representations that simplify the subject to emphasize its basic qualities; **abstract** designs, which may be based on familiar motifs but are generally used in such a way as to be unrecognizable and include nonrepresentational **geometric** designs, using stripes, plaids, or geometric shapes.

In developing a pattern, motifs may be organized and repeated in a variety of ways. Units may be repeated regularly, matching straight across the surface, or

- **4.35** (top, left) The *naturalistic* design of this textile from the "Suzanne Collection" uses motifs of plants and flowers that complement the fabric, whether folded, draped, or flat. (Courtesy Grey Watkins Ltd.)
- **4.36** (top, right) "Winter Tree," by Jack Lenor Larsen, has a *stylized* design that is not strictly representational but emphasizes basic qualities.
- **4.37** (bottom, left) Abstract designs, such as "Jerusalem" from S. Harris & Co., are nonrepresentational. (Photograph: Christopher Weeks)
- **4.38** (bottom, right) "Blueprint" and "Skyscraper" employ *geometric* motifs of stripes and rectangles turned at various angles. Susan Lyons, designer. (Courtesy DesignTex. Photograph: William Whitehurst.)

4.39 Ornament growing naturally out of the material, form, and function enhances these crystal goblets. Pavel Hlava, designer. (Courtesy © Rosenthal Bilderdienst)

dropped so the figure matches midway in the design, or alternated or varied in size, color, position, or subject, to name just a few of the variations. The effect created when the pattern covers a flat surface may be quite different from the same pattern seen draped or folded as illustrated in Figure 4.23. Also, when viewed from a distance, the contrast of light and dark colors used in patterns are interpreted as visual textures, adding yet another variation to their effect. An allover pattern has no single feature that predominates, unlike the use of a single ornament. For this reason, such patterns often lend themselves to backgrounds such as floors, walls, and fabrics. Pattern also camouflages wear on floors and upholstery, extending the life of materials used and providing added economy.

Pattern applied to either an object or the surface of a room (floor, walls, or ceiling) will modify the apparent size of the object or space enclosed. The larger the pattern, the larger it makes the object appear while the smaller it makes the space seem. This is explained by the expectation that nearer objects and surfaces should seem larger than those that are farther away. A large pattern covering the walls of a small room will thus seem to diminish the size of the room more than its actual dimensions.

Only two factors limit the range of applied ornament: the nature of the materials and the imagination and taste of the designer. Ornament can be admirably suited to an object's use, form, and materials—or it can be distressingly inappropriate. The most satisfying ornament fits the functions, form, size, and material of which it is a part, being, moreover, worthwhile in itself. Specifically, ornament should be:

- Pleasant to feel, especially if it is touched frequently. Resting one's arms or back against sharp carving on a chair or handling angular silverware can be physically uncomfortable.
- Supportive of the form it enriches. Ornament generally is at its best when it accentuates the form of an object, its edges, handle, contours, or other important aspects.
- Related to the size, scale, and character of the form. Generally, ornament and pattern should be similar to the object they adorn in both scale and character;

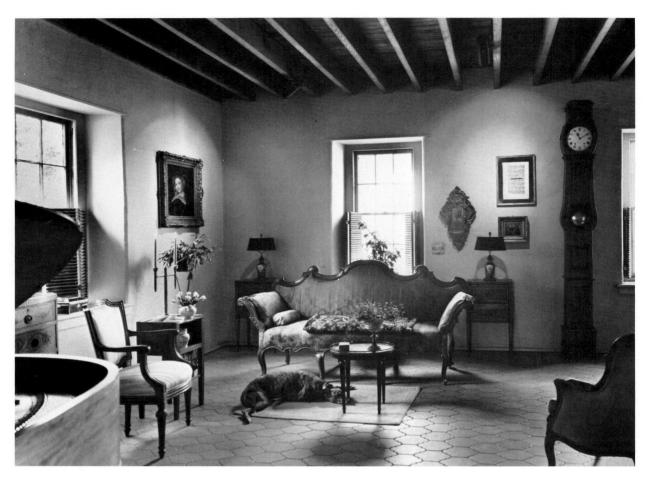

4.40 In a restored 18th-century mill in Pennsylvania, French and Italian antiques with restrained ornament seem perfectly at home. Lilias Barger and Raymond Barger, designers. (Photograph: John T. Hill)

pattern should be similar to the object they adorn in both scale and character; small areas are best covered with small patterns that are less dominant than the form of the object itself and that reinforce its character.

- Appropriate to the material. Fine, linear decoration can be effective on smooth, light-reflecting metal or glass, whereas on wood it might look merely scratchy.
- Vital in itself. Spirit and character are as crucial in ornament as in the design of form and space.

The stemware in Figure 4.39 (page 87) embodies all these criteria. Taking the form of a delicate, perfect flower poised on a striated stem, these glasses contrast the pure, unadorned transparency of crystal against the overlapping pattern that is possible with molten glass. Beyond its decorative capacities, the textured pattern in the stem actually enhances function, since it provides a better grip. The ornament, while rich, has a light, linear quality in keeping with the size and fragility of the glasses, and it leads the eye upward to the expanding volume of the bowl.

Attitudes toward ornament, especially toward applied ornament, vary from one period to another. In contemporary design two seemingly contradictory viewpoints are evident: on the one hand, a distaste for any kind of applied ornament, with emphasis on keeping design clean and "minimal" (see Figure 2.32); on the other, a great delight in ornament, especially as provided by old furnishings and hand-crafted objects (Figure 4.40). The quality that should be stressed in each home depends upon the tastes, personalities, and lifestyle of the occupants.

Pattern as applied to furnishings and surfaces or as achieved through the simple repetition of colors, textures, or materials is a major influence in many interi-

ors. Pattern is also derived from the contrast between light and shadow, forms, colors, lines, and/or textures in an interior. A wall of books, plants silhouetted against a wall, the shadow of furniture pieces on the floor, and the changing play of light over textured surfaces, all create patterns that satisfy one of the most basic human impulses, the need to beautify our environment.

Our discussion of space, form, shape, line, texture, and ornament has necessarily been rather abstract, isolating one quality at a time for analysis. In practice, however, these elements plus light and color, considered in the next chapter, are so closely interwoven in the fabric of design that each reacts upon the others. This synthesis will be analyzed in Chapter 6 when the principles of design, such as balance, rhythm, and emphasis, are examined to explain how the elements and principles together contribute to the total effect.

NOTE TO THE TEXT

1. Hall, Edward T. *The Hidden Dimension*. (Garden City, N.Y.: Doubleday & Company, Inc., 1966, Chapters 4–6.)

REFERENCES FOR FURTHER READING

Betti, Claudia and Teel Sale. *Drawing: A Contemporary Approach*, 3rd ed. Fort Worth: Harcourt Brace Jovanovich College Publishers, 1992.

Bevlin, Marjorie Elliott. Design Through Discovery, brief ed. New York: Holt, Rinehart and Winston, 1984. Chaps. 1–7.

Cheatham, Frank R., Jane Hart Cheatham, and Sheryl A. Haler. *Design Concepts and Applications*. Englewood Cliffs, N.J.: Prentice-Hall, 1983.

Grieder, Terence. Artist and Audience. Fort Worth: Holt, Rinehart and Winston, Inc., 1990.Hall, Edward T. The Hidden Dimension. Garden City, N. Y.: Doubleday & Company, Inc., 1966.

Lauer, David A. Design Basics, 3rd ed. Fort Worth: Holt, Rinehart and Winston, Inc., 1990.Nemett, Barry. Images, Objects and Ideas: Viewing the Visual Arts. Fort Worth: Harcourt Brace Jovanovich College Publishers, 1992.

Ocvirk, Otto G., Robert O. Bone, Robert E. Stinson, and Philip R. Wigg. Art Fundamentals: Theory and Practice, 4th ed. Dubuque, Ia.: William C. Brown, 1981.

Richardson, John Adkins, Floyd W. Coleman, and Michael J. Smith. *Basic Design: Systems*, *Elements, Applications*. Englewood Cliffs, N.J.: Prentice-Hall, 1984.

Russell, Stella Pandell. Art in the World, 2nd ed. New York: Holt, Rinehart and Winston, 1984.

Zelanski, Paul and Mary Pat Fisher. *Design: Principles and Problems*. New York: Holt, Rinehart and Winston, 1984.

Elements: Light and Color

LIGHT

COLOR THEORY

Hue

Value

Intensity

COLOR SYSTEMS

Munsell

Ostwald

PLANNING COLOR HARMONIES

Monochromatic

Achromatic

Analogous

Complementary

Double Complementary

Split Complementary

Triad

Tetrad

FACTORS TO CONSIDER IN SELECTING COLORS

Effects of Hue, Value, and Intensity

ECONOMIES WITH COLOR

Although color has long been considered a fundamental of interior design, only recently have we become fully aware of its potentialities beyond mere pleasantness or unpleasantness. Color can be influential, for better or for worse. Such phrases as *functional color* and *color conditioning* describe its use in business for increased efficiency. And psychologists have reported studies that seem to show that young children tested in brightly painted rooms that they thought of as "beautiful" earned higher IQ scores than those tested in rooms of "ugly" (black, brown, and white) colors. In the theater the emotional and symbolic effects of color have long been exploited. Color can work similar magic in homes, by cheering us or relaxing us. With receding colors or appropriate contrasts, the apparent size of a room can be markedly increased. Ceilings can be made to seem higher or lower with a coat of

paint. Where there is no sunlight, its effects can be simulated with yellow walls, and excessive brightness or glare can be reduced with cool, darkish surfaces. Some or all furnishings can be brought into prominence or unified with their use of color. In short, color can significantly alter the appearance of form and space, change our moods, and even affect our performance abilities.

LIGHT

Color, however, and the other elements of design discussed in the preceding chapter, depend upon **light** to make them visible. Most of our perceptions are based upon the sense of sight. Light is the most vital element of design, for without it there is no sight. Light is electromagnetic energy from the sun or other celestial bodies, from fire, or from artificial (electric) sources traveling in *wavelengths* that range in size from too long (infrared) to too short (ultraviolet) for us to see. A wavelength is the distance between waves or oscillating vibrations of electromagnetic radiation, measured in meters. Between the infrared and ultraviolet sections of the spectrum lies a short visible band of light energy, ranging in wavelength from approximately 380 to 760 nanometers, that makes vision possible. (A nanometer is one-billionth of a meter.) This *visible spectrum* can be broken into equal bands of colored light (red, orange, yellow, green, blue, and violet) with a prism, each color having a different wavelength. When recombined in equal amounts, these colors of light create the seemingly "white" or colorless light that we regard as normal and ideal.

The color of an object that we see results from three factors: the way in which the object absorbs and reflects light, the kind of light that makes the object visible, and the physical condition of the viewer's eyes. When light strikes an opaque object, some of the colors of light rays (or wavelengths) are absorbed and others

5.1 When visible light is refracted or broken into wavelengths, as by a prism, the colors of the spectrum are revealed, from red (the longest wavelength) to violet (the shortest wavelength). (Photograph: Mike Spinelli. Reprinted courtesy *In My Room: Designing For and With Children* by Antonio F. Torrice, ASID, and Ro Logrippo)

5.2 The three primary colors (or wavelengths) of light, red, blue, and green, demonstrate the *additive* principle, meaning that they combine to form white light. When any two primary colors are added together, they create a secondary color of yellow, cyan, or magenta.

reflected. Those wavelengths that are reflected give the object its color quality. Lemons and yellow paint, for instance, absorb almost all colors of light except yellow. White objects reflect almost all the colors in light, while black objects absorb most of them. We say *almost* because pure colors are very seldom found. The true color quality of anything is revealed when it is seen in white light. Usually, however, light itself is not completely colorless.

The color of light depends on its source and whatever it passes through before coming to our eyes. Light from the noon sun contains all the spectrum's hues balanced and blended so that the effect is white or colorless. Light from the moon is bluish, while that from open fires, candles, and the typical incandescent lamp is yellowish. Incandescent and fluorescent lights, however, come in many colors, and we can choose those that are most effective, even changing them for special occasions or blending colors by means of colored spot- or floodlights. We can also alter the color of artificial light with filters, reflectors, diffusers, or translucent shades that are not white. Daylight can also be changed by sheer, colored curtains or by tinted glass. In general, warm light intensifies red, yellow, and orange and neutralizes blue and violet. Light that is cool and bluish does the opposite. (Lighting, as a component of interior design, is considered in greater detail in Chapter 21.)

Working with light and color is a science as well as an art. As a designer, one must consider more than just aesthetics; light and color are vitally important to people's physical and psychological responses to environment as well, and even affect health. The designer must know what result is desired, how to achieve it, and how to predict its effects. Although much research has been conducted on the physical, chemical, biological, physiological, optical, psychological, and neurological aspects of color by scientists from these areas of study, it has been Faber Birren who has accumulated much of the information relevant to architects and interior designers and disseminated it in practical form. (The reader is encouraged to pursue additional study from the reference list at the end of the chapter.)

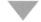

COLOR THEORY

Organizing facts and observations on color into a systematic theory is the first step in understanding color relationships and effects. Three different kinds of theories have been developed: physicists base theirs on light, psychologists on sensation, and artists on pigments and dyes. Our interest is chiefly with the last, because anyone who works with paint or fibers—from the interior designer to the do-it-your-self home painter, from a textile manufacturer to a handweaver—necessarily works with pigments and dyes. There are a number of accepted color theories, but basically all are predicated on the fact that to describe a color with reasonable precision at least three terms are needed that correspond to the three dimensions or attributes of color: hue, the name of a color; value, the lightness or darkness of a color; and intensity or chroma, its degree of purity or strength.

HUE

The simplest and most familiar pigment color theory is based on the concept that there are three primary hues—red, blue, and yellow—that cannot be produced by mixing any other hues; however, mixtures of them will result in nearly every other hue. Note that pigment primaries differ from light primaries; pigments are molecules that absorb and reflect different wavelengths of light. Reflected light waves stimulate color sensors (cones) in the eye which cause an electrical impulse to transfer to the optical nerve and on to the brain where it is translated as color.

If the visible spectrum of color is bent into a circle and intermediate hues placed between red, orange, yellow, green, blue, and violet, it can be diagrammatically visualized as a twelve-hue color *wheel* (Figure 5.3). The twelve hues divide into three categories:

- **Primary hues**, labeled 1 on the color wheel, are red, blue, and yellow. Theoretically, the three primary hues cannot be created by mixing any other hues together.
- **Secondary** or **binary hues**, labeled 2, are green, violet, and orange. Each stands midway between two primary hues of which it is the product, as green is equidistant from blue and yellow.
- Tertiary or intermediary hues, labeled 3, are yellow-green, blue-green, blue-violet, red-violet, red-orange, and yellow-orange. These stand midway between a primary and a secondary hue of which they are the product. For instance, yellow-green is between the primary hue yellow and the secondary hue green.

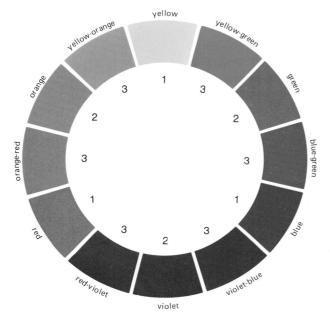

5.3 A color wheel shows the sequence of hues, divided into primary (1), secondary (2), and tertiary (3) hues. Complementary colors appear opposite each other.

5.4 The relativity of color is apparent in this exercise which makes one color appear to be two different colors by changing the surrounding colors. The ocher color, seen against different backgrounds, appears to change noticeably. (Plate IV-1 from The Interaction of Color by Joseph Albers, 1963. The Joseph Albers Foundation, Inc.)

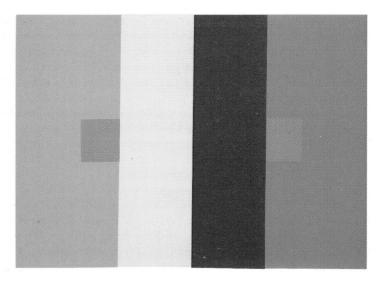

Hues are *actually* changed, or new ones produced, by combining neighboring hues as indicated above. Red, for example, becomes red-violet when combined with violet. If more violet were added, the hue would be changed again. The twelve hues on the color wheel are only a beginning because there can be an almost infinite number of hues.

The effects of light and background also lead to *apparent* changes. Cool light will make any blue-based hue seem bluer and any yellow- or red-based hue seem gray, while warm light enhances the yellow and red hues, graying blue. Backgrounds are equally important: orange placed against cool blue or violet seems warmer and brighter than when seen against another orange or yellow (Figure 5.4). Texture, reflectance, and size of the color areas also affect an individual's color perceptions, as will be explained later.

In the retailing industry, colors are given fanciful names to represent color trends which are subject to frequent change. But these are imprecise and could easily bring different visual images to different people. To identify colors accurately, it is better to name their standard hues, as affected by value and intensity—such as light, grayed green.

INTERACTION OF HUES When placed next to each other, hues produce effects ranging from unity to decisive contrast. Some combinations, such as blue, blue-green, and green, give a unified, restful sequence. But if blue is put next to orange, there is excitement and contrast. Two adjectives describe these relationships:

- **Analogous hues** are near each other on the color wheel, as are yellow, yellow-green, and green.
- Complementary hues lie directly opposite each other, as do yellow and violet.

Hues can be combined to produce any degree of harmony or contrast. If only one hue is used in a room, a strong **monochromatic** unity results. When analogous hues are placed next to each other, the effect is one of harmonious sequence. By intermingling small areas of color as in small-scale patterns, the original hues may appear to combine to form in-between colors.

Complementary hues, when placed next to each other, contrast vividly; each color seems to gain intensity if the area of each hue is large enough to be perceived as a separate color. This effect is known as **simultaneous contrast**. But if

the areas of two complementary hues are very small, as in a textile woven of fine red and green yarns, the effect at normal distances is lively but more neutralized, a result of visually blending the two hues. And if opposites are actually mixed together, a brownish gray is likely to be the result.

Another phenomenon associated with complementary colors is **afterimage**, an effect created by concentrated exposure to a bright hue. The complementary hue is "cc_n" when the eyes shift away as a relief from the visual fatigue experienced from the first hue. The designer needs to be aware that such an effect can occur and affect surrounding colors if areas of strong hue are used where the eyes may focus for any length of time. Afterimage can be a particular problem for the individual who works at a personal computer, looking at the video display terminal for an extended period of time. In other circumstances, such as an operating room in a hospital, afterimage can be a positive factor, providing relief for a doctor who is concentrating on a surgical procedure involving red blood with green walls and clothing.

WARMTH AND COOLNESS OF HUES Each hue has its own "temperature" that affects us and our homes in several ways. Red, orange, and yellow seem warm and active; they tend to bring together whatever is seen against them. Warm hues are called **advancing** hues because they seem nearer to us than they actually are, which leads to two seemingly paradoxical results. Upholstering a piece of furniture in intense red increases its apparent size, but painting the walls of a room red decreases the room's apparent spaciousness because the walls seem closer to us. The *area* of color usage determines the effect: a piece of furniture is a *segregated* color area while the walls are a *surrounding* color area.

Blue, green, and violet tend to seem cool and restful. Because they appear to be farther away than they actually are, they are referred to as **receding** hues. They reduce the apparent size of objects, but when used on walls they seem to increase a room's dimensions.

Any hue can be made warmer or cooler in effect by mixing with another hue of the desired temperature or by contrasting it with adjacent or surrounding hues of the opposite temperature. For example, green can be made warmer by mixing with yellow, cooler by adding blue; or, by placing a green color next to or within yellow, it can be made to *appear* cooler and, when surrounded by blue, it will tend to appear more yellowish, or warmer.

VALUE

Value is defined as relative lightness or darkness. It is perhaps easiest to understand in neutrals, where it indicates degree of lightness or darkness between pure white (full light) and pure black (the absence of any light). But value gradations apply equally to colors and are determined by the amount of light the colors reflect.

There can be any number of value steps between white and black, but the nine shown in the **gray scale** (Figure 5.5) make a convenient number. Even without considering color for the moment, we can see how value levels affect the character of a home. A room composed of nearly all light values seems bright, airy, and cheerful; its effect is distinctly "uplifting", but if not handled with care, an environment of all light values can seem cold and clinical. A room consisting of nearly all dark values, handled skillfully, can bring a sense of security and solidity. But if not carefully designed, it can be very gloomy and claustrophobic. Sharp contrasts of light and dark in a room are dramatic and stimulating, emphasizing the shapes of furnishings. A few middle values are usually needed to provide a transition and avoid harshness. Close values blend together (even when the hues are strongly

5.5 A gray value scale shows equal gradations between black and white. The dots are all of identical (middle) value, but appear lighter against a dark background and darker against a light one.

5.6 "Labyrinth," a fabric designed by Jack Lenor Larsen, utilizes a modulated succession of value contrasts to repeat its geometric theme.

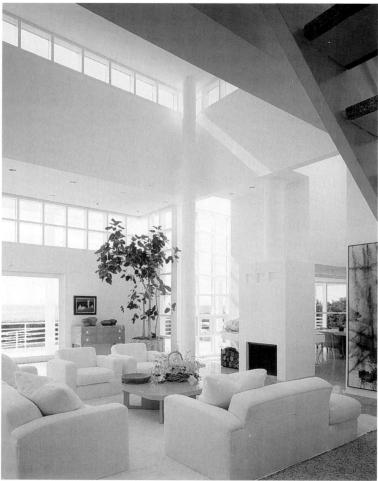

5.7 Gradations of value, including changing patterns of light and shadow, contribute to the sophistication of this Malibu, California, home designed by Richard Meier in 1987. (Photograph: Wolfgang Hoyt/ESTO)

contrasting, if viewed from any distance or under a low level of illumination) and may be calm and serene or monotonous and a safety hazard, depending upon the circumstances and characteristics of individual occupants. Even apparent size is affected by value; light values seem to increase size because they reflect light while dark values reduce size because they absorb light.

Value gradations become very important in a monochromatic color scheme or in a design based primarily on neutrals. Figure 5.7 illustrates a masterfully subtle treatment of the latter. A room of unusual tranquility, this room has been planned almost entirely around white, with subtle variations of value and hue. The walls, a cool off-white, provide a background for the dramatic splash of cool colors in the painting at the far right. The upholstery and rug are warmer whites, reflecting the warm wood cabinet against the wall. The soft gray coffee table and granite floor provide contrast and a link between cool and warm tones. In this interior, Richard Meier has maximized subtle value transitions and changes in plane emphasized by a flood of natural light. An accent of strong color complements the neutral, understated room.

The intervals in the gray scale also correspond to the **normal value** of the pure hues in the sequence of the color wheel. We know from subjective experience that yellow is a naturally light color and violet a dark color. But if we were to place the hues of the color wheel side by side with the gray scale, they would appear to have equal value in the following order:

Hue	Value Step	Hue
yellow	8, high light	yellow
yellow-orange	7, light	yellow-green
orange	6, low light	green
red-orange	5, middle	blue-green
red	4, high dark	blue
red-violet	3, dark	blue-violet
violet	2, low dark	violet

Every hue can range in value from light to dark, but we tend to think of hues at their normal values. Yellow, for example, comes to mind as the color of a lemon or dandelion rather than of a cream-colored carpet. **Tints** are values lighter than "normal" as indicated on the color wheel; **shades** are values darker than those on the color wheel. Pink is a tint of red, maroon is a shade of the same hue. Sky blue is a tint, navy blue a shade. Figure 5.8 illustrates value scales for three hues.

Combinations of hues appear most natural when normal value relationships are maintained, particularly when used in large areas. **Discord** results when normal values are reversed or when one color is lightened or darkened so as to be out of its natural order, then used with an unmodified hue. Discord can be very effective as an exciting accent but may be regarded as unpleasant in large quantity. However, color combinations which utilize discords (blue and green or orange and magenta, for example) may gain acceptance over a period of time, and some discordant color schemes even occur in nature (deep brown earth and blue sky).

Values are changed by making colors reflect more or less light. With paints, *actual* changes are made by adding black, gray, or white, or by adding another hue lighter or darker than the original. *Apparent* changes can be made by reducing or raising the amount of natural or artificial light reaching the color surface, providing corresponding effects (less light, darker-appearing color; more light, lighter-appearing color), or by placing the color against backgrounds of differing degrees

5.8 Value scales for green, orange, and violet, show tints, shades, and normal values.

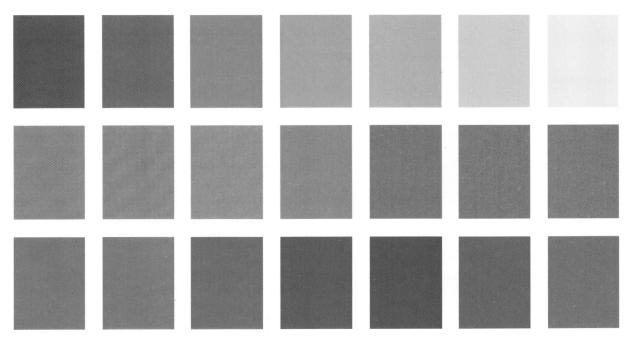

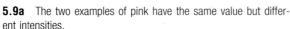

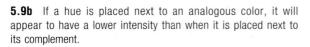

of light or dark. Values affect one another much as hues do—contrasts accentuate differences (simultaneous contrast). The same gray looks much darker when seen against a light surface than when seen against black (Figure 5.5). The same holds true for values of any hue.

Value contrasts are vital in distinguishing form, judging depth, and discerning changes in plane, particularly for the very young, elderly, or anyone with limited vision. When seen in full daylight, all three aspects of color are discernible. But under minimal lighting conditions, value contrasts are the most distinguishable aspect of color, yielding perception of shape and form; differences in hues and intensity are lessened. (The *cones*, or color receptors in the human eye, do not function in minimal light; only the *rods*, which distinguish light from dark, operate in dim lighting.) Thus, value is the single most critical characteristic of color where perception is concerned.

INTENSITY

Any hue can vary in its purity and strength—in other words, in the degree to which it differs from gray. Pink, for example, is always red in hue and light in value, but it can be *vivid*, almost pure pink, or it can be *neutralized*, grayed pink (Figure 5.9a). This is called intensity. A *pure* hue is at its fullest intensity, as on the color wheel. **Tone** is often used to describe intensity; a *jewel* tone is a brilliant color while a *muted* tone denotes a grayed color.

Scales of intensity can have many or few steps. Full intensities, which are possible only at the normal value of each hue, are often described as *high* or *strong*, the more neutralized as *low* or *weak*.

Intensities can be *actually heightened* by adding more of the dominant hue. They can also be *apparently raised* by illuminating the object with bright light of the same hue or by throwing it into contrast with its complementary hue, a grayed tone of the hue, or a completely neutral color. For example, a wall of grayed yellow can be intensified by repainting it with a purer yellow, by casting a yellowish light on

it, or by placing chairs in front of it that are upholstered in violet, a less intense yellow, or gray.

Actual and apparent intensities can also be decreased in several ways. First, the designer can lessen the amount of the dominant hue by adding varying amounts of its complementary hue; yellow is grayed by adding violet, violet by adding yellow, blue by adding orange, and so on. A similar effect is produced by mixing a color with gray, black, or white. A second method calls for illuminating an object with less light, more diffuse light, or light of the complementary hue. A blue wall, for example, would be grayed during the day by light filtering through sheer, orange-tinted glass or curtains and at night by translucent lampshades of the same hue, by a lower level of light, and by the warm-colored light from incandescent lamps. A third device is to introduce something—a painting, a wall hanging, a chair, a sofa—that is noticeably more intense in color than is the wall. This apparent change is most pronounced if the object and the wall are of the same or similar hues; a bright blue chair against a gray-blue wall. Even placing a hue beside an analogous hue makes it appear less intense compared to placing it beside its complement (Figure 5.9b).

Changing any one dimension of a color almost inevitably changes the other two, at least slightly. Available pigments are not absolutely pure: grays, blacks, and whites tend to be either warm or cool and thus alter the hue with which they are mixed. It is possible to change intensity without altering value if a gray or complementary hue that absolutely matches the color's value is used, but this is seldom achieved except in theory. One of the dimensions can be modified much more than the other two, but it is difficult to change one and hold the others constant.

Large areas of color tend to be more pleasing in effect if they are of less than pure intensity. Bright color can be very tiring and confusing if overused. Nature uses large areas of lower intensity enlivened with small quantities of pure color, the basis for the **law of chromatic distribution** used by artists and designers. Bright colors weigh heavily in their power to attract attention and can balance much larger areas of grayed color.

COLOR SYSTEMS

Although similar to the color system discussed above (in that the hues are arranged in a circle, which becomes a three-dimensional form when fully developed) the systems formulated by Albert Munsell and Wilhelm Ostwald deviate from it in two basic ways. First, the primary hues are not the same, and second, both have intricate, standardized methods of notation with which innumerable colors can be precisely labeled and identified by referring to the appropriate color charts. These are of inestimable value in science, commerce, and industry where universal specifications of color are necessary; they are also useful to professional designers for precise communication.

MUNSELL

The **Munsell system**¹ of color notation has *five principal hues*—red, yellow, green, blue, and purple—and five intermediate hues—yellow-red, green-yellow, bluegreen, purple-blue, and red-purple (Figure 5.10). Each of these hue families has been subdivided into four parts, indicated by the numerals, 2.5, 5, 7.5, and 10, which, when combined with the initial of a hue, designates the exact hue. The

5.10 The Munsell system divides the spectrum into five principal and five intermediate hues, indicated by letters on the color wheel. Each of the ten hues can be subdivided into ten more, creating the hundred hues indicated by the outer circle of numbers.

Relationship Between Munsell Value and Reflectance*

Munsell Value	Reflect-
9/	79%
8.5/	68%
8/	59%
7/	43%
6/	30%
5/	20%
4/	12%
3/	7%
2/	3%

For standard source C as specified by the International Commission on Illumination, approximating daylight at 6500 K. (Reprinted with permission from Design Criteria for Lighting Interior Spaces, Publication #RP-11. Illuminating Engineering Society of North America.)

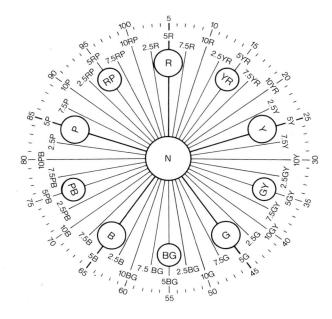

number 5R, for example, refers to "pure" red, 7.5R is toward yellow-red, and 2.5R toward red-purple. Further refinement divides each hue into ten steps, as indicated on the outermost circle of Figure 5.10.

Figure 5.11 shows the nine *value* steps ranging from 1/, the darkest, to 9/ as the lightest, with 0/ and 10/ theoretically pure black and pure white respectively. The relationship between Munsell value and reflectance of light is shown in Table 5.1. This information is used by designers when calculating the quantity of light needed in a room.

The term *chroma* is used instead of intensity. The chroma scale begins with /0 for complete neutrality at the central axis and extends out to /10, or further for very vivid colors (Figure 5.11). The number of chroma steps is determined by the varying saturation strengths of each hue. Notice in the diagram that red, a very strong hue, extends to /10, but the weaker blue-green reaches only to /5.

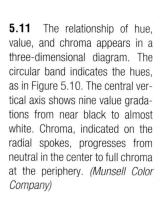

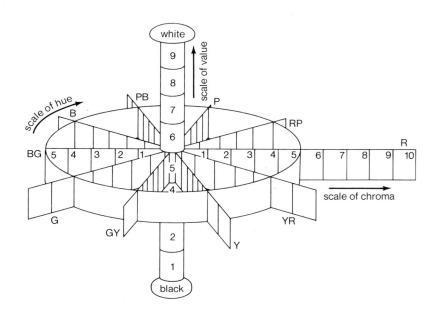

The complete Munsell notation for any color is written as *hue value/chroma*. Hue is indicated by the letter and numeral that defines that particular hue on the color wheel. This is followed by a fraction in which the numerator designates value and the denominator specifies chroma. Thus 5R 5/10 indicates "pure" red at middle value and maximum chroma. Blue that is light in value and low in chroma is written 5B 9/1.

OSTWALD

The **Ostwald system**² is derived from three pairs of complementary color sensations—red and green, blue and yellow, and black and white. The color wheel begins by placing yellow, red, blue, and green equidistant from one another. Placing five intermediates between each pair of hues makes a circle of twenty-four hues (plus six additional hues that are needed to complete the color range). These are indicated by the numbers around the equator of the color solid (Figure 5.12).

No sharp distinction is made between value and intensity: the hues are lightened or darkened or neutralized by adding appropriate amounts of white and black. This expands the color wheel into a color solid composed of a number of triangular wedges packed together as in Figure 5.12. In each wedge there are eight steps from top to bottom and eight from center to periphery.

Colors are designated by a formula, which consists of a number and two letters (8 pa for example). The number indicates the hue. The first letter indicates the proportion of white in any color, and the second letter designates the proportion of black. The scale goes from a, which is almost pure white, through c, e, g, i, l, n, to p, which is almost pure black. Thus these two letters tell how light or dark a color is as well as the degree of saturation. In each triangle there are twenty-eight colors, which multiplied by the twenty-four hues gives 672 chromatic colors. Adding the eight neutral steps brings the total to 680, which is about as many as most people need. Study of the diagram and a few examples should make this clear. Pure red has the symbol of 8 pa: the number indicates "pure" red, and the letters indicate that no black or white has been added. Intense orange-red has the symbol 5 pa, grayed orange-red has the symbol 5 lg, and dark orange-red has the symbol 5 pn.

Many other color systems have been devised in the effort to arrange colors in logical sequences. One of the most recent is the PANTONE® Professional Color

5.12 The Ostwald color system is illustrated by a solid double cone, partially cut away here to show relationships inside. Colors are most saturated at the equator and become increasingly neutralized as they approach the central axis of gray values. Colors become lighter toward the top, darker toward the bottom. At the right, a triangle illustrates 28 variations of one hue with lightest at the top and darkest at the bottom, proceeding from neutral at the black-white axis to saturation at the periphery.

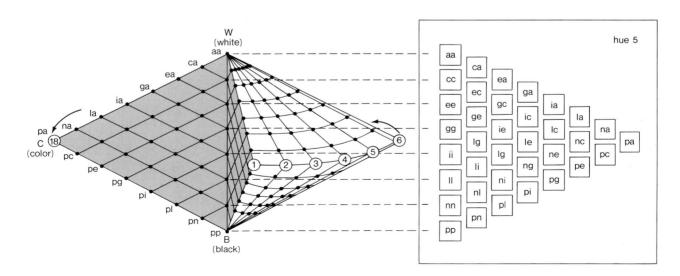

System, developed for architects and designers, which features 1,001 opaque colors identified by hue, lightness, and saturation. This system is designed for color matching in all media, including fabrics, paints, plastics, ceramics, and carpets.

PLANNING COLOR HARMONIES

Planning the colors to be used in a room or a series of rooms can be a delightful part of furnishing a home. Color that is satisfying and exhilarating costs no more than hues that are depressing and without character. But colors are not used alone. We need to know what happens when colors are combined to be able to produce the effect that is wanted. The systematic relating of colors has resulted, over the years, in easily recognizable color harmonies or schemes. These do not dictate colors but they do give us an orderly way of discussing and predicting what will happen when various hues are combined.

In theory, countless color harmonies are suited to homes. Any hue can be made to harmonize with any other hue by manipulating value, intensity, and balance. As illustrated in Figure 5.13, two hues that appear incompatible at normal value, can be more harmonious if grayed or if one is darkened and the other lightened. In color selection, as in design, an underlying sense of order is satisfying but stereotyped, commonplace organization is tedious. Standard color harmonies are nothing more than time-tested basic recipes; actual color schemes may not fit perfectly into any of the categories.

5.13 Full-intensity red and green may be visually uncomfortable in large areas, but combinations of dark brick red and pale yellow-green, or light pink with dark green are more palatable.

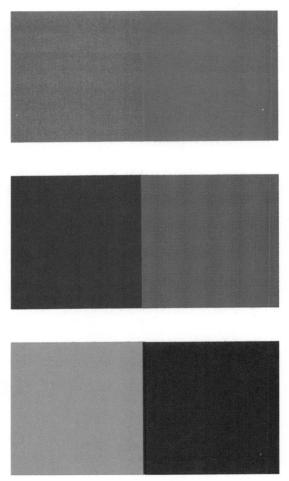

Typical color harmonies fall into two major categories, related and contrasting. Related color schemes, which are composed of one or several neighboring hues, lead toward an unmistakable harmony and unity. Contrasting schemes, based on hues that are far apart on the color wheel, offer greater variety as well as a balance of warm and cool hues. The two types are basically different, but neither is inherently better than the other. Depending on the hues chosen and the dominant pattern of intensities, any color harmony can be vividly brilliant or comparatively quiet. Beyond this, we can subdivide color harmonies into eight categories, of which the first three may be considered related, the other five contrasting. Most color plans utilize no more than three hues for backgrounds and major furnishings, varying values, intensities, and amounts. In all schemes, one hue should predominate. Equal quantities of the colors chosen would lack interest in rhythm, emphasis, and balance. Neutrals provide visual relief, particularly from strong color, and they may add contrast or the harmony of close values. Accessories can enlarge a color scheme, adding depth and variety, especially if unique in character.

YO Y YG G G BG RV V BV

5.14 Monochromatic harmony.

MONOCHROMATIC

Monochromatic (literally, "one hue") color harmonies (Figure 5.14) evolve from a single hue, which can be varied from high light to low dark and from full saturation to almost neutral. White, grays, black, and small amounts of other hues add variety and accent, as do applied and natural textures and decorative patterns. Thus, even with only one basic hue, the possibilities are legion.

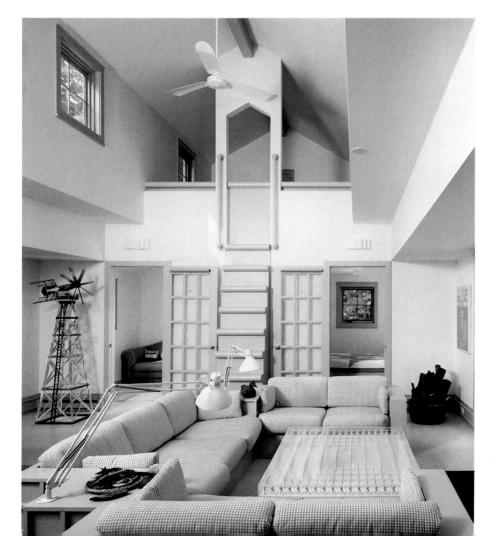

5.15 Cool blues and muted grays visually enlarge a living room designed by architects Margaret McCurry and Stanley Tigerman. (Photograph: © Howard N. Kaplan)

The advantages of monochromatic color schemes are that some degree of success is almost assured, because unity and harmony are firmly established. Usually, spaciousness and continuity are emphasized, and the effect is quiet and peaceful (Figure 5.15) except in those dramatic cases in which saturated color predominates or extreme contrasts are utilized. A major danger—monotony—can be avoided by diversified values and intensities and by differences in form, texture, and spatial relationship.

ACHROMATIC

Achromatic or neutral color schemes utilize only value variations, without intensity. Neutral harmonies usually need accent color in accessories or a few furnishings. (An accent is a strong or vivid contrasting color used in limited amount to highlight or accentuate predominant colors. Accent is introduced to give visual excitement and may be used with all color harmonies.) Although black, white, and gray are the only true neutrals, the very low intensities of the warm colors (ranging from ivory to dark brown) are neutral in effect when used for the majority of surfaces and furnishings. Basic hue identity is important in these subtle colors to ensure harmony. Off-white colors or wood tones may be cool or warm in hue, for example—a factor to consider when coordinating any scheme.

The room shown in Figure 5.7 is achromatic, since it contains primarily the neutral grays and off-whites; while it seems reserved, it could scarcely be described as dull. We might imagine this same room done in a hue—blue or green or red—with the same slight value variations.

ANALOGOUS

Analogous color harmonies are based on two or more hues each of which contains some degree of a common hue (Figure 5.16). In other words, the hues fall within a segment of the color wheel that is no more than halfway around it. Thus, if the common hue is blue, the colors could be as closely related as blue-green, blue, and blue-violet, or as separated as yellow-green, blue, and red-violet. Analogous color schemes have more variety and interest than do monochromatic color schemes (Figure 5.17, on the facing page). The effect is usually automatically unified because of the shared color, and analogous schemes are often used throughout an entire home, carrying the common thread of color from room to room, yet allowing individual rooms some variety.

COMPLEMENTARY

Built on any two hues directly opposite each other on the color wheel, **complementary** harmonies (Figure 5.18) are exemplified by orange and blue, or yellow-orange and blue-violet. They offer a great range of possibilities. Yellow and violet, for example, can be as startling as gold and aubergine, as moderate as ivory and amethyst, or as somber as olive drab and gunmetal. Complementary schemes provide the balance of opposites (which, when mixed, form neutrals) and of warm and cool hues (Figure 5.19). They tend to be livelier than related harmonies but their success depends upon careful handling of value and intensity.

DOUBLE COMPLEMENTARY

A development of the complementary scheme, **double complementaries** (Figure 5.20) are simply two sets of complements. Orange and red-orange with their respective complements, blue and blue-green, are an example. Worth noticing in this case is the fact that orange and red-orange, as well as their complements, are

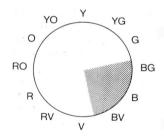

5.16 Analogous harmony.

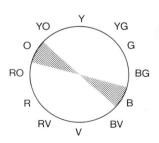

5.18 Complementary harmony

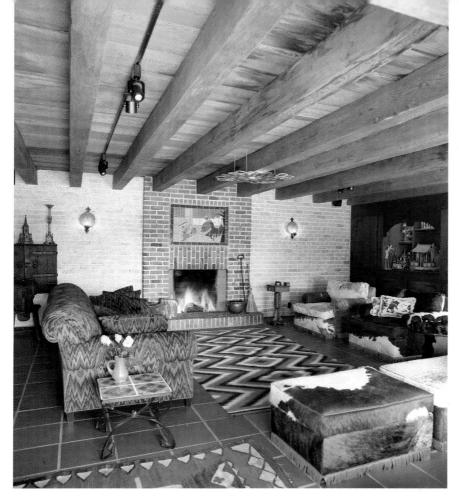

5.17 A range of warm analogous hues maintains unity in the midst of a bold variety of materials and textures in this 1927 California home restored by Ace Architects. Lillian Bridgeman, architect. (Photograph: Alan Weintraub)

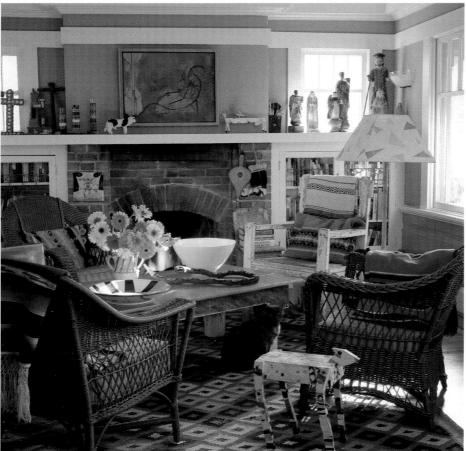

5.19 The complementary color scheme in this Berkeley, California, kit house living room was inspired by Mexico. Brightly colored folk art accessories fit comfortably with red, white, and green furnishings and backgrounds. Lisel Schwarzenbach, interior designer. (Photograph: Mark Darley/ESTO)

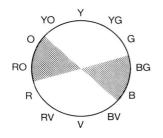

5.20 Double-complementary harmony.

near each other on the color wheel. This is usually the case, because if the hues are widely separated, it is difficult to see the order on which this harmony is based.

SPLIT COMPLEMENTARY

Another variation on the complementary theme, the **split complementary** (Figure 5.21) is composed of any hue and the two hues *at each side of* its complement, as in yellow with blue-violet and red-violet. Violet, the complement of yellow, is split into red-violet and blue-violet. This makes the contrast less violent than in the simple complementary type and adds interest and variety.

TRIAD

Red, blue, and yellow; green, orange, and violet; blue-green, red-violet, and yellow-orange—any three hues equidistant from one another on the color wheel—are known as **triad** color harmonies (Figure 5.22). In case such combinations sound shocking, remember that full-intensity hues are seldom used in homes. Red, blue, and yellow might be translated as mahogany, French gray, and vanilla. Green, orange, and violet could be sage green, cocoa brown, and dove gray. Thus, although triad harmonies can be vigorous, they can also be subdued. In any case, the effect is one of well-rounded balance with variety held in check by a readily apparent systematic unity.

TETRAD

Any four hues that are equidistant from one another on the color wheel produce a **tetrad** color harmony (Figure 5.23). Yellow-orange, green, blue-violet, and red are an example. Such combinations lead to rich, varied yet unified, fully balanced compositions.

Ideas for color harmonies are derived from a wide range of sources beyond the formal classifications just discussed. Nature is an inexhaustible source of inspiration; paintings, textiles and any type of art or craft can provide ideas; magazine illustrations, including advertisements, will present many examples. Sometimes these samples can be shown to a client to dispel confusion that may arise from verbal description.

FACTORS TO CONSIDER IN SELECTING COLORS

Color preferences and responses of different cultures, ages, sexes, and mental states have been researched extensively. Consensus of findings, however, is elusive, apparently because so many variables are involved. Reaction to color is highly sub-

- **5.21** (left) Split-complementary harmony.
- 5.22 (middle) Triad harmony.
- **5.23** (right) Tetrad harmony.

jective and emotional. Therefore, the designer must spend the time to learn the preferences and responses of individuals in the client's household before making color decisions.

To aid in selecting specific colors, swatches of fabric, and carpet and wallpaper samples as large as possible will enable the client to visualize the finished effect. Color chips from paint stores are a starting point for deciding on the hues for walls and ceilings. It may be wise in the long run to paint a large piece of wallboard the color under consideration. These samples and *strike-offs* of special colors or designs for paper or fabric, run off before actual production, can then be studied at different times of day and night since their appearance will change with the kind and color of light.

Colors should be viewed either in their proposed setting or at least under the same lighting in order to avoid mismatching. When two colors appear to match

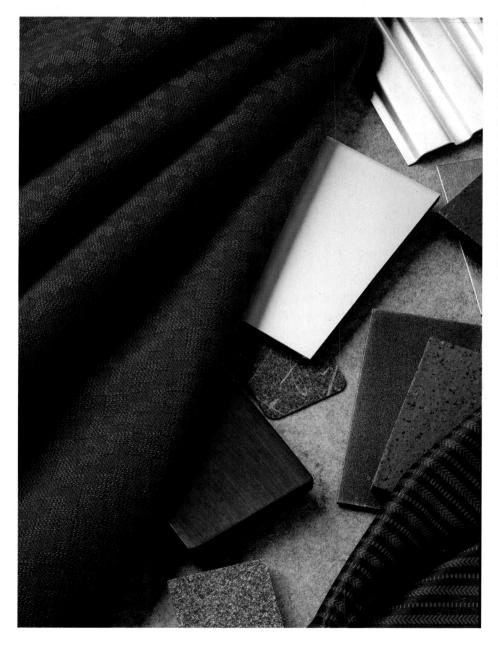

5.24 Warm and earthy materials were selected for the Augusta Medical Center in Fishersville, Virginia, to reflect the rural site. Designers from KnollTextiles and Ellerbe Becket collaborated to produce a line of fabrics that would meet stringent health care requirements and also harmonize with the deconstructivist architecture of the building which breaks the structure down into simplified forms from the surrounding countryside. Mark Molen, project architect, and Deborah Kasmir, interior designer/Ellerbe Becket; Hazel Siegel and Suzin Steerman/KnollTextiles. (Photograph: Michael Agelopas)

under one type of lighting but not under another, they are referred to as a *metameric pair*. Differences in the color makeup of both the pigments or dyes used and the lighting itself account for **metamerism**, a common problem in color matching and coordinating, particularly when working with near-neutral hues.

Another reason large color samples are important is that increasing an area of color changes its apparent hue, value, and intensity as a result of **amplification**, a phenomenon in which light reflected from one surface to the next gains intensity and increases the strength of the color we see. Reflection from the walls, floor, and other furnishings alters color perception, as does the amount and color of light available in the room. Paint will also appear several times darker when seen on a large area such as a wall, in part because vertical surfaces receive less direct illumination than horizontal surfaces.

Textures of materials and finishes will have an effect as well. Color appears brighter on a smooth, shiny surface than on a matte or rough surface that neutralizes intensity. Where strong light strikes a very shiny surface, color may disappear entirely from *specular reflection*, the mirror-like reflection of the actual light source on the surface. Color combinations, whether solid or patterned, in small scale only hint at the full-scale effect.

When choosing colors for an interior, any existing materials used, including wood, stone, tile, brick, or metals, should be taken into consideration as well. They may add pattern, texture, or definite coloration to the space. Also, large window areas bring nature's colors inside—blues, browns, greens, and other hues which may vary with the seasons.

The walls of a room—including the windows and their treatment, the doors, and fireplaces—are the largest color areas. Floors and ceilings come next in size, then furniture and, finally, accessories. In the past, typical color relationships broke down as follows:

- Floors moderately dark in value and low in intensity to give a firm, unobtrusive base and to simplify upkeep, particularly for clients with children or environments where soiling and heavy traffic are prevalent.
- Walls usually lighter in value than floors in order to provide a transition between them and the ceilings, and typically quite neutral in intensity to keep them as backgrounds.
- Ceilings very light in value and very low in intensity for a sense of spaciousness and for efficient reflection of light. (See Table 21.3, for actual light reflectances recommended for each of these surfaces.)

Although this standard approach can give a satisfying vertical equilibrium, there are many reasons for deviating from it. Light floors, for example, make a room seem luminous and spacious, and maintenance is less of a problem with new materials and textures. Dark walls give comforting enclosure, and they unify miscellaneous dark objects (Figure 5.25). Intense colors for floors, walls, or furniture are a welcome relief from all-too-prevalent drabness. A survey of the color illustrations in this book will disclose many of the devices that can be used successfully to personalize and individualize color harmonies.

EFFECTS OF HUE, VALUE, AND INTENSITY

Room size, shape, and character seem to change with different color treatments, a factor often underestimated. In planning a new home, color should be considered along with the other aspects of design. Older homes are often easily remodeled by an "architectural" use of color on the structural planes that define the space (walls, floors, ceilings) and added treatments such as moldings, wainscots, and panels. Generalizations about color relationships and their effects are well worth knowing, although we should be aware that none of them always holds true. A great

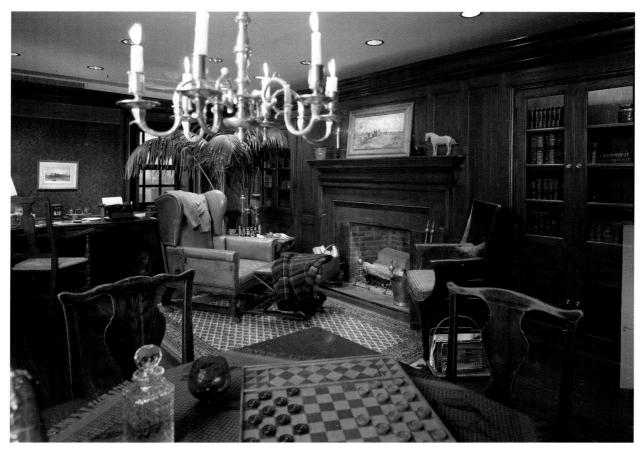

deal can be learned about the qualities of hue, value, and intensity by analyzing the color organizations seen in rooms, furniture and textiles, and gardens.

Warm hues, values lighter than the middle range, and high intensities tend to raise our spirits and stimulate us to be active. Pronounced contrasts of any sort, such as blue-green and red-orange or deep brown and white have similar energizing effects. Such vigorous color use often implies noisy, social spaces. Intermediate hues, values around the middle range, and moderate intensities are relaxing and visually undemanding. Cool hues, values below the middle range, and low intensities usually seem quiet and subdued. Sleeping areas and spaces for quiet work benefit from similar color choices. There are, of course, innumerable other ways of selecting and organizing varied hues, values, and intensities to achieve the effect that is desired. For example, colors that flatter complexions are desirable in bathrooms and grooming areas; however, personal preferences and dislikes will affect feelings about appropriate color selection for all residential spaces.

The degree to which color can seem to alter the apparent size of any object is often dramatic, but this, too, is a matter of complex relationships. In general, warm hues, values above the middle range, and strong intensities make an object look large. Cool hues, darker values, and lower intensities reduce its apparent size. Decisive contrasts, textures, and ornamentation may or may not increase apparent size, depending on exactly how they are handled.

Apparent distance, or spaciousness, is increased by cool hues, the lighter values, and the lower intensities. This is the effect of *aerial perspective* taken from observation of the natural landscape in which colors appear cooler, lighter, and grayer on the far horizon than they do in the immediate proximity of the viewer. These

5.25 The Ralph Lauren Showroom, located in an old existing property in New York City, employs warm, dark mahogany paneling to unify a variety of antique furnishings and richly patterned textiles in a masculine environment. Naomi Leff, designer. (Photograph: Normal McGrath)

5.26 The light value of this sofa blends with the light value of the background, making it seem smaller and increasing the apparent spaciousness of the room. Deborah Rae Sanchez, ASID, interior designer. (Photograph: Kenneth D. Rice)

color characteristics can be used to make a small room seem larger, give the appearance of a higher ceiling, or alter and improve the apparent proportions of a square-shaped room. The latter is accomplished by using a cool, light, dull color on one wall or two opposite walls and possibly the ceiling. On the other hand, warm, dark, bright colors can be used to make a large room seem smaller and more intimate, make a ceiling appear lower, or visually widen a long, narrow space (by placing the advancing color on one or both end walls). Although some contrast is needed as a yardstick, strong contrasts usually make objects seem nearer than they actually are (diminishing apparent space), while low contrast can increase the sense of spaciousness. Similar colors carried from one room to another also increase visual space.

Putting all of this to work is fascinating but complex. Rooms with white or very light, cool walls seem more spacious than those with darker, warmer surfaces. Houses painted white seem bigger than those of red brick or natural wood. *But* the value relationship between any object and its background is more important than the object's color alone because strong value contrasts make objects stand out, which tends to increase their apparent size. Thus, against a white background a sofa with light upholstery might look much less conspicuous than it would set in a room of predominantly dark and middle values (Figures 5.26 and 5.27).

Any degree of dominance or subordination can be produced by skillful handling of color. We are immediately attracted by colors that are striking and bold,

5.27 A light sofa stands out in marked contrast to its setting of predominantly dark values—a scheme that increases the apparent size of the sofa. (Courtesy Ege Rya, Inc.)

and these may be indicated where dominance is wanted. Extreme values and strong intensities also tend to attract attention, but no more so than emphatic contrasts or unexpected, out-of-the-ordinary color relationships. Colors that are grayed and moderate in value, as well as familiar color combinations, are unemphatic and seldom noticed, which makes them passive backgrounds unless they are interestingly textured or otherwise patterned. Thus, with color alone, attention can be directed toward that which is important and away from that which is less consequential.

Differences in hues, intensities, and especially values also make us conscious of an object's outline and contours. White against black makes the strongest contrast, and as the values become closer to each other, forms tend to unify and merge with their surroundings. The shape of a white lamp is much more emphatic when seen against dark gray or black than when seen against a light value of any hue. Diametrically opposite hues attract attention to outlines, but if the values of the two hues are similar, the edges seem fuzzy rather than distinct, a visually disturbing phenomenon known as **vibration**, in which the boundary between the two colors appears to move when viewed at close range and to blend into neutral color at a distance. Varying the values of the two complements, usually with the cool hue darker, will restore a more pleasing effect. Related hues also soften contours, and warm hues make the edges of anything seem less sharp than do those that are cool.

We can summarize the effects of hue, value, and intensity, as in Table 5.2, bearing in mind that all generalizations about any one of these three factors assume that the other two dimensions of color, the background, and the lighting, are held constant. For example, artillery red is normally more stimulating than mint green—both are of middle value and full intensity. But mint green is likely to attract more attention than cocoa brown, a color that is red in hue but low dark in value and tending toward neutral in intensity.

Windows and their orientation affect the character of rooms and have a bearing on color schemes as well. In rooms well lighted by large windows or good artificial illumination, colors will not be distorted. In rooms with less light, colors seem darker and duller. Rooms facing south and west get more heat and more

Summary of Effects of Hue, Value, and Intensity

	Hue	Value	Intensity
Feelings	warm hues are stim- ulating, cool hues quieting	light values are cheering; dark values range from restful to depressing; con- trasts are alerting	high intensities are heartening; low intensities are peaceful
Attention	warm hues attract more attention than cool hues	extreme values tend to attract the eye; but contrasts or surprises are even more effective	high intensities attract attention
Size	warm hues increase apparent size of ob- jects; used on walls, they decrease ap- parent size of room	light values increase apparent size of objects; but strong contrast with background is equally effective	high intensities in- crease apparent size of objects; used on walls, they de- crease apparent size of room
Distance	warm hues bring objects forward; cool hues make them recede	light values recede, dark values advance; sharp contrasts in values also bring objects forward	high intensities de- crease apparent dis- tances
Outline, or contour	warm hues soften outlines slightly more than cool hues; contrasting hues make outlines clearer than related hues	value contrasts are a potent way of em- phasizing contours	intensity contrasts emphasize outlines

light (of a yellowish hue) than those facing east or north. These differences can be minimized by using cool colors in south and west rooms, warm colors in east and north rooms.

Regarding the rooms of a home separately, especially those of the group living spaces, has dangers because a home is a unit, not a collection of rooms. Unified color schemes recognize this and bring harmony and continuity; they increase visual spaciousness and make it possible to shift furnishings from one room to another without disturbing color harmonies.

ECONOMIES WITH COLOR

Color can more than earn its cost; it can actually save money if wisely used:

- A coat of paint on one or more walls of a room will change the atmosphere less expensively than any other single device.
- Old, battered, nondescript furniture takes on renewed vitality with new color.
- Bands of color applied around windows are inexpensive substitutes for draperies; floors painted or stained in suitable colors, possibly textured or patterned, lessen the need for rugs; painted graphics on walls cost less than wallpaper.
- A preponderance of light-value colors can cut electric bills and probably improve vision.

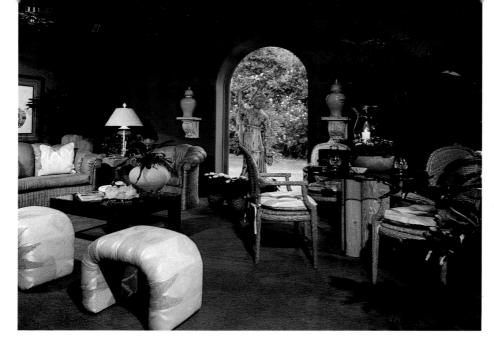

5.28 Dennis Haworth, FASID, has created an intimate, cool, calm retreat in this home, using green walls, plants, natural wood, and wicker, reflecting the view outdoors. (Photograph: Steve Simmons)

- Warm colors can help make people more comfortable at lower temperatures and cool colors can aid in minimizing the discomfort of heat.
- Colors that do not fade or that fade gracefully minimize replacement.
- Nature's muted colors, especially if patterned, not only reduce daily and weekly maintenance but remain passably good-looking longer than do most clear, sharp colors.
- A unified color harmony throughout the home makes for economical interchangeability of furniture, draperies, rugs, and accessories.

Color is perhaps both the most emphatic and the most subjective element in interior design. In appeal and response it may well be the most important ingredient in an interior. A thorough understanding of the complexities of color theory and interaction is essential to the successful practice of design. It is the designer who synthesizes the science with the art of color to produce effective results.

NOTES TO THE TEXT

- 1. The Munsell system of color notation is accepted by the United States of America Standards Institute for color identification.
- The Ostwald system of color notation is used as the basis for the Color Harmony Manual and Descriptive Color Names Dictionary, published by the Container Corporation of America (Chicago, 1948).

REFERENCES FOR FURTHER READING

Albers, Joseph. Interaction of Color, revised pocket ed. New Haven: Yale University Press, 1975.

Beebe, Tina. An Expert's Guide to Color. *House & Garden*, September 1981, pp. 146–150. Birren, Faber. *Color and Human Response*. New York: Van Nostrand Reinhold, 1978.

Birren, Faber. Light, Color, and Environment, rev. ed. New York: Van Nostrand Reinhold, 1982.

Birren, Faber. Principles of Color: A Review of Past Traditions and Modern Theories. New York: Van Nostrand Reinhold, 1977.

Birren, Faber (ed.). Color Primer: A Basic Treatise on the Color System of Wilhelm Ostwald. New York: Van Nostrand Reinhold, 1969.

Birren, Faber (ed.). A Grammar of Color: A Basic Treatise on the Color System of Albert H. Munsell. New York: Van Nostrand Reinhold, 1969.

Blake, Jill. Color and Pattern in the Home. New York: Quick Fox, 1978.

Buckley, Mary, and David Baum (eds.). Color Theory (Arts and Architecture Information Guide Series, Vol. 2). Detroit: Gale, 1975.

Design Criteria for Lighting Interior Living Spaces. New York: Illuminating Engineering Society of North America, 1980.

Drimer, Margaret. Structuring and Detailing with Color. *Residential Interiors*, January–February 1980, pp. 74–77.

Ellinger, Richard G. *Color Structure and Design*. New York: Van Nostrand Reinhold, 1963. Faulkner, Sarah. *Planning a Home*. New York: Holt, Rinehart and Winston, 1979. Chap. 6, pp. 130–148.

Halse, Albert O. The Use of Color in Interiors, 2nd ed. New York: McGraw-Hill, 1978.

Horn, Richard. Connecting with Color. *Residential Interiors*, January–February 1980, pp. 78–81.

Itten, Johannes. The Art of Color. New York: Van Nostrand Reinhold, 1961; reprint 1974. Kuppers, Harald. Color: Origin, Systems, Uses. New York: Van Nostrand Reinhold, 1973.

Ladau, Robert F., Brent K. Smith, and Jennifer Place. Color in Interior Design and Architecture. New York: Van Nostrand Reinhold, 1989.

Libby, William Charles. Color and the Structural Sense. Englewood Cliffs, N.J.: Prentice-Hall, 1974.

Light and Color. Cleveland, Ohio: General Electric Company, 1974.

Mahnke, Frank H. and Rudolf H. Mahnke. Color and Light in Man-Made Environments. New York: Van Nostrand Reinhold, 1987.

Marshall Editions Limited (ed.). Color. Los Angeles: Knapp Press, 1980.

Munsell Color Company, Inc. Munsell Book of Color: Defining, Explaining and Illustrating the Fundamental Characteristics of Color, standard ed. Baltimore: Munsell Color Company, 1929.

Sharpe, Deborah T. The Psychology of Color and Design. Chicago: Nelson-Hall, 1974.

Sidelinger, Stephen J. Color Manual. Englewood Cliffs, N.J.: Prentice Hall, 1985.

Sloan, Annie and Kate Gwynn. Color in Decoration. Boston: Little, Brown and Company, 1990

Smith, Charles N. Student Handbook of Color. New York: Van Nostrand Reinhold, 1965.

Truex, Van Day. Interiors, Character and Color. Los Angeles: The Knapp Press, 1980.

Vincent, Helen Diane. Color in Design. Restaurant Design, Fall 1981, pp. 48-57.

Wagner, Carlton. The Language of Color. *Designers West*, September 1982, pp. 140–148. Wagner, Carlton. *The Wagner Color Response Report*, revised edition. Chicago: Wagner Institute for Color Research, 1988.

Wagner, Carlton and Kay MacKenzie-Chertok. *Color Power*. Chicago: Wagner Institute for Color Research, 1985.

Wilcox, Michael. Blue and Yellow Don't Make Green. Rockport, Mass.: Rockport Publishers, 1989.

Wilson, Jose and Arthur Leaman. Color in Decoration. New York: Van Nostrand Reinhold, 1971.

Design Principles

BALANCE

Symmetrical Balance Asymmetrical Balance Radial Balance

RHYTHM

Repetition Progression Transition Contrast

SCALE AND PROPORTION

HARMONY Unity Variety

EMPHASIS

In the search for ways to create functional and pleasing objects, certain principles are observable in both nature and art. **Balance**, **rhythm**, and **emphasis**—a simple but inclusive trio—explain why some combinations of space and form, of line and texture seem to work better and to look better than others. To these we add the concepts of **scale**, **proportion**, and **harmony**. No one can set absolute rules for the creation of effective design. Indeed, some of the most striking designs seem deliberately to violate theory, but they are the exception rather than the rule. If the elements of design described in Chapters 4 and 5 are the raw ingredients of design, the principles outlined here can be considered the organized fashion in which those ingredients should be combined. They are aesthetic concepts that have evolved to explain how and why certain combinations and relationships of elements are pleasing. A working knowledge of these guidelines gives us a means of communication to evaluate the success of design in achieving its objectives. (The objectives of good design—utility, economy, beauty, and character—were presented in Chapter 1.)

BALANCE

Defined as *equilibrium*, balance is a major precept in all phases of living, from furniture arrangements to bank accounts. Through balance we gain a sense of

equipoise, but this may range from static permanence to repose and from suspended animation to actual motion. Balance results when interacting forces, attractions, or weights tend toward resolution.

Nature provides many examples of divergent kinds of balance. The Rock of Gibraltar typifies static permanence, with changes too slight to be noticed. Sand dunes are continuously shifting, but without loss of equilibrium. Trees, too, are always changing equilibrium, because their shapes vary as they grow and because winds and the seasons affect them. Thus, balance can be an ever-changing resolution of forces as well as an equalization of dead weights. It is also evident from nature that balance exists in four dimensions—time as well as length, breadth, and width.

In balancing an interior, we deal with the **visual weights** of architecture and furnishings. The visual weight of anything is determined by the psychological impact it makes on us and the attention it demands. Although there are no rigid formulas that always hold true, some general characteristics apply:

- Large objects and spaces appear heavier than small ones, but a grouping of small objects can counterbalance a large mass.
- Physically heavy materials such as stone have greater visual weight than lighter materials.
- Opaque materials appear heavier than transparent materials.
- Bright, warm, dark colors seem heavy when compared to grayed, cool, light colors.
- Active textures and patterns hold attention longer than smooth, plain surfaces.
- Unique, irregular shapes and objects have importance beyond their size, while the expected and typical usually settle into the background.
- Strong contrasts of texture, pattern, and color have greater impact than close harmonies.
- Objects placed above eye level appear heavier than those placed below.
- Brightly lighted areas attract more attention than dim ones.

For example, a small spot of bright color can balance a large grayed area; visually, a significant painting may be as "heavy" as many square feet of plain wall. Well-balanced interiors hold this interplay of forces in poise.

Balance in a home is as ever-changing as nature's equilibrium is, but in different ways. People are the first factor, for a room is never complete except when being used. As people walk about, they not only see a home from different angles but actually change the equilibrium by their movement and by the clothes they wear. The second factor is light. Natural illumination is altering every minute of the day and changes markedly with sky conditions and the seasons. Only within small limits can its effects be controlled, yet it affects our homes drastically. For example, subtle nuances of color and very fine detail can be readily appreciated in moderately bright light, but they are all but obscured in very strong sunlight or at dusk. Artificial light can be precisely controlled but has to be flexible to meet a number of needs, and flexibility brings variance. The third factor is the composite of all the little things that happen in the course of a day (the reading material and other portable paraphernalia brought in and left) as well as the modifications that come with the months and years (the scarcely noticed fading of textiles and mellowing of wood, to say nothing of the replacement of worn-out or unwanted objects). What does this all mean? Simply that in view of these inevitable changes, many of them beyond our strict control, the fundamental pattern of equilibrium should be strong enough to take these onslaughts in stride, to gain from them rather than be destroyed by them.

It is customary to differentiate three types of balance: symmetrical, asymmetrical, and radial.

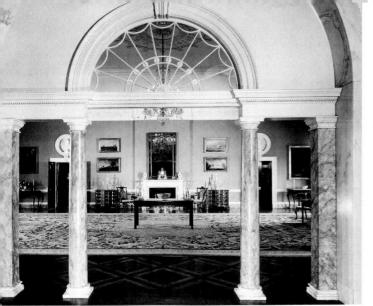

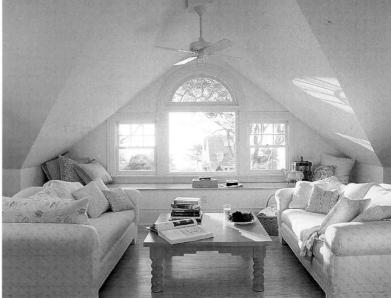

SYMMETRICAL BALANCE

Also known as *bisymmetrical*, *formal*, or *passive* balance, symmetry is achieved when one side of something is the exact reverse (mirror image) of the other half. Our clothes, furniture, and household equipment are nearly all symmetrical to fit our symmetrical bodies. Such balance is easy to appreciate, because we can see quickly that, since one side is the reversed replica of the other, the two must be in equilibrium. The effect is typically quiet and restful, perhaps because it demands little effort from the observer. Its overtones of stateliness, restraint, and dignity are exemplified by classical architecture and traditional interiors. Also, people stand or sit as symmetrically as they comfortably can when they wish to appear dignified and in control. Symmetrical balance tends to stress the center, creating a logical focal point for something one wishes to emphasize. But the resultant division into two equal parts usually reduces apparent size.

Although these observations are generally true of symmetrical balance as used in interiors, we should note that totally different effects are possible. Violent rhythms or swirling curves, regardless of symmetrical arrangement, will not seem stable or reposed. Shapes or colors that lead the eyes away from the middle weaken the focal point at the center.

Basically, symmetrical balance is as simple as *aba*, the quantitative formula or pattern from which it is derived, and this simplicity contributes to its popularity. While very easy to handle at an elementary level, it can be imaginative, subtle, and complex. Few entire homes or even single rooms are completely symmetrical (utility and the need for variety rules this out) but many have such symmetrical parts as centered fireplaces or identical sofas or chairs facing each other. Often, however, symmetry is imposed arbitrarily or comes out of habit or laziness when it is not appropriate. Then it can lead to inconvenience or dullness. For example, doors in the centers of walls are seldom logical because they leave two equal areas that may be difficult to furnish unless the room is very large, and they generally contribute to poor traffic patterns. Too much sameness can lead to predictable monotony, although in small areas or objects symmetry is familiar and comfortable. Minor variations within the major theme of symmetry help maintain interest. Sometimes the two halves are *approximately* the same, having equal weight but different form, rather than being identical.

Symmetry is indicated but not dictated when

- formal, traditional, or tranquil effects are desirable;
- the designer wishes to focus attention on something important;

- **6.1** The Thomas Jefferson State Reception Room, at the U.S. Department of State in Washington, D.C., employs symmetrical balance in both architecture and placement of furnishings to enhance the stately, formal character and function of the space. Edward Vason Jones, architect. (Photograph courtesy the U.S. Department of State, Fine Arts Committee)
- **6.2** The third floor attic of an early 20th century renovated cottage in Watch Hill, Rhode Island, was completely rebuilt to accommodate a large master bedroom, bath, and sitting room. The focal point of the symmetrical arrangement of the sitting area is the large window topped by a fan light which makes the space light and airy. Lyman Goff, AlA, architect; Cohen Design, interior design. (*Photograph: Karen Bussolini*)

- use suggests symmetry—such as a table with chairs positioned so that diners face one another for easy conversation;
- contrast with natural surroundings is a desirable factor since the natural landscape, as seen through large expanses of window, is seldom symmetrical.

ASYMMETRICAL BALANCE

Also referred to as *informal*, *active*, or *occult* balance, asymmetry results when visual weights are equivalent but elements differ in size, form, color, pattern, spacing, or distribution on either side of an invisible center axis. This is the principle of the lever or seesaw: weight multiplied by distance from center. Both physical and visual weights follow similar laws in that heavy weights near the center counterbalance lighter ones farther away. Asymmetrical balance is often found in buildings or gardens designed to harmonize with their natural surroundings and to use space most efficiently, as well as in furniture arrangements planned for convenience. It is seen in some historical periods—Rococo and Art Nouveau, for example—and in much Oriental and contemporary design.

The effects of asymmetrical balance differ markedly from those of symmetry. Asymmetry stirs us more quickly and vigorously, and it suggests movement, spontaneity, and informality. Being less obvious than formal balance, it arouses our curiosity to see how equilibrium was found and, in so doing, it provokes thought and is therefore more lasting in appeal. Subject to no formula, asymmetry allows freedom and flexibility in arrangements for utility as well as for beauty and individuality but requires imagination and individual *qualitative* judgments regarding weight and placement factors.

6.3 The types of balance can easily be seen in these diagrams which illustrate how weight can be distributed to achieve equilibrium.

6.4 The dynamic character of asymmetry can be seen clearly in this vacation home built in Joshua Tree, California, and nicknamed "The Monument House" for its colorful series of geometric boxes inspired by the surrounding land-scape. Joshua Schweitzer, architect. (Photograph: Timothy Hursley)

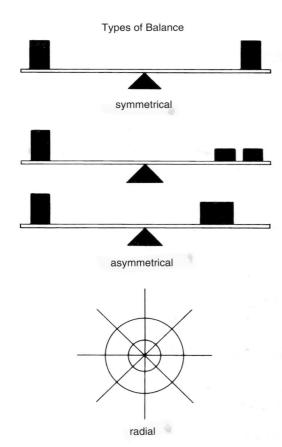

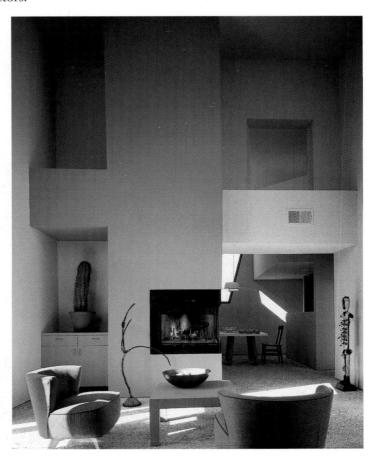

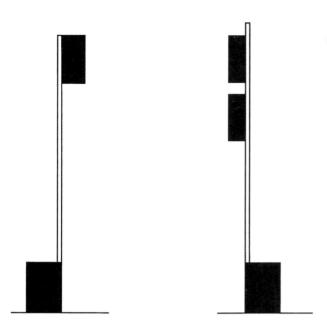

6.5 Simple diagrams illustrate the concept of vertical balance, a type of asymmetry which places more weight near the bottom than at the top of a composition, yet achieves balance due to the increased gravitational weight of objects positioned higher.

A specific aspect of asymmetry is seen in the **vertical balance** of wall elevations that position heaviest items at the bottom and succeedingly lighter objects toward the top to counteract the expected pull of gravity. The same object "weighs" more as its distance above eye level increases. A kind of *perpendicular* balance can also be achieved by playing horizontal configurations against vertical with distance from the point of junction increasing apparent weight, as seen in cantilevered construction (Figure 6.6).

Asymmetrical balance is indicated when

- informality and flexibility are desirable,
- an effect of spaciousness is required,
- use suggests asymmetry, or
- harmony with nature is sought.

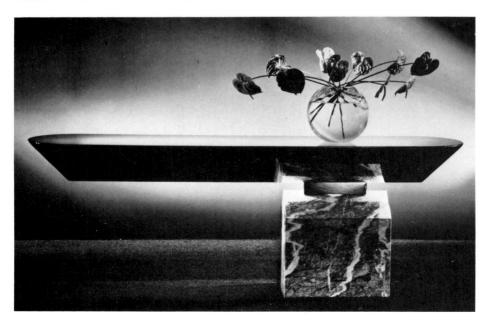

6.6 A daring use of asymmetry is seen in this coffee table of marble and glass. We know that the top must be firmly anchored on the base, but the bowl of anthuriums reinforces its equilibrium. J. Wade Beam, designer. (Courtesy Brueton Industries)

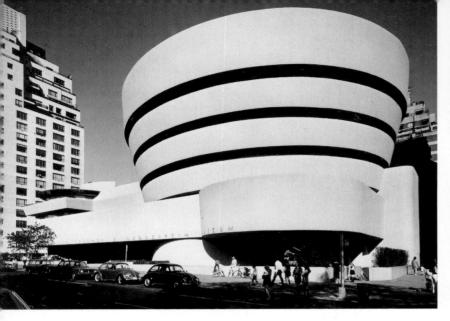

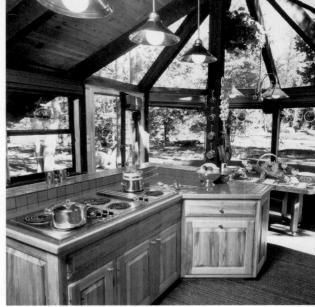

6.7 (above, left) Frank Lloyd Wright's design for the Solomon R. Guggenheim Museum in New York is dominated by an organic shell-like design of radially balanced concentric circles. (Photograph: Robert E. Mates © Solomon R. Guggenheim Foundation, New York)

6.8 (above, right) "Star House" gained its name from the radial structural configuration, dramatically emphasized in a 1979 remodel of the kitchen area which opened a six-sided glass enclosure to add dining space and a secondary entrance during the Alpine winters of Olympic Valley, California. Betty Cutten, ASID, interior designer. (Photograph: Stephen de Lancie)

RADIAL BALANCE

When all parts of a composition are balanced and repeated around the center—as in the petals of a daisy or the widening ripples from a pebble thrown into a pond—the result is called radial balance. Its chief characteristic is a *circular movement* out from, toward, or around a focal point. In homes it is found chiefly in such circular objects as plates and bowls, lighting fixtures, flower arrangements, and textile patterns. It may be static and formal, focusing on the pivotal center point, as in a table with a floral centerpiece, or active and swirling about a less emphasized central focus, as in a spiral staircase. Although of lesser importance than the two preceding types, radial balance makes its own distinctive contribution in many small objects and provides a refreshing counterpoint to rectangularity.

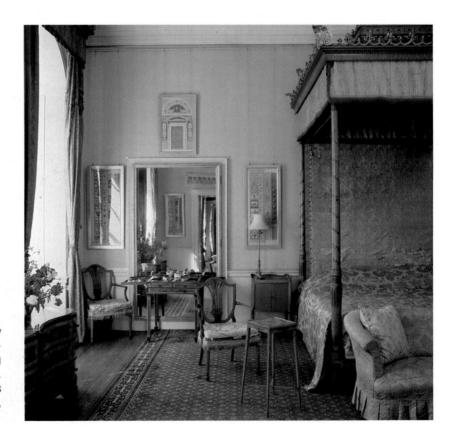

6.9 Castle Howard, an 18th-century Baroque palace in England, has been renovated and refurnished in a style befitting its history but comfortable for today's tastes. The mirrored reflection of smaller furnishings aids in balancing the room. John Vanbrugh, architect. (Photograph: Derry Moore)

Balance lends stability to a composition. In the design of a room a balanced distribution of high and low, large and small objects and spaces is needed. In Figure 6.9 the quiet composition of smaller objects counterbalances the large four-poster bed, giving the room a dignified equilibrium.

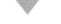

RHYTHM

Defined as *continuity*, *recurrence*, or *organized movement*, rhythm is a second major design principle and one through which an underlying unity and evolving variety can be gained. It is exemplified in time by the repetition of our heartbeats, the alternation of day and night, and the progression of one season into another. In form and space it appears in the more or less repetitive character of the leaves on a tree, the alternating light and dark stripes of a zebra, and the sequences and transitions in a river of curves that lead our eyes along its path.

Rhythm contributes to the beauty of homes in several ways. Unity and harmony are consequences of rhythmic repetition and progression. Character and individuality are in part determined by the fundamental rhythms—festive and light, dynamic and rugged, precise and serene. Homes gain a quality of "aliveness" through the implied movement and direction that rhythm induces. This, however, is fully achieved only when a congruent pattern of rhythms prevails—a pattern of which we may be consciously or only subliminally aware. **Repetition, progression, transition** and **contrast** are the four primary methods of developing rhythm.

REPETITION

Repetition is as simple as repeated rectangles or curves, colors, textures, or patterns; but it can be given more intriguing complexity in *alternation* of shapes, colors, or textures, or in *continuous related movement* seen in the natural textures and patterns of the earth, plants, water, and all living, changing things. Furnishings or patterns arranged in a circular or spokeline manner add yet another variation to

- **6.10** (below, left) A series of gossamer strips with curvilinear designs, hung in two parallel lines, changes in response to the slightest air movement. This art fabric by Gerhardt Knodel could act as a room divider or window treatment, yet it remains a creative work in its own right. (Courtesy of the artist)
- **6.11** (below, right) Custom design of sofa and tables along with alternation of color, texture, and pattern make this a distinctive sitting area. Tisch Alexander, ASID, interior designer. (Photograph: Hewitt/Garrison)

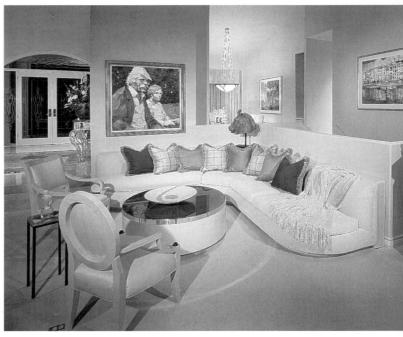

6.12 A subtle moire pattern forms the underlying design for "Paisley Square" and "Paisley Leaf" textiles from Grey Watkins, Ltd. The continuous related movement is reminiscent of ripples in water or figures in wood grain, a flowing rhythm which binds these designs together and enhances their undulating folds.

6.13 (above, right) A unique corner cupboard designed by Charles Moore depicts stepped progression in its design. (Photograph: Hedrich-Blessing, courtesy Formica Corporation)

simple repetition, *radiation*. The same as radial balance previously discussed, radiation lends a sweeping, often dramatic, circular motion to a room. Even the most commonplace home is full of repetition—evidence of its universal appeal and also of the fact that merely repeating anything anywhere is not very stimulating. Some useful guides follow:

- Repeat consistently the forms and colors that underline the basic character.
- Avoid repeating that which is ordinary or commonplace.
- Too much repetition, unrelieved by contrast of some sort, leads to monotony.
- Too little repetition lacks unity and leads to confusion.

PROGRESSION

A sequence or *gradation* produced by increasing or decreasing one or more qualities, progression is ordered, systematic change. Because it suggests onward motion by successive changes toward a goal, progression can be more dynamic than simple reiteration.

Progression is easiest to see in small things—in patterns on china and in textiles or furniture. Charles Moore, for example, has designed a corner cupboard (Figure 6.13) composed of intriguing sequences of steps leading the eye across and up, in and out to the final piling up of blocks in precarious equilibrium at the top. But while it will necessarily be more subtle, progression is just as valid in design for the whole home, even in exterior design. The facade of a wood-sheathed house

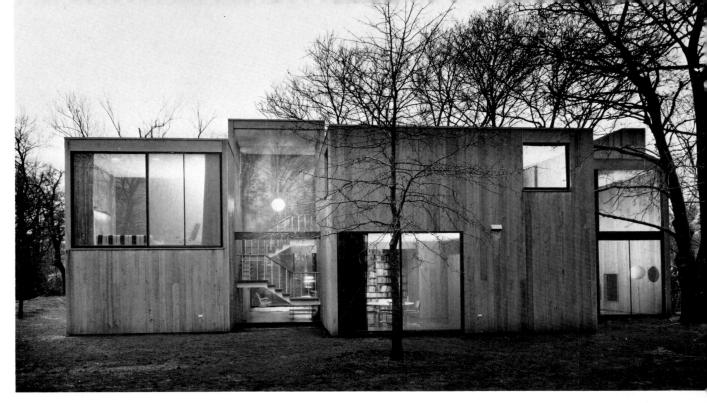

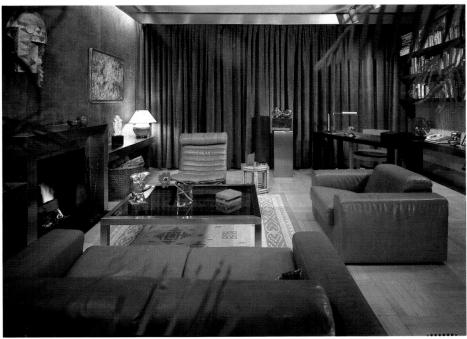

6.14 The basic rectangular forms of this house are enlivened by a series of progressions in forms, placement, weights, and materials. George Nemeny, architect. (Photograph: John T. Hill)

6.15 A gradation of values establishes subtle rhythm in a monochromatic color harmony. Dark draperies and desk progress to medium value linencovered walls and leather upholstery to light wood floors and a high contrast dark-againstlight patterned rug. Linda Warren Associates, interior designer. (Photograph: Peter Aaron/ESTO)

(Figure 6.14) is broken by rectangles of different shapes and sizes, beginning with a small square at upper right, progressing through stacked vertical rectangles in the entry and at far right, and culminating in large horizontal rectangles in the center and at far left. This exterior also illustrates the principle of asymmetrical balance, for the visual weights of the windows on either side of an imaginary central axis (supplied here by the single leafless tree) offset each other to create equilibrium. In an interior, progression may be seen in the ways in which a single pattern is used, or in the building up of a group of furniture, or in the sequence of spaces, shapes, or colors gradually changing within a room or throughout the interior.

TRANSITION

A more subtle form of rhythm, transition leads the eye in a gentle, *continuous, un-interrupted visual flow* from one area or object to another. Often curved lines achieve a smooth transition, leading the eye easily over an architectural feature such as an arched doorway or a curved sofa back. The implied curve of a conversation circle, with chairs set at an angle, draws the group into a cohesive unit, while a plant or chair set at an angle near the corner of a room softens the angularity of the space through transition. During the Rococo period in eighteenth-century France, nearly all angles were avoided in architecture, furnishings, and textiles to produce continuous flowing movement. Although differing greatly in character, the Art Nouveau period also exemplified the use of transition in its organically-inspired plant forms. Today, some textiles and wallcoverings utilize uninterrupted linear patterns which may provide a similar visual rhythm.

CONTRAST

Contrast is the deliberate placing of forms or colors to create *opposition* by abrupt change instead of gradual—round next to square, red beside green, the 90-degree angles of vertical lines or forms meeting horizontals. It is a favorite device to awaken response. The rhythm produced is exciting (Figure 6.18). If the manner in which the forms or colors adjust to one another is bolstered by similar juxtaposition of opposing forces elsewhere, it provides the continuity upon which rhythm is established.

Contrasting rhythm has become an increasingly popular theme in interior design, although it has always been used to some extent. Ornate objects are complemented by quiet backgrounds; old is played against new. This can be an exciting and challenging design concept but is one that must be used knowledgeably and with some restraint so as not to disrupt the overall continuity.

- **6.16** Transition may be achieved by placing furniture in such a way as to form a circular group (a) or soften the appearance of a right-angled corner (b) with an implied curve.
- **6.17** The continuous flowing lines of both French Rococo and Art Nouveau furnishings, an elaborate swag and cascade drapery, floral and paisley patterns, and an abstract painting combine to create an interesting eclectic apartment interior. Frederick Victoria, interior designer. (*Photograph: Peter Mauss/ESTO*)

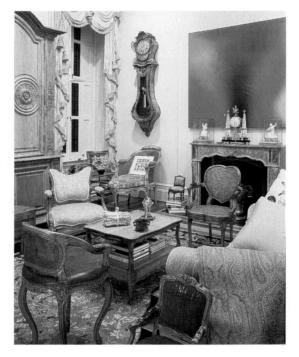

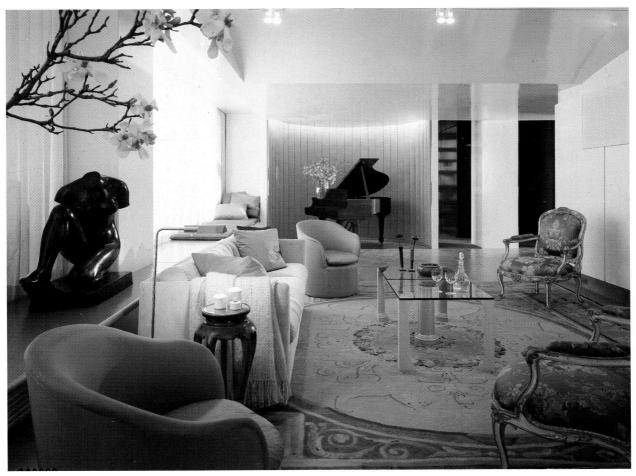

The key to rhythm, in a dance, a fabric, or a room, is *continuity*—the organized movement of recurring or developing patterns into a connected whole. Consistency of rhythm—through repetition, progression, transition, or contrast—establishes a solid foundation upon which composition rests.

EMPHASIS

A third design principle, emphasis, is often considered in terms of *dominance* and *subordination*. Emphasis suggests giving proper significance to each part and to the whole, calling more attention to the important parts than to those of lesser consequence, and introducing variety that will not become chaotic. It has to do with *focal points*, "rest areas," and progressive degrees of interest in between. Without emphasis, homes would be as monotonous as the ticking of a clock, and without subordination as clamorous and competitive as a traffic jam.

Many homes suffer from a lack of appropriate dominance and subordination. Such homes may have rooms in which almost everything has about the same dead level of unimportance or, at the opposite extreme, rooms in which too many assertive elements compete for simultaneous attention. Those rooms in which attention is directed toward a few important elements are usually more livable—a

6.18 Designer John Saladino juxtaposes ornate Louis XV chairs, a 19th century Aubusson rug, and a Chinese lacquer table with his own sleek furniture designs, a fabric-paneled alcove, smooth high gloss walls, and parquet floors painted with aluminum auto paint. The opposing elements create stimulating contrasts in a high-rise apartment in New York City. (Photograph: Peter Aaron/ESTO)

6.19 The dominant visual theme throughout architect C. W. Kim's own home is circular elements balanced with squares, as expressed in the kitchen design. (Photograph: Hewitt/Garrison)

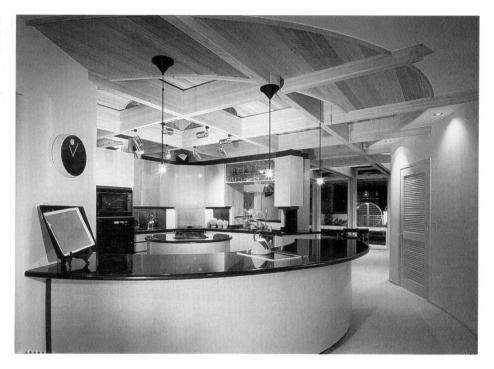

substantial fireplace or a distinguished piece of furniture, a painting, or a window with an outlook, shown to advantage by quieter visual rest areas. Rooms of this kind result in neither boredom nor overstimulation. Attention is held and relaxed at many levels, providing balance and rhythm throughout.

Two steps are involved in creating a pattern of emphasis: deciding how important each unit is or should be and then giving it the appropriate degree of visual importance. This is not so simple as the superficial concept of "centers of interest and backgrounds," because here we are dealing with a scale of degrees of significance, not with two categories. A start can be made by thinking in terms of four levels of emphasis, such as emphatic, dominant, subdominant, and subordinate (although this, too, is an oversimplification, because there can be innumerable levels). For example, the room shown in Figure 6.20 might break down in the following way:

- Emphatic—view of the outdoors through a window wall
- Dominant—fireplace, one important painting
- Subdominant—major furniture group, storage wall, and sculpture
- Subordinate—floor, walls, ceiling, and other accessories

If we analyze this room, it becomes clear that certain elements have been consciously manipulated to assume levels of importance they might not otherwise possess. Because the house sits on a mountain side, full access to the dramatic view was important to the owners. Large window walls in the living room thus make the outdoor panorama the most emphatic feature in the composition. At the next level, the fireplace—dark and isolated in a light-colored wall—stands out and assumes major significance, a not surprising treatment in the wintry climate. And, since the painting on the wall has virtually the only color in a room full of neutrals (its hue echoed in a bench and a few sofa cushions), it too becomes dominant. Ordinarily, a large multisection seating unit would be a dominant element in any room, but here the sofa components have been upholstered in black, so they

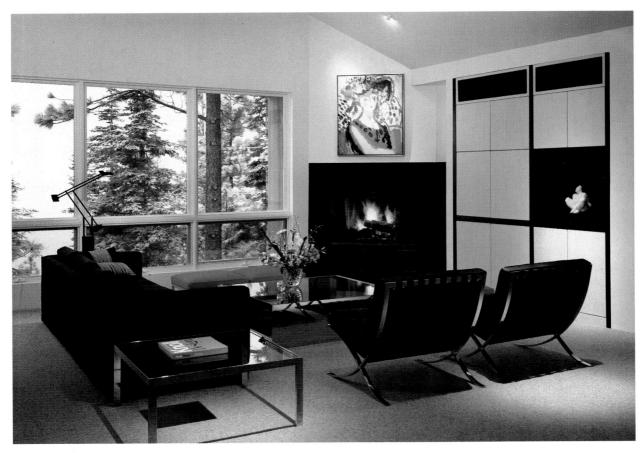

take a secondary or subdominant role to the fireplace and painting. The sculpture contrasts with the cubicle it occupies, so in the overall view of the room it also acts as a subdominant. The floor and walls, as neutral, two-dimensional planes, retain their accustomed roles as subordinate elements, and the ceiling, painted white, also recedes into a subordinate role.

Other conditions and desires would lead to different solutions. Many people do not have an impressive fireplace, an extensive view, a distinctive collection of paintings and sculpture, or a dramatic architectural feature. Fortunately, there are many ways of creating interest in a dull room. One approach is to concentrate spending on a single important piece of furniture, to locate it prominently, and to key it up with accessories, a painting, lighting, or a mirror. Funds permitting, one or two other distinctive pieces or an area rug, less emphatic than the major unit, might be secured and made the centers of secondary groups. A strongly patterned wallcovering or a large painting or graphic on one wall would also be effective. Very low in cost is an out-of-the-ordinary color scheme achieved by painting walls, ceiling, furniture, and perhaps even floor so that the color harmonies and contrasts become noteworthy. Thus, at virtually no expense, a room can be given exciting emphases.

In general, the focal point in a room should be supported by other elements so that it is not the only area of interest. It should bear some relationship to the other furnishings that rhythmically lead the eye to the dominant area. No single feature in a room should demand constant attention, else the whole will lack balance.

6.20 Upon entering this room, one is drawn immediately to the mountainous view through large, untreated windows. Attention is then directed to the painting and fireplace; furnishings and architectural backdrop follow, each with less emphasis. Borelli Smith, AIA, architect; Thompson Design Associates, Inc., interior designer. (*Photograph: Eric Zepeda*)

SCALE AND PROPORTION

Two closely associated terms, scale and proportion, relate to both the size and the shape of things. They deal with questions of magnitude, quantity, or degree. In architecture or interior design, **proportion** is relative, describing the *ratio* of one part to another part or to the whole, or of one object to another, such as 2:1. **Scale** deals with the absolute *size* or character of an object or space compared to other objects or spaces, such as 20 feet to 10 feet. In these definitions, the proportion is the same but the scale may have varied substantially. The fine shade of meaning between these two may seem elusive until we offer some examples.

In the most simplistic terms, proportions usually are said to be satisfactory or unsatisfactory, scale to be large or small, "in" scale or "out of" scale. For instance, the design on an object should have a satisfactory relationship to the size, shape, and heaviness of the object. If the design were very large, it would appear awkward and overwhelm the form; if very small, it would become lost and seem like an afterthought. Similarly, large, massive, and bulky—almost monumental—furniture in a small, low-ceilinged room would appear ludicrous, almost like standard-size furniture filling a doll's house. But in a towering, oversized space, it would be in perfect scale. Interiors by both Billy Baldwin and Joe D'Urso exhibit a fine sense of scale although their work is sharply contrasting (see Figures 2.31 and 18.6).

No foolproof system of proportioning that holds good in all cases has been devised. The so-called *golden rectangle* and *golden section* of ancient Greek origin, which often give safe, pleasing results, come nearest. According to Greek design, a square is the least pleasing proportion for an enclosure while a rectangle, with its sides in a ratio of 2:3, is the most pleasing. Square rooms do, in fact, present many design problems. Among them are an often forced symmetry and an awkward relationship of typically rectangular furniture forms to the square enclosure itself. The golden section is the division of a line or form so that the smaller por-

6.21 The Golden Mean and Extreme Rectangle demonstrate that the proportion of side A to side B is the same as the proportion of side B to side A plus side B, thus making the smaller rectangle the same proportions as the larger one. This proportional relationship is also known as the Golden Section.

THE GOLDEN MEAN AND EXTREME RECTANGLE

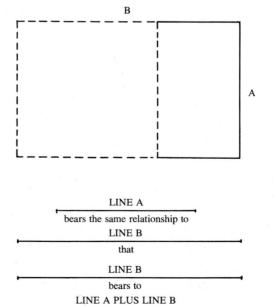

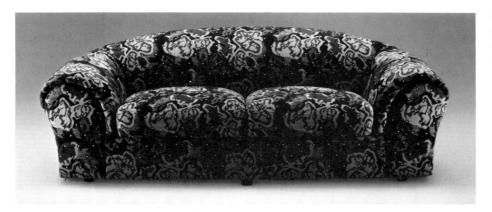

6.22 Robert Venturi's overstuffed traditional sofa seems even larger because of the large-scale pattern that covers it. (Courtesy The Knoll Group. Photograph: Mikio Sekita)

tion has the same ratio to the larger as the larger has to the whole. The progression 2, 3, 5, 8, 13, 21 . . . (known as the *Fibonacci sequence*), in which each number is the sum of the two preceding ones, approximates this relationship. For those in need of formulas, these are as good as any. They may aid in deciding on the proportions for a room, or of many architectural features such as window shapes and molding placement, or of the size, shape, and placement of furnishings within a room. Skillful use of color, texture, pattern, and furniture arrangement can alter and improve *apparent* proportions of spaces as well. But the application of formulas may be limited. Specific pieces of furniture may not always be able to follow such rigid guidelines and still fulfill needs adequately.

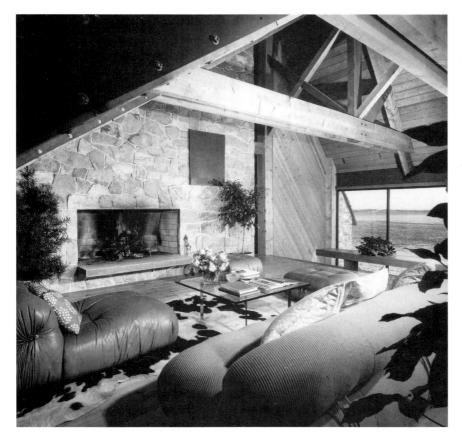

6.23 The massive scale of a vacation house on Long Island is carried out in every detail, but the soft, casual, yet bulky seating helps humanize the effect. Norman Jaffe, architect. (*Photograph: Bill Maris*)

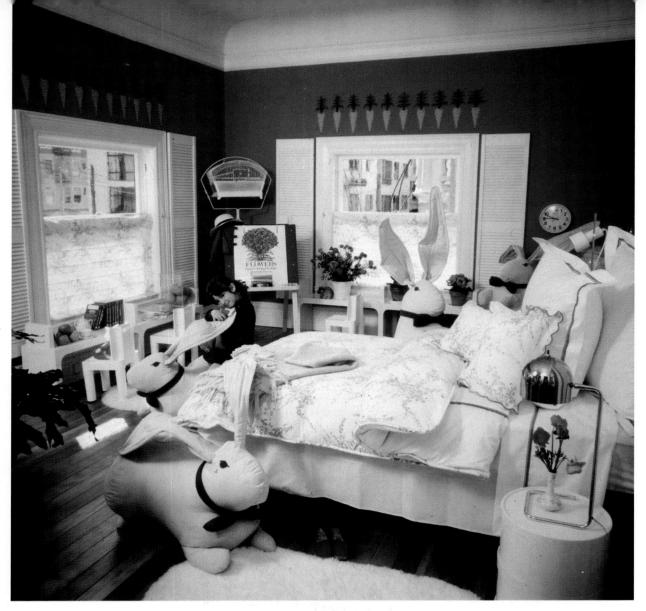

6.24 Antonio Torrice, ASID, designed many personal environments with children, incorporating their physical stature as well as their imagination and color preferences. In this bedroom, storage and activity areas are scaled to a child's height and the Roman shades are mounted on the window sill so she can reach the cords and adjust their position. The bed is standard size (to provide ample room for growth and utilize standard bedding), and the rabbits are an overscaled expression of imagination, protecting the sleeping area and serving as softsculptured furniture. (Photograph: Ray Scotty Morris. Reprinted courtesy In My Room: Designing For and With Children by Antonio F. Torrice, ASID, and Ro Logrippo)

Scale, as we said, is generally described as large or small, but by this we mean large or small compared to something else. The sofa shown in Figure 6.22 (page 129) has large, heavy contours compared to the furniture we normally see, and the upholstery fabric is an unusually large floral pattern. Both elements, then, could be spoken of as large-scale and the pattern is in scale with the sofa. Large textures and patterns and bold colors that attract attention can also make an object or area *look* larger than small-scale textures and patterns and subdued colors.

A phrase one often hears is *grand scale*, and this certainly describes the house in Figure 6.23 (page 129). Everything here is oversized, from the massive masonry wall, through the thick boards that form the uprights and immense wood beams, to the generous-size furnishings. A house as expansive as this needs very careful use of scale, for otherwise people would feel lost and intimidated. Public spaces are often designed on a grand, even monumental, scale for dramatic effect.

A vital consideration in the home is **human scale**. Physically, typical people are between 5 and 6 feet tall and weigh between 100 and 200 pounds. These figures are a yardstick for sizes of rooms, furniture, and equipment. Suitably scaled homes make us look and feel like normal human beings, not like midgets or giants. Yet within this framework there is ample room for variation. A room for a child or children may be deliberately *scaled down* to small-human size. Furnishings that are low and shallow and relatively narrow spaces between pieces make a child

feel comfortable and at home. Designer Antonio Torrice, ASID, specialized in children's rooms and worked closely with his young clients to create successful living environments scaled to their small stature (Figure 6.24). Size may be diminished or scaled down while proportion remains constant, as in a model or drawing, completed in 1/16-, 1/8-, or 1/4-inch scale.

The success with which scale is used depends on some consistency. It is not simply a matter of similar size—of placing small furniture in a small room—but of harmonious relationships. Scale relationships in the home cover the entire range of design: of furnishings to space and to each other; of texture, pattern, and ornament to surfaces and furnishings; and of accessories to larger pieces. The standard of measurement relating objects to each other, to us, and to the spaces they occupy may well be one of the most important principles in interior design.

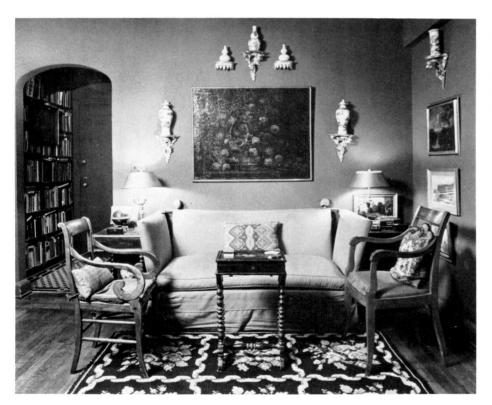

6.25 Designer Stanley Barrows solves the problem of a small room with a skillful use of scale and proportion. Tall objects are used around the perimeter of the room with low furnishings in the center of the space, directing the eye to the elements above and behind the seating area. (Photograph: Gene Maggio/NYT Pictures)

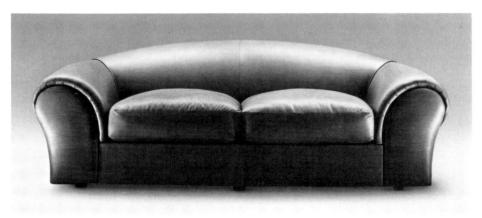

6.26 Robert Venturi's sofa (see Figure 6.22), even in a plain fabric, would still seem out of scale in the room in Figure 6.25 because of its bulk. (Courtesy The Knoll Group. Photograph: Mikio Sekita)

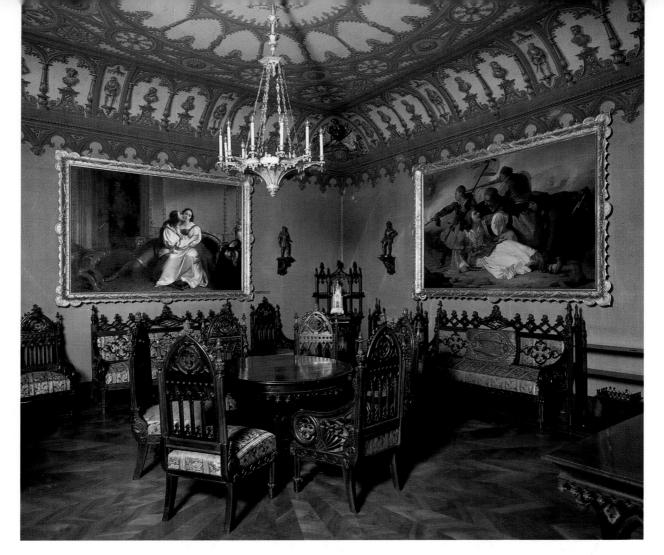

6.27 Furniture and architecture are totally unified in design in this Gothic Revival room in the Museo Sartorio in Trieste, Italy, created during the 1850s, when the city belonged to Austria. (Photograph: Giornalfoto)

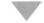

HARMONY

Even within the schema of different levels of emphasis, it is important to maintain an overall harmony, so that various elements do not seem to be thrown together arbitrarily or to be competing with one another. Defined as *consonance*, *concord*, or *agreement among parts*, harmony suggests carrying through a single unifying theme that consistently relates the varied components of an interior, whether a single room or an entire house.

In essence, harmony results when its two aspects—unity and variety—are combined. Unity unrelieved by variety would be monotonous and unimaginative; variety without some unifying factor, such as color, shape, pattern, or theme, would be overstimulating, unorganized, and discordant.

UNITY

Generally, unity is achieved by repetition, similarity, or congruence of parts in a composition. Architecture usually establishes the basic character of a space, both inside and out. Furnishings that echo the structural lines of the interior architecture may be chosen. Or color, texture, or patterns may be matched or coordinated to provide continuity, as when the same color of carpet is used throughout the

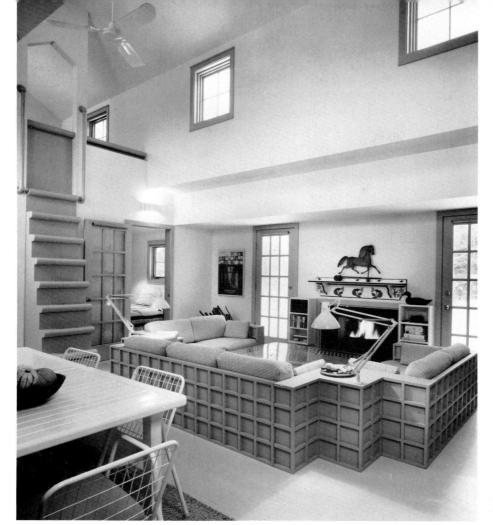

6.28 A single structure forms sofa frames and end tables, creating a unified conversation area in front of the fireplace in this weekend house in Michigan. Stanley Tigerman and Margaret McCurry of Tigerman, Fugman, McCurry, architects. (Photograph: Karant and Associates, Inc.)

6.29 Rounded corners on cabinet frames, doors, and handles are an important safety feature in the kitchen and provide a harmonious overall effect. Kitchen cabinets are carefully fitted to give a unified design. (Courtesy Poggenpohl USA)

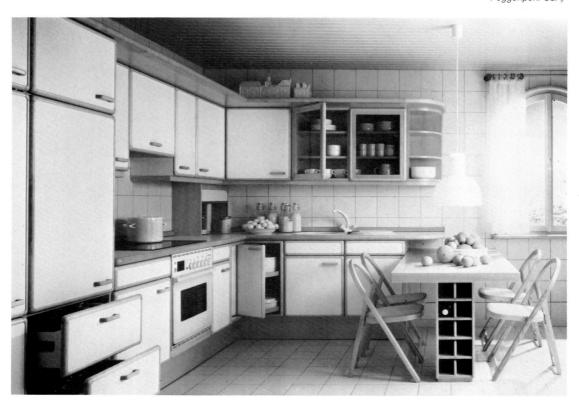

6.30 Excessive unity can be overwhelming or monotonous; a bold pattern can quickly become tiresome. (Courtesy Warner)

6.31 Storage units may be designed to perform double duty as free-standing space dividers with individual compartments concealed behind a unified facade. Variety is provided here by the open cubicle in the center and by contrast of the simple contemporary storage unit with the ornate historic column. Charles Damga, designer. (Photograph: © Wolfgang Hoyt ESTO)

house. Major components should express a consistent basic character with subordinate elements complementing the dominant feature. There have been periods in history when furniture was designed to blend with architecture as part of a total unit, as in Figure 6.27. In more recent times, "built-in" furniture accomplishes a similar goal (Figure 6.28). Our kitchens today are a prime example of unity in the home, with components built in, both to appear uncluttered and for ease of maintenance. Occasionally, too much unity can lead to visual discomfort if complicated design elements are too often repeated. The Gothic Revival interior seen in Figure 6.27 might have too much carving (even if related) for comfort.

VARIETY

Variety brings vitality, diversity, and stimulation to design. It may be as subtle as slight differences in color and texture or in form and space that are easily assimilated, or it may be a surprising contrast such as the juxtaposition of old and new (Figure 6.32). Excessive diversity without any apparent underlying scheme can appear chaotic, cluttered and confusing. A profusion of patterns, colors, textures, and

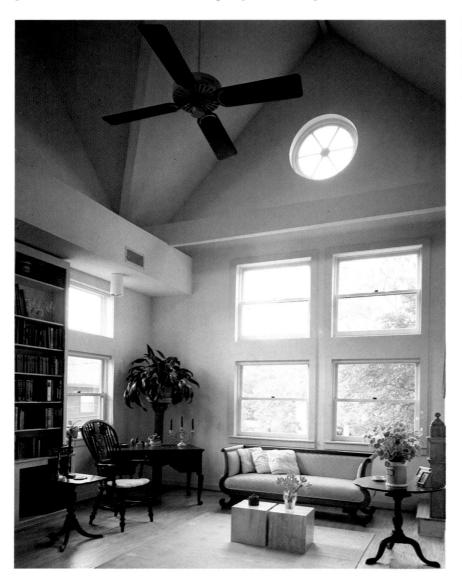

6.32 Variety is introduced through an eclectic mixture of old and new in both furnishings and architecture in many homes being designed today. Val Glitsch, architect. (Photograph: Paul Hester)

forms seen against one another, as exemplified by Victorian design, may lack visual clarity. With such complexity, the relief of some empty "rest" space is needed to provide the contrast necessary for full appreciation of intricate design.

As should be clear from the foregoing discussion, variety and unity achieve a happy merger when most of the design elements—space, form, line, texture, light, and color—are held fairly constant and only one or two are changed. Harmony is the result of able use of the other guidelines to design—balance, rhythm, emphasis, scale, and proportion.

The elements and principles of design can seldom be applied self-consciously. Indeed, it is folly to imagine that by injecting suitable doses of balance, rhythm, emphasis, harmony, scale, and proportion into an interior we will inevitably arrive at the perfect design. More often, such principles come to our attention only when we have violated them, perhaps when two chairs placed together are obviously in awkward proportion to each other. However, once we have come to understand the factors involved, we can more easily grasp what is wrong and how we can correct it. The purpose of studying this language of design is not to memorize rules but, first, to recognize the basic elements we are working with and, second, to discover what principles have proved successful in other designs. By studying designs that have worked for different situations, we will gradually develop a sense of how elements can be combined. As stated by Marjorie Bevlin, "in no area of design are the elements and principles more obvious or more dynamic than in the design of interiors."

NOTE TO THE TEXT

1. Marjorie Elliott Bevlin, *Design Through Discovery*, 5th ed. (New York: Holt, Rinehart and Winston, Inc., 1989), p. 340.

REFERENCES FOR FURTHER READING

Bevlin, Marjorie Elliott. *Design Through Discovery*, 5th ed. New York: Holt, Rinehart and Winston, Inc., 1989.

Cheatham, Frank R., Jane Hart Cheatham, and Sheryl A. Haler. *Design Concepts and Applications*. Englewood Cliffs, N.J.: Prentice-Hall, 1983.

Faulkner, Sarah. Planning a Home. New York: Holt, Rinehart and Winston, 1979.

Friedmann, Arnold, John F. Pile, and Forrest Wilson. *Interior Design: An Introduction to Architectural Interiors*, 3rd ed. New York: Elsevier Science Publishing Co., 1982.

Grieder, Terence. Artist and Audience. Fort Worth: Holt, Rinehart and Winston, Inc., 1990.Kleeman, Walter B., Jr. The Challenge of Interior Design. Boston: CBI Publishing Company, 1981.

Lauer, David A. Design Basics, 3rd ed. Fort Worth: Holt, Rinehart and Winston, Inc., 1990.
 Nemett, Barry. Images, Objects, and Ideas: Viewing the Visual Arts. Fort Worth: Harcourt Brace Jovanovich College Publishers, 1992.

Ocvirk, Otto G., Robert O. Bone, Robert E. Stinson, and Philip R. Wigg. Art Fundamentals: Theory and Practice, 4th ed. Dubuque, Iowa: William C. Brown, 1981.

Richardson, John Adkins, Floyd W. Coleman, and Michael J. Smith. *Basic Design: Systems*, *Elements, Applications*. Englewood Cliffs, N.J.: Prentice-Hall, 1984.

Russell, Stella Pandell. Art in the World, 2nd ed. New York: Holt, Rinehart and Winston, 1984.

Thiel, Philip. Visual Awareness and Design. Seattle: University of Washington Press, 1981. Zelanski, Paul, and Mary Pat Fisher. Design: Principles and Problems. New York: Holt, Rinehart and Winston, 1984.

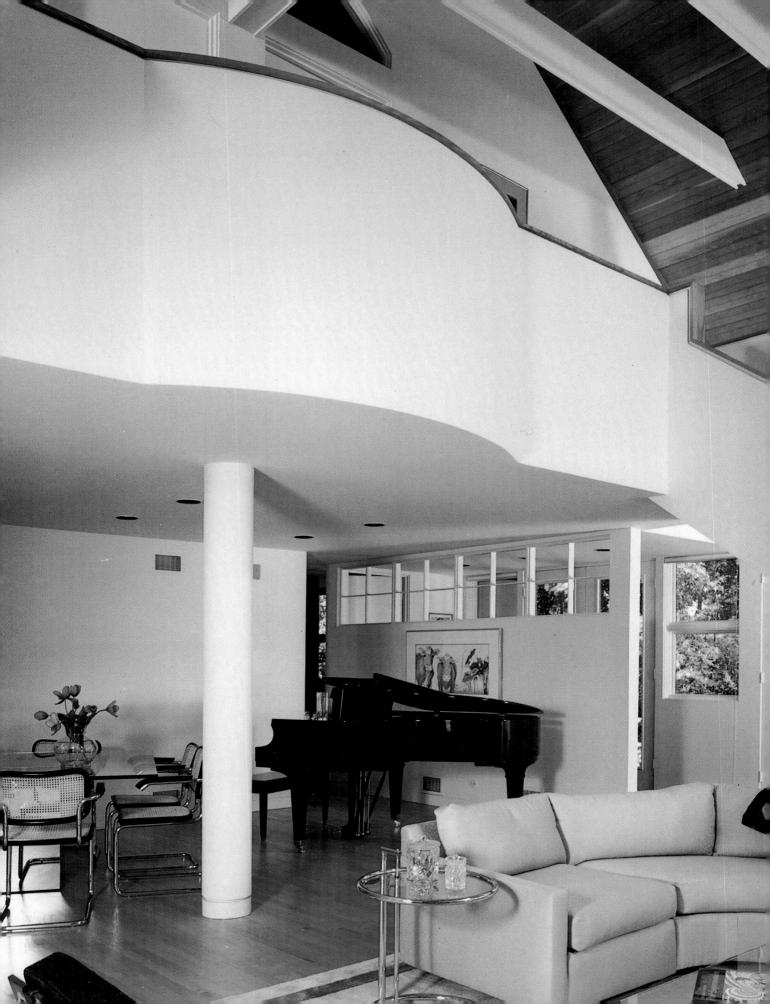

PART THREE

Designing Residential Spaces

Human Factors and Special Needs

PHYSIOLOGICAL REQUIREMENTS

BEHAVIORAL BASIS OF DESIGN

Ergonomics

Cultural Influences

Psychological and Social Needs

SAFETY AND ARCHITECTURAL BARRIERS

Stairs

Bathrooms

Kitchens

Throughout the Home

SPECIAL NEEDS POPULATIONS

Children

The Elderly

The Disabled

CASE STUDY

A Universal Kitchen Design for the Low-Vision Elderly

The home plays a critical role in our lives, more today perhaps than at any other time in history. It not only shelters and protects us from physical harm but also nurtures our growth, enhances our self-image, insulates us from the stress of the outside world, provides a feeling of control over at least a small segment of our environment, fosters development of our individual potential, provides a setting for social interaction, and serves as an outlet for our need for creative self-expression. In short, our home is central to the satisfaction of the hierarchy of human needs first proposed by the late psychologist Abraham Maslow, who ranked needs at five levels from physiological to security, social, self-esteem, and self-actualization. Needs at the lower level must be met to some extent before higher needs begin to manifest themselves. Feelings of personal worth, enhanced by "moving up" to a better/larger/more expensive home, or desires to customize and personalize space to a large degree are not likely to appear until more basic needs for physical well-being, safety, and social interaction are reasonably well met.

The concept of home—the space we call our own, within which a good portion of our social and private living takes place—is a constant in our rapidly changing world. The physical facility and geographic location may change many times

7.1 The Jefferson lounge chair and accessories, designed by Niels Diffrient, incorporate the human comfort factors of ergonomics in an innovative, adjustable design suited for a variety of tasks in a high-tech environment. (Courtesy Domore/DO®. Photograph: Bill Kontzias)

during each of our lives. But, in spite of the diversity of types and locations of living spaces available today, the *ideal* of home, where our basic needs are fulfilled, remains unchanged. And, we all have common biological needs and are subject to certain human factors, including ergonomics, culture, and psychological influences that guide our choices in designing our personal dwellings.

PHYSIOLOGICAL REQUIREMENTS

Physical needs are, of course, basic: protection from the elements and from intruders, a safe and healthful place for bodily rest and nourishment. These needs are our most immediate and are easy to understand. We must have food and sleep and we cannot endure without shelter and protection when exposed to the extremes of climate or to other living things that might harm us. Other hazards, such as fumes, airborne bacteria, and noise, have become concerns in recent years and are being addressed by designers today. (See Chapters 13 and 14 for discussions of air quality and human comfort relative to the thermal and acoustical environment; Chapter 21 addresses lighting needs in the built environment.) But ways of meeting these needs have long been diverse and imaginative and are conditioned by complex behavioral influences.

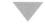

BEHAVIORAL BASIS OF DESIGN

Growth of the design profession has been paralleled in recent years by an increased interest in understanding the symbiotic relationship between people and the built environment. A number of different disciplines have contributed studies of human needs and continue to research the interaction of designed spaces with the human beings who utilize them. The design profession is now attuned to the findings of more scientific disciplines such as anthropology, psychology, and sociology, and has become part of an interdisciplinary approach to the study of **human factors** in relation to design, recognizing that the designed environment exerts a powerful influence on our daily satisfaction, behavior, productivity, and both physical and mental health and comfort. With the majority of our lives spent indoors, the application of human factors research and/or employment of such specialized consultants is of critical importance in making successful design decisions.

ERGONOMICS

Everyone wants space and furnishings that "work" effectively, that serve the purposes for which they are intended, that fit the human body. This includes space

7.2 Accessible storage should be related to human dimensions as illustrated here. When designing for an unknown user, as is often the case in contract design, measurements for the smaller person should be used; when designing for specific clients, individual measurements can be used. These guidelines are designed to accommodate 90% of the population. (From Human Dimension & Interior Space: A Sourcebook of Design Reference Standards by Julius Panero and Martin Zelnik, Whitney Library of Design, 1979, p. 137).

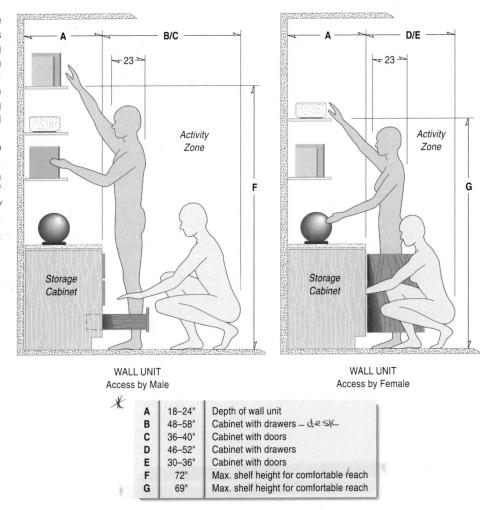

that is planned for the intended activities, furniture that is the right size and shape for the comfort of the expected user, storage that is convenient and accessible, lighting that provides adequate illumination without glare, and acoustic treatments that enable hearing with ease.

An increasing amount of research is being undertaken which provides the interior designer with useful data to aid in functional design. **Ergonomics** or **human factors engineering** combines *anthropometric* (human body measurement) data, physiology, and such psychological factors as personal space to improve the interface between users and their environments. Ergonomic design acknowledges that people and their surroundings participate in molding each other, a crucial transaction which affects the measurement of user satisfaction with the built environment. Sensory responses to temperature, sound, and illumination combined with anatomical measurements and body mechanics help form standards for the design of both humanistic and functional spaces, equipment, and furniture.

CULTURAL INFLUENCES

The complex term **culture** refers to the system wherein a group of people—a society—shares certain values; that is, there are common ways of doing things, common notions of right and wrong, common ideas of how things ought to be, even fairly common perceptions of what is beautiful or ugly. These shared values

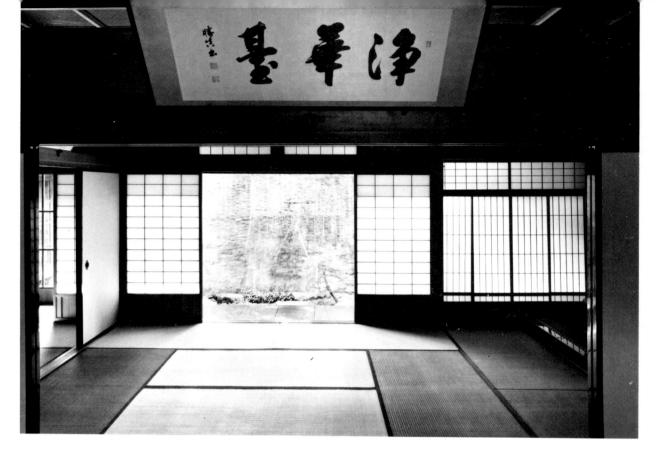

are passed from generation to generation and often preserved when people immigrate to a new country. Many diverse cultural groups in the United States have been quite persistent in maintaining their separate identities, resulting in neighborhoods in many cities with distinct ethnic character, where respect for tradition maintains a collective and accepted way of life. Housing norms suggest the "right" kind of home, and the degree to which this expectation is met affects social acceptance and self-esteem. Architect Amos Rapoport¹ notes that even for primitive people, the house was more than just a physical shelter. It was a symbol of the ideal life, a culturally controlled concept, and it took its form primarily because of the common goals and values of the people, with climate, materials, and technology having less influence.

Even today our attitudes toward eating, bathing, privacy, and relaxation have a definite impact on the form and use of eating areas, bathing facilities, and sleeping spaces within the home. The culturally established norms of behavior we take for granted dictate that in our homes we sit on chairs and sleep on beds, whereas Japanese people sit and sleep on the floor; Irish bathtubs are traditionally much shorter than American bathtubs because, in Ireland, bathers are not used to stretching out.²

In general, Western dwellings consist of a *multipurpose house* with *single-pur-pose rooms*. Traditionally in our culture, all the functions of daily life except working are performed within one structure—sleeping, preparing food, eating, bathing, entertaining, and so on. Yet within this multipurpose structure, we have most often assigned specific regions to each activity and called them bedroom, kitchen, dining room, bathroom, or living room. As activities or needs change, people must shift location from one room to another, or even from one structure to another when our jobs take us to the office or factory "working house." In other cultures, quite different arrangements are seen as normal.

The classic Japanese home, for example, is a multipurpose house with multipurpose rooms. Spaces are not demarcated permanently by walls; instead, screens or sliding panels that can be closed or opened easily adapt the space to changing needs over the course of the day (Figure 7.3). What is by day the "eating room"

7.3 The classic Japanese house has sliding doors and panels that can be closed or opened to structure the interior spaces as needed over the course of the day. (Photograph: © Paul Warchol)

7.4 Sliding fiberglass shoji screens of Oriental inspiration temper the light and divide the space in this long L-shaped loft, creating privacy without being permanent. Katja Geiger, designer. (Photograph: Chester Higgins, Jr./NYT Pictures)

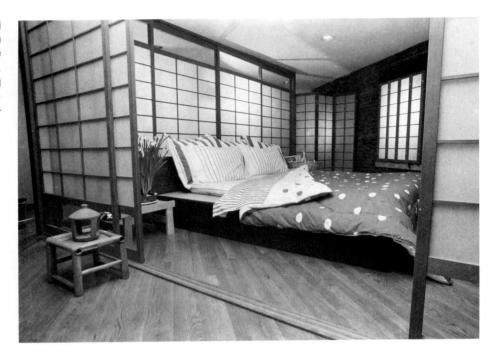

or the "living room" becomes at night, with the addition of mats, the "sleeping room." The same place thus serves different functions and changes with needs. Conversely, in our own culture, a shift in needs requires that people change location; we sleep in a bedroom and move to the living room for social gatherings. In parts of the South Seas, by contrast, we encounter single-purpose houses; the principal family dwelling serves for sleeping, while cooking and eating are done communally in a separate "cooking house."

In recent years more and more households in the United States have broken free of the boxes-within-a-box formula to create spaces more suited to their individual needs. Also, the high cost and reduced size of homes have contributed to a more efficient use of space. The studio apartment or loft is not very different in concept from the Japanese house and embodies the same goal in its planning: the most flexible utilization of space possible.

PSYCHOLOGICAL AND SOCIAL NEEDS

Psychologist Robert Sommer³ has studied the effects of the physical environment upon the attitudes and behavior of the people who use it. Architecture, Sommer says, must be functional in terms of user behavior and satisfaction; "not only must form follow function, but it must assist it in every way." In other words, a space should contribute positively to the comfort and efficiency with which activities take place within it. In a living room, obviously, furniture should be arranged to promote social interaction in an easy, friendly conversational grouping; in the bedroom, adequate provision for privacy and light control will contribute significantly to the effectiveness of the space.

Concern with the behavioral effects of the physical environment, and our ability to design our surroundings for our greatest benefit, has led to the ever-widening interdisciplinary field of study known as **environmental design** or **environmental psychology.** Professionals in this field combine the scientific disciplines of psychology, sociology, biology, anthropology, geology, and ecology with

the practitioner disciplines of architecture, urban and community planning, interior design, and landscape architecture. The approach is both humanistic and holistic rather than purely aesthetic or narrowly specialized. Environmental design emphasizes the dynamic ecological view that we have an active role in creating our own environment, suggesting that we need to become more aware of the possibilities for using and shaping our personal environs in a positive, effective manner. We are often unwilling to reshape our immediate surroundings actively; rather, we remain passive, tending to adapt to even the most undesirable spaces and furnishings. In fact, our ability to adapt may be the reason we tolerate so much poor design—uncomfortable chairs or closets that have not been planned in terms of actual use. A good user environment "fit"—body/chair, clothes/closet—is the desired outcome in the environmental design process.

Social psychologist Irwin Altman⁵ has examined how people can and do use the environment to shape social interaction with others in terms of four behavioral concepts: **privacy**, **personal space**, **territoriality**, and **crowding**. He suggests that "privacy is a central regulatory process by which a person (or group) makes himself more or less accessible and open to others and that the concepts of personal space and territorial behavior are *mechanisms* that are set in motion to achieve desired levels of privacy." Crowding occurs when these "mechanisms have not functioned effectively, resulting in an excess of undesired social contact."

PRIVACY The home provides privacy from outsiders with walls that protect us from physical, visual, and various degrees of acoustical intrusion. Windows provide some flexibility between total seclusion from and total exposure to the outside world. They can be large or small, placed for outward views but shielded from inward observation, whether open or closed, curtained or not, as desired.

7.5 Solid paneled walls and doors segregate the study in this remodeled Colonial house to provide a quiet, private weekend retreat in the Connecticut countryside. John Strittmatter and Dana Donaldson, interior designers. (Photograph: Robert Perron)

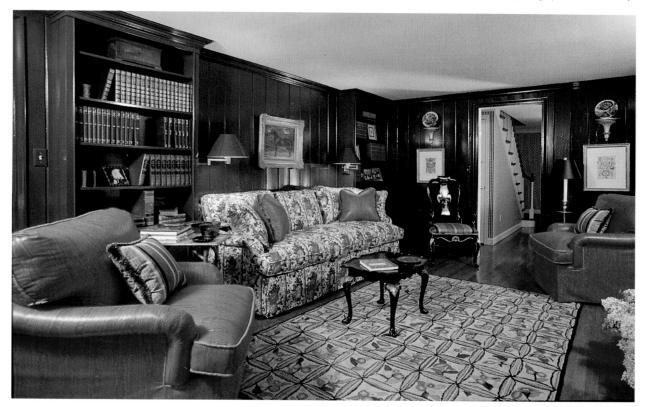

Inside the home, the floor plan first sets the privacy levels at which the home functions. A very open plan might satisfy a single person; internal privacy and access are controlled by the owner (Figure 7.6). A larger family group would probably be happier with some spaces that can be closed off as the need for seclusion arises (Figure 7.7). Closed doors establish off-limits boundaries in our culture and secure privacy for those behind them.

PERSONAL SPACE Each person moves within an area or bubble of personal space that expands and contracts according to individual needs and social circumstances. Its size varies with personality, age, and cultural background. The size of our space bubble determines our perception, experience, and use of a particular space; people with large space bubbles use furniture arrangements to create physical barriers between themselves and others and perceive a tightly arranged space as crowded, experiencing it as uncomfortable.⁶ Any intrusion into our invisible space bubble is viewed as threatening, creating stress and a sense of malaise. **Proxemics** is the study of our personal and cultural spatial needs and the behavioral and social impact of our interaction with surrounding space.

Anthropologist Edward T. Hall⁷ has identified four **interpersonal distances** (each with a near and far phase) as closely related to personal space and the regulation of privacy and social interaction. **Intimate** distance ranges from zero to 18 inches and stimulates all the senses in unmistakable involvement with another person. In some cultures, intimate distance among adults is accepted only in the privacy of the home. **Personal** distance of 18 inches to 4 feet generally coincides with

7.6 Built into a hillside on a site north of San Francisco, California, this home can take advantage of the spectacular panoramic view without need for privacy-controlling window treatments. The open plan extends beyond the window walls onto an aerial balcony. Francis Collins of Banta/Collins Architecture, architectdesigner. (Photograph: John F. Martin)

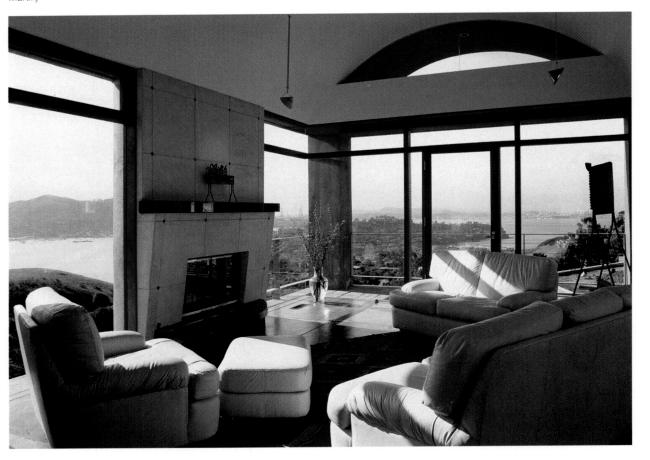

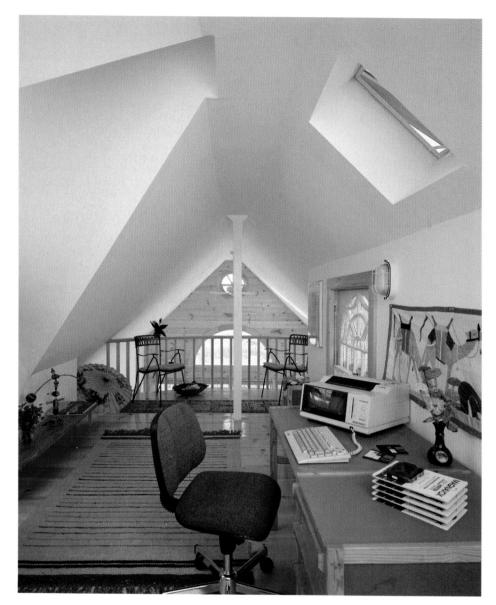

7.7 This work space adjoins the master bedroom in the loft and overlooks a studio below, permitting privacy without total seclusion in a small remodeled home on Martha's Vineyard in Massachusetts. The bowed balcony allows a magnificent view through the halfround window over the water to the Elizabeth Islands. Armstrong Associates, architects. (Photograph: Norman McGrath)

the invisible bubble of space that can literally be physically dominated by an individual. It can be likened to keeping someone at "arm's length." The relationship between two people may be indicated by how close to each other they stand or sit. **Social** distance (from 4 to 12 feet) is maintained for impersonal business, casual social gatherings, or more formal interactions. Furniture arranged for easy conversation in the home should not exceed this distance between pieces. Finally, **public** distance ranges from 12 to 25 feet and implies decreased warmth and individuality of interaction. These categories of relationships and the activities and spaces associated with them hold generally true for Americans and Northern Europeans. (See Table 7.1, p. 148.) Other patterns exist in other parts of the world. What is intimate in one culture might be personal or even public in another.

More recent research by Alton J. De Long suggests greater refinement of Hall's proxemic zones related to arrangement of furniture, proportionality of living rooms, perception of formality/informality of spaces, and the location of areas

TABLE 7.1

Interpersonal Distance Zones

	Near Phase	Far Phase	Interaction
Intimate	0"-6"		Physical involvement; vision is blurred; olfaction, thermal, and muscular/kinesthetic sensations intensified; minimum vocal communication
		6"-18"	Hands can easily reach; clear, detailed vision with distorted features; low voice or whispered communication; muscles may be tensed, eyes fixed on infinity in public
Personal	$1^{1/2}'-2^{1/2}'$		Within grasp; no visual distortion, details and textures very clear; soft voice, intimate style; standing distance signals relationships
		21/2'-4'	Arm's length, just outside touching distance, the limit of physical domination; clear detailed vision with hands in periphery; no olfactory or thermal sensations (for Americans); moderate voice level
Social /	4'-7'		Beyond physical domination, no touching without special effort; intimate visual detail not perceived, whole body seen; normal voice level
		7′–12′	Interaction has more formal character; eye contact important during conversa- tion, other people seen if present; louder voice can be heard in adjacent areas
Public	12'-25'		Flight distance; objects begin to look flat; voice is loud but not full-volume, communication more formal with words carefully chosen
		25' or more	Distance around public figures, entered by invitation only; objects/people per- ceived in a setting; voice and gestures exaggerated, nonverbal communication important

Adapted by L. Nissen from Edward T. Hall, The Hidden Dimension. New York: Doubleday & Company, Inc., 1966.

within a space relative to the entry point.⁸ De Long's ongoing findings are particularly pertinent to interior design because they are based on people seated in actual furniture arrangements.

By studying these proxemic patterns, the designer can plan a living room in which a conversational grouping will be successful; people will be close enough to hear each other, see each others' faces and expressions, and get cues from them, but not so close (or far) that they will feel uncomfortable (Figure 7.10). Individual family members can also be provided with personal spaces ranging from intimate to social, as an extension of their personality and physical self and to suit their varying needs (see Figure 7.11 on p. 150). (These concepts will be presented in greater detail as the use of space is discussed in Chapters 9, 10, and 11.) It is important that the designer understand human behavior and that the environment can either facilitate or hinder human interaction, depending upon its design.

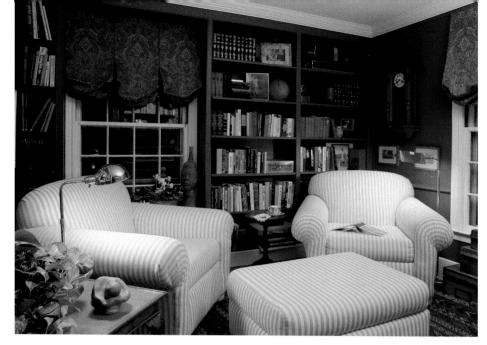

7.8 The chairs in this study, although separate, are spaced for personal interaction. Combined with warm, dark-painted bookshelves and many personal possessions, the overstuffed Scandinavian design chairs create a cozy retreat in this remodeled Colonial home in West Hartford, Connecticut, Kenneth W. Peterson, CKD, interior designer. (Photograph: Karen Bussolini)

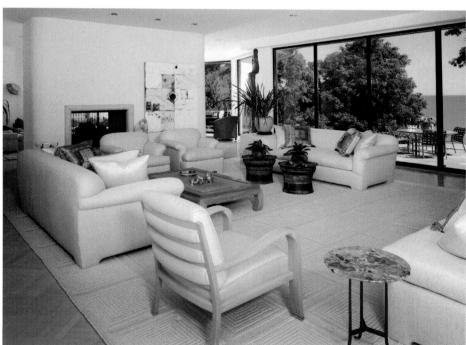

7.9 Seating in this living room in Winnetka, Illinois, is arranged to form two large conversation groups, or two individuals may sit closer together for more personal interaction. Marvin Herman & Associates, architects; Bruce Gregga, ASID, interior designer. (Photograph: Howard N. Kaplan)

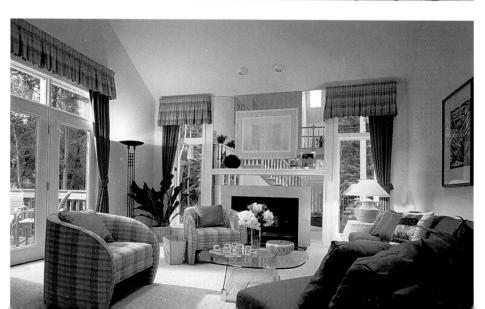

7.10 A comfortable conversation group provides flexibility to meet varying needs with optional side-by-side or face-to-face seating, enough spaces for family members plus the usual number of guests, surfaces on which to place things, enough light to see facial expressions, and a pleasant atmosphere. Furniture spacing should not exceed a social distance of 12 feet. Sara Olesker Ltd., interior designer. (*Photograph: Scott Frances/ESTO*)

7.11 (above) A family room provides a comfortably informal space where family members and friends can congregate. (Courtesy: Armstrong World Industries, Inc.)

7.12 (above, right) A small sofa, chairs that can pull up, and two small coffee tables form an intimate conversation area with easy access in designer Stanley Barrows' Manhattan apartment. Many personal possessions not only lend character, but also denote a safe and comfortable territory in which to express individuality. (Photograph: Gene Maggio/NYT Pictures)

TERRITORIALITY The concept of territoriality in humans is closely related to the attainment and protection of privacy. A territory is a specifically defined area owned or controlled and personalized by defensive boundary markers such as fences, signs, nameplates, or sometimes behavioral cues as simple as a cold stare. Symbolic of our psychological identification with "our" place is our attitude of possessiveness and arrangement of personal objects and furnishings within it (Figure 7.12). Within our territory we feel safe and comfortable; our self-image and sense of well-being are enhanced, and we feel in control. Often this is the only space in our lives we feel we can exert control over, and, as such, it satisfies our need to be creative and express our individuality. Because our home is considered a retreat or haven from the unwanted stresses of everyday life, we also protect and defend it from intrusion without invitation.

Not only does each household establish a territory of its own; each individual in it should also have a particular territory that remains inviolate. In an affluent household, each member may claim rights to an entire bedroom and may express unhappiness or discomfort if forced to share or exchange. But even in shared spaces, individuals are typically territorial about those portions that are theirs, such as furniture, closets, drawers, and play or work spaces. Boundary markers such as closed doors are usually not crossed without permission. Even in very small quarters, one chair often belongs to one person and that person only. Places at a family dinner table may be so firmly allocated that any change in the seating plan brings protests from a young child deprived of his or her usual place. Such territorial habits seem to smooth day-to-day life, with all family members having "places."

CROWDING Many studies have shown the adverse effects of crowding on animals, but similar studies of humans have yielded conflicting results. Perhaps that is because adverse effects such as stress generally build up over a period of time, and in some situations, density is desirable. We tolerate being crowded in an elevator, even though it is unpleasant, because we know it is a temporary condition and we have learned many coping mechanisms for dealing with invasions of personal space on a short-term basis. On the other hand, we often seek out a crowded dance floor or sports arena: the density is part of the fun. In either situation, however, psychological discomfort is instantly introduced if we are confined. If we are

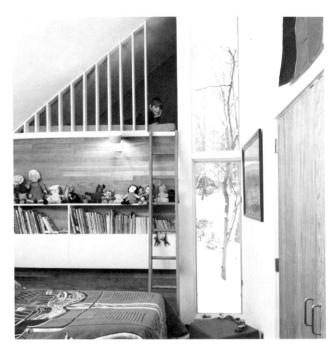

- **7.13** A child's nook for privacy is a feature many adults would treasure. Architect Murray Whisnant designed his home with many windows, soaring ceilings, and private space for all family members. (*Photograph: Gordon H. Schenck, Jr.*)
- **7.14** An individual with a large personal space bubble may feel crowded if seated between two other people behind a coffee table such as this. Others may enjoy the comfort of being close. The large custom sofa and individual chairs allow both to choose the most comfortable space in this remodel of a 1950s house in Glenview, Illinois. Deanna Berman of Design Alternatives Inc., interior designer. (Photograph: Howard N. Kaplan)

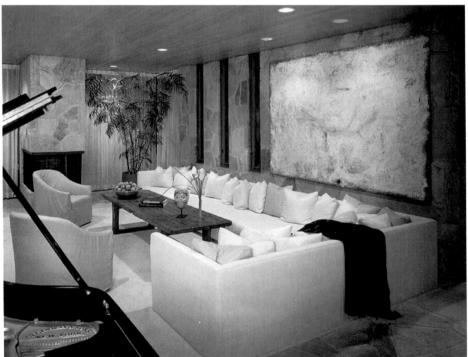

unable to leave a stranded elevator or packed dance floor, stress quickly builds up and panic may set in.

We can relate this concept to selecting and arranging furniture in our home. For example, a person seated in the middle of a 6-foot sofa may feel vaguely or even acutely uncomfortable. Penned in by the people on either side and often trapped by a coffee table in front, the unfortunate prisoner may long to escape. A more comfortable arrangement might incorporate smaller seating pieces such as love seats and individual chairs that allow more freedom of movement on the part

7.15 Sharon Campbell, ASID, remodeled this Art Deco home in Tiburon, California, in 1991, adding roomy leather chairs for individual seating in a comfortable family space. (Photograph: David Livingston)

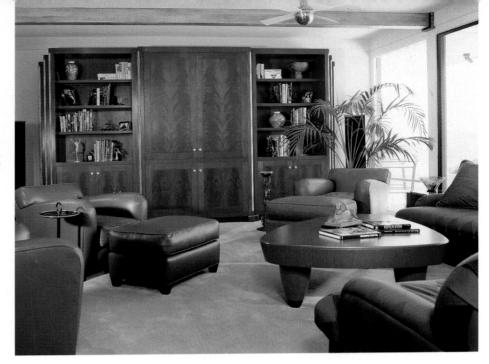

of each occupant (Figure 7.15). Other people may be drawn to large sofas or heaps of floor pillows on which they can congregate as closely as they wish.

Crowding appears to lead to territorial behavior; controlling a territory reduces the stress and overstimulation of crowding. The more affluent and socially powerful we are, the larger the space we usually claim for ourselves to ensure against feeling crowded.¹⁰

SAFETY AND ARCHITECTURAL BARRIERS

Architectural barriers create unnecessary difficulty in day-to-day living and generally limit the safety, security, comfort, and convenience of *all* people. It is the designer's responsibility to acquire and apply hazard reduction knowledge for the safety of all users. The most opportune time to apply this critical knowledge is during the planning process. The Americans with Disabilities Act mandates change in the design of public spaces and has recently served to alert designers to more barrier-free design alternatives for all spaces.

There are three major hazard areas in the home: stairways, baths, and kitchens. Many details throughout the home could benefit from an effort toward design that is **universal**, accessible to and usable by all of us, young or old, large or small, able-bodied or not, throughout our lifetimes. With some forethought, many functional features can increase the safety of the home without affecting cost or aesthetics.

STAIRS

Changes in level are hazardous to everyone and are the most frequent location of home accidents. A slight change in level such as a platform should be at least two to three steps above or below the main level, and the change in the horizontal plane should be clearly marked by a balustrade or handrail, plants, or furniture (Figure 7.17). Stairways should have *uniform* riser heights (7" is recommended) and tread depths (11"–12" for low risk), a slope of 33°–40°, sufficient head room (84"), handrails at a height of 30–34 inches (24" for children), a minimum width of 3 feet (3'6" or 4' is better), adequate lighting with switches at top and bottom, and enough contrast between the stair and its surroundings for accurate perception. The total

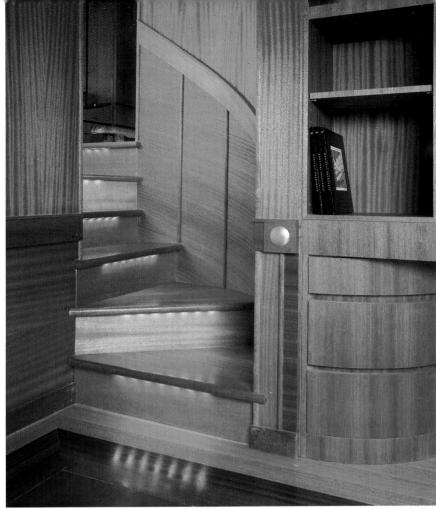

7.16 In renovating a New England style shingle home in Newport, Rhode Island, cast iron circular stairs were removed and replaced with red oak winding stairs. Lighting was added under the nosing of each stair tread for safety. WINDIGO Architects, P.A. (Photograph: Mark Darley/ESTO)

7.17 A loft in Milwaukee, Wisconsin, features a change in floor level, used to separate activity areas in the open plan. Lighting accents the steps, alerts occupants to the change in level, and reduces the danger of falling. Zimmerman Design Group, architects; Robert E. Lewcook, ASID, interior designer. *(Photograph: Howard N. Kaplan)*

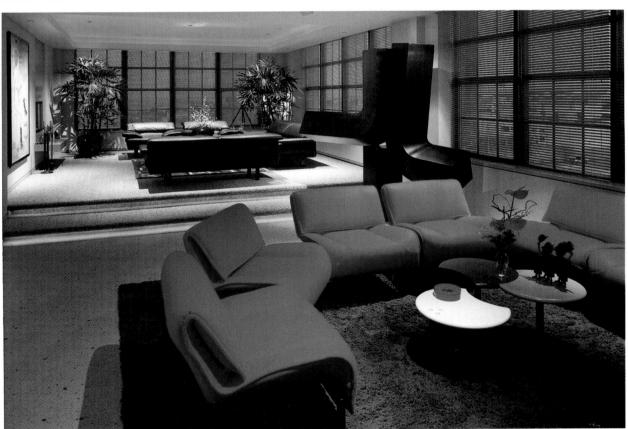

length of run (tread less nosing) for a residential flight of stairs that rises the average 9 feet from floor to floor is approximately 13 to 14 feet, depending upon exact tread depth, and contains 15 risers and 14 treads. (As riser height increases, tread depth must decrease for a normal stride.)

Unnecessary steps should be eliminated during planning: consider the extra energy expended if laundry facilities are located either up- or downstairs from bedrooms and baths. All stairs are barriers to individuals with mobility problems. Where changes in level cannot be avoided they should be accomplished with ramps having a maximum angle of incline of 1 foot in 12 feet of horizontal distance (1:12) and equipped with at least one handrail (preferably two) which extends 1 foot beyond the top and bottom of the ramp.

BATHROOMS

Bathroom equipment should, of course, be chosen with safety in mind. In some cases, wheelchair access will determine types, widths, heights, and locations of bathroom fixtures. Grab bars may be necessary in tub and shower enclosures and near toilet fixtures. For specific positioning, consult the American National Standard for Buildings and Facilities—Providing Accessibility and Usability for Physically Handicapped People (ANSI A117.1-1986). In addition, doors that open outward instead of inward allow someone to enter the bathroom in case of a fall or need for assistance, and slipfree surfaces should be specified for floors and fixtures. Single-lever faucets are easier to grasp than individual hot and cold water controls in the shower and tub or at lavatories in both baths and kitchens. (Various bathroom plans are detailed in Chapter 11.)

7.18 This small bathroom meets minimum requirements of the American National Standards Institute (ANSI) and the Uniform Federal Accessibility Standards (UFAS) for access by an individual in a wheelchair. (Courtesy The U.S. Department of Housing and Urban Development, Office of Policy Development and Research, by Barrier Free Environments, Inc.)

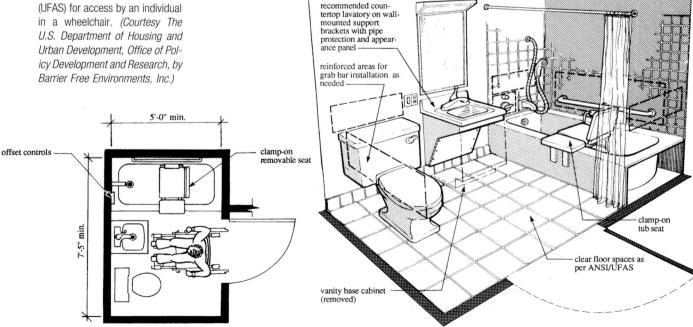

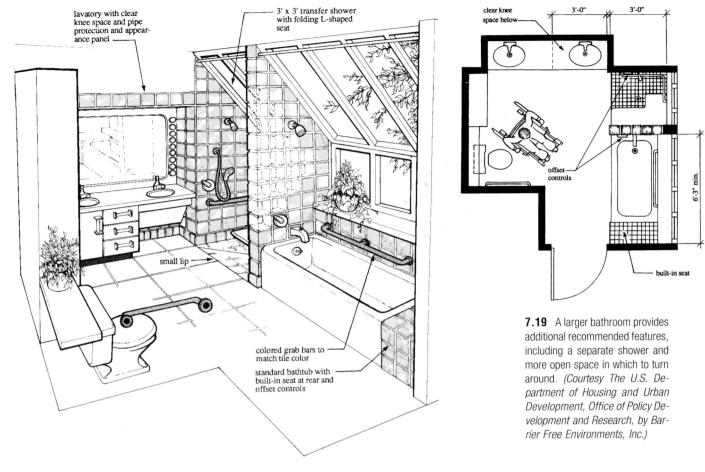

KITCHENS

Cooking areas (discussed in detail in Chapter 10) can be designed so that frequently used utensils and foods are stored within easy reach, eliminating the need to climb on a chair to reach things, risking a fall. For someone who needs or wants to sit down while working or for a child or short person, a section of counter or pullout work surface 2-8 inches below the standard 36-inch counter height can be installed. (Too many changes from standard measures, unless necessary, can have a negative effect on resale value; however, when necessary for wheelchair access, all counters and cabinets should be either adjustable or mounted at lower fixed heights within reach and base cabinets should be removed for a minimum of 30-inch frontage to provide knee space underneath the counter.) Cabinet and appliance doors should not swing into pathways where they can cause accidents, and deepdrawer storage or roll-out shelves provide easier access than ordinary base cabinets. Loop-type handles make cabinets easier to open, and front or side controls on the range or cooktop are less hazardous than those which require reaching across heat elements. A lower cooktop can also eliminate the need to bend over front burners. (See Figure 7.20 on the next page.)

THROUGHOUT THE HOME

Other areas needing attention to safety are lighting, bedrooms, and traffic paths. In general, illumination should be sufficient and without glare or abrupt changes in lighting levels. Three-way switches at both ends of hallways or stairs, night

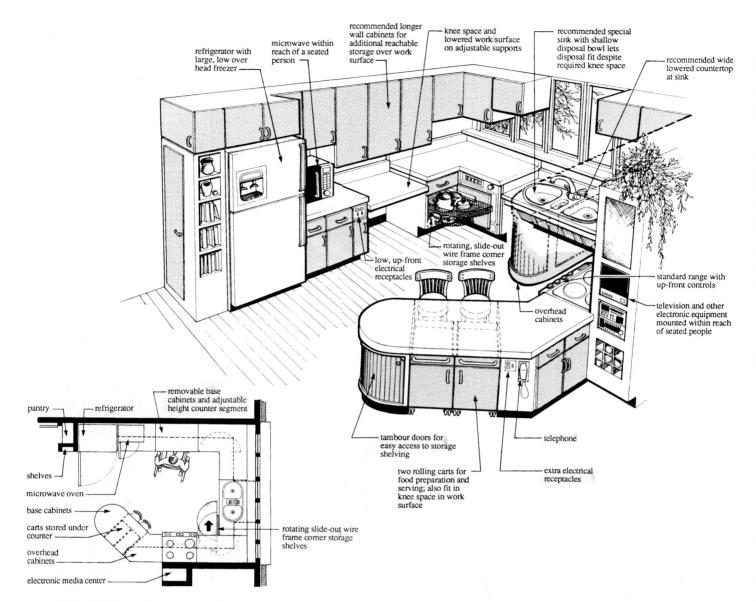

7.20 This floor plan and perspective illustrate an elaborate kitchen containing many convenient features adapted for a disabled user. It exceeds minimum ANSI and UFAS requirements. (Courtesy The U.S. Department of Housing and Urban Development, Office of Policy Development and Research, by Barrier Free Environments, Inc.)

lights, automatic timers, and exterior lighting add security. Both switch and outlet heights can be adjusted for easy access.

In the bedroom, storage position and access are as important as in the kitchen. Adjustable shelves and closet rods allow flexibility. A window positioned for view while reclining (24" sill height) is desirable, whether for someone confined to bed permanently or for occasional illness. A light switch near the bed takes the hazard out of night walking; a telephone within reach is another safety precaution. A nearby smoke detector and maximum window sill height of 36 inches, allowing egress in case of fire, add further safety. Careful avoidance of synthetic materials which emit deadly toxic fumes when burned will also reduce risks.

Traffic paths should be convenient, unobstructed, and safe, with trip-proof, nonskid, durable floors. For barrier-free design, changes in level between flooring materials should not exceed ½ inch, and doorways between rooms should have no sills, which can trip anyone who walks unsteadily. Door openings should be at least 32 inches wide (36" is even better) and hallways 48–60 inches wide rather than the standard 36–42 inches for "lifetime" universal design flexibility.

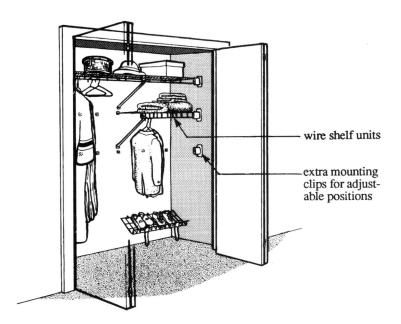

7.21 Adjustable closet systems help make storage accessible to people of all ages, sizes, and abilities. (Courtesy The U.S. Department of Housing and Urban Development, Office of Policy Development and Research, by Barrier Free Environments, Inc.)

7.22 In this home, designed by architect Alfredo De Vido, doorways are wide enough for wheelchair access. The door between the kitchen and dining area slides easily and has no sill to impede passage. (Photograph: © Daniel Cornish)

SPECIAL NEEDS POPULATIONS

Safety, security, comfort, and convenience in home design are important in producing a positive self-image and reducing the expenditure of physical energy for everyone. Three groups of people who need special consideration in planning—children, the elderly, and the disabled of all ages—each have some unique problems and some that are common to all. It is important to keep in mind that we all belong to each of these groups at some time during the normal course of our lives; even some of the physical limitations of the disabled are experienced for brief periods as we endure broken or injured limbs, illness, or pregnancy. Also in need of special consideration are the growing numbers of homeless people, including children, and those with debilitating illnesses such as AIDS, dementia, or Alzheimer's disease. Many socially-conscious designers are turning their attention to these serious problems as well.

CHILDREN

The young have problems of undeveloped body coordination and strength, small body dimensions, and insufficient experience with and knowledge of their environment. For their safety, play areas must be located within range of sight and sound for adequate supervision; stairs may require toddler gates and should have railings at a height of 24 inches, with balusters no more than 4 inches apart between which a child's head cannot be caught; safety plugs should be placed in unused outlets; and out-of-reach, lockable storage facilities must be provided for toxic substances. Bathroom wash basins, light switches, door handles, and closet rods are difficult for small children to reach. Some fixtures can be designed for flexibility and change to keep pace with growth (i.e., adjustable height storage); others may require temporary measures such as a step stool to accommodate small statures. Lever-type faucet and door handles are easiest for children to operate, as

7.23 A single-lever-control kitchen sink faucet with an integral pull-out spray makes use easier than separate knob-type faucets. (Courtesy Kohler. Photograph: Allan-Knox.)

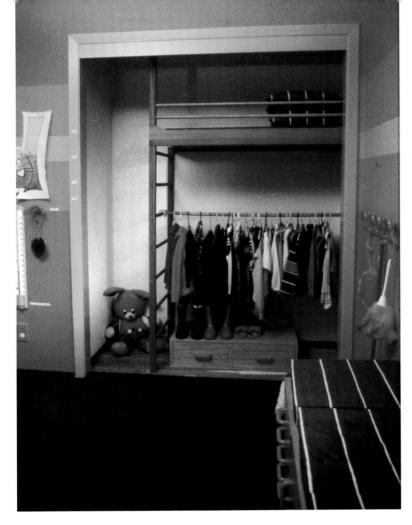

7.24 A child's closet designed by Antonio Torrice, ASID, features adjustable height storage, a ladder to climb, and a hideaway loft nap or play space. (*Photograph reprinted courtesy* In My Room: Designing For and With Children by Antonio F. Torrice, ASID, and Ro Logrippo)

they are for the elderly and individuals with limited hand function. Furniture for young children is subject to strict government safety regulations. Tall pieces should be secured to walls to prevent tipping. Non-toxic paints and finishes and flame-resistant fabrics further reduce hazards.

In addition to safety, children need environments that provide curiosity, challenge, aesthetics, and self-actualization. They can be actively involved in the design of their own spaces when communication is initiated in a manner that encourages them to talk about what they would like. Antonio Torrice, ASID, was among the first designers to specialize in creating supportive and stimulating environments that satisfy the needs of children (Figure 7.24).

THE ELDERLY

As we grow older, we experience difficulties caused by diminished strength, size, coordination, and speed of reaction, as well as impaired senses. There are approximately 20 million Americans over the age of 65; as lifespan lengthens and baby-boomers grow older, this segment of the population continues to increase and deserves more design consideration.

Most elderly individuals prefer to remain independent in their own homes as long as possible. Some of their problems include maintenance, stairs, hard-to-reach storage, and too much space for decreased energy levels and mobility. As vision dims, more light is needed, glare becomes a confusing problem, and greater color contrast is needed for clarity. Resilient floorcoverings reduce the severity of injuries from falling, a frequent type of home accident. (See Table 7.2 for additional guidelines for adapting housing to the needs of the elderly and disabled.) As the

TABLE 7.2

Guidelines for Adaptive Housing

Design Feature	Wheelchair Confined	Ambulatory	Visually A Impaired	Hearing Impaired	Hand Impaired
bathtub	bottom flat and slip- resistant; built-in seat; 2 accessible sides	bottom flat and slip- resistant; built-in seat 2 accessible sides			
climate	shield radiators; controls 2'-4' high	shield radiators			
counter	28"-34" high; recess 27" high, 30" wide, 19" deep; pull-out boards continuous counter	pull-out boards; continuous counter			pull-out boards; continuous counters
dishwasher washer/dryer	front loading; combination washer/dryer; front controls	top loading; combination washer/dryer; front controls	controls raised or color coded		combination washer/dryer; pushbutton controls at front
door	32" wide (minimum); interior door pressure 5 pounds; exterior door pressure 8½ pounds; top- hung sliding doors; kickplates; bathroom door open out; lever knob; knob 3' high	top-hung sliding doors; door pressure 8 pounds; bathroom door open out; lever knob	color contrast on frames; door open against wall		interior door pressure 5 pounds; exterior door pressure 8½ pounds; lever knob
faucet	thermostatic control; spray attachments; swing spouts; at side of sink	thermostatic control; spray attachments; swing spouts; at side of sink	single control lever; thermostatic control		single control lever; thermostatic control; spray attachment; swing spouts; at side of sink
floor	slip-resistant; cork or wall- to-wall low pile (½") carpet	slip-resistant; cork or wall-to-wall low pile carpet	slip-resistant; low gloss; changes in material hard enough to echo	muffle sound	
floor plan	single story; level; open plan; wide halls; L -kitchen, 5' between counters	single story; level; open plan; parallel kitchen	level; open plan with clearly divided sections	open plan	
grab bar	slip-resistant; support 250–300 pounds; 1 ¹ / ₄ "–1 ¹ / ₂ " diameter; extend 1 ¹ / ₂ " from wall	slip-resistant; support 250–300 pounds; 1 ¹ / ₄ "– 1 ¹ / ₂ " diameter; extend 1 ¹ / ₂ " from wall			slip-resistant; support 250–300 pounds; $1^1/4''-1^1/2''$ diameter; extend $1^1/2''$ from wall
kitchen storage	2'2"-4'6" high; 1' deep; open storage; revolving and pullout shelves; vertical storage; pegboard	2'2"-6'4" high; 1' deep; open storage; revolving and pullout shelves; vertical storage; pegboard			2'2"-6'4" high; 1' deep; open storage; revolving and pullout shelves; vertical storage; pegboard; magnetic catches; bar handles 3"-4" long at 45° angle
lavatory	wall-hung; 3"-7" deep; shallow front; 2'5" high, 19" deep recess; pipes insulated				

Design Feature	Wheelchair Confined	Ambulatory	Visually Impaired	Hearing Impaired	Hand Impaired
lighting	pull-down fixtures; increase at changes in floor level	pull-down fixtures; increase at changes in floor level	increase illumination; increase at changes in floor level		pull-down fixtures
mirror	3' high or slanted				
oven	wall oven with pull-out board beneath; side opening; controls on front	wall oven with pull-out board beneath; side opening			wall oven with pull-out board beneath; side opening
range •	2'6"-3' high; burners straight or staggered; burners flush with counter	burners straight or staggered; burners flush with counter	burners straight or staggered		burners straight or staggered burners flush with counter
refrigerator	upright, vertically divided; non-tip, swing out and revolving shelves	upright, vertically divided; non-tip, swing out and revolving shelves			upright, vertically divided; non-tip, swing out and revolving shelves
shower 9	eliminate curbs; at least $3' \times 3'$ 17"–19" high hinged shower seat; curtains	eliminate curbs; 17"– 19" high hinged shower seat; curtains			
sink ,	4"-61/2" deep; sink and pipes insulated				
stairs		uniform dimensions; riser 6"–7"; tread 11"; non-projecting nosing; handrails extend 1'6"; at ends; handrails 1½"–1½" diameter; handrails support 250 pounds	uniform dimensions; non-projecting nosing; handrails extend 1'6" at ends; riser and tread contrasting color		handrails 1½"–2" in diameter handrails extend 1'–1'6" at ends; handrails support 250 pounds
storage	midpoint height; sliding doors; low clothes rods (54")	midpoint height; sliding doors			midpoint height; sliding doors
switches and outlets	switches 3' high; 3-way switches; outlets 1'3" high	3-way switches	3-way switches		rocker switches
threshold	flat, ½" high, or polyethylene	flat, ½" high, or polyethylene	flat; contrasting colo if raised	r	
toilet	wall-hung; 17"–19" high; built-in spray and warm air dryer; backrest	built-in spray and warm air dryer; backrest			built-in spray and warm air dryer
walls	smooth	smooth	smooth; right angles at corners	sound absorbent; right angles at corners	smooth
window	sliding; 2–3' high	sliding	large window area; spaced to avoid contrasts of light and dark		sliding; cranking controls

Source: Marilyn Dee Casto and Savannah S. Day, "Guidelines for Adaptive Housing for the Elderly and Handicapped," Housing Educators Journal/Housing and Society, Vol. 4, No. 2, May 1977, pp. 34–35 (with minor modifications based on ANSI 117.1 1980).

aged are more and more confined to their homes, it becomes increasingly important that they feel secure and able to function independently in this environment. The case study on universal kitchen design for the low-vision elderly at the end of this chapter provides examples of kitchen adaptations for independent living.

THE DISABLED

The physically limited constitute an even larger percentage of the total population than the elderly, and include many elderly. Whether the impairment is limited or extensive, temporary or permanent, it handicaps the individual in his or her ability to function. Many standard and accepted architectural features such as stairs and narrow passageways can become access barriers to the disabled. Some can be avoided during initial planning: doorways that are at least 32 inches wide and hallways 36 inches wide can accommodate a person using a wheelchair, crutches, or a walker. Other barriers may require adaptation, such as ramps or remodeling of kitchens and bathrooms to provide lowered work surfaces and appliances, knee space under counters, reachable storage, and adequate clearances for wheelchairs. A diameter of 5 feet is required to pivot turn a wheelchair in tight spaces. (See Table 7.2 for specific adaptive recommendations.) Many devices, fixtures, and appliances are specifically designed to assist the disabled. Responsible designers are aware of the problems of this group and sensitive to their needs; they provide supportive lifespaces that facilitate a positive self-image through self-sufficiency rather than dependency.

People in their environmental context are the measure against which all decisions must be made in designing a home. The home is not a painting to be looked at and admired in short glances; it is a living place, constantly changing, interact-

7.25 (below, left) Visual cues assist the visually disabled, the elderly, or the disoriented in finding his/her way along a hallway at the San Diego Service Center for the Blind. Contrasting borders distinguish perimeters, and arrows on the floor locate doorways, which are also contrasted strongly with wall colors. The handrail also is made visible by value contrasts. (Photograph: Roberta Null, IDEC)

7.26 Designed for the disabled, this 1240-square-foot plan can accommodate a family or two individuals living with a personal-care attendant. Juster Pope Associates, architects.

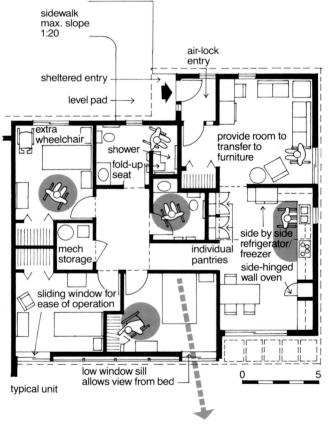

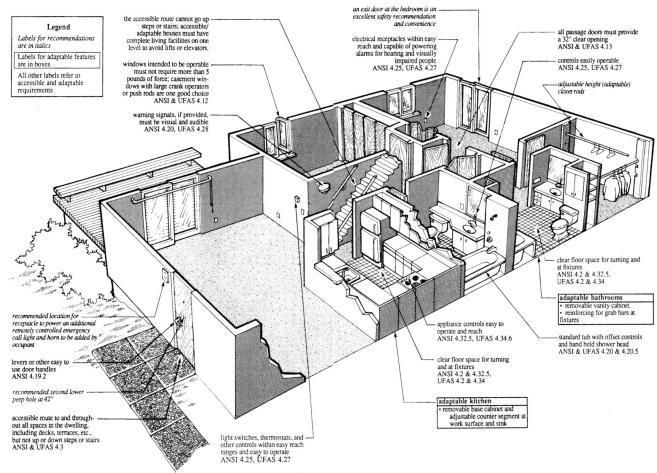

ing with the people who live in it, having an impact on the natural world and on those who share it with us. Only by taking into consideration the human factors and special needs discussed in this chapter can the outcome be successful. We can exercise much control over the quality of the homes we inhabit, both in the initial choice of a living space and in the shaping of it afterward; in turn, our environment then shapes our behavior and productivity in addition to contributing to our physical health and psychological well-being.

7.27 This cut away axonometric drawing shows ANSI/UFAS minimum requirements for accessibility, recommended conveniences, and other adaptable features through the house. (Courtesy U.S. Department of Housing and Urban Development, Office of Policy Development and Research, by Barrier Free Environments, Inc.)

CASE STUDY

A Universal Kitchen Design for the Low-Vision Elderly

by Roberta Null, IDEC

With people living longer and demanding new services, there is now a large group of low-vision elderly who do not fit the traditional client profile for rehabilitation services. The following case study describes how a training facility was adapted to shifting client needs.

For most older Americans, particularly those with visual impairment, the kitchen is the hinge upon which their independence swings. Kitchen design and adaptation are thus rapidly growing needs that are creating opportunities for forward-looking designers.

(continued)

(continued)

The San Diego Service Center for the Blind offered a training program for the elderly blind, and what started as a student project to remodel the center's kitchen evolved into one of the largest rehabilitation training facilities in the United States.

An interdisciplinary design team adapted student designs, aiming to expand and remodel the training area to include basic kitchen types—one-wall, corridor, and L-shaped—and develop and equip a state-of-the-art L-shaped apartment kitchen with an island as a prototype for designers, architects, and builders (Figure 7.28a and b). The project goal was to show how kitchen designs could easily and inexpensively be adapted to meet the needs of the elderly blind.

7.28a & b Plans of the kitchen area at the San Diego Service Center for the Blind show the space before and after remodeling to demonstrate how kitchens can be adapted to meet universal needs. Michael De Luca and Roberta Null, IDEC, designers.

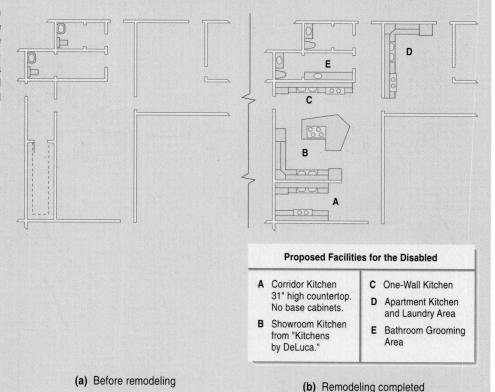

Universal kitchen design features incorporated into the renovation kitchen design included the following:

- Supportive Features: D-shaped or lever handles on cabinets; visible and accessible storage through pull-out shelves, Lazy-Susan corner cabinets, etc.; color contrast provided whenever possible; large-print directions, Braille overlays, and easily grasped controls on appliances; appliances arranged in order of their use; and extra lighting.
- Adaptable Features: Work surfaces of varying heights; rheostats for incandescent lighting; storage inserts for pantry and other cabinets; and adjustable cabinet shelves.
- Accessible Features: Side-by-side refrigerator/freezer with slide-out shelves; refrigerator with water and ice dispensers in the door and a mini-door for frequently used items; single-lever faucet controls; faucets with spray attachments so pans could be filled without placing them in the sink; and ranges with front controls (see Figure 7.29).

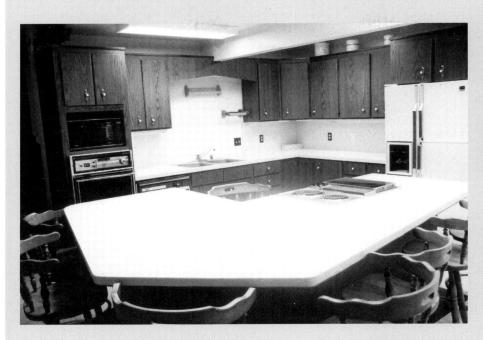

7.29 The L-shaped kitchen with a large island for cooking and light meals utilizes contrasting countertops and cabinet hardware for clear visual cues. The double door refrigerator has convenient front access to water and ice, and the magnetic induction range with front controls and down-draft ventilation is important for safety. (Photograph: Roberta Null, IDEC)

Safety-Oriented Features: Pull-out boards below microwave and other sideopening oven doors; faucets with temperature controls; sliding doors on cabinets to minimize hazards of doors extending into the room; easily reached
telephone; magnetic-induction cooktops that are cool to the touch and sound
a warning when a pan is removed or improperly placed; and nonslip, nonshiny flooring material.

By applying available research, product information, and universal design concepts to the Blind Center kitchen project, designers were able to create a maximally accessible facility at reasonable cost that provided ease of maintenance and enhanced users' safety and independence.

Corridor Kitchen Features (Kitchen A):

- 1. 32-inch counter height with no base cabinets (for wheelchair access and provision of a variety of counter heights).
- 2. Lowered placement of wall oven.
- 3. Built-in and counter placement of microwave ovens.
- **4.** Contrasting colors for cabinet doors, countertop edge, and counter top supports.
- 5. Under-cabinet lighting.

Features of L-shaped Kitchen with Island (Kitchen B):

- 1. Contrasting countertops and cabinet knobs.
- 2. Pull-out work surfaces.
- 3. Double-door refrigerator/freezer includes
 - equal access to refrigerator and freezer space from any position,
 - access to ice and water without opening door,
 - partial door for easy access to frequently used items,
 - entire refrigerator door opens for complete access,
 - contrasting, easy-grip handles.

(continued)

- 4. Cooktop features:
 - front location of controls
 - down-draft ventilation system, eliminating need for overhead fan
 - interchangeable cartridges including a magnetic induction burner unit that
 is cool to the touch and sounds a warning when a pan is removed or improperly placed, a standard electric coil two burner unit, and a grill unit
 cartridge

One-Wall Kitchen Features (Kitchen C):

- 1. Contrasting counter edges and switch plate covers.
- 2. Under-cabinet lighting.
- 3. Faucet features:
 - single control lever
 - contrasting color spray/evenflow head with push button control
 - flexible hose for filling containers without placing them in the sink

(Please see Chapter 10 for more detailed information on kitchen design.)

NOTES TO THE TEXT

- Amos Rapoport, House Form and Culture (Englewood Cliffs, N.J.: Prentice-Hall, 1969).
- 2. William H. Ittelson, Harold M. Proshansky, Leanne G. Rivlin, and Gary H. Winkel, *An Introduction to Environmental Psychology* (New York: Holt, Rinehart and Winston, 1974), p. 354.
- 3. Robert Sommer, *Personal Space: The Behavioral Basis of Design* (Englewood Cliffs, N.J.: Prentice-Hall, 1969), p. 5.
- **4.** Ittelson et al., p. 5.
- Irwin Altman, The Environment and Social Behavior: Privacy, Personal Space, Territory, Crowding (Monterey, Calif.: Brooks/Cole Publishing Company, 1973), p. 3.
- **6.** Joanne Henderson Pratt, James Pratt, Sarah Barnett Moore, and William T. Moore, *Environmental Encounter: Experiences in Decision-Making for the Built and Natural Environment* (Dallas, Tex.: Reverchon Press, 1979), p. 105.
- 7. Edward T. Hall, *The Hidden Dimension* (Garden City, N.Y.: Doubleday, 1966), chap. 10.
- **8.** Alton J. De Long, Rethinking Proxemic Zones for Microspatial Analysis. *Journal of Interior Design Education and Research* 17(1):19–28, 1991.
- 9. Irwin Altman, Amos Rapoport, and Joachim F. Wohlwill, *Human Behavior and Environment: Advances in Theory and Research*. Vol. 4: *Environment and Culture* (New York: Plenum Press, 1980), chap. 4, by John R. Aiello and Donna E. Thompson.
- **10.** Albert Mehrabian, *Public Places and Private Spaces: The Psychology of Work, Play and Living Environments* (New York: Basic Books, Publishers, 1976), p. 107.
- **11.** Richard Rush, Body Insults from Buildings, *Progressive Architecture*, July 1981, p. 124.

REFERENCES FOR FURTHER READING

- American National Standards Institute. American National Standard for Buildings and Facilities—Providing Accessibility and Usability for Physically Handicapped People (ANSI A117.1–1986.) New York: ANSI, 1986.
- Bostrom, James A., Ronald L. Mace, and Maria Long. *Adaptable Housing*. Raleigh, N.C.: Barrier Free Environments, Inc. for the U.S. Department of Housing and Urban Development, Office of Policy Development and Research, 1987.
- Bush-Brown, Albert and Dianne Davis. Hospital Design for Healthcare and Senior Communities. New York: Van Nostrand Reinhold, 1992.
- Castro, Marilyn Dee and Savannah S. Day. "Guidelines for Adaptive Housing for the Elderly and Handicapped," *Housing Educators Journal*, V. 4, n. 2 (May 1977).
- Deasy, C. M. and Thomas E. Lasswell. *Designing Places for People: A Handbook of Human Behavior for Architects, Designers and Facility Managers.* New York: Whitney Library of Design, 1985.
- Friedmann, Arnold, John F. Pile, and Forrest Wilson. Interior Design: An Introduction to Architectural Interiors, 3rd ed. N. Y.: Elsevier, 1982, pp. 157–164.
- Hall, Edward T. The Silent Language. Garden City, N. Y.: Doubleday, 1959.
- Harrigan, J. E. Human Factors Research: Methods and Applications for Architects and Interior Designers. New York: Elsevier Dutton, Inc., 1987.
- Hartwigsen, Gail Lynn. Design Concepts: A Basic Guidebook. Boston: Allyn and Bacon, Inc., 1980, Unit 1.
- Ittelson, William H., Harold M. Proshansky, Leanne G. Rivlin, and Gary H. Winkel. An Introduction to Environmental Psychology. New York: Holt, Rinehart and Winston, Inc., 1974, pp. 200–201, 352–353, 356.
- Keiser, Marjorie Branin. Housing: An Environment for Living. New York: Macmillan, 1978, pp. 128–132.
- Kleeman, Walter B., Jr. The Challenge of Interior Design. Boston: CBI Publishing Company, 1981. Chaps. 2, 8, 10.
- Leibrock, Cynthia and Craig Birdsong. Supportive Home Environments for People with AIDS. *Journal of Interior Design Education and Research* 15(1):23–28, 1987.
- Lesnoff-Caravaglia, Gari. Aging in a Technological Society. New York: Human Sciences Press, Inc., 1988.
- Lindamood, Suzanne and Sherman D. Hanna. Housing, Society, and Consumers: An Introduction. St. Paul, Minn.: West Publishing Company, 1979. Chap. 5.
- Maslow, Abraham. Motivation and Personality. New York: Harper, 1954.
- Maslow, Abraham. Toward a Psychology of Being. New York: D. Van Nostrand, 1962.
- Maslow, Abraham (ed.). New Knowledge in Human Values. New York: Harper, 1959.
- Meeks, Carol. Housing. Englewood Cliffs, N.J.: Prentice-Hall, 1980.
- Minimum Guidelines and Requirements for Accessible Design. Washington, D.C.: U.S. Architectural and Transportation Barriers Compliance Board, 1982.
- Naisbitt, John. Megatrends: Ten New Directions Transforming Our Lives. New York: Warner Books, 1982.
- Newcomer, Robert J., M. Powell Lawton, and Thomas O. Byerts (eds.). *Housing an Aging Society: Issues, Alternatives and Policy*. New York: Van Nostrand Reinhold, 1986.
- Newman, Oscar. Defensible Space: Crime Prevention Through Urban Design. New York: Macmillan, 1972.
- Newmark, Norma L. and Patricia J. Thompson. Self, Space and Shelter: An Introduction to Housing. San Francisco: Canfield Press, 1977.
- Null, Roberta L. A Universal Kitchen Design for the Low-Vision Elderly: Research Applied in Practice. Journal of Interior Design Education and Research 14(2):45–50, 1988.
- One- and Two-Family Dwelling Code, 1983 ed. Whittier, Calif.: International Conference of Building Officials.
- Packard, Robert T. (ed.). Ramsey/Sleeper Architectural Graphic Standards, 7th ed. New York: John Wiley & Sons, 1981.
- Panero, Julius and Martin Zelnick. *Human Dimension and Interior Space: A Source Book of Design Reference Standards.* New York: Whitney Library of Design, 1979.

Proshansky, Harold M., E. M. Brody, and L. G. Rivlin. *Environmental Psychology: People and Their Physical Settings*, 2nd ed. New York: Holt, Rinehart and Winston, 1976.

Raschko, Bettyann Boetticher. Housing Interiors for the Disabled and Elderly. New York: Van Nostrand Reinhold, 1982.

Reznikoff, S.C. Interior Graphic and Design Standards. New York: Whitney Library of Design, 1986.

Rush, Richard. The Age of the Aging. Progressive Architecture, August 1981, pp. 59-63.

Rush, Richard. Body Insults from Buildings. *Progressive Architecture*, July 1981, pp. 122–129. Slesin, Suzanne, For Elderly, The Triumph of Having a Place to Call Their Own. *The New*

Slesin, Suzanne. For Elderly, The Triumph of Having a Place to Call Their Own. *The New York Times*, August 13, 1981.

Sommer, Robert. Design Awareness. San Francisco: Rinehart Press, 1972.

Sommer, Robert. Personal Space: The Behavioral Basis of Design. Englewood Cliffs, N.J.: Prentice-Hall, 1969.

Sommer, Robert. Social Design: Creating Buildings With People in Mind. Englewood Cliffs, N.J.: Prentice-Hall, 1983.

Sommer, Robert. Tight Spaces: Hard Architecture and How to Humanize It. Englewood Cliffs, N.J.: Prentice-Hall, 1974.

St. Marie, Satenig S. Homes Are for People. New York: Wiley, 1973, pp. 13-201.

Thompson, Marie McGuire. *Housing and Handicapped People*. Washington, D.C.: The President's Committee on Employment of the Handicapped, 1976.

Torrice, Antonio F. and R. Logrippo. In My Room: Designing For and With Children. New York: Fawcett Columbine, 1989.

Uniform Building Code, 1982 ed. Whittier, Calif: International Congress of Building Officials.

Uniform Federal Accessibility Standards. Washington, D.C.: U.S. Government Printing Office, 1984.

Winchip, Susan. Dementia Health Care Facility Design. Journal of Interior Design Education and Research 16(2):39-46, 1990.

Wineman, Jean D. (ed.) Behavioral Issues in Office Design. New York: Van Nostrand Reinhold, 1986.

Planning and Design Development

PROGRAMMING

Client Profile

Functional Goals

Equipment Needs

Space Requirements

Character

Site and Orientation

Cost Estimates and Budget

Analysis

CONCEPT DEVELOPMENT

Ideation

Schematics

Concept Statement

DESIGN DRAWINGS

Plans

Sections, Elevations, and Details

Axonometric Views and Perspectives

SPECIFICATIONS AND SCHEDULES

CASE STUDY

Remodel from Second Home ("Ski Cabin" Townhome) to Primary Residence

The person or persons involved in designing a home may be the individual homeowner or family, an architect, builder/contractor, and/or professional interior designer. Ideally, the homeowner and all of these professionals work cooperatively. An interior designer provides expertise in programming and design development that can assist the family or household in assuring that their needs and desires are met, both initially and throughout their life span.

Residential designers need a background of information to make the results workable, comfortable, reinvigorating, and aesthetically pleasing. This knowledge will range from a profile of the people who will be living there to expertise with design drawings and documents; from all the practical considerations that enter into choosing fixtures, furnishings, and equipment to the codes and regulations

that apply. First an analysis, then a synthesis of many factors must be made before a home is designed or selected in order to achieve the most harmonious relationship between people and their living environment. Chapter 1 outlined the steps in the planning process: problem statement, programming, preliminary schematic design and concept development, presentation, final design development and documentation, construction and installation, and evaluation. Programming and design development activities are revisited here with greater detail for residential space planning.

PROGRAMMING

Programming, the identification of all the elements that should be considered or the list of things to be done, in its simplest sense, is a critically important aspect of design because the more detailed the information and analysis, the more likely it will be that all needs will be met.

When the designer first touches pencil to paper to draw a plan, a number of decisions should already have been made. Professional architects and interior designers have a carefully researched, written **program** identifying the requirements of a home long before the graphic stages of planning are begun. The elements of this program may include the following:

- Client profile
- · Functional goals
- Equipment needs
- Space requirements
- Desired character
- Site and orientation
- Cost estimates and budget
- Analysis

CLIENT PROFILE

The people who will live in the home are the most important planning factor because they are not only the reasons for the home and the basic ingredient in the mix of elements but also the final judges of how well the home functions. Initially, time should be spent gathering as many facts as possible about the inhabitants of a home, getting an idea of who they are and what they like. This information may be acquired informally by communication between family members and an interior designer or consultant. More formal interviews may also take place with an interior designer who may utilize a detailed questionnaire or **client profile** covering as many topics as the designer thinks necessary to assist in preparing the design program. Questions such as the following are pertinent:

Who will live in the home? The number, ages, sex, sizes, activities, and relationships of people who make up a household must be a primary factor in planning a home in order that the special needs and interests of each individual, and of the group as a whole, can be met. Optimally, the residence planned for more than one person will provide just the degree of privacy and interaction with others that each desires.

Anthropologist Paul Bohannan¹ defines the *household* as "a group of people who live together and form a functioning domestic unit. They may or may not constitute a family, and if they do, it may or may not be a simple nuclear family." Clearly, this definition encompasses a great variety of living arrangements: single-person households; two or more people who may or may not be related; child-free

married couples; nuclear families of husband, wife, and children; single-parent families; extended families, including grandparents and/or uncles, aunts, or cousins; aggregate families, consisting of divorced parents who remarry and their children from previous marriages as well as their own; groups of elderly, ethnic minorities, or other nonfamily units who come together to share communal living space; and long- or short-term guests.

Alvin Toffler² reports that no single family form now dominates the U.S. population as the extended and nuclear families of the past did. Families of the future will be characterized by diversity of form and might even be "expanded" by unrelated outsiders who, with the proliferation of home computers, might join the household in a modern-day version of cottage industry.

Whatever the type of household, the ages and the stage in the life cycle of household members are determining factors in planning pleasant, efficient, and flexible spaces for various activities. Planning should include long-range goals. The same residence may be used for decades by a single family so changing needs must be accommodated. Consider a young childless couple both with professional careers, who might use a room with a pleasant view, sun exposure, and access to the kitchen and living areas for a home office or study. If children are planned, the same room might become first a nursery, then a playroom, and finally a family room while they are being reared. When the children leave the family home, the room's use might again be changed, this time to a large bedroom suite for the older, perhaps retired couple—or for their parents. Other unused bedrooms might be rented to provide companionship and additional income. Safety needs may also vary over the life span, influencing choices for types of furniture, floor coverings, lighting, and hardware.

What is their lifestyle? For the purposes of programming, lifestyle is the amount of time devoted to various activities in the home. This definition includes entertainment habits: large or small, formal or informal gatherings of friends or relatives; types of social activities such as meals, music, games, or television viewing; and the location of these activities within the home—living room, family room, kitchen, library, or patio. Closer, more detailed study could also be made of cooking habits, eating patterns, study and work needs, and the client's approach to housekeeping. Some families prefer a very clean and neat home while others have a casual attitude toward housekeeping.

The household itself and the way in which the members regard their home must also be considered. Are they a close-knit family, playing, studying, working, and eating together, or a loose-knit group with members who pursue individual interests? One family might regard their home as the center of activity while another household might view the dwelling simply as a base of operations—a place to eat and sleep—with all other pursuits undertaken elsewhere. Expectations and values conditioned by ethnic and cultural backgrounds will undoubtedly emerge from these explorations and must also be considered.

Any such delving into people's lifestyles should include not only how they live, but also how they would like to live in the future. Many remodeling projects are undertaken to improve the *ergofit*—the user-environment fit—between physical structure and desired lifestyle.

How long will they stay in the home? In a day when mobility is a fact of life, this is an important consideration. It is easy to see that a studio apartment rented for a few months in the city is a different proposition from a three- or four-bedroom home purchased in an outlying suburb, but today even a house is apt to be only one in a series. As the cost of housing has risen, many families view their first home as an entry-level position in the housing market, to be "traded up" several times, each time more closely approaching the ideal satisfaction of their needs and tastes.

8.1 (right) At this hillside home of aggregate concrete and redwood, sliding glass doors and a two-way fireplace extend indoor entertainment out onto a covered patio overlooking San Francisco Bay. (below) A home-oriented family may spend most of their time in a "great room" like this open-plan kitchen/eating area/ family room, which fosters interaction among family members. Redwood Architectural Group, architects; Werner Design Associates, interior designers. (Photographs: David Livingston)

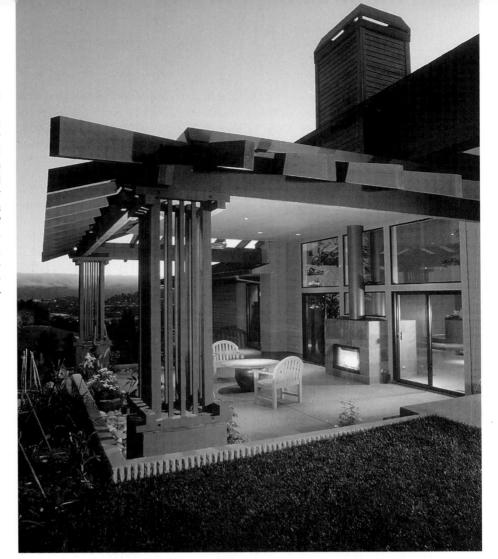

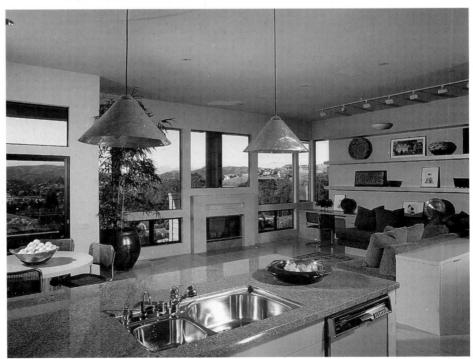

Whether "home" is an apartment, townhouse, or single-family detached unit, people's attitudes toward it are often affected by how long they plan to stay there. Research has shown that longer-term occupants tend to personalize their homes more than those who have only a short-term residency and regard the home as temporary.³ In addition to practicality, this response to stability versus mobility may account for the number and type of furnishings and personal possessions a family accumulates. A young couple in their first rather tentative home may well furnish it with a few lightweight, collapsible furnishings that can easily be moved or even replaced. Sometimes, furniture is rented in a temporary residence until decisions are reached about a more permanent location.

The family who owns a houseful of traditional furniture certainly might not want to throw it all out and start afresh upon moving into a contemporary home. The challenge then becomes one of making the old furniture fit gracefully into a new environment. Figure 8.2 shows how one family accomplished this adjustment. The house itself is strikingly contemporary, with varied heights and a bright airiness enhanced by broad areas of glass; the furnishings are a mixture of antiques and modern classics. Yet there is no jarring sensation of incompatibility. Rather,

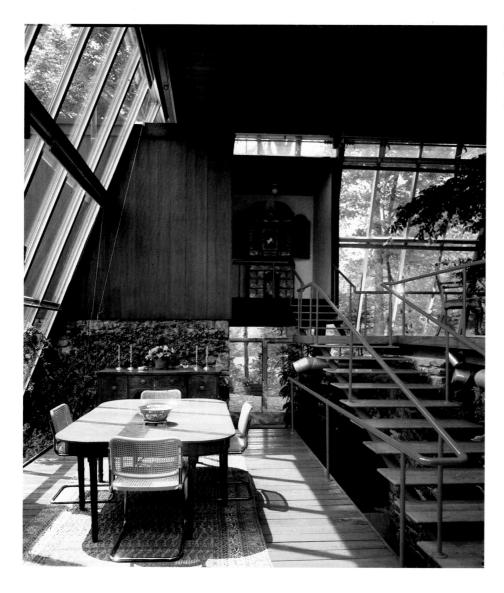

8.2 Old and new furnishings are blended in a very contemporary house set in the midst of the changing tableau of nature. John M. Johansen, architect. (Photograph: Pedro E. Guerrero)

8.3 A remodeled home, built in 1905 in the San Francisco area, poises an eclectic mix of contemporary art and furnishings against a traditional architectural backdrop, including an old pine mantel added recently. David Wright, interior designer. (Photograph: David Livingston)

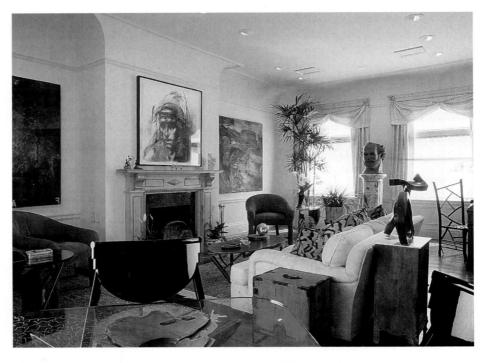

8.4 The owners of this traditional home in San Francisco value fine French antiques. Their home reflects a taste for refined ornament. Paul Vincent Wiseman, interior designer. *(Photograph: John F. Martin)*

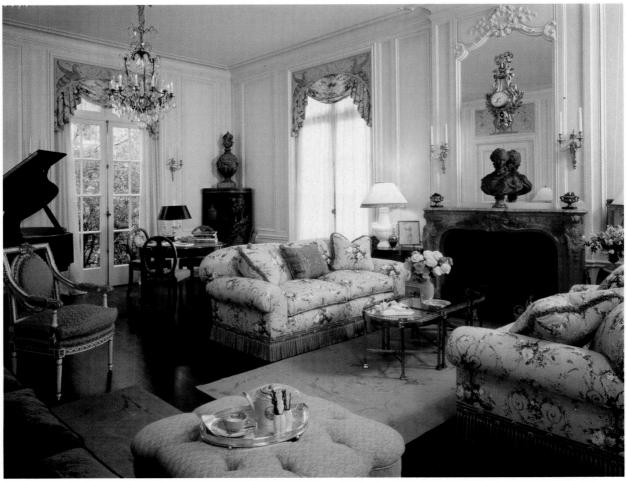

the two elements settle together comfortably and in such a way that each heightens the drama of the other.

What are the tastes of the bousehold members? Taste, the particular likes and dislikes of an individual or of a family, is perhaps the single most important abstract factor in determining what a home will look like (Figures 8.3–8.5). It expresses the personality and values of the home's occupants. We often learn more about an individual or a family by visiting their home than after many conversations in less personal environments such as the workplace. At home, they surround themselves with furnishings of their own choice that express and extend their personalities, offering a broader and more intimate view of who they are.

A comparison of Figures 8.6 and 8.7 (next two pages) shows how dramatically personal rooms can be because of the tastes of their owners. The loft in Figure 8.6 is an extravagant feast for the eyes, a bazaar of objects of various shape and texture filling every possible corner. Obviously, the owner feels most at home surrounded by the clutter of "things" left out in view. Many people share such a taste for objects that carry special associations or that simply delight the senses.

An opposite pole of taste created the stripped-down living space in Figure 8.7. Walls, floors, and ceilings are all minimally treated. Even the furniture, which has been reduced to the barest essentials, is simple and streamlined.

These two examples are extremes; many people would not want their homes to be either as stark or as rich. Nevertheless, these rooms do illustrate how important a role personal taste plays in designing a space that is successful for the individuals who will occupy it. If we were to transpose the owners of these two homes, each would certainly feel uncomfortable.

Taste is not a constant, unvarying phenomenon but may change considerably over the lifetime of an individual. The home one furnishes at the age of forty will probably look quite different from the one planned at twenty. It would be an oversimplification, however, to assume that personal taste gradually "improves", becomes increasingly refined, and perhaps becomes more conservative with advancing age. A great many factors—daily experiences, travels, friends, cultural and ethnic backgrounds, status consciousness, and fashions in general, to name but a few—

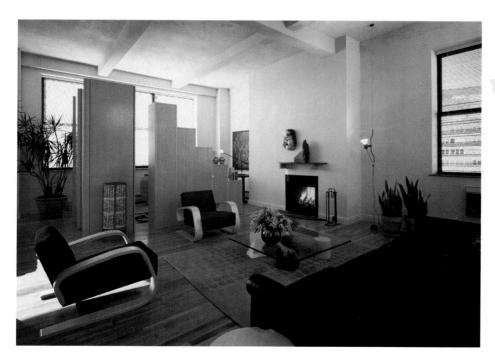

8.5 This Manhattan loft apartment is an adaptive reuse of a 1200 square foot printing facility. The open space minimally divided by movable modular units constructed of birch, the original structural ceiling beams left exposed, and some modern classic Aalto chairs express the owners' tastes. Kevin Walz, designer. *(Photograph: Jock Pottle/ESTO)*

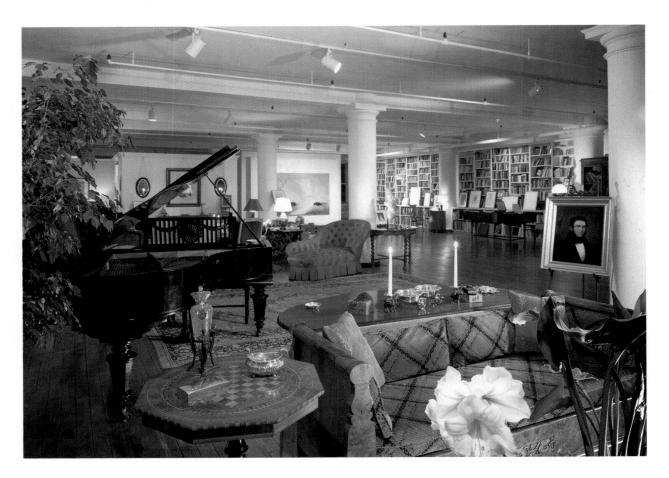

8.6 A cozily cluttered loft gives the feeling of having all the accumulated possessions of a lifetime close at hand to enjoy. Peter Stamberg, architect. (Photograph: ESTO Photographics)

affect the development of taste. A study of illustrations in magazines or books, or a file collection of appealing ideas, will reinforce subjective expressions of taste and allow objective decisions.

Taste involves a conscious level of decision making. "Good" taste is developed through study, experience, discrimination, and judgment. It is the selection of furnishings and accessories that meet the needs and suit the personalities of the individuals involved as well as having the properties of good design and construction.

What are bousehold members' psychological reactions to the surrounding environment? Much of this information may be hard to come by directly. Most people are only dimly aware of why they respond positively or negatively to a certain space or color. They may be drawn toward the space because it is inviting and comfortable in some unspoken way, or they are bothered by a certain color. Subtle nuances—the fact that the space is reminiscent of a childhood home, or the color of an unpleasant experience—may cause reactions only at a subliminal level.

Here, too, a collection of illustrations of rooms or objects that appeal to the family members may be helpful. Not only does such a file show individual taste, it also gives an unconscious overview of basic responses to many environments. By studying the illustrations, the designer can begin to understand whether a person might feel most at home in an active environment or that s/he is a very private individual who would like small, quiet areas in which to enjoy seclusion. A room with the furniture widely spaced might signal an individual whose personal space dimension requires more distance from other people in order to feel comfortable. Of course, many clear questions should be asked to supplement these silent cues.

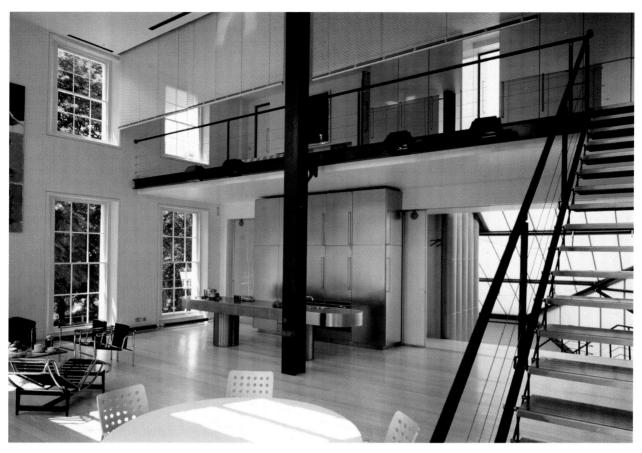

FUNCTIONAL GOALS

The way in which the home functions should be determined by the values and lifestyle of the family for which it is being planned. If reduction of human energy expended in the operation and maintenance of the home is desired, a computer could be installed to control and monitor utilities and household inventories, even to command a household robot to perform routine chores. The increased leisure time thus made available might result in special consideration being given to a media room equipped with video and sound systems that demand planning attention to the lighting and acoustical qualities of the space, its reflective and absorptive characteristics. Other functional goals could include a home office with separate access, maximum energy efficiency, or barrier-free design for an elderly or disabled person, to name just a few. Planning needs vary among people living in the same home. Ideally, each person should be interviewed individually to determine his or her special needs and interests so that the activities of each household member as well as group interaction are used to determine planning objectives.

EQUIPMENT NEEDS

Basic mechanical requirements such as plumbing, electricity, heating and cooling units, telephone wiring, and television cables are an obvious consideration. Particular needs must also be met: safety and security devices, sound and video systems, computers and other specific furnishings, or a power workshop, for example.

8.7 Architect Richard Rogers' own residence in a house dating from 1840 in London reveals a minimal approach to furnishings, finishes, and treatments. The simple, unembellished interior focuses maximum attention on the space itself. Even the kitchen work area is reduced to a single stainless steel cooking island. *(Photograph: Timothy Hursley)*

SPACE REQUIREMENTS

Spatial requirements are based on careful study of the activities, behavioral patterns, developmental needs, values, and desires of the occupants as discussed in the questions posed in the client profile. First, general area size and shape are indicated to accommodate activities, furnishings, and open spaces; then a corresponding allotment of square footage is determined. Of course, space for storage, utilities, walls, and traffic corridors must be estimated as well. Overall, the home should provide each person with a minimum of 200 square feet, although 300 square feet per person would be better and 500 allows for truly comfortable living. These figures represent gross area, including walls, partitions, and all service spaces.

CHARACTER

In describing the character of the proposed spaces, aesthetic goals are established. This part of the program concerns itself with the emotional impact of the spaces and design of the home upon its occupants, and their impact upon it, as discussed in Chapter 7.

Character is the quality that differentiates one home from another and expresses the personality of its owners. While we can analyze a room to determine the components of its beauty, in the end the real determinant is the people it serves. Individuality—and therefore character—ensues almost automatically when a home is allowed to grow naturally from its inhabitants' needs, interests, and preferences.

8.8 A guest house such as this one in Florida can express whimsical character without becoming tiresome because it is used only periodically. Steven Harris & Associates, architects. (Photograph: Timothy Hursley)

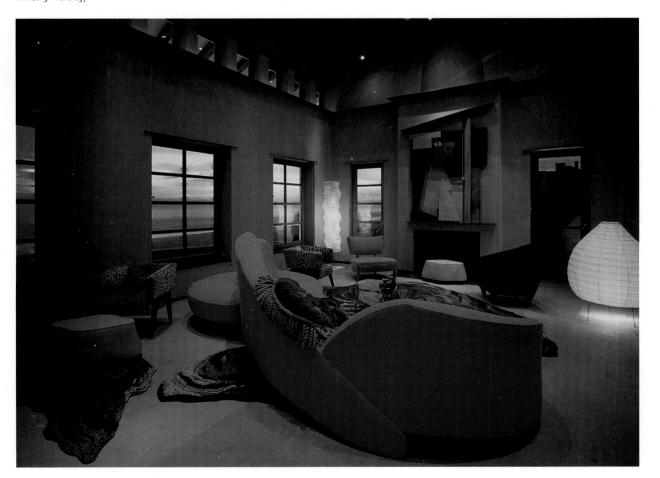

While vision plays an important part in our perception of character, other senses contribute as well. The tactile sensation of walking across a soft carpet produces quite a different response from that experienced in touching a polished marble floor. Also, the manner in which voices and other sounds are reflected or absorbed by an enclosed space gives us clear messages about the qualities of that space—messages that may elicit feelings of well-being, comfort, uneasiness, awe, safety, or fear. Room size, ceiling height, window area, style of furnishings and their arrangement, choice of color, texture, and pattern—all contribute to the character of space when they reflect the individuals who occupy it.

SITE AND ORIENTATION - Placement for sun

A study of the site provides descriptive information regarding size, shape, location, topography, wind and sun directions, views, relation to the street, and natural features, such as trees, on the lot chosen for construction. Local building codes and zoning limitations as well as specific covenants, conditions, and restrictions (CC&Rs) must also be known. These regulations will affect the orientation of the house, type of plan, allowable height, placement on the lot, methods and materials of construction, and energy-conservation possibilities for the structure. Even styling and color choice (for the exterior) may be influenced, either by other homes in the area or by deference to environment.

Referring to the relation of house to environment, orientation is the compass location of various rooms to make best use of sun, topography, wind, and views. A **solar orientation** provides large southern exposures to collect heat, and morning and afternoon sun where desired (see Figure 8.10, next page). **Topographical orientation** takes full advantage of the contour of the land (a split-level or multiple-story house on a sloping lot, for example). **Wind orientation** captures desirable summer breezes while blocking cold winter winds. **View orientation** allows both pleasant vistas from major rooms and privacy from outsiders.

A graphic site analysis, as in Figure 8.11, illustrates pertinent information as it relates to the particular property being considered. This simple sketch can be an important tool to aid in orienting a new home or studying an existing home for remodeling possibilities. Placement of existing features, both natural (trees, rocks, water) and man-made (streets, driveways, walkways, power supply, drainage systems), and restrictions (such as views from neighboring homes which cannot be blocked) can be indicated on the site analysis. Although the concern of this text is primarily the interior, climate-sensitive design and orientation for energy efficiency and environmental ecology are also considered (see Chapters 13 and 14).

A city or country location does not dictate the type of interior design, but does often suggest or even strongly indicate the type of furnishings that might be suitable. A city apartment occupied on a permanent basis lends itself more readily to

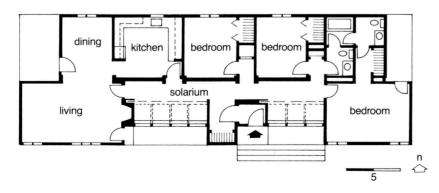

8.9 A passive solar plan such as this must be oriented with the solarium facing south to collect the sun's heat. Designed by Cy Merkezas and Belinda Reeder, Archetype of Washington, D.C., with technical assistance from the Department of Energy and the Solar Energy Research Institute.

traditional, relatively expensive furnishings than does a vacation home. But no rules demand that such an apartment be formal or that a house in the woods necessarily be rustic.

Figure 8.13 (on page 182) illustrates a contemporary, rather sophisticated interior that might be found in a townhouse or city apartment. Actually, it is located in the country.

A house in Nevada, however, exploits to the fullest the character of the Old West, with thick adobe walls, rough-hewn beams, and unfinished brick floors (page 182, Figure 8.14). Furniture and artifacts reflect the dual influences of Southwest Indians and Spanish missionaries. Regardless of the approach—harmonious contrast or true authenticity—location will nearly always affect the character of a home.

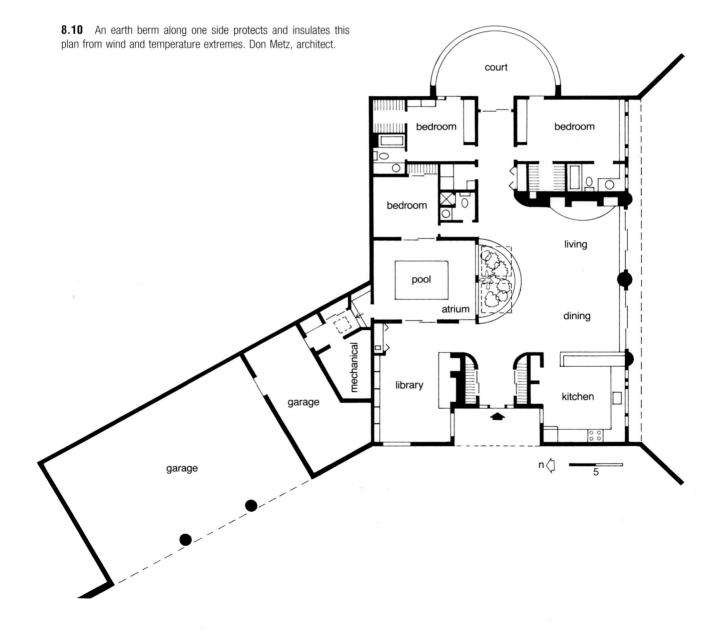

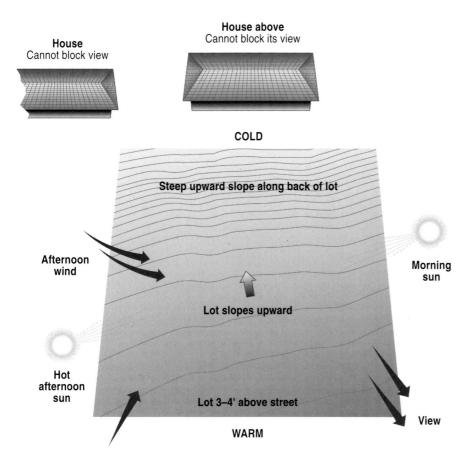

8.11 A simple sketch records important information for site analysis before any new construction or remodeling is begun.

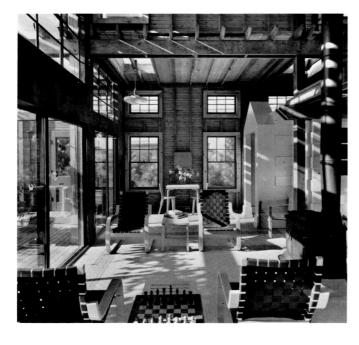

8.12 Webbed chairs look and feel cool in a summery pavilion home. Peter Wilson, architect. *(Photograph: © Norman McGrath)*

- **8.13** (right) If it is thoughtfully planned, a country house can be as elegant and sophisticated as the owner wishes, yet still blend with its surroundings. Myron Goldfinger, architect. (Photograph: © Norman McGrath)
- **8.14** (below) A reflection of the architectural heritage of the old Southwest, this modern adobe house is well-suited to the high desert landscape of Reno, Nevada. Maurice J. Nespor & Associates, architects; Diana Cunningham, interior designer.

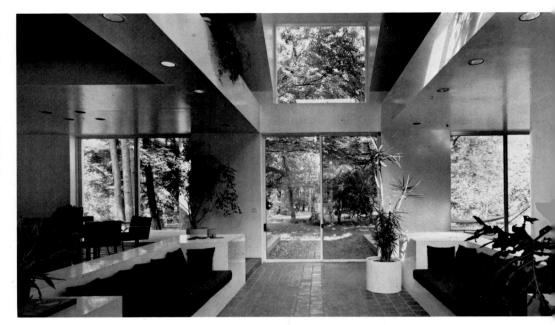

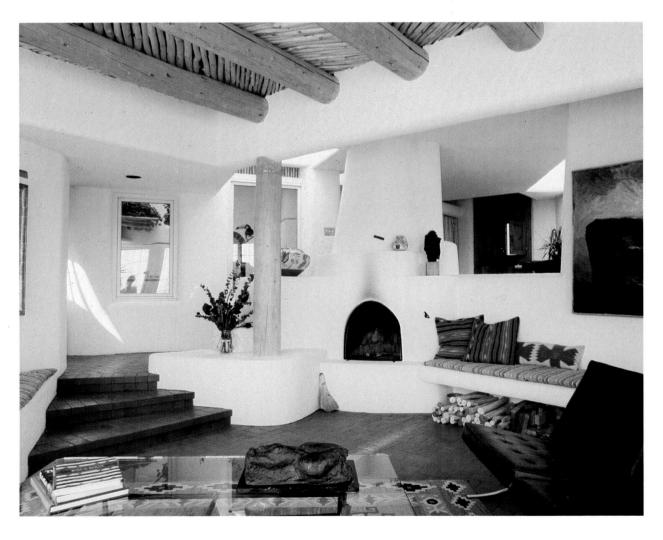

COST ESTIMATES AND BUDGET

Costs are critical to planning. A house is usually the largest single purchase a family will make. Home prices are rising faster than median household incomes, resulting in a reduction in the size of the average new home to less than 1400 square feet.

When either building or remodeling, an accurate estimate of cost is essential. Some rooms, such as kitchens and baths, are more expensive to build or remodel than others because of their special equipment, built-in cabinetry, and plumbing and wiring needs. Other areas, such as basements, porches, and garages or carports, are less expensive to construct. Contractors and suppliers can provide cost estimates which include materials, labor, and a percentage for their overhead costs and profit. They will need plans and specifications detailing the design work and items to be purchased in order to quote firm prices. Several steps can be taken during planning to limit costs, both initially and over the life of the structure.

LIMITING EXPENSES A simple shape encloses the maximum amount of space for minimum construction costs. The more the house deviates from a square shape, the more lineal feet of wall and foundation are required. Even a rectangle increases costs. The addition of ells in L-, U-, and T-shaped plans increases lineal feet, number of costly corners, and expense of roof framing, without necessarily increasing square footage, as can be seen in Figure 8.15.

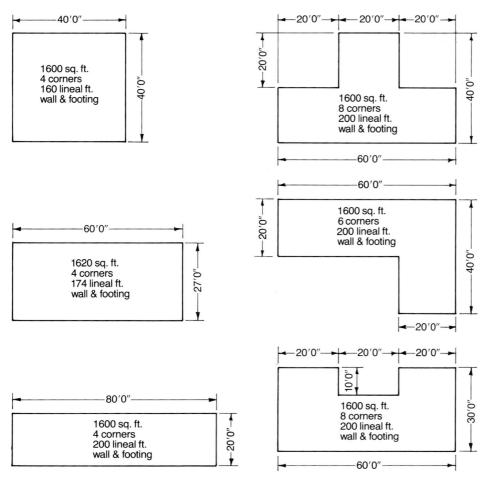

8.15 The more complex the shape of a plan, the more expensive it is to construct, without necessarily increasing square footage of interior living space. (Adapted from Architecture: Design-Engineering-Drawing by William P. Spence. © 1979 McKnight)

Utilities can be centralized to help reduce expenditures. For example, plumbing fixtures can be located back-to-back in adjacent rooms or stacked above one another in multiple-story plans; all utilities can be located in a central core; fire-places can use a single chimney stack.

Further economies in materials and labor can be realized by using modular planning (a standard unit of measure of construction material, such as a 4- or 6-foot module), standard milled items (doors, window frames, stairways, cabinets), and readily available native materials. Long-term costs can be minimized by taking advantage of climate to reduce heating and cooling costs, selecting materials and equipment that will have a long life with low maintenance, and designing for flexibility and change rather than permanence. Good design costs no more than poor design and its value often increases with time.

Existing resources should be taken into account as well. An inventory of present possessions can help household members decide what should be kept and what is needed. The individuals' skills, hobbies, and creative abilities may also contribute. For example, old pieces of furniture may be refinished, some new furnishings may be built, and home crafts can provide many highly personal and attractive accessories.

MAINTENANCE COSTS The amount of time and energy family members have or wish to devote to the upkeep and maintenance of the home versus the time desired for other activities is also important. Materials and finishes should be selected to provide a balance between care required and aesthetic qualities desired. Hardwood floors, for example, can be treated for minimum care while still maintaining the warmth and beauty of the wood.

Labor-saving devices have contributed much to conserving time and energy for life-enhancing avocations. This advantage can nevertheless be negated by poor planning, such as arranging a kitchen so that meal preparation requires twice as many steps as necessary. Each person's productivity is influenced by the environment in which s/he works and relaxes: a well-planned kitchen allows those who cook to work effectively and efficiently while also increasing their enjoyment.

BUDGETS AND LIFE-CYCLE COSTING Costs—original and continuing—can never be ignored. A realistic evaluation of the budget, how much is available for spending over what period of time, is necessary. This is most often the area where compromises must be made and a clear look taken at both probabilities and possibilities. A long-wearing, easily maintained carpet, although expensive, may be a better investment in the long run than a less costly one that is neither very durable nor easily cleaned. Thus, *life-cycle costing* may be an important consideration. What expenditures will give the greatest satisfaction? With new construction costs soaring, many people are concentrating their expenditures on interior design and renovation of existing structures. New projects may need to be designed in *phases*, sometimes over a period of years, as money becomes available. It is then the designer's task to make each phase as self-contained and livable as possible, responding to changing needs as time goes on.

ANALYSIS

To progress from programming to space planning, the professional designer must first digest, analyze, and evaluate the information gathered in a systematic way. The design process, as a method of problem solving, provides a number of ways by which to organize and translate information into tangible solutions. Simple projects may not require complex methods; however, all design problems should be

processed in an orderly manner (similar to mathematical equations or research methodology) to assure thoroughness in their solution. A cursory effort will almost surely result in overlooking important objectives and goals that make a satisfying result for the client.

Several underlying planning concepts are useful as a foundation for analysis of program data. They include general principles of interior zoning and orientation, circulation, storage, and efficiency, as well as adjacency studies and analyses of traffic patterns and activity relationships. As designers are accustomed to graphic communication, much of the data specific to the project at hand can be illustrated in diagrams and drawings. The intent of various analysis techniques is to categorize information and study it for similarities, patterns, and relationships that will guide the designer to a holistic design solution rather than unrelated piecemeal answers to a series of individual problems or needs.

ZONING From the smallest living module to the largest house, space divides itself into **zones** that group similar kinds of activities and separate incompatible uses according to the degree of privacy or sociable interaction each requires. The three primary zones in the home encompass social, private, and work activities. Transitional zones or semi-public and semi-private spaces—including entries, exits, and

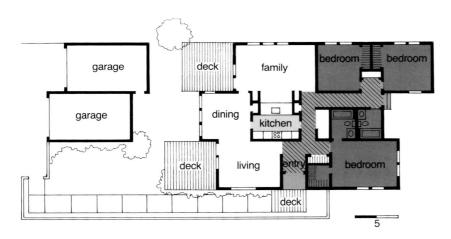

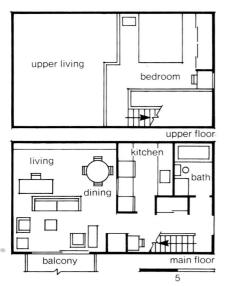

- **8.16** (above) This plan clearly separates activity zones with circulation routes buffering private areas from the noise and the view of social and work zones. Donald MacDonald, architect.
- **8.17** (left) Furniture placement alone can establish zones for different activities. Dining space, a library–study, and a conversation grouping all borrow from the surrounding areas without intruding on them. A low-walled bedroom–balcony further extends the feeling as well as the actuality of space. George C. Oistad, Jr., architect.

circulation routes—are used as control points and buffers between major zones. The purpose of zoning as a planning tool is simply to assist in the arrangement of blocks of space so that relationships between them are functional and practical.

Social Zone This is the public and semi-public area of the home where social activities take place. The design of these spaces is discussed in detail in Chapter 9; here, we are concerned with the way in which these spaces relate to the general principles of overall planning.

The social zone relates closely in function to the work area of the kitchen and to access from the main entrance. It may also be oriented toward a view or outdoor living areas such as terraces or balconies. This requires shielding from the view of passersby, accomplished by facing windows away from the street or by means of protective fencing, shrubbery, or earth berms.

Living spaces that accommodate more than one group activity can be subdivided architecturally by room shapes that offer alcoves or ells for different activities without sacrificing a visual sense of spaciousness and freedom, by careful placement of furnishings, or by a change in floor levels or ceiling heights (perhaps between dining and conversation areas). In many homes the provision of two or more completely separated group spaces helps maintain harmony in the household or simply gives a choice of the kind of room in which to gather for various activities. A playroom opening off either the kitchen or children's bedrooms is a good solution in a one-story house. The latter arrangement also gives older children a degree of privacy and room to expand. When children are small and need fairly constant supervision, the kitchen-to-family-room connection may be ideal. This solution also creates a relaxed entertainment center for adults and teenagers. A private study gives the seclusion needed for two or three people to meet away from the larger group for quiet conversation. In homes with more than one story, a secondary multipurpose space on an upper or lower floor allows some isolation.

Work Zone Chapter 10 details explicit planning for the utility, service, or operative "nerve center" in the home. The spaces and facilities labeled work zones include those for cooking, laundry, heating, cooling, and storage. During the last several decades the amount of space in the home devoted to some of these functions has been shrinking steadily—partly because of inflated construction costs and partly because of streamlined equipment. To reduce the size of homes, square footage is first eliminated from service areas because they can sustain a cut without apparently reducing the living standard. Much of the equipment itself is smaller,

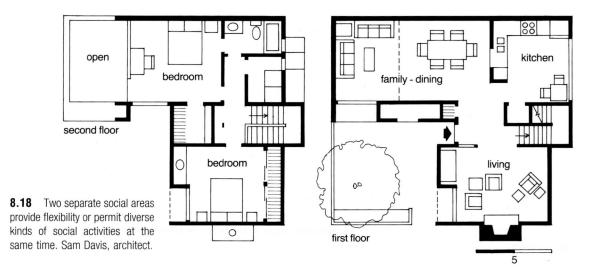

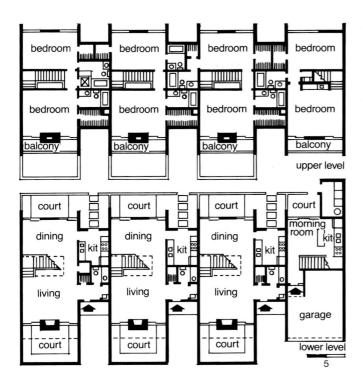

8.19 An open stairway provides circulation between two stories of a row of townhouses and indicates division of areas on the lower level without shutting them off from each other. The inset bands of closets, bathrooms, and kitchens between units result in an unusual degree of privacy for this type of housing as well as consolidation of utilities. Ralph A. Anderson, architect.

cleaner, and less noisy: a closet often suffices to house heating and air-conditioning equipment, a second closet to hold laundry appliances.

For maximum efficiency, service areas and utilities should be centrally located in the house plan. This reduces the length of all sorts of umbilical cords that thread through the house to distribute energy in various forms. The shorter the run of the hot water supply, the sooner hot water appears at the faucet; the closer the kitchen to the various dining areas, the greater the likelihood of food being the desired temperature and appetizing when it is placed on the table.

The **utility core** is a refinement of this idea. A predesigned industrial module, it contains all the equipment necessary for basic support functions: cooking, laundry, bathing, space heating, air conditioning, and water heating. Utility cores can be produced in standard sizes, shipped to the site in one piece, and installed with unskilled labor.

Often it is possible to merge one of the service areas with the group space. As cooking has become more of a family operation and less the exclusive province of a single member, this function has been more completely integrated with other family activities. Thus, we find the lines that separate kitchens from major group spaces increasingly blurred.

Private Zone The rest or sleeping areas of the home are the private and semi-private spaces, discussed in detail in Chapter 11. The primary consideration in locating private spaces is to ensure that they truly are private. A common error in house planning is placement of the bathroom—surely the most private of sanctums—in a position that offers a vista from hallways or even the living space. Various possibilities exist for isolating private spaces, the most obvious being their segregation in a separate wing of the home. In the so-called binuclear plan developed by Marcel Breuer, a house divides into two wings, one for group living and work spaces, the other for private space. An entry area that serves both wings connects them.

8.20 An efficient circulation system helps this 1185-square-foot plan seem much larger than it really is, with a minimum of space used for traffic. G. Hugh Tsuruoka, AIA, architect.

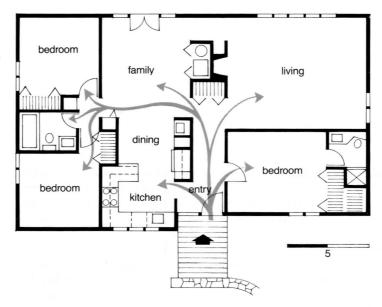

When bedrooms and baths are placed on a second floor, the desired seclusion results automatically. Sometimes (perhaps with a hillside topography) an upsidedown solution is better, with the private spaces underneath the group living area.

In the best of circumstances, private spaces are easily accessible from the cooking and eating areas. The heart of the home continues to be the food center, and all members of the household will tend to converge there.

CIRCULATION, STORAGE, AND EFFICIENCY When economy is a factor, the barest minimum of square footage is allotted to passageways into and within the home—entry halls, corridors, and stairways. Minimum hall width is 3 feet, but Edward Hall's "hidden dimensions" of interpersonal space reveal that two people passing in a 3-foot hallway might feel a psychological infringement on each other's personal space; one would probably wait for the other to come through the corridor, particularly if the two were not well acquainted. Average hallways in the home are usually 3½ feet wide (which accommodates a wheelchair more comfortably), with the central hall often 4 feet or even wider. Generally, the longer the hallway, the wider it should be so as not to seem like a dark tunnel. Short hallways obviously consume less space. Stairways are part of the circulation system and must be a minimum of 3 feet wide, but 3½ to 4 feet is more desirable for heavy traffic and for moving furniture. (Stairway design is addressed in Chapter 19.)

In any plan, paths of circulation should be economical of space: short, direct, and as free of turns as possible, radiating from the principal entrance, and connecting zones without directing traffic through them. All rooms should be conveniently accessible without going through another room, with some occasionally permissible exceptions: the family room, which is often the nucleus of activity; the dining room, which is used only at specific times of the day; and the kitchen, which may also be the hub of family activity, but only if it is large enough so that traffic does not interfere with food preparation. Bedrooms, the ultimate private territory, should never be traffic routes. When rooms are used for circulation, they should be planned so that the most direct route is across a corner or along one side of the room in order not to interrupt activities in progress, a conversation circle, or a view.

Besides major circulation routes through the house, determined by architectural structure, each room will have its own minor traffic paths, influenced heavily by furniture placement and the space needed to perform tasks, the ergonomics or human factors engineering mentioned in Chapter 7. Various furnishing arrangements can be tried on the plan in order to analyze circulation paths to other rooms, doors and windows, storage, heating/cooling vents, electrical switches and outlets, and major pieces or groups of furniture. The most frequently traveled routes, both major and minor, should be the shortest. A good circulation plan avoids causing fatigue (inconvenient routes), conflict (invasion of privacy), and accidents (traffic crossing work areas).

Closets and other storage facilities should be located where needed throughout the home, and should be abundant. The floor space occupied by all storage areas in the house, including kitchen cabinets, should amount to at least 10 percent of the total square footage. Well-designed storage makes maximum use of minimum space; closets, especially walk-ins, may have one third less storage potential than a storage wall of equal square footage. Flexible storage (movable clothes rods and shelves) also allows more efficient use of space. General storage principles advise storing items where they are used, storing at convenient heights (light, small objects in higher places; heavy, bulky items lower), storing similar things together, and storing objects where they are easy to see and easy to reach.

The efficiency of a plan is the percentage of area that is actually usable, livable space; it does not include space taken by halls, walls, closets, stairs, or utilities. Although these are all necessary, they need to be kept to a minimum; hallways should occupy no more than 10 percent of the total area in the efficient house, while approximately 75 percent of the total area should be occupied by rooms with

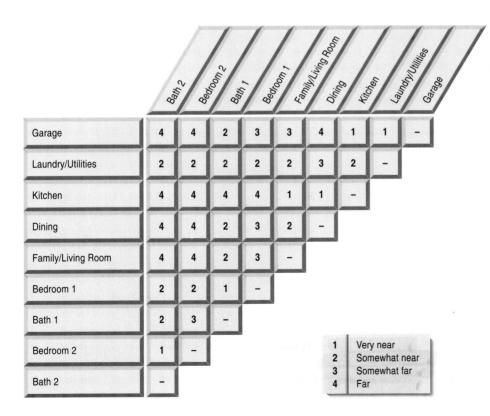

8.21 An adjacency matrix is a convenient tool for analyzing the necessary proximity of various spaces.

floor area sufficient for furnishings and activities.⁵ Usable space is increased by good zoning, a convenient relationship among rooms, minimum traffic through rooms, rooms that permit good furniture arrangement, and livable outdoor areas.

ADJACENCY STUDIES The relationships between various spaces and activities can be depicted with a **matrix** which designates the degree of closeness or distance desired between them. Figure 8.21 (previous page) provides an example of an adjacency or proximity matrix.

A matrix, analysis chart, or graphic can be used to indicate any number of important factors to be included in the design. Where differing degrees of visual or auditory contact or privacy may be necessary in adjoining spaces, additional matrices can indicate the importance of these functions, as in Figure 8.22. Such additional matrices may be more important in contract design projects (such as open office planning or health care facilities), but can be useful in home design as well.

Bubble diagrams, loosely drawn, free-form bubble shapes, are drawn to roughly outline different space uses grouped and organized according to zoning principles and circulation needs. In their proportion to each other, the bubbles can show the relative size and importance of each area. Proximities and connecting lines illustrate relationships between spaces and activities as determined in the matrices. Arrows signify *ingress* and *egress* as well as general circulation patterns. Various aspects of the site and orientation can also be indicated. The designer rearranges the bubbles into many different configurations to analyze relationships from a variety of perspectives.

8.22 The importance of proximity or distance between various activity areas in terms of sight and sound can also be studied by creating a matrix.

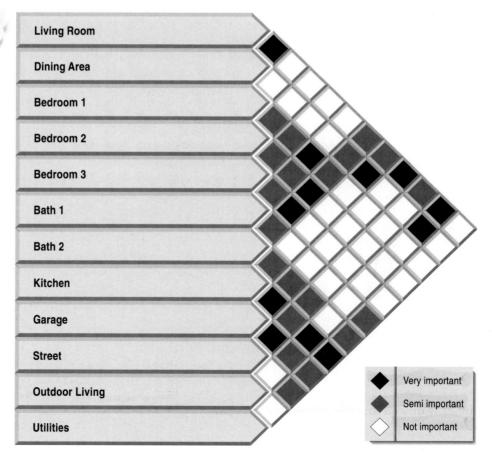

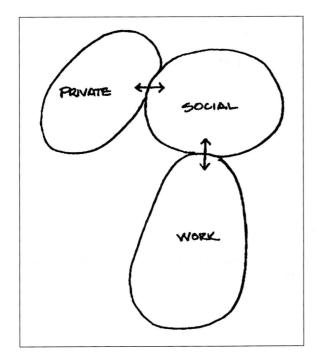

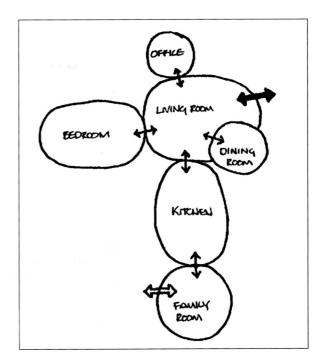

CONCEPT DEVELOPMENT

IDEATION

At this point in the process, ideas should be allowed to develop, evolve, and gain expression freely. The imagination can be given rein without restraint to summon creativity for solutions to the design problem. Often it is helpful to work with an associate, colleague, or team to *brainstorm* and inspire each other. An interdisciplinary *think tank* approach may be helpful to break away from preconceived ideas and examine the problem from a different perspective. The purpose is to generate as many ideas as possible without blocking creative inspiration or idealism. At this stage of the design process, imaginative deliberation begins to synthesize all of the previously gained data with professional knowledge and experience into a totally unified concept which will underlay the core of the design solution. The solution itself is not yet developed, but the prevailing idea that will guide the designer's approach through each step to the final design is conceived.

SCHEMATICS

Most ideas or concepts are explored graphically at the time they are conceived. **Schematic drawings** or sketches are made to help visualize concepts. They are refinements of the bubble diagrams used in analysis, with greater detail, more accurate proportion, and more character, suggesting how the space might look and feel. Schematics may depict methods of approaching the design problem and ideas that will set the theme or character of the space. They may be redrawn several times, with considerable adjustment and balancing of priorities, to establish the most desirable configuration that meets specific planning goals within time lines.

8.23 A bubble diagram is the first step in designing a floor plan and/or placing furnishings. (In this case, including also Figures 8.24 and 8.25, only the first floor of a two-story home is shown.) Initial rough diagrams show zones of activity, their relationships and importance to each other; they may be redrawn several times as relationships are studied and defined (left). The bubbles are then refined and redrawn to indicate living spaces (right).

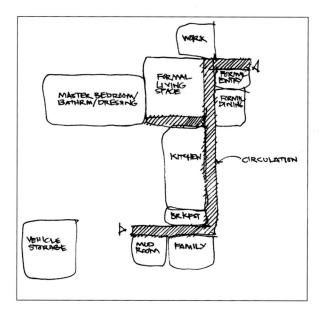

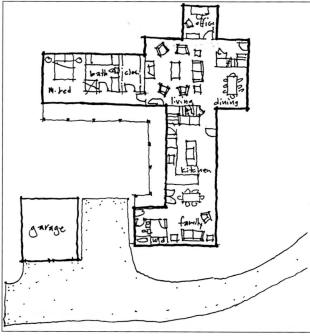

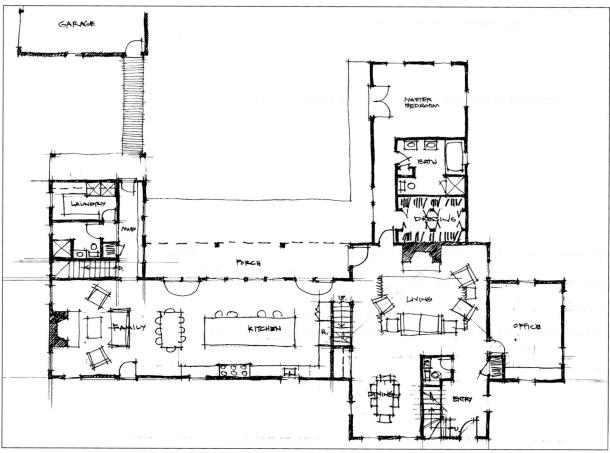

8.24 (top left) A schematic diagram further refines the bubblegram to indicate, in rough sketch, possible room placement. (top right) Area calculations develop and more details are added as the plan evolves. (above) A rough floor plan is drafted with further revisions. Christopher L. Dallmus, AIA/Design Associates Inc., architect.

TABLE 8.1

Typical Room Sizes (in square feet)

Room	Small	Medium	Large
entrance	25-30	35-40	45+
living space	150-200	220–280	300+
dining area	100-130	150-180	200+
dining space in kitchen	25-40	50-70	80+
kitchen	75-90	100-140	160+
bedroom	80-130	140-190	200+
bathroom	33–35	40–45	50+
utility room	12–15	18–25	30+

CONCEPT STATEMENT

These initial experimental *design concepts* can then be further defined, criticized, and rejected, or revised, refined, and developed until a few workable solutions remain. As these concepts are thought through in relation to program requirements and objectives, one dominant theme should emerge; an assimilation of the myriad of details results in one all-encompassing concept. This concept is the beginning of design. It must then be transformed into tangible form—words and drawings—extracted from the designer's full arsenal of aesthetic, technical, scientific, and humanistic education and training. After these initial studies and decisions, the **concept statement** is written and the process of organizing space as a more precise two-dimensional plan begins.

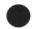

DESIGN DRAWINGS

PLANS

The floor plan evolves from adjacency studies, bubble diagrams, and schematic drawings via a series of sketches which begin to allocate more concrete shapes and square footage to activity spaces. Number of square feet can be determined from the space needs outlined in the program and from various charts which suggest average room sizes (see Table 8.1). Rough plan proposals are reviewed and revised until a finished plan which meets all requirements is presented and approved.

A floor plan may seem an innocuous and sometimes hard-to-read two-dimensional drawing, but its importance in determining the kind of life possible in any given space can scarcely be overestimated. It not only establishes the basic character of a particular structure but also seriously influences the lifestyle that can flourish there. For example, an open space with minimum floor-to-ceiling partitions might be suitable for a family or group of people who enjoy the easy contact and group interaction such a plan engenders. Conversely, people who desire a dependable amount of privacy—and prefer their interaction with others be confined to certain life rituals such as dining together or social entertaining at prescribed times—will be happiest in a home that provides designated, separated areas for the various functions of living.

8.25 Finally the finished plan is accurately drafted. Christopher L. Dallmus, AIA/Design Associates Inc., architect.

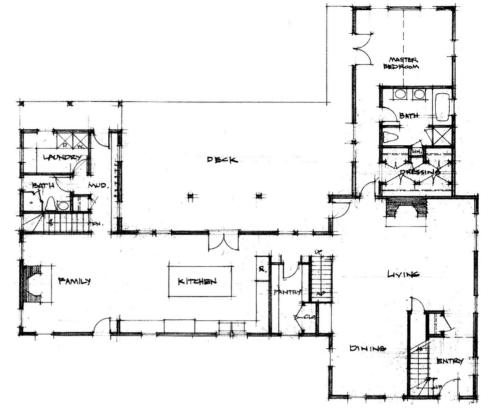

The **floor plan** is an outline of space, depicting the exact dimensions of rooms, either as they currently exist or as they will be built, that physically limit and enclose the spaces in which we live. It is drawn from a bird's-eye view, looking straight down upon and into each floor level as though the roof and/or each higher level were removed. Each level of a multiple-story home is drawn separately and must be envisioned "stacked" when reading the total plan. The drawing indicates placement of walls, doors, windows, and other structural elements that shape the spaces for living, eating, and resting as well as major built-in cabinets and appliances. It shows the constraints within which the designer must work, but also provides the challenges and indicates the possibilities. Furniture is often drawn in to help understand the way the house functions and to help provide an accurate estimate of the amount of space available for the various furnishings and activities.

Floor plans are always drawn to *scale* so that all aspects of the space are represented in accurate size relationship to one another. This means that, while the plan on paper will, of course, be much smaller than the actual house itself, the proportions will remain the same. Everything is reduced in size so that a fraction of an inch on the plan represents a foot of actual space in the physical structure of the house. The scale $\frac{1}{4}$ inch equals 1 foot is standard for house plans. Any scale may be used to represent the space accurately ($\frac{1}{2}$ " = $\frac{1}{0}$ "; $\frac{1}{8}$ " = $\frac{1}{0}$ ") as long as everything is drawn to the same scale. Generally, plans for single rooms use $\frac{1}{2}$ " = $\frac{1}{0}$ ". Details, such as cabinetry, use $\frac{1}{2}$ " = $\frac{1}{0}$ ".

One purpose of drawing a living space is to illustrate it simply, without requiring verbal explanation. For this, *symbols* are very useful. They indicate basic structural features such as walls, windows, stairways, and doors as well as specific types of windows and doors, appliances, cabinets, storage facilities, electrical fixtures, and furniture. The precisely drawn floor plan and a series of additional plans, including wiring and lighting, act as a guide for the builder as well as a useful tool

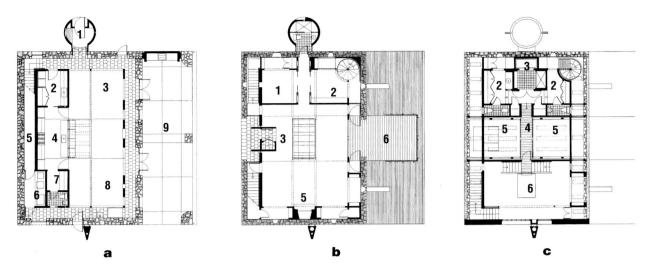

8.26 A stone barn, built in 1820 on a farm in southeastern Pennsylvania, was transformed into a modern home which maintains the expression of simple dignity, materials, and volumes of the original structure. Plans of the three levels of living space reveal the original 20-inch thick rough stone walls and narrow ventilation slits, called "windeyes," with a new box of smooth cherry wood built inside to support structural loads and building systems. (North is up). The space between old and new structures is utlized for circulation, fireplaces, and intimate sitting areas next to the light. **a:** The first level, at top left, includes a mud room (1), laundry (2), dining room (3), kitchen (4), storage (5), mechanical (6), office (7), living area (8), and porch (9). An opening in the second level maple floor exposes original hand-hewn oak floor timbers and admits light to the floor below. **b:** The second level, at center, provides a guest room (1), more office space (2), the entry vestibule (3), more living area (5), and a roof deck (6). The stairway at top left goes down; that at bottom left, up. **c:** The third level houses the tubroom (3), the master bedroom (6) and the dressing areas (2), connected by a steel, glass, and maple catwalk (4) across a 30-foot-high volume perforated with skylights (5). (The down stairs are in the lower left and upper right corners.) William Leddy, partner in charge, Tanner Leddy Maytum Stacy Architects.

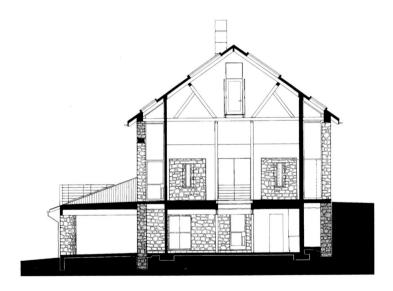

8.27 A transverse section (looking south) of the stone barn adaptive reuse illustrates interior features, including the new structural walls and the bridge (under the apex of the roof) between master bedroom and dressing area above the existing oak roof structure. The arrow on the first level plan above show where the section cuts through the plan. Tanner Leddy Maytum Stacy Architects. (Scale:

for the designer and homeowner. (The architectural, electrical, and furniture symbols commonly used for these purposes appear in Appendix A. Lighting plans appear in Chapter 21; wiring in Chapter 14.)

For the professional designer, expertise in reading and drawing plans is an integral part of the design process. As a means of communicating with other professionals such as architects and contractors, a way of explaining ideas to the client, and to be certain that the finished space will work for its intended uses, plans are a valuable graphic tool.

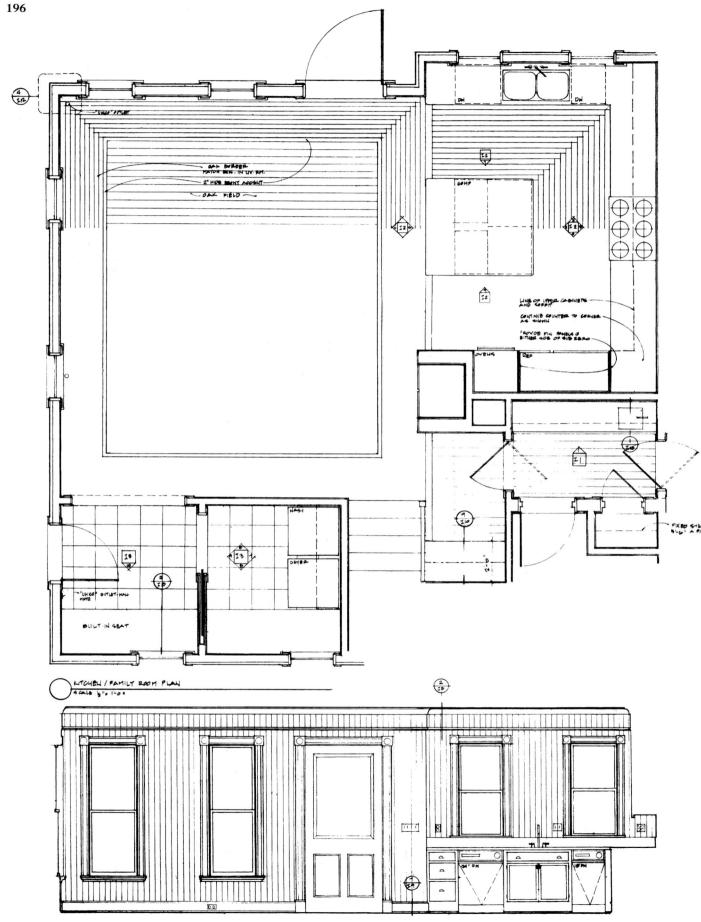

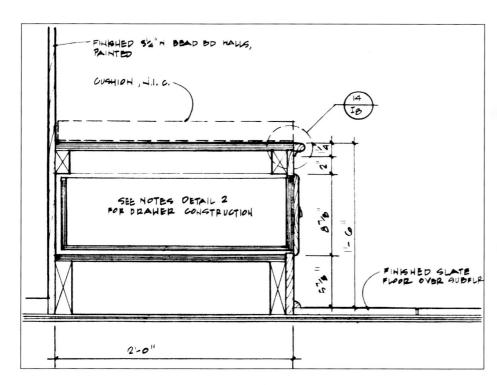

- **8.28** (facing page) At top: kitchen/family room plan. At bottom: Elevations of the north interior wall of a kitchen/family room reveal the heights of windows, architectural details, and kitchen cabinetry and appliances. An interior designer may illustrate furnishings and window treatments as well in an elevation drawing. Christopher L. Dallmus, AlA/Design Associates Inc., architect.
- **8.29** (left) Detail drawing clarifies built-in seat (1½" = 1') of the kitchen/family room seen in Figure 8.28. Christopher L. Dallmus, AIA/Design Associates Inc., architect

SECTIONS, ELEVATIONS, AND DETAILS

When a design proposal is presented to the client, in addition to the floor plan, it may include sections, elevations, and details as part of the technical *working* or *construction drawings* used to guide and instruct those who will build the house. **Transverse** or **longitudinal sections** (across the width or through the length respectively) cut through the structure to show interior features (see Figure 8.27). They help gain a better understanding of the structure; the entire width or length of the building is drawn to scale. Care must be taken in selecting where to cut through the plan in order to show desired relationships and features.

Elevations are two-dimensional scale drawings of the vertical sides of rooms or structures. They present a view looking directly at the subject and are commonly used to depict kitchen cabinetry and walls with built-in furnishings or appliances, but may be used to illustrate many features. Elevations, like sections, show only height and width of the walls and furnishings they depict.

Details are used for any aspect of the plan or elevations that must be enlarged for clarification. Cabinetry, fireplaces, and built-in or custom-designed furnishings are typically the subject of detail drawings. Details are drawn, at an enlarged scale, in elevation and/or section and must be fully dimensioned. Notes are often added to drawings to convey additional information necessary for construction.

AXONOMETRIC VIEWS AND PERSPECTIVES

Pictorial projections are often used in design, either as quick sketches to illustrate an idea, or as finished *presentation drawings* to help clients and others not trained in reading plans, elevations, and sections understand and picture the space. In pictorial projections, all three principal faces of an object are shown in one view;

8.30 An axonometric drawing of the stone barn conversion, seen in Figure 8.26 and 8.27, illustrates the spatial volume. At top, the roof; middle, the interior; bottom, the exterior. Larger axonometrics can be used to show greater interior detail. Tanner Leddy Maytum Stacy Architects.

in addition to height and width, depth is represented, giving a more realistic appearance to the space and objects within it.

Axonometric views are most easily drawn. One type of axonometric, the *isometric drawing*, utilizes parallel lines drawn at an angle of 30 degrees (or 30 degrees and 60 degrees) to the horizontal as well as vertical lines (see Figure 8.30). Principal edges are drawn true length in whatever scale used, producing visual distortion but accuracy in measurement. An illusion of depth results, similar to a perspective drawing but not in true shape.

Perspectives present the most realistic picture of the proposed project, showing exactly how it will look, with depth foreshortened as it appears to the eye. Perspective drawings require more skill and time to prepare than axonometrics and are often *rendered* in color to show finishes, materials, colors, and textures, further enhancing their photo-like qualities. They can serve as a valuable sales tool, presenting the design as a very concrete image. Even thumbnail sketches in perspective can assist significantly in visualizing the design.

SPECIFICATIONS AND SCHEDULES

Written information is often necessary to describe in accurate detail all materials, fixtures, furnishings, and equipment used in the design project. **Specifications** provide requirements for kinds and quality of materials and workmanship. They may also call for a specific manufacturer or model, or its equal if purchases will be open to competitive bidding.

Schedules are used to supplement drawings with information about particular types of doors and windows selected, for example, and their installation locations. Finish materials for walls, ceilings, floors, and trim may also be indicated on schedules which indicate the material, color, style, and placement. (See Figure 8.33, page 200.)

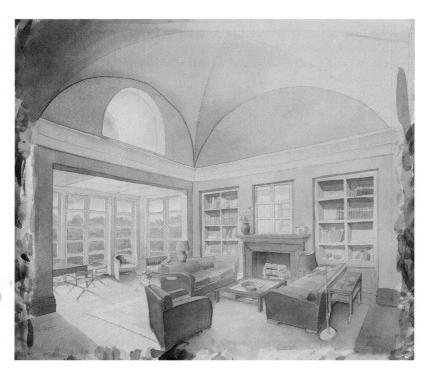

8.31 A fully rendered perspective drawing depicts how a space will actually look and feel, translating materials, lighting, and space into reality for the client. Robert A.M. Stern, architect.

OUTLINE SPECIFICATIONS—ALLEN'S WAY PROJECT

- I. KITCHEN APPLIANCES
 - A. Sink: Stainless steel with faucet (all other appliances by owner, not contractor)
 - B. Cabinets: Merillat, Nouveau Laminate cabinet or equal
 - C. Counters: Laminate
- II. FLOORS
 - A. Kitchen: Sheet vinvl
 - B. Baths: Sheet vinyl
 - C. Living room, dining room, stairs, bedroom: Carpet
- III. BATHROOM FEATURES
 - A. Vanity: Merillat, Nouveau cabinet or equal
 - B. Vanity Top: Laminate
 - C. Bathtub: Kohler or equal fiberglass with shower rod
 - D. Shower: Kohler or equal fiberglass with shower rod
 - E. Sink: White
 - F. Water Closet: White
 - G. Surface-mounted medicine cabinet with light
 - H. Faucets: Sink-Moen or equal

Shower—Symmons Temptrol or equal Bathtub—Symmons Temptrol or equal

I.Additional Features: One toilet paper holder; one towel bar

- IV. DOORS AND WINDOWS
 - A. Windows: Double-glazed Perma-Shield—"Andersen" with wood muntins and full screens
 - B. Exterior Doors: Insulated steel
 - C. Sliding glass doors or patio doors: Double-glazed wood frame—Peachtree
 - D. Interior Doors: Flush, hollow-core Masonite or Luan. Clamshell interior trim.
- V. HARDWARE: Dexter or Kwikset (not decorator style)
- VI. INTERIOR TRIM FINISH: By owners—\$8000 extra for contractor to oil trim and prime walls
 - A. Walls and Ceiling
 - B. Door, window, and baseboard trim:
- VII. TELEPHONE JACKS: Kitchen
- VIII. FIRE PROTECTION: Smoke detectors installed, one on each level (2 total)
- IX. ELECTRICAL FIXTURES AND SERVICES
 - A. Lighting fixtures at locations designated:
 - Kitchen
- 4. Laundry Room
- Hallways
- Entry
- 3. Bathrooms 6. Garages
- B. Electrical Services: Circuit box and meter provided for each unit—200 amp service
- X. HEATING, HOT WATER, AIR CONDITIONING
 - A. Heat by Electric Baseboard, Federal Pacific, or equal
 - B. Hot water
- XI. INSULATION
 - A. Exterior walls: 31/2" fiberglass batt
 - B. Single party walls
 - C. Ceiling 6" batts, R = 9
- XII. ATTIC VENTILATION
- XIII. FRAMING-EXTERIOR AND INTERIOR MATERIALS
 - A. Wood bearing walls, 1/2" Sheetrock, interior
 - B. Clear wood shingles over Tyvek over plywood sheathing over wood studding, cedar trim boards, silicon or oil treated
 - C. Roof Shingles—asphalt or fiberglass, 235# tab shingles
 - D. Garage—interior: Fire coat Sheetrock, including ceilings
- XIV. WOOD, PRESSURE TREATED
- XV. WATER: Public
- XVI SEWER: Public
- XVII.LAUNDRY HOOK-UP: Washer/Dryer hook-ups provided

NOTE: SELLER RETAINS THE RIGHT TO SUBSTITUTE EQUIVALENT OR BETTER PRODUCTS OR MATERIALS FROM THOSE STATED ABOVE OR DIFFERENT MANUFACTURERS OR SUPPLIERS.

8.32 Specifications may encompass many pages of requirements for products, materials, and workmanship. These specs are more in the nature of an outline for the sake of brevity. Design Assiciates Inc., architects.

8.33 Schedules provide a convenient method of communicating many details and cross-referencing information to plans by letter, number, or room key. Design Associates Inc., architects. *(Continued on facing page)*

DOOR SCHEDULE

NO.	LOCATION	MANUFACTURER	MODEL NO.	SIZE	TYPE	MATERIAL	FINISH	REMARKS
1	Entry	Custom		$3'-0'' \times 7'-0''$	6 Panel	Pine	Painted	
2	Basement	Morgan	M1074	$2'-6'' \times 6'-8''$	4 Panel	Pine	Painted	
3	Powder room	Morgan	M1074	$2'-4'' \times 6'-8''$	4 Panel	Pine	Painted	
4	Mudroom	Morgan	M1074	$(2) 2'-0'' \times 6'-8''$	4 Panel	Pine	Painted	
5	Mudroom	Morgan	M3912	$3'-0'' \times 6'-8''$	15 Lite	Pine	Painted	
6	Laundry	Morgan	M1074	$2'-6'' \times 6'-8''$	4 Panel	Pine	Painted	Pocket door
7	Pantry	Morgan	M1074	$2'-6'' \times 6'-8''$	4 Panel	Pine	Painted	
8	Family room	Morgan	M3912	$3'-0'' \times 6'-8''$	15 Lite	Pine	Painted	
9	Bedroom #2	Morgan	M1074	$2'-6'' \times 6'-8''$	4 Panel	Pine	Painted	
10	Bedroom #2 closet	Morgan	M1074	$(2) 2'-6'' \times 6'-8''$	4 Panel	Pine	Painted	
11	Bedroom #1	Morgan	M1074	$2'-6'' \times 6'-8''$	4 Panel	Pine	Painted	
12	Bedroom #1 closet	Morgan	M1074	$(2) 2'-6'' \times 6'-8''$	4 Panel	Pine	Painted	
13	Master Bedroom	Morgan	M1074	$2'-6'' \times 6'-8''$	4 Panel	Pine	Painted	
14	Master dressing room	Morgan	M1074	$(2) \cdot 2' - 0'' \times 6' - 8''$	4 Panel	Pine	Painted	
15	Master dressing room	Morgan	M1074	$(2) 2'-0'' \times 6'-8''$	4 Panel	Pine	Painted	
16	Master bath	Morgan	M1074	$2'-6'' \times 6'-8''$	4 Panel	Pine	Painted	
17	Master bath	Morgan	M1074	$2'-6'' \times 6'-8''$	4 Panel	Pine	Painted	Pocket door
18	Bath #1	Morgan	M1074	$2'-6'' \times 6'-8''$	4 Panel	Pine	Painted	
19	Bath #2	Morgan	M1074	$2'-6'' \times 6'-8''$	4 Panel	Pine	Painted	
20	Bath	Morgan	M1074	$2'-6'' \times 6'-8''$	4 Panel	Pine	Painted	
21	Closet	Morgan	M1074	$1'-3'' \times 6'-8''$	2 Panel	Pine	Painted	
22	Guest bath	Morgan	M1074	$2'-6'' \times 6'-8''$	4 Panel	Pine	Painted	
23	Closet	Morgan	M1074	$2'-6'' \times 6'-8''$	4 Panel	Pine	Painted	
24	Mechanical room	Morgan	M1074	$3'-0'' \times 6'-8''$	4 Panel	Pine	Painted	

WINDOW SCHEDULE

NO.	SASH	R.O.	LITES	MANUF.	MANUF. NO.	REMARKS
Α	$2'-8'' \times 5'-2''$	$2'-10 \%" \times 5'-5 \%"$	12/12	Marvin	WDH2828	
В	$2'-0'' \times 5'-2''$	$2'-2\%" \times 5'-5\%"$	9/9	Marvin	WDH2028	
С	$2'-4'' \times 4'-6''$	$2'-6\%'' \times 4'-9\%''$	12/12	Marvin	WDH2424	
D	$1'-8'' \times 4'-6''$	$1'-10 \%" \times 4'-9 \%"$	6/6	Marvin	WDH1624	
E	3'-0" × 5'-10"	$3'-2\%" \times 6'-1\%"$	12/12	Marvin	WDH3232	Lower sash to be tempered glass
F	$2'-4'' \times 3'-0$ ¹ / ₁₆ "	$2'-5'' \times 3'-0$ %16"	9	Marvin	WAWN2836	
G	2'-0" × 3'-10"	$2'-2\%'' \times 4'-1\%''$	6/6	Marvin	WDH2020	
Н	$2'-4'' \times 5'-2''$	$2'-6\%'' \times 5'-5\%''$	12/12	Marvin	WDH2428	
	$3'-0'' \times 1'-2''$		4	Brosco	CW50	Transom
J	$1'-9^{1/2}'' \times 2'-3^{1/2}''$			Velux	VS101	

Note: Marvin units to be thermal pane, simulated divided lites.

The program document, concept statement, all of the design drawings, specifications, and schedules become a part of the **contract** for design services. This written agreement specifies the parties involved, the work to be completed, the services the designer is to provide, the method and rate of compensation, the time frame for completion of the project, and any other terms or conditions of the working relationship between the designer and client. The contract is prepared by the designer (with advice from an attorney) and, when signed by both designer and client, becomes a legal document. The intent of the contract is to protect both parties by

ROOM FINISH SCHEDULE

ROOM NO.	ROOM	FLOOR	CEILING	WALLS	TRIM	REMARKS	
Basement							
0.001	Basement	Existing concrete slab	Exposed framing	Existing brick, concrete block	Existing		
0.002	Crawl space	Existing	Existing	Existing	Existing	Remove all debris	
1st flr plan	Fatan farma	F 1-11 - 1 - 1 - 1 - 1 - 1 - 1 - 1 - 1 -	F. 1	E today			
101 102	Entry foyer Basement stair	Exist'g w/ new oak fill	Existing	Existing	Existing	5.1	
102	basement stan	Exist'g w/ new oak fill	Existing	Existing	Existing	Exist. Bd Bd from 1st floor level &	
						above. Open rail	
						below 1st floor leve	
103	Living room	Exist'g w/ new oak fill	Existing	Existing	Existing	Floor banding	
104	Library	Exist'g w/ new oak fill	Existing	Existing	Existing	Floor banding	
105	Dining room	Exist'g w/ new oak fill	Existing	Existing	Existing	Floor banding	
106	Utility closet	Bead board/painted		Bead board/painted			
107	Powder room	Wood/stained	Plaster/painted	Bead board/painted	Wood/stained		
100	C	We safetal and	D 11 1/1 1	D	with tile inserts		
108	Serving pantry	Wood/stained	Bead board/stained	Bead board	Wood/painted	Built-in millwork/	
109	Kitchen	Wood/stained	to match ext.FOH Bead board/painted	Bead board/painted	Wood/pointed	stained	
103	KILGHGH	wood/stailled	beau board/pairiteu	beau buaru/painteu	Wood/painted	Built-in Millwork/ painted	
110	Desk	Wood/stained	Bead board/painted	Bead board/painted	Wood/painted	panitod	
111	Breakfast room	Wood/stained	Bead board/painted	Bead board/painted	Wood/painted		
112	Family room	Wood/stained	Bead board/painted	Bead board/painted	Wood/painted		
113	Laundry	Slate	Bead board/painted	Plaster/painted	Wood/painted		
114	Mudroom	Slate	Bead board/painted	Bead board/painted	Wood/painted		
115	Veranda	Wood planking	Bead board/painted	Clapboard	Wood/stained		
116	Deck	Wood planking	Bead board/painted	Clapboard	Wood/stained		
117	Porch	Wood planking	Bead board/painted	Clapboard	Wood/stained		
2nd flr plan							
201	Reading nook	Carpeting	Bead board/painted	Bead board/painted			
202	Master bedroom	Carpeting	Existing bead board	Existing bead board	Existing wood		
203	Master bathroom	Existing wood/stained	Existing bead board	New bead board	Wood/stained		
				where required			
204	Master bath linen	Existing wood/stained	Existing bead board	New bead board	Wood/stained		
005		e		where required			
205	Master closet	Existing wood/stained	Existing bead board	New bead board where required	Wood/stained		
206	Front hall	Existing wood/stained	Existing to remain	Existing to remain	Existing to remain		
207	Front stair	Existing wood/stained	Existing to remain	Existing to remain	Existing to remain		
208	Guest bedroom	Carpeting	Existing bead board	Existing to remain	Existing to remain		
209	Guest closet	Bead board/painted	Bead board/painted	Existing to romain	Existing to romain		
210	Guest bathroom	Wood/stained	Plaster/painted	Ceramic tile/plaster	Tile & wood/		
		E-Colymonous Population (systematical	, and the same of	, ,	painted		
211	Guest linen	Wood/stained	Plaster/painted	Existing bead board	Wood/painted		
212	Rear hall	Wood/stained	Existing bead board	Existing bead board/ painted	Existing		
		M/l/-t-il	Existing bead board	New & existing bead	Existing		
213	Linen	Wood/stained	EXISTING Dead poard				

Note: "Existing" conditions need to be V.I.F. for repair & replacement.

spelling out their agreement in writing so as to avoid any misunderstandings as the project progresses. For residential clients, a more personal type of document, a **letter of agreement**, may be used to accomplish the same understanding as a matter of good business practice. Standard form contracts are available, but a contract should always be specific to the job at hand.

The following three chapters detail space planning for the social, work, and private zones of the home. Briefly outlined here, this information becomes a part of the assimilated knowledge of the professional designer which is synthesized with the design program and the plan, first envisioned as an overall concept, then given physical form as the design solution.

CASE STUDY

Remodel From Second Home ("Ski Cabin" Townhome) to Primary Residence

by Betty Cutten, ASID

DATA/PHYSICAL SPECIFICATIONS The project objective was to remodel a mountain-area, second-home townhouse to become the owner's primary residence. The unit consisted of 1,366 square feet of living space on two floors, plus a 234 square-foot garage and a storage loft. Cathedral ceilings rose from 8 feet at the front and rear of the unit to 16 feet at the ridge. The property was an interior unit of a four-unit building; the first phase of a project development of 30 units.

The property adjoins a ski area.

The shape of the residence was a 20' wide × 40' deep rectangle. All doors and windows were located on the 20-foot sides, with the 40-foot sides abutting neighboring units. A covered entry adjacent to the garage door was located on the west-facing front; and an east-facing deck adjoined the 20-foot exterior side of the unit in the rear. The second floor, as is typical in heavy snow areas, contained the living-dining area and kitchen, as well as the master bedroom and bath, and allowed the rooms on this floor to take full advantage of spectacular views. The public rooms were contained in one space. Two bedrooms, a bath, linen closet, and a water heater closet large enough for storage of miscellaneous equipment occupied the lower floor. The owners had purchased the unit new in 1967 and all finishes and furnishings were 1967 vintage "ski cabin" style. It had been completely furnished for second-home, primarily winter use until their retirement.

ANALYSIS/PROGRAM

Client Needs. The recently retired owners' prior residences had ranged in size from 4,500 square feet down to, most recently, 2,200 square feet. Space requirements in the remodeled residence needed to include rooms to sleep guest families as well as provide privacy for the owners to conduct necessary business activities during the longer-than-usual vacation visits of their guests. Typical guests are family members—children and grandchildren—and friends of all three generations who enjoy outdoor recreation and all of whom are exceedingly active. Storage space for a large quantity and variety of both seasonal and consistently used items was also a major priority.

Character. The clients wished to project an image of warmth and comfort that would surround and relax guests and tired athletes. All finishes and furnishings needed to be updated, renovated, or replaced. Because the owners had not dis-

posed of many of the furnishings from their prior homes in anticipation of their move into this remodeled townhouse, there were approximately three houses of furnishings from which to cull and select the best items for the new residence. The selected items needed to be reorganized, refinished, and/or recovered, depending on their new location. Few new items needed to be purchased. Budget considerations were a concern and required strict observance as the couple is retired.

PROGRAM

Strategy/Composition/Traffic Concerns. Remodeling for this project needed to be accomplished between Labor Day, the end of the summer season, and Thanksgiving, the start of the holidays and ski season, a time when the clients could live on site without guests. Existing space was extremely limited but fairly well organized, so only two major structural alterations were made: first, the addition of a stairway to access the attic space above the existing master bedroom closet and adjoining master bath to create private space for office use and, second, the gutting and remodeling of the small galley kitchen that occupied one corner of the informal living space to improve both operational efficiency and circulation. This was accomplished without changing the kitchen dimensions; an opening was cut into the living room side of the galley counter, creating an island plus a second access to the work area. New cherry cabinets in an "L" configuration were installed on the kitchen's two joining right-angled walls, and all cabinets were color-blended to match the existing redwood paneling of the living/dining area. A new refrigerator and dishwasher with front

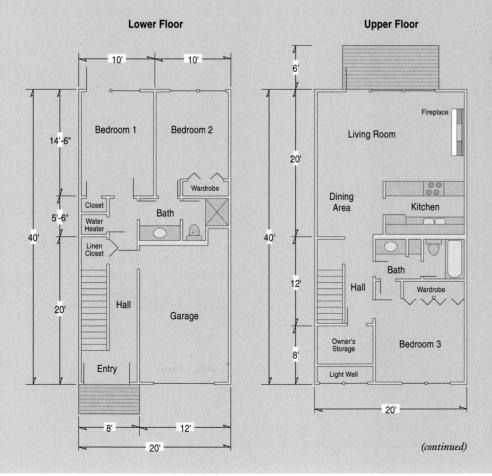

8.34 The existing floor plan (shown) of the townhouse required only two alterations: the addition of a stairway to the attic space above the master bath and closet, and the conversion of one side of the galley kitchen (next to the living room) to an island. Betty Cutten, ASID, interior designer.

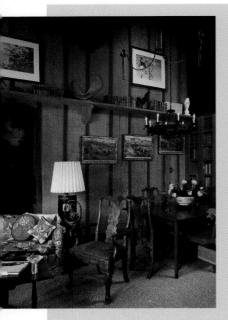

8.35 Furnishings collected over the years were given new life in this retired couple's townhome by rearranging and recovering, with only a few new pieces added in order to limit expense. Betty Cutten, ASID, interior designer. (Photograph: Bob Swanson)

panels matching the cabinets, a stove with vented hood above, and a new partitioned sink replaced the developer-supplied 1967 appliances. A third major alteration—increasing the office size by extending the floor out over the adjacent kitchen area—was considered but rejected because it interfered with the architectural and spatial integrity of the public area.

Minor alterations included moving the laundry equipment from its former location in the winter-frigid garage to the downstairs hall water heater closet, a move that also allowed better organized storage for athletic gear and gardening and carpentry tools; changing a door opening from one wall of a large hall closet to another so the closet would serve the master bedroom instead of the hall; the inclusion of storage drawers in stair risers wherever practical; and the opening of walls between studs where possible for further additional storage. These last two ideas were borrowed from ship design.

Color. Existing colors were a mixture of autumn hues inappropriate for this application, its background, and its visible adjacencies. Four separate wallpapers, redwood paneling, charcoal-brown laminate cabinet facing, and a dark carpet had been used by the developer in the one-space public area. The aged wallpapers in the living and dining areas were replaced with redwood paneling matched to the existing redwood paneling on one wall and above the fireplace on the opposite wall, which, when included with the color-coordinated kitchen cabinets, created one large unified space. Light natural Berber carpet replaced the dark carpet to interact with the existing white-stained ceiling and to provide better light in the east-facing living area. A bleached wood, plank-form, resilient vinyl flooring replaced the old charcoal-brown vinyl floor in the kitchen work area. Upholstered seating in the living area was recovered in French country polished cotton in a multicolored floral print with red background. A pattern-coordinated blue linen fabric was used to cover the chair seats in the dining area. In the master bedroom, fresh white wallcovering replaced the existing stained, yellowed papers, and a residential-grade, cut-pile floor covering which complimented the owner's furnishings replaced the old commercial-grade carpet. The carpet and wallcoverings in the downstairs bedrooms were replaced so that they coordinated with the furnishings selected from both prior homes and the ski-home collection. Window coverings throughout the house were replaced using treatments appropriate to room use with both daylight and/or artificial illumination.

Lighting/Electrical Needs. In mountain areas in 1967, insufficient attention was paid to electrical and lighting standards. Mountain homes were provided only with base receptacle electrical outlets for lighting rooms other than the kitchen and bathrooms. Fewer than necessary electrical circuits were available, and several of these were overloaded. Circuits were added and overloaded circuits were modified to conform to current codes and standards. Track lighting was added in the living/dining rooms and kitchen area to provide better ambient and task lighting. In the master bedroom, a fan/light, operated from an electronic control located at the entry door, was installed to improve air circulation in the small, high-ceilinged, west-facing space.

An interesting fact should be noted in regard to safety considerations. Egress and ingress to the units in this development via the main floor primary entries is by in-opening doors while all other building exit doors open out. The purpose of this arrangement is to allow egress from the buildings when snow and ice block out-opening exits, a not uncommon occurrence in heavy snow areas.

NOTES TO THE TEXT

- 1. Paul Bohannan, *Social Anthropology* (New York: Holt, Rinehart and Winston, 1963), p. 86.
- 2. Alvin Toffler, The Third Wave (New York: Morrow, 1980), chap. 17.
- 3. Irwin Altman, *The Environment and Social Behavior: Privacy, Personal Space, Territory, Crowding.* (Monterey, Calif.: Brooks/Cole Publishing Company, 1973), p. 131.
- **4.** Marjorie Branin Keiser, *Housing: An Environment for Living* (New York: Macmillan, 1978), pp. 134–135.
- 5. Ernest R. Weidhaas, Architectural Drafting and Design, 4th ed. (Boston: Allyn and Bacon, 1981), p. 156.

REFERENCES FOR FURTHER READING

Family Housing Handbook. Ames, Iowa: Iowa State University, Midwest Plan Service, 1971. Friedmann, Arnold, John F. Pile, and Forrest Wilson. *Interior Design: An Introduction to Architectural Interiors*, 3rd ed. New York: Elsevier, 1982, pp. 105–112, 157–164.

Hartwigsen, Gail Lynn. Design Concepts: A Basic Guidebook. Boston: Allyn and Bacon, Inc., 1980, chaps. 4, 5, 6, 9.

Keiser, Marjorie Branin. Housing: An Environment for Living. New York: Macmillan, 1978, chaps. 7, 8, 12.

Kleeman, Walter B., Jr. *The Challenge of Interior Design*. Boston: CBI Publishing Company, 1981, chaps. 2, 8, 10.

Lindamood, Suzanne and Sherman D. Hanna. *Housing, Society, and Consumers: An Introduction.* St. Paul, MN: West Publishing Company, 1979, chap. 5.

Meeks, Carol B. Housing. Englewood Cliffs, N.J.: Prentice-Hall, 1980, chap. 9.

One- and Two-Family Dwelling Code, 1983 ed. Whittier, Calif.: International Conference of Building Officials.

Packard, Robert T. (ed.). Ramsey/Sleeper Architectural Graphic Standards, 7th ed. New York: Wiley, 1981.

Panero, Julius and Martin Zelnick. *Human Dimension and Interior Space: A Source Book of Design Reference Standards.* New York: Whitney Library of Design, 1979.

Spence, William P. Architecture: Design, Engineering, Drawing, 3rd ed. Bloomington, Ill.: McKnight Publishing Company, 1979, chap. 4.

St. Marie, Satenig S. Homes Are for People. New York: Wiley, 1973, pp. 13-201.

Staebler, Wendy W. Architectural Detailing in Residential Interiors. New York: Whitney Library of Design, 1990.

Tate, Allen and C. Ray Smith. *Interior Design in the 20th Century*. New York: Harper & Row, Publishers, 1986, chap. 6.

Uniform Building Code, 1982 ed. Whittier, CA: International Congress of Building Officials.Veitch, Ronald M., Dianne R. Jackman, and Mary K. Dixon. Professional Practice: A Hand-book for Interior Designers. Winnipeg, Canada: Peguis Publishers, 1990.

Weidhaas, Ernest R. Reading Architectural Plans for Residential and Commercial Construction, 2nd ed. Boston: Allyn and Bacon, 1981.

Social Zones

ACTIVITIES AND SPACES

Greeting Guests
Conversation
Reading
Quiet Games
Audio-Visual Entertainment
Active Indoor Entertainment
Outdoor Entertainment
Children's Activities
Dining

PLANNING SOCIAL SPACES
Location

Room Shapes and Sizes

The social zone in any home encompasses the areas where members of the household gather and where friends are entertained. It should provide a congenial atmosphere for such activities as general conversation, games, parties, meals, listening to or making music, and watching television. Most homes throughout history have included such communal gathering places in which the entire household could assemble for recreation, companionship, and often warmth. In medieval England the "great hall" of a castle or house functioned as a group space and was perhaps the only room that was adequately heated. American families of the seventeenth and eighteenth centuries typically congregated in the kitchen, drawn by the triple sensory pleasures of warmth, pleasant aromas, and food-all conducive to easy companionship. For the same reasons, the kitchen in many homes today serves as a magnet for the entire family. Comparatively recently, however, new kinds of activities have become important in family life—reading, watching television and movies, listening to music, pursuing home crafts or hobbies, and even working. All of these, plus increased leisure time (thanks to labor-saving devices), make different demands on the living spaces in today's home, demands that architectural design is only beginning to satisfy. A recent trend toward "cocooning" has characterized the large group of people known as baby boomers, who are reaching middle age in the 1990s. They are spending more time at home, with the result that

increased emphasis is placed on home design. The social zone is the most intensely used area in the home.

The emphasis given each social activity varies from individual to individual and from household to household. Furthermore, our priorities inevitably change as we grow older and experience changes in family life and economic status. The group space that, for example, makes ample provision for children's play will assume a different character when those children are grown. Because none but the very wealthy can accommodate all kinds of activities equally well, most people must decide carefully which social pursuits are most important, then plan accordingly. A logical first step is to consider specific group activities, as well as the environment and equipment desirable for each, and then to design the living space so that it will best meet these requirements. Time spent in leisure refreshes the mind and body; the social core of the home should be pleasant and stimulating to attract people to it and, once there, encourage interaction with others or with the environment itself.

ACTIVITIES AND SPACES

GREETING GUESTS

Greeting and welcoming guests as they enter the public sector of the house is an important social activity. Although perhaps taken for granted by household members, the entry foyer creates visitors' first strong impression of the home and sets the stage for their ensuing introduction to the lifestyle of the inhabitants. The entry also serves the critical function of efficiently directing and controlling traffic into and throughout the home. Guidelines for the physical requirements may include the following:

- **Space** sufficient to open the inward-swinging front door and stand aside for visitors to pass, and to assist them with coats. A space of 3 feet by 5 feet allows the host to open the door, stepping out of the way, while a 5- by 7-foot entry provides space to remove coats and hang them in a closet.
- Closet in or near the entrance with an interior at least 2½ feet wide and 2 feet deep. A 27- to 30-inch depth is better for accommodating bulky garments.
- **Lighting** both indoors and out for safety, security, and *ambiance*. Visitors should be able to see to enter without being blinded by excessive brightness; soft foyer lighting helps direct traffic to the brighter living area.
- Window(s) or a peephole device to identify visitors before opening the door.
- **Surfaces** on which to place packages, gloves, keys, or other objects while waiting or removing coats. A table or chest, a wall-hung console, or a shelf in a small foyer will serve this purpose and also add character.
- **Seating** for donning or removing boots or just waiting. A bench can provide both seating and a surface on which to put things.
- Mirror for checking appearance.
- Flooring that is durable and easily cleaned.

The entrance provides the transition from outdoors to indoors and should be compatible with both, architecturally and decoratively. It establishes the character and mood for the rest of the home and for the reception of guests. It can be friendly and inviting, indicating a warm open hospitality, or fortress-like, perhaps reflecting a desire for privacy on the part of the occupants. Either way, the first impression is often lasting.

9.1 The view from the entry establishes the character of this adobe house and draws guests into the living area without exposing it completely. Maurice J. Nespor & Associates, architects; Diana Cunningham, interior designer. (Photograph: Maurice Nespor)

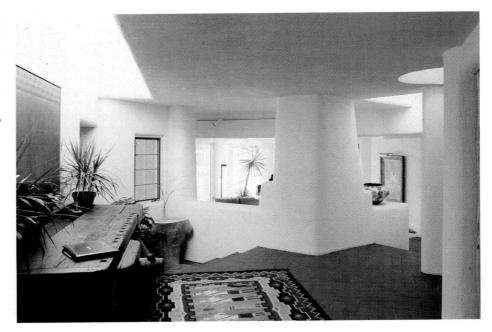

If at all possible, full sight of the living/dining quarters should be shielded from immediate view at the entry. In larger homes this can easily be accomplished by a separate, centrally located entrance foyer that routes visitors to the major social areas located adjacent to it or off the central hall. However, since it doesn't contribute to the living space, a separate area is not often included in lower-cost or smaller homes. In this case a divider—storage wall, bookcase, planter, or screen—can help segregate activities, provide some privacy, and create a sense of the larger living space drawing one toward it.

CONVERSATION

The most pervasive social activity is conversation, an exchange so much a part of life that we tend to take it for granted. Conversation may be seen as an amalgam of both verbal and nonverbal forms of communication—a pleasant exchange among family and friends. Obviously, we can and do talk together in any part of the home, but the most natural settings for group interaction are those spaces where people congregate—the living and dining areas. There are identifiable elements that are conducive to easy conversation:

- Space sufficient for the usual number of people who are present. A person in an easy chair, for example, needs a space nearly 3 feet wide by 4 feet deep, but with legs extended, a tall person may need a space over 5 feet deep. Aisle space for easy movement is also needed. Table 9.1 provides some standard furniture sizes and necessary clearances.
- Comfortable seats for each participant; a minimum of one good seat for each permanent member of the household and additional ones to accommodate guests. Stable seating, not too low and with arm supports, is advisable for the elderly or disabled. The choice of individual or multiple seating pieces may be a reflection of the size of household members' personal space bubbles, discussed in Chapter 7.
- Arrangement of seats and tables in a generally circular or elliptical pattern so
 that each person can look at others easily and talk without shouting, and so that

TABLE 9.1

Furniture Sizes and Clearance Spaces

		Small		Large		
Living Room	Depth	Width		Depth		
sofa	2'6"	\times 6'	to	3′	× 9′	
love seat	2'6"	\times 4'	to	3'	\times 5'	
easy chair	2'6"	\times 2'4"	to	3'4"	\times 3'3"	
pull-up chair	1'6"	\times 1'6"	to	2'	\times 2'	
coffee table, oblong	1'6"	\times 3'	to	3'	\times 5'	
coffee table, round	2' dia	meter	to	4' dia	meter	
coffee table, square	2'	\times 2'	to	4'	\times 4'	
occasional table	1'6"	\times 10"	to	3'	\times 1'8"	
card table	2'6"	\times 2'6"	to	3'	\times 3'	
flattop desk	1'6"	\times 2'8"	to	3′	\times 6'	
secretary	1'6"	\times 2'8"	to	2'	\times 3'6"	
upright piano	2'	\times 4'9"	to	2'2"	\times 5'10"	
grand piano	5'10"	$\times 4'10''$	to	9'	\times 5'2"	
bookcase	9"	\times 2'6"	to	1'	\times —	
Clearances						
traffic path, major	3'	to 6'				
traffic path, minor	1'4"	to 3'				
foot room between						
seating units and edge of top of						
coffee table	1'3"	to 1'6"				
floor space in front of chair						
or sofa for feet and legs	1'6"	to 2'6"				
chair or bench space in front						
of desk or piano	3′					

Small		Large
Depth Width		Depth Width
$3' \times 3'$	to	5' × 5'
$3'4'' \times 4'$	to	$4' \times 10'$
3' diameter	to	7'6" diameter
$1'4'' \times 1'4''$	to	$1'8'' \times 1'8''$
$1'10'' \times 1'10''$	to	$2' \times 2'$
$1'6'' \times 3'6''$	to	$2' \times 6'$
$1'6'' \times 3'$	to	$2' \times 4'$
$1'6'' \times 3'$	to	$1'8'' \times 4'$
1'6" to 1'10"		
1'10" to 2'10"		
1'6" to 2'		
	Depth Width 3' × 3' 3'4" × 4' 3' diameter 1'4" × 1'4" 1'10" × 1'10" 1'6" × 3'6" 1'6" × 3' 1'6" × 3' 1'6" to 1'10" 1'10" to 2'10"	Depth Width $3' \times 3'$ to $3'4'' \times 4'$ to $3'$ diameter to $1'4'' \times 1'4''$ to $1'10'' \times 1'10''$ to $1'6'' \times 3'6''$ to $1'6'' \times 3'$ to $1'6'' \times 3'$ to

a dead end is formed, averting traffic intended for other destinations that might disrupt conversation. One primary conversation arrangement should be ready for group conversation without moving furniture. A diameter of 8 to 10 feet across the seating area has proved the most desirable in typical situations. Research has shown that people prefer to sit across from one another to talk. However, if the distance across the conversation space is greater than the distance between two people seated side by side, most people will choose to sit side by side. Also, there is some evidence that as room size increases, conversation seating distance decreases. (Conversation distance in the home is much longer than

9.2 A self-contained conversation area, with sofas that face one another and optional individual chairs at right angles to another sofa, provides flexible seating arrangements to suit most people's spatial preferences in this Napa Valley, California, home. Thomas Bartlett, designer; Beth Christensen, art consultant. *(Photograph: Jay Graham)*

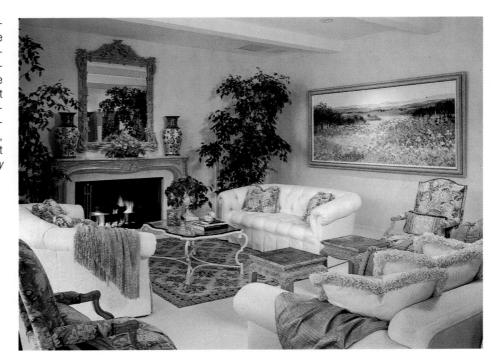

longer than in larger scale public places because of the smaller scale and more intimate atmosphere.) Increasing noise level and distraction also draws people closer together. 1

• **Light** of moderate intensity with highlights at strategic points. Soft, subtle general illumination helps create an intimate atmosphere while bright lighting is very arousing.

• Surfaces (tables, shelves, and the like) on which to place accessories and refreshments.

• Privacy from the entry and from traffic to other parts of the home.

Conversation thrives in a warm, friendly atmosphere if the architecture, furnishings, and accessories are spirited but not overpowering, if distractions are minimized, and if sounds are softened. Segregation from noise and traffic, and good ventilation (particularly if some members of the household smoke) help create pleasantly intimate and relaxed surroundings conducive to social interaction. Flexible seating arrangements that allow easy eye contact yet sufficient personal space for everyone are generally more successful than rigid built-in seating units, furniture lining the walls of the room, or too many long sofas. Movable, light-weight chairs provide flexibility in conversation areas. The very formal parlor (from the French *parler*, "to talk") or sitting room of past eras, used only on special occasions when someone came "to call," is not suited to most current lifestyles, activity patterns, or budgets.

A large space may accommodate a secondary seating group or activity center for one to several people. Usually smaller than the primary grouping, the additional furnishings may consist of two easy chairs with a table and reading lamp, a window seat, a game table and chairs, writing desk and/or a comfortable reading chair with good lighting, or a piano. Figures 9.4–9.7 illustrate spatial requirements for both primary and secondary seating arrangements. Each unit should be held together visually by a compact arrangement and by the use of architectural or decorative features that make it cohesive. A fireplace or pleasant view, for example,

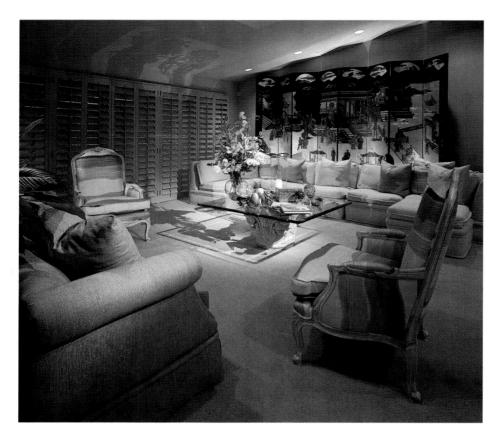

9.3 This interior by Dennis Haworth, FASID, evokes tranquility—insulating its occupants from distractions with a wall of plantation shutters and providing a beautiful Oriental screen for visual emphasis. It also offers seating arrangements to accommodate a range of proxemic patterns. (*Photograph: Steve Simmons*)

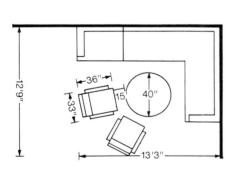

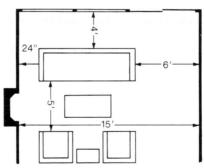

- **9.4** (left) A corner group with coffee table and occasional chairs, with dimensions noted, is one possibility for arranging furniture in the major group space.
- **9.5** (right) A sofa facing two easy chairs and set at right angles to a fireplace creates a strong unit for the primary conversation center.

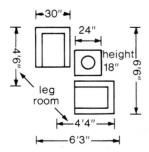

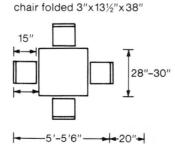

table height 251/2"-263/4"

- **9.6** (left) Two easy chairs flanking a table with a reading lamp provide a secondary seating area in the social space.
- **9.7** (right) A game table with four chairs requires only 25 to 30 square feet of space and creates a secondary activity unit.

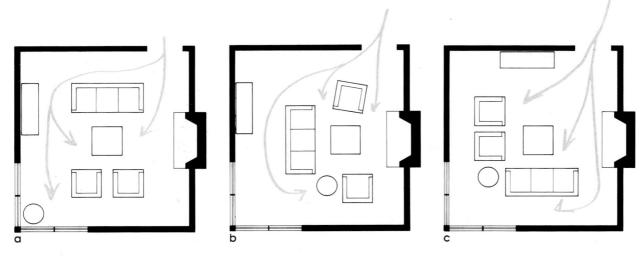

9.8 Furniture placement creates traffic patterns within a room. **a**:This arrangement is cumbersome. The sofa blocks the main view into the room. Although privacy is afforded for conversation, moving around would be difficult. **b**:Here the sofa is better placed, allowing room for circulation. **c**: A living room should welcome people into the conversation area; this is the best arrangement.

creates a strong natural focal point, while an area rug delineates a specific space. The arrangement should invite use while discouraging the cross-traffic of non-participants, as shown in Figure 9.8.

Group conversation is also the normal accompaniment of meals because the furniture and its arrangements afford ideal conditions for an hour or so. Terraces and patios are natural conversation centers as well when they offer good seating, privacy, and some degree of shelter.

READING .

Some fortunate people can read with total concentration even in the most trying circumstances—noise, people talking, movement back and forth around them—by screening out all distraction. Most of us, though, when we settle down for a quiet hour or an evening with a book, prefer a more tranquil environment. Here are some essentials:

9.9 This quiet balcony provides a perfect spot for a variety of activities with its natural light, beautiful view, and card table and chairs all set up for a game. Nelson Denny, designer-builder. (Photograph: © Karen Bussolini)

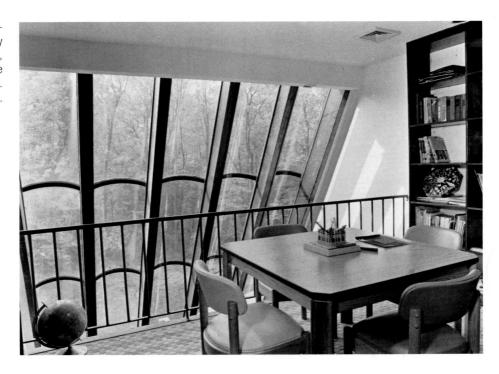

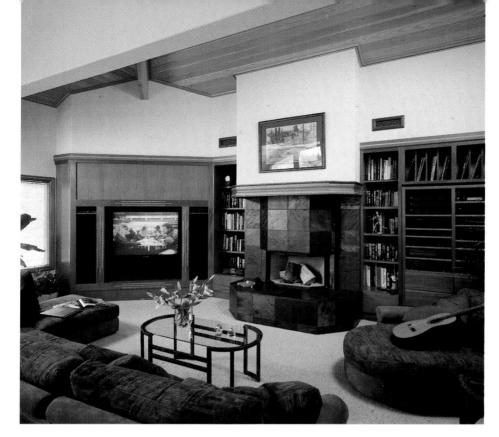

9.10 The design concept in this multimedia room was to create an elegant living room and theater in one. Black slate was used on the fireplace to balance the 50-inch theater screen on one side and the electronic components on the other. All three are unified by the mahogany casework with maple inlay. Cathy Nason, ASID, interior designer. *(Photograph: Jay Graham)*

- **Seating** that is resilient but not soporific, giving adequate support to the back (and to the neck and arms as well) for maximum comfort.
- Light coming over one shoulder. Either moderately strong daylight or artificial lighting that generally illuminates the room and concentrates fairly intense but diffused light specifically on the reading material. The entire room does not need to be flooded with uniformly strong light, but neither should it be left in darkness with only a pool of light on the reading material. (More specific lighting information is provided in Chapter 21.)
- Security from distracting sights, sounds, and household traffic. Soft music can
 provide a soothing method of muffling other household sounds without distracting attention from reading material.

Beyond these minimum amenities, add nearby tables or other surfaces, accessible shelves to hold books and magazines, and enough space to stretch the eyes occasionally. Such conditions, which are adequate for more-or-less casual reading, can be achieved easily in the typical living area. If, however, one or more members of the family often do serious or technical reading, they may require greater seclusion, and a study or other private place should be planned appropriately. (Requirements for a home office are discussed in Chapter 13. However, depending upon intended use and need for seclusion, a place for study or business-related paperwork may be located within the social zone or even the work zone of the home.)

QUIET GAMES

Most games require some degree of concentration. A well-illuminated table about 27 inches high plus moderately high straight chairs—all situated free from distractions—will provide the most relaxing conditions. Folding card tables or the new lower dining tables and dining chairs set up in the living, dining, or family room will suffice for most households. Serious gamesters, however, may want a table and chairs permanently and suitably placed, a neutral background for fewer distractions, lighting over the table, and storage for games and accessories nearby.

AUDIO-VISUAL ENTERTAINMENT

Bringing the theater, cinema, concert hall, sports field, and even the classroom, office, and arcade into the home has markedly altered patterns of both leisure and home life. Stereo and television especially, but also home theaters and computers, have become important sources of home entertainment and require special planning if they are to become integrated into the total home design.

MUSIC For many Americans today, music is an integral part of life, as natural as eating or sleeping. Its source may be simply a small FM tuner, CD (compact disc) or tape player, but more and more in recent years, music in the home has become centered on a complex arrangement of sound system components that may require considerable space. Further, the space must be kept flexible, because the number and shape of the components change as new designs become available and as the listeners' sophistication increases.

At the same time, greater numbers of people enjoy creating their own music. Small instruments such as guitars pose few problems, but the placement of a piano is a major design consideration. An upright piano can be flat against a wall or at a right angle, in the latter case helping to demarcate a partially segregated area while also allowing clearer musical tones. For spatial efficiency or architectural harmony, diagonal placement is not generally recommended. A concert grand piano requires 50 square feet of space (a baby grand occupies just over 20 square feet, a parlor grand 30 square feet) and should be placed with straight sides parallel to walls and curved side facing listeners so that when the top is raised, it will project sound toward them. Because fluctuations in temperature and humidity can affect sound quality, a piano should not be placed near a window or heating/cooling vent. Placement near an interior wall is recommended.

9.11 This custom cherry sound system cabinet is designed not only for flexible configuration but also so that the geometry of the wall unit is deliberately broken up to serve the acoustical function of diffusing sound. Keith Yates AudioVideo, designer. *(Photograph: Ed Asmus)*

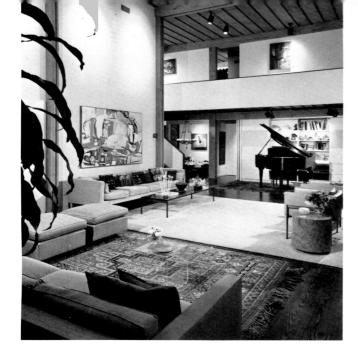

9.12 A living room designed for live musical performances should meet as many of the criteria for good acoustics as possible: a combination of live surfaces to bounce sound and dense ones to absorb reverberations, both properly placed for their sound-enhancing qualities. (The floor plan is shown on the next page.) Eve Frankl, interior designer; George Van Geldern, architect. (Photograph: Ezra Stoller © ESTO)

Serious musicians may want a separate music center in a corner, an alcove, or even a whole room, where everything can be kept together and out of the way of other activities. Such an arrangement would be especially necessary when several instruments are involved or when they are connected to amplifiers—a combination that occupies quite a bit of space, produces a staggering volume of sound, and may require sound insulation or barriers from the rest of the house, such as acoustical paints, wallboard, and ceiling; sound traps in ducts; and insulated pipes. During initial planning and construction, hallways, stairs, closets, built-in cabinets, and bookshelves can be located to help provide *sound barriers* (further explained in Chapter 14.)

Optimum acoustic conditions for listening to music depend on what the particular listeners want. For many people, conditions similar to those recommended for group conversation or quiet reading will suffice—comfortable seating, moderate illumination, and a minimum of distraction. But committed musicians who have an intense concern for the quality of sound will demand further refinements. Although the quality can be no better than that produced by the instruments and performers or by the sound system, several factors (notably the arrangement, composition, and shape of a room) can enhance or detract from the production of ultimate quality:

- **Seating** should be arranged so that the listeners hear a balanced projection from the instruments or from multiple speakers.
- **Space** can be shaped to enhance the sound. Experts have long known that musical sounds have a finer quality in rooms whose opposite surfaces are not parallel to each other or in which the space is broken up in some way.
- Materials are often chosen and placed for their acoustical qualities. In acoustical terms, materials are classified as sound-reflecting or "live" if they bounce the sound (as does plaster or glass) and as sound-absorbing or "dead" if they soak up sound (as do heavy draperies, upholstered furniture, carpet, books, cork, or other so-called acoustical materials). An excess of live materials gives strident amplification and reverberation; the converse, having too many dead surfaces, robs music of its brilliance. For best results, live surfaces should be opposite dead surfaces.

Many of the devices that improve acoustical quality have been incorporated in the living room planned by interior designer Eve Frankl whose husband, Michael Pollen, is a pianist and conductor (Figure 9.12). Placed before a storage wall at the

9.13 The plan shows the flexibility of space for accommodating large or small audiences. Eve Frankl, interior designer: George Van Geldern, architect.

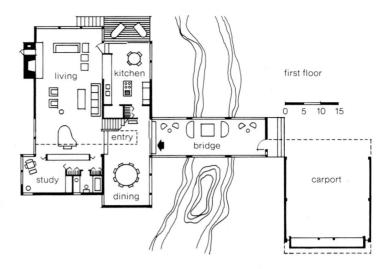

inner end of a long living area, the piano is protected from sudden temperature changes that might affect the strings and hammers. An overhanging balcony at this end of the room and a slanting wood surface above a glass wall at the opposite end answer the requirement for contradictory opposing surfaces, breaking up the space for good sound quality. Rugs, deep upholstered seating and pillows, and a bookshelf-storage wall balance sound-absorbing materials against the live surfaces of plaster and glass. As the plan above shows (Figure 9.13), sufficient seating is provided for a small group of listeners, but plenty of open area leaves the potential for a larger audience who could sit on the floor or on specially set-up chairs. Good lighting is suspended above the piano for reading music, and enough space has been left for other instrumentalists to participate in an evening of live music.

Stereo Speakers The placement of speaker systems within a room can have a significant influence, for better or worse, on the way they sound. Some experimentation is always necessary to achieve best results and a consultant may be needed for elaborate sound systems installed throughout the house. In general, speakers should be installed as the manufacturer recommends: systems intended for shelf mounting should not be placed on the floor, nor should they be installed too high above the ear level of a seated listener. Placing speakers in, or too close to, a corner, or directly adjacent to a wall or floor, adds significant bass to the sound. Avoid installing speakers behind draperies or large pieces of upholstered furniture that will acoustically absorb their high-frequency sound output.

When only two speakers are used, they usually have the most balanced sound when they are located on the long wall of a room, spaced 6 to 10 feet apart, equidistant from the room corners. The preferred listening position is in the area opposite the speakers and roughly centered between them. In general, the speakers-to-listening area distance should be a little less than one and a half times the distance between the speakers. For speakers placed 7 feet apart, this would mean a listening distance of roughly 10 feet (see Figure 9.14). This rule depends very much upon the specific acoustic characteristics of the speakers and of the room. A thick rug or carpet between the speakers and listening area will do much to control excessive acoustic reflections.

If the stereo image is too narrow, the speakers are too close together for the listening area. If, on the other hand, there appears to be an acoustic "hole" between the speakers, they are spaced too far apart. The distance between the speakers—and between the speakers and the listening area—should be adjusted by trial and error to achieve the most natural spread of sound. Newer "surround sound"

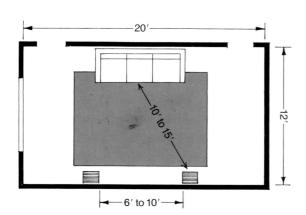

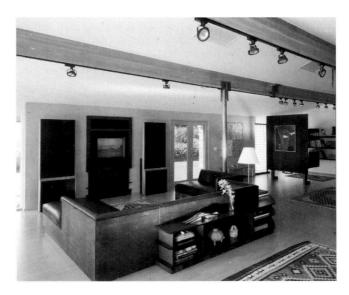

systems require as many as six or more small speakers located throughout the room, often recessed in the walls and/or ceiling, with more speakers toward the rear of the room.

VISUAL MEDIA Major considerations for home projection activities are good seating, control of light and sound, and insulation for those who do not care to participate.

- Seating requirements are much like those for conversation, except that the seating should be arranged within a 30-degree angle of the center of the screen to avoid distortion. Easily moved or swivel chairs offer flexibility; backrests or cushions on the floor increase a room's seating capacity, while long lounges accommodate viewers in a variety of positions.
- **Height of screen** should be as near eye level as possible, with the angle from the eye to the center of the screen no more than 15 degrees for maximum viewing comfort. Eye level for most seated adults is 38 to 42 inches above the floor.
- **Lighting** of low intensity is necessary especially for watching television, but the light should shine neither on the screen nor in the viewers' eyes. Flexible control is important; the area around the screen should be darker than the viewing area.
- Acoustical control is similar to that for music.

Although still cumbersome, especially in depth, television receivers can be put in many places, depending upon the lifestyle of the household and its members. Living rooms and family rooms are perhaps the most typical locations, but television sets, possibly small second ones, also appear in bedrooms and kitchens. If they are mounted in walls, television receivers can be treated as part of the wall design or hidden behind doors. Where feasible, they can be positioned to serve more than one room. Mounted on a portable stand, a television set can be pushed from place to place as it is needed, although this precludes permanent hookup with an outside antenna or cable. A swivel base permits turning the set toward viewers.

With the introduction of large-screen projection television, a specially designed space may be desired for audio-visual entertainment—the media center or even a home theater. The projection television set provides a movie-size picture with a screen as large as 6–10 feet. With cable television networks, home satellite

- **9.14** (above left) The stereo speakers and seating are positioned for optimum sound quality in this plan. (Adapted from Larry Klein)
- **9.15** (above right) Large-screen television viewing should be from within a 30-degree angle of the screen, as in this seating arrangement, which permits either stretching out for maximum comfort or seating several people within the critical viewing angle. Frank Israel, architect. (Photograph: Tim Street-Porter)

receivers (microwave dishes), videocassette recorders (VCRs), and video laserdisc players, the home entertainment center offers a wide choice of viewing subjects. Even the sound can be enhanced by connecting the projection set to an audio system also located (often built into the walls) in the media room. Videodisc players can be connected to the projector and the home stereo system.

The components of big-screen television may be either a one-piece unit that folds up in a cabinet about the size of a regular TV console when not in use or two pieces—a video projector (receiver) that can be used as a table, built-in or suspended from the ceiling, and a separate screen. The two-piece format offers more flexibility in design. Distance from projector to screen should be approximately 1.5 to 1.7 times the width of the screen. Rear projection units can also be used, but they require a large space behind a flat, fixed screen. The specific viewing requirements are as follows:

- Space for comfortable viewing at a distance of two to three times the diagonal measurement of the screen. The depth of the viewing area should be greater than its width, but room size will probably be more directly related to the number of viewers to be accommodated and other desired uses for the room (a guest room, for example). Or, a separate room may not be necessary: an alcove or corner of another living/social space may be used.
- Seating that is comfortable and within the critical viewing angle and distance.
- **Lighting** of low to moderate level, placed outside the viewing angle so that it doesn't reflect on the screen. Curved screens reject ambient light better than flat screens which require a darkened room. If placed so that windows are not within the viewing angle, projection television can be used in daylight.

Portable screens for slide viewing fold easily for storage when not in use. However, when home projection is an important activity, a permanently mounted screen that disappears behind a cornice or other fixture near the ceiling should be considered.

Unlike stereo and television, which are usually a group diversion, electronic video games are essentially a one- or two-person pastime. They range from small handheld units through a great variety of components that can be plugged into computers or into the television receiver itself. Being small or movable, they can usually fit into any available space, from hand to table to floor, but the noise they may generate can quickly become disruptive. Placement in a space remote from general living may be indicated—a separate family or media room or a bedroom.

The computer, however, is more than just an entertainment medium. It has become increasingly important as a tool for work in the home, the processing of data, business transactions, and even shopping. Its place in the total pattern of home life is still being explored. (See Chapter 11 for further discussion of the home office.)

ACTIVE INDOOR ENTERTAINMENT

Dancing, table tennis, billiards, and other such vigorous activities require plenty of space, noise control, light, storage, a durable floor, and furniture that can be pushed out of the way. So do a stationary bicycle or other exercise equipment. Space may be the primary consideration and a precluding factor for activities such as table tennis, which requires 5 feet of clearance on each side and 7 feet at each end of the 5-by-9-foot table, or pool, with the table measuring approximately 5 feet by 10 feet and requiring 5 feet of clearance all around. A large family room, recreation room, or similar space accessible to family members and visitors in the social zone—and, increasingly, community group spaces—can offer an ideal location.

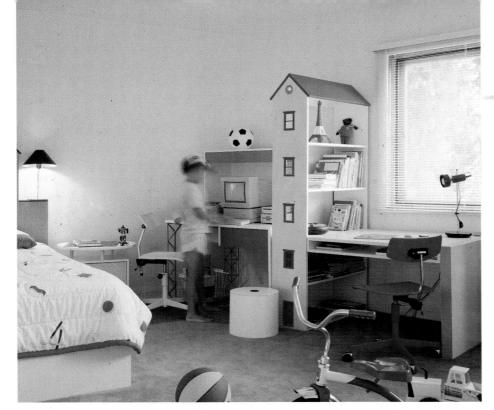

9.16 In addition to toy, game, and book storage, and a work/ study space, a child's bedroom often contains a computer, which may provide entertainment and be used as a learning tool. It should be placed, as shown, where strong light from a window neither reflects on the screen nor shines in the user's eyes. (*Photograph: Tim Street-Porter*)

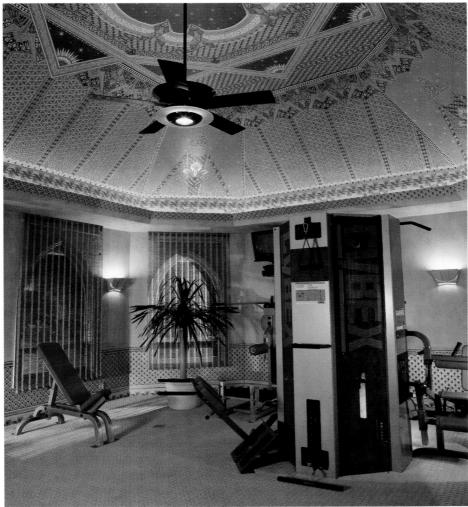

9.17 Few homes offer the luxury of a separate exercise room. This was an addition to a home in San Jose, California. The exotic Middle Eastern Moorish theme was achieved with a collage of approximately twenty different wallpapers on the 15' ceiling and windows with Moorish arches finished in gold leaf. A sound system is built into the soffit around the room, which houses two exercise stations in addition to the weight training unit. Suzy Schradle-Walker, interior designer. (Photograph: David Livingston)

OUTDOOR ENTERTAINMENT

Most of us feel the urge to get a little closer to nature. Even in the cities, more and more apartments boast outdoor terraces, which may be quite small but give a semblance of expansion into the out-of-doors. For those fortunate enough to live in more spacious quarters, outdoor areas—decks, terraces, patios, porches, gardens, or lawns—are a logical extension of the indoor group space. Well conceived, out-door living areas can augment the usable entertainment area. For maximum use, these spaces should be located adjacent to living rooms, family rooms, and/or dining rooms and kitchens, and oriented for sun (or shade), breeze, and privacy. Out-door furniture should be lightweight, durable, and easily cleaned to cope with sun, rain, dust, and casual treatment. Many times furnishings can be used indoors in a solarium, greenhouse, or recreation room during winter months.

The frequency with which outdoor space is enjoyed depends on the durability and dryness of the underfoot surfaces, the protection from weather, the privacy given by fences or hedges, the safety for young children, and the comfort with which some can rest while others play energetically.

9.18 The Malibu, California, home of architect Buzz Yudell and graphic designer (and avid gardener) Tina Beebe fits the constraints of a long, narrow hillside lot bordered by a dry creek, and it invites interaction with the landscape and mild climate by incorporating pergolas that function as garden rooms and a terraced street that links a series of courts. Here, a vine-covered pergola invites a leisurely lunch or a peaceful respite. Moore Ruble Yudell, architects. (Photograph: Timothy Hursley)

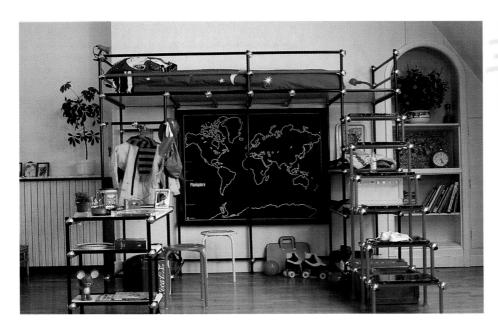

9.19 "Power Diffusion", a modular unit for a child's room serves as both functional furniture and play structure. It also frees floor space for other activities. (Photograph: Annet Held/Arcaid)

CHILDREN'S ACTIVITIES

The needs of children range from boisterous play to quiet reflection; from eagerness to join others of their own age to desire for solitude; from wanting to be with the family to carefully avoiding it. Basic elements of a child's play area are as follows:

- Space adequate for the discharge of abundant energy.
- **Convenience** to a toilet and to the outdoors, as well as to the kitchen or informal eating area, and perhaps the home office for adult supervision.
- Surfaces and fixtures (walls, floors, and furniture) that can take punishment gracefully and lend themselves to change.
- Light, warmth, and fresh air conducive to healthy young bodies.

Ideally, all this should be segregated from what (it is hoped) will be the quieter portions of the house.

A living room is clearly unsuitable for a permanent play space, and the dining area is only slightly better. A kitchen has the requisite durability, but even without children's play it is usually the most intensively used room in the house and, moreover, contains the household's greatest assembly of potential hazards. In older houses attics and basements served as playrooms for children, but these were often cold, dark, damp, and far from any supervising eye. Garages and carports have obvious disadvantages. This leaves two major solutions.

A family room, particularly if it is located off the kitchen or near the children's bedrooms, can be an ideal play space during the day, transformed into a general group leisure area in the evening. A truly multipurpose space, the family room can provide for changing needs as children grow. Furnishings in a family room are generally less "formal" and more durable than those in the living room and may be dual-purpose for greater flexibility. Too, such rooms often serve for storage of games and books, and frequently house the television set and other audio-visual equipment.

The children's bedrooms themselves or an adjacent area may make excellent play spaces since they already are (or should be) planned for the children to make into their own territories. A widened bedroom hallway can be both economical

9.20 This community swimming pool in Highland Village, Texas, like many such facilities, provides outdoor recreation for occupants of the housing development. (Courtesy Highland Shores, a Mobil Land Community. Photograph: Gary Donahue/Photos Aloft.)

and efficient; the bedrooms might open into a multipurpose room or combine with each other to provide a space large enough for playroom, library, museum, and hobby center as well as study and retreat for teens who need privacy and sound control.

Many small houses and apartments cannot offer even a modest area that meets the above criteria. This limitation is one of the reasons for the inclusion of community leisure facilities in large-scale housing developments, a feature that is becoming ever more popular (Figure 9.20). Such entertainment spaces often serve adults as well as children.

DINING

Eating is a lively part of group living, for meals are often one of the few daily events that bring an entire household together with a single purpose. Entertainment of friends almost always involves the consumption of food, ranging from snacks to multicourse dinners. Nearly every society recognizes the offering of food as the standard token of hospitality to guests.

The traditional multipurpose house with single-purpose rooms, common in the United States through the early part of this century, generally set aside one enclosed space called the *dining room* in which all meals—with the possible exception of breakfast—were taken. Frequently, this room had no purpose other than dining. Even today many families enjoy the specialness of a separate dining room that creates a particular atmosphere for meals; however, with increasing interest in flexible space, fewer and fewer households are willing to set aside a completely isolated space that will be used for only a couple of hours a day.

Just how open or closed the dining space should be depends in large part on the amount of room available and on the lifestyle of the household. In many homes, instead of one totally separated dining room, there are two or more dining spaces that merge into other areas and that can be used as circumstances indicate. Common examples include the living-dining area in an open plan home and eating space provided in kitchens or family rooms.

DINING NEEDS When planning dining situations, consider the requirements for eating in general, the specific needs for meals of different types, and finally the individual living patterns of the household. The essentials are as follows:

- Access from the kitchen for ease in serving and clearing, and on the same floor level as the kitchen for convenience and safety. Easy access from other social spaces, including outdoors, is also advantageous for both guests and family members.
- Surfaces on which to put food and utensils, usually 27 to 30 inches high, but lower when indicated or desired. The age and physical condition of various group members are important here: limber young people can be happy at low tables that would be uncomfortable for many older people; small children are safer and more content at child-size tables. Each place setting requires a space 2 feet wide and 16–18 inches deep.
- **Seats** giving comfortable, usually upright support, such as chairs, stools, builtin or movable benches (banquettes), scaled to the height of the table. Chairs with arms assist the elderly or disabled in sitting and rising from the table.
- Light, natural and artificial, that illumines food, table, and people without glare. Too strong light in a downward direction on diners' faces is very unflattering; softer light in an upward direction, such as candlelight or light reflected from the table top itself, is more becoming. Chandeliers or other pendant fixtures must not be hung so low as to interfere with visual contact across the table or head room needed when preparing or clearing the table.
- Ventilation free of drafts.

To these essentials we must quickly add that convenience to kitchen and dish storage saves energy, freedom from excessive noise calms nerves and helps digestion, and pleasant surroundings and table settings raise spirits.

Many dining areas allow little choice in arranging furnishings. The table is usually placed in the center with a cabinet or buffet for storage against the longest wall. A storage wall between kitchen and dining area, accessible to both, is very efficient. Corner cupboards provide storage and display space in small rooms. Where space is limited, a round or oval table will free more floor space and seat people more easily than a square or rectangular table of the same outside dimensions. Chairs that are wider in front than in back often unnecessarily take up too much space around the table. Figure 9.21 illustrates the amount of space required for six people in various dining arrangements. A wall-hung shelf or counter can suffice for serving or eating in cramped quarters (Figure 9.22).

Remember that people need space too: 24 inches wide by 18–24 inches deep when seated at the table (24"–30" of depth for a wheelchair), with 20 inches of leg

9.21 a: A rectangular table in the center of the room requires space for access and circulation all around. b: A round table in the center of the room requires less space than the rectangle seating the same number of people. c: A rectangular table with one short side placed against a wall can seat an additional person in still less total area. d: A table placed for built-in seating along two sides seats six in the least amount of space but limits accessibility.

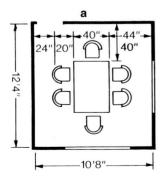

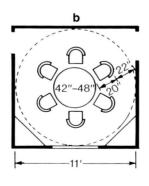

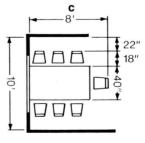

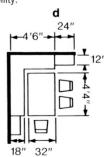

- **9.22** (right) A counter eating space is usually limited to informal, quick dining. Drawing by Robert L. Keiser. (Adapted with permission of the Macmillan Company from Housing: An Environment for Living, © 1978, by Marjorie Branin Keiser)
- **9.23** (far right) Space required to access a dining table. (Adapted with permission of the Macmillan Company from Housing: An Environment for Living, © 1978, by Marjorie Branin Keiser)

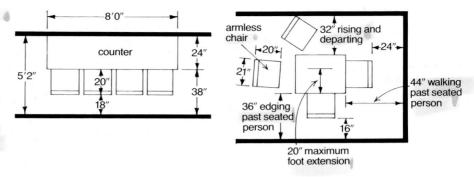

room under the table. Figure 9.23 shows the access space that people need for serving and dining. Figures 9.24 and 9.25 illustrate standard sizes of rectangular and round tables, indicating the number of people they can accommodate.

DINING PATTERNS In many homes a variety of eating patterns prevail, but usually one will predominate, sometimes at different times of the day: a short breakfast at the kitchen counter as members start the day one by one; snacks during the day, often in front of the television set; and perhaps a leisurely sit-down dinner where the day's events are discussed.

Sit-Down Meals Because they traditionally represent the ideal norm, sit-down meals deserve first attention. For these there should be one adequately large, relatively permanent space planned so that the table can be prepared, the seating arranged, the meal served and eaten, and the table cleared with minimum interference to and from other activities (Figure 9.26). The dining area may answer these criteria and yet remain integrated with the rest of the group space, flowing easily into kitchen and/or living space with only partial seclusion from other activities. The household that entertains frequently with rather formal dinners may want a completely separate dining space that can be screened from living-room view during setting and clearing and is protected from kitchen odors and noises.

- **9.24** (below) Standard sizes for rectangular dining tables. (Adapted from Nomadic Furniture by James Hennessey and Victor Papanek)
- **9.25** (right) Standard sizes for round dining tables. The figure in the center shows the number of people that can be accommodated comfortably by each. (Adapted from Nomadic Furniture by James Hennessey and Victor Papanek)

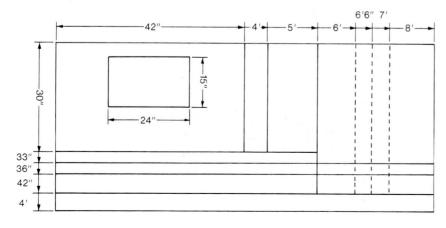

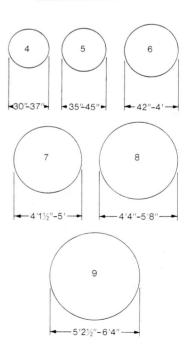

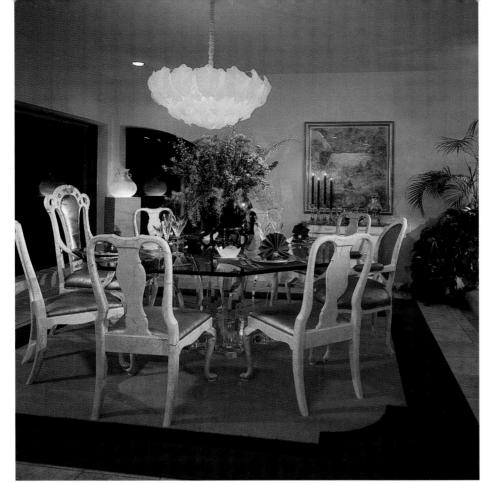

9.26 A formal dining space should be at least partially segregated from other activities and should provide a pleasant atmosphere for eating and social interaction. Dennis Haworth, FASID, interior designer. *(Photograph: Steve Simmons)*

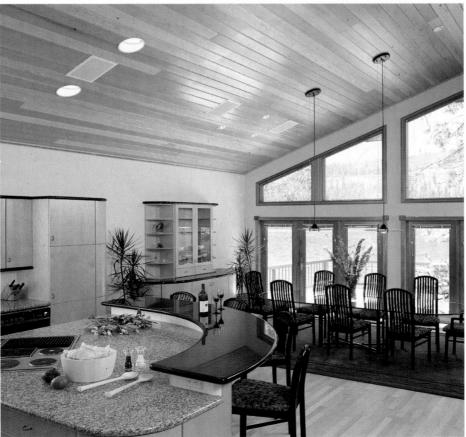

9.27 The dining space in this home is defined yet open to adjacent areas for expansion when necessary. Open space planning was used so that no walls would interrupt the view of Donner Lake, located in the mountains above Truckee, California. Black granite slabs and black lacquer chairs unify the dining area and distinguish it from the kitchen. Maple cabinetry, a single ceiling plane, and wood floors are common elements of the two areas. Cathy Nason, ASID, interior designer. (Photograph: Jay Graham)

Important events involving the extended family may occur infrequently, and the necessary space can rarely be reserved for them alone. This suggests a dining area with at least one side opening to another part of the house or to the out-of-doors, permitting the celebration area to extend as the number of participants increases.

Buffet Meals Buffet meals simplify the labor of serving food and make it possible to use the entire group space for eating, all of which can lead to a lively informality. If buffet meals are to be handled often and successfully, cafeteria procedures suggest a number of guidelines: good carrying trays, not-too-precious dishes and glassware, service counters near the kitchen, traffic paths that avoid collisions between tray-laden people, convenient places to sit and to rest the food. The dining space in Figures 9.28 and 9.29 would serve well for buffet meals, since

9.28 A separate dining room provides a fresh and pleasant area specifically designed for serving and eating meals. In this room built-in cupboards hold tableware and linen and act as serving counters. A small breakfast for one or two would be delightful in the bay window. Judith Chaffee, architect; Christina A. Bloom, interior designer. (Photograph: Ezra Stoller © ESTO)

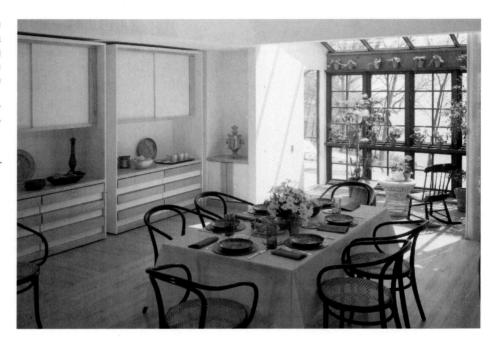

9.29 The serving cupboards pivot 90 degrees to open the dining area to the living room. Judith Chaffee, architect; Christina A. Bloom, interior designer.

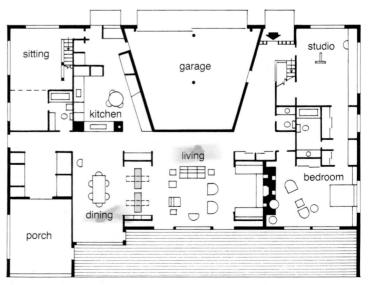

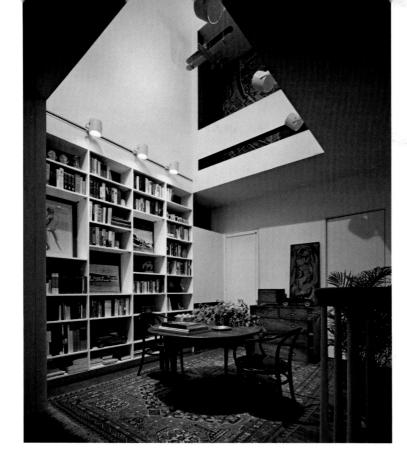

9.30 In most households today, dining space must fulfill more than one role. When not in use for meals, this handsome room doubles as a library-study. George Hartman and Ann Hartman, designers. *(Photograph: Robert C. Lautman)*

it opens to both the outside deck and the living room. Built-in buffet cupboards on one side of the dining area pivot 90 degrees to merge the living and dining spaces.

Snacks and Quick Meals Some people rarely eat "meals" at all but rather maintain a lifestyle that calls for a series of snacks or fast foods, for one or several, at frequent intervals throughout the day. When members of the household function on different time schedules, mealtimes will inevitably vary. The primary goals in planning space for eating, then, will be speed and economy of effort, but a minimum of interference with other activities is also important. Counters and stools adjacent to the cooking area of the kitchen often work well. A small dining table and chairs near a supplementary quick-meal preparation unit such as a microwave oven can be most helpful in reducing congestion in the kitchen proper. Small, collapsible TV tables can be useful elsewhere in the house. A scaled-down table for children's snacks may also be desirable, particularly if an adult is not sitting at the table with them and, of course, if space is available.

Small Children's Meals A central part of family life, consuming food, is both an adventure and a challenge for small children who often play and experiment as well as eat. Common sense suggests providing a place—preferably in the kitchen, playroom, or family room—with durable, easy-to-clean surfaces where spilled or scattered food does not precipitate a crisis. But at an early age children want to eat with adults and mealtime can be an important time for family bonding. Again, the design of the house, as well as the selection of finishes and furnishings, should reflect this usage so that everyone in the family can enjoy dining together.

Because dining space functions for only short periods during the day, many newer houses are designed in such a way that the dining area has a dual role. For example, in a small remodeled house in Georgetown (Figure 9.30), the dining space is also a library, with a bookcase wall and a table serving for reading or study when it is not needed for meals.

After considering the character and demands of specific social activities, it is obvious that many social activities occur in more than one part of the home and result in different levels of noise and movement. Planning for the social spaces demands that everyone's needs and desires be considered and realized as completely as possible. If the spaces are designed to elicit positive emotional reactions, what environmental psychologist Albert Mehrabian² terms *approach behavior*, rather than the negative *avoidance behavior*, they will draw people to them, enhance interaction, and can even improve the performance of tasks. Living areas will also be used more often if they provide a pleasurably stimulating atmosphere that allows the household members to feel in control.

LOCATION

Basically, two options present themselves in designing the living space for a home. It can be one large open area, suitable to a variety of purposes and used intensively by all members of the household, or the total space may be subdivided into a series of smaller spaces, each suitable for a particular range of activities.

The converted barn illustrated in Figure 9.32 obviously chooses the former point of view. Spacious, airy, and open, this group space functions as sitting room,

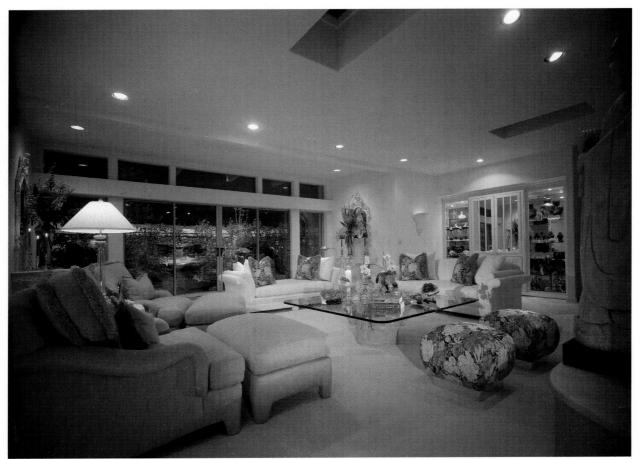

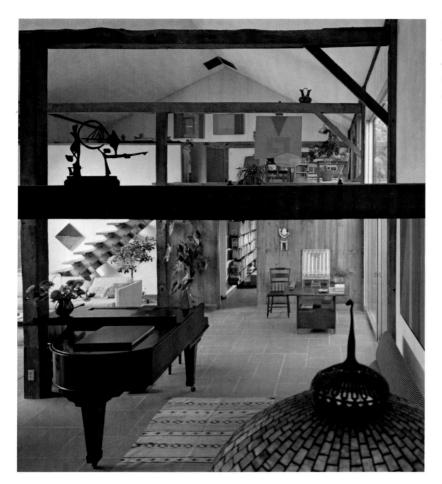

9.32 A sensitive demarcation of different areas—created by varying levels, structural members, and furniture placement—can prevent a large, open group space from seeming barnlike, even in a converted barn. James McNair, designer. (*Photograph: John T. Hill*)

entertainment center, music room, and game room; it flows easily up onto the balcony studio and into the library. Nevertheless, the space has been shaped imaginatively to partially segregate various activities. Exposed wood beams serve visually to break up the space and demarcate certain areas; the placement and orientation of furniture cause it to fall into several natural groupings; and positioning the studio on a balcony isolates it from the rest of the space both physically and psychologically to allow for a greater measure of privacy.

For many homes today, two separate group spaces seem the only way to meet the needs of differing ages, activity groups, and household types. The first, of course, is what for the last century has been called the living room—a portion of the home intended as the main social area. But in the second half of the century the need for a second discrete social space came to the fore. Originally considered as a device to keep the living room neat and clean, such areas (called family rooms, playrooms, recreation rooms, media rooms, multipurpose rooms, or great rooms) have increasingly become alternative spaces for group living. As a rule they are informal and easily maintained. They can be partially visible extensions of the main group space, but work best when they have the potential for total segregation. Typically, such rooms provide for children's or adults' play and possibly for hobbies. They are ideal locations for television, radios, games, and both live and recorded music. Family rooms often adjoin the kitchen for ease in serving informal meals or snacks, or they may be near children's bedrooms to provide overflow space for their play. Easy access to the outdoors is highly desirable.

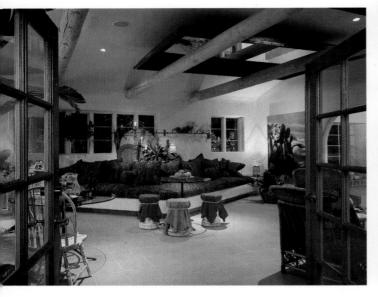

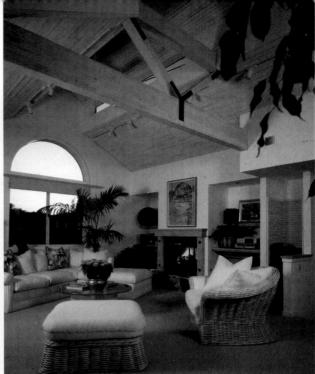

9.33 (above,left) A family room can accommodate many activities in an informal setting such as this space with adobe walls, lodgepole beams, terracotta pavers, and ample French doors to an outdoor entertainment area. A variety of seating and tables permit whatever pursuits family members enjoy. Paulette Trainor and Bruce Benning, both Allied Members ASID, interior designers. *(Photograph: Ed Asmus)*

9.34 (above,right) Casual furnishings, a fireplace, an openbeamed ceiling, and unobstructed light offer a comfortable place in which to relax, watch television, listen to music, talk, or just watch the sun set. Graber/Rasmussen, architects; Bruce Benning, Allied Member ASID, interior designer. (Photograph: Steve Simmons)

ROOM SHAPES AND SIZES

Engineer Ernest Weidhaas³ advises that "there is no such thing as an average, or standard, or even ideal, size or shape for a room. Design a size and shape that will best meet the requirements of function, aesthetics, and economy." Architects and designers begin with minimum or average room sizes and a knowledge of good proportion, then plan spaces according to how and by whom and for what they will be used.

Most rooms are rectangular with width and length approximating a ratio of 2:3. (Proportion is discussed in Chapter 6.) Another shape based on the rectangle is the **L**, popular for combined activity areas such as living-dining. Square shapes are difficult to arrange furniture in, as are long narrow rooms that may seem like corridors; however, much can be done to alter apparent size and shape through furnishings, light, and color. Arrangement of space can be more important than amount; well-planned multipurpose spaces can functionally surpass the individual rooms often found in the larger homes of years past; open plans contribute to an illusion of space by combining activity areas, while large window areas and outdoor living spaces appear to expand space to the outdoors. From the beginning, it is important to realize that perceptual space consists not only of physical space but also of visual and acoustical space that may contribute as much to psychological well-being as actual square footage.⁴

The size of these social spaces may be strongly affected by family values in the areas of aesthetics, leisure, and social prestige. Many people want their living room to be the largest and best-furnished room in their home. Generally, the more occupants to the household, the more space devoted to personal and/or leisure activities. This rule of thumb directly increases the relative size of social and private zones while the service areas remain fairly constant in size.⁵ Reduced workweeks and household labor-saving devices also increase leisure space needs. Federal agencies such as the Public Housing Authority and the U.S. Department of Housing and Urban Development recommend minimum sizes for some rooms, but average sizes are usually considerably larger. The figures in Table 9.1 (page 193) are only a starting point. Each room should be planned with its specific purpose in mind; size is interdependent with function and psychological space needs.

The many details discussed in this chapter are important, but they should not obscure major goals, which focus on basic human values. The social quarters of any home should give each person who lives in it a sense of belonging in the household group and encourage each to play a supportive but unconstrained role in the family pattern. Each individual deserves the opportunity to express personal aptitudes, feelings, and desires. In short, a successful group space should promote the security, self-realization, and socialization of each member of the family.

NOTES TO THE TEXT

- 1. Robert Sommer, *Personal Space: The Behavioral Basis of Design.* (Englewood Cliffs, N.J.: Prentice-Hall, 1969), pp. 66-67.
- 2. Albert Mehrabian, Public Places and Private Spaces: The Psychology of Work, Play, and Living Environments. (New York: Basic Books, 1976), pp. 5-7, chaps. 2 and 3.
- 3. Ernest R. Weidhaas, *Architectural Drafting and Design*, 4th ed. (Boston: Allyn and Bacon, 1981), p. 139.
- 4. Gail Lynn Hartwigsen, *Design Concepts: A Basic Guidebook*. (Boston: Allyn and Bacon, 1980), p. 25.
- 5. Marjorie Branin Keiser, *Housing: An Environment for Living*. (New York: Macmillan, 1978), p. 123.

REFERENCES FOR FURTHER READING

Family Housing Handbook. Ames, Iowa: Iowa State University, Midwest Plan Service, 1971.
Gilliat, Mary. The Complete Book of Home Design, rev. ed. Boston: Little, Brown and Company, 1989, pp. 10-89, 150-183.

Keiser, Marjorie Branin. *Housing: An Environment for Living*. New York: Macmillan, 1978, chap. 11, pp. 199-204.

Packard, Robert T. (ed.). Ramsey/Sleeper Architectural Graphic Standards, 7th ed. New York: Wiley, 1981.

Panero, Julius and Martin Zelnick. Human Dimensions and Interior Space: A Source Book of Design Reference Standards. New York: Whitney Library of Design, 1979.

Spence, William P. Architecture: Design, Engineering, Drawing, 3rd ed. Bloomington, Ill.: McKnight Publishing Company, 1979, pp. 30-37, 68-71.

Weidhaas, Ernest R. Architectural Drafting and Design, 4th ed. Boston: Allyn and Bacon, 1981, chap. 19.

Work and Support Areas

KITCHENS

Anthropometrics Work Centers Storage Space Designing the Kitchen

UTILITY SPACES

Laundry Facilities Sewing Areas Workshops and Garden Rooms General Storage

Those areas of a home responsible for the maintenance of daily living—for the stocking and preparation of food, the care and perhaps fabrication of clothing, the physical upkeep of the home, the storage of equipment—can be termed support spaces in the sense that they nurture the individuals and the lifestyle that takes place within the home. Group spaces and private spaces would exist in a vacuum if they were not supported by the work areas of the home. The kitchen—the major work center—provides bodily sustenance, and often emotional sustenance as well when it serves as the principal gathering point for family members. Depending upon the requirements of the household, work spaces may also include facilities for laundry, housekeeping, sewing, record-keeping and paying bills, and different types of shopwork or hobbies as well as various storage needs. Taken together, these areas constitute the foundation on which life in the home rests. Both the tasks and the people who perform them need to be considered when work-spaces are designed.

KITCHENS

The kitchen is usually the control center for the household. In addition to providing a place for food preparation, eating, planning, and sometimes laundry, the kitchen is often the most lived-in room and a strong selling feature in a house. It is initially the most expensive room to complete and, during the life of the home,

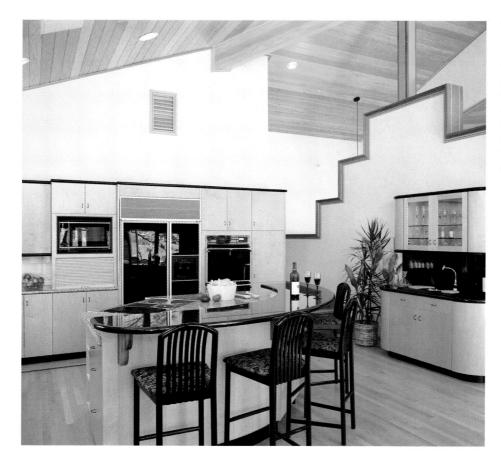

10.1 The kitchen in this home is the center of activity, with an open plan that allows the cook(s) to be a part of social gatherings and have a full view of Donner Lake. The raised black granite eating counter keeps the visual clutter of the kitchen work counters from full view of social areas. Cathy Nason, ASID, interior designer. (Photograph: Jay Graham)

the room most likely to be remodeled. Remodeling the kitchen is often a good investment because it increases the value of an older home while money spent to remodel other rooms may not. A rule of thumb estimates approximately 10 percent of the value of the home or the price of a new car as the cost of remodeling a kitchen. Of course, much depends upon the extent of renovation and the market value of the house.

Few areas of the home have received such intensive study as the kitchen. Manufacturers continually redesign standard appliances and equipment to make them more efficient, more attractive, and thus more desirable to potential buyers. Research has provided designers with many facts, figures, and formulas that offer assistance in organizing the physical layout of work areas. Studies have focused on the use and efficiency of facilities, performance of tasks, the design and placement of work centers, and the relationship of work centers to each other as well as to changing lifestyles. Three concepts of functional planning have emerged from the research:

- 1. The physical size and proportions (anthropometrics) of the principal cook or cooks should be a major determinant in achieving an energy-saving, comfortable working environment.
- The kitchen is best organized around work centers that incorporate appropriate appliances with sufficient storage and work surfaces and that are arranged in logical sequences.
- **3.** The **storage principle of first use**—of storing items where they are needed rather than by category—fosters efficiency.

Standard Kitchen Appliance and Cabinet Sizes

	Small						Large					
	Height		Depth		Width		Height		Depth		Width	
Cooktop (built-in)			21"	×	26"	to			21"	×	36"	
Range (cooktop at 36")	43"	×	24"	\times	20"	to	66"	\times	25"	×	40"	
Oven (built-in)**	27"	×	21"	\times	$22^1/2^{\prime\prime}$	to	42"	\times	21"	\times	24"	
Microwave oven	9"	×	$12^{1/2}$ "	×	$18^{1}\hspace{-0.5mm}/\hspace{-0.1mm}2^{\prime\prime}$	to	$15^{1}/2''$	\times	21"	\times	24"	
Refrigerator	52"	×	24"	\times	20"	to	66"	\times	29"	\times	30"	
Refrigerator-freezer	65"	×	29"	\times	31"	to	66"	\times	29"	\times	60"	
Freezer	33"	×	25"	\times	42"	to	66"	\times	29"	×	33"	
Dishwasher (built-in)							35"	\times	24"	×	24"	
Dishwasher (portable)							38"	\times	28"	×	24"	
Clothes washer	42"	×	25"	×	25"	to	45"	\times	28"	×	29"	
Clothes dryer	42"	×	25"	×	27"	to	45"	\times	28"	×	31"	
Ironing board	30"	\times	44"	\times	11"	to	36"	×	54"	×	14"	
Trash compactor							36"	×	24"	×	15"	
Sink	(single)		20"	×	24"	to	(double)		22"	×	33"	
Cabinets (base)	30"	×	25"	\times	15"	to	36"	\times	25"	×	30"	
Cabinets (base)	12"	\times	6"	×	15"	to	30"	×	13"	×	30"	

'Larger sizes are available for special installations. Dimensions do not include an allowance of 3 to 5 inches clearance behind large motored appliances and ranges.

"Cut-out space needed for single and double units.

These findings say little about how a kitchen should look, dealing only with efficiency and comfort. Coupled with standard appliance and cabinet sizes (Table 10.1), they can serve as a foundation for planning the work areas of the room. The emphasis here is on *work*—physical exertion. People work in the kitchen; the kitchen must work for them. Design efficiency is particularly important for busy working people. Bear in mind, however, that functionalism and aesthetics need not be incompatible. The most efficient kitchen should also be aesthetically pleasing to those who will spend time in this most widely used room in the home.

ANTHROPOMETRICS

In general, physical limitations vary with a person's height; to conserve energy, consider normal work curves when planning the dimensions of counters and cupboards or the placement of storage and appliances within reach at each work center (see Figure 10.3). Of critical importance in work comfort is the distance between elbow and work surface. Most tasks can be performed easily on a counter that is 3 inches below the level of the elbow (with the upper arm vertical and the forearm horizontal to the floor). But when a particular chore—like beating, kneading, or chopping—requires force, a work surface 5 to 7 inches below elbow height serves better. This suggests that not all counters in the kitchen should be at the same level. Kitchens are usually designed for the average person; it is up to the

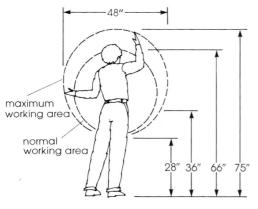

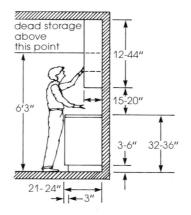

10.2 (above) This small kitchen in the designer's high-rise condominium is functional and efficient while having strong aesthetic appeal. Aniegre and black lacquer cabinets are complemented by black granite countertops and black mirrored backsplashes. Halogen down lighting illuminates the rich wood and the countertops. A Kentucky cherry parquet floor, Persian rug, faux finish table, and Italian black lacquer chairs complete the dramatic, rich effect. Wendell Norris, ASID, and Colleen Warren, interior designers. (Photograph: Vance Fox)

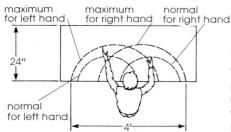

10.3 Kitchen dimensions should be based on the height and reach of the person who will use the room most. The dimensions given in these drawings would encompass the majority of the population. The critical counter work-zone, using small body dimensions, is 18 by 30 inches, an area that is directly in front of the body and all within easy reach with little side arm extension. (Maximum right hand reach = 18"; normal right reach = 12"; upper cabinet depth = 12".)

10.4 Whirlpool Corporation has designed this prototype kitchen and laundry for the disabled person confined to a wheelchair. Countertop work areas are lowered, appliances are placed for easy view and reach, pull-out shelves and open space beneath counters provide knee space. The topmost storage areas are used for accessories, or a tool is used to reach them; lower storage areas offer pull-out bins and shelves.

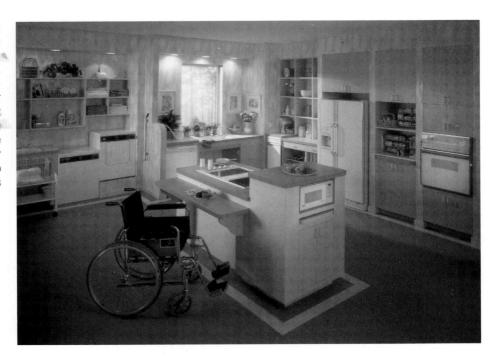

designer to adapt or refit standard cabinets and appliances to the individual user when desired or necessary. If the client is in a wheelchair, many adaptations may be necessary: lower work surfaces (28"–34"), knee space beneath cabinets and sinks (30"–60" wide area with base cabinets removed), reachable storage (12"–48" high), and plenty of unobstructed floor space for maneuverability (minimum 60" diameter for turning). The problems of shrinking stature and diminished strength (among others) that accompany aging must also be considered when designing kitchens and selecting cabinets, hardware, and appliances. The case study at the end of Chapter 7 (pages 163–166) details how kitchens can be adapted for a specific elderly population as well as for greater universal function.

WORK CENTERS

The design of work centers and the sequence in which they are arranged determines how smoothly a kitchen functions and how much energy will be expended in everyday tasks. Each work center should have adjacent counter and cabinet space. The center may be classified by a major appliance that dictates the activities performed there or by the type of activities performed, whether in conjunction with a large major appliance or smaller, less basic ones. There are three primary centers, each containing a necessary major appliance; two supplementary work centers encompassing mix and serve activities, which are often combined with the primary areas; and several specialty centers that are found in some but not all kitchens for planning, quick-cooking, eating, storing additional food and equipment, or doing laundry. Work should progress continually forward from task to task, center to center, without backtracking, to save time and energy.

The refrigerator/storage center is placed first in the work sequence, near the outside entrance and the sink for easy storage of food. In addition to the refrigerator, it should have these elements:

• A **counter** at least 18 inches wide and normally 36 inches high on the latch side of the refrigerator door for holding supplies. This often can be integrated with the counter space of adjacent centers.

- Wall cabinets to hold serving dishes for cold food and storage containers for foods going into the refrigerator. File space for trays often fits well here.
- A base cabinet with drawers for bottle openers, refrigerator and freezer supplies, and bottle storage.

The refrigerator itself should not be placed within 15 inches of a cabinet corner, beside a wall, or next to a line of cabinets because the door usually needs to be free if it is to open more than 90 degrees for removal of shelves and crisper. (Some refrigerator models are designed so that they do not need to open more than 90 degrees; these models can be placed next to a wall.) So that it doesn't interrupt the flow of counter work space, the refrigerator is often placed at the open end of a line of cabinets, always opening on the side toward the counter.

The refrigerator center often incorporates a **freezer**, although a larger freezer can be placed in a pantry, storage or utility room, basement, or garage. With a side-by-side refrigerator/freezer, 18 inches of counter space on both sides is desirable. A pantry, which is often considered a specialty storage center, may also be included in this work center. Non-perishable food items can then be stored nearby for greatest efficiency.

The **sink/clean-up center** is indeed multipurpose, serving to wash fruits and vegetables, dishes, and children's hands, and providing water for mixing, cooking, freezing, and drinking. The sink center is often located between the cooking and the mixing centers, since its proximity to both is desirable and it is involved in both the beginning and the end of kitchen activities. Since 40 to 47 percent of all activities take place here, the sink center is often the first center to be positioned when planning the kitchen to ensure its central convenience.² This center needs the following elements:

• A **sink** or **sinks**, probably the most important piece of equipment in the kitchen by virtue of frequency and variety of use. Double bowl sinks facilitate hand dishwashing, but they may be too small for large cooking pans unless they have one small and one large well. With a dishwasher, a single large sink often suffices.

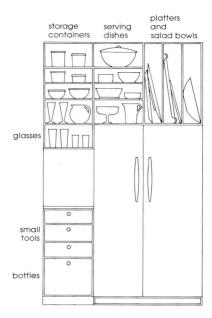

10.5 The refrigerator and adjacent counter and storage space make up one of the major kitchen work centers. A counter on one side of the refrigerator is the minimum; counters to right and left of a side-by-side refrigerator-freezer are recommended.

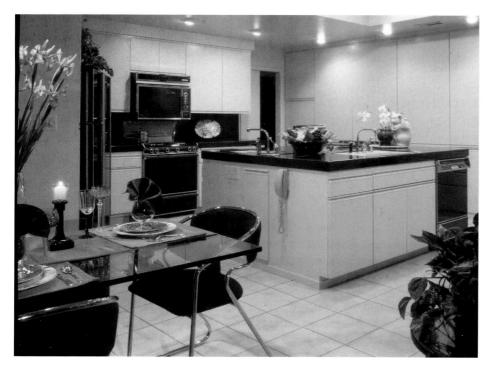

10.6 The center island in this kitchen contains two separate sink centers, one within the major work triangle for food preparation and cooking, the other, with the dishwasher, closer to the dining area for cleanup. Dennis Haworth, FASID, interior designer. (Photograph: Steve Simmons)

Two separated sinks are especially convenient when more than one person uses the kitchen (see Figure 10.6). For comfort, the sink should be about 3 inches below elbow height and not more than 3 inches back from the front edge of the counter.

• Counters on both sides—at least 30 inches wide on the left for draining or stacking clean dishes if there is no dishwasher, 36 inches wide on the right for stacking dirty dishes, and commonly 36 inches high—with at least one of them a waterproof drainboard. The left and right side measurements may be reversed according to direction of work flow.

• A dishwasher, which will generally be easier to use if it is placed to the left of the sink for right-handed users and to the right for left-handed users. However, the location of dish storage must also be considered. The 24-inch counter width above a front-opening dishwasher is adequate for stacking dishes. Do not position the dishwasher in a run of cabinets at an immediate right angle to the sink; 18 to 24 inches is needed from the corner for standing space when the door is opened. The dishwasher may be raised above the floor to facilitate use by elderly persons or wheelchair users. The empty space below can be made into a storage drawer.

Cabinet space for those items generally used at the sink—utensils for cleaning, cutting, and straining food; dish cloths and towels; soaps and detergents. Many people find it convenient to store near this center the foods that need peeling or washing or require water in their preparation, a miscellany ranging from potatoes and onions to coffee and dried legumes. Wall cabinets, if hung above the

sink, should provide clearance of 30 inches.

- Provision for garbage and trash, with a food waste disposer in the sink (perhaps a triple bowl sink, with one small bowl primarily for the disposer) and possibly a trash compactor (12", 15", or 18" wide) placed on the opposite side of the sink from the dishwasher. (As recycling programs are becoming more prevalent, trash compactors, which can harbor bacteria and odor, are being used less
- A stool and knee space, which lessen the labor of cleaning vegetables and dishes, especially when conservation of human energy is a factor.
- Light directly over the sink.

A hot water heater and water softener may also be considered clean-up center appliances. A water heater may be installed beneath the sink to supply nearboiling tap water for the preparation of instant foods and drinks.

10.7 The sink(s), dishwasher, and trash compactor, as well as counters on either side and cabinets, comprise the most-used kitchen work center.

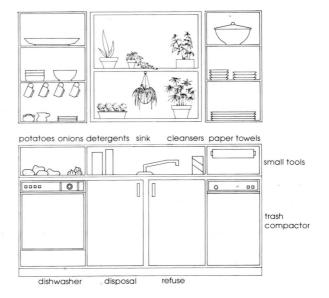

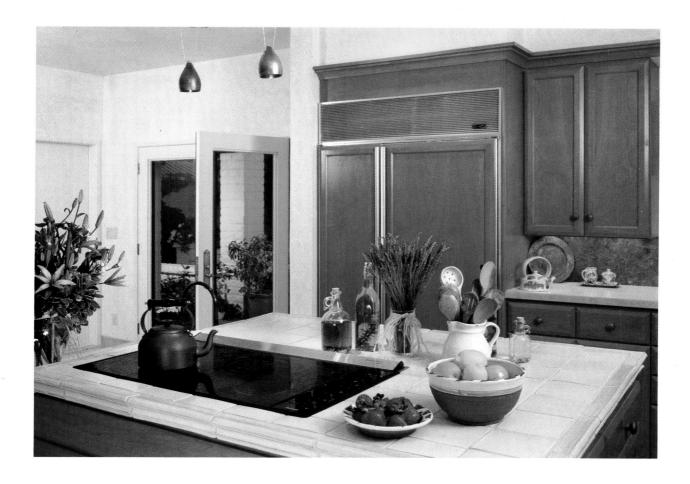

The **cook center** becomes the busiest area of the kitchen during the half hour or so before meals, accounting for approximately 22–29 percent of all kitchen activities.³ A location near the sink, mixing, and serving centers and convenient to the eating space is most desirable. The cook center should include these elements:

- Gas, electric, induction, or halogen quartz **surface units** incorporated into a range or cook-top installed in the countertop. Range tops are almost uniformly 36 inches high, but surface components can be installed on counters of whatever height the cook prefers. Usually, this would mean 3 inches below elbow height, but if the typical cuisine demands much stirring of sauces or use of a portable mixer, 5 to 7 inches below elbow height is more comfortable. The cooking unit should be at least 12 inches from a window and 9 inches from an adjacent corner cabinet for safety.
- A heat-resistant counter 24 inches wide and usually 36 inches high on at least one side of the surface units and built-in wall ovens. For safety, counter surfaces on both sides of the range are best with 12 inches the minimum for the second side. A 15-inch counter or cabinet should separate the range from a kitchen doorway or traffic path.
- An oven or ovens, either as part of the range or separate from the cooking surface. Single ovens below the surface units make a compact cook center, but access requires bending over and reaching across the oven door. Many ranges incorporate a built-in second oven above the surface units, and this can be a desirable feature provided it presents no hazard to head and eyes. This arrangement, however, does not leave sufficient space for such oversize vessels as canning kettles and large soup pots and may position the oven racks above

10.8 A halogen cooktop has a smooth, easily cleaned ceramic surface. The lighting suspended over the island unit is a 12-volt wire system. Julie Atwood, interior designer. (Photograph: John F. Martin)

10.9 Cooking units, ovens, ventilation systems, counter tops, and storage cabinets form the cook center.

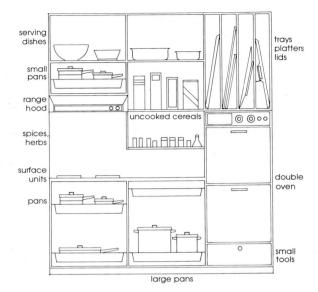

10.10 (below) Small or portable appliances compactly arranged can form a secondary quick-cook center.

10.11 (bottom) The mix center, often located between two of the major work centers, contains counter space and storage cabinets.

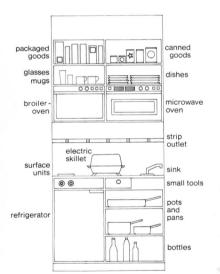

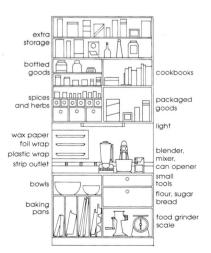

convenient view and reach. **Built-in wall ovens** should not interrupt the flow of counter space, although they need an adjacent counter area of heat-resistant material 15–18 inches wide; they are best positioned so that the opened door is between 1 and 7 inches below elbow height for safety and convenience. A **microwave oven** for quick cooking of certain foods may be located in the cooking center or elsewhere, perhaps in the mix center, serve center, or quick-cook specialty center. Oven doors should not open into traffic at the end of a line of cabinets or into a corner. **Convection ovens**, long popular in Europe and restaurants, are being incorporated with microwave ovens. By circulating heat around food, convection ovens reduce cooking time by one-third compared to conventional ovens.

- Wall cabinets nearby for cooking utensils, small appliances, and seasonings.
 A 24- to 30-inch open vertical space is required between the range top and the bottom of the hood or wall cabinet respectively above it.
- Ventilation provided by a quiet exhaust fan over (hood) or within (downdraft) the cook surface and oven.
- Light directly over the cook surface but shielded from the eyes.

In many homes, the availability of new equipment and the presence of two cooks has caused the cook center to expand into two or more smaller components. A kitchen might have, for example, a **quick-cook center** in addition to the major cooking area. Quick-cook apparatus could include a microwave or convection oven, an electric broiler—oven, electric skillet, gas or electric barbecue, and a whole array of other small electric appliances. With the addition of a small sink and two or more surface units, even an undercounter refrigerator, this unit becomes totally self-contained. If it is properly arranged, a person working in this center would not interfere in the least with the activities of another cook in the major cooking area.

The supplemental **mix center** handles all kinds of mixing, from breads and pastries to salads and casseroles. It might be located between the sink and the refrigerator (which holds many mix-first items) or next to the cook center. The mix center should include these elements:

 A counter at least 36 inches wide; if combined with another center, a width of 48 to 54 inches is needed. If considerable time is spent in mixing, knee space

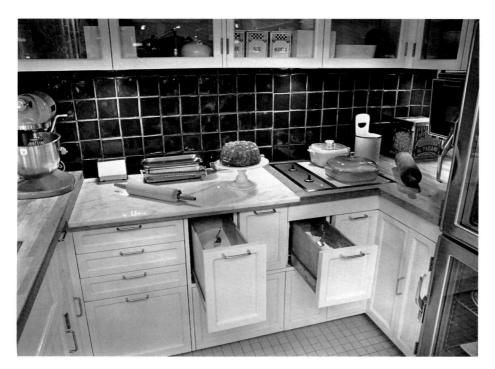

10.12 The mix center of this kitchen has special bins for dry ingredients and a marble top slightly lower than the adjacent counter for rolling pastry. (Photograph: © Norman McGrath)

and a stool or chair could be provided, and a countertop at a height comfortable for the principal cook. Often this will be 30- to 32-inches high (in contrast to the standard 36-inch height), although a pull-out cutting/rolling board at this height (or lower) may suffice.

- Sufficient electrical outlets for small appliances—mixers, blenders, and food processors.
- Wall cabinets to store condiments, packaged foods, and cookbooks.
- Base cabinets with drawers for small tools and either drawers or sliding shelves for bowls, pans, and heavy items used in mixing. An appliance garage may also house equipment and electrical outlets at the back of the work counter.
- Light directly over the work surface but shielded from direct view.

The oven is often located within or next to the mix center for baking convenience. Specially designed storage spaces for flour, sugar, and bread as well as for small appliances such as mixers and food processors will often be included in the wall or base cabinets of this center. Some 11 to 15 percent of kitchen activities take place in the mix center.⁴

The **serve center** holds those items that go directly from storage to table—dishes and flatware, linens and accessories, possibly toasters and waffle irons, and condiments. Often integrated with either the cook or the refrigerator center, it should be near the eating area and include the following:

- A durable **counter** at least 24 inches wide and from 30- to 36-inches high, perhaps with a pass-through to facilitate serving to a dining area beyond. When combined with another center, the widest counter should be used with 12 inches added to it.
- Ample cabinet space designed for the items to be stored. If the serve center is
 located between the kitchen and the dining area, cabinet space might well be accessible from either side. This space usually must be supplemented by cupboard
 space in the dining area or by a pantry.

10.13 The supplemental serve center is primarily a storage area with some counter space for collecting dishes and mealtime accessories.

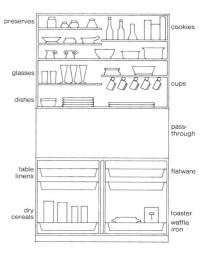

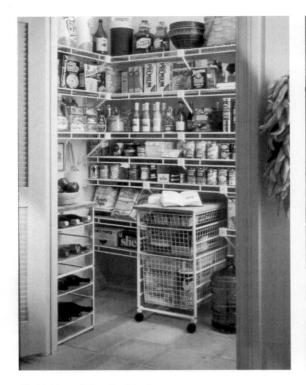

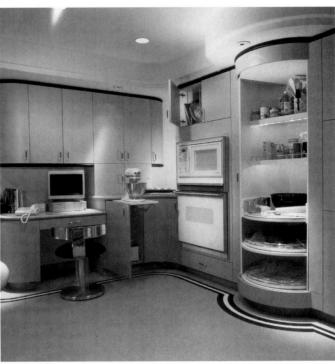

10.14 (above, left) Flexible storage systems can be assembled to maximize pantry space with all items visible and accessible. (Courtesy The Container Store)

10.15 (above, right) A planning center in the kitchen provides a place to use the telephone and computer for household shopping, bill paying, and meal planning. Pull-up mixer storage, eye level microwave oven, and lazy susan pantry shelves are added conveniences. The contrasting border around the floor perimeter is a visual cue for the visually impaired. (Courtesy Whirlpool Corporation)

Besides these centers, a **storage wall** or **pantry** serves to accommodate extra supplies and is especially necessary if wall-cabinet space over counters is lost to windows and ovens. It should be near the refrigerator/storage center. **Cleaning equipment** and **supplies** need a well-planned utility closet either in the kitchen or laundry. A **planning center** may include a place to sit down to make shopping lists and pay household bills, cookbook storage, a telephone, and a computer. A minimum of 30 inches in width is needed, located outside the work and traffic areas. A **kitchen eating area** may consist of counter space (29-inches high for chairs, up to 42-inches high for stools, a minimum of 24-inches wide by 15-inches deep per person) or a table with built-in seating or chairs. The table should be located conveniently for serving but at least 48 inches from a base cabinet front and 60 inches from a major appliance front.

STORAGE SPACE

The principle of first use assumes primary importance in organizing storage space for the work centers. The cook will conserve time and energy if items are stored where they will be needed, rather than putting all similar things—bowls or sharp knives, for example—in one place (see Figures 10.5, 10.7, and 10.9–10.11 for examples).

The *amount* of storage space in the work centers is a critical factor in their design. Research in this field indicates that the sizes given for counter space in each of the five work centers will ensure enough storage space for the average kitchen if wall and base cabinets are placed above and below the counters. According to these formulas, the counter space provided by the work centers totals at least 10 lineal feet. If the work centers are placed alongside one another, all counters between appliances can be eliminated *except the largest counter*, which then should be made 1 foot wider than usual. Accessible frontage for base and wall cabinets is lessened by installation of appliances, windows, and hard-to-reach locations (in corners and above 72 inches). Recommended standards from The Small Homes

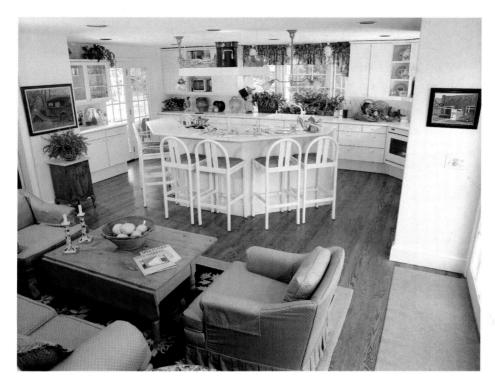

10.16 This kitchen remodel included an island with a raised eating bar that can seat six people, a bay window, and French doors that brighten the space. Informal kitchen dining is convenient, and the bar invites casual guests or family members to be near the kitchen and interact with the cook without being in the way. Ken Peterson, designer. (Photograph: Karen Bussolini)

Council at the University of Illinois⁵ are 6 feet minimum and 15 feet maximum total counter frontage to prevent either too cramped to too excessive distances between centers. Each set of dinnerware for twelve demands an extra 4 feet of wall cabinet space beyond the 6-foot minimum for service for four.

Equally important, the *quality* of the storage space deserves careful consideration of when and how objects will be used and who will use them:

- Visibility suggests storing items (except for such identical articles as tumblers) only one row deep. Ideally, canned goods and condiments should be shelved in this manner to facilitate finding a particular item.
- Accessibility indicates putting the most frequently used items at the most convenient height, heavy objects below, and those seldom used above. Drawers in base cabinets are more accessible than fixed shelves; pull-out shelves are intermediate in convenience. Space located above the maximum reach of a given person (69 inches for women, 72 inches for men if over base cabinets) can be considered dead storage since a stool or ladder would be required to reach articles kept there. For accessibility of often-used items, the area within most comfortable reach is from approximately 24 to 60 inches off the floor (12 to 48 inches for someone wheelchair-bound).
- **Flexibility** will be enhanced by adjustable shelves and drawers with removable dividers.
- Maintenance generally benefits from enclosed storage, but items that are used daily may be kept on open shelves.

DESIGNING THE KITCHEN

PLANNING THE WORK CENTERS The cardinal principle of work-center organization is appropriateness to the desires and work habits of those using the kitchen most intensively. For most situations, four general planning principles are basic.

10.17 This "ship's galley" pantry requires minimal space and provides storage that is visible and accessible. Doors with shallow shelves for one-deep storage fold out in succession to reveal yet more storage behind. The space below keeps the family pets from being underfoot. Betty Cutten, ASID, interior designer. (Photograph: Stephen de Lancie)

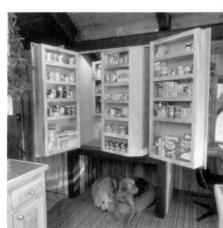

Location of the work centers usually starts with placing the sink, since it is used most, in the most desirable location (perhaps under a window) with the other centers located around it according to the busiest paths between them. Work should progress from storing to preparing to serving food in a constantly forward-moving direction with as little backtracking as possible. The normal sequence of work is counterclockwise from refrigerator to sink to range for a right-handed person but it can be reversed. Traffic in and around the work centers should be limited to that connected with preparing meals, with miscellaneous traffic diverted elsewhere.

Clearance between a counter and an opposite wall is a minimum of 40 inches; between counters with appliances that face each other, 48 inches is minimum for one worker, 60 to 70 inches is desirable for two. A greater distance requires unnecessary steps between work centers. Needed clearance between a counter and a breakfast table is at least 48 inches. Distances between work centers are best kept short and the routes as direct as possible while still allowing for the necessary counters and storage. Vertical clearances are also required: wall cabinets must be hung at least 15 inches above counter tops, higher over appliances or a planning desk (24 to 30 inches).

The **traffic routes** between the three primary work-center appliances form the efficiency experts' **work triangle**, the perimeter of which should not exceed 26 feet nor be less than about 16 feet. Each segment or leg should be at least 4 feet in length to avoid crowding and insufficient storage space. The shortest of the three legs is the most traveled path, from sink to range; it should not exceed 6 feet. The maximum distance from refrigerator to sink is 7 feet, and from refrigerator to range, the least traveled route, the maximum is 9 feet.

The standard arrangements for work centers fall into four categories: one wall (*Pullman*, or strip), corridor (or galley), L-shape, and U-shape. The one-wall assembly is awkward except in living arrangements such as efficiency apartments

10/01

10.18 (top left) One-wall kitchens can be fitted into alcoves and concealed with folding doors when not in use. They are available in complete prefabricated units and concentrate plumbing and wiring economically. However, if they contain standard-size appliances (rather than scaleddown "kitchenette" units), they require a great deal of walking. Not shown: There should be at least 12" of countertop between the range and the left wall and a space between the refrigerator and the right wall.

10.19 (top right) Corridor arrangements decrease distances between work centers but invite unwelcome traffic when often-used doors are located at both ends. *Not shown:* There should be a space between the refrigerator and the right wall.

plans also have somewhat less distance between centers than one-wall kitchens. They leave room for eating or other activities and divert miscellaneous traffic.

10.21 (bottom right) U-shape kitchens generally have a compact work triangle and are most efficient. They have the further grace of almost eliminating bothersome intrusion.

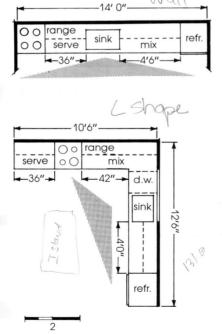

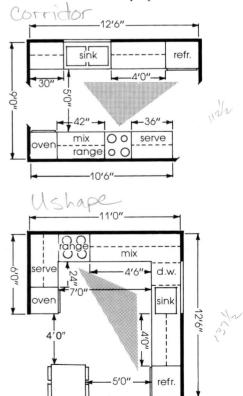

or guest quarters where only one wall is available. It results in a very inefficient work triangle with excessive distance between the far ends (or insufficient counter and storage space) and much backtracking. The corridor kitchen occupies the least area of all other arrangements. The refrigerator and sink are usually located on one side with the range on the other. The work triangle is efficient; however, work is interrupted by traffic between doors at opposite ends of the corridor. Space between counters must be at least 48 inches and should not exceed 60 inches. The efficient L- and U-shaped kitchen plans began with home economists who analyzed the steps necessary in meal preparation and the backtracking required, then applied time-motion studies from industry to work out the best way to eliminate unnecessary steps and wasted energy. The L-shaped plan provides continuous work surfaces, little opportunity for disruptive traffic through the work triangle, and plenty of open space for an island, additional storage, dining, or other activities. The U-shaped kitchen also has continuous counters, and no traffic through the work triangle. Work centers are easily kept in sequence but appliances must not be crowded into corners. When placed within a U shape, an island must contain either the range or sink to avoid becoming an obstacle in the flow of work, and the U must be expanded considerably to maintain required clearances. The broken U, a variation, often loses efficiency when the break is caused by the location of a door, resulting in unwanted traffic. A peninsula may be used to divide an open U-shaped kitchen from the adjoining space and may incorporate informal counter eating space. Although most kitchens relate basically to one of these four types, those designed to meet individual needs may differ markedly from standard practice.

In planning the physical layout of the kitchen, the *subtraction method* is useful. The width of each cabinet or appliance used is subtracted from the total space available until all space is used to best advantage. The size or placement of appliances is adjusted so standard-sized cabinets can be used with no more than a single 3-inch filler at the end of a run or in conjunction with corner units. Costs can

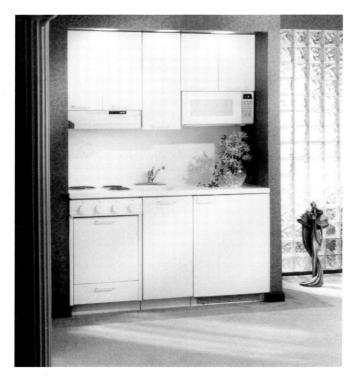

10.22 This compact kitchen contains a sink, countertop work area, three cooking elements, an oven, a non-ducted range hood, an undercounter refrigerator-freezer, upper and lower storage cabinets, and a full-size, built-in microwave oven. Overall dimensions are only 60 inches wide by 26 inches deep by 84 inches high. (Courtesy Dwyer Products Corporation)

be held down by using stock dimensions for cabinets and appliances. Manufacturers produce cabinets based on 3-inch modules in widths of 12 to 48 inches. Base cabinets are 36 inches high unless otherwise specified and 24 inches deep. Wall cabinets range in height from 12 to 36 inches and in widths of 12 to 48 inches in 3-inch increments; standard depth is 12 inches.

The sink/clean-up center is placed first, then corner cabinets, the range, and the base and wall cabinets between. The refrigerator is located at the end of a run of cabinets (or the broom closet at the end, next to the refrigerator) with base and then wall cabinets filled in back to the sink.⁶

Some kitchens are planned for maximum efficiency, others with children foremost in mind, some for two-cook (or more) families, others for households that do almost no cooking. At one end of the spectrum we might find an enormous, professionally equipped kitchen in which domestic employees do most of the work, at the other a modular unit (see photograph on previous page) that makes an instant kitchen wherever it is placed. In every case the lifestyle of the particular family will determine the major factors in kitchen planning. However, to be functional, kitchen planning must also take into consideration location within the home, size, shape, placement of doors and windows, lighting, and maintenance.

LOCATION A kitchen placed at the shortest feasible distance from indoor and outdoor eating and entertainment areas, as well as from the garage and service areas, will save steps. Further, the kitchen should be convenient to the main entrance and to any service entrance, and if possible not far from a lavatory. (The last of

10.23 The kitchen should be easily accessible from all other areas of the home and from outdoor eating and service areas. This kitchen meets those needs admirably, providing an open, airy atmosphere with views to the outdoors and close proximity to indoor dining. Dennis Haworth, FASID, interior designer. *(Photograph: Steve Simmons)*

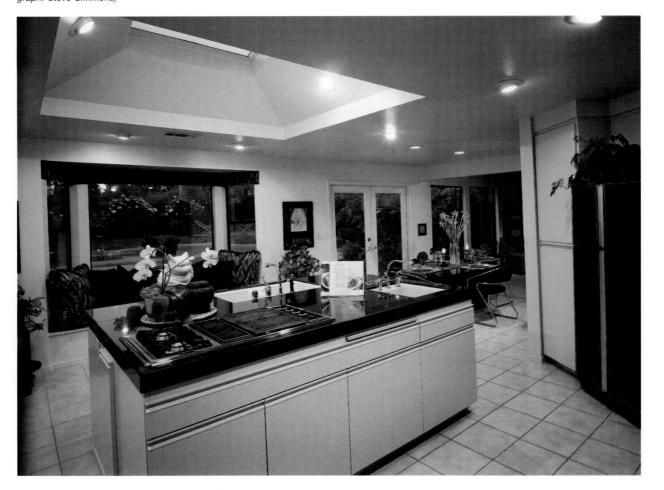

these often follows naturally, since many homes centralize plumbing to save expense.) It should be accessible to and from all parts of the home without being a thoroughfare. Access and traffic should be limited and kept in one part of the space to prevent interruption of the work flow. As long as these requirements are taken into account, there can be great freedom in placement, especially in a one-family home.

A pleasant view from kitchen windows is desirable, although in a multifamily or high-rise construction the economics of building often suggest interior placement in a service core that concentrates utilities.

SIZE Size is determined not only by the number of persons using the kitchen and the amount of food prepared for family or guests but also by the kind and number of other activities that take place in the kitchen area. The space needed in a small home for food preparation alone should be at least 80 to 100 square feet, in larger homes it should not exceed 150 to 160 square feet. The addition of laundry or eating space and family, hobby, or relaxation areas may be necessary to maintain efficiency if the kitchen is oversized. Too large an area results in too great a distance between work centers; too small an area creates cramped spaces difficult to work in, particularly for more than one person. Open spaces with kitchens visible from living areas do not isolate the cook during meal preparation, an ideal time for the family and/or friends to interact.

SHAPE Although typically rectangular, kitchens lend themselves to many other configurations. Experts generally agree, however, that a small food-preparation area requires fewer steps if its shape falls between that of a square and a rectangle with proportions of about 2:3.

DOORS AND WINDOWS **Doors** in kitchens are necessary evils—necessary as entrances and exits, evils because they take space, determine location of work centers, and invite miscellaneous traffic. The best solution is to keep doors to a minimum (no more than 2 or 3), set them as close together as possible, and locate no major work center between them. Of course, the overall design of a plan may make this ideal impossible.

10.24 Windows between counters and wall cabinets bring light into this Westport, Connecticut, kitchen while taking advantage of river views. The bay contains a breakfast nook. All windows are divided into small panes, in keeping with the shingle-style cottage architecture. Bruce Beinfield & Jonathan Wagner/Beinfield Wagner and Assoc., architects. (Photograph: Robert Perron)

Windows make kitchens light and pleasant as well as provide ventilation, but they do take space. Many people are more comfortable working in a kitchen that has some natural daylighting, perhaps a window over the sink that admits light and also gives an outlook. HUD/FHA minimum property standards specify a minimum window area totaling 10 percent of the floor area; a good kitchen has 15 percent, though 20–30 percent is even better. Two windows are desirable whenever possible for cross-ventilation and more balanced light.

Sometimes small windows between counters and wall cabinets (see Figure 10.24) or high windows over the cabinets bring light in unexpected ways. Skylights illumine many interior kitchens without reducing wall cabinet space, and some rooms open over a counter wall to a windowed dining area. Among the most pleasant kitchens are those that lead directly to a garden or deck. However, care must be taken so the sun does not shine directly into the individual's eyes while s/he works. This problem can be prevented through initial planning and orientation, the addition of a roof overhang, plants, fences, or louvers to the exterior, or with interior window treatments.

Artificial lighting must also be planned in the design of kitchens. More light is required here than in any other room in the house. Both general lighting and task lighting over the work surfaces and the cooking and sink/clean-up centers must be provided in generous amounts. (Lighting is discussed in detail in Chapter 21.)

MAINTENANCE Kitchens require the most maintenance of any room in the house. They are noisy and the center of all housework. These factors suggest choosing shapes and materials for floors, counters, cupboards, walls, and ceilings with an eye to *resistance to wear*, *beat*, *dirt*, and *grease*; *ease of cleaning, sound control*, and *pleasantness* to sight and touch. (Part Four, "Construction Materials", provides more information to aid in the selection of appropriate materials.)

New lifestyles, new concepts of planning, and technological advances all play a role in transforming kitchens from necessary but dull and sterile work areas to cheer-

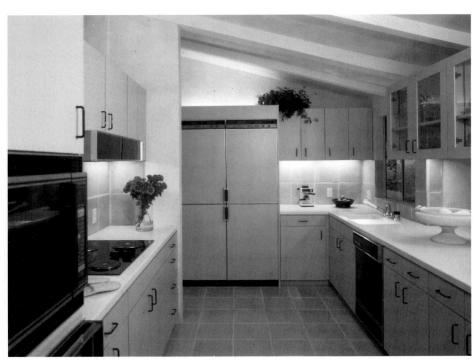

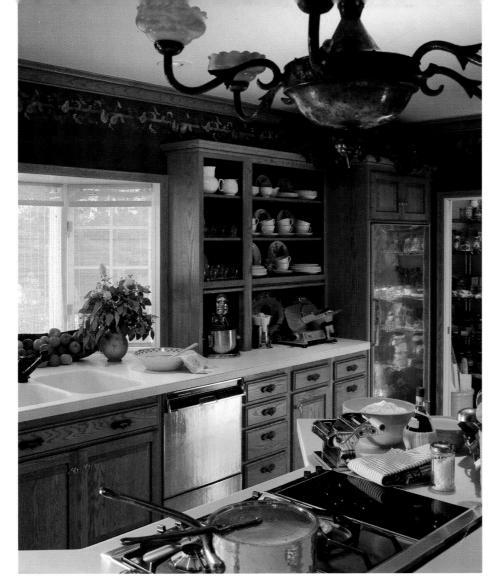

10.26 Hammered copper panels front the refrigerator and dishwasher in coordination with an antique hanging light fixture and copper pulls on oak cabinets; wall cabinets have had the doors removed and the interiors painted a rich eggplant color in contrast to dark green walls, giving this remodeled kitchen as much charcter and individuality as any other room in the home. Carol S. Shawn, interior designer. (Photograph: David Livingston)

ful, colorful centers for group living (Figures 10.2 and 10.26). Whether brand-new and ultramodern or old and full of mellowed charm, a kitchen can happily reflect the tastes and character of its owners while also serving functional requirements.

UTILITY SPACES

Undeniably, the kitchen is the most important service area in the home, and in some smaller houses and apartments it may serve as the *only* work space. But larger homes often delegate supplementary areas according to the particular needs of a given family. These may include provisions for laundry, sewing, shopwork, flower arranging or potting, or storage, among others.

LAUNDRY FACILITIES

Every week millions of pounds of clothing and household linens are washed in American homes. Three factors have altered the nature of this chore: the development of automatic washers and dryers; the trend toward bringing laundry equipment up from dark, inconvenient basements; and the evolution of fabrics that require minimum care. Provisions for home laundering range from a sink or washbasin in which small things can be rinsed out to a fully equipped separate laundry.

Laundry planning will be affected by the size and age distribution of the household, the size of the home, and the attitude toward sending out laundry. If, for example, economy of time is more pressing than economy of money, a family may prefer to have the laundry dealt with by commercial services.

Laundry activities fall into four categories:

- **Receiving, sorting,** and **preparing,** steps that may require a 6-foot counter, a cart, sorting bins, or simply the top of the washer plus a sink or tub for presoaking.
- Washing, which necessitates laundry tubs and/or an automatic washer as well as storage for supplies.
- **Drying** in an automatic dryer or convenient drying yard, with some provision for drip-drying indoors.
- **Finishing** and **ironing**, which require a 3- by 5-foot folding counter, an iron and ironing board or ironer, plus space to put finished laundry and, ideally, space and equipment for mending. Ironing boards which fold down from the space between two studs in the wall are gaining in popularity due to the limited space available in most houses. They can even be placed in a bedroom closet.

In small houses and apartments, laundry space may be reduced to a minimum and compacted into the kitchen or a closet. Utility rooms, however, segregate the clutter and noise of laundry processing. Rooms that have laundry tubs or deep sinks, even a shower, and are near the family entrance can also serve as "mud rooms"—good places to clean up after work or play. In basementless houses, the utility room will also house heating and cooling equipment, a water heater, and perhaps a freezer. It is desirable that the washer be as near the water heater as possible, while the dryer needs to be near an outside wall for venting. The maximum venting distance is 30 feet less 5 feet for each elbow (2 elbows maximum). The washer and dryer should not be placed beside the freezer; heat forces the freezer to be less energy-efficient.

Although space may be saved by incorporating a laundry in the kitchen, it should be kept separate from food preparation counters for sanitation, and the inevitable noise of the machinery may be bothersome. Basements and garages are

10.27 When not in use, this compact laundry and sewing area can be hidden behind cabinet doors and stowed away. It may occupy one end of a kitchen or even a family room, or be housed in a separate laundry room. (Courtesy Maytag)

TABLE 10.2

Minimum Space Needs in the Laundry to Permit Freedom of Action'

Space in front of the washer or dryer alone	3'-3'8"	×	3'6"
Space in front of the washer and dryer	5'6"	×	3'6"
Space between opposing washer and dryer (or if the space between is a traffic path)			4′
Space for ironing (ironing board, chair, laundry cart)	5'10"	×	4'3"
Working space beside a clothes rack			2'4"

From a University of Illinois study of home laundry operations. These measurements are in addition to space for the appliances.9

practical alternatives, chiefly because they offer plenty of space and give sound insulation, although stairs present a hazard. Washers and dryers can be placed side by side or stacked on a frame in a closet in the bedroom area, usually in a space adjoining or within a bathroom for plumbing economy, keeping in mind the minimum space needs given in Table 10.2. Since most laundry originates in and returns to bedrooms or bathrooms, and since laundering is seldom done at night when noise might disturb those trying to sleep, this location deserves consideration. Many apartment houses provide laundry facilities on each floor for tenants, or there may be one large common laundry room somewhere in the building.

Like the kitchen, the laundry should be easy to keep clean, with washable walls, durable stain-resistant countertops, and nonabsorbent, nonslip flooring. Smooth surfaces will help prevent dust and lint accumulation. (Woven wood blinds, so often selected for utility room and kitchen windows, collect dust, lint, and grease.) Good general lighting is necessary plus task lighting for preparing, mending, and ironing.

SEWING AREAS

The household in which one or more members do considerable sewing almost mandates a permanent, isolated sewing area, perhaps even a whole room. Extensive sewing not only requires a vast array of small tools and supplies but also generates a fair amount of debris in the form of fabric scraps and threads. A well-designed sewing center helps organize all this paraphernalia and allows the work-in-progress to be left out by incorporating the following:

- A **sewing machine**, either built into a 2-by-5-foot cabinet or placed on a smooth surface, and so arranged that fabrics will not drape on the floor.
- An upright **chair** of a height that will permit the sewer to work comfortably without excessive bending. (Anthropometric research suggests a secretarial chair. A minimum of 3 feet is needed in front of the machine for the chair and access.)
- A cutting surface at least 3 feet wide, 6 feet long, and 35 to 38 inches high, with work space on two sides, for laying out patterns.
- Adequate storage for fabrics and remnants as well as for tools and supplies. (Pegboards are useful for holding and keeping at hand the many small pieces of equipment needed.)
- A **steam iron** and **ironing board**, possibly including a sleeve board. (An area approximately 4½-feet wide and 6-feet long is needed for ironing.)
- Good **lighting** directly over the sewing machine and illuminating the general area to facilitate hand work.

10.28 The greenhouse addition to this home in Guilford, Connecticut, has a wet bar that also provides a perfect work surface for gardening and flower arranging. The Pennsylvania bluestone counter and floor is durable as well as attractive. Peter Kurt Woerner, FAIA, architect. (Photograph: Karen Bussolini)

Optional equipment includes a dress form, three-way mirror, skirt-hemming guide, and comfortable chair for hand sewing. There should also be provision for a library of sewing books and patterns and an area for hanging garments.

As with kitchens and other work spaces, strict efficiency need not preclude charm and attractiveness. Bright colors, attractive furnishings, and perhaps a sunny window will help make even the most utilitarian sewing more enjoyable.

WORKSHOPS AND GARDEN ROOMS

For many individuals woodworking and the many chores associated with home maintenance represent more than a hobby or a necessary evil. The serious cabinetmaker deserves a suitably equipped workshop, as does the person involved in furniture refinishing and similar pursuits. Specific needs will vary widely according to the nature of the work, but most such activities require these:

- a **location** reasonably isolated from the rest of the household so that the debris, odors, and noise created will not contaminate living spaces. (Often this means a garage or basement, but a large-scale operation may suggest a separate outbuilding. Some large housing projects provide special facilities.);
- storage for tools and supplies;
- sufficient **electrical outlets** of the proper voltage for power equipment;
- if possible, a **sink** for cleaning hands and tools;
- lighting, both general and for tasks.

The dedicated gardener can, if space permits, indulge in a special potting or flower-arranging room or greenhouse either within or adjacent to the house. An ideal space would offer

- durable and easily cleaned surfaces, perhaps even a floor that could be hosed down
- storage for vases, pots, soil, fertilizers, and tools
- plant lights for starting seeds
- a sink for watering and for cleaning hands

10.29 Kitchen base cabinets serve a second function as a storage wall with angled shelves to display magazines and books, open storage, and cabinets facing into the living-dining area of this open plan home. Michael Moyer, architect; MILLER/STEIN, interior designers. (Photograph: David Livingston)

GENERAL STORAGE

It is a lamentable fact that many small houses and apartments dismiss the problem of storage outside the kitchen with a few small closets. This ignores the reality that *people*, by and large, have *belongings*. The kinds of storage that each household needs will depend, of course, on what kinds of possessions its members own, so we can give only general guidelines and show how some families have met their storage requirements. One planning guide is to allow 10 percent of the total square footage of the home for storage. This includes the space occupied by kitchen cabinets as well as closets and all other available spaces. (Storage needs for private spaces are presented in Chapter 11.) Other guidelines include storing articles according to frequency of use, where they are used, together if they are used together, at convenient heights (heavy items lower, lighter ones higher), and for ease in seeing, reaching, and replacing if they are used often.

A storage wall with built-in shelves, drawers, and cupboards holds many diverse objects and can be decorative. Some units of this type are set at right angles to the wall and function as space dividers. More individual needs, however, require specific planning. For example, the family that enjoys games and puzzles might consider a bank of very shallow drawers or closely spaced shelves. At the other extreme, a large collection of bulky sports equipment warrants generous space and perhaps special hanging racks. Closed storage will best protect some possessions while others may safely be stored in an open display. Good storage is not only planned, but also flexible. Children grow and needs and hobbies change, suggesting adjustable fixtures rather than elaborate, permanent facilities.

When either designing a house or renting an apartment, consider the availability of some empty, lockable, storage space for such limited-use items as suitcases and tents, bicycles and lawn mowers, summer furniture and winter sports equipment, out-of-season clothing and bedding, and furniture and other items not presently in use but not yet ready for discard.

10.30 (above) An extravagant kitchen designed to the last detail according to the specifications of two master cooks provides the most efficient working spaces possible for preparation of all manner of foods. It incorporates a sewing area and office and also serves as the major entertainment center for the household. Donald Mallow, architect. (Photograph: © Normal McGrath)

10.31 (right) The plan shows how various work centers have been arranged to allow for a smooth progression of activities. Donald Mallow, architect.

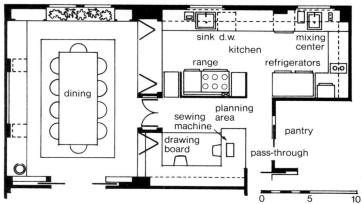

The design of standard household fixtures and appliances has changed markedly over the past two decades as manufacturers have understood and demonstrated that function and beauty are not mutually exclusive. There is no reason, after all, why something that works hard at some mundane chore needs to advertise that fact by its drab appearance. With skillful planning, the work spaces in a home can be supportive not only of its daily maintenance but of its overall character as well.

NOTES TO THE TEXT

- 1. Cecile Shapiro, David Ulrich, and Neal DeLeo, *Better Kitchens*. (Passaic, N.J.: Creative Homeowner Press, 1980), p. 8.
- 2. Robert Wanslow, *Kitchen Planning Guide*. (Urbana, Ill.: Small Homes Council-Building Research Council, University of Illinois, 1965), p. 14.
- 3. Ibid., p. 14.
- 4. Ibid., p. 14.

- **5.** The Housing Press. *The House and Home Kitchen Planning Guide* (New York: McGraw-Hill Book Company, 1978), p. 83.
- 6. Ibid., pp. 174–175.
- 7. Ibid., p. 88.
- 8. Ibid., p. 122.
- 9. Ibid., pp. 120-121.

REFERENCES FOR FURTHER READING

Basic Training Manual for the Kitchen and Bath Designer/Sales Specialist. Hackettstown, N.J.: National Kitchen & Bath Association, 1988.

Beltsville Energy-Saving Kitchen, Design No. 2, U.S. Department of Agriculture Bulletin No. 463. Washington, D.C.: U.S. Government Printing Office, 1961.

Beyer, Glenn H. (ed.), *The Cornell Kitchen. Product Design Through Research*. Ithaca, N.Y.: Cornell University, College of Human Ecology, 1952.

Bostrom, James A., Ronald L. Mace, and Maria Long. *Adaptable Housing*. Raleigh, N.C.: Barrier-Free Environments, Inc. for the U.S. Department of Housing and Urban Development, Office of Policy Development and Research, 1987.

Brett, James. The Kitchen: 100 Solutions to Design Problems. New York: Whitney Library of Design, 1977.

Faulkner, Sarah. *Planning a Home*. New York: Holt, Rinehart and Winston, 1979, Chap. 14.

Galvin, Patrick J. Kitchen Planning Guide for Builders and Architects. Farmington, Mich.: Structures Publishing Co., 1972.

Gilliatt, Mary. The Complete Book of Home Design, rev. ed. Boston: Little, Brown and Company, 1989, pp. 90–149.

The Housing Press. The House and Home Kitchen Planning Guide. New York: McGraw-Hill, 1978.

Keiser, Marjorie Branin. Housing: An Environment for Living. New York: Macmillan, 1978, chap. 10.

Kleeman, Walter B., Jr. *The Challenge of Interior Design*. Boston: CBI Publishing Company, 1981, chap. 10.

Klein, Stephan Marc. Images of Housework. Residential Interiors, May/June 1980, pp. 92–93.
Lindamood, Suzanne and Sherman D. Hanna. Housing, Society and Consumers: An Introduction. St. Paul: West Publishing Company, 1979, pp. 119–129.

Midwest Plan Service. Family Housing Handbook. Ames: Iowa State University, 1971.

Panero, Julius and Martin Zelnick. *Human Dimension and Interior Space: A Sourcebook of Design Reference Standards*. New York: Whitney Library of Design, 1979, pp. 37–45, 157–162.

Pickett, Mary S., Mildred G. Arnold, and Linda E. Ketterer. *Household Equipment in Residential Design*, 9th ed. New York: John Wiley & Sons, 1986.

Riggs, J. Rosemary. *Materials and Components of Interior Design*, 3rd ed., Englewwod Cliffs, N.J.: Prentice-Hall, Inc., 1992, chap. 8.

Shapiro, Cecile, David Ulrich, and Neal DeLeo. Better Kitchens. Passaic, N.J.: Creative Homeowner Press, 1980.

Small Homes Council–Building Research Council. Kitchen Planning Principles, Equipment, Appliances. Urbana, Ill.: University of Illinois, 1975.

St. Marie, Satenig S. Homes Are for People. New York: Wiley, 1973, pp. 115-145.

Steidl, Rose E. Functional Kitchens, Cornell Extension Bulletin 1166. Ithaca, N.Y.: Cornell University, College of Human Ecology, 1969.

Wanslow, Robert. Kitchen Planning Guide. Urbana Champaign, Ill.: Small Homes Council-Building Research Council, University of Illinois, 1965.

Private Spaces

SLEEPING AND DRESSING

Size of Sleeping Area Number, Location, and Layout of Bedrooms Individual Needs

HYGIENE Location, Layout, and Details

GUEST ACCOMMODATIONS

HOME OFFICE AND STUDIO SPACE

CASE STUDY

The Home Office

Privacy is both a basic necessity and a luxury today. At the same time that every human being needs privacy for psychological well-being, increasing numbers of people concentrated in increasingly smaller areas make that necessity progressively less attainable. In an environment of rapidly growing population, privacy may be, in the words of Professor Alexander Kira, "one of the last luxuries left."

Privacy can be attained in many ways, ranging from total physical seclusion to the ability to concentrate so intensely that the rest of the world is screened out. Individuals require different degrees of privacy—both physically (for sleeping, dressing, bathing, and sexual intimacy) and psychologically (for development and

Most families today cannot afford to provide individual rooms or suites to satisfy each member's privacy quota. The huge, rambling houses of a few generations ago-built when materials, labor, and fuel were cheap-have ceased to be practical. Intelligent planning is therefore crucial to provide each person a private space in which to retreat for rest and spiritual regeneration, perhaps even work as increasing numbers of people are working at home. Typically, that space is in the private sector of the house containing bedrooms, bathrooms, and the home office, grouped for privacy of sight and sound, and separated from the social and work spaces of the house.

SLEEPING AND DRESSING

One of the basic human needs is sleep—the blessed time that "knits up the ravell'd sleave of care" while physically refreshing the body. Historically, this need has been met in increasingly refined style. Primitive peoples slept on the ground on piles of leaves or straw (or fur hides if they were fortunate) in a spot sheltered from the elements. They simply made bed-room. With civilization came the building of shelters and the reservation of a specific place for sleeping. However, the evolution of a separate room for sleeping came slowly, and with it the idea that beds should be elevated from the floor. Gradually people, particularly the wealthy, began to regard the bed as more than utilitarian, seeking comfort, warmth, and even privacy with pillows, mattresses, quilts, curtains, and canopies. Today many traditional ideas such as tents, alcoves, and curtains are retained while at the same time newer innovations like the water bed are being adopted. Most bedrooms now are planned to accommodate only one or two people, and considerable attention is devoted to making the time spent in those rooms as pleasant, relaxing, and comforting as possible, adding space for reading, relaxing, exercising, or working in addition to sleeping.

Comfort, warmth, and privacy can be precisely and scientifically controlled to provide an optimum sleeping environment. Some research has indicated that effective sleeping time can be reduced by about two hours under such ideal conditions. The scientifically optimum requirements for sleep, however, may not be the most psychologically gratifying. Too small a space, accommodating only a bed and other minimally necessary furnishings, may produce claustrophobia. Too much space or too "busy" a space may cause feelings of insecurity or provide too much stimulation, preventing relaxation and sleep, particularly for children.

Nevertheless, since we spend almost one-third of our lives in bed, provisions for sleep are the first consideration in planning a bedroom. The requisites for sleeping are as follows:

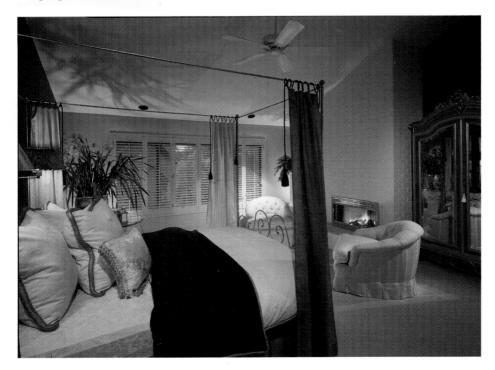

11.1 Although not necessary for warmth or privacy, bed curtains contribute drama and emphasis in contemporary homes. Bruce Benning, Allied Member ASID, interior designer. (Photograph: Ed Asmus)

11.2 Mattresses are available in a wide range of sizes to accommodate people from infancy to adulthood.

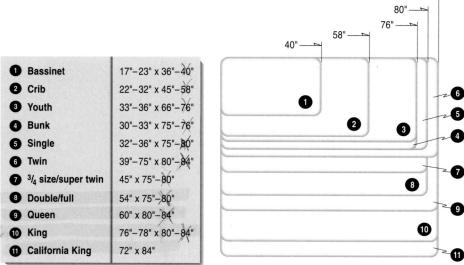

84" -

- Eastern King is 2 twins together
 - A **bed** or **beds** long enough and wide enough for one or two people. Figure 11.2 illustrates standard mattress sizes.
 - A bedside table or built-in storage unit to hold necessary items within convenient reach.
 - A light source next to or over the bed for reading and emergencies.
 - Control of natural light by draperies, blinds, or shades.
 - Ventilation from windows or other air sources. The best solution calls for cross-ventilation with windows on opposite walls, next best on adjacent walls but away from corners, minimum on only one wall with an open door to draw air from another part of the house. High strip windows allow the escape of hot air to reduce summer heat in many climates. Mechanical heating and cooling vents should be located to avoid causing a draft near the bed or being partially blocked by large pieces of furniture.
 - Quietness, achieved by locating bedrooms away from (or insulating them
 against) noisier parts of the house and by using sound buffers such as closets,
 halls, and absorptive materials.

Nevertheless, in our culture a bedroom is usually more than just a "bed room." It also doubles as a dressing room and sometimes as a study, den, play area, exercise room, or work room. These various roles, and the activities related to them, will affect the design of the space. Dressing activities involve a variety of requirements, many of them quite different from those best for sleeping:

- Space sufficient to stand, stretch, turn around, and bend over. An area with a diameter of 42 inches is considered sufficient for these dressing motions. Space is also needed in front of closets and drawers to retrieve clothing (see Table 11.1).
- Seating for donning shoes and stockings.
- **Storage** for all types of clothing; a minimum of 5 lineal feet of hanging space per person, plus shelf and/or drawer space.
- Counter space with a well-lighted mirror, combined with storage for shaving and hair-care equipment and cosmetics.
- A full-length **mirror** for the overall view, if possible.
- Lighting, artificial and/or natural, that enables us to find things and evaluate
 the effect.

TABLE 11.1

Bedroom Furniture Sizes and Clearances

	Small		Large		
Sizes	Depth Width		Depth	Width	
in hed Danland	$6^{2}/6'6'' \times 3'3''$	to 6	7'6"	× 3′8″	
in bed Daybed I bed	6'6" × 4'6"	to	7'6"	\times 6'	
	$5'9'' \times 3'$				
b	$2' \times 4'$	to	2'6"	\times 4'6"	
htstand	$1' \times 1'3''$	to	2'	\times 2'	
est of drawers	$1'6'' \times 2'6''$	to	1'10"	\times 5'	
drobe or closet	$2' \times 3'$	to	2'6"	\times 5'+	
y chair	$2'4'' \times 2'4''$	to	2'8"	\times 2'8"	
ll-up chair	$1'3'' \times 1'6''$	to	1'6"	× 1′9″	
earances	1171 21				
ce for making bed	1'6" to 2'				
e between twin beds	1'6" to 2'4"				
ice for cleaning under bed	4' (on one side)				
ce fronting chest of drawers	3' 2'9"				
ace fronting closet		th dimon	tions)		
e for dressing	3'6" to 4' (in both directions)				

Ideally, a separate dressing area exists between the sleeping space and the bath, but too often it is sandwiched into whatever space the bed and other furniture leaves in the bedroom. Such conditions will be less frustrating if a "dressing center" is planned with the clearances indicated in Figure 11.3. Certainly, each person deserves an adequate closet, incorporating or near a chest of drawers.

In designing a bedroom, several factors come into consideration: the number of people who will occupy the room and their ages (children, teenagers, and adults will have quite different priorities), the various roles the room will have to play, and the amount of space that can be utilized. Particularly when space is very limited, the amount of room available may be a major determining factor in planning a private area.

11.3 A bedroom should have sufficient space in front of the closet and chest of drawers for dressing and space on either side of the bed for making it up and cleaning beneath it. (Adapted from the Family Housing Handbook MWPS-16, 1/e, 1971. © Midwest Plan Service, Ames, lowa)

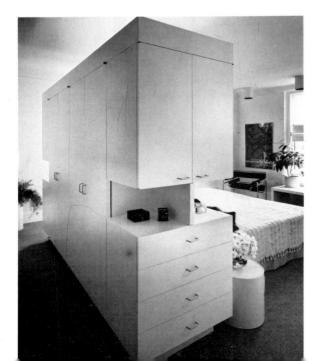

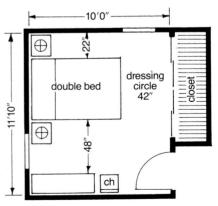

11.4 A large free-standing unit contains closet, cupboard, and drawer storage for two people's wardrobes. On one side, the storage unit serves as a headboard, on the other, it creates a dressing area. Robert A. M. Stern and John Hagman, architects. *(Photograph: Maris/Semel)*

SIZE OF SLEEPING AREA

Sleeping spaces can range in size from the berths found in inexpensive accommodations on trains and ships—barely large enough to contain a human body—through extravagant quarters that include areas for reading, relaxing, working at a desk or sewing table, and keeping fit. In between we find an entire spectrum of variations. A tiny bedroom of 90 square feet allows only a single bed and little space for other furniture or activity. A primary bedroom with adequate space for a double bed and other necessary furniture contains approximately 120 square feet. Adult bedrooms are usually larger than children's bedrooms; master bedrooms must be approximately 145 square feet to accommodate a king-size bed.

Generally speaking, as housing construction costs rise, bedroom size decreases. Expanding the size of bedrooms can indeed add to the cost of a house if the space is added just for more elbow room; or it can reduce the overall cost of a house if the extra space eliminates the need for additional play, study, hobby, work, or exercise areas. The bedroom should thus be considered a possible source of bonus living/working space.

Since we spend two-thirds of our lives awake, we must concern ourselves with the function of the bedroom during those hours as well. A well-designed bedroom is more than just a place in which to sleep or dress; it affords a quiet retreat at any time of the day as a haven for rest and relaxation, peace and comfort, solitude and intimacy (Figures 11.5 and 11.6). For these reasons, a bedroom ideally should be a moderate-size, multipurpose, segregated space. Among the many methods of maximizing usable space in the bedroom are built-in storage, work, hobby, and play areas.

11.5 A spacious master bedroom suite addition invites use as a quiet place to relax and read, talk, watch television, or have a light meal while viewing San Francisco Bay. Wilkinson & Hartman, architects; Kendall Potts Wilkinson, interior designers. (Photograph: David Livingston)

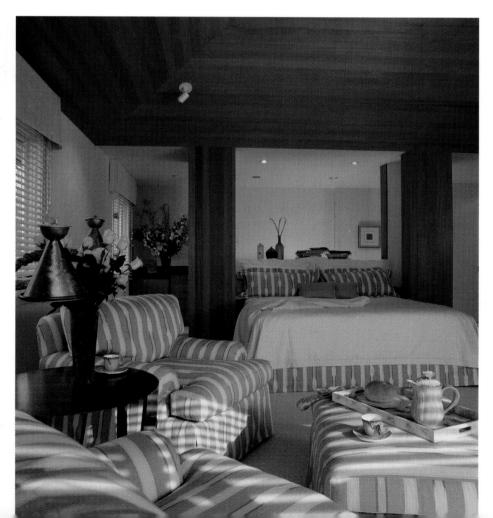

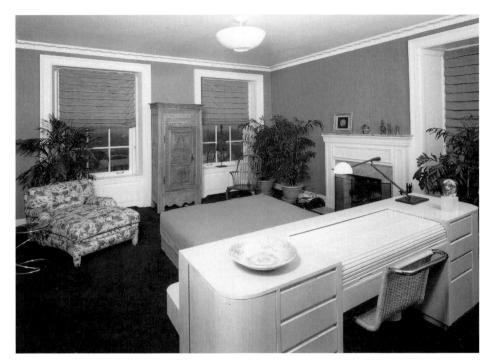

11.6 In the bedroom of a vintage Chicago building overlooking Lincoln Park, the bed is freestanding, with a dual-purpose headboard that provides a tranquil place to work. The rolltop cover allows the owner to leave work in progress undisturbed until s/he returns. The old French chest houses a sound system and television. Joseph Meisel, architect; Carol Wolk, interior designer. (Photograph: Howard N. Kaplan)

NUMBER, LOCATION, AND LAYOUT OF BEDROOMS

The **number** of sleeping areas in a home is conditioned by the size of the household, its economic status and lifestyle, and often by the stage of family life that prevails. Generally, the number rises with the number of people in the household and with income. The maximum number of people per bedroom is considered to be two, with three bedrooms per family accepted as standard. The one- or two-bedroom home, however, is often the preferred choice at either end of the family life cycle—by the childless person or couple setting up separate living quarters or retiring from overly large accommodations.

In **location**, bedrooms demand accessibility from a hallway rather than another room, physical separation from social and work spaces, and easy but out-of-view accessibility to baths. When these basic needs are met, more sophisticated wants such as segregation of adults from children, greater acoustic seclusion, and visual privacy can be considered. Families often feel opposing needs of supervision and emancipation as children grow. The amount of surveillance children require must be balanced against a desire for the quiet and independence that separated private spaces will give to different age levels. Buffering the bedroom wing of the house from both indoor and outdoor noise and view requires careful orientation of the entire plan (see Chapter 14).

Careful, efficient, well-planned **placement of doors** and **windows** contributes substantially to a bedroom's effectiveness. Doors should open into the room against the wall and, if more than one, should be as close together as is compatible without interfering with each other. Since we change clothes more often than we lie down to rest, the traffic path to closet and chest of drawers should be short and direct without the necessity of circumnavigating the bed. If the door is not directly in line with the bed or dressing area, there will be some measure of privacy even when the door is open.

The U.S. Department of Housing and Urban Development (HUD) specifies a minimum of 10 percent window area in relation to bedroom floor area with a

11.7 Careful placement of bedrooms and bathrooms in the home contributes to their effectiveness as private spaces. (top left) Bedrooms and bathrooms are normally grouped together in the guietest part of the house. Moreover, both parents and children may find greater peace if their bedrooms and baths are separated. Dreyfuss and Blackford, architects. (top right) In more complex plan shapes, bedrooms and baths can be in a segregated wing remote from household noises. Richard Pollman, architect. (bottom, left and right) In two-story houses, the bedrooms and baths are usually upstairs, as in this house designed by Suzanne Kasler, ASID, IBD.

11.8 (below) Practical windowsill heights vary with room use and furniture arrangement.

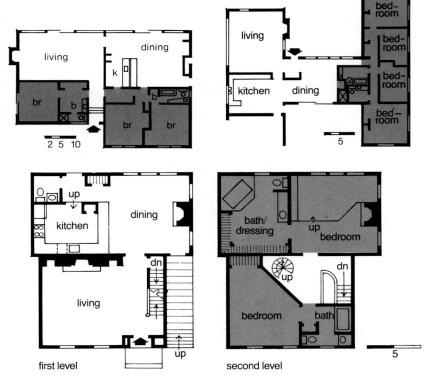

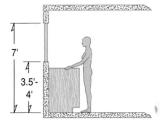

(a) 42"—48" sill height above kitchen counter

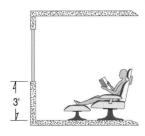

(b) 36" sill height for fire exit

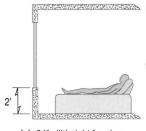

(c) 24" sill height for view from bed

ventable portion of at least 5 percent.² Ten percent is barely adequate by most standards; 20 percent is much better. High strip windows 5 feet above the floor increase privacy, but at least one window should be both large enough and low enough (36 inches to the sill) to be used as a fire escape. Many building codes require at least one window in bedrooms for emergency egress. It may also be desirable to have one window low enough (sill within 24 inches of the floor) to allow an outdoor view from a reclining position on the bed.

Windows grouped on one wall can make the room seem larger and result in more usable wall space, although the need for ventilation dictates placement of windows in two or more walls. Sunlight is desirable psychologically and aesthetically, and also as a home heating source with the best orientation generally being southerly. Architectural methods such as skylights can also be utilized to gain natural light, ventilation, and warmth when a south orientation is not possible.

STORAGE

The demand for convenient **storage** in bedrooms is exceeded only by the same need in kitchens. Basic principles suggest designing storage space specifically for whatever it is to hold. Minimum closet dimensions are 2 feet in depth and 5 lineal feet of hanging space per person. For children under twelve, the hanging rod should be 48 inches high, adjusting to a standard 64 inches with growth. The wardrobe closet takes up more wall space than the walk-in but requires less depth; the deeper the walk-in area, the more space wasted for traffic passage. All closets should be equipped with artificial light for visibility of contents. Closets located near the bedroom door are most convenient. Closets, shelves, and surface areas are needed elsewhere in the room to store and display books, hobbies, toys, sound equipment, and television sets as well as clothing.

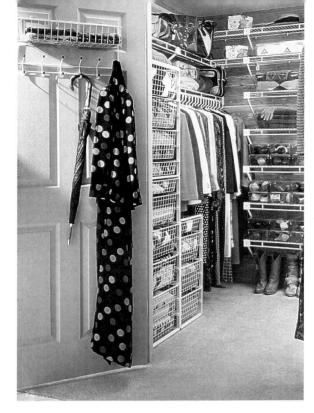

11.9 A closet storage system can make the most of available space. This coated wire system allows the cedar lining to permeate the drawer-like bins and open shelves. Even the door provides storage. *(Courtesy The Container Store)*

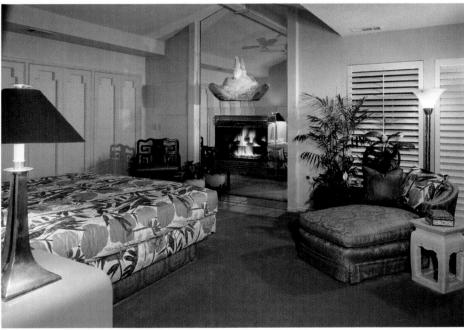

11.10 This bedroom reveals the owners' appreciation for Oriental design in a contemporary setting. Dennis Haworth, FASID, interior designer. *(Photograph: Steve Simmons)*

INDIVIDUAL NEEDS

Bedrooms are perhaps the most appropriate places in the home for members of the household to indulge their individuality. Dramatic color, lighting, and materials may be chosen to suit individual taste.

Children delight in having space to play without having to be careful of expensive furnishings or wary of getting into things that don't belong to them. They may select their own color scheme or enjoy a fantasy environment or flexible space that permits changing at will. Durability is the prime consideration in selection of materials for the child's room, along with easy-access storage that encourages

11.11 Antique furniture, handmade quilts, and simple accessories create a cozy, personal retreat for a young girl. Mary Emmerling, designer. (Photograph: © Robert Perron)

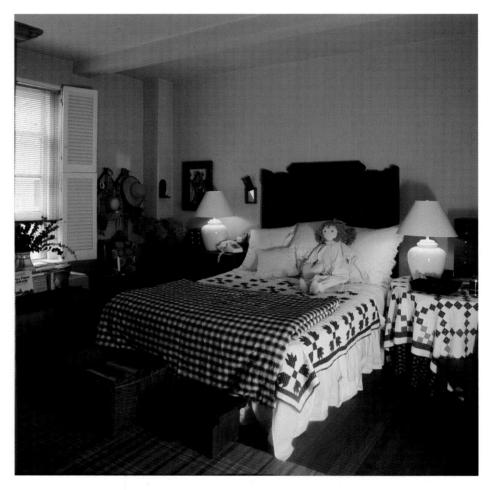

putting belongings away. Needs for play and study space will change as children grow older. For older children, a room designed for day use will satisfy a desire for privacy, provide a place for friends and study, and insulate the rest of the family from music and other noisy activity.

When two people share a bedroom, a different situation arises, for the room should suit and express both. One or both may want a bedroom that doubles as a private study, which would affect the character of the space and the furnishings selected. When different tastes demand individual expression, separate areas, such as "his" and "her" dressing areas, may meet the need if space permits. Thoughtful choices can satisfy both partners aesthetically and functionally.

In addition, sexual privacy should be provided in the master bedroom. Intimacy is an integral part of life. A door latch, soundproofing, and direct access to hygienic facilities help ensure seclusion.

Finally, lighting should be given special consideration in bedrooms. Lighting can help create a climate for relaxation with different intensities in different areas—brighter in the dressing area, lower in intensity for a central ceiling luminaire or other general lighting, more direct for reading in bed. Intensities can also be made variable by the simple installation of a dimmer switch to create desired moods or add brightness when needed (see Chapter 21). Many homes today are built without a light fixture in the center of the bedroom ceiling. Instead, convenience outlets are placed on all four walls in sufficient number for the use of portable lamps wherever light is needed, providing greater flexibility.

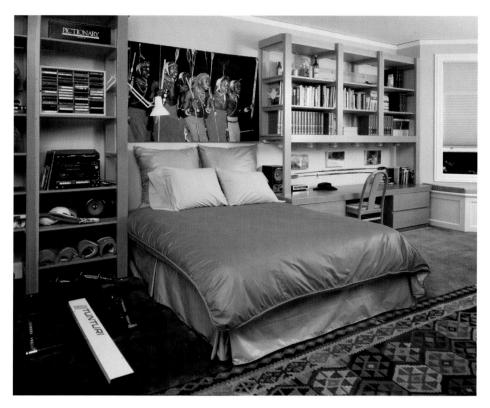

11.12 Plenty of flexible open storage for important possessions and current interests, a place to study, and space for exercising suit the needs of an 18-year old. (*Photograph: Mike Spinelli. Reprinted courtesy* In My Room: Designing For and With Children *by Antonio F. Torrice, ASID, and Ro Logrippo.*)

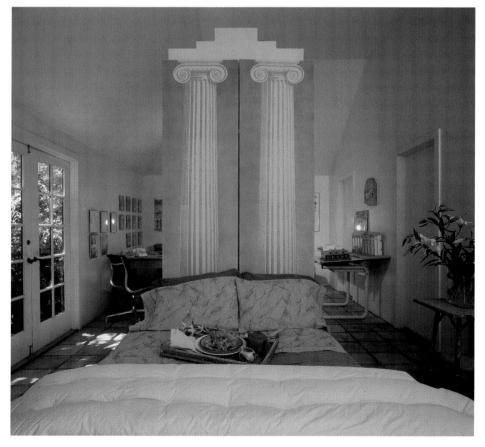

11.13 Faux lonic columns divide this spacious room into sleeping and work areas. The studio has two work tables which may be used by one person or simultaneously by two. The character of the sleeping area is mellowed by a down comforter, fresh flowers, and a natural wood table. Andrew Batey, architect. (Photograph: Tim Street-Porter)

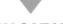

HYGIENE

The bathroom is used every day by every person within the household. This once utilitarian necessity has become a major selling point for new homes and often an ultimate expression of self-indulgence and luxury. Indeed, features at one time considered an extravagance are now quite common—the partitioned bathroom, dual lavatories, sunken tub, and bidet. Quick heat, abundant light, and rapid and effective ventilation ensure comfort and convenience. Today people want more, larger, and brighter bathrooms with plenty of space. In both number and size, bathrooms are equated with status.

Cost alone checks the desire to multiply bathrooms. The minimum acceptable standard for a three-bedroom home is one full bath with tub and shower and one lavatory (half bath), or one bath or lavatory per floor. Ideally, a home for three or more people will have at least two bathrooms, as will one with sleeping quarters on two floors. As the household expands, so should the plumbing. The number of bathrooms can be decreased, however, if the tub or shower and the toilet are in separate compartments so they can be used by more than one person at the same time, or if dressing areas incorporate washbasins.

Ergonomic research into the design of bathrooms, primarily by Alexander Kira³ at Cornell University, has led to the reshaping of standard fixtures for greater ease of use and safety. Nonskid surfaces and grab bars as well as seating spaces are often built into one-piece bathing facilities; controls are located within reach and may be designed for ease of operation. Water closets can be wall-hung for ease of maintenance and acrylic, fiberglass, and prefabricated steel make all fixtures easy to install, clean, and maintain because they are seamless and mold-resistant.

However, many of Kira's findings have yet to be incorporated in standard fixture design and installation. For example, both the washbasin and water closet are

11.14 Kohler's MasterShower™ turns a shower into a drenching sheetflow waterfall, a variety of invigorating sprays, or a penetrating hydromassage directed to weary muscles. Two rejuvenating functions can even be combined with a touch of the control panel. (Courtesy Kohler®)

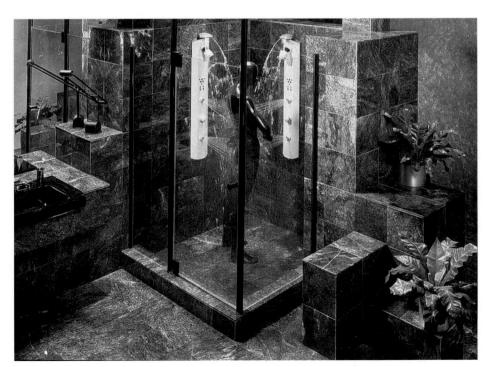

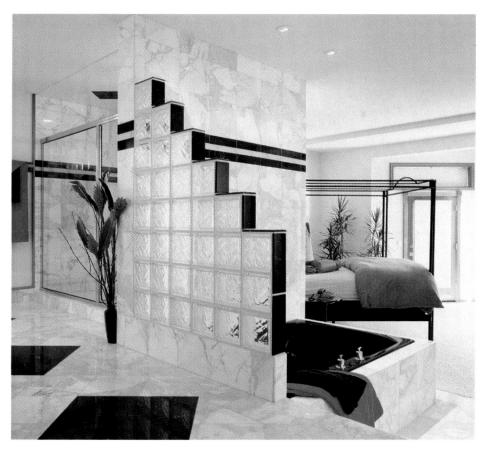

11.15 A luxurious master bath, designed by Cathy Nason, ASID, contains both a spa and a large shower. White marble with black accents, stepped glass block, and halogen lights on dimmers contribute to the elegance of this more-than-functional space. *(Photograph: Jay Graham)*

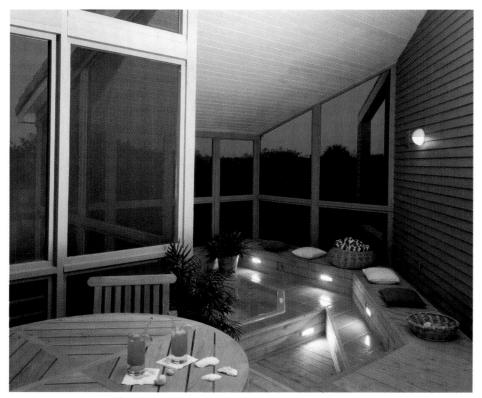

11.16 This hot tub enclosure has an outdoor atmosphere with a view of the Florida wetlands, yet it is sheltered and protected. Mexican tiles and cedar flooring were chosen to withstand the moist, humid environment. Gigi McCabe, Carol Phelan, Richard Whitaker, architects. *(Photograph: Howard N. Kaplan)*

poorly designed, according to Kira, due in part to improper height for function or comfort. (For the average of the total adult population, a comfortable working height for the hands is 38 inches, with a water source at approximately 42 inches and the height of the washbasin rim at 36 to 38 inches. Present standards set the rim at approximately 30 inches and the water source at 29 inches, forcing a working height for the hands of 26 inches, about one foot lower than desirable. Water closets are currently designed to provide maximum comfort in sitting and rising rather than to facilitate elimination of waste, which would indicate both shape and height more akin to a squatting position.)

Designers now recognize that bathing and grooming can be pleasurable as well as hygienic activities. Related to interest in bathing as a therapeutic pastime are the spa and sauna. Many Americans bathe primarily in the shower; relaxation is often the basic reason for taking baths, with the result that soaking tubs (hot tubs, whirlpool baths, and spas) for shoulder-deep water have gained considerable popularity. Of Scandinavian origin, the invigorating sauna, with its hot, dry atmosphere, is often a cubicle adjacent to the bathroom in the American home, while the spa or hot tub, often with whirlpool jets, may be located in the bathroom, in the master bedroom, or outdoors. (See photographs on the previous page.)

As interest in and awareness of the importance of physical fitness rises, a home gym is being combined with the master bath or bedroom area with increasing frequency. We steam, tan, exercise, and bathe our bodies in bathrooms that can be a personal paradise.

LOCATION, LAYOUT, AND DETAILS

Location of bathrooms is primarily a matter of convenience, privacy, and cost. A bath should be accessible from all bedrooms without visibility from group spaces. On the other hand, at least a lavatory with washbasin and water closet should be as near the kitchen and major group space as feasible. Bathrooms located between two bedrooms with a door to each, although often convenient, can also cause problems with "leaks" of both noise and light under the doors, and forgotten locked doors preventing use from one of the bedrooms. For soundproofing, fixtures backed

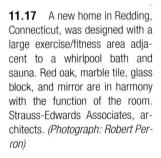

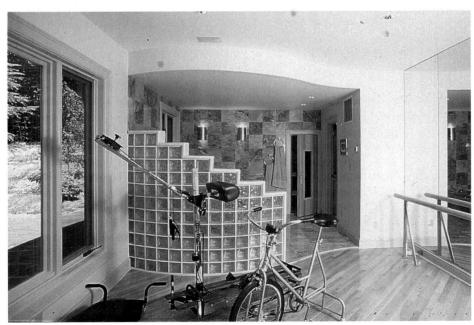

TABLE 11.2

Standard Bathroom Fixture Sizes and Clearances*

	Small	Large		
Sizes	Depth Width	Depth Width		
bathtub soaking tub	$37'' \times 42''$ $42'' \times 54''$	42" × 66"		
lavatory water closet	$15'' \times 18''$ $26\frac{1}{2}'' \times 19''$	$24'' \times 30'' \\ 30'' \times 22''$		
bidet shower	$25'' \times 14''$ $30'' \times 30''$	$28'' \times 16''$ $42'' \times 60''$		
bathinette vanity cabinet	21" × 35" 30" × 24"	$24'' \times 36''$ $32'' \times 26''$		
Clearances				
space between front of tub and opposite wall space in front of water closet space at sides of water closet space between fronts of fixtures	30'' - 42'' $18'' - 24''$ $12'' - 18''$ $24'' - 36''$			

^{*}Luxury fixtures are available in larger sizes.

against closet walls are most efficient and economical; however, pipes in shared walls can be insulated to help deaden sound.

Because of the bathroom's restricted area and need for light, heat, ventilation, and humidity control, the design of the bathroom, its layout, and finishes take careful thought. Layout is usually predetermined, but the following criteria can be of help in evaluating a room and in remodeling:

- Minimum size is 5 by 7 feet for a full bath, but these dimensions preclude use by more than one person at a time and seriously limit storage space. A few more square feet usually justify their cost. A 2-foot-wide traffic path is necessary; other clearances are listed in Table 11.2. For wheelchair access, a small bath should be approximately 6½ by 10½ feet.
- The **door** should be located so that, when opened, it will swing into the bathroom without hitting anyone using any appliance, and can be left partially open for ventilation without giving full view of the room, most particularly the water closet. It should be equipped with a device on the outside to permit emergency entry or, for use by someone in a wheelchair, it should swing outward and provide a *minimum* clear opening width of 32 inches to allow passage. Sliding or folding doors may also be used, although they provide a less soundproof closure.
- Critical factors in **window design** include light, ventilation, easy operation, and privacy. The bathroom requires the most heat and best ventilation of any room in the house. Windows should not be located over the tub or toilet because of the danger of uncomfortable drafts, moisture deterioration of window frames and treatments, and difficulty of operation and cleaning. For privacy, windows should be 48 to 60 inches above the floor. High windows, skylights, and vented fans can illuminate and/or ventilate inside bathrooms while exterior-wall bathrooms can have entire window walls with secluded gardens or balconies outside to protect privacy.
- **Heat** can be provided quickly and efficiently by electric heaters, infrared lights, or quartz heaters, while skylights make use of solar heat. (Unshaded skylights are not recommended in hot climates.)

11.18 Glass block admits light without reducing privacy, and it can be set in grand sweeping curves such as the wall behind this elegant marble-enclosed tub. Carol J. Weissmann Kurth and Peter C. Kurth, architects. (Photograph: Peter Mauss/ESTO)

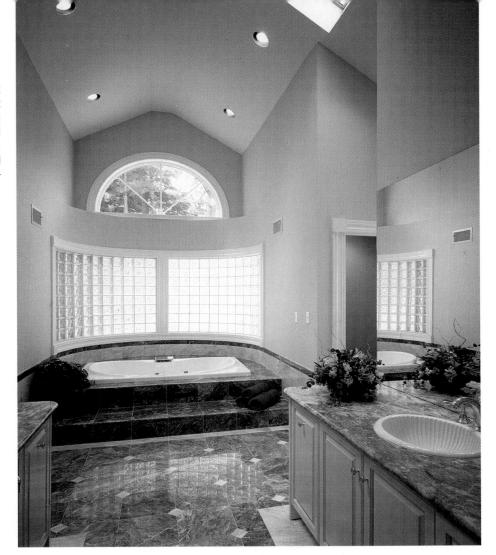

Typical arrangements of fixtures are illustrated in Figure 11.19. Compartmentalized bathrooms increase utility considerably for relatively small expense.
 To simplify plumbing and reduce costs, the appliances should be located so all plumbing can utilize one wall.

• Storage at point of first use is a cardinal principle, as always. This indicates the need not only for medicine cabinets (with locks for security) but also spacious cupboards and drawers for the miscellany of supplies and equipment associated with hygiene and grooming. Professor Kira recommends at least 1 square foot of storage per user near the washbasin.

• Finishes for walls permit almost total freedom of choice. Nearly every material can be made to withstand moisture and mildew.

• **Flooring materials** range from practically impervious tile through the more resilient vinyls to the warmth of carpet. Nonskid flooring is recommended.

• Color is important both for its visual impact and for its *reflectance*, which can change skin tones. Oranges and pinks make one look healthy; blues, yellows, and greens may cast a sallow tinge. Light values with high reflectance factors assist in distributing light throughout the bathroom. Lower-value colors require more attention to both quantity and location of light.

• **Lighting**, both natural and artificial, is critical to provide good illumination for shaving and cosmetic application. In type and placement, lighting must avoid glare and harsh shadows. Light fixtures should be located in front of the

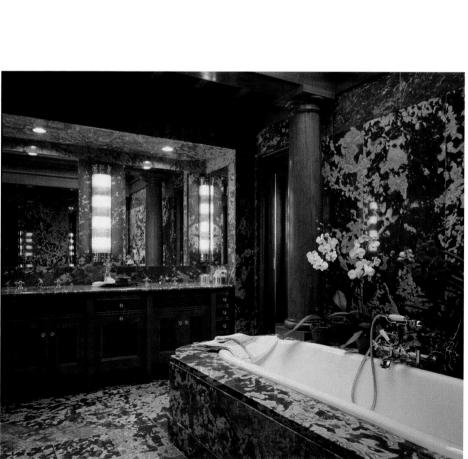

11.19 Various types of bathrooms can fulfill different functions. (a) A master bathroom/ spa, entered from the bedroom. may occupy a considerable amount of space, with twin lavatories, compartmentalized bidet and water closet, separate walkin shower, and luxurious soaking tub, combined with his and her closets. Design Associates, architects. (b) A powder room near the main entrance to a house is often useful for quick cleanups, especially in a two-story home. (c) A family bathroom should be large and centrally located, but out of sight of the social spaces. Since all family members use this room, dividing the space to increase simultaneous use is often a good idea. (d) A semiprivate bathroom, planned for two or three members of the family should be near bedrooms but entered from the hall. (e) A private bathroom for one or two persons is entered from a bedroom. A second entrance is useful if guests use the room as well. Dividing a private bathroom gives even more privacy. (f) A service core concentrates all plumbing—for bathrooms, kitchen, and laundry-and centralizes the inevitable noise. Construction costs are also lowered.

11.20 Lighting both above and beside vanity mirrors assures shadow-free grooming. In addition, a skylight above the tub brings daylight into this French marble master bath in a Mediterranean-style villa located on the New Jersey shore. The marble floor is warmed for greater comfort underfoot. Robert A.M. Stern Architects. (Photograph: Timothy Hursley)

person using the mirror and placed to provide light evenly on all sides of the face, including under the chin. This can be accomplished with small luminaires (light fixtures) surrounding the mirror, light sources on both sides of the mirror, or a strip of lights above the mirror combined with a light-color countertop to reflect the light back up onto the lower part of the face. Light sources must not reflect directly in the mirror, but if located near the mirror they provide reflected indirect light for the entire room. Incandescent sources are most flattering to skin tones; if fluorescent sources are used, deluxe warm white and natural white are the most complimentary. If the bathing facility is located so it does not receive sufficient general room illumination, supplementary lighting is necessary. Also, for safety, night lighting is desirable. All electrical outlets and switches should be at least 3 feet from the tub or shower.

• Shape and size of fixtures become critical factors in space planning. Typical dimensions and necessary clearances are listed in Table 11.2, but luxury fixtures can be much larger and of irregular shapes. A word of caution: although elegant, the sunken tub is both hazardous and difficult to clean.

Aesthetically, the bathroom need no longer look like a laboratory. Its functionalism can be made delightful to the senses with appliances, finishes, and accessories in a wide range of colors, textures, and designs. The bathroom, particularly the powder room or guest lavatory, is a relatively small space in which a limited amount of time is spent. This allows boldness in decor which would not be attempted in other areas. Theatrical lighting adds drama, perhaps framing the mirror on two, three, or four sides with thin chrome or brass strips studded with small lamps (if they do not produce too much heat or glare). The strong task light recommended for the bathroom allows the use of darker colors; pastels are not mandatory for light reflectance, although they do help distribute light more evenly than dark surfaces. Mirrors are visual spacemakers, as are luminous ceilings and windows. The bath can be humanized and individualized with plants for a soothing private garden atmosphere. This aura of relaxation can be further enhanced with paintings, graphics, and other personal accessories.

11.21 A 1923 vintage powder room, by designer Carol K. Douglass, ASID, retains original fixtures, refinished in black to contrast dramatically with goldleaf wallpaper. The marble floor is echoed in a wall molding that conceals miniature lights reflecting off the ceiling. Oriental accessories complete the bold decor. *(Photograph: Eric Zepeda)*

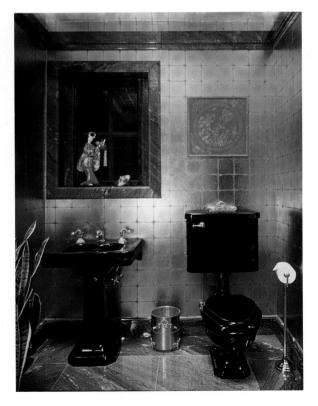

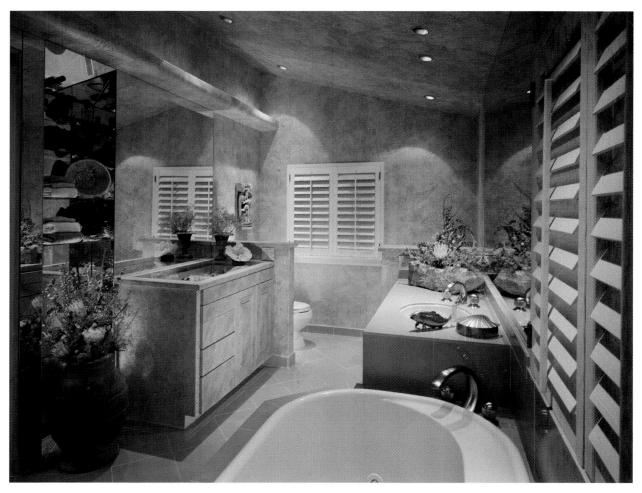

11.22 Carol Tippett, ASID, remodeled this bathroom to show a collection of antiques and serve functional needs. Floor-to-ceiling, mirror glass shelves display Asian temple carvings and a Mexican basket; a Balinese carving is hung on the wall; an antique fish graces the vanity. The glass top on a vanity reveals earrings in a shallow drawer below. Flower arrangements add color and texture. (Photgraph: Ed Asmus)

11.23 A separate guest house affords quests private time away from their hosts. It can also present an opportunity to explore new design ideas, as seen in these Ormond Beach, Florida, guest quarters designed by Steven Harris & Associates, Architects. The counterweighted mirror can be raised or lowered on tracks to open a 3½' diameter hole between bedroom and living room, allowing a view of the ocean or secluding the bedroom. (Photograph: Timothy Hursley)

GUEST ACCOMMODATIONS

Until only a few decades ago, entertainment of overnight guests represented a major form of recreation, a welcome change of pace from everyday living. The combination of great distances separating friends and relatives and somewhat larger houses, often with domestic help, made hospitality a simple pleasure. Guests could be accommodated for long periods of time without seriously disrupting the household, and the visitor who arrived for dinner and stayed for a week was not cause for dismay.

Today, houses are smaller and live-in servants almost unknown; even one unoccupied bedroom seems a luxury. Nevertheless, with careful planning most houses can accommodate overnight guests in a comfortable manner, particularly if their lifestyles correspond to those of their hosts.

For those who travel lightly, perhaps even with their own sleeping bags, comfortable surfaces on which to place them may be all that is necessary. Many vacation houses provide this minimum in bunk rooms.

Going one step beyond this, we should consider that houseguests deserve the same elements of private space as do members of the family: a secluded area in which to sleep and dress, storage space for clothing, bathroom facilities, and the possibility of getting outside the social circle occasionally. The ultimate would be a separate **guest house**, with its own kitchenette and eating counter. Other possibilities include

- a **bedroom-sitting room** with private bath, separated from family areas and always in readiness because it serves no other purpose;
- a **secluded room** or study that doubles as a guest room—a sensible solution because a room well planned for seclusion has most of the qualities of a good guest room;
- a **quiet alcove** or small room off the group space that can readily be made private by folding or sliding doors, curtains, or screens;
- an extra bed in one or more of the bedrooms—perhaps a bunk or a studio couch;
 and
- a living room sofabed.

11.24 Most guests appreciate having a small sitting area where they can enjoy some quiet time in or near their sleeping/dressing space. Lewis & Bristou, architects; Dennis Haworth, FASID, interior designer. *(Photograph: Steve Simmons)*

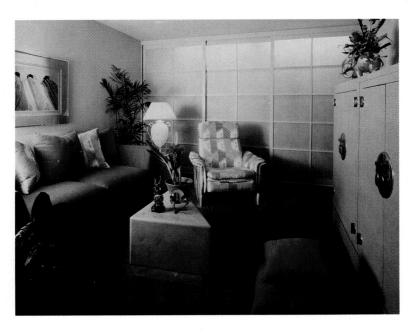

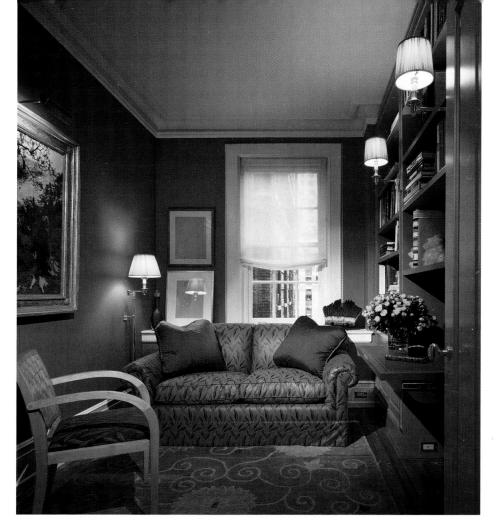

11.25 A study or home office is often the primary daily use for a guest room. A sofabed quickly converts the space to accommodate guests in this Manhattan apartment. Roger Ferri, architect; Virginia Cornell, interior designer. (Photograph: Paul Warchol)

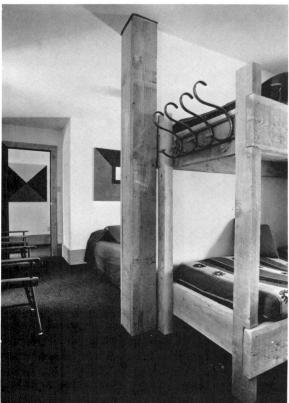

11.26 Vacation homes are often expandable to accommodate overnight guests. In a minimally divided bunkroom, recycled lumber makes sturdy double-decker beds, while coat hooks take the place of closets for short-term use. Donald MacDonald, architect. (*Courtesy* American Home Magazine)

HOME OFFICE AND STUDIO SPACE

Home business activities, individual work, and hobbies (ranging from paying bills and computer shopping to writing and painting) may take place in several areas within the home or be concentrated in a single area. Since segregation from noisy activities is generally desirable, full discussion of these work centers and the requirements for the business of running a home and personal record-keeping is included here rather than with exploration of social or work spaces.

Every household has family documents—medical and tax records, legal papers, bills, receipts, addresses, household inventories, and so forth—that must be organized, filed, or simply kept in some manner and in some place. It is convenient if much of this information is stored in a single location for easy reference. Such a home business center might be located in the kitchen, family room, or bedroom, or it might be a separate study, office, or library. In addition to storage facilities, it should contain communication devices and materials—a telephone, typewriter and/or writing supplies, and increasingly a computer, facsimile machine, or even a copy machine.

The case study at the end of this chapter details how a bedroom space was converted to a comfortable, efficient, home-based business office. Basic needs include:

• Work surfaces for writing and paying bills, for a typewriter, or for computer components (keyboard, video display terminal, and perhaps a printer). A standard desk of 29- or 30-inch height is suitable for writing; a typewriter return is normally 3 inches shorter. A computer keyboard can utilize approximately the same 26-to-27-inch-high surface while the display screen should be closer to eye level, requiring a surface height of 33 to 36 inches. Modular furniture can allow flexible keyboard height, screen height, and viewing distance for the comfort of all users. Drawing tables, easels, and other special work surfaces may be appropriate for different types of work.

 Seating for one or more, with one adjustable ergonomic office chair to avoid backaches and stress while working at the computer or typewriter. Other seating may consist of side chairs that can be pulled up to the desk or used for com-

fortable reading.

- Storage for writing supplies, computer disks, books, and files. Built-in units do not take up precious floor space but are expensive to construct and perhaps less flexible than freestanding units. As more transactions are conducted by computer, less storage space for printed materials will be required; all the information will be stored in the computer memory bank or on small disks. There will nevertheless still be a need for storage space for computer software and other materials.
- Lighting, with no shadows or glare in the work area. Windows, shiny work surfaces, computer monitors, and bright or incorrectly placed lighting can all cause glare. Some computer screens have nonreflective glass and many can tilt and swivel to reflect glare away. Green, yellow, and orange lettering on the screen has been found to be easier to view for long periods than black and white. (Lighting for task performance will be discussed further in Chapter 21.)

The computer is capable of streamlining many business transactions—from electronic banking to ordering products from the comfort of home. It can also be hooked up to a master computer to provide fire, burglar, and medical alert devices that call for help automatically if the computer senses anything wrong.

If the home office is used for professional business pursuits (which might involve visits from clients), it may need a separate outside entrance and increased

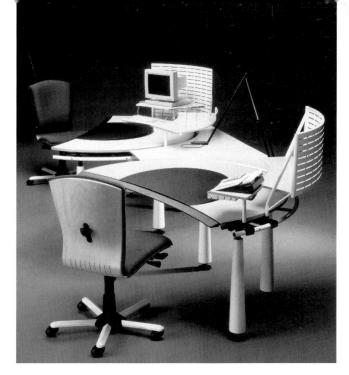

11.27 Many workstation components are ergonomically designed to adjust to the needs of the individual for maximum comfort and flexibility. This "Soleil" unit can even be joined to a second workstation. (Courtesy SITAG, U.S.A., Inc.)

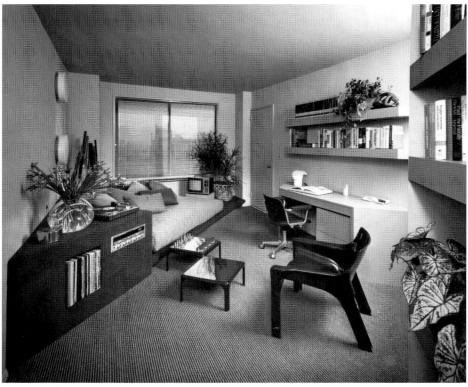

11.28 This room doubles as a study when the owners' son is away at college. The diagonal platform holds the bed, out of the way yet always ready for his return. Built-in shelves and work surface, with a well-designed office chair make up the work area. Barbara Ross and Barbara Schwartz/Dexter Design, Inc., designers. (Photograph: Norman McGrath)

privacy from family activities. This would require a location in the plan that is farther removed from the noisy areas of the house, or at least good acoustic control to provide quiet, uninterrupted working conditions.

Knitting and crocheting can be done wherever one can read, but sewing, needlework, weaving, and other crafts—either as profession or hobby—are not so easily handled. The collection of needles, scissors, and "findings" seems to invite disorder and the fingers of small children, to which they are a definite hazard. Adding a sewing machine and space for a cutting table, or a loom, brings further complications. In descending order of desirability would be: a separate studio (these days a luxury); space in one of the bedrooms; or a spot in the family room, the already crowded kitchen, or laundry.

Pursuits such as woodworking, photography, drawing, or painting also deserve appropriate space and equipment. Important as these may be to individuals, however, such enterprises can quickly endanger the composure of other household members unless they are isolated in a separate room or studio.

For people who live in groups and for parents raising children—as well as for the children being raised—occasional solitude is a rare and precious gift. Too often the bathroom provides the only haven in the home, the only area in which one feels reasonably secure from being disturbed—and this leads to certain difficulties. Much stress is laid upon the two-week vacation to "get away from it all," but travel cannot substitute for the half-hour vacations most individuals need every day. This returns us to the question of privacy. In the quest for solitude some families and individuals have planned tranquil "meditation rooms," in the home or in a partly or wholly separate building; most find it in a bedroom or study. The opportunity to find total seclusion, free from interruption, not only sustains the emotional well-being of individuals but also enriches their contacts with other people when the private space is left behind.

11.29 This room contains a modern version of the Murphy bed, a unique solution to the problem of multiuse space. When the bed is folded into the storage cabinet at right, the room becomes a spacious studio for an artist or designer. Joan Regenbogen, designer (Photograph: © Norman McGrath)

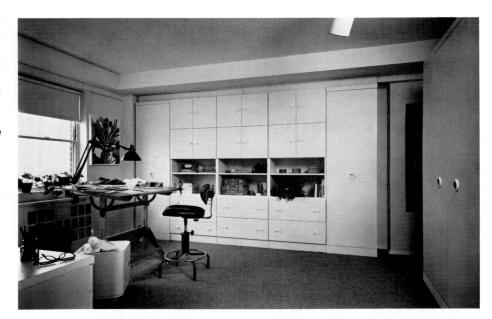

11.30 The bed takes up a good part of the room when opened. Joan Regenbogen, designer. (*Photograph*: © *Norman McGrath*)

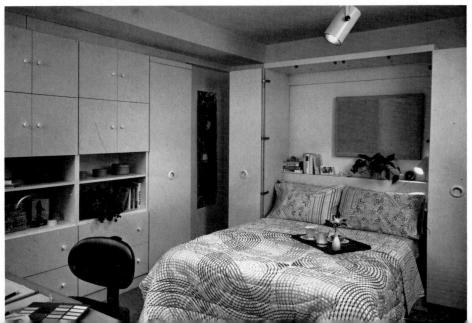

CASE STUDY

The Home Office

by Bruce Goff, ASID

Changing values in the 1990s have brought about the resurgence of a home life for many people. Cocooning, nesting, romance, the family, and working at home have become growing trends. In keeping with the increasing frequency of people working in their homes, basements, bedrooms, dens, and areas adjacent to the kitchen are being converted to offices.

For one client, available space was evaluated and an unused bedroom in the basement was selected for a workspace. Instead of making the client feel that he was being banished to the basement to work, an escape niche was designed to belie its location.

The recessed space that was formerly a closet was converted to a generously proportioned work station for a computer. The desk was then placed in front of this built-in work area so that paperwork and the computer were both easily accessible.

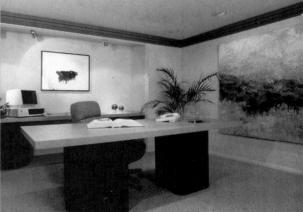

At the opposite end of the room, bookcases were installed to house the extensive library of research material needed by the client. In addition, a comfortable sitting area conducive to long hours of reading was included. A good reading light completed this area.

As is often the case, the original lighting was a single incandescent 120-watt fixture placed in the center of the ceiling. Design goals were to increase lighting levels evenly while maintaining a residential character, to eliminate glare, and to provide a changeable, restful space. The existing fixture was removed and recessed lighting was installed around the perimeter of the room with directional fixtures over the desk. Track lighting over the credenza/computer area provided direct light without glare on the computer screen. All fixtures could be dimmed by area. With lighting reflected off the light-colored walls, no additional task lighting directly on the work surfaces was necessary. The new lighting gave the room a calm, relaxed feeling.

The colors chosen for the office had to be non-aggressive so that the client would be able to spend long hours at work. Values of light gray were selected for the backgrounds with dark gray, red, and black artwork. A contrasting molding was added at the ceiling for architectural interest. The total budget was \$3,000.

11.31 Before being converted to a home office, this space was an unused basement bedroom. (*Photograph: Ron Hildebrand*)

11.32 The closet became a recessed area for a built-in credenza/work surface with track lighting overhead and a large desk in front. Simple, uncluttered forms and the large scale of individual elements actually make the room seem more spacious. Bruce Goff, ASID/Domus Design Group, interior designer. (Photograph: Ron Hildebrand)

NOTES TO THE TEXT

- 1. Suzanne Lindamood and Sherman D. Hanna, *Housing, Society and Consumers: An Introduction.* (St. Paul, Minn.: West Publishing Company, 1979), p. 83.
- 2. Marjorie Branin Keiser, *Housing: An Environment for Living.* (New York: Macmillan, 1978), p. 138.
- 3. Alexander Kira, *The Bathroom: Criteria for Design*, Research Report No. 7. (Ithaca, N.Y.: Center for Housing and Environmental Studies, Cornell University), pp. 15–16, 64–65.

REFERENCES FOR FURTHER READING

American National Standard Specifications for Making Buildings and Facilities Accessible to and Usable by Physically Handicapped People. ANSI A117.1-1980. New York: American National Standards Institute, 1980.

Family Housing Handbook. Ames: Iowa State University, Midwest Plan Service, 1971, pp. 21–30.

Gilliat, Mary. The Complete Book of Home Design, rev. ed. Boston: Little, Brown and Company, 1989, pp. 184–367.

Hartwigsen, Gail Lynn. Design Concepts: A Basic Guidebook. Boston: Allyn and Bacon, 1980, chaps. 3 and 4.

Keiser, Marjorie Branin. Housing: An Environment for Living. New York: Macmillan, 1978, chaps. 9 and 12.

Kira, Alexander. *The Bathroom: Criteria for Design*. Research Report No. 7. Ithaca, N.Y.: Center for Housing and Environmental Studies, Cornell University, 1966.

Lindamood, Suzanne and Sherman D. Hanna. *Housing, Society and Consumers: An Introduction.* St. Paul: West Publishing Company, 1979, chaps. 4 and 5.

Packard, Robert T. (ed.). Ramsey/Sleeper Architectural Graphic Standards, 7th ed. New York: Wiley, 1981.

Panero, Julius and Martin Zelnick. Human Dimension and Interior Space: A Sourcebook of Design Reference Standards. New York: Whitney Library of Design, 1979.

Pickett, Mary S., Mildred G. Arnold, and Linda E. Ketterer. *Household Equipment in Residential Design*, 9th ed. New York: John Wiley & Sons, 1986, chaps. 10 and 22.

Riggs, J. Rosemary. *Materials and Components of Interior Design*, 3rd ed. Englewood Cliffs, N.J.: Prentice-Hall, Inc., 1992, chap. 9.

Small Homes Council–Building Research Council. *Bathroom Planning Standards*. Champaign: University of Illinois, 1978/1979.

Floor Plan Selection

TYPES OF PLANS
Closed Plans
Open Plans
Horizontal and Vertical Plans
HOUSING FORMS
Multifamily Housing
Attached Housing
Single-Family Detached Housing
EVALUATION

Few people have the opportunity to custom design their own homes from the ground up. The majority of homeowners enter the picture after construction of the housing unit is complete, with spatial arrangements, floor coverings, and fixtures already determined. Most people select a home that most nearly suits their space needs and do what they can to make it as habitable and pleasing as possible, personalizing it with their own selections of furnishings, colors, patterns, and textures. A professional interior designer can provide objective and cost effective services in the selection, alteration (if necessary), and furnishing of a home, whether tract or custom, single or multiple unit. An understanding of the various types of plans and housing forms and the ability to evaluate them is essential.

TYPES OF PLANS

The two basic determinants in shaping a plan—the intended occupants and the space available—can be interrelated in countless ways. Family size, resources, ages of members, and way of life indicate the amount of square footage desirable and economically feasible, as well as the disposition of space for satisfactory living on one level or two, compacted or spread out. The size, shape, contour, and environment of the space, in turn, suggest whether a given amount of square footage can be contained in one story or will need more than one, whether the plan should be a square or rectangle or can be expanded into an L or T shape or a cruciform,

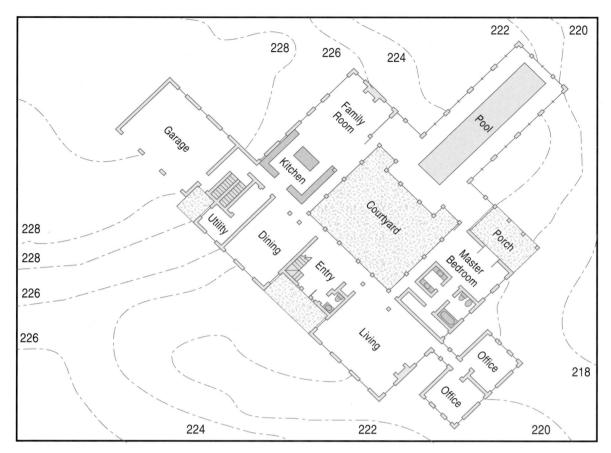

12.1 A courtyard plan can give all inward-facing rooms a view of the enclosed private outdoor space. This home (ground floor plan only shown) uses the light-filled area adjacent to the courtyard for circulation. Christopher L. Dallmus, AIA, Design Associates, architect.

and perhaps whether an inward-turning courtyard plan would be better than one that opens outward to a nonexistent view, to a street, or to nearby neighbors.

Over the centuries the concept of space within the home has fluctuated between two basic arrangements: a single large, undifferentiated area in which most of the homelife took place and a series of tightly segregated rooms with minimum intercommunication. In the late nineteenth and early twentieth centuries, specialized rooms meant for designated activities appeared in the house plan. The terms card room, drawing room, music room, and even smoking room suggest the compartmentalization of a time now past. This century has witnessed changing lifestyles that in turn are reflected by more open space planning, with slightly demarcated but expansive spaces flowing into one another. As modern life became less marked by formality, elaborate social rituals, and rigid distinctions, so our homes changed in response to these demands. People with active, mobile, informal lifestyles today often find a combination of the two plans, with one part of the home more open and another more closed, most responsive to their needs.

CLOSED PLANS

The **closed plan** divides space into separate rooms for specific activities. It has several points in its favor and still appeals to many people because it affords privacy for different age groups and pursuits. A closed plan allows modulated levels of upkeep: for instance, children's play space does not necessarily have to be neat at all times, while adults often prefer their social spaces at least moderately ordered. Conflicting activities can also take place simultaneously in different rooms without interference. Furthermore, it is possible to close off certain portions of

the house so that only those spaces in constant use need be heated or cooled at a given time—an important energy-conserving feature. The house shown in Figure 12.3 exhibits such a plan as it is conceived today. If desired, the downstairs bedrooms can be totally or partially shut off from the rest of the house and left unheated; levels of heat throughout the house can also vary according to need. One disadvantage of closed plans is the division of space into many separate cubicles that may be quite small unless the house is very generous in size.

OPEN PLANS

An open plan provides a minimum of fixed, opaque, floor-to-ceiling partitions and a maximum of flexible group space. Instead of being tightly closed into boxlike rooms, space is organized as a continuous entity, flowing from one area to another and from indoors to outdoors, all of which greatly expands the potential of any one area. The advantages of open plans include a sense of spaciousness beyond actual dimensions, diversified use of space, and recognition that family or group activities are not isolated events. For people with ambulatory problems or vision or

may interfere with those requiring quiet, and the retiring soul finds little opportunity for solitude. Also, if not sensitively planned, the large space may seem barnlike. However, these drawbacks can be overcome in several ways. Incompatible functions can be segregated by shaping the space with partial walls, different floor levels, and furniture arrangement. L-shaped rooms, balconies, furniture set at right angles to the wall or placed away from the walls, and flexible screens or movable

lower level

12.2 A floor plan can combine open and closed spaces. The living and dining rooms and kitchen occupy the large open second level; bedrooms and studio are distinct spaces separated by changes in level. Alexander Seidel and Jared Carlin, AIA, architects.

dn

bedroom

open to dining

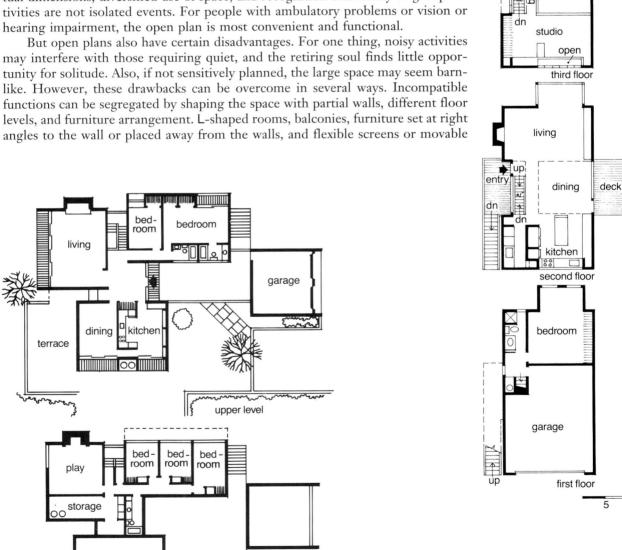

12.3 A plan divided vertically as well as horizontally into group and private, active and quiet zones is easily encompassed within a two-story format. Willis Mills, architect.

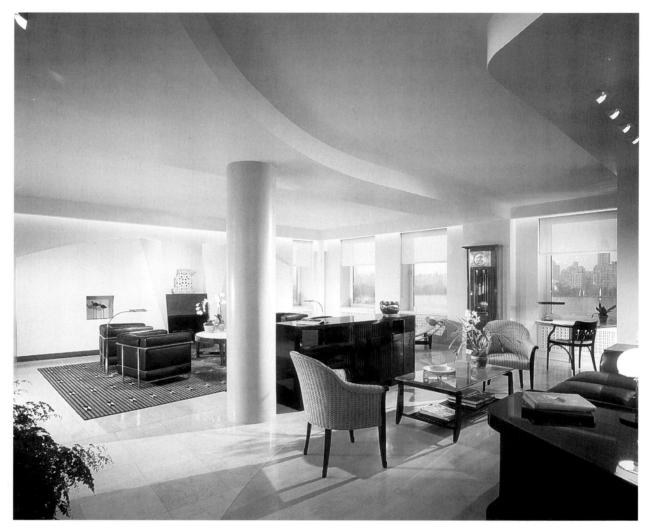

12.4 Changes in flooring materials and ceiling heights, one large column, and distinct units of furniture break up the space in an apartment in New York. Each group is cohesive while the airy open atmosphere is maintained. Charles Gwathmey, architect. *(Photograph: Paul Warchol)*

walls represent some of the major design possibilities. Noise can be controlled with surfaces that absorb sound waves. Some segregated areas can be provided—multipurpose or family rooms for active pursuits, seclusion rooms for quiet study, meditation, and relaxation.

The open plan owes much of its development to the inspiration of Frank Lloyd Wright with his prairie house designs and later to the innovations of Le Corbusier and Ludwig Miës van der Rohe. (See Chapter 2 for further discussion of these architects and illustrations of their open-plan designs.) The open plan reached its full flowering in one-story ranch houses that spread out over the land and into the landscape by means of terraces and decks, at a time when acreage was relatively inexpensive—from the 1940s through the 1970s.

Today compact but open plans of 1½ and 2 stories capitalize on the natural potential for maximum air circulation to provide economical heating and cooling. Many solar home designs utilize multilevel open plans effectively for this purpose.

HORIZONTAL AND VERTICAL PLANS

Plans can also be divided into one-or-more-storied types, with resultant advantages and disadvantages.

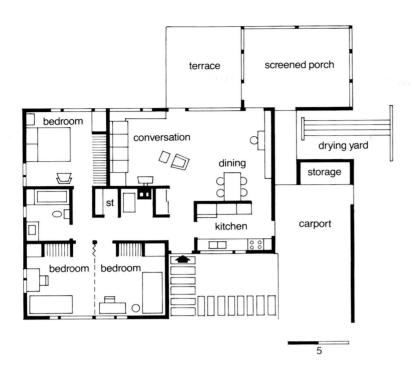

12.5 Within an enclosed area of only 1000 square feet this plan compacts most of the amenities that result in comfortable family living while still allowing both physical and psychic expansion of space. Bruce Walker, architect.

ONE-STORY PLANS One-level plans are well suited to small houses, and to larger ones for which the cost of greater land, roof, and foundation area and of an extended perimeter will not be an excluding factor. Single-story plans avoid stairways, permit easy supervision of children, give ready access to the out-of-doors, and generally result in a horizontal silhouette that fits comfortably on level land. Until recently, individual apartment units have also been predominantly one-story even though contained in multistory apartment buildings.

MULTILEVEL PLANS A major interest in the design professions today involves the manipulation of vertical spaces, of *volumes*. The sense of excitement produced by soaring interior spaces has found a ready acceptance among large segments of the public; even speculative builders resort to high ceilings with mezzanine or balcony projections. This trend indicates a radical departure from the Uniform Building Code minimum 8-foot ceiling that has been standard since World War II.

Coincidental with the growing taste for verticality has been the pressing economic need to conserve square footage. The hollowed-out effect of tall interior volumes tends to counteract our awareness of shrinking floor areas and to eliminate a feeling of constriction. Whatever the reasons, the results often have been dramatic.

Multiple-story plans offer several advantages. Given two homes of equal square footage, the double-story version is less expensive to build than the single because of its smaller foundation and roof. Heating and cooling are also less expensive. Moreover, vertically separated rooms simplify the problem of zoning spaces for different activities. As the cost of land rises, multiple-story houses seem more practical, fitting onto awkward hillsides, tight city lots, or modest suburban sites, thereby freeing more land for outdoor enterprises. Sometimes multistory plans rise to catch desirable breezes or an otherwise hidden view. And the large steep roofs that can be a natural, effective part of the design have proved ideal for solar heating panels if the house is suitably oriented.

The 1½-story plan, often called the Cape Cod house, provides a smaller upper floor beneath a high-pitched roof. About half the area of the attic floor is useful (space with less than 5 feet of head room is usable only for storage), and dormer windows penetrating the roof to admit light are characteristic. Although the upper rooms are small, this is a very inexpensive way to add living space with minimal effect on construction cost and exterior design. Even more square footage of

12.6 The *multilevel* floor plan of the house in Figure 12.7 easily and naturally divides group and private spaces, a concept enhanced by the way rooms cluster around the space-saving circulation core. Charles Moore and Rurik Ekstrom, architects.

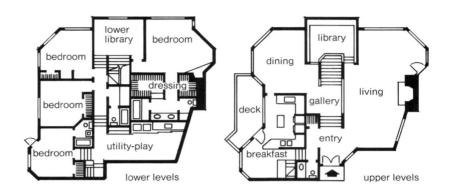

12.7 Tantalizing glimpses of different levels and areas bring an exhilarating sense of the spaces beyond. In this house, each activity has its own separate but not isolated room. Charles Moore and Rurik Ekstrom, architects. (*Photograph: Maris/Semel*)

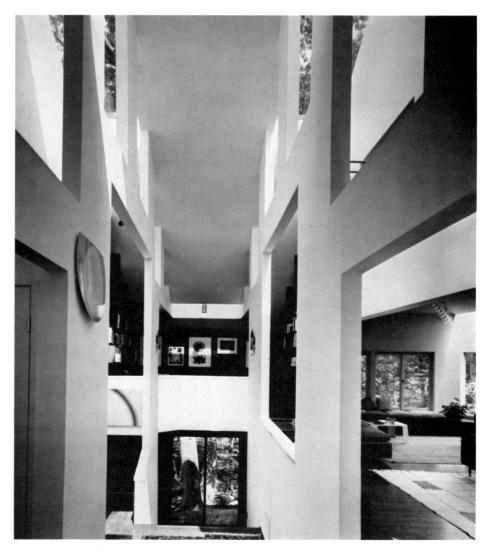

living space results from the full two- or even three-story plan without increasing the overall ground area occupied.

The only real disadvantage of the multiple-story house is the necessity of always climbing and descending stairs, an especially hazardous activity for the very young, the elderly, and the infirm. Increased interest in these groups of people has brought with it research into different stairway designs. A flight of stairs broken

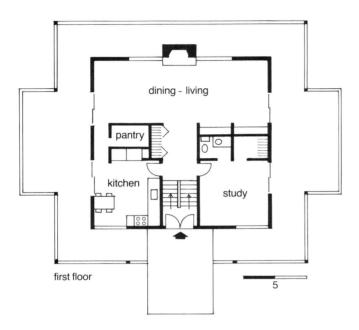

12.8 The plan of this house is a square, which encompasses the most space with the least foundation, exterior walls, and roof. A two-story square plan further reduces exterior maintenance and keeps heating costs low. John Black Lee and Harrison DeSilver, architects.

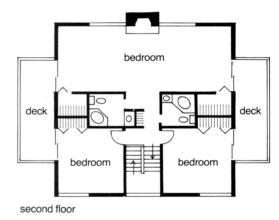

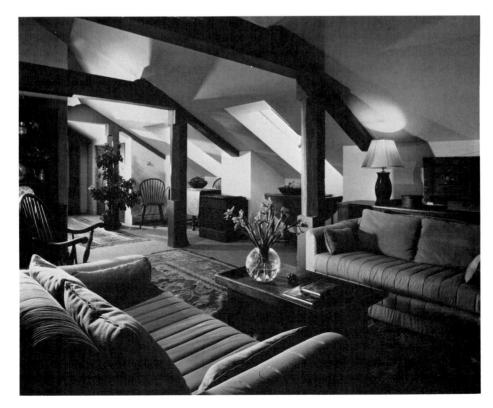

12.9 Heavy-beamed ceilings, enclosing spaces, plush upholstery, patterned rugs, and the earthy texture of wood and plants help establish a feeling of warmth in an interior that adds to its comfort. The oftenunused space under a pitched roof has been put to effective use. CBT/Childs Bertman Tseckares & Casendino, Inc., architects. (Photograph: Nick Wheeler)

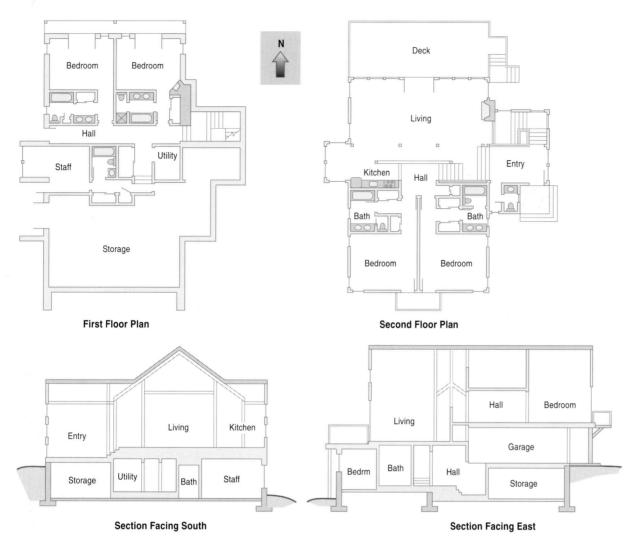

12.10 The plan of a split-level house in Massachusetts indicates a clear separation of social and private zones. Section drawings reveal how the rooms are vertically stacked and staggered, with the entry and garage at grade level on the east side. Christopher L. Dallmus, AIA, Design Associates, architect.

at some point by a landing provides the easiest way for the climber to bridge the space between two floors. Spiral staircases occupy the least space, but this economy may be offset by the difficulty of moving furniture up and down, as well as the increased danger of accidents on the narrow treads near the center support.

The multilevel floor plan has reestablished itself in popularity after a period of disfavor caused by the aggressive onslaught of the one-floor ranch house. The split-level plan first reignited interest in multilevel living, since it offered the opportunity for three well-separated zones of activity over a relatively small ground area. Originally an adaptation to hillside lots, it pushes the basement halfway out of the ground for light and ventilation while still benefiting from the earth's insulation. At a time when acreage is scarce and expensive, we can no doubt anticipate a greater concentration on vertical building to exploit each plot of land more fully.

HOUSING FORMS

MULTIFAMILY HOUSING

The Romans built thousands of apartment houses, some of them seven and eight stories high, during the second century. Their presumed reasons were the same as those that motivate multifamily housing today: commerce and industry concentrated in specific large cities require a parallel concentration of people; also, land in such focal areas tends to be scarce and expensive, so it is more efficient to expand vertically than horizontally. The plans of the individual units are much the same as those for single-family housing except that most of the windows may face in only one or two directions along the facade of the building. A major disadvantage then is often an absence of cross ventilation for summer cooling, rendered unnecessary perhaps by air conditioning but once again becoming an important energy-saving device. Other disadvantages of such plans are the relative lack of privacy and the absence of outdoor living areas. Many newer multifamily dwellings overcome the latter problem with terraces or outdoor decks and balconies. Much of the residential housing stock in many cities consists of multifamily units in which individuals and families spend their entire lives. Indeed, a single family detached house in the suburbs may seem very unusual to a resident of Tokyo or Paris or even New York City! (See Figures 12.11 and 12.12.)

ATTACHED HOUSING

Called row houses, townhouses, or garden apartments, attached dwellings have once again become a major solution to the problem of accommodating a large number of families on a small area of land. They represent one of the fastest growing segments of the current housing market. Rising two to four or five stories in height, row houses by definition have their side walls abutting those of adjacent houses. They combine the psychological privacy of a completely integral structure with the economy of limited ground area and shared walls.

A major disadvantage of the row house plan is the necessity of placing all windows on the two short walls at front and back. In older buildings, space tended to be broken up into many small rooms, with the result that internal spaces were completely deprived of daylight and fresh air. Traffic patterns also tended to be

12.11 (below left) High-density row housing in Berlin, Germany, completed in 1987, steps up to form a tower, identifying the development from more distant viewpoints. The courtyard is shared by four houses and connects to land-scaped commons that end with a view of Tegel Harbor, giving the complex an atmosphere seemingly far from the city center. Moore Ruble Yudel, architects; Tina Beebe, color consultant. (Photograph: Timothy Hursley)

12.12 (below right) In large urban areas such as Rio De Janeiro, Brazil, highrise multi-family housing units are prevalent. The inclusion of open spaces and access to outdoor recreation, such as boating in Botáfogo Bay, can help compensate for the high density. (Photograph: Will & Deni McIntyre/Photo Researchers)

12.13 (left) A remodeled row house makes the most of its 16-by-80 foot space through the virtual elimination of interior walls except where they are necessary for privacy. Peter Samton, architect.

12.14 (right) Illustrating the privacy and amenities essential to viable shared housing, this design provides two widely separated master suites—self contained apartments that include bed, bath, dressing room, sitting alcove/media center, and compact laundry facilities. The balance of the interior is one grand room, with functions defined by changing levels rather than walls. Barry A. Berkus, AIA, Berkus Group Architects.

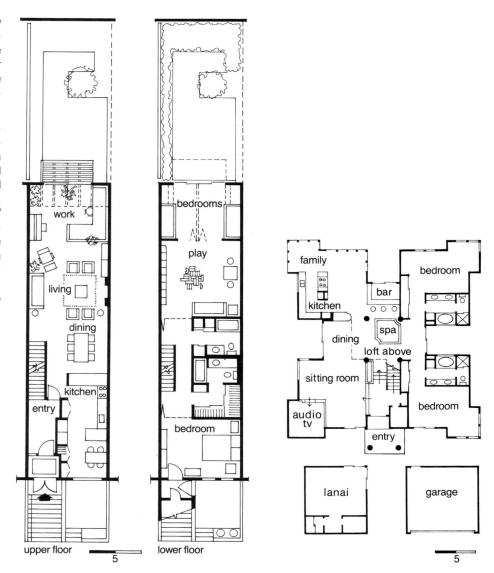

poor, with rooms arranged along a long corridor of wasted space, or traffic routed through activity areas. However, the present wave of interest in building or renovating townhouses has fostered new ideas for opening up the long, narrow space. The remodeled Samton house (Figure 12.13) admirably answers the problems of light, ventilation, and articulation of space. Two main structural changes were made: as many internal walls as possible were removed to create a free-flowing space, and window walls were added at back on two floors to flood the interior with natural light.

Duplexes offer many of the advantages of the single-family detached house with only a single shared wall or floor between two otherwise distinct units.

A more recent innovation in multifamily plans is the living environment shared by two individuals or two groups of people. The plan provides two large bedroom suites with baths and sitting areas for complete privacy when desired. The living, dining, and kitchen areas are shared. However, such a plan can be designed with nooks and crannies for semi-private intimacy so that independent adults don't feel that too much togetherness is being forced upon them. The advantage is that both parties save on utility bills, mortgage payments, and maintenance. This type of cooperative, shared lifestyle probably began as a necessity but may well become a popular solution to rising housing costs.¹

SINGLE-FAMILY DETACHED HOUSING

The home we often envision for ourselves is a free-standing dwelling built for a single family. The house in the suburbs, a small city, or the country is typically such a structure. It offers the feeling of more space, more privacy, more freedom, and more individuality. The degree to which it actually affords these luxuries depends, of course, upon how it is designed. A single family residence which is not physically attached to its neighbors does provide more spatial separation than multifamily or attached housing which accounts for many of the desirable features attributed to it. The drawbacks of a separate structure may include higher energy consumption for heating and cooling and more exterior maintenance, including landscaping. In large tracts, single-family housing may offer little variety in style or orientation and little space between units. Larger homes, with more space inside and out, or custom-designed homes, which offer greater individuality, can be very expensive.

EVALUATION

It is all very well to talk about various planning possibilities and requirements, but sooner or later everyone must select a place to live. In order to effect the transition from abstract to concrete, this section presents a series of questions designed to bring out the pertinent factors to consider in choosing a home.

Is the total amount of space suited to the needs of the occupants? To arrive at a per-person space quota, simply take the entire gross area of the house plan and divide it by the number of occupants. While the 200-square-feet-per-person minimum suggests a convenient rule of thumb, many factors (including, of course, finances) will influence the actual amount of space available to each member of the household. For one thing, as the size of the group increases, the amount of space required by each individual generally diminishes. Households composed of people who are heterogeneous in age and interests, as well as those who are gregarious and extroverted, generally need more space per person than those whose members are homogeneous and relatively quiet. The home with flexible and multiuse space—enhanced by good zoning, convenient relationships among rooms, minimum traffic through rooms, thoughtful furniture arrangement, and livable outdoor areas—may be satisfactory with considerably less space per person. The measure should not be limited to square feet alone, but should incorporate as well shapes of floor areas, number of rooms and sleeping areas, number of occupants, their ages, sex, relationships, and how their leisure time is spent. Multi-use space becomes more and more the solution to shrinking square footage.

In addition, the mood or atmosphere of the home should be appropriate to the needs of the family. Image can also play a role in selection. An impressive entry or one that projects friendliness may be important to some while one that is less open might provide the security and privacy desired by others. Many people think they want as much space as possible until they see a large old house for sale or rent. Then they begin to wonder about cleaning, maintaining, and heating it, and how they and their furnishings would fit into rooms planned for another way of life. This suggests that the largest affordable space may not be ideal, even though there is no substitute for adequate square footage. On the other hand, people are

beginning to realize that the ample space provided by some old houses and apartments can be recycled to fit the kinds of lifestyles practiced today.

Is the space appropriately allocated? The portion of space devoted to living, sleeping, and working can vary markedly even in homes of the same size. The most significant relationship probably will be that between group and private spaces. One plan may offer a condensed living space so that bedrooms and baths can be larger and more numerous for individuals who like privacy; another could limit the bedrooms to mere cubicles, thus allowing for large or multiple group spaces. The importance of the personal zone may be further indicated by the seclusion given bedrooms and baths accessed via a private hallway, or the potential of a separate space for individual pursuits.

Work areas normally occupy proportionately larger sections of the overall plan in bigger homes, because, as noted earlier, when space is limited the service functions are the first to be compressed. Even so, families to whom the kitchen is very important may want to devote a greater portion of the space to that room even in

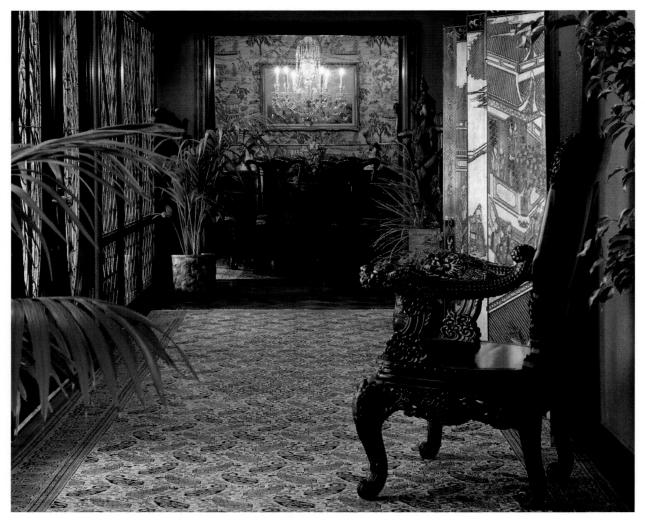

12.15 The entry of this Midland, Texas, home makes an instant impression with its leaded glass, rich colors, exotic screen, and heavily carved chair. A glimpse of the dining room reveals a continuation of Oriental influence. (*Photograph: Darryl Baird*)

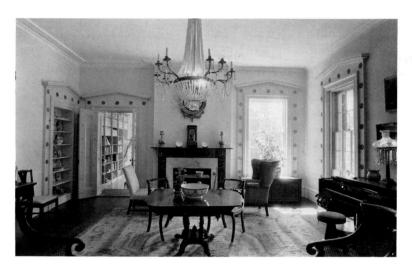

12.16 In homes such as Forth House near Livingston, New York, a brick manor house built in the 1760s, restoration of traditional character is the design goal. Lead rosettes ornament door and window frames and a Federal table rests on an Aubusson rug beneath a crystal chandelier. (*Photograph: Robert Levin*)

a small home. The specific requirements of the activities carried out in each space must be considered.

Is the enclosed space well zoned and adjacent to related outdoor areas? The basic consideration in zoning involves segregating quiet areas from noisy areas. Plans can be checked quickly for this factor by coloring noisy spaces red, quiet ones green, and transitional or buffer areas yellow on a tracing paper overlay, then studying the resulting pattern. One of the most common zoning errors in onestory houses appears in the indoor—outdoor relationship: separating the kitchen from the garage (thereby precluding a convenient service entrance) and yard or facing the living room toward the street (which makes it difficult to unite the major group space with a protected terrace or lawn).

Is the pattern of circulation satisfactory? Short routes from point to point simplify housekeeping and make home life more pleasant, but they can be hard to achieve. Trace traffic paths on the floor plan or an overlay to aid in analyzing the distance of frequently traveled routes and the privacy needed for the job being done, keeping in mind the points raised regarding circulation in Chapter 8 (pp. 188–190).

Are the rooms of suitable size? Beyond the actual square footage of a room, we must consider its usable and apparent size. These factors are affected by shape, location, and size of openings; relation to other rooms and to the landscape; treatment of walls, floors, and ceiling; kind, amount, and arrangement of furniture. Some families prefer many small rooms, others a few large spaces. Table 8.1 (p. 193) lists typical small, medium, and large room sizes. An open plan with wide expanses of window to unite indoors and out with built-ins or minimal furnishings can visually provide more space in the small home.

Will the rooms take the required furniture gracefully and efficiently? The primary consideration here is naturally adequate floor space for both furniture and traffic. But also consider the question of suitable wall space—especially for such large items as beds and sofas—and the problem of arranging the furniture into satisfactory groupings. Doors, windows, heating and cooling vents, electrical switches and outlets, closets, and built-ins all take wall space and require access. (Furniture arrangements are considered in detail in the previous three chapters.)

Is there adequate storage space? A phenomenon almost everyone faces sooner or later is that storable items expand to fill and overflow the space allocated to them, regardless of how commodious that space might be. Ample built-in storage reduces the amount of furniture needed and thus provides more living space. Often-used items should be stored where used; seasonal or infrequently used

articles can be stored in more out-of-the-way locations. Storage demands are usually heaviest during the expanding family years and also later years when a lifetime's accumulation of possessions (and often children's possessions) must be dealt with. For houses without basements or attics, rental storage is often necessary. Specific storage requirements are addressed in previous chapters.

Is the plan effectively oriented on the site? Skillful orientation for maximum climate control is treated in Chapters 13 and 14. But other factors that affect the livability of a plan also deserve consideration: the presence or absence of pleasant views, the degree of privacy needed in each room, and the amount of light—particularly sunlight—desirable in various parts of the house at different times of the day. All these are very personal decisions and must be dealt with on an individual basis. Even so, several typical situations present themselves:

- Major group spaces deserve the best view, the privacy needed for living behind large windows, and the winter sun. South to southeast is generally preferred.
- Kitchens merit a pleasant vista outdoors and ample daylight, preferably with morning sun. This suggests northeast orientation.
- Bedrooms demand privacy; if the occupants enjoy the morning sun, these rooms could be focused generally toward the east.
- Bathrooms have no great need for outlook or sunlight, although both are pleasant.
- Utility rooms can be anywhere, since they need few if any windows.
- Garages and carports must only be convenient to the street and house entrances.
 They may be placed on the least desirable side of the house to buffer noise, block wind, shade the walls of living spaces, or protect privacy.

All of these factors represent ideals. Most people, in choosing a preexisting plan, find they have to compromise on a few essential qualities. Perhaps the overriding factors in site orientation will be knowing the house is not so dark that electric lights must burn all day, so much subject to relentless summer sun that it can never be comfortable, or so lacking in privacy that its occupants feel continually exposed to neighbors and passersby.

Is the plan economical? Both initial and continuing costs must be evaluated to determine whether the plan is affordable. Use costs can be minimized if plumbing and other utilities are located in close proximity, low-maintenance materials are used both inside and out, windows are located to capture natural ventilation, and flexible spaces allow changing uses as needs vary over time. Location may also influence initial cost independent of the merits of the plan itself. A good location increases the home's value while a poor location decreases it.

Does the home lend itself to desirable or necessary change? It is impossible to predict just what the future will bring, but knowing that life and change go together suggests planning for flexibility. Family patterns change as children are born, develop, and leave home (and sometimes return again), or parents or grandparents move in. The typically limited funds of young people may necessitate beginning with minimum quarters, but as financial stability increases the question of upgrading or enlarging the lifespace—or moving to a new one—arises. Business opportunities, health, or simply the desire for something new can result in selling or renting one home and looking for a new, or different one. New lifestyles are continually evolving, and tastes inevitably change and develop over the years. Demands on the lifespace will vary with them. A floor plan that incorporates the concepts of universal design provides the flexibility needed to adapt to changing needs over the life of the home.

The selection of an existing floor plan or the design of a new home to fit the needs of an individual, family, or household requires careful consideration. By pro-

viding an informed and objective analysis, a professional designer can assist with the many decisions to be made. Time spent evaluating a number of plans helps ensure the best possible fit.

NOTE TO THE TEXT

1. Constance Roe, Shared Design: A New Concept for Contemporary Needs, *Designers West*, June 1982, pp. 158–163.

REFERENCES FOR FURTHER READING

Cabins and Vacation Houses, 2nd ed. Menlo Park, Calif.: Lane Books, 1967.

Dumarcay, Jacques. The House in South-East Asia. New York: Oxford University Press, 1987.

Lerup, Lars. Planned Assaults. Montreal: Centre Canadian d'Architecture, 1987.

Mackie, B. Allan, Log House Plans. New York: Scribner, 1981.

Myller, Rolf. From Idea into House. New York: Atheneum, 1974.

Multi-Level Home Plans. Topeka, Kan.: Garlinghouse Publications, 1989.

New Home Plans for 1990. Topeka, Kan.: Garlinghouse Publications, 1989.

140 Designs for Narrow Lots. Minneapolis, Minn.: HomeStyles Publications, 1989.

Paul, Samuel. Apartments: Their Design and Development. New York: Reinhold Publishing Co., 1967.

Roth, Leland M., (ed.). America Builds: Source Documents in American Architecture and Planning. New York: Harper & Row, 1983.

Wells, Malcolm. Underground Buildings. Beallsville, Ohio: Raven Rocks Press, 1990.

Wright, Frank Lloyd. The Natural House. New York: Horizon Press, 1954.

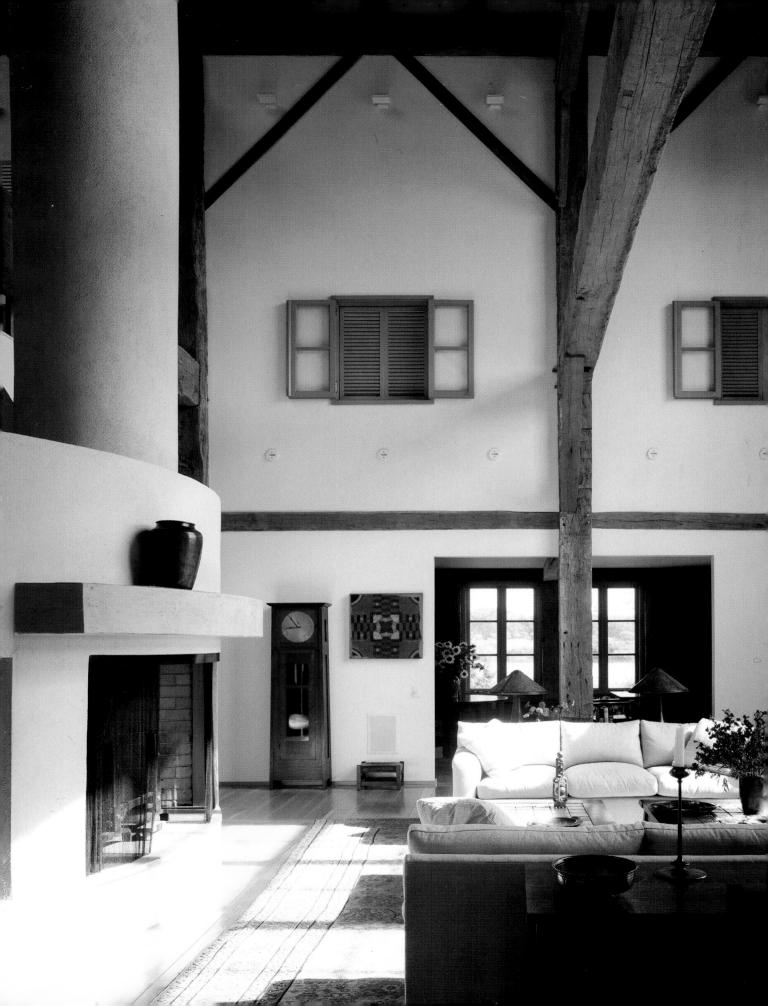

PART FOUR

Construction and Materials

An 18th century Pennsylvania Dutch barn was moved to East Hampton, Long Island, where it was reassembled to conceptually link this home to its historical site. White plaster walls, an immense sculptural fireplace, and Arts and Crafts furniture are juxtaposed with the weathered frame and siding of the old barn (exposed inside on the walls and ceiling), combining the familiarity of history with the vitality of modernity. Gwathmey Siegel & Associates, architects. (*Photograph: Richard Bryant/Arcáid*)

Environmental Issues

ENERGY CONSERVATION AND EFFICIENCY

Conservation Measures Sustainable Energy Resources

INDOOR AIR POLLUTION Sick Building Syndrome

Health Consequences

PRESERVATION
Restoration/Adaptive Reuse/Remodeling
Endangered Species

GLOBAL IMPACT OF DESIGN DECISIONS

The home itself is an environment, one we create for ourselves and can control far more easily than we can our surroundings as a whole. James Marston Fitch¹ speaks of architecture as the "third environment" formed by building an interface between the *micro*environment of the human body and the *macro*environment of nature. This interface provides a selective filter capable of either excluding or admitting specific elemental forces. The middle or *meso*environment of architecture has as one of its primary functions the shielding of people from excessive energy in nature—severe cold, intense heat, driving wind, and rain.

But all too often such protection requires an excessive expenditure of energy. Certain office buildings and other public structures built during the late 1960s stand as the worst examples of this approach. Windowless, or fitted with windows that cannot be opened, they rely utterly upon artificial lighting, heating, cooling, and ventilation. Even noise control is dealt with artificially, with unpleasant sounds masked by the "white noise" of the air conditioner or by canned music. Given a power or fuel shortage, these buildings are useless. Such design shortcomings and excessive energy consumption were brought to public attention by the oil embargo in 1973, which also spurred interest in energy-conserving practices.

If modern technology can devise artificial support systems, it can also teach us to refine natural systems of environmental control. Egyptians and Romans, Eskimos, and South Sea Islanders adapted their homes to their climates with remarkable efficacy. Fortunately, not all contemporary builders ignore the most obvious devices for living in equilibrium with nature. A house designed to temper the impact of natural forces in its surroundings not only represents an economy for its owners and for the environment as a whole but simply makes good sense.

We in the United States have increasingly become a people who live the greater part of our lives indoors. We even travel about in a kind of mesoenvironment—the automobile—to a larger extent than any other nation. Nevertheless, we cling to our desire for union with nature, as evidenced by the widespread use of glass in houses and the popularity of a second home in the country. This apparent contradiction can be resolved only when we cease trying to bend nature to our will and learn the lesson that every other surviving species on earth has mastered: the technique of adapting ourselves to our environment. One of the most pressing factors in that adaptation involves the rational use of energy. People are again thinking in terms of warmth from the sun, cooling from the wind, and an intelligent use of natural resources and modern technology. Our goal should be to maintain a reasonable level of comfort and convenience while simultaneously preserving environmental harmony.

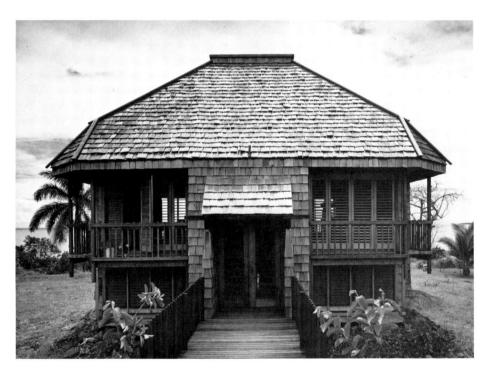

- **13.1** (left) A house designed to exploit the natural elements of Hawaii also achieves distinctive cultural and structural expression. A series of louvered doors around the second floor can be completely rolled aside to catch sea breezes, partially closed to control the sun, or shut altogether to protect from the daily rain showers. Oda McCarty, architect. *(Photograph: Julius Shulman)*
- **13.2** (below) On the hot, arid, windswept coast of the Gulf of California, insulation from the elements is of preeminent concern. Thick, projecting walls shelter both interior and exterior spaces of a house designed to moderate the climate. James Flynn, architect. (Photograph: Koppes)

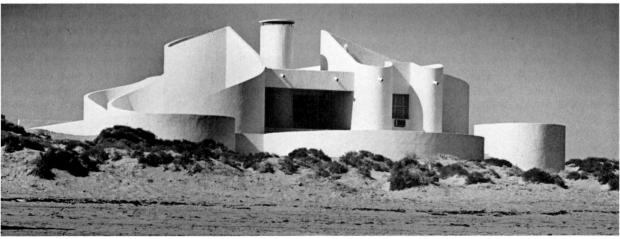

Other concerns of growing importance to designers today include indoor air pollution, another consequence of "tight" buildings constructed as impermeable barriers to the outdoor environment, and preservation of the earth's flora and fauna and of our architectural heritage. As designers become aware of the global impact of their choices of materials and products, they are becoming more environmentally responsible in their practice. The "green" or environmentally sensitive designers represent this new consciousness.

ENERGY CONSERVATION AND EFFICIENCY

About one-fifth of the energy consumed in the United States is used in the home, mostly for temperature modulation. Energy in the home can be conserved both by reduction of initial intake (consumption) and by prevention of unnecessary loss. There are several methods by which each can be accomplished in either new or existing homes. Some require human behavioral adaptation; others can be achieved with more energy-conscious planning in the design of the structure itself.

CONSERVATION MEASURES

BEHAVIORAL ADAPTATIONS In order to maintain comfort, the human body demands a relatively stable, quite narrow range of temperature variation in its near environment. Traditionally, thermostats were set at 75 degrees Fahrenheit (75°F) in winter and 72° F in summer to maintain maximum bodily comfort. If the air surrounding the body is too cool, the body's natural heat is lost too rapidly, causing one to feel chilled; if the surrounding air is too warm, too slow a heat loss results in feeling hot.

Although people are generally slow to change habits, recent years have witnessed a definite modification in standards for comfortable temperature ranges. Thermostat settings have dropped in winter (to approximately 68°F) and risen in summer (to 78°F) at the urging of power companies and as a result of government regulation in public places. People adjust by wearing warmer or cooler clothing.

An alternative to reducing temperatures throughout the house is to close off parts of it that are not in use at various times of the day or night, heating only major activity areas. Sleeping spaces need not be heated during the day, for example; any activities that would have taken place there may be relocated to warmer parts of the home. In summer, naturally cooler parts of the house may be used more, with activities "migrating" according to seasonal temperature fluctuations as much as possible.

Surface materials, textures, colors, and spatial arrangements may also be chosen to heighten an *atmosphere* of warmth or coolness in rooms used predominantly in one season or the other, or may be changed each season (Figures 13.3 and 13.4). A home containing light colors and broad areas of uncluttered space may make its owners feel cooler to the point that they actually are cooler. Cold, wet weather may be counteracted by warm colors—reds, oranges, yellows—cozy spaces, and patterns that delight the eye and bring the quality of sunshine indoors regardless of its presence or absence outside. Texture and finish of materials can also add to the psychological effect: smooth, hard surfaces feel cooler while thick, plush, and rough surface effects add warmth so that people feel less in need of heat or air conditioning.

DESIGN FEATURES In housing design, many steps can be taken to conserve energy. All-year comfort is a matter of house orientation, design, and materials

and construction as well as of mechanical equipment and energy consumption. Although many of these aspects of design are determined by architects and building contractors rather than interior designers, they are presented here to encourage an understanding of energy conservation which will facilitate communication and consultation between design and construction professionals.

First, overall shape and size, discussed in Chapter 8 as it affects construction costs, also affects heating/cooling costs: the more square in shape, the more enclosed space in relation to the amount of perimeter. (Technically, circular shapes,

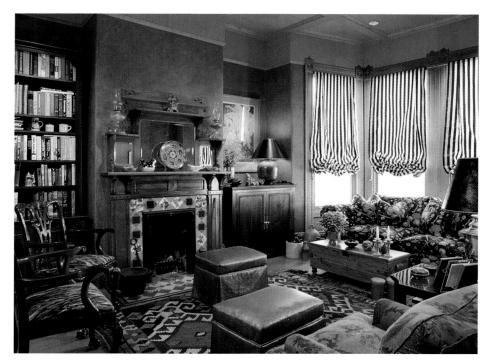

day, the living room in a late 1800s remodeled Victorian house in San Francisco exudes warmth from active patterns, warm earthy colors, natural textures, and colorful accessories. The coffee table, an old pine toy chest, brings back memories from the owner's childhood. Richard Banks /Design Solutions, interior designer. (Photograph: David Livingston)

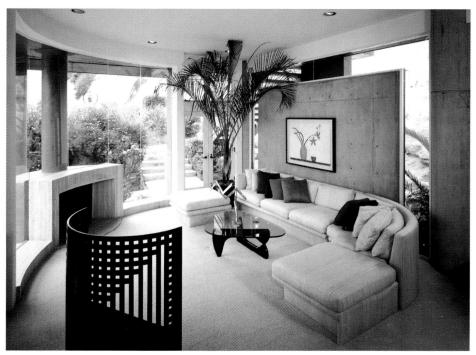

13.4 Concrete, glass, and travertine combine with neutral light color, a spacious furniture arrangement, and uncluttered surfaces to make this home seem as cool as the greenery outdoors. Broad overhangs keep the interior shaded from direct sun. Richard Bokal/Bokal Kelley-Markham, architect. (Photograph: Hewitt/ Garrison)

13.5 Restored townhouses in Greenwich Village, New York, have only their narrow ends exposed, sharing common side walls which insulate them from temperature extremes. Heather Faulding, architect. (Photograph: Frederick Charles)

exemplified by the geodesic dome, are the most efficient, but they create unconventional interior spaces that have not gained wide acceptance.) Interior spaces maintain constant temperatures with less heat loss or gain potential than exterior exposures. H-shaped plans have the most outside wall area. Multifamily housing structures such as row housing expose even less exterior surface to climatic extremes than single-family detached homes. Also, the more space covered with the least roof area (as in multistory homes or multiple unit structures), the more efficient in terms of both energy intake and energy loss. However, open vertical spaces make it difficult to maintain comfortable temperatures at different levels; open stairways and high ceilings draw warm air to the upper spaces, leaving lower levels cool. (The warm air can be returned to lower levels by a system of ducts and/or fans.) Compact plans of smaller size present fewer cubic feet and less volume to heat and cool.

Internally, homes can be zoned for energy savings as well as for activities. Dayuse rooms can be grouped in the most desirable location for natural heat and light (a characteristic feature of passive solar design), with provision for closing them off from other sections of the home. Night-use spaces, also clustered, can have smaller and fewer windows, and sleeping areas can have lower thermostat settings. Access through vestibules or air chambers with double doors prevents the entry of cold (or hot) air from outside and the escape of temperature-controlled air from inside. Enclosed stairways help maintain desired temperatures on each level and internal chimneys radiate heat to internal spaces rather than the outdoors. Mechanical systems (the furnace, air conditioner, and water heater) should be located near the center of the residence to minimize the length of ducts and hot water pipes. In a large home, locating heating, cooling, or water heating systems according to usage zones may be sensible.

Siting and orientation in relation to sun exposure can also reduce heating/cooling costs. A home can be designed and constructed to maximize and/or minimize the effects of climate. Walls that face hot sunlight or a cold wind can be sheltered through siting and orientation as well as landscaping and design, thus shielding the interior of the house from uncomfortable temperatures and drafts. Windows can also be oriented to collect warmth and provide ventilation; all homes in cold climates can benefit from a reduction in the total amount of window area, with necessary glazing oriented to gain natural solar heat as much as possible. If more than 15 percent of the wall area in a room is devoted to windows, they should be used for solar gain.

These structural considerations reduce the amount of energy required to maintain comfort inside the home and thus help conserve precious nonrenewable resources. Interior treatments can also assist in this effort, either complementing structural design or, when necessary, providing temperature control even in poorly oriented homes. For example, wide window walls may need draperies to insulate

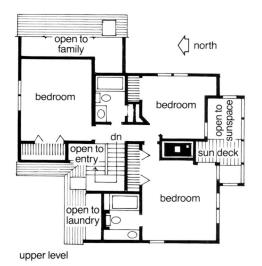

13.6 (left) A compact 2000-square-foot two-story house plan has an air-lock entry, and it positions utility and night-use spaces with few windows on the north side to conserve energy. Douglas Gidvan, chief designer, and Mark Kelley, energy systems engineer, Acorn Structures, Inc.; Gordon Tully, Tudor Ingersoll, and Stewart Roberts, Massdesign Architects and Planners.

13.7 (below) The south side of a house in Connecticut orients living spaces to maximize direct solar heat gain while other exterior exposures have reduced window areas to minimize heat loss. (Courtesy Acorn Structures, Inc.)

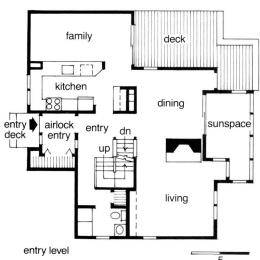

rooms from excessive heat loss, or west-facing windows may need sun control to prevent heat gain. Floor and wall materials can also be selected to store natural solar heat or to insulate against cold.

Where excessive heat is a problem, high-pitched roofs collect less heat and permit easy attic ventilation. Light-colored roofs also reflect the sun's heat and help keep attic temperatures lower. Exterior walls and windows can be shaded with roof overhangs, verandas, awnings, trees, or shrubs. Planted areas around the house reflect significantly less heat than do paved areas or bare ground. Reflecting glass, permanent window film, or low-E (low emissivity) glass can be used on windows to further reduce solar heat gain as well as to block fading ultraviolet rays. Various manual or motorized interior (and exterior) window treatments such as blinds and pleated or quilted shades help control heat gain. Glazed areas facing the hot sun may need to be reduced in size.

13.8 (above) The north side of this contemporary saltbox house is protected from winter winds by the long sloping roof and small windows, while the taller south side, nearly all glass, captures the low angle of the winter sun to heat the interior. Alfredo De Vido, architect. (Photograph: Hans Namuth)

13.9 (right) A quilted shade, installed in tracks at either side, provides effective insulation for large glass exposures. Prevention of heat loss during the night is an important advantage. *(Courtesy Appropriate Technology Corporation)*

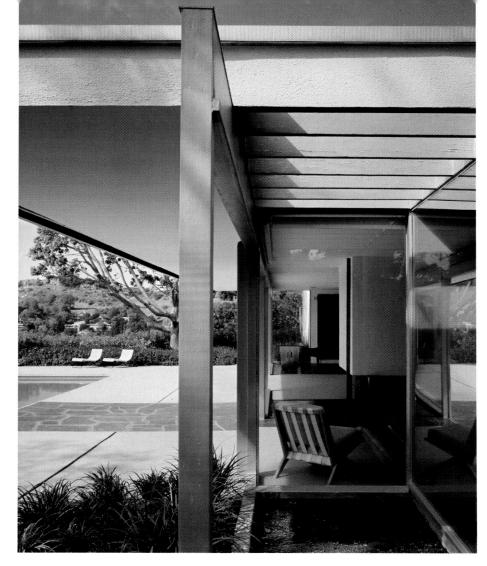

13.10 The Loring house, designed by Richard Neutra, employs a broad roof overhang and greenery to shield the interior from sun and heat in Los Angeles, California. (Photograph: Timothy Hursley)

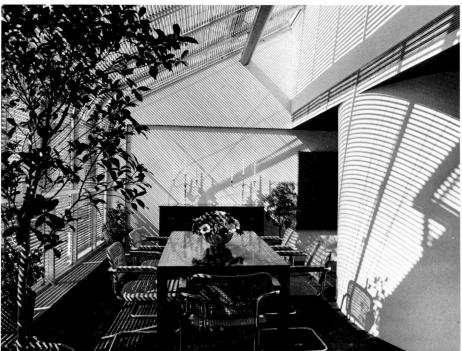

13.11 Standard greenhouse blinds across the top and down the side of a solarium-dining room create fascinating patterns of light and aid in temperature control. Robert A.M. Stern and John Hagman, architects. (Photograph: © Robert Perron)

13.12 Located in the middle of a vineyard in Sonoma Valley, California, the transom windows in this great room are operable to aid in air circulation and cooling. Mexican pavers on the floor and a limestone fireplace outlined in copper are combined with other earthy, natural materials and cool white walls. French doors and the lower sections of windows on the right also help capture breezes. Roland Miller and Associates, architects: Arnelle Kase, Barbara Scavullo Design, interior designer. (Photograph: David Livingston)

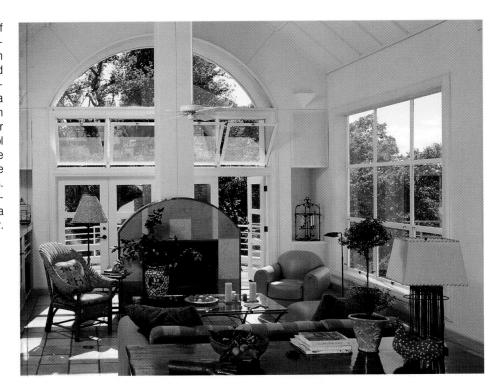

Natural ventilation is aided by carefully locating windows (fenestration) and selecting the best types of windows to capture breezes. Air should be drawn into the interior from close to the floor, where it is coolest, and vented out as high as possible, where it is warmest. (For a more complete discussion of windows, see Chapter 20.) Ceiling fans help circulate air throughout rooms. Venting hot air that accumulates under the roof as well as careful orientation of rooms and windows is the most economical means of cooling; when it is not sufficient, it must be supplemented with mechanical air conditioning.

Recent technological developments have made it possible to control all systems in the home electronically—heating, cooling, lighting, security, fire alert, even some electric appliances—from one central location. All systems are monitored and controlled by computer and can be programmed to activate at specified times or respond to various conditions. Manufacturers, utility companies, and trade groups involved in electric, electronic, telecommunications, and gas-fired products and home services developed the "Smart House" with its innovative built-in wiring system which enables residents to have better control over their surroundings with greater convenience. The Smart House, endorsed by the National Association of Home Builders (NAHB), can significantly reduce energy consumption and, at the same time, increase comfort, enjoyment, and security.

Lighting is another component of energy conservation. Some states regulate energy consumption for lighting needs in public buildings. Light sources which operate more efficiently with less power and have a longer life have been developed to answer this demand. (Lighting is discussed further in Chapter 21.)

INSULATION Heat conduction through exterior walls, windows, and the roof accounts for most of the energy loss in the average home. Insulation provides resistance to heat loss or gain. The two basic elements in insulation are the materials in the house shell and the way they are put together. Generally speaking, dense and uniform materials, such as metal and glass, conduct heat and cold readily;

porous substances such as wood or lightweight-aggregate concrete blocks are poor conductors and, therefore, good insulators. Most houses, regardless of construction material, need further applied insulation.

Standard housing insulation is produced in three basic forms:

- 1. Porous substances—cellulose fibers, rock wool, fiberglass, and vermiculite granules—which imprison air in the small spaces between particles. Such materials are available either loose, for blowing into walls, or in blankets or batts to be stapled between studs and joists.
- 2. Rigid panels of plastic materials or glass fiber that are installed above roof decking but under finished roofing, between wall studs, or against masonry walls. Rigid foam insulation sheets provide the most thermal protection per inch of thickness and also form a natural air barrier for reduced air infiltration. They must be covered with ½-inch gypsum board or other material for fire safety.
- 3. Sprayed polyurethane foam or expandable pellets which become rigid or semi-rigid.

Materials are rated by their *R value*, or thermal resistance (the higher the R value, the greater the insulating properties). The use of recommended amounts of insulation for walls, ceilings, and floors can retard heat loss substantially more than ordinary building materials. Because heat rises, higher R values are needed in ceilings. Vapor barriers keep insulation dry, a necessity for it to be effective.

Insulation installed for heating efficiency also helps keep the house cool in summer. Water pipes and heating/cooling conduits can be wrapped with insulation too. Both initial building costs and operating costs can be reduced by insulating since smaller heating and cooling units will be needed for the space. It has been estimated that a properly insulated house uses only 50 percent of the energy required to heat a noninsulated one, and appreciable savings will also be realized in air-conditioning costs.

AIR INFILTRATION Windows can be a source of much heat loss and gain because of the high conduction qualities of glass and air leakage around the frame and between parts. Single-pane glass transmits up to 35 times as much of the sun's radiant heat and 10 times as much heat from the outside air as insulated walls. Double- or triple-glazed construction or storm windows, plus weather stripping

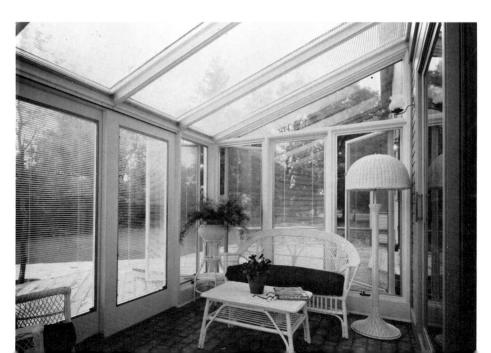

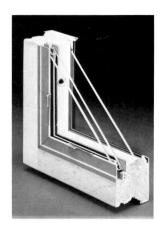

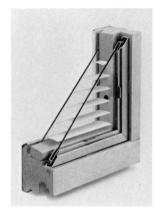

13.13 (above, top) The triple-glazed window has an air space between all three panes to provide a thermal barrier against air leakage and heat loss or gain. (Courtesy Pella/Rolscreen Company)

13.14 (above, bottom) Between the two panes this double-glazed window contains a narrow-slat blind that allows privacy and control of light. Specially coated blinds that reflect radiant heat are available, helping to keep inside heat in and outside heat out. (Courtesy Pella/Rolscreen Company)

13.15 The sunroom is an ideal use for windows with blinds incorporated between panes, which can help control heat gain and loss. (Courtesy Pella/Rolscreen Company)

and caulking, reduce heat loss and gain by more than half. High performance or high efficiency windows with insulating values up to R-9 are generally worth the additional cost. Insulating interior window treatments are very effective in preventing inside heat loss; exterior treatments prevent heat gain most effectively. Methods of automatically insulating window areas, such as the Beadwall system in which Styrofoam beads are blown between the two layers of glass at night, are continually being developed, especially in conjunction with solar heating technology.²

Doors also need to be tight-fitting, weatherstripped, and caulked to prevent drafts. Solid-core, insulated fiberglass or steel doors, or wood-veneer insulated steel doors are better than hollow doors for the exterior. Wood doors are subject to warpage from humidity and temperature changes, making it difficult to maintain an air-tight seal. Storm doors or air-lock entries are desirable.

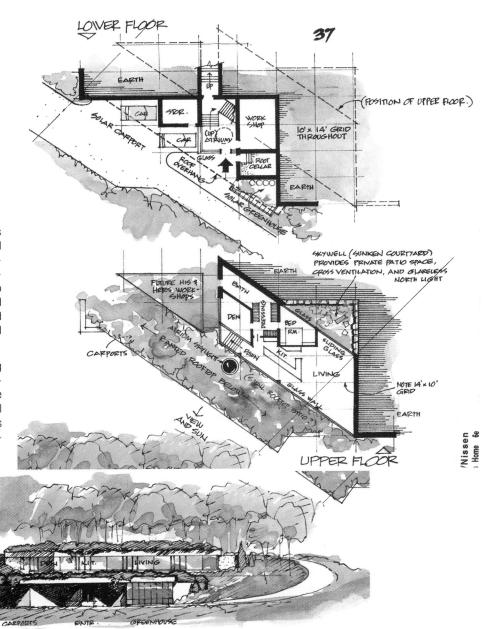

13.16 (right) Malcolm Wells designed this earth-sheltered home for a hillside site overlooking Amish farmland. One long diagonal wall has full exposure to the sun while the others are buried in the hillside. A sunken courtyard opens the north side to natural light.

13.17 (below) The south-facing elevation provides access and admits light and solar heat. The unique plan allows nearly all rooms to take advantage of this orientation. Malcolm Wells, architect.

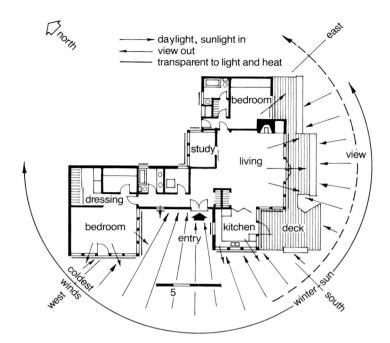

13.18 James Marsten Fitch designed and oriented his own house to take full advantage of the site and to moderate the climate in as many natural ways as possible. (*From* American Building 2: The Environmental Forces That Shape It)

EARTH-SHELTERED HOUSING The earth is an excellent temperature moderator. This has led to the development of *earth-sheltered* housing where underground portions are warmed by direct contact with the earth which, at 8 to 12 feet down, remains close to the average annual temperature at the surface for any given location.³ Savings of up to 75 percent in energy consumption can be realized—the deeper the earth cover, the greater the energy savings.⁴ Earth-sheltered housing can be built entirely underground, with only window openings, light shafts, or atriums penetrating the ground or mostly above ground, with earth *berms* on one or more sides. The "elevational" type, with one side exposed and the other three buried, is ideal for combination with solar systems.

RETROFITTING Existing homes can be *retrofitted* with materials and devices to reduce energy consumption and loss. Newer, more efficient heating/cooling systems can be installed if long-range savings justify their expense. Older oil and gas systems may be tuned up for increased efficiency and measures can be taken to recover some heat loss. Active solar heating systems can quite easily be retrofitted for water heating. They may also be used for space heating but require considerable adaptation of the typical hydronic radiator or forced-air register distribution system found in most homes. Passive solar techniques might involve major remodeling, though sun-capturing windows, skylights, or even greenhouses may be enlarged or added without too much expense. Energy loss may be prevented with added insulation, storm windows, weather stripping, caulking, wind buffers, and exterior shading, if needed.

Energy conservation has gained widespread attention, both because of concern for the environment and high costs. There may be some trade-off of convenience, luxury, and conventional form in housing for affordable energy, but as human expectations and values change, new technology continually offers exciting solutions for the future.

The plan shown in Figure 13.18 represents a house in Stony Point, New York, that was designed with several environmental considerations in mind: sun, prevailing winds, slope of site, and view from the windows. Nearly all glass faces toward the south, the southeast, and the southwest, while the opposite side of the

house is sheltered with opaque and insulated materials. Because the northwest portion of the building is partially submerged in a hillside, it acquires further protection from both cold winds and the hot summer sun of late afternoon.

SUSTAINABLE ENERGY RESOURCES

SOLAR ENERGY The primary source of energy in this solar system is our star, Sun. Conventional sources of energy—fossil fuels, wind, and hydropower—all began with the sun giving life to photosynthesis, heating air masses, and producing the cycle of evaporation and rainfall.

Now we are capturing the sun's thermal radiation to heat our homes. There are many alternative methods of using the sun's energy, but all can be categorized as basically active or passive, or a hybrid combination of the two.

Active Solar Systems. If mechanical devices—pumps, fans, and controls—are required to help transfer heat from one place to another, the system is active. Active systems consist of **collectors**, usually panels, that use water or air to transport the heat to **storage**, usually a large container of either water or rock, so that it is available for **distribution**, usually through forced-air registers or radiant floor or ceiling systems, as needed.

Collectors are most often mounted on the roof, where they are easily angled to face the sun at approximately 90 degrees, but they may be attached to the vertical side of the house or placed on the ground. When incorporated into new housing design, they are less noticeable than when added to existing homes, giving the appearance of dark skylights or windows on the south-facing facade.

The heat-storage component enables the system to retain the heat for use at night and on cloudy days. In addition to water and rock, phase-change chemicals, most often salt hydrates, are used for heat storage. They undergo a change in state from solid to liquid at a melting point readily obtained from solar collectors, and release heat for the home as they "cool" to a solid state again. Salt systems require a much smaller area for heat storage than either water or rock.

Automatic controls activate the movement of heat from collectors to storage when heat is being gained, and stop the circulation system when the temperature in storage is higher than that at the collectors, preventing heat loss on cloudy days and at night. The distribution of heat to the interior spaces is also regulated by mechanical controls, the same as conventional heating systems. The heat supply registers must be carefully located within the home to provide a slow and even air flow unfelt by occupants because the heat supply is lower in temperature than the

13.19 Architect Sam Davis' design for a northern California condominium project incorporates active and passive solar features.

- 1 Water type solar collectors 8 12" grey roof gravel
- 2 Solar storage tanks
- 3 Domestic hot water tank
- 4 Deciduous trees provide summer shade
- 5 Recessed south facing windows6 Clareston, windows for
- **6** Clerestory windows for light and ventilation
- 7 Wingwalls provide wind protection
- **8** 12" grey roof gravel insulation equalizes heat transfer
- 9 Skylights
- 10 All double-glazed windows
- 11 6" wall insulation
- 12 White stucco reflects heat gain
- 13 Protected south entrance
- **14** Trellis provides east-west shading
- 15 Minimal north windows

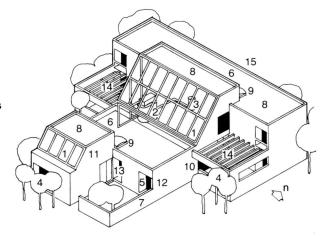

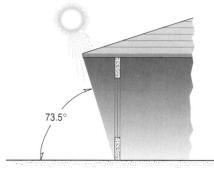

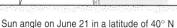

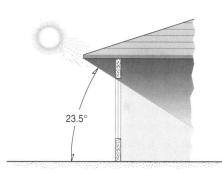

Sun angle on December 21 in a latitude of 40° N

13.20 Properly designed roof overhangs admit desirable winter sun through south-facing windows but keep hot summer sun off the glass. They also reduce glare and soften the light.

warm air from conventional furnaces and may feel cold by comparison. Radiant floor or ceiling systems provide uniform, "draft-free" heat but are less responsive to immediate needs.

Although the fuel is free, active solar heating systems can be quite expensive to install, with their complex of controls, ducts, and fans. And a back-up conventional heating system is required as well, although it may be smaller than would have been necessary without the solar system. Over the long run, as the price of fossil fuels continues to rise and as supplies diminish, the initial expense of installation can probably be justified. Combined solar heating and air-conditioning could use the same equipment year-round for greater economy.

Today solar energy is more widely used to provide domestic hot water. It requires little specialized machinery and is used year-round, so it is very economical. (A conventional back-up system is also required for heating water.)

Passive Solar Systems Simple solar heating methods that utilize the house itself to absorb, store, and distribute the sun's heat to the interior without mechanical aids are called passive and have been utilized for centuries. Selection and use of building materials and orientation to sun and wind reveal a deference to environment in vernacular architecture throughout the world. Nearly every existing home can take advantage of the sun to gain some direct and immediate heat through windows oriented to the winter sun and the use of dark-colored surfaces to absorb heat. However, to make maximum use of the solar energy available, homes must be designed and built with that purpose in mind.

Properly oriented windows provide direct solar gain without adding too much to construction cost since some windows are needed anyway for light, ventilation, and view. In the Northern Hemisphere, south-facing windows gain heat in winter and can easily be shaded by a roof overhang to prevent overheating in summer. North-facing windows lose heat, so they are undesirable. Windows that face east and west also gain heat in winter, but the overheating problem in summer is not so easily solved because the sun from these directions is much lower in the sky. Mature deciduous trees can provide the ideal solution, with needed shade in summer and not in winter. Though less effective than exterior solutions, interior window treatments can be helpful in insulating against overheating, but they block light and ventilation as well. To maximize window orientation, the house should be rectangular, positioned on an east-west axis. Generally, rooms used during the day are located on the south side of the house; rooms having morning use warm up more quickly with exposure to the rising sun.

Problems associated with direct gain include excessive heat gain and excessive light and brightness which can fade and deteriorate fabrics and furnishings and cause visual discomfort. Also, large areas of glazing present problems of heat loss, requiring insulating panels or treatments at night.

13.21 The greenhouse addition to a Roxbury, Connecticut, home includes solar collectors and water tubes across one roof section. The sunspace has triple-glazed windows with operable casement windows for venting at the end and southern pine laminated beams. A glazed Mexican tile floor absorbs and holds heat from the sun. Stephen Lasar, architect. (Photograph: Robert Perron)

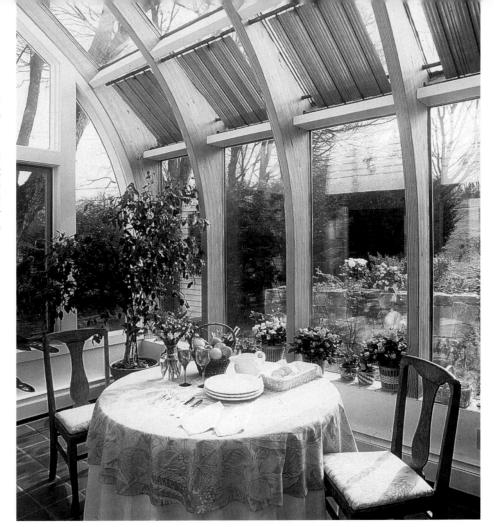

A greenhouse or solarium attached to the home provides indirect solar heat gain while adding living and indoor gardening space at less cost than a fully insulated extra room. By opening the greenhouse to the rest of the house during the day, warm air can be drawn to other rooms by natural convection or assisted with fans. If heat is not removed from the sunspace during the day, it may become too hot to use as living space. Also, building materials, fabrics, and furnishings must be carefully chosen to withstand sun fading and drying, or mildew if many plants share the space. Glaze or film between the glass panes or low-E glass with silver oxide on the inside helps keep heat in or out, reflects radiant heat, and filters ultraviolet light. To prevent heat loss at night, the greenhouse can either be closed off from the rest of the house or have dual glass panes. During summer months, it must be shaded and ventilated to prevent overheating. In addition to free heat, the greenhouse provides humidity and fresh, clean air from plants.

Roof monitors (cupolas, skylights, or clerestory windows) normally designed for light and ventilation can also be used to help evenly heat interior spaces that would otherwise gain little or no solar heat. In addition, they allow natural cooling ventilation in summer.

To ensure availability of heat during the night and on overcast days, passive solar systems also need some method of heat **storage**. Materials used in house construction become the heat storage mass or "heat sink." Dark-colored masonry of adobe, brick, ceramic tile, concrete, or stone is used for Trombe walls or floors because they absorb the sun's direct heat slowly and store it until the air in the room cools sufficiently to draw the heat from them. Sand or water can also be used

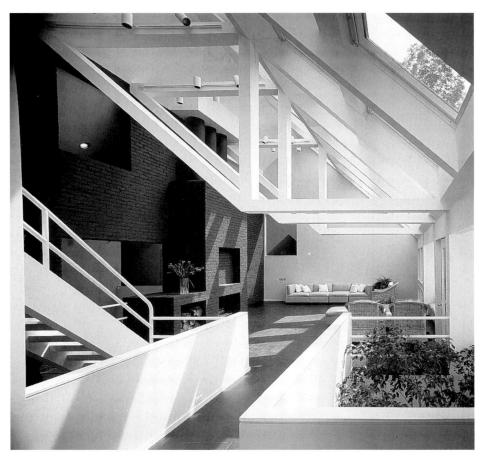

13.22 A thick, dark-colored masonry wall absorbs solar heat from south-facing skylights above and, because of its mass, stays warm after the sun has set. The interior draws heat from the warm wall through cold New Jersey winter nights. Insulating shades, controlled by automatic temperature sensors, prevent heat loss and summer overheating yet admit daylight. Alfredo De Vido Associates, architects. *(Photograph: Peter Aaron ESTO)*

13.23 The tile floor functions as a heat-absorbing thermal mass in Con Edison's Conservation House in Briarcliff, New York. (A floor plan is provided on the next page, Figure 13.24) Alfredo De Vido, architect. (Photograph: © Norman McGrath)

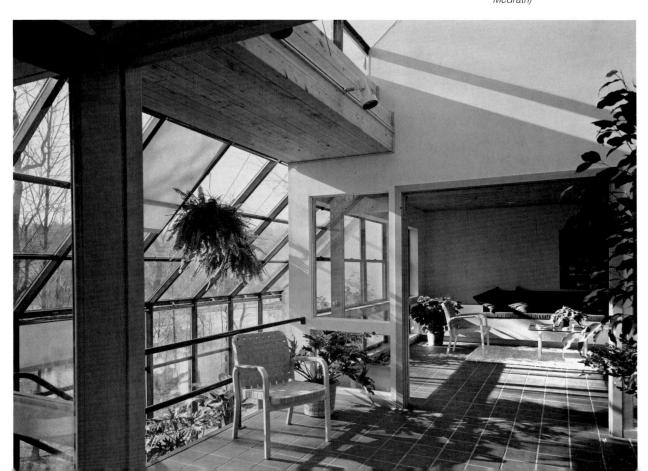

13.24 Con Edison's Conservation House was designed to demonstrate that energy-conservation concepts can be combined with conventional construction techniques to produce an atrractive and energy-efficient house. The house is divided into three space-heating zones: it has 85 percent of its glazing and most of its social spaces on the south, with no north windows: the plumbing and wiring are contained in interior walls to avoid puncturing the vapor barrier, and energy- and water-saving appliances, lighting, and plumbing fixtures are installed. Alfredo De Vido, architect.

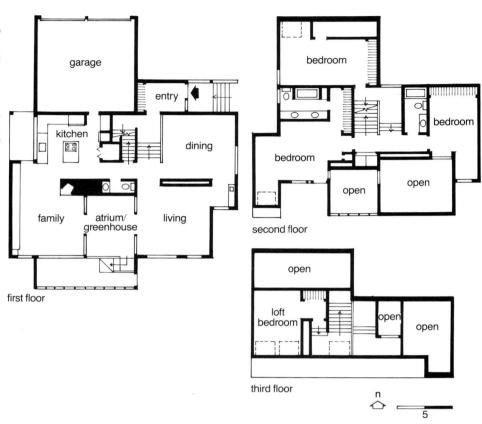

in drums, columns, roof ponds, or building panels. These high-thermal-capacity materials also help control overheating because of the time lag between absorption of heat on one side of the wall, conduction through it, and radiation of heat from the opposite side. Heat thus absorbed during the hottest part of the day is not released until nighttime. Wall composition and thickness can be designed to control the time lag of the day's heating effect into the interior at night.

Passive solar design represents a high level of energy consciousness attainable at little additional cost in new housing construction. Taking advantage of site, windows, and heat-absorptive materials are simple requirements that can at least reduce the energy consumption of mechanical systems.

With presently available technology, very nearly all of the power requirements in a typical house can be met by utilizing solar systems. The long-range advantages are obvious. While conventional fuel reserves are rapidly being depleted, solar energy is theoretically unlimited. Furthermore, it does not pollute the environment in any way. When installation costs become more reasonable, solar systems will undoubtedly become more common.

ALTERNATIVE ENERGY SOURCES Many other ways of producing energy are now being investigated: windmills on land and ocean, geothermal energy from the heat of the earth's interior, hydroelectric power from tides that in some places form huge waves, solar photovoltaic cells for electric conversion, nuclear fission and fusion, even biological methods that utilize bacteria to change organic materials such as algae and sewage into gas and oil.

Supplies of oil, gas, and coal are finite; we cannot continue tapping them at an ever-increasing rate. In order to cope with the problem of energy for the present and for future generations, we must undertake a two-faceted program: curtailment of waste in currently available energy resources and development of new methods to produce energy for the years to come.

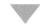

INDOOR AIR POLLUTION

In recent years, much research has been focused on indoor air quality. Interior designers must be sensitive to this aspect of the environments they design, particularly when the decisions they make in selecting materials and finishes could result in indoor air pollution. Sources of pollutants are numerous in both building materials and furnishing products. Designers must evaluate their work not only on function and aesthetics, but also on the effects of serious risks to health and life.

SICK BUILDING SYNDROME

Among the unforeseen consequences of the effort to design and construct airtight, closed system, energy efficient buildings have been inadequate ventilation and the accumulation of air pollution which is no longer diluted and dissipated by the leakage of fresh air into the interior and contaminants to the outdoors. As toxic gases are emitted from textiles, plastics, cabinetry, and adhesives, they build up in well-insulated, airtight interiors. In addition, micro-organisms multiply and spread in textiles and HVAC systems, contributing further to the **sick building syndrome**. The tragic 1976 incident of "Legionnaire's Disease" in Philadelphia brought attention to the potentially severe consequences of organic threats in buildings' air handling systems. A severe respiratory infection, caused by bacteria spread through the air conditioning system, claimed the lives of 29 people attending the state convention of the American Legion and afflicted many others. Since then, other outbreaks of this disease have occurred in both the United States and Europe.

HEALTH CONSEQUENCES

Some contaminants have existed in buildings for years. Although banned from house-paints since 1977, lead-based paints are still contained in millions of older homes. Dust or fumes (from the natural "chalking" of aging paint or attempts to remove lead paint by sanding, scraping, or burning) are easily inhaled and absorbed into the bloodstream. Small children in older homes with peeling, flaking paint are at particular risk of lead poisoning, as are those involved in renovation work. Asbestos is also present in many older homes. Once prevalent in many building materials as a fire retardant, this fibrous mineral has since proven to be a highly carcinogenic (cancer-causing) particulate. Radon, a natural radioactive gas which enters through the building foundation, can reach dangerously high levels in energy efficient homes. Plywood and particleboard used in building and cabinetry, many synthetic fabrics and fabric finishes, carpet and carpet backing emit formaldehyde for as long as four years after installation; plastics used for wall covering, carpet, and seating as well as plumbing and electrical wire insulation are made of unstable, volatile compounds (toluene, benzene, and naphtha) which begin to degrade almost as soon as they are manufactured and emit many toxic chemicals such as nitrogen oxide, cyanide, and acid gases. Many upholstery fabrics and adhesives release volatile chemicals as well. In addition, plasticizers, added to plastics to maintain

TABLE 13.1

Indoor Air Pollutants, Sources, and Solutions. One potted plant per 100 square feet of floor space can help clean the air in the average home or office. Three common indoor air pollutants, their sources, and the flowering plants that remove them are listed below.

Pollutant	Sources	Solutions
formaldehyde	foam insulation plywood particle board clothing carpet furniture paper goods household cleaners water repellents	Ligustrum Azalea Photinia Liriope Pittosporium Tulip Orchid Chrysanthemum Dieffenbachia
benzene	tobacco smoke gasoline synthetic fibers plastics inks oils detergents	English Ivy Marginata Janet Craig Chrysanthemum Gerbera daisy Warneckei Peace lily
trichloroethylene	dry cleaning inks paints varnishes lacquers	Gerbera daisy Chrysanthemum Peace lily Warneckei Marginata

Source: Foliage for Clean Air, Falls Church, VA

pliability, are also toxic. Since the 1960s when plastics began to have widespread use, many deaths have been caused, not by flames, but by the toxic fumes of burning and melting plastics. Survivors have suffered respiratory and other illnesses long after such exposure. Tobacco smoke is yet another air pollutant.

These and other contaminants present a serious health hazard; interior designers must be cognizant of the environmental risks posed by the products they specify since "off-gases" distilled from them may contribute many indoor air pollutants. Health hazards range from mild allergic reactions to the spread of infectious diseases, chronic tissue irritation or respiratory problems, acute destruction of tissue, short- and long-term damage to organs or processes, and life-threatening toxic or carcinogenic effects. A fundamental dimension of interior design is its impact on public health, safety, and welfare.8 Interior designers can make a positive difference in the health and safety of building occupants. Content labels should be studied on all interior materials and only those with the least contaminants should be used. Where textile products are specified, natural fibers provide a healthy alternative to synthetics. Ventilation systems should provide a continuous supply of clean, fresh air and should be cleaned and checked regularly. Live plants can be used to help cleanse the air as well. Smoking areas should be isolated by space and air handling mechanisms. Space planning, particularly in offices, can affect the distribution of air, heating, and cooling. Other aspects of a healthful interior environment include acoustics, lighting, ergonomically-designed furniture

and equipment, psychological well-being, safety, and barrier-free design, all discussed elsewhere in this text and all aspects over which interior designers have some degree of control. Knowledge of environmentally sound products and practices will continue to be important to designers sensitive to themselves, to others, and to the planet we all share.

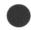

PRESERVATION

In the last few decades, we have come to realize the value of preserving the historical heritage of our built environment as well as our natural resources for ourselves and for future generations. Rather than tear down the old in an unending search for renewal and deplete the earth of valuable and, in some cases, life-sustaining natural resources, designers have become attuned to the delight of giving old structures new life and to the delicate ecological balance of our planet.

RESTORATION/ADAPTIVE REUSE/REMODELING

The changing needs of today's households are reflected in the fact that nearly three-fourths of owner-occupied dwellings are altered or repaired each year. Much of our existing housing supply was built when the nuclear family household and

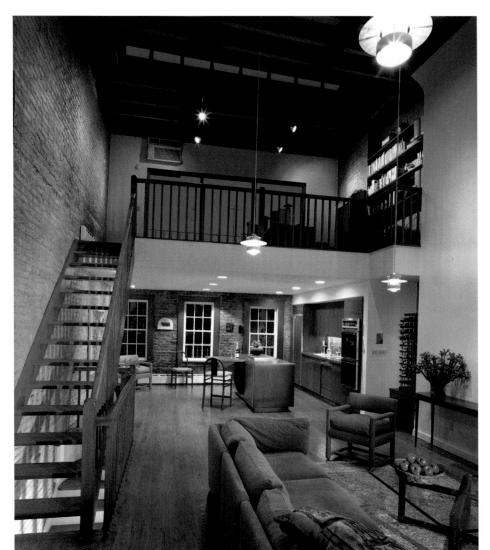

13.25 A four-story townhouse in a landmark district in Greenwich Village, New York, was restored by architect Heather Faulding (see Figure 13.5). Although the exterior restoration had to meet strict guidelines, the interior space could be opened up to accommodate contemporary needs. A new kitchen, new flooring, and the loft area above are complemented by exposed original brick and ceiling beams. (Photograph: Frederick Charles)

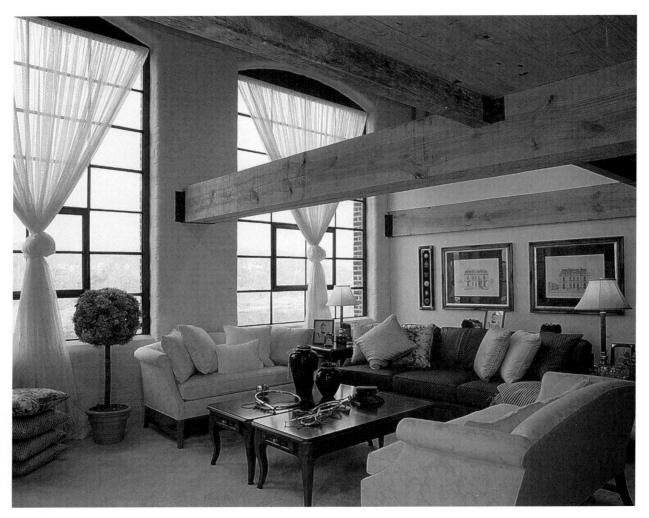

13.26 This adaptive reuse project converted what was formerly an American Thermos factory in Norwich, Connecticut, to 86 condominium units during the first phase of renovation. Original factory windows and high wood ceilings were retained, as was the brick exterior. Interdesign Architects; "Gear", NY, interior designers. (Photograph: Karen Bussolini)

the industrial society were the norm. Today we are a technological society, and a wide variety of household forms exist. Older structures are being expanded, opened up, retrofitted, rehabilitated, renovated, restored, subdivided, refurbished, reused, and updated in every conceivable way to make them more livable. And, with housing in short supply, even industrial and farm buildings are being converted to living spaces to help satisfy the need. The resurrection of these and other historic structures also preserves some of our architectural heritage. Historic preservation and adaptive reuse have become design specialties.

Existing space is usually altered to add more amenities. Kitchens and baths are the most commonly remodeled spaces; they have become areas of specialization for some designers. Entertainment areas and kitchens are frequently joined and opened up into a "great room" where families and friends can gather and relax. In particular, many middle-aged owners decide to remodel instead of purchase another home, to increase the value of their dwelling or in conjunction with necessary maintenance and repair. The case study at the end of Chapter 8 (pages 202–204) details the remodel of a townhouse ski cabin to become a primary residence.

The addition of more space is another important reason for remodeling. Structurally, floor space can be expanded by removing interior or exterior walls. When *load-bearing* walls are involved, the structure must be supported by some alternative method such as steel beams or columns. (An architect, engineer, or licensed

building contractor should be consulted.) Exterior walls are usually removed to allow the addition of square footage to the home, while interior walls are removed to open up inside spaces without adding square feet. Baths, living or family rooms, and kitchen expansions are often-added spaces.

Space can be added physically and/or visually by adding new rooms, perhaps a greenhouse or a remodeled garage, even just a bay window, dormer windows, or possibly skylights. By finishing the attic space, a one-story house can be expanded

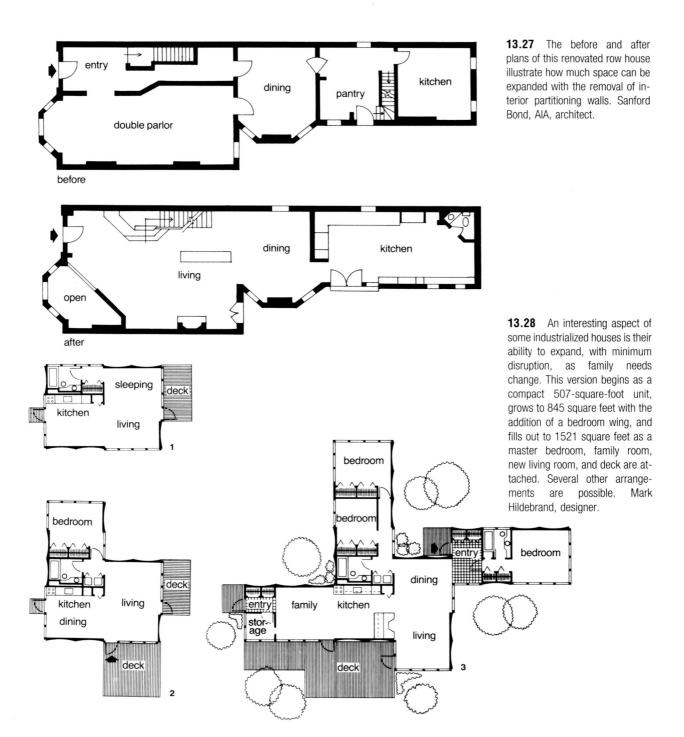

to 1½ stories. A full second story can even be added although this requires major reconstruction. To give the feeling of spaciousness in a small living area with a standard 8-foot ceiling, the ceiling can be removed and extended up to the rafters. Skylights can be added and beams can span the open space, or a soffit can be left around the perimeter to support the roof. Lighting installed in the soffit will dramatize the heightened space at night.

If the problem is too much space, walls and partial walls can be added to enclose and separate activities and provide greater privacy. When differentiation of the space is desired without actually closing off sections of it with walls, vertical distinctions can be made. A platform can be constructed to raise one activity area above another. Or, sometimes, part of a group space can be lowered to ground level if the house has a raised foundation with an aboveground crawl space. This requires pouring a concrete slab for the new floor surface.

If the existing rooms have high ceilings, a false or lowered ceiling can create greater intimacy for some areas. Very high ceilings also permit the construction of loft spaces that can be used for sleeping, play, or work.

13.29 A Colonial stone farmhouse that is over 200 years old, located in a southern New Jersey historic area, has had various additions over the years. Most recently, while preserving the original facade, the interior was opened up by replacing a loadbearing wall with two structural columns and adding a glass wall with French doors to the private back yard. The stairs lead to a bedroom and exercise area. Kris Misra, Misra and Associates, architect. (Photograph: Frederick Charles)

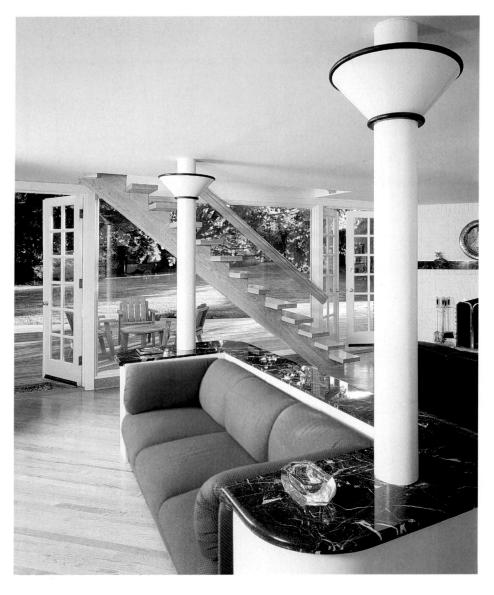

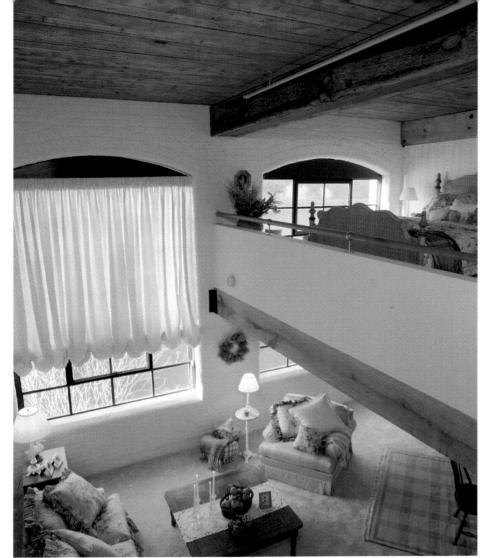

13.30 The Thermos factory's high ceilings (see Figure 13.26) allowed the loft bedroom area to be added, creating a two-story townhouse effect in the condominium units. Interdesign Architects; "Gear", NY, interior designers. (Photograph: Karen Bussolini)

13.31 (below) A bay window admits more light than an ordinary window and permits one to feel closer to the outdoors. The bay window, French doors, and cathedral windows brighten the interior of a modern log house more than the tiny windows of an authentic traditional log cabin. (Courtesy Andersen Windows, Inc.)

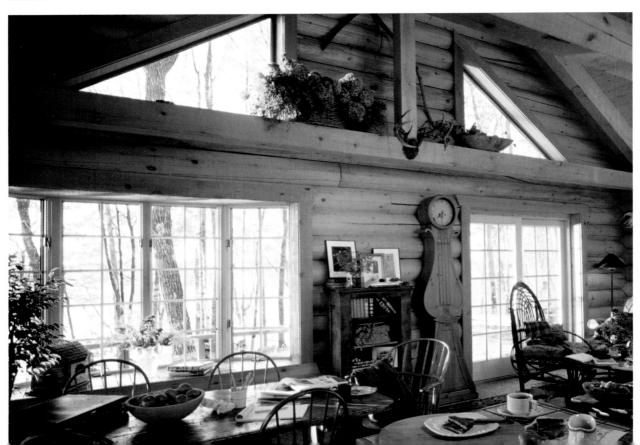

Outdoor living space can be found even in crowded areas with balconies and bay-, box-, sunroom-, and greenhouse-style bump-out windows added to the exterior of the home. They admit light and visually (as well as physically) extend space by linking indoors and outdoors. In these ways, space built for another time, for other occupants, can be altered to suit the needs of the present day.

ENDANGERED SPECIES

Another aspect of preservation is the exploitation and depletion of various natural resources and the impact of this practice on environmental degradation. At the forefront of this issue is the widespread usage of tropical hardwoods by interior designers. Tropical hardwoods include varieties of mahogany, rosewood, ebony, and teak, found primarily in Africa, Central and South America, India, and Malaysia. Many of these woods are becoming scarce, endangered, or depleted to the point of extinction through over exploitation. Logging of tropical hardwoods, although not the primary cause, contributes to global deforestation. Designers and manufacturers should give careful consideration to the use of these hardwoods unless they can be grown and harvested on a sustainable basis. The Herman Miller Company has already adopted such an environmentally sensitive policy.

The use of animal pelts may be another area of concern, although most skins, furs, feathers, etc. used in home furnishings and related products do not come from endangered species. If interior design decisions result in endangering either plant or animal species, these decisions do not meet our responsibility as designers to provide for the public welfare of our clients.

GLOBAL IMPACT OF DESIGN DECISIONS

Concern for the environment; the conservation of nonrenewable **natural resources**; provision for our health, safety, and welfare; and the harnessing of renewable energy sources have become increasingly important in recent years. We have become more aware of our great and too often unthinking impact on the environment, and the effect it in turn has on us. Environmental awareness should underlie all our decisions and may well change our way of life fundamentally in the years ahead. We have much to learn about this field, and wise choices are not always easy to make.

It is hard to decide whether a chair, for example, should be made of wood or plastic. Wood objects have a long life, can be refinished and reused (recycled) many times, and when no longer useful are readily reabsorbed into the environment; but our forests are being depleted, and for the first time in our history wood has become scarce and expensive. Plastics are relatively inexpensive to produce but are derived from petroleum and volatile, often toxic chemicals. A plastic object can also be both beyond repair and indestructible; it is *nonbiodegradable*, adding to the growing problem of waste disposal.

Such environmental factors will concern us at all levels of home planning—from choice of materials in furnishings and accessories to kind and amount of heating, cooling, and lighting we should use to components, types, and placement of our housing. Because these concerns for a sustainable society have just begun to attract widespread attention, and because the choices are so basic and controversial, we can point out only some of the issues as we discuss other aspects of creating a home.

We are also learning the value of preserving both our natural and our worthy built environments for all living things, for their beauty, and for the feelings of self-renewal we derive from them. More than ever before we are reusing our homes—rehabilitating, remodeling, and restoring them—to provide living quarters for today and to preserve our heritage for the future.

NOTES TO THE TEXT

- **1.** James Marston Fitch, *American Building 2: The Environmental Forces That Shape It.* Boston: Houghton Mifflin, 1972.
- 2. Donald Watson, *Designing and Building a Solar House: Your Place in the Sun.* Charlotte, Vt.: Garden Way Publishing, 1977, pp. 27–28.
- 3. Ibid., pp. 15-16.
- 4. David Martindale, Earth Shelters. New York: Dutton, 1981, pp. 38-42.
- **5.** Katherine Warsco, Interior Design and Indoor Air Quality. *Conference Proceedings*. Interior Design Educators Council, 1989, pp. 164–165.
- **6.** Fred Malven, Threat-Based Definition of Health, Safety and Welfare in Design: An Overview. *Journal of Interior Design Education and Research* 16 (2):12–13, 1990.
- 7. Deborah Wallace, In the Mouth of the Dragon: Toxic Fires in the Age of Plastics. Garden City, N.Y.: Avery Publishing Group, 1990.
- **8.** Fred Malven, The Professional Imperative: Health, Safety and Welfare in Interior Design. *Conference Proceedings*. Interior Design Educators Council, 1990, pp. 83–89.
- 9. Joan McLain-Kark, An Investigation into the Use of Tropical Woods in Interiors and its Impact on Tropical Deforestation. *Conference Proceedings*. Interior Design Educators Council, 1991, pp. 86–89.

REFERENCES FOR FURTHER READING

American Society of Interior Designers. Preservation of Global Life. *The ASID Report*, July/August 1990, p. 24.

American Society of Interior Designers. Profiting From Environmental Awareness. *The ASID Report*, March/April 1992, pp. 12–13.

Berger, C. Jaye. Environmental Law and the Design Professional. *The ASID Report*, May/June 1991, p. 12.

Brubaker, C. William. Indoor Environment. Interior Design 62(11): 40 & 43, 1991.

Danko, Sheila, Paul Eshelman, and Alan Hedge. A Taxonomy of Health, Safety and Welfare Implications of Interior Design Decisions. *Journal of Interior Design Education and Research* 16(2):19–30, 1990.

Fitch, James Marston. American Building 2: The Environmental Forces That Shape It. Boston: Houghton Mifflin, 1972.

The Housing Press, Hugh S. Donlon and Jeremy Robinson (eds.). *The House and Home Kitchen Planning Guide*. New York: McGraw-Hill, 1978, pp. 88, 132–136.

Keiser, Marjorie Branin. *Housing: An Environment for Living*. New York: Macmillan, 1978, chap. 13.

Kleeman, Walter B., Jr., Francis Duffy, Kirk P. Williams, and Michele K. Williams. *Interior Design of the Electronic Office: The Comfort and Productivity Payoff.* New York: Van Nostrand Reinhold, 1991.

Knox, B. When Buildings Get Sick. Interior Design, October 1988, pp. 272-273.

Kobet, Robert J. Sick Building Syndrome: How to Focus Attention on the Problem. *The ASID Report*, March/April 1992, p. 17.

Lindamood, Suzanne and Sherman D. Hanna. *Housing, Society and Consumers: An Introduction.* St. Paul: West Publishing Company, 1979, chap. 6.

Malven, Fred. The Professional Imperative: Health, Safety and Welfare in Interior Design. Conference Proceedings. Interior Design Educators Council, 1990, pp. 83–89.

Malven, Fred. Threat-Based Definition of Health, Safety and Welfare in Design: An Overview. *Journal of Interior Design Education and Research* 16(2):5–18, 1990.

Martindale, David. Earth Shelters. New York: Dutton, 1981.

Maserjian, Karen. Products That Are Environmentally Benign. *Interior Design* 62(11): 108–113, 1991.

McLain-Kark, Joan. Green Design—Can Designers Protect Tropical Forests? *The ASID Report*, March/April 1991, pp. 10–11.

McLain-Kark, Joan. An Investigation into the Use of Tropical Woods in Interiors and its Impact on Tropical Deforestation. *Conference Proceedings*. Interior Design Educators Council, 1991, pp. 86–89.

Pearson, D. The Natural House Book. New York: Simon and Schuster, 1989.

Roske, Mildred Deyo. *Housing in Transition*. New York: Holt, Rinehart and Winston, 1983, chap. 14.

Seale, William. Recreating the Historic House Interior. Nashville, Tenn.: American Association for State and Local History, 1979.

Spence, William P. Architecture: Design, Engineering, Drawing. Bloomington, Ill.: McKnight, 1979, chaps. 12, 13.

Wallace, Deborah. In the Mouth of the Dragon: Toxic Fires in the Age of Plastics. Garden City, N.Y.: Avery Publishing Group, 1990.

Warsco, Katherine. Interior Design and Indoor Air Quality. Conference Proceedings. Interior Design Educators Council, 1989.

Watson, Donald. *Designing and Building a Solar House: Your Place in the Sun.* Charlotte, Vt.: Garden Way Publishing, 1977.

Weale, Mary Jo, James W. Croake, and W. Bruce Weale. *Environmental Interiors*. New York: MacMillan, 1982, chap. 10.

Weber, Margaret J. and Jacquelyn W. McCray. Perceptions of Earth Sheltered and Passive Solar Housing by Consumers and Housing Intermediaries. Division of Agriculture, Research Report P-849. Stillwater: Oklahoma State University, July 1984.

Whitehead, Randall. Fear of Fluorescents. The ASID Report, March/April 1992, p. 15.

Willard, Kim. Interior Design and Indoor Air: A Partnership for Better Health. The ASID Report, March/April 1992, p. 10.

Wines, James. Inside Outside: The Aesthetic Implications of Green Design. *Interior Design* 62(11): 114–119, 1991.

Technical Requirements

HVAC
Heating
Ventilation
Air Conditioning
PLUMBING
ELECTRICAL
ACOUSTICS
SAFETY AND SECURITY
Fire Safety
Home Security
COMMUNICATIONS

The technical aspects of residential design—the mechanical (heating, ventilating, air conditioning, electrical, and plumbing) systems, acoustics, safety, security, and communication devices—are primarily the responsibility of the architect, the mechanical engineer, and the building contractor rather than the interior designer. (Lighting is the exception; a technical issue of critical importance to the function, aesthetics, and comfort of interiors, lighting is addressed in Chapter 21.) However, the interior designer must be cognizant of the way mechanical and other technical systems function and how they are installed as these realities of design affect interior spaces. The selection and placement of materials and furnishings may enhance, or be limited by, considerations of air circulation, sound transmission or reverberation, type of heating system, or location of registers, radiant panels, or thermal storage areas (walls or floors). Access to plumbing and location of pipe chases (the thick plumbing or "wet" walls through which pipes run) will determine the feasibility of locating or relocating kitchen, laundry, and bathroom fixtures and appliances. The interior designer must have a working knowledge of these systems in order to communicate with the professionals and consultants who deal with these technical issues, and to advise their clients accurately, often acting as a liaison between the architect, engineer, or contractor and client.

The heating, ventilating, and air-conditioning (HVAC) system or systems in a home are of primary importance; unless outdoor temperature and humidity levels **14.1** Baseboard-style radiators provide a blanket of warmth along exterior window walls. Newly designed hot water radiators, such as this, do not recycle indoor air pollutants and require less bulky heat units and elements than forced hot air heating systems. (Courtesy Runtal North America, Inc.)

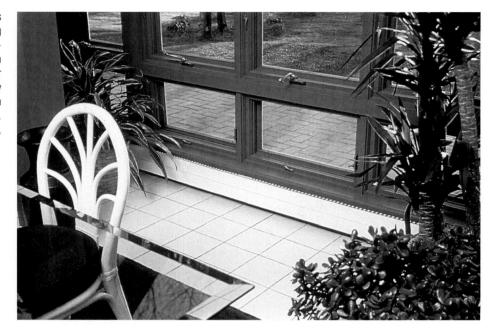

are within comfortable ranges, virtually all of the air entering a house must be heated or cooled, humidified or dehumidified, cleaned, and circulated. All HVAC functions (including air cleaning and humidification) can be, and often are, most conveniently handled by a single central forced-air system. However, heating, ventilation, and air conditioning will each be considered separately in this chapter.

HEATING

Space heating for homes can be produced by

- heating air in a warm-air furnace, fireplace, or wood-burning stove;
- heating water in a boiler;
- sending electricity through a resistant conductor, as in toasters; or
- extracting heat energy by means of a heat pump.

Warmth is delivered to living spaces through

- registers or grilles, which are small openings in floors, ceilings, or walls emitting warmed air;
- baseboard heaters—comparatively long high-temperature units along baseboards or sometimes ceilings; or
- radiant panels with large low-temperature floor, ceiling, or wall surfaces that present no obvious evidence of heating devices.

Heat, then, affects us and our homes by *conduction* through solid matter, either continuous or in close contact, as when our feet are warmed by a warm floor; by *convection*, or moving currents of air, as when the warm air blown from a register decreases the heat loss of our bodies and when warm air rises naturally; and by *radiation*, when heat waves travel from one solid to another without making the air uncomfortably hot and stuffy, as from radiant panels or the sun's warmth. Heat-delivery units should be located around the perimeter of rooms, along outside walls and beneath windows to minimize drafts. The heat blankets the inside surface of the exterior walls and thus prevents room air from being chilled by contact with it. For maximum comfort, heat must be delivered either continuously or in short

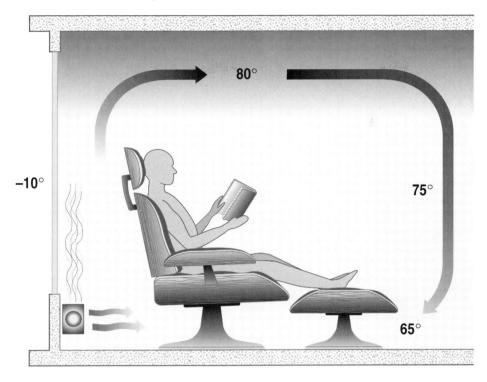

14.2 This diagram illustrates the effect of placing heat delivery units (registers or radiators) along the exterior perimeter of a room, under windows where cold air enters. The rising heat blankets the exterior wall, preventing room air from coming into contact with cold glass, reducing the temperature difference between upper and lower parts of the room, and decreasing uncomfortable, chilly drafts. (Adapted from Household Equipment in Residential Design 9th ed., by Mary S. Pickett, Mildred G. Arnold, and Linda E. Ketterer. John Wiley & Sons, 1986)

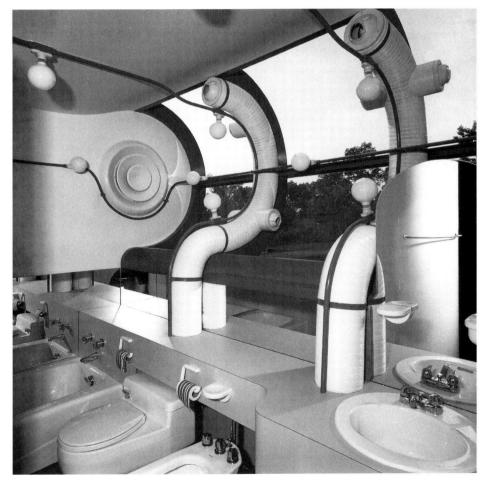

14.3 A 500-square-foot addition appended to the master bedroom of a Highland Park, Illinois, home includes a sitting room, an exercise room, and a large bath. Exposed flexible ducts, with electrical conduit attached, follow the steel mullions in curved mirrored glass. Stanley Tigerman, architect. (Photograph: Howard N. Kaplan)

14.4 Glass doors prevent heat loss without diminishing the visual effect of a fire. A red granite hearth and custom-designed, polished chrome mantel accentuate the contemporary character of this Sacramento, California, home. Charles Crockett Associates, designers. *(Photograph: Ed Asmus)*

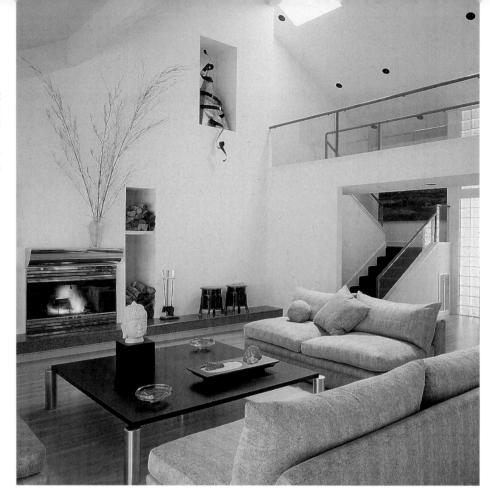

14.5 This Sheboygan, Wisconsin, open plan kitchen–family room permits both areas to enjoy the warmth of a fire from an efficient wood stove. The fire-resistant tile wall treatment behind is an emphatic element in the design of the space. Cynthia Weese/Weese Langley Weese, architect. (Photograph: Howard N. Kaplan)

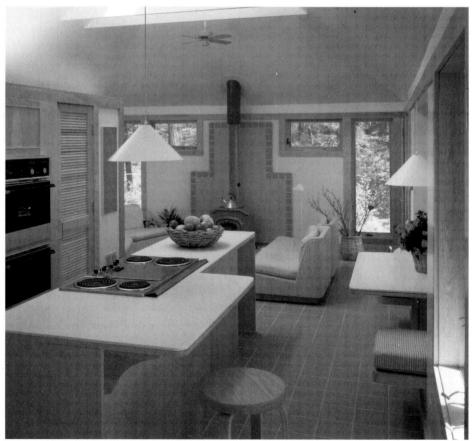

but frequent intervals to prevent fluctuations in room air temperature. The general characteristics of different heating systems can best be understood if they are grouped in terms of the way heat is brought into rooms.

Registers convect air warmed in a furnace, give quick heat, and are moderately low in initial cost. The moving air, which can be cleaned and humidified, dispels stuffiness and tempers moisture content. Since the same ducts and registers can serve also for cooling, the additional cost of air conditioning is lowered. A system of pipes or *ducts* running through the ceiling or walls or under floors—or sometimes left exposed as design components in High Tech or adaptive reuse interiors—distributes warm air to the rooms and returns cold air from them. The registers and cold air return may interfere with furniture arrangement and floorlength window treatments. Except in the best installations, temperatures may fluctuate noticeably, and the air may seem uncomfortably hot at times.

An old-fashioned fireplace is the most inefficient method to heat a room; nearly ninety percent of the heat, plus warm air from the house, is drawn up the chimney. A glass door over the opening can substantially reduce this loss. Fireplace inserts or wood- or coal-burning stoves are more efficient alternatives. In most cases, fire-resistant materials must be used in immediate surrounds and heat will be uneven throughout the space, perhaps uncomfortably warm in the near vicinity.

Fireplaces and wood-burning stoves can be equipped with conducting pipes or air ducts that convect hot air, naturally or with the assistance of a fan, even into adjacent rooms.

Baseboard heaters circulate hot water or steam, or the heat generated by electric resistance coils, to provide relatively uniform temperatures through natural convection and radiation. Rooms cannot be heated or cooled as quickly as

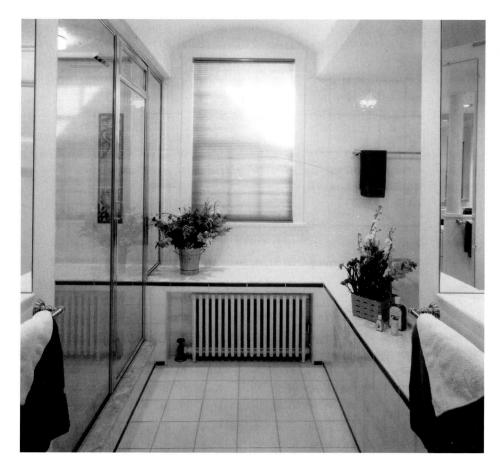

14.6 A 100-year-old home in Winchester, Massachusetts, remodeled by David Corbin, incorporates an existing radiator into the design of a continuous tiled counter-bench that extends into the $3' \times 7^{1/2}$ ' steam shower. (Photograph: Howard N. Kaplan)

with registers. Usually more expensive to install, they give no control of the air other than temperature. **Radiators**, usually placed below windows, also circulate hot water or steam. They are commonly seen in older structures, and the designer may wish to conceal them without obstructing their ability to deliver warmth.

Radiant panels, most often installed in ceilings but occasionally in floors or walls, are transformed into large warmed surfaces by means of water or air heated in a furnace or by wires that convert electricity to heat. The heat radiates to opposite surfaces without affecting the air. Thus they keep us, our furnishings, and the architectural shell pleasantly and uniformly warm while the air stays relatively cool and without drafts. No intrusive registers or radiators mar the design of the room. However, this system has a slow heating response since it must heat the ceiling, wall, or floor before it can heat the room. Materials for these surfaces (plaster, concrete, brick, tile, or stone) must conduct heat well and require good insulation, but do not work effectively if blocked by rugs or floor coverings. Also, people may feel cold if furniture blocks the radiant energy from reaching all parts of the body. A table, for example, may shield the legs from panels located in the ceiling. Radiant panels are rather expensive to install, and operating costs can be very high because of the expense of converting primary fuel, such as oil or natural gas, into electricity. Air circulation, cooling, purification, and humidification cannot be provided by this system.

Humidity affects comfort by retarding or enhancing the loss of body heat. High moisture levels in the air slow evaporation of skin moisture, keeping the body warm, while low humidity increases skin moisture vaporization, cooling the body. Moisture added to the normally dry warm air emitted from heat registers in the

14.7 A ceiling fan circulates the air within a room and, with doors or windows open, draws in fresh air and moves out stale, hot air. Earl Combs, architect. (Photograph: Scott Frances/ESTO)

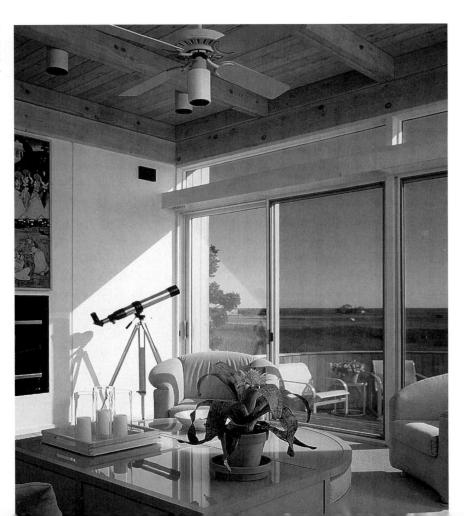

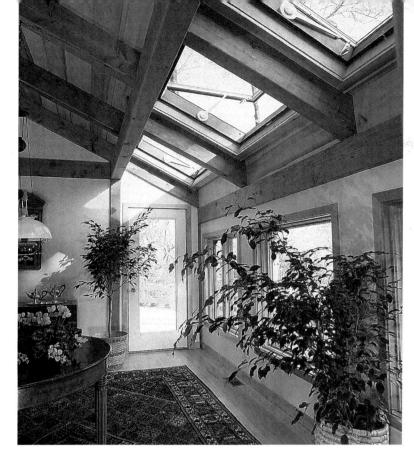

14.8 Installed when the house was renovated, these ventilating skylights open up to eighteen inches to exhaust stale air and increase the circulation of fresh air. Low-emissivity argon filled glass with an R-value of 4.17 prevents excessive heat gain and blocks damaging ultraviolet light rays. *(Photograph: Karen Bussolini)*

winter increases human comfort. A relative humidity range of 20 to 60 percent is comfortable. In summer, a lower relative humidity increases comfort.

Proper humidity levels prolong the life of wood, metal, and painted surfaces. Too much moisture causes wood to warp and mildew, condensation and rust to form on metal surfaces, musty odors, and peeling paint and wallpaper. Not enough moisture dries woods, leather, and adhesives, causing splitting and separation, and increases static electricity as well as "fuzzing" of carpets. Too little moisture also causes human discomfort by parching delicate respiratory membranes, aggravating allergies, and contributing to the build-up of static electricity.

Excess humidity and too little humidity can both be controlled. Mechanical humidifiers and dehumidifiers can be included as part of a year-round central heating/cooling system or installed separately. Exhaust fans in baths, laundries, and kitchens help remove high humidity during use. Ventilators in basements, crawl spaces, and attics also remove water vapor before damage occurs, particularly in airtight newer homes.

VENTILATION

In addition to temperature control, providing a pleasant indoor climate includes regulating air movement, providing fresh air, and removing odors, pollen, dust, and smoke. Balancing air temperature, humidity, and circulation creates the most comfortable environment and can even help moderate heating and cooling costs.

Good ventilation removes hot, stale air from the tops of rooms, brings in fresh air, keeps the air in gentle motion, and accomplishes all this without uncomfortable drafts. The major devices involved are doors and windows that can be opened, ventilating grilles, exhaust fans, warm-air furnaces with blowers, air-conditioning units, and fans.

Hot air rises, so it is best removed by windows, grilles, or exhaust fans placed high in the room or house. Ventilating skylights also release stale air. A forceddraft warm-air furnace, with the heat on or off, circulates air, as does most cooling equipment or a ceiling fan. Without one or more of these, a layer of practically motionless air will stay near the ceiling or in the attic. When this dead air is taken out, fresh air will enter to replace it.

Usually fresh air comes through windows or doors, but *ventilators* strategically placed in the walls sometimes work better. Ventilators generally have horizontal louvers on the outside to ward off rain or snow, fixed insect screens, and hinged or sliding panels on the inside to control the flow of air. Their advantages are numerous: being unobtrusive, ventilators can vary more in size, shape, and location than can windows; since they do not interfere with privacy, they can be placed where windows are unsuitable; and their permanently fixed and inconspicuous screens lessen the need for visually distracting insect barriers at windows.

Of all rooms, kitchens require the best ventilation; most kitchens have exhaust fans, used when necessary, to supplement windows and doors. (See also Figure 14.11.) Bathrooms are equally important to ventilate well; local building codes determine the amount of ventilation required. Windows or grilles high in the wall help remove stale air; controllable ceiling ventilators or skylights furnish both privacy and fresh air. Interior bathrooms, lacking windows, are required to have mechanical ventilation, usually ducts and fans.

Living and dining spaces also need good air circulation, but the fact that they are often combined and therefore usually larger and may have windows on two or more sides often takes care of the problem automatically. In contemporary planning, air flows through group spaces and to the outside as easily as people do. A good solution includes doors and windows plus grilles, some high and others low, located on different walls.

Bedrooms benefit from fresh air without drafts. Again, high windows or ventilators on two walls, supplemented by other windows and doors, allow flexible control.

Pollutants such as pollen, dust, and smoke are partially removed from the air by filters on most forced-air heating systems or more completely eliminated by

14.9 An architects' weekend cottage near Lake Michigan is ventilated by louvers in the end walls and ceiling fans. In addition, all rooms have openings on at least two sides for cross ventilation. Stanley Tigerman and Margaret McCurry of Tigerman, Fugman, Mc-Curry, architects.

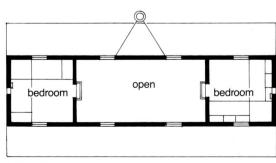

loft level

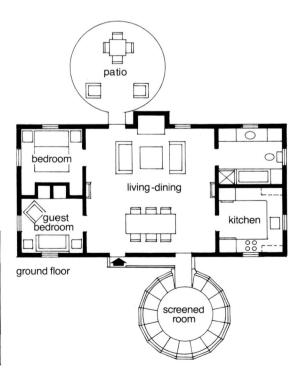

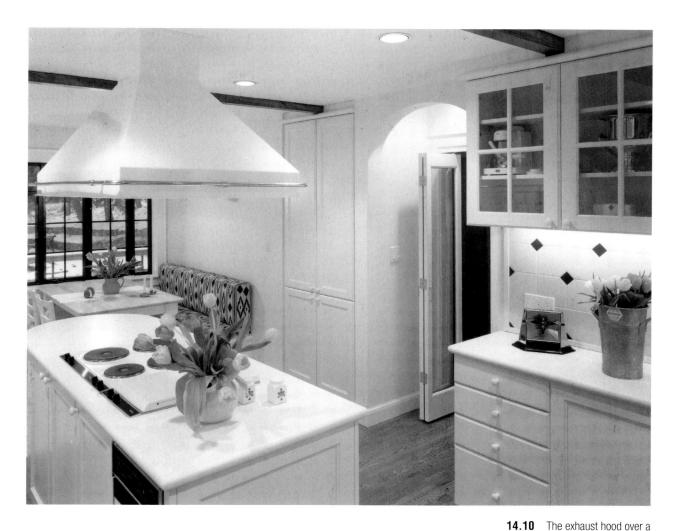

electronic air cleaners that can be added to the central air system. Recirculated air may contain contaminants propagated in ductwork. All air filtration systems must be kept clean to be effective and, when installed in a central forced-air system, only work effectively if the blower is run continuously.

kitchen cooktop may be a featured element in kitchen design if placement, design, and materials warrant it. Spigot, Ltd., architects. (Photograph: Howard N. Kaplan)

AIR CONDITIONING

In many parts of the United States, home air conditioning has come to be regarded as essential, since excessively high temperatures and humidity enervate us so that we cannot function at full capacity for either work or play. The elderly and those with heart ailments particularly benefit from air conditioning.

Operating on the same principle as mechanical refrigerators, most air conditioners remove heat and moisture from the air, keep clean air in motion, and reduce housecleaning. Evaporative coolers (swamp coolers), which extract cool air from evaporation of water, add additional moisture to the air and, for this reason, may be desirable in dry climates. Central cooling systems (often combined with heating apparatus) are generally much more efficient and cheaper to operate than individual room units, although the cost of installation is higher. To function effectively, window units or under-window air conditioner vents must have sufficient clearance from furniture and window treatments (Figure 14.12). Built-in systems

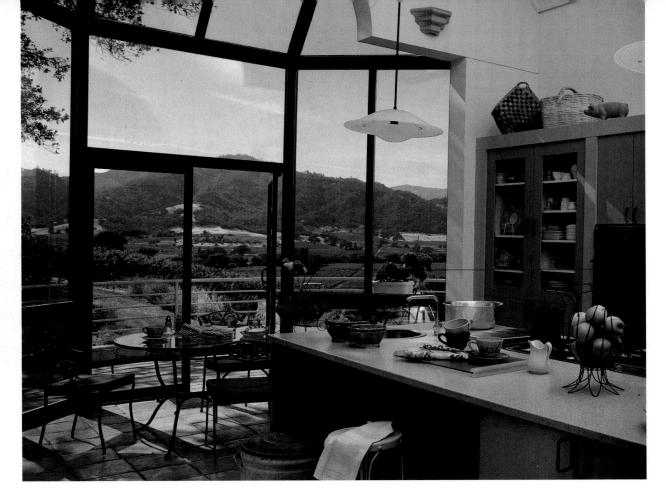

14.11 A glass-enclosed bay opening onto a deck overlooking vineyards ensures adequate ventilation in the eating area and kitchen of this Sonoma, California, house. Roland Miller, architect; Arnelle Kase/Barbara Scavullo Designs, interior designer. *(Photograph: David Livingston)*

emit cool air at the floor level and exhaust warm air from ceiling level, or vice versa. Most air conditioning systems rely on electrical energy, so operating costs may be high. Cooling a house is more difficult than heating it because many normal daily activities, including lighting, add heat and/or moisture to the air.

In years to come the demonstrable advantages of air conditioning will have to be weighed against the potential dangers of excessive fuel consumption and detriment to the environment. One example demonstrates how an overdependence on artificial climate regulation can spiral out of control. The weather in New York City has actually changed over the last quarter century, partly because of the great amounts of moisture released into the atmosphere by air conditioners. Night breezes can no longer move in to cool the paved streets and heat-retaining surfaces of the buildings. Instead, heat builds on heat, so that yet more air conditioners must be called into service. If such chains are not broken, the results could be disastrous.

Ductwork, delivery units, and air returns must be taken into consideration when the designer recommends furniture selections and arrangements, window treatments, or remodeling. Changes in walls, ceilings, or floors that conceal ductwork, plumbing, or electrical service require consulting a contractor or engineer.

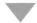

PLUMBING

Minimum standards for health and safety are established by federal, state, and local housing policies. Building codes specify, among other regulations, the installation of plumbing to assure sanitary conditions for both water supply to the home and disposal of sewage waste from it. Water is necessary to bodily functions, to life itself. In the home, it is also needed for cooking, laundry, cleaning, and bathing. Health officials set standards for safety of the water supplied to the home, while building codes stipulate the materials and methods through which it is delivered. Pipes should not corrode, rust, leak, or in any way affect the taste or color of the water. Neither should they make noise or reduce water pressure. Hot-water pipes should be kept as short as possible to conserve energy; if longer than 15 feet, they need insulation. The water heater should be centrally located in relation to fixtures supplied by it, or, if fixtures are widely separated, more than one water heater should be considered. For economy, all plumbing should be kept as central as possible, with kitchen, baths, and laundry located back to back or stacked vertically.

If the water supply contains undesirable though not harmful minerals, softeners and/or purifiers can be installed in the home to remove them. Minerals can affect the taste of the water, cause laundry problems, and accumulate as deposits in pipes and on fixtures.

Soil and waste pipes remove solid and liquid refuse from the house without contaminating the fresh-water supply. Sanitary conditions for the disposal of sewage are necessary to prevent the spread of contagious diseases. Materials and methods involved are regulated by government agencies and building codes. Sewage systems depend upon gravity, so soil pipes must be large, must avoid sharp turns, and must slope downward to prevent clogging. Traps and vertical vent pipes are required to prevent seepage of sewer-gas odors into the house.

14.12 Window air conditioner units can be quite small, but they require an unobstructed space for adequate air flow. (Courtesy Carrier Air Conditioners)

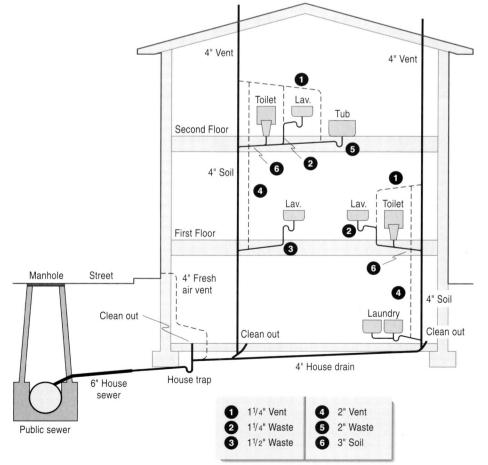

14.13 The water supply distribution and sewage disposal systems are installed in a new house before interior walls are finished. A typical sewage disposal system is illustrated, with parts labeled. (Adapted from Architectural Drafting and Design, 4th ed., by Ernest R. Weidhaas. Allyn and Bacon, Inc., 1981)

Bathtubs, showers, and whirlpools are installed when *rough plumbing* is done during framing, before drywall is hung. *Finish plumbing* is the final installation of fixtures such as sinks and toilets and hookup of appliances such as washing machines and dishwashers. When fixtures or appliances are relocated or added, the designer must be aware of the location of existing pipe chases/plumbing walls as well as have a basic understanding of how plumbing systems function. It is easiest to locate new wet facilities near existing drainpipes and stacks, especially in multistory structures. A plumbing contractor may have to be consulted before final decisions are made. In high-rise condominium or apartment buildings, sprinkler

14.14 Rough plumbing, including both intake and discharge systems, is installed during framing so that pipes can be threaded through floor joists and between studs. (*Photograph: Richard Howard*)

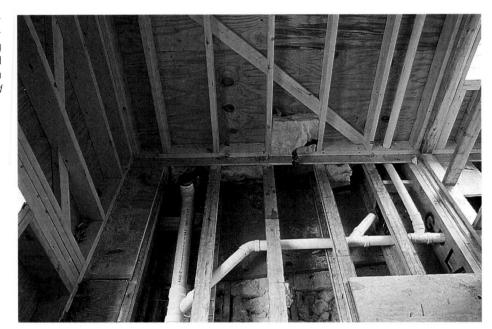

14.15 When an egg warehouse in Tribeca, New York, was converted to apartments, the existing fire sprinkler system was retained with pipes exposed. Existing wood strip flooring was refinished and is complemented by a Roy Lichenstein area rug and Isamu Noguchi coffee table. Morrison Murakami Architects. (Photograph: Paul Warchol)

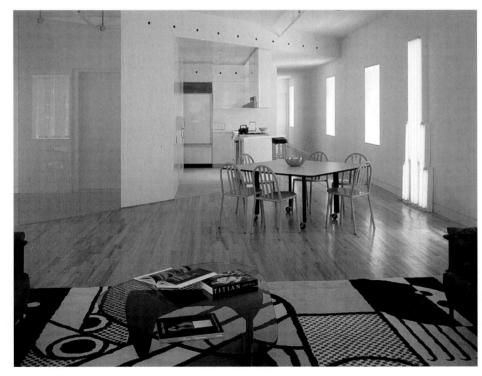

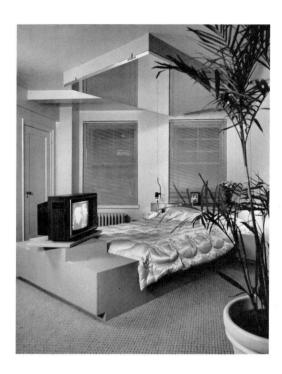

14.16 This bedroom has an electrical outlet placed for the convenience of the occupant's television viewing. Peter Wilson, architect. (Photograph: © Norman McGrath)

systems may be required to meet fire-safety codes. Plumbing for sprinklers includes supply mains, shut-off valves, sprinkler pipes, and sprinkler heads, installed in ceilings with only the heads exposed. Plumbing plans must be approved, installations completed by licensed contractors, and work inspected before space can be occupied.

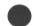

ELECTRICAL

Electrical needs are also primarily the responsibility of the engineer and contractor. A licensed electrician assures that adequate service is provided (usually a three-wire, 120/140-volt system); performs the wiring with a sufficient number of circuits of the correct size wire for present and future needs; installs switches, outlets, and fixtures; and obtains required inspections and approvals.

The interior designer's responsibility is to place switches and outlets at convenient locations and accessible heights based on the planned function of the space, arrangement of furnishings and equipment, and needs of the client. Enough outlets should be located in each room so that extension cords are not needed. A minimum of two outlets per room, placed 10"–16" above the floor, is a general requirement but, in the living room and bedrooms, no point of any usable wall space should be more than 6 feet from any outlet; in the dining room, all points must be within 10 feet of an outlet; in the kitchen, an outlet should be placed every 4 feet above work surfaces, excluding the sink and range, with a separate one for the refrigerator; and the laundry requires grounding outlets placed 40"–42" above the floor for the washer and dryer. Bathrooms also require a grounded outlet above the lavatory or countertop. A ground fault interrupter circuit (GFIC) in bathrooms provides a very sensitive circuit breaker that prevents electrical shock when water is present near switches and outlets. Outlets should not be placed in the center of long walls where large pieces of furniture (beds, sofas, bookcases) will likely

14.17 Master switching for the entire living area of this house is placed within easy reach in the kitchen, eliminating the need to walk through every room to turn lights on or off. Studio E Architects; Brad Burke, designer. (Photograph: Hewitt/Garrison)

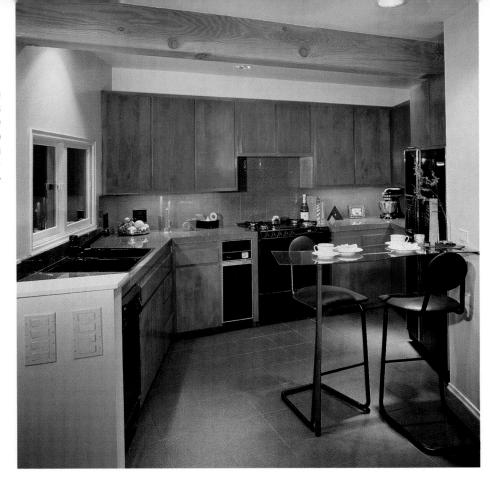

be placed in front of them. Hallways must also have outlets for cleaning appliances. Since most electrical requirements are regulated by building codes, interior designers must understand and be familiar with codes applicable to the locale of their work.

Switches should be placed at both ends of hallways and stairways, and at entrances of rooms, with multiple switches for rooms with multiple access so that they can be illuminated on entering and darkened on leaving without retracing steps in darkness. Every room should have at least one light controlled by a switch placed 4 feet above the floor on the lock side of the door. Switches should never be located behind doors. Lighted switches ease their location in dark rooms.

Designers may also select and locate special controls such as dimmers to adapt the level of light to a particular task or mood. Circuit-breaker panels must be placed as well, and types of switch plates and controls chosen for their appearance. The technical aspects of lighting and light fixtures, for which the designer bears responsibility, are presented in Chapter 21. The Smart House wiring system, described in Chapter 13, can include lighting controls for dimming and security.

A wiring plan showing the locations of fixtures, placement of switches and outlets, and which switches control which outlets or fixtures is an essential tool for both the designer and electrician. Designers must be familiar with electrical symbols and be able to read wiring diagrams (Figure 14.18) and lighting plans (see Chapter 21); standard electrical symbols are illustrated in Appendix A.

ACOUSTICS

A pleasant living environment, offering comfort and privacy, requires sound control. Noise levels in general are on the rise. Sound is measured in *decibels* on a scale of 0 to 130, with 30 decibels being a general noise level to which people can adapt.

The reverberation characteristics (amount of sound absorption) of interior spaces are of proven importance in reducing stress, irritability, nervousness, and sleep-lessness and in promoting a restful environment conducive to psychological composure, physical comfort, and physiological well-being.

Homes are zoned, to some extent, according to the noise levels of various kinds of activities, with the work zone being the noisiest, the private zone the quietest, and the social zone somewhere in between. A good floor plan incorporates structural sound buffers between zones, with walls, closets, hallways, staggered doorways, and windows placed so as not to reflect sound back to the interior. (See Part Three, Chapters 7–12.)

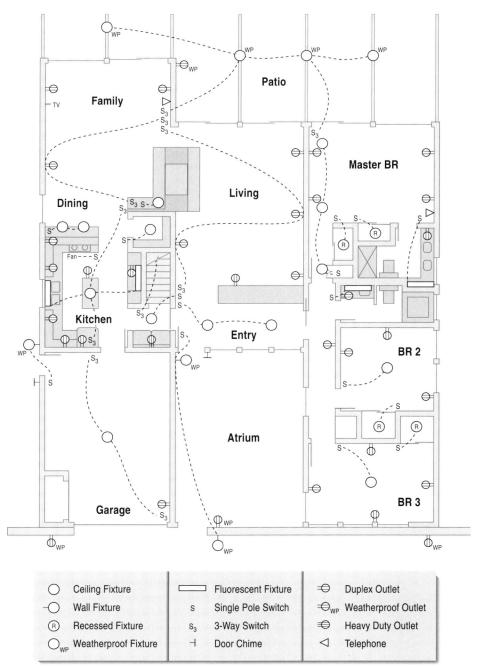

14.18 A typical electrical plan shows the placement of outlets, switches, fixtures of various types, telephone jacks, television hookups, and door bells. (Adapted from Architectural Drafting and Design, 4th ed., by Ernest R. Weidhaas. Allyn and Bacon, Inc., 1981)

14.19 Architect Alfredo De Vido zoned this New Jersey solar house to provide quiet sleeping quarters. Bedrooms are placed on a different level than the entry, living and dining rooms, and kitchen, with none directly below the entry or living area. The master bedroom is separated from other bedrooms by the family room, with a booklined study to buffer it from the noise of any social activity; teenagers' bedrooms are insulated from each other by closets; and all bedrooms have windows only on sides facing away from any noise emanating from the driveway, street, and entry.

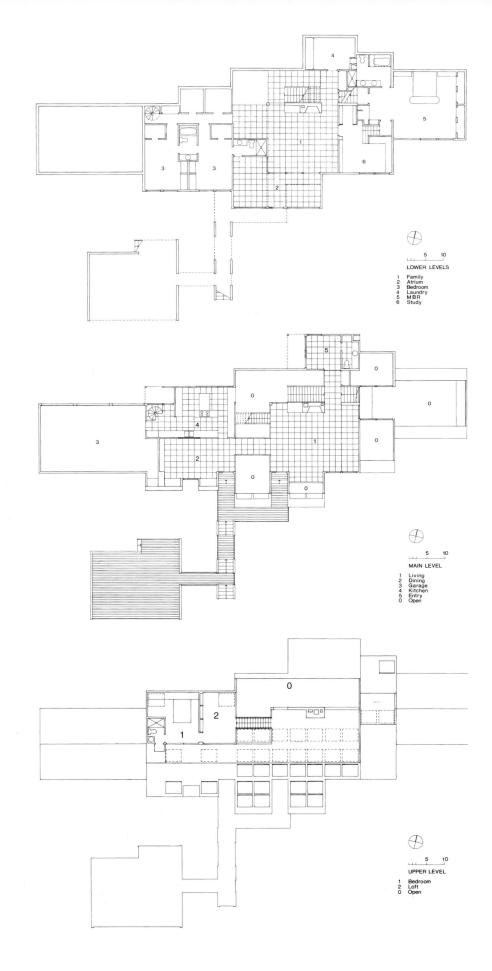

Exterior noise from the street can be controlled somewhat by the insulating materials and devices used to conserve energy (double- or triple-glazed windows, double doors with gaskets at the edges, insulated walls and ceilings), trees and shrubs, fences or walls, and earth berms. For maximum buffer from street noise, the quietest areas within the home should face away from the street, the street side should have as few windows and doors as possible, and the house should be placed as far from the street as possible.

Special construction techniques can help reduce the transmission of noise from one space to another. Walls can be built of heavy materials such as thick masonry, or with staggered studs so the two wall faces do not connect directly. Floors can be similarly constructed and carpeted with thick padding underneath, but it is difficult to eliminate sound transmitted through floors. Suspended ceilings of sound-deadening materials also deter noise conduction. Conduits and pipes can be insulated to prevent sound from traveling through them; heating ducts can contain sound traps. Quiet mechanical equipment and appliances can be selected; they can be placed away from walls and mounted on sound-absorbing rubber, vinyl, or cork pads to reduce vibration. Stair landings that change direction and hallways that turn help diffuse sound, while stairwells and courtyards with one open side eliminate reverberation of noise from hard surfaces such as tile, plaster, glass, and metal.

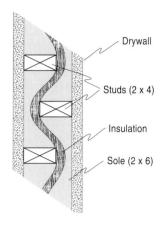

14.20 Staggered stud wall construction.

14.21 Acoustical ceiling tiles can reduce noise transmission and reverberation in multiple story structures or noisy work spaces. *(Courtesy Celotex)*

14.22 Upholstered walls, plush carpet, and draped, quilted, and pleated fabrics all play a role in insulating this master bedroom from the outside. Mary Jean Thompson, ASID, interior designer. *(Photograph: Barbeau Engh)*

14.23 A wall of built-in bookcases integrated beside, above, and below the stairway helps to deaden sound between a quiet social space and work areas in a northern California coast vacation home owned by a collector of books and art objects. Daniel H. Levin, AIA, architect; Donna Berry, ASID, interior designer. *(Photograph: David Livingston)*

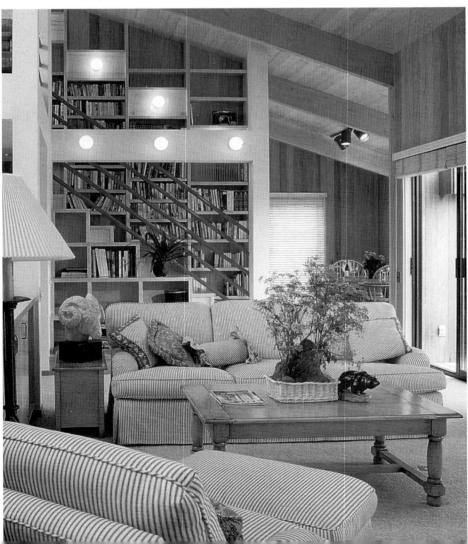

14.24 Exterior lighting provides security from unwanted intruders and safety for traversing driveways and walkways at night, especially where stairs are present. Maurice J. Nespor & Associates, architects. (Photograph: Maurice Nespor)

Finally, acoustical materials that absorb sound can be used in the interior spaces. Floors can be covered with carpet, vinyl, or cork; walls and ceilings can be covered with acoustical panels, acoustical paints, or fabric. Bookcases, cabinets, upholstered furniture, draperies, and curtains also absorb sound. Acoustical materials can cut decibel levels in half, making work, conversation, and rest more enjoyable. Quiet background music can also contribute to a pleasant environment, masking other noise and setting the mood for rest, concentration, or social activity. (Acoustical control for music in the home is discussed in Chapter 9.)

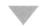

SAFETY AND SECURITY

FIRE SAFETY

Home safety systems are primarily early-warning fire detection devices. Many home fires occur while people are asleep, and most deaths are due to smoke inhalation, often before occupants awaken. Widespread use of synthetic materials in everything from upholstery and floor covering to PVC (polyvinyl chloride, a plastic) drainpipes has increased the danger of death due to deadly chemical gases given off when synthetics begin to smolder.

Smoke detectors sound an alarm sooner than heat-sensing devices unless the fire begins in places remote from the proximate spaces in the home most commonly occupied, such as a garage or attic. When located near bedrooms and living spaces, smoke detectors are most effective because smoke is the earliest symptom of a fire and smoke fires cause the most deaths. The alarm is designed to wake the soundest of sleepers with a four-minute, 8-decibel horn. Most states have laws requiring all new homes to be equipped with smoke detectors.

Fire extinguishers for the home should be mounted near a doorway within 50 feet of any part of the house. Large homes will need more than one extinguisher.

HOME SECURITY

Home security consists of lighting, locks, and alarms that protect against burglary and uninvited entry. Outdoor lighting discourages prowlers by reducing the concealment of darkness. Exterior lighting and a wide-angle peephole at entry doors

14.25 Even freestanding entertainment centers require prior thought to provide an adequate number of outlets for complete audio/visual systems. (Courtesy Henredon Furniture Industries, Inc.)

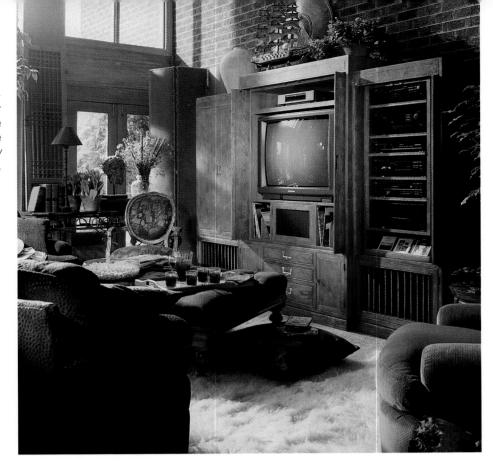

allow identification of visitors before opening the door. Automatic timers can turn lights, radios, or televisions on and off to give the impression someone is home.

Most burglars enter a home the easiest way, through a door; breaking windows makes noise and draws attention. Good, secure doors and locks discourage entry; the longer it takes to open a lock, the more protection it gives. Both doors and windows should have good locks.

Perimeter protectors and motion detectors are two types of alarm systems which sense intrusion and alert the household, neighbors, or the police. Perimeter alarms establish an electronic boundary around the home which warn of attempts to cross it. Motion detectors alert the homeowner when an intruder has entered the area being monitored; however, when located in hallways or on stairways, they can be accidentally activated by family members who move about at night. Security devices are usually installed by professionals who are experienced in the devices' function.

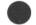

COMMUNICATIONS

Telephones, intercoms, facsimile machines, computers, and various other sound and audio-visual systems constitute the communications, and sometimes entertainment, equipment installed in residences. Installations should be planned ahead and wiring completed by specialists during construction, if possible. Often consultants are needed for complex projects involving sound systems or elaborate audio-visual equipment and controls for media rooms. Telephone wiring and outlets may be added after-the-fact if the requirements are simple. Intercom systems allow family members to communicate between rooms, parents to audibly monitor children, or music to be piped to various locations throughout the house and even to outdoor areas. It is estimated that nearly one-third of the workforce may be

working at home (with computers and facsimile machines) by the turn of the century, placing ever greater technical requirements on the home and the residential designer. The Smart House wiring system can support several telephone lines, including lines designated for a facsimile machine or computer modem, and it features a built-in answering machine that allows the resident to receive messages from inside the home (with touch-tone telephones used as a whole-house intercom) as well as outside calls.

Control of temperature, air quality, sanitation, sound, safety, security, and communication makes our homes physically comfortable. Most have little to do with the beauty or character of the completed home, but they do seriously affect human health and happiness. The most attractively designed home cannot be considered successful if it is too hot, too cold, too damp, too noisy, too dark, airless, unsanitary, or unsafe. Planning for technical requirements should begin at the very outset and continue through every aspect of home design. Because the structure of the home must often accommodate technical equipment and controls unobtrusively, they have been considered here as realities of design rather than later as interior components.

NOTE TO THE TEXT

Mary S. Pickett, Mildred G. Arnold, and Linda E. Ketterer, Household Equipment in Residential Design, 9th ed. (New York: John Wiley & Sons, Inc., 1986), p. 459.

REFERENCES FOR FURTHER READING

- Ching, Francis D. K. Building Construction Illustrated. New York: Van Nostrand Reinhold, 1975, chap. 11
- Flynn, John E., Arthur W. Segil, and Gary R. Steffy. *Architectural Interior Systems*, 2nd ed. New York: Van Nostrand Reinhold, 1988.
- The Housing Press, Hugh S. Donlon and Jeremy Robinson (eds.). *The House and Home Kitchen Planning Guide*. New York: McGraw-Hill, 1978, pp. 88, 132–136.
- Keiser, Marjorie Branin. Housing: An Environment for Living. New York: Macmillan, 1978, chap. 13.
- Lindamood, Suzanne and Sherman D. Hanna. *Housing, Society and Consumers: An Introduction.* St. Paul: West Publishing Company, 1979, chap. 6.
- Pickett, Mary S., Mildred G. Arnold, and Linda E. Ketterer. *Household Equipment in Residential Design*. New York: John Wiley & Sons, Inc., 1986, chaps. 2, 3, 10, 19, 20.
- Roske, Mildred Deyo. Housing in Transition. New York: Holt, Rinehart and Winston, 1983, chap. 14.
- Spence, William P. Architecture: Design, Engineering, Drawing. Bloomington, IL: McKnight, 1979, chaps. 12, 13.
- Weidhaas, Ernest R. Architectural Drafting and Design, 4th ed. Boston: Allyn and Bacon, Inc., 1981, chaps. 31–35, 42, 43.

Wood and Masonry

WOOD
Forms
Ornamentation
Finishes
MASONRY
Block Materials
Moldable Materials

Wood and masonry have served as building materials ever since the earliest civilizations. Wood and the raw materials for masonry offer the advantages of strength and relative permanence, yet they can be shaped with a measure of ease. In addition to its role in structural building, wood has functioned as a basic material for furniture and other artifacts in the home at least since the days of ancient Egypt (see Chapter 22). Despite the incursion of plastics, many people still think automatically of wood as the material for furniture construction.

Both wood and masonry possess special natural qualities that cause them to retain their popularity, even though other newer materials may prove superior for practical considerations (Figure 15.1). In the case of wood, there is perhaps a subtle awareness of its once having been part of a living tree, and thus being more responsive to us as living creatures. Masonry, on the other hand, has as its major component the substance of the earth itself; a timeless, enduring quality in masonry makes us feel safe and protected.

IOOD

WOOD

As a material, wood has many useful and aesthetic qualities inherent in its very nature. One is the remarkable strength of wood in relation to its size and shape. Notable in this respect is its *tensile strength*: it resists breakage when subjected to bending or pulling forces. Its tensile strength permits wood to be used for spanning gaps, such as those above windows and in the wide stretches of ceilings, and in table tops. Tensile strength also suits wood to *cantilever* construction, in which a horizontal member projects beyond a support, as in a table top that extends beyond the table legs.

Wood, further, has considerable strength in *compression:* it retains its shape under pressure. This feature makes wood practical for such upright forms as posts, columns, and chair legs. In addition, wood is slightly *resilient*, so it is appropriate for floors and furniture; a good *insulator*, it does not get as hot or cold as masonry and metal, nor does it readily transmit heat or cold.

Wood is comparatively expensive in original cost, but it can be maintained with relative ease and lasts a long time. Such woods as cedar, cypress, and redwood survive exposure to weather with little upkeep, making them suitable for exterior walls and outdoor furniture. The original cost of wood walls for interiors exceeds that for plaster walls, but wood requires less frequent maintenance. Hardwood furniture requires relatively little care beyond keeping it from drying out by timely waxing and polishing.

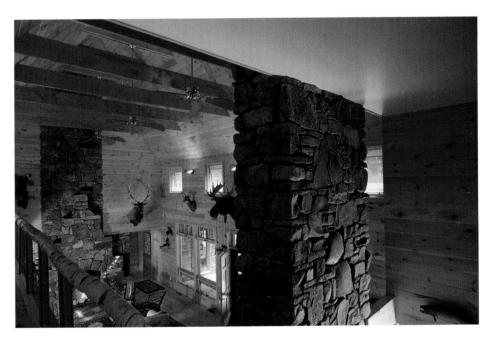

15.1 A rustic vacation home in New York uses local stone for fireplaces, white birch logs for handrails, pine for tongue and groove walls, maple floors, and Douglas fir beams. In the spirit of a hunting lodge, blades for the ceiling fans are miniature fishing rods with stretched canvas. Michael Timchula, architect. (Photograph: Robert Perron)

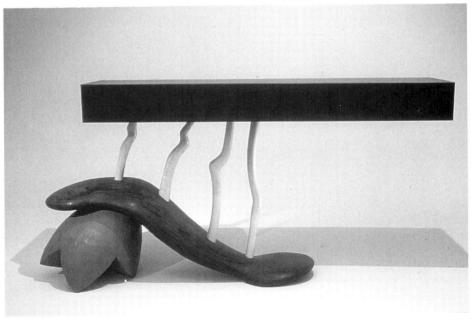

15.2 In its cantilevered construction, Wendell Castle's innovative hall table exploits the tensile strength of mahogany. *(Photograph: Michael Galatis)*

15.3 (right) Wood is both long-lasting and versatile, taking a wide variety of finishes, forms, and end uses. Here wood is the building material for floor and ceiling, furniture, fireplace surround, and window treatment. Finishes range from natural to highly polished, inlaid, painted, and lacquered. Scott Johnson and Margaret Alofsin/ Johnson, Fain & Pereira, architects. *(Photograph: Tim Street-Porter)*

15.4 (below) In a Philadelphia renovation, a red oak floor inlaid with squares of walnut coordinates comfortably with a collection of antique chairs and cabinets and a new dining table designed by Garry Knox Bennett. David Beilman, architect; Richard Dallett, builder. *(Photograph: Matt Wargo)*

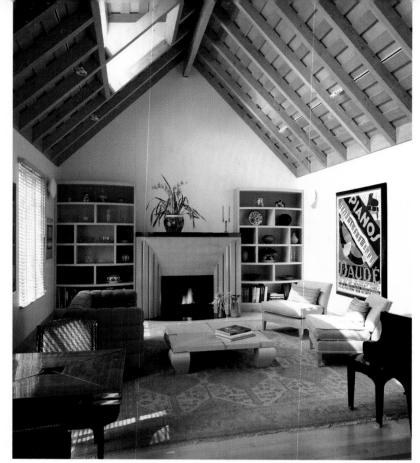

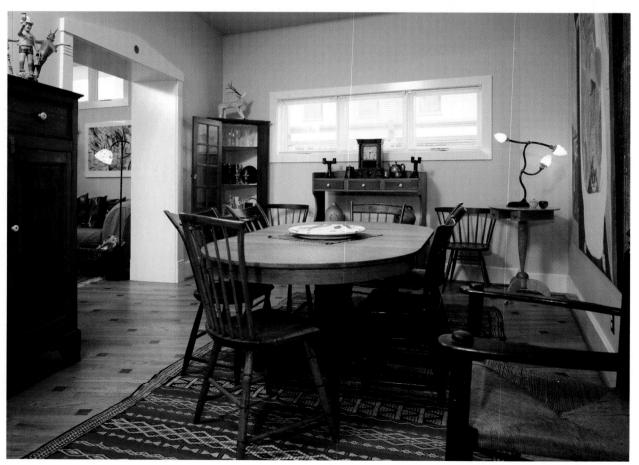

We would enjoy wood for its beauty and character even were it not for its utility and economy. Wood grain and color show a perfect union of variety and unity; no two pieces of wood are identical and yet a powerful, organic unity marks each piece and relates one to the other (Figure 15.4). The rhythms are as subtle and inevitable as those in waves or clouds, ranging from almost parallel linearity to an intricate complexity of curves. Some wood grains are emphatic, others quietly subordinate. Finally, wood is as pleasant to touch and to smell as it is to the eye.

Wood does have several major limitations: it scratches, burns, rots, and decays; insects attack it; and it may swell, shrink, or warp with changes in humidity. Also, as a natural resource, it is finite in quantity. Some woods, particularly the exotic tropical hardwoods (mahogany, ebony, rosewood, teak), are endangered and may become extinct. Responsible designers must be conscious of this serious depletion and the consequent environmental impact of continued use (see Chapter 13). These factors, however, can be minimized to a great extent. Research has disclosed many processes for eliminating the less desirable qualities of wood. Impregnation with plastics, for example, will harden and stabilize wood. Of greatest importance is the judicious farming and management of our forests to ensure a continuing stock, coupled with the consideration of other materials, such as masonry, metal, and plastics, where their qualities can serve to advantage.

FORMS

Wood normally grows in tapering, pole-shaped trunks and branches or vines, such as rattan. Refined in shape, such poles are found in homes as posts and pillars, as legs of tables, chairs, or cabinets, and as lamp bases. However, further refinement is necessary to make the material truly versatile. Trunks and branches can be squared to make beams, or they can be sawed into planks or boards for furniture, floors, ceilings, and wall paneling.

Beyond cutting and sawing, several other possibilities exist for handling wood. Pieces can be glued or **laminated** together to create forms and strength that would

15.5 Furniture designed by Richard Meier expresses clarity of form using the basic linear quality of wood. (*Photograph: Richard Meier & Partners, Architects*)

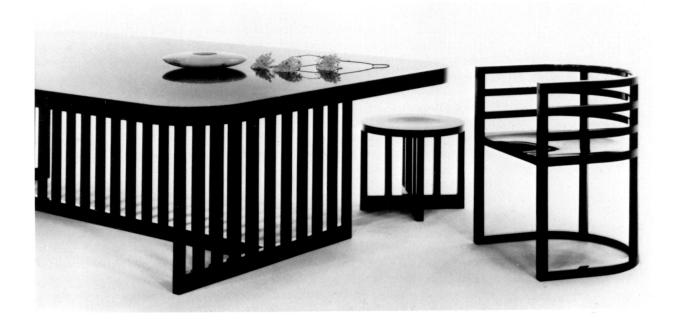

15.6 The Pantonic chair, designed by Verner Panton, is formed from a single piece of plywood into a sculptural, yet functional and ergonomically comfortable seating piece. Its cantilevered form moves when you move. (Courtesy HÁG, Inc.)

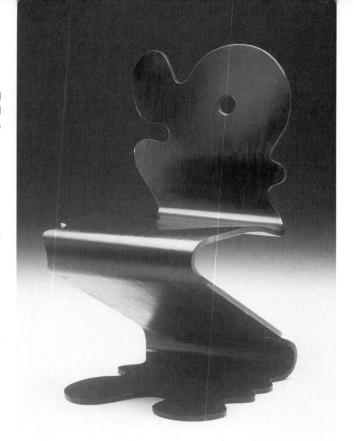

be impossible in straight-sawed lumber. Another method consists of literally "unwrapping" the log by peeling it into thin continuous sheets for veneers and plywood. Wood can also be subjected to heat and bent or molded into curved shapes often seen in chairs. Finally, wood can be ground or split into small pieces, then the fragments pressed and adhered together for particleboard or hardboard. (As discussed in Chapter 13, the outgasing of formaldehyde from particleboard used in building, cabinet, and furniture construction presents a serious environmental hazard. New adhesives need to be developed to alleviate this continuing problem.) In addition, many synthetic fibers depend upon dissolved wood as one component of their mixture.

Wood structure is a complex organization of cellulosic fibers and pores. Concentric annual rings of growth increase the tree's girth; vertical fibers and pores run parallel to the trunk; and medullary rays radiate from the center at right angles to the vertical fibers and pores. When wood is cut, this structure becomes apparent and is called grain and figure. The method of cutting the flitch or portion of log will therefore produce notably different results, often a structural ornament of great beauty. Quarter slicing produces a straight linear stripe figure or edge grain in most woods; plain or flat slicing results in an uneven slash grain from cutting tangential to annual rings; rotary cutting exposes a bold, variegated watery or ripple pattern.

In selecting wood, every piece does not have to be top quality in all respects. Of course, wood must be strong enough to do its job, but for some purposes relatively weak wood suffices. Wood is classified as **hard** if it comes from broadleafed, deciduous trees that drop their leaves in winter, such as maple, oak, birch, and various fruit and nut trees such as cherry or walnut. **Softwood** comes from those trees called evergreens, with needlelike leaves retained throughout the year, such as pine, spruce, fir, cedar, and redwood. In general, the hardwoods are in fact harder, as well as finer in grain, more attractively figured, and more expensive. The more rapidly grown, less costly softwoods shape more easily with typical tools, but they do not take fine finishes and intricate shapes as well.

Hardness offers an advantage when the wood is subject to wear, but may be unnecessary otherwise. Capacity to take a high finish, desirable for the surface of furniture, is not needed for the hidden framework. And beautiful grain and figure provide a rewarding type of indoor ornament that would be wasted outdoors. Table 15.1 lists the significant characteristics of woods often used in homes.

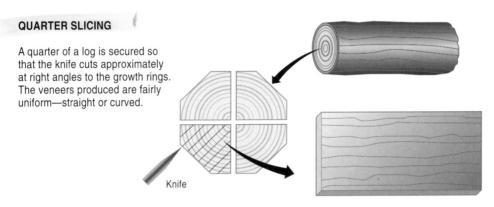

15.7 Quarter slicing, cut at right angles to the growth rings, produces a fairly uniform straight stripe or curved grain pattern.

FLAT (PLAIN) SLICING

A log is sliced parallel to a line through its center. Cuts produce veneers with varying grain patterns and figures.

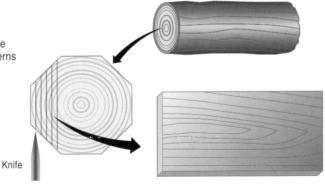

15.8 Plain or flat slicing produces varying grain patterns and figures, resulting from cutting parallel to a line through the center of the log.

ROTARY

A log is secured in a lathe and spun against a sharp knife. The resulting veneer has a predominate grain figure as the cut follows the tree's annular growth rings.

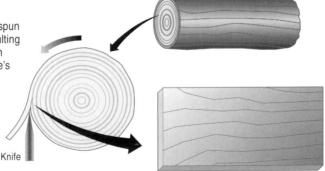

15.9 Rotary slicing follows the annual growth rings, peeling off a very wide veneer with a bold grain figure.

TABLE 15.1

Qualities of Selected Woods

	Source	Color and Grain	Character	Uses
alder (red)	one of few native hardwoods in Pacific Northwest	pleasant light colors from white to pale pinks, browns; close, uniform grain	lightweight, not very strong; resists denting, abrasion; shrinks little; stains well	chairs, other furniture
ash (white)	central and eastern United States; Europe	creamy white to light brown; prominent grain resembling oak; emphatic elliptical figures in plain-sawed or rotary cut	hard, strong; wears well; intermediate to difficult to work; intermediate in warping	furniture frames requiring strength; exposed parts of moderate-priced furniture; cheaper than most durable hardwoods
bamboo	tropical Asia	yellowish tan; treelike grass with smooth, lustrous woody stem up to 6" in diameter	knobby joints, tubular	furniture and many decorative purposes
beech	central and eastern North America; Europe	white or slightly reddish; inconspicuous figure and uniform texture, similar to maple	strong, dense, hard; bends well; warps, shrinks, subject to dry rot; relatively hard to work, but good for turning; polishes well	middle-quality, country- style furniture; good for curved parts, rocker runners, interior parts requiring strength; also floors, utensil handles, woodenware food containers
birch	temperate zones; many species; yellow birch most important	sapwood, white; heartwood, light to dark reddish brown; irregular grain, not obtrusive; uniform surface texture; undulating grain	usually hard, heavy, strong; little shrinking, warping; moderately easy to work; beautiful natural finish; stains, enamels well	plywoods; structural, exposed parts of furniture, usually naturally finished (esp. Scandinavian); can be stained to imitate mahogany, walnut
cedar *	north Pacific coast and mountains of North America	reddish brown to white; close-grained	rather soft, weak, lightweight; easily worked; little shrinkage; resists decay; holds paint; red cedar repels moths	shingles, siding, porch and trellis columns, vertical grain plywood, cabinetwork, interior paneling
cherry	United States, Europe, Asia	light to dark reddish brown; close-grained	strong, durable, moderately hard; carves and polishes well	associated with Early American and Colonial furniture; now often used as a veneer
cypress (southern)	southeastern coast of United States; southern Mississippi Valley	slightly reddish, yellowish brown, or almost black; weathers silvery gray if exposed	moderately strong, light; resists decay; holds paint well	doors, sash, siding, shingles, porch materials; occasionally outdoor furniture
ebony *	Africa, Sri Lanka, India	heartwood black or coffee brown with black streaks, sometimes red or green; close or indistinct grain	dense, hard, heavy; smooth texture takes a high polish	furniture and inlay

^{*} Endangered species

	Source	Color and Grain	Character	Uses
elm	Europe and United States	light grayish brown tinged with red to dark chocolate brown; white sapwood; porous, open, oak-like grain; delicate wavy figure	hard, heavy; difficult to work; shrinks; swells; bends well	somewhat sparingly in furniture; curved parts of provincial types; extensively used now for decorative veneers
fir (Douglas)	Pacific coast of United States	yellow to red to brownish; coarse- grained, irregular wavy patterns, especially in rotary-cut plywood; "busy"	rather soft, quite strong, heavy; tends to check, split; does not sand or paint well	plywood for exterior, interior walls, doors; cabinetwork; interior, exterior trim, large timbers, flooring; low- cost furniture, especially interior parts
gum (red or sweet)	eastern United States to Guatemala	reddish brown; often irregular pigment streaks make striking matched patterns; figure much like Circassian walnut	moderately hard, heavy, strong; tends to shrink, swell, warp; susceptible to decay; easy to work; finishes well	most-used wood for structural parts, with or imitating mahogany, walnut; also exposed as gumwood
mahogany *	Central and South America, Africa	heartwood pale to deep reddish brown; darkens with exposure to light; adjacent parts of surface reflect light differently, giving many effects; small-scale, interlocked, or woven grain; distinctive figures	medium hard, strong; easy to work, carve; shrinks little; beautiful texture; takes high polish; always expensive	most favored wood for fine furniture in 18th century; much used in 19th century; used today in expensive furniture finished naturally, bleached, or stained dark
maple (sugar and black, both called hard)	central and eastern United States, Canada	almost white to light red-brown; small, fine, dense pores; straight- grained or figures (bird's-eye, curly, wavy)	hard, heavy, strong; little shrinking, swelling if well seasoned; hard to work; has luster; takes good polish	Early American furniture; now used as solid wood for sturdy, durable, moderate- priced furniture and hardwood floors
oak (many varieties; two groups: white and red)	all temperate zones	white oaks; pale grayish brown, sometimes tinged red; red oaks; more reddish; both have quite large conspicuous open grains; fancy figures rare	hard, strong; workable, carves well; adaptable to many kinds of finishes	standard wood in Gothic period, Early Renaissance in northern Europe, continuously used in U.S.; suitable for floors, panels, plywood; furniture, solid and veneer
pecan	southern United States, east of Mississippi	sapwood creamy white; heartwood reddish brown often accented with dark streaks; very little figure with small pores, close grain	strong, dense, heavy, durable, hard; easily stained and finished	furniture and veneer
Philippine mahogany (actually red, white Lauan, and Tanguile)	Philippines	straw to deep reddish brown according to species; pales when exposed to light; interlocking grain gives ribbon figure	about as strong as mahogany, less easy to work; greater shrinking, swelling, warping; less durable, harder to polish	extensively used for furniture in past few decades; also plywood wall panels, which should be fireproofed

	Source	Color and Grain	Character	Uses
pine (many varieties similar in character)	all temperate zones	almost white to yellow, red, brown; close-grained	usually soft, light, relatively weak; easy to work; shrinks, swells, warps little; decays in contact with earth; takes oil finish especially well, also paint; knotty pine originally covered with paint	used throughout world—provincial, rustic furniture; in Early Georgian for ease of carving, also paneled walls; often painted or has decorative patterns; used for inexpensive cabinetwork, doors, window frames, structural parts, furniture
poplar	northern United States, Canada	white to yellowish brown; close-grained, relatively uniform texture	moderately soft, weak, lightweight; easy to work; finishes smoothly; stains and paints well	siding; interior, exterior trim; inexpensive furniture, cabinetwork, especially when painted or enameled
rattan	Philippines and Indonesian jungles (dwarf variety from Hong Kong)	light yellowish tan; vine rather than wood, rarely over 2" in diameter	can be bent into curved forms	wicker furniture; peel- cane, naked pole-reed
redwood *	Pacific coast of United States	reddish brown; lightens in strong sun; weathers to gray or blackish; parallel grain in better cuts, contorted in others; decorative burls	moderately strong in large timbers, but soft and splinters easily; resists rot and decay	exterior siding, garden walls, outdoor furniture; some use for interior walls, cabinetwork
rosewood * (several species, grouped because of fragrance)	India, Brazil, Central America	great variation: light to deep reddish brown; irregular black, brown streaks in fanciful curves	hard, durable; takes high polish	used in fine 18th- century furniture— veneers, inlays; 19th- century solid wood.
teak *	Asia (East India, Burma, Siam, Java, and Thailand)	straw yellow to tobacco brown; striped or mottled in pattern	heavy, durable, oily; works and carves well; takes oil finish beautifully	used in Far East, plain or ornately carved furniture; used by Scandinavians for sculptural qualities
Tupelo gum	southeastern United States	pale brownish-gray heartwood merges gradually with white sapwood; lack of luster makes interlocking grain inconspicuous	hard, heavy, strong; good stability; moderately easy to work; tendency to warp	same purposes as red gum, although it is somewhat weaker, softer
walnut (American or black)	central and eastern United States	light to dark chocolate brown, sometimes dark irregular streaks; distinctive, unobtrusive figures of stripes, irregular curves; or also intricate figures	hard, heavy, strong; warps little; moderately easy to work, carve; natural luster; takes good finish	in America from earliest times for good furniture, but espcially in 19th century; now in high-grade furniture, paneling
walnut (Circassian); (also called English, Italian, European, Russian, and so on)	Balkans to Asia Minor, Burma, China, Japan; planted in Europe for wood and nuts	fawn-colored; many conspicuous irregular dark streaks give elaborate figures; butts, burls, crotches add to variety	strong, hard, durable; works, carves well; shrinks, warps little; takes fine polish	in furniture since ancient times; in Italian, French, Spanish Renais- sance; in England (1660– 1720, Queen Anne "age of walnut"); imported for American use
yew	Europe, England, U.S. Pacific Coast, S.W. Canada	white to pale lemon or pink, orange to red brown to rose red; close-grained, fine, compact	hard, resilient; resists dents	cabinetwork, veneer

15.10 Tage Poulsen's settee exposes its solid white oak frame and slats as an attractive design feature. *(Courtesy C. I. Designs)*

Other factors that enter into the choice of wood for specific applications center on whether it is solid or layered; each type has its advantages and possibilities.

SOLID WOOD **Solid wood** is the same throughout and is used primarily for furniture legs, bases, and frames, particularly if these parts are visible. Its advantages include the following:

- The satisfaction that comes from knowing all the wood is the same as the surface.
- The edges of table tops, chair seats, and other pieces do not expose the layer-cake construction of plywood (although these are usually concealed by another strip of plywood covering the edge).
- The wood can be turned or carved.
- The surface can be planed in case of damage, or thoroughly sanded for refinishing, without fear of going through to another wood.
- The surface cannot loosen or peel off (as it may in improperly constructed veneers).

Major disadvantages are high cost and a tendency to warp, shrink, or swell.

LAYERED WOOD **Veneers, plywood,** and **laminated wood** are layered constructions consisting of one or more sheets of thin wood, thicker boards, or even paper.

Veneers. Thin sheets of wood produced by slicing or rotary cutting, veneers can be glued to a core of lesser quality solid wood, plywood, or particleboard, or glued to paper for wall coverings. The term is used to refer specifically to the exterior surfaces that are of fine wood more expensive than that underneath. "Genuine" furniture construction denotes veneered surfaces (particularly wide, flat surfaces of case pieces) over hardwood plywood on all external exposed parts. Veneers may be cut thin enough to be very flexible or up to ½" in thickness. Rotary cutting produces veneers in continuous sheets, making matching of pattern unnecessary; slicing from a flitch produces veneer leaves of varied width for which matching is very important. The veneer leaves are glued to plywood panels, several of which may derive from a single flitch. Various methods of matching

Thin slices of wood

Flexible sheets

Laminated to cores

15.11 (above) Veneers may be used in a variety of forms.

15.12 (above, right) Wood veneer can conform to curves and have grain patterns matched to reinforce direction or shape. Solid zebra wood stairs, slip-matched veneer walls, and a faux sky ceiling emphasize the height of a stair tower in a Florida guest house designed by architect Steven Harris. *(Photograph: Timothy Hursley)*

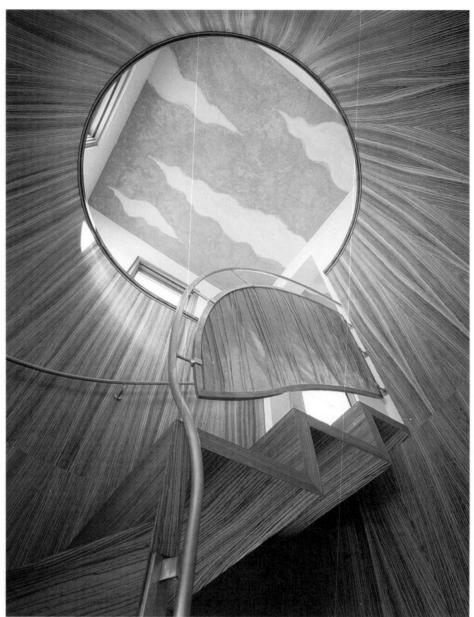

veneers are used to produce different visual effects in grain-pattern. Figure 15.13 illustrates the following veneer matching techniques:

- Book-matched veneers have every other leaf turned over to achieve maximum continuity with matching patterns at joints.
- *Slip-matched veneers* are placed next to one another in sequence, producing a repeated pattern with unmatched edges but greater color conformity.
- End-matched or butt-matched veneers are book-matched both horizontally and vertically for uniform patterns in both directions and very interesting effects on pieces such as table tops. End-matching is also used when the panel height needed

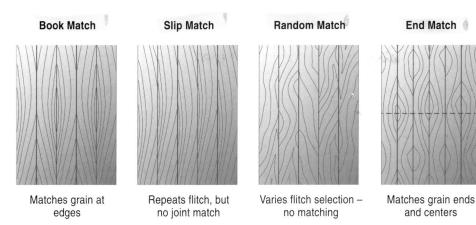

15.13 Veneers cut from wood flitches are glued to panels to produce a variety of patterns.

is greater than the length of veneer available.

• *Random-matched veneers* utilize randomly selected leaves that are unmatched, giving a variation in pattern characteristic of placing solid boards side by side.

Plywood. Lumber-core plywood is composed of a number of plies or sheets glued to either side of a thicker center core of solid wood with the grain of adjacent sheets at right angles to each other; it is suitable for table tops and cabinet doors. Particleboard plywood is similar, but with a thick center core of particleboard or hardboard (a composite of small pieces of wood held together with resin binders) and is common in table or desk tops. Veneer-core plywood, used for paneling or curved shapes, has a center core of veneer and all layers of approximately the same

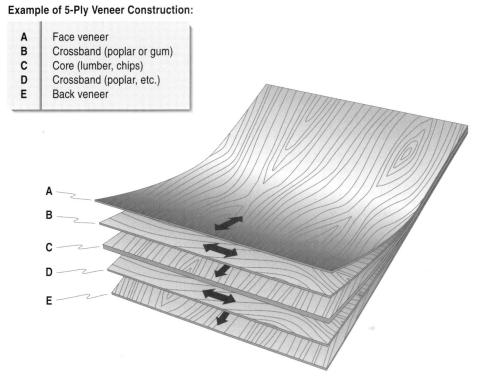

15.14 Five-ply veneer plywood is constructed of layers with the lengthwise grain at right angles to each other.

15.15 (right) The individual layers of laminated wood are separated to ornament the center stretcher of this table designed by Tom Bouschard. *(Courtesy Norman Petersen & Associates)*

15.16 (below) A butcher block countertop mounted on a distressed alder center island is combined with sugar pine reproduction French country cabinets in this remodeled 1870s Victorian home in Highland Park, Illinois. Richard Becker, architect. (Photograph: Howard N. Kaplan)

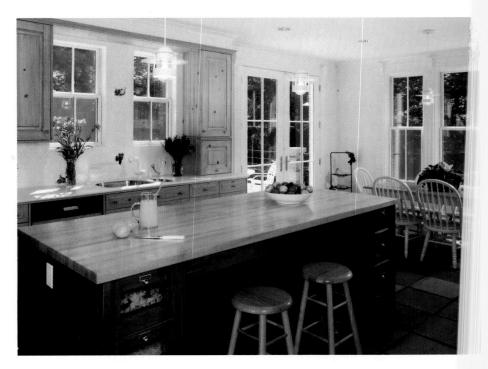

thickness. All plywoods contain an odd number of layers glued together. La range from $^1/8''$ to more than $1^1/8''$ in thickness.

Laminated Wood. A type of plywood in which the grain of successive laruns in the same direction, laminated wood is frequently used for those par furniture that are molded into curved forms and in which the major stresses strains are in one direction. Laminated wood is also used for "butcher block" contents and tables, giving them their distinctive appearance, and for "glubeams seen in many contemporary homes. These beams may be straight or contents of considerable length because laminated wood is very strong.

The popular notion that veneers and plywood are cheap substitutes for real thing is a misconception. To be sure, they are usually less expensive than wood, especially the better grades of hardwood, because the expensive wood much further when used as a veneer. But they also have other advantages:

• They are available in much larger pieces than solid wood. Plywood wall ping, for example, is commonly available in 4' × 8' or 4' × 10' sheets.

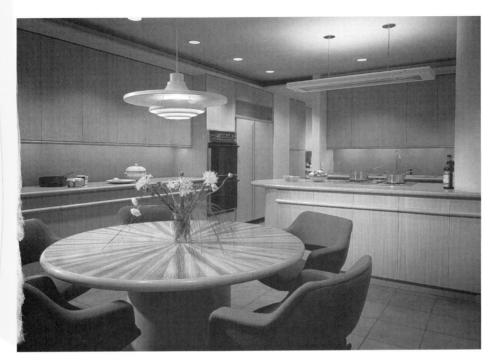

15.17 The inherent pattern of wood grain can be used as ornament in furniture design or wall paneling. Wedge-shaped pieces of zebra wood veener take advantage of a distinctly stripped grain to emphasize the radial qualities of this table. Ian J. Conn, Diversity: Architecture & Design. (Photograph: Paul Warchol)

- Typically they are stronger than solid wood of the same thickness and weight.
- They are less likely than solid wood to shrink, check, or warp.
- They are not as liable to splitting or puncturing by sharp objects as solid wood.
- Almost identical grain on several pieces can be matched to produce symmetrical figures.
- They permit the use of fragile, highly figured wood that, if solid, might split apart or shrink irregularly.
- They lend themselves readily to curved and irregular forms.
- They permit flush surfaces of large size that are dimensionally stable.
- They allow rare and costly woods to be used more extensively.

The disadvantages of veneers and plywood include limited refinishing capability, possible separation and peeling of the layers if improperly constructed or poorly cared for, and occasional visibility of the sandwichlike edge. Some people may also object to not knowing what is underneath the surface finish.

Layered woods open many new design possibilities, such as factory-built wall paneling that speeds the construction of housing and results in a prefinished surface that is attractive in itself. Many pieces of furniture, especially chairs, make optimum use of molded plywood, with compound curves of remarkable strength. Finally, veneers are popular because they enable designers to match grain and figure effects.

ORNAMENTATION

Wood possesses a great diversity of inherent or structural ornament in its grain, figure, texture, and color. Not only does each species of wood have its own general type of pattern, but different aspects of these patterns can be brought to light by the ways in which the wood is cut, as we have seen. In addition to the beauty of typical grains, some woods show amazingly intricate deviations of figures. *Stripes*

and broken stripes, mottles and blisters of irregular, wavy shapes, and fiddleback, raindrop, curly, and bird's eye figures are but a few, to which must be added the figures found in stump and butt wood: crotches, burls, and knots.

TEXTURE Actual surface texture makes a kind of ornament and largely determines the effectiveness of a grain. *Roughly sawn* wood has an uneven, light-diffusing texture that minimizes grain and is not pleasant to touch, so wood designers normally reserve it for exterior work or for pieces that exhibit a rustic character. *Resawn* wood is considerably smoother, with a soft texture not unlike that of a short-pile fabric; it reveals but does not emphasize the grain. *Smoothly finished* wood reflects light, emphasizes the figure, and is pleasant to touch.

COLOR Different woods naturally display an enormous variety of colors, from whitest birch to darkest ebony. A room entirely paneled in redwood, for example, has a warm, mellow quality; knotty pine paneling is also warm but actively patterned. Furniture made of birch has a light, airy character quite different from the usually more formal rosewood. Designers often exploit the contrast of different wood colors in such techniques as inlay and parquetry. Table 15.1 provides color descriptions for many woods, and Figure 15.19 provides samples of color stains available.

15.18 Maple and walnut are combined in the cabinetry to give distinctive character to this kitchen in Presidio Heights in San Francisco. Michael Harris, architect; Paul Vincent Wiseman, interior designer. *(Photograph: John F. Martin)*

METHODS OF JOINING Beyond the need for structural stability, the ways in which different pieces of wood are brought together can create structural design of considerable importance. Beveled edges (cut at an angle) on wall paneling result

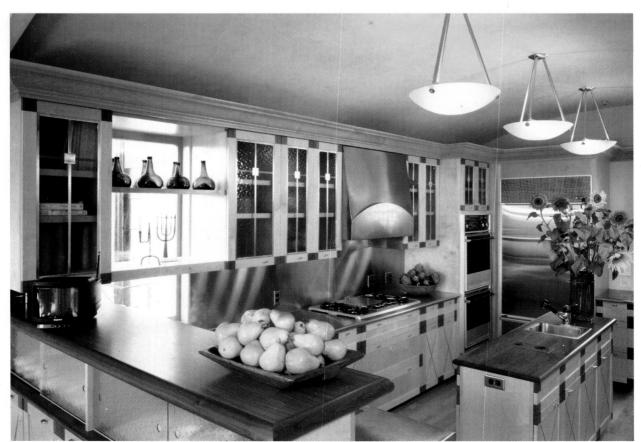

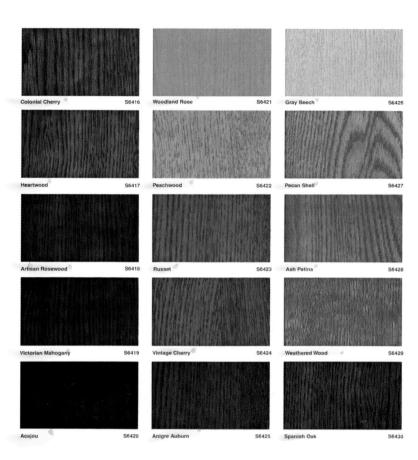

15.19 Wood stain is available in a wide range of colors and various degrees of transparency or opacity. *(Courtesy Sherwin Williams)*

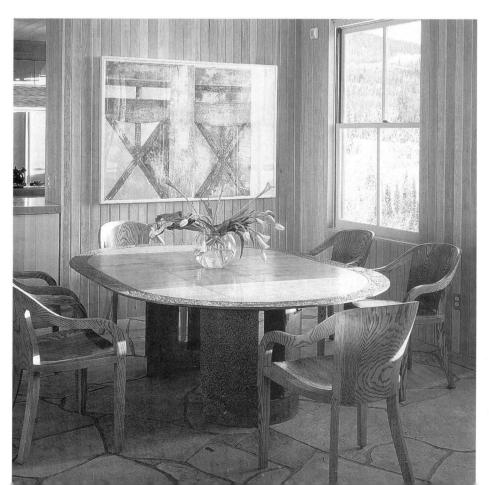

15.20 The wooded setting of a mountain home in Telluride, Colorado, is reflected in the $1'' \times 3''$ cedar paneling with beveled edges, which also enhance the vertical lines, in the heavily grained Ward Bennett chairs, and in a custom-designed wood table top. The flagstone floor contributes to the natural theme. Solomon Architects; Terry Hunziker, designer. *(Photograph: Mark Darley/ESTO)*

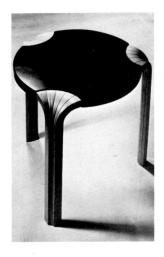

15.21 (above) Alvar Aalto's 1954 fan-legged table-stool eloquently expresses structure in the joining of legs and top. (Courtesy ICF Inc.)

15.22 (top, right) "Swan House," or the Edward Inman House, was completed in 1928 in Atlanta, Georgia. Lindenwood moldings give definition to the pickled pine library paneling; H.J. Millard handcarved the ornament above the door; and the molding pieces around the fireplace were purchased in England. The cornice molding is actually plaster, painted to match the lindenwood. This home is now part of the Atlanta Historical Society. Philip Trammell Schutze, architect. (*Photograph: Timothy Hursley*)

15.23 (bottom, right) Although the interior of this early 1900s shingle style cottage was completely gutted during remodeling, the baseboard inspired the layered detail for the window frames. It was painted white so that it would not stop the eye short of the view. Lyman Goff, architect; Cohen Design, interior design. *(Photograph: Karen Bussolini)*

in a rhythmic pattern of subtle light and shadow around a room; the joining of horizontal to vertical members in a piece of furniture can be emphasized as design features by the way they are joined. (Types of joining for paneling and furniture construction are illustrated in Chapters 18 and 22.)

MOLDINGS Applied, narrow strips of wood that project from the surface of walls or ceilings are called **moldings.** Their popularity declined in modern interiors with emphasis on simplicity and clean lines, but they are used in all period rooms and have regained favor in post-modern design. In practical terms, wall moldings can help maintain the home, since they prevent furniture from rubbing against the wall proper. They can also emphasize direction or set up a pattern of their own that must be acknowledged when placing furniture, wall ornaments, or fixtures. Often they frame such elements as paintings to separate them from their background and form transitions between planes, as in elaborate *crown*, *cornice*, and *cove* moldings that relate walls to ceilings. *Baseboard* moldings finish walls where

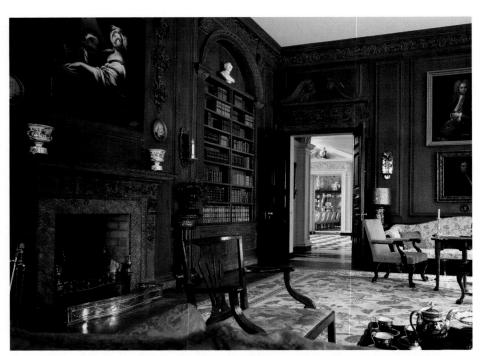

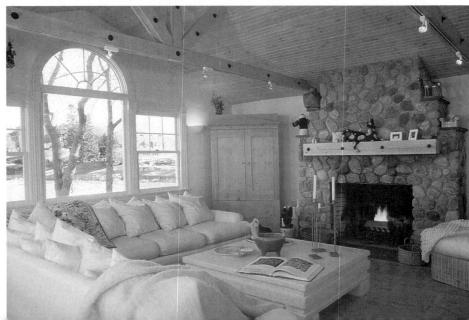

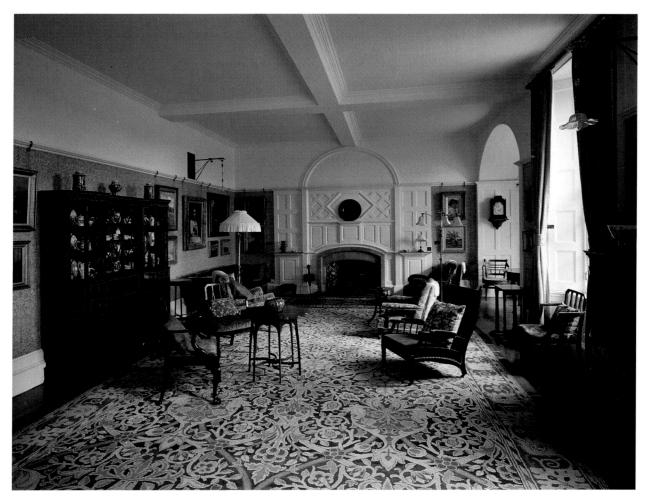

they meet the floor, serving also to protect the wall from being marred during cleaning. (Moldings of this type, when not made of wood, are simply referred to as bases or base moldings.) A *chair rail* is placed on the wall at the height of a chair back, usually 30 to 36 inches, to protect the wall. *Picture moldings*, placed just below or several inches below the ceiling, provide a continuous support around the walls of a room from which to hang pictures without damaging the walls. (Of course, the picture wires show.) Moldings were important protective elements in times when walls were surfaced with plaster which was susceptible to chipping, cracking, and water damage when floors were mopped. Today moldings are used for their aesthetic qualities in finishing edges and corners or emphasizing linear aspects or proportions of walls. Many moldings are made of a variety of materials in addition to wood; metal and polymer are two which can be fire rated for commercial installations.

CARVING AND TURNING The nature of wood has suggested **carving** from earliest days in all parts of the world, and the great periods of furniture are known as much for their carving as for their more basic qualities of design. Gothic carving in oak, Renaissance carving in walnut, and eighteenth-century carving in mahogany effectively enhanced form. **Turning** is also an old art, and ever since the lathe was invented we have enjoyed the many diverse ways in which a rapidly rotating piece of wood can be shaped for furniture parts, balusters, columns, and

15.24 Drawing room in historic house, Standen, Sussex, England. Picture moldings served a convenient function and saved piercing holes in lath and plaster walls before the advent of drywall. It was also often used, as seen here, to effect a change in wall treatment that helps large rooms seem cozier. (Photograph: A.F. Kersting)

utensils. Designers of almost every period produced turnings with distinctive profiles, such as the sixteenth-century melon bulbs, the seventeenth-century balls or sausages, and the spool, the bead and ball, the knob, the vase, and composite types that were popular in many countries at various times.

Elaborate turning and carving of high quality are rare but not unknown in contemporary design. They require much time and skill to produce and can in-

15.25 (below) Heavily carved furniture, made in 1840 by the Galusha Brothers of Troy, New York, is at home in Waverly Plantation, an antebellum home built in 1852 in West Point, Mississippi, and now a National Historic Landmark. It was restored in 1962 by the Snow family. *(Photograph: Scott Frances/ESTO)*

15.26 (right) A victorian residence in Chicago illustrates the art of turning in the newel post and balustrade of the entry hall stairway. (*Photograph: Howard N. Kaplan*)

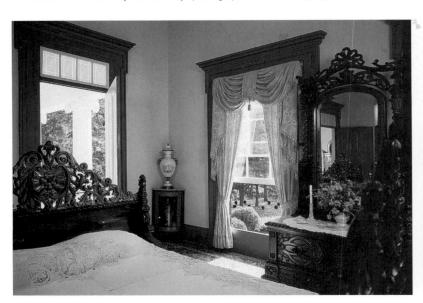

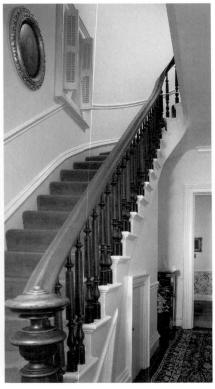

15.27 (right) A Leopold Bauer sofa with a simple but distinctive marquetry pattern graces the Chicago apartment of two collectors of art and early 20th century European furniture, including a French Deco area rug and Josef Hoffmann tables. Marvin Herman, architect; Bruce Gregga, ASID, interior designer. (Photograph: Adam Bartos)

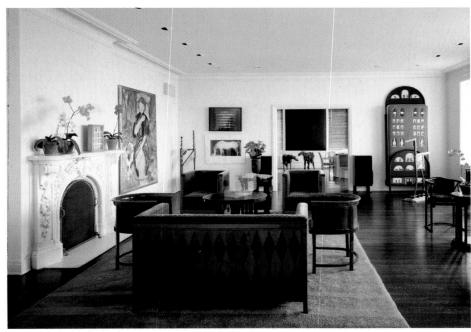

crease household maintenance noticeably. But beautifully carved elements offer wonderful decorative accents for otherwise clean-lined designs.

PIECED DESIGN IN WOOD Inlay, intarsia, marquetry, and parquetry are techniques that combine different woods—or sometimes metals, ivory, shell, and other materials—in such a way that the contrasting colors and textures make patterns in a plane surface.

- Inlay is a general term that has come to encompass all the various methods of
 excising shapes and inserting, flush with the surface, different materials for ornamentation.
- Intarsia refers to that type of incised work employed in the Italian Renaissance in which the pieces are inlaid in solid wood, somewhat like a mosaic using shell, bone, and ivory insets.
- Marquetry applies to intricate designs inlaid in hardwood veneers like puzzle pieces and then glued to a solid backing.
- Parquetry indicates strips of wood laid in geometric patterns and glued to a solid ground, especially in floors and tables.

Contemporary taste has moved away from the austerity often associated with modern design, but there is still very little complex applied wood ornamentation of good quality. Design in wood today covers a wide range, from the simple contrast of putting old, ornate furniture in a contemporary setting to the exploration of concentrated enrichment suited to our own age. Many designers are working with sculptural form in wood that is pleasing when seen from any angle and that combines comfort and convenience with sensuous delight and lyricism.

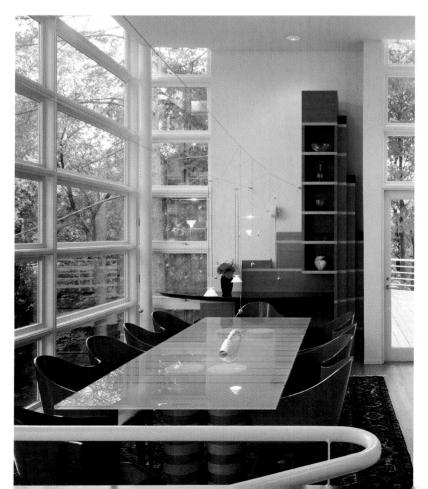

15.28 Contemporary design in wood may borrow from the past or be completely new and innovative, or combine the two approaches. Kenneth Neumann designed the breakfront, dining table, and chairs for a contemporary home in suburban Detroit, using bird's eye maple, mahogany, and ebony. The breakfront has a marble surface; the tabletop is ¾" etched glass. Traditional hardwood floors are natural oak, and window and door casings are unobtrusively painted white. Neumann-Smith & Associates, architects. (Photograph: Timothy Hursley)

15.29 Often the same piece of furniture is available in a number of finishes, some revealing the natural wood grain, others covering it. Each gives a different quality to the piece. (*The Richard Meier Collection, Richard Meier & Partners, architects*)

FINISHES

Anything done to a freshly sanded piece of wood takes away some of its pristine satiny beauty—but that beauty will soon disappear if no finish whatsoever is put on it. Most woods need some protective finish to keep the surface from absorbing dirt and stains; to give an easy-to-clean smoothness; to minimize excessive or sudden changes in moisture content; to protect the wood from rot, decay, and insects; and to prevent wood from drying out by replacing lost oils. An appropriate finish might enhance the grain with oil, change the color with stain, or hide an unattractive color and grain with opaque paint. Table 15.2 lists the typical wood finishes and their characteristics. Some finishes, such as lacquer, are being eliminated by many manufacturers today because of new regulations regarding environmental hazards.

Finishes can penetrate or stay on the surface; they can be transparent and colorless, transparent but colored, semiopaque, or opaque; and they can vary from a dull matte to a high gloss. To say that any one of these finishes is better than the others, except for a specific purpose, would be pointless. Many people like to see wood changed as little as is compatible with its use and therefore prefer transparent, colorless, satin finishes. On the other hand, extremely durable, opaque finishes are becoming popular for certain applications. The following general principles may serve as guidelines in choosing the best finish for a particular wood and purpose:

- **Opaque** finishes hide the wood character, give a smooth uniformity, and offer great possibilities for color with *stains*, *paints*, and pigmented *lacquer*.
- Transparent finishes reveal the character of the wood and absorb minor damage that comes with use. Varnish and lacquer protect wood from stains and moisture damage.
- **Penetrating** finishes, such as linseed oil, produce a soft surface that may absorb stains but will not chip or crack.
- Plastic-impregnated finishes harden wood, give it greater density and strength, and can make it almost totally impervious to damage although the natural texture and aroma of the wood are lost.
- Glossy finishes reflect more light than matte ones, are more durable because of their hard, dense surface, and facilitate cleaning, but they also show blemishes more readily. Gloss can be reduced by adding thinner to the paint or by rubbing with sandpaper, steel wool, or pumice. The shine also dulls with age and use.

15.30 Duo Dickinson designed this unique "'57 Chevy" platform bed with lacquered sides and drawers and magenta-colored polyester resin shelves/steps. (Photograph: Mick Hales)

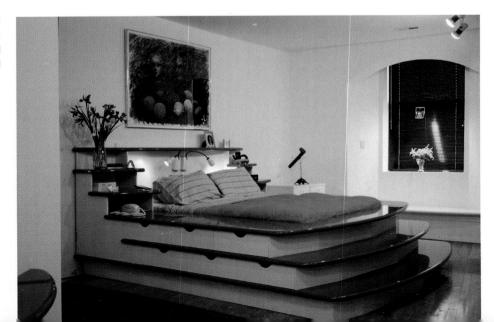

TABLE 15.2

Wood Finishes

	Composition	Application	Result	Use
bleach	various acids, chlorine compounds	brushed on	lightens wood, neutralizes color, usually makes grain less conspicuous; not dependably permanent; wood loses some luster	to make furniture and wood paneling pale, blond; also used on out- door furniture to give a weathered look
enamel	varnish mixed with pig- ments to give color, opaqueness	brushed or sprayed over un- dercoat since it has less body and covering power than most paints	generally hard, durable coat, like varnish; usually glossy, may be dull; wide range of col- ors	chiefly on furniture, cabinets, walls getting hard use and washing; also on floors
lacquer	cellulose derivatives, con- sisting of resins, one or more gums, volatile sol- vents, a softener, and a pigment (if colored)	regular lacquer best applied with spray since it dries rapidly (15 min.); brushing lacquers dry slowly, make brush application feasible	hard, tough, durable; resistant to heat, acids; not suitable for outdoor wood because of ex- pansion, contraction; glossy, satiny, or dull	transparent lacquers much used on furniture, walls; opaque on furni- ture
oil	boiled linseed oil or vari- ous other oils; usually thinned with turpentine	brushed or wiped on, excess wiped off, allowed to dry, sanded or rubbed; between five and thirty coats—more the better; hot oil sinks into wood, brings out grain	penetrating, very durable finish with soft luster; darkens and yellows wood somewhat at first, considerably in time; pro- tective, not conspicuous; must be renewed	oil, often mixed with beeswax, used in Eu- rope from early times to 17th century; now used on indoor and outdoor furniture
paint	pigments suspended in linseed oil or, more com- monly now, in various synthetics and water; usu- ally contain a drier to hasten hardening	brushed, rolled, or sprayed on	opaque coating, varies from hard, durable gloss to softer dull finishes; hides character of wood; new types dry quickly with little odor, are easy to ap- ply and have good covering power	protects and embell- ishes; painted furniture popular in ancient Egypt, the Orient, Eu- rope since Middle Ages; much Colonial furniture was painted; widely used now on walls and furniture
shellac	resinous secretion of an insect of southern Asia, dissolved in alcohol	brushed, rubbed, or sprayed on; dries rapidly; many thin coats, each rubbed, gives best finish	changes character and color of wood very little; soft satiny to high gloss finish; fragile; wears poorly; affected by heat, mosi- ture; water spots	primarily as an easily applied, quick-drying undercoat
stain	dye or pigment dissolved or suspended in oil or water	brushed, sprayed, or rubbed on	changes color of wood without covering grain (often empha- sizes grain or changes surface noticeably); usually darkens wood to make look richer	used to alter color of furniture woods thought unattractive, or in imi- tation of expensive woods; outdoors com- pensates for weathering
syn- thetics	wide range of polyester, polyurethane, polyamide, vinyl; liquid or film; newest type finish; con- tinuing new develop- ments	usually factory-applied; <i>liquid</i> impregnates wood; <i>sprays</i> form a coating; <i>film</i> , typically colored, is bonded to wood with laminating adhesive	durable, long-lasting finish; resistant to abrasion, mars, chemicals, water, or burns; clear or colored, mat to glossy surface; film type difficult to repair	walls, floors, furniture; very good wherever abrasion, mositure, or weathering is a problem
varnish	various gums, resins dis- solved in drying oils (lin- seed, tung, or synthetic), usually combined with other driers; dye or pig- ment makes varnish-stain	brushed or sprayed on; many thin coats best; dries slowly or quickly, depending on kind, amount of thinner used	thin, durable, brownish skin coating, little penetration; darkens wood, emphasizes grain; dull mat to high gloss; best when not thick, gummy	known by ancients; not used again until mid- 18th century; widely used today on furniture, floors, walls
wax	fatty acids from animal, vegetable, mineral sources combined with alcohols; usually paste or liquid; varies greatly in hardness, durability	brushed, sprayed, or rubbed on, usually several coats; of- ten used over oil, shellac, varnish, but may be used alone	penetrates raw wood; darkens, enriches, emphasizes grain; soft to high luster; must be re- newed often; may show water spots and make floor slippery; other finishes cannot be used	very old way of finishing wood; generally used today as easily renewed surface over more durable undercoats; some liquid waxes used alone on walls, floors, furniture

- **Distressed** finishes are artificially aged by gouging and denting with chains or spraying to imitate wormholes and flyspecks.
- Antiqued finishes are also artificially aged with paint or stain applied in layers with the surface rubbed off to produce an effect of aged *patina* (a soft sheen, color, and texture produced by age, use, and care).
- Bleached finishes lighten the natural wood color.
- Many coats of any finish, sanded or rubbed between coats, give a more durable, attractive result than one or two coats applied thickly.

More than any other material, wood ties the house together structurally and visually. It remains one of our most useful, beautiful resources and has more than held its own in spite of the great advances in plastics, glass, and metal. As much as we admire other materials, few of them arouse the deep responses that wood generates. Metal and plastic, for example, can never replace the warmth, texture, and aroma of wood although they have other appealing attributes.

15.31 In his own apartment in an 1898 building on Manhattan's Upper East Side, Architect Alfredo De Vido used painted pine trim and pilasters and pickled white oak furniture he designed himself. (*Photograph: Frederick Charles*)

MASONRY

Strictly speaking, masonry is defined as anything constructed of such materials as stone, brick, or tiles that are put together, usually with mortar, by a mason. Today, however, the term also includes plastering and concrete construction. The

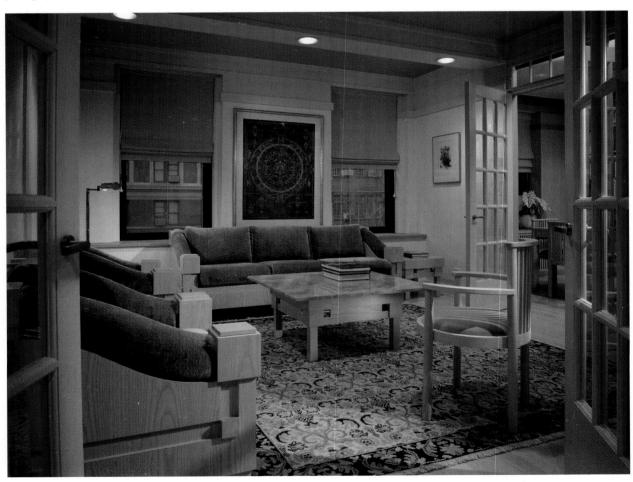

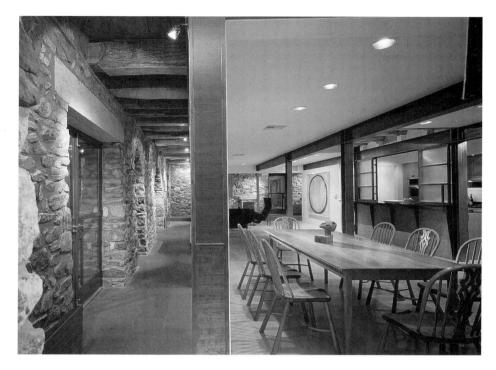

15.32 A stone barn, built in 1820 in Pennsylvania, has 20"-thick walls and hand-hewn oak timbers at floor and roof. Both were retained when the barn underwent an adaptive reuse rehabilitation into a modern home. William Leddy, partner in charge/ Tanner Leddy Maytum Stacy Architects. *(Photograph: Paul Warchol)*

materials of masonry are derived from inorganic mineral compounds in the earth's surface. They are of crystalline structure and typically hard, dense, and heavy.

Masonry materials offer numerous advantages. They do not support combustion, rot, or decay; nor do they invite insects or rodents. Most of them are long-lasting, require little maintenance, and retain their shape under great pressure. Their colors and textures range from smooth white plaster, through an almost limitless range of colors and patterns in tile, to abrasive black lava rock. They can be shaped with rectangular solidity or curved buoyancy; some are left plain and simple, others laid in complex patterns. Above all, a timeless quality—the seeming imperviousness to destruction—makes us feel secure.

These properties explain why most historic architecture still in existence is of masonry. Best known are the large religious or public buildings, but throughout the world thousands of unpretentious houses of stone and brick still stand. The essence of historic masonry construction (with the exception of Roman work in concrete) was the piling of blocks on top of one another and usually joining them with mortar. Because such walls must be very thick and rest on solid foundations, they did not allow large unobstructed openings (unless they were arches), and they offered no space for the pipes and wires now so essential. Thus, solid masonry construction is seldom used today for an entire structure, but may still serve one or more walls of a home, often a fireplace wall. Tile is used extensively as a wall, floor, or countertop finish surface, and many houses and high-rise apartment buildings have concrete floors that are then covered with wood or vinyl flooring or wall-to-wall carpet.

In the nineteenth and twentieth centuries, many new methods and materials for masonry construction have been developed: steel reinforcement to decrease weight and bulk while adding tensile strength, hollow blocks of brick or concrete, and thin-shelled concrete structures. In the latter part of the twentieth century, another use of masonry has appeared, brought about by the interest in solar energy. Rocks, concrete, brick, and tile absorb heat slowly and release it slowly. Thus, a rock wall or a concrete floor can be designed to act as a passive heat trap during the day and a passive radiant heater at night (see Chapter 13).

15.33 An old mill in Bucks County, Pennsylvania, has a rubble masonry wall and rough-hewn beams that contrast with a rather formal tile floor and traditional furnishings. The whole achieves a gracious "country" look. (Photograph: John T. Hill)

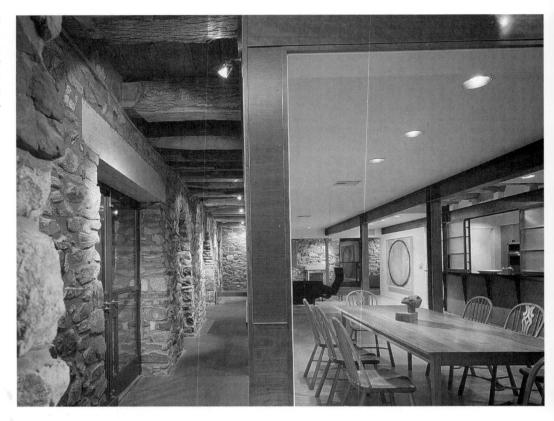

Masonry has its limitations, including high original cost for some types. Although comparatively permanent, plaster and stucco crack, as do tile and marble; concrete blocks chip, and the softer stones disintegrate more rapidly than might be expected. All are difficult to repair. In comparison with wood or metal, masonry is not very strong in tension. Further, most masonry offers fairly poor insulation against cold and dampness, most types reflect rather than absorb noise, and many masonry surfaces are slippery when given a smooth finish.

BLOCK MATERIALS

Stone, bricks, tiles, and concrete or glass blocks—block materials—are delivered to a building site in their finished form and assembled on the job with mortar. Block masonry further subdivides into three basic types:

- Rubble masonry, rugged and informal, has untrimmed or only slightly trimmed stones laid irregularly (Figure 15.33). It is generally the least costly and least formal kind of stonework.
- Random ashlar masonry is more disciplined but still rustic. The stones will be more or less rectangular but will vary in size. Usually it gives a decided feeling of horizontality, even though the joints are not continuous.
- Ashlar masonry calls for precisely cut rectangular stones or bricks laid with continuous horizontal joints. It tends to have a more formal quality and is the most expensive type of stonework.

Stone. Stone has so many desirable qualities that it would undoubtedly be used more widely if it were not so expensive. Because of its resistance to fire, most stone seems naturally associated with walls and fireplaces. Belonging to the earth,

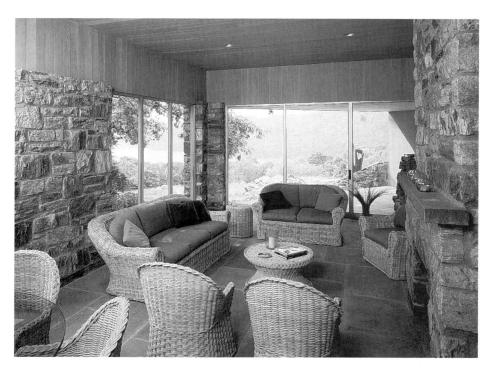

15.34 Fieldstone walls laid in a random ashlar pattern combine with a tongue-and-groove cedar ceiling, natural slate flooring, and natural wicker furniture in the remodeled sunroom of a 50-year-old home in Westchester, New York. Myron Goldfinger, FAIA, architect. *(Photograph: Norman Mc-Grath)*

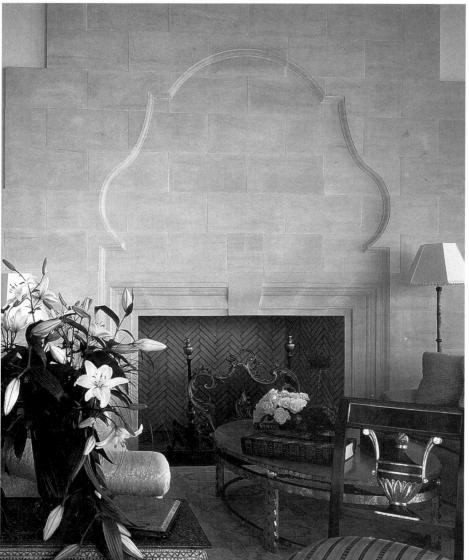

15.35 Robert A.M. Stern designed an elaborate frame-withina-frame baroque-curved mantelpiece of French limestone in ashlar formation for a Meditteranean-style summer villa on the New Jersey coast. A Rococo firescreen matches the curved silhouette. (*Photograph: Timothy Hursley*)

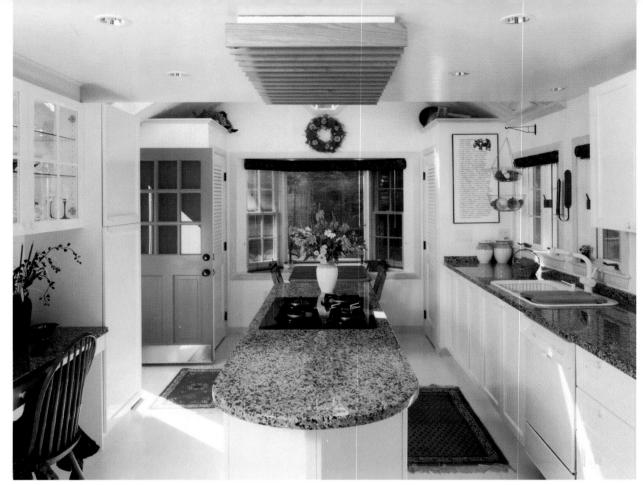

15.36 (above) Pink granite countertops cued the color for the door in this remodeled and enlarged kitchen. White-painted maple cabinets and a white ceramic tile floor allow the polished countertops to predominate. David Corbin, architect. (Photograph: Howard N. Kaplan)

15.37 (right) Faux marble columns have been painted to match the inset pattern in the Rosa Portas marble floor in a 5,000-square-foot, five-story converted brownstone residence overlooking the East River in Manhattan. Richard Blinder/Beyer Blinder Belle, architect; Janet LeRoy, interior designer. (*Photograph: Frederick Charles*)

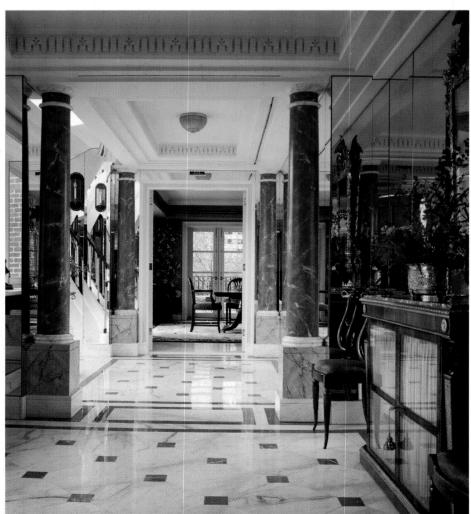

it has a natural application in floors that are subject to hard use. Absorbing heat and releasing it slowly makes it ideal as a solar heating mass. Its permanence gives walls a uniquely reassuring character. Wherever stone is used, its crystalline structure, varied colors and textures, and differing degrees of opaqueness and translucency provide a very special visual and tactile appeal.

Although innumerable kinds of stone could be adapted to homes, four are commonly seen today:

- Granite, an igneous rock composed of feldspar, quartz, and various minerals, is dense, hard, and fine- to coarse-grained. Available in light to dark grays, pinks, greens, yellows, browns, and blacks, it can take a high polish (or be left dull) and be precision-cut for use in furniture pieces (usually tables) or on countertops. Granite is often used in its natural state for walls and fireplaces and as a solar heat mass.
- **Limestone**, which includes various sedimentary rocks, is relatively soft and easy to cut. Colors range from almost white to dark grays and tans. Its most common use is in fireplace walls and, as *travertine*, (without its holes filled) in table tops.
- Marble, a compact crystalline limestone, takes a beautiful polish, is often variegated, and comes in white, grays, pinks and reds, greens, and black. Contemporary designers, searching for structurally ornamented materials, have found it a handsome substance for fireplaces, table tops, and countertops. Terrazzo, a smoothly polished composite material of marble chips mixed with a cement mortar, may be poured as a solid sheet flooring, divided into areas with decorative strips between, or made into tiles. It offers a wide choice of color and textural effects as well as making good use of otherwise wasted material.
- **Slate**, a sedimentary rock that splits easily into thin sheets with smooth surfaces, makes good flooring or table tops. In addition to the typical bluish-gray, slate is available in green, red, or black.

15.38 A Pennsylvania bluestone floor and bar top act as heat sinks in this sunroom addition to a home in Connecticut. Peter Kurt Woerner, FAIA, architect. (Photograph: Karen Bussolini)

15.39 Brick floors are laid with individual bricks "locked" in place by fine grains of sand sprinkled between them rather than mortar in this modern adobe home in Nevada. Maurice J. Nespor & Associates, architects; Diana Cunningham, interior designer. *(Photograph: Maurice Nespor)*

Brick. Among the oldest of artificial building materials, brick is still much in favor because, in addition to having the assets of masonry, it can be made by hand or machine from clays found almost everywhere. Brick weighs less than stone, an important factor in shipping and laying. Because of their relatively small size, bricks can be laid up around a hollow core or simply as a facing on one side of a wall, which leaves room for pipes and wiring and still forms a reasonably thin wall. Bricks are made in many sizes, shapes, colors, and textures, and they can be laid in a number of patterns. Being fireproof, weather-resistant, and easy to maintain, they have long been a popular material for fireplaces and their surrounding walls and hearths. They are also increasingly used as flooring in solar rooms where an informal or country effect is desired. No matter where they appear, bricks introduce an orderly rhythmic pattern of a scale suitable for homes. They are particularly effective in large, comparatively simple masses. Their chief drawback is cost. Also, when used as a structural material in areas which are prone to earthquakes, bricks need reinforcement bars to provide strength and stability.

Typical **clay bricks** are blocks of clay hardened by heat in a kiln. A standard size is $2^{1/4''} \times 4'' \times 8^{1/4''}$, but the dimensions can vary considerably. Although *brick red* is a common designation, colors range from almost white, pale yellow, and pink, through oranges and reds to browns and purples. Their somewhat rough, uneven texture hides dirt and stains, but at the same time they can be difficult to clean when such soil is apparent. Brick can be sealed with polyurethane to prevent absorption of stains. On the basis of texture, as well as resistance to breakage, moisture, and fire, clay bricks are conventionally divided into several types:

- Common or sand-struck bricks, made in a mold coated with dry sand, have slightly rounded edges and are used for exposed side walls or as a base for better-quality bricks.
- Face bricks, generally formed by forcing clay through a rectangular die and cutting it with wire, have sharp edges and corners; they are more uniform in color and texture, as well as more resistant to weather than common bricks.

- Paving or flooring bricks (called "pavers") are still harder, because they have been fired at higher temperatures to withstand abrasion and to lessen absorption of moisture.
- **Firebricks** are most often yellow. They make an ideal material for places subject to great heat, such as the lining of fireplaces.
- Glazed bricks, with one surface finished with a hard ceramic glaze, are more
 impervious to stains and are available in a wider range of colors than are other
 bricks.
- Adobe brick differs from clay brick in that the clay is generally combined with a cement or asphalt stabilizer and dried in the sun. Builders in the warm, dry parts of the world have employed adobe brick for centuries, and the material has come back in favor in the southwestern United States.

Tile. Like clay and adobe bricks, ceramic tiles consist of heat-hardened clay, but they are thinner than bricks and more often glazed. They are used essentially as a surface finish rather than a structural material.

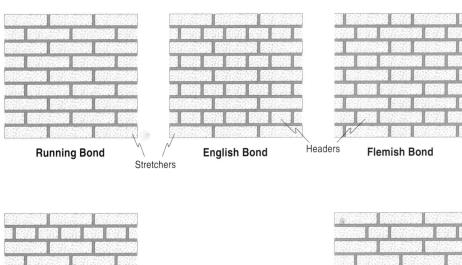

15.40 Common brick bonds.

- Mosaic tiles, usually 1" to 2" square and \(^{1}/_4\)" to \(^{3}/_8\)" thick, are available in innumerable colors, often back- or face-mounted on mesh or paper, or even produced on preset sheets for ease of installation. They can, however, be hand-laid in creative designs of any complexity on walls, countertops, or floors.
- Wall or floor tiles are somewhat larger in size (often 4¹/₄" square), usually heavily glazed with a wide range of finishes—shiny, smooth, matte, or rough—to withstand hard use. They are also available unglazed and in a rainbow of colors, either plain or patterned. These tiles are often used on countertops and backsplashes as well as walls and floors. Wall tiles are generally thinner (¹/₄" to ¹/₂") than floor tiles which are also heavier; however, many are interchangeable in use. *Paver* tiles are more than 6" square.
- Quarry tiles, made of clay and graded shale, have a smaller range of natural colors in customarily unglazed versions, but can also be glazed in almost any color.
 The color, ranging from typical terra cotta red to warm beiges, may be solid,

15.41 A variety of glass and porcelain tile sizes and colors have been imaginatively combined in a guest house bathroom in Florida. Steven Harris & Associates, architects; Lucien Rees-Roberts, tile work designer. (Photograph: Timothy Hursley)

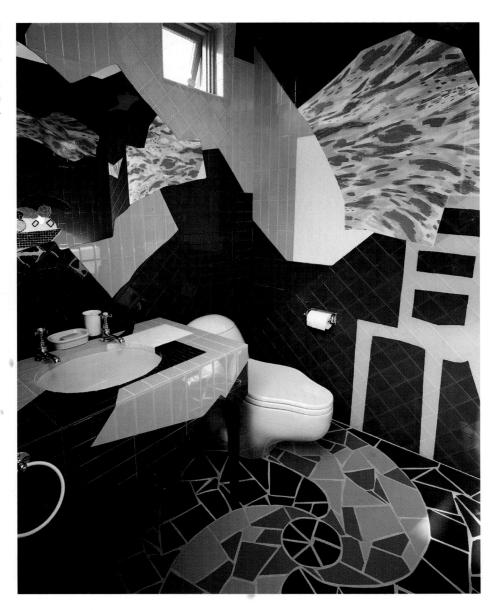

15.42 Mexican quarry tiles link indoors and out and function as a heat-storage mass in this sunspace. Gus Dudley, designer. (Photograph: © Karen Bussolini)

variegated, or *flashed*, with the edges darker than the center. In size they range from 4" to 9" squares to interlocking shapes (often hexagonal) that create quiet patterns on the floor. Quarry tile is ½" thick and may have a grit surface for slip resistance.

- Mexican tiles are shaped by hand from clay taken directly from the ground and allowed to dry in the sun before being kiln fired. They are uneven in thickness and may have imperfections, both of which add to their character and charm. Mexican tile is fragile and very porous, needing a surface treatment of linseed oil or paste wax to prevent staining and give greater durability.
- Porcelain tiles are fired at high temperature, causing the high grade ceramic material to vitrify, making it impervious and therefore appropriate for use in heavy traffic commercial and retail settings. Porcelain tile is usually light in color.

Ceramic tiles have long been a favorite way of introducing into the home color and pattern combined with durability. Glazed-tile kitchen and bathroom counters and walls are practically impervious to water and are easily cleaned. Floor tiles in various configurations and patterns are also easily swept and mopped. The chief disadvantage of tile floors, which they share with all masonry floors, is that they may seem hard and cold, but they can act as a mass dispenser of heat once they have been warmed. Smooth slippery finishes are potential safety hazards for all masonry materials, particularly when wet. Tile may be given a rough or matte (dull) finish for greater safety in areas such as bathrooms. The cement or grout, which is more porous than most tile, should be sealed so that it does not stain or

15.43 (above) Architect Antoine Predock designed this modern concrete block home for a steep site in Paradise Valley, Arizona. The red-painted steel "party bridge" shelters the home's entry while fixed steel grilles shade windows from the hot desert sun. The concrete block also aids in keeping the house cool. *(Photograph: Timothy Hursley)*

15.44 (right) A glass brick shower enclosure creates a polished sculptural form as an extension of the main master bath in a Manhattan triplex penthouse apartment. Steven Forman and Sandra Forman, architects. (Photograph: Paul Warchol)

discolor. In areas of heavy use, such as sink surrounds, grout will need to be replaced and resealed because it tends to wear away. The hardness and noise reflection of tile, however, cannot be mitigated. When ordering, two percent extra will allow for breakage and replacement with exact color match.

Concrete Blocks. Concrete blocks, today usually lightweight aggregate blocks made with such porous materials as cinders, pumice, or volcanic ash, are larger than bricks, typical sizes being $8'' \times 8'' \times 16''$ and $4'' \times 8'' \times 16''$. Consequently, they can be laid quite rapidly. Their porosity and hollow cores provide some insulation against heat and cold and also absorb noise. Moreover, the hollow cores provide a natural space through which utilities can be threaded. They are available in a narrow range of colors, tending toward very light pinks, greens, yellows, and grays, and need no treatment other than waterproofing, although they can be painted, plastered, or stuccoed.

Glass Blocks. Hollow blocks of glass that can be set together in mortar are produced in many sizes and shapes. Different types vary in the amount of light and heat they transmit. Some, for example, reflect the high summer sunlight but allow the winter sun's low rays to penetrate to warm a home's interior. Glass blocks are one of the few materials that admit light but give a degree of privacy, provide reasonable insulation against heat and cold, and make a supporting wall of any strength. Further, the manner in which they diffuse light and create changing abstract patterns from objects seen through them can be highly decorative. Although a rectilinear medium, glass blocks have the potential for a certain "softness" when laid in a curvilinear form. Solid glass blocks 3" thick by 8" square are used for floors or over light fixtures. They have high-impact strength and transmit light very effectively. The chief drawback of glass block is its high cost.

MOLDABLE MATERIALS

Those masonry materials that are shaped at the building site from a semiliquid state include **concrete**, **plaster**, and **stucco**. They are hardened in forms or molds, or in a thin layer on a wall, extruded through dies in plain or fanciful shapes, and even carved after hardening.

Concrete. Concrete is a mixture of cement with sand and gravel or other aggregates. It begins its existence as a thick slush, takes the form of any mold into which it is poured, and hardens to a heavy, durable mass. The bland, rather institutional color and texture has tended to limit poured concrete to such basic but deemphasized parts of the home as foundations, floors, walls, and terraces. However, the inclusion of aggregates other than sand and gravel improves the color and texture of concrete, as well as its insulating properties. The surface can be varied by adding colored pigments or other materials, troweling it smoothly or giving it any number of textures, and by exposing the aggregate. Broom-finished or exposed aggregate describes a pebble-surfaced concrete made with round pebbles from which the surface coating of concrete has been cleaned. Plaster or stucco can be applied as a surface coating over concrete, and paints and dyes change the color. Paints generally are thick enough to smooth the surface somewhat, while dyes are transparent and penetrating.

Plaster and Stucco. Plaster and stucco have been popular building materials for centuries in many parts of the world because of their special qualities. Plaster is a thick, pasty mixture of treated gypsum and water, combined with such materials as sand and lime. (Plaster walls and moldings are discussed in Chapter 18.)

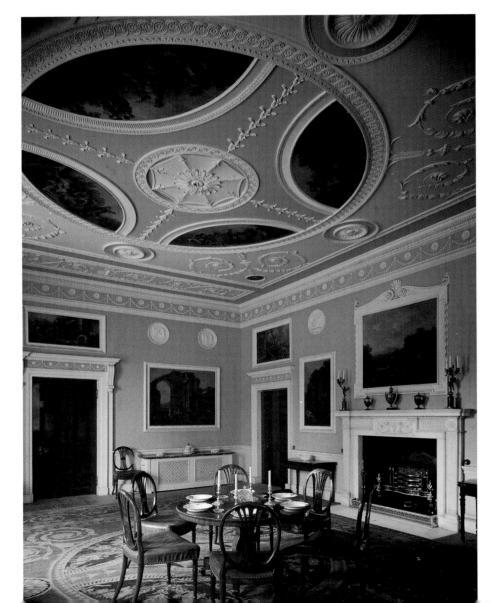

15.45 Robert Adam, the arbiter of English neoclassic taste, designed the dining room of Saltram House, Devonshire, England, in about 1768. A delicate play of straight and curved lines governs the entire room from the ornate plaster relief designs on the ceiling and matching carpet pattern to architectural moldings and oval-back Hepplewhite chairs. (Photograph: A. F. Kersting)

Stucco refers to weather-resistant Portland cement (a mixture of clay and limestone) most often used on exteriors. Both plaster and stucco generally are applied over a *lath* subsurface, a lattice of thin strips of wood, metal sheets with grille-like perforations, or special types of hardboard. They can also be applied to any masonry surface that is rough enough to hold them, such as concrete blocks.

Like concrete, plaster and stucco will hold any shape given them before they harden. They can smoothly cover simple or complex surfaces with no visible joints. Both accept texturing, coloring, or painting, and plaster can be covered with paper or fabrics for embellishment and protection. Plaster can also be sprayed onto walls or ceilings to create various textural effects. Many older homes show how well suited these materials are to varied kinds of sculptural enrichment, including ornate ceiling cornices and medallions used as backplates for chandeliers and ceiling fans. Interest in renovating and restoring older homes has resulted in a revival of such craft skills, and even in their use in new construction, although many moldings and medallions are reproduced in lightweight polymer, fiberglass-reinforced gypsum, or other combinations of materials today.

Under some conditions both plaster and stucco create maintenance problems. Cracks or chips are common unless precautions are taken. On smooth, light-colored walls these may be conspicuous, as are fingerprints, soot, and scratches. Although not expensive, the original cost of plaster (due to the labor involved) is higher than that of many of the hardboards, which provide better insulation against heat, cold, and noise.

15.46 An Egyptian wall painting from the tomb of Rekmere in Luxor—Thebes depicts activities of daily life. (*Photograph: Erich Lessing/Art Resource N.Y.*)

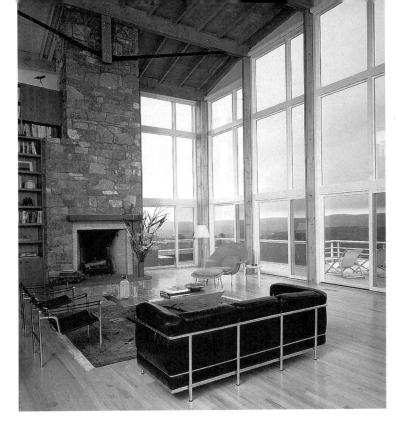

15.47 A country vacation home in upstate New York, designed by architect Warren Schwartz, counters a rugged stone chimney mass of local granite with polished oak floor and large walls of glass. (*Photograph: Paul Warchol*)

Over the centuries, much masonry has been recycled, linking the past with the present. For example, archeologists often find only foundations when they search for evidences of earlier civilizations; the stones or bricks from the old walls provided the raw material to build new structures. In our own time, many people prefer "used brick" to new for its more mellow look, and stone barns are recycled into homes or give up their stonework for new fireplaces. It is evident that masonry has its own very special appeal of enduring and substantial security. What is particularly of this century is the way in which the weight and density of masonry is contrasted with the comparative lightness of wood and the transparency of large areas of glass.

REFERENCES FOR FURTHER READING

Brodatz, Philip. Wood and Wood Grains: A Photographic Album for Artists and Designers. New York: Dover, 1972.

Constantine, Albert. Know Your Woods. New York: Scribner, 1972.

Dieter, A. Waste Knot, Want Knot—Boise Cascade's Wood Products Mix. *Boise Cascade Quarterly*, November 1979, pp. 2–5.

Hayward, Charles. Complete Book of Woodwork. New York: Drake, 1972.

Kilmer, Rosemary and W. Otie Kilmer. *Designing Interiors*. Fort Worth: Harcourt Brace Jovanovich College Publishers, 1992.

Raffel, Deanne. A Lumberyard Primer: What You Should Know to Choose the Right Building Materials. *House & Garden*, April 1980, pp. 56–58.

Riggs, J. Rosemary. Materials and Components of Interior Design, 3rd ed. Englewood Cliffs, N.J.: Prentice-Hall, 1992.

Rupp, William with Arnold Friedmann. Construction Materials for Interior Design. New York: Whitney Library of Design, 1989.

Templin-Miller, Amy E. Interior Designers Responsibility Regarding Mahogany, A Threatened Tropical Hardwood. *Conference Proceedings*. Interior Design Educator's Council, 1991.

Thomsson, Arne. Wood Veneer. ASID Industry Foundation Bulletin (reprinted from Interior Design, October 1974).

Willcox, Donald. New Design in Wood. New York: Van Nostrand Reinhold, 1970.

Ceramics, Glass, Metals, and Plastics

CERAMICS

Clay Bodies Form in Ceramics Ornamentation

GLASS

Form in Glass Ornamentation Architectural Glass Mirrors Fiberglass

METALS

Form and Ornament in Metal

PLASTICS

Families of Plastics Environmental Problems Form and Ornament in Plastics

As materials, ceramics, glass, metals, and plastics share important characteristics. Since all are shaped while in a plastic, liquid, or malleable state, they lend themselves to a tremendous diversity of shapes. All are subjected to heat and/or pressure in processing. Except for some plastics, all are inert; that is, they will not burn, rot, decay, or appeal to insects and vermin. Each of these materials nonetheless has its own special potentialities and limitations, sensory and aesthetic qualities that have led to forms characteristic of its unique nature. Further, glass and metal may be considered more integral to a building's structure, while ceramics and plastics are applied in a more independent manner. Of course, all four materials may be used for a variety of fixtures, furnishings, and accessories.

CERAMICS

Long before early civilizations began to write, they fashioned useful and symbolic objects from clay. *Ceramics* denotes all objects made of clay hardened by heat. Essential steps in the forming process are

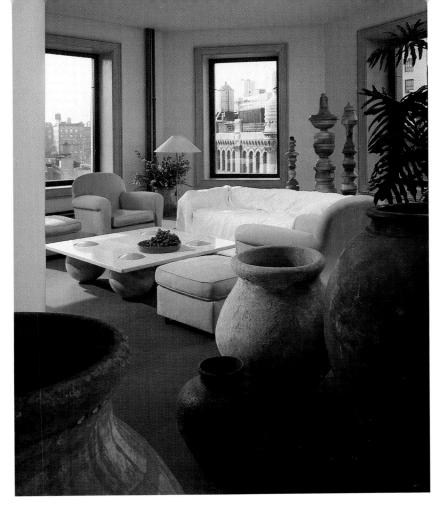

16.1 Large European earthenware oil pots are clustered as unique accessories in an adaptive reuse loft in Manhattan. Their sculptural forms and soft, natural colors and textures complement the simplicity of the interior and relate to the large-scale architecture seen through untreated windows. Donato Savoie, architect; Antonio Morello, interior designer. *(Photograph: Paul Warchol)*

- combining clays to make a suitable *body*;
- · moistening the clay sufficiently to make it workable;
- · shaping the clay by hand, on the potter's wheel, or in a mold;
- allowing the pieces to dry; and
- firing the pieces to harden them permanently

The process may also involve decorating the object with carving, painting, or other techniques—and perhaps *glazing* (that is, applying a glasslike coating to the surface and then firing the piece once again to form a protective seal).

CLAY BODIES

The clays used for a ceramic body naturally affect the characteristics of the finished product, and clays differ in many properties. Colors range from white through the most common reds, tans, grays, and browns to black. Textures vary from coarse, irregular, and open to fine, even, and dense. Clays also have different *maturation points*, or firing temperatures at which they will attain their maximum hardness but not yet begin to melt and deform. Generally, those clays that hold their shapes at high temperatures make the stronger objects, because the separate clay particles fuse together, or *vitrify*, into a homogeneous and waterproof mass. Almost never does a single clay offer all the qualities desirable for working and design; consequently, the ceramist will mix two or more clays in varying proportions to produce the desired combination. The result is a clay *body*. For convenience, ceramic bodies can be grouped into four major types, although each has a wide range of characteristics that may overlap those of the other types.

Earthenware. Coarse clays fired at comparatively low temperatures produce earthenware, a typically thick, porous, fragile, and opaque ware. Most often red or brown, earthenware is the material of bricks, tiles, and most folk pottery. Unglazed,

16.2 This delicately flowered pedestal sink of vitreous china with scallop shell basin would be a beautiful but durable centerpiece in any bathroom. (Courtesy Phylrich International)

it lends itself particularly well to flowerpots and planters, since the clay body "sweats" and allows the soil to breathe. The glazes suitable for earthenware tend to be soft and may have very bright, glossy colors. (Brick and tile were described with masonry materials in Chapter 15.) In recent years, many artists have begun to explore the possibilities of earthenware for sculptural form.

Stoneware. Finer clays—generally gray or light brown—fired at medium temperatures result in stoneware, a relatively strong, waterproof, and durable ware. Most common in medium-price dinnerware, stoneware is also the predominant material of sculptural ceramics. Typical glazes have a matte finish, more subtle colors, and a much wider range of effects than are possible with earthenware.

China. A somewhat general term, china describes a white, vitrified ware that is translucent if thin. Originally the term was coined for European ceramics that imitated fine Chinese porcelains. *American vitreous china* offers unusual resistance to breakage and chipping of the body, and to scratching in the glazes and decorations. Toilets are always made of vitreous china, though lavatories may be of this or several other materials.

Porcelain. High-grade, expensive dinnerware and ornamental ware represent the major products of fine porcelain. For commercial and retail spaces, porcelain floor tiles are inherently impervious to heavy use. A brilliant white, translucent ware fired at extremely high temperatures, porcelain is a completely vitrified combination of white kaolin clay and the mineral feldspar. The body resists breakage, and the glazes are very hard.

The purist would say, with some justification, that earthenware suggests simple, vigorous shapes and ornamentation and that increasing precision and refinement should be expected as one goes from stoneware to china and porcelain. Not always, however, does this formula apply, for other factors affect ceramic design.

FORM IN CERAMICS

The possibilities and limitations of form in any material are determined by its physical properties, the methods by which it is formed, the intended use of the end product, and the skill and sensitivity of the designer.

16.3 An unglazed porcelain bowl reveals the strength of this fine ware in its thin undulating walls. Marsha Berentson, designer. (Exhibited at the Elaine Potter Gallery, San Francisco)

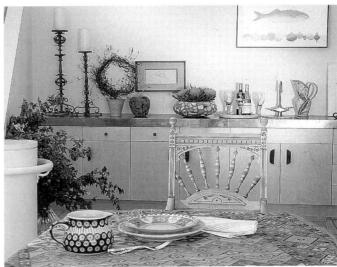

The physical properties of clay differ markedly before and after firing. In its unfired state, clay consists of small powderlike or granular particles. When a small amount of water is added to the dry clay, the result is a malleable, plastic mass; the addition of more water produces a creamy liquid called *slip*. After firing, clay is hard and brittle, with little tensile strength. Ceramic objects therefore break quite easily when struck or dropped, and thin edges or protrusions including raised surface designs are vulnerable.

The forming methods for clay divide into two general categories: hand techniques and mass-production techniques. In hand construction, the clay can be thrown on the potter's wheel, rolled into sheets or slabs (which may then be assembled in different ways), coiled from ropes of clay in the tradition of Native American potters, pinched between the fingers into various forms, or carved and molded sculpturally. Mass-produced ceramic ware is shaped by pouring slip into molds, by pressing plastic clay in molds, or by jiggering, a process in which plastic clay on a revolving mold is formed by a template. Almost any shape is possible in clay, but most dishes, vases, and similar household objects are round and relatively compact, because round forms come naturally from the wheel and the jigger. Important, too, is the fact that they have a minimum of edges to chip; however, angular shapes are basic in bricks and tile, which receive wear only on their flat surfaces. (See Chapter 15 for specific information on brick and tile.)

ORNAMENTATION

Glazes are coatings compounded from glasslike materials fused at high temperatures to the body of ceramic ware. In purely utilitarian terms, they increase efficiency by making the ware waterproof and easy to clean. Most important, though, as an example of structural ornament, the textures and colors of glazes are primary sources of beauty.

Glazes differ in the degree to which they join with and "fit" the clay body. A broken piece of glazed earthenware will show that the glaze forms a distinct layer on the porous body, but on most porcelains the glazes are so completely wedded with the clay that no sharp division can be perceived. Both clay and glazes shrink in firing. If the glaze and the body do not have the same rate of shrinkage, the glaze may develop a network of cracks. Some potters plan such effects deliberately

16.4 (above left) "Throwing" clay on the potter's wheel is a practiced skill that transforms a ball of clay into a wide range of symmetrical objects.

16.5 (above right) Ceramic pieces make colorful accessories and, in addition, serve functional needs. One piece, sitting on the copper-topped buffet, is actually formed from broken pieces of pottery. Arnelle Kase/Barbara Scavullo Design. (Photograph: David Livingston)

for their ornamental value, but on dishes meant to hold food the cracks are more likely to be the result of poor workmanship.

Often the basic form of a clay piece, with the addition of a glaze or glazes, is sufficient unto itself, making applied ornamentation unnecessary. However, because of the ever-present urge to enrich a plain surface, ceramic objects seem to invite modeling, carving, and painting.

Modeling and **carving**, which give a three-dimensional play of light and shade, range from scarcely noticeable incised designs to vigorous shaping and cutting. Sometimes stamps are used to impress designs on the clay while it is still plastic. *Sgraffito* (literally, "scratched") decoration results from coating a piece with slip—different in color from that of the base—and then scratching through to reveal the color underneath. These techniques have been practiced for centuries.

Colored pigments can be applied with a brush or through a stencil, transferred from decalcomanias, or printed mechanically. This decoration might be either under or over the glaze, and it offers endless design possibilities. *Underglaze* designs are applied before the final glazing (which is transparent), so they are protected from scratches and wear. *Overglaze* patterns are applied to the surface of glazed ware and fused with it at a low firing temperature. An overglaze design represents the least costly and most common type of ceramic enrichment and, done well, can be moderately durable. Gold and silver trim on dinnerware are applied as overglazes which explains why they soften in dishwashing if the water temperature is high.

16.6 Humble earthenware drain tiles imaginatively shelter a passageway from extreme natural elements while still allowing in some light and breeze. Anshen and Allen, architects. (*Photograph: Maynard L. Parker*)

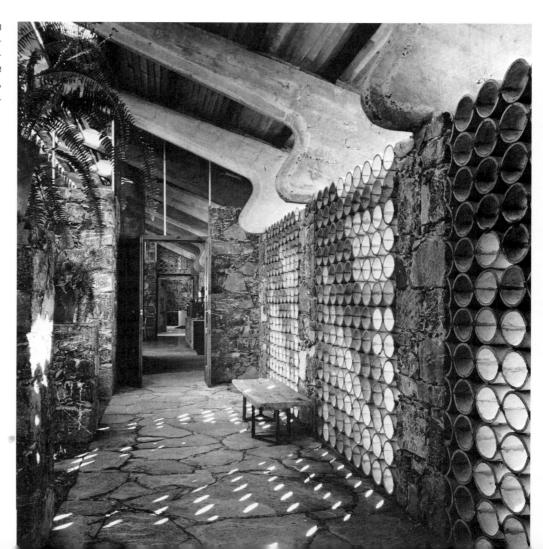

16.7 A Roman millefiori bowl dates from the 2nd or 1st century B.C. (Photograph: Schecter Lee. Courtesy The Metropolitan Museum of Art, Edward C. Moore Collection. Bequest of Edward C. Moore, 1891.)

Clay is, first and foremost, a sensuous material. A lump of it in the hands invites manipulation. Fascinated perhaps by this direct urge transmitted by the material and by the variety of modeled forms it would take and hold, both artists and industrial producers have made clay one of the most versatile media known.

An interesting and unique application of ceramics in the home marks a house in Mexico (Figure 16.6) in which ordinary clay drain pipes, banked in even rows, have been used to make a whole wall, filling the gaps between stone piers. They not only create an ever-changing pattern of light and shade but give protection against rain, sun, and wind as well.

Finally, of course, there remains the potential for "spot" enrichment in the home with individual ceramic pieces. Their design importance and character can range from a large, dramatic pot that is a major focus of attention to the simple, classic lamp base. Either one represents a modern interpretation of a continuing tradition for clay objects in the home that is almost as old as civilization.

GLASS

The evolution of glass from a semiprecious substance available only in small quantities (for making such things as beads and amulets) to a commonplace material that can be bought anywhere and installed in large sheets has altered our homes as much as any single factor. Glassmaking appears to have developed from ceramic glazes, some of which were made at least six thousand years ago; but the oldest known glass objects are about four thousand years old. The Romans fabricated glass objects of such beauty that the best were valued higher than vessels of gold. Sheets of glass for windows were also known in the Roman Empire, but window glass was not common in small homes until the end of the eighteenth century. To-day glass is an everyday, extraordinarily versatile material found in everything from cooking utensils to house walls.

Glass is made by melting and fusing at very high temperatures the basic ingredients—silicates, alkalis, and lime—plus various other materials that give certain qualities. *Crystal*, the finest glass, contains lead. Color traditionally comes from

minerals: red from gold and copper, blue from copper and cobalt, yellow from cadmium and uranium. Many of these minerals are too costly or have other more critical uses today, which explains why old glassware has risen in value. Special effects such as opacity, bubbles, or crystallization and special forms, including glass fibers and insulation, result from chemicals or from the way in which glass is treated. *Obsidian*, a natural glass that is usually black, is created by volcanic heat.

The general characteristics of glass are

- transparency unrivaled until recently by any other common material;
- capacity to refract light in a gemlike way;
- wide range of colors, degrees of transparency, and textures;
- plasticity, malleability, and ductility that permit a great variety of shapes, from threadlike fibers to large thin sheets;
- imperviousness to water and most alkalis and acids;
 - resistance to burning (but will melt at very high temperatures);
 - moderately high resistance to scratching; and
 - low resistance to breakage through impact, twisting or bending, and sudden temperature changes (except with special types).

In sheet form, glass serves as the standard material for mirrors, windows, sliding doors, and table tops. For her Lunario tables, Italian designer Cini Boeri cantilevers severely plain round or oval glass shapes from bases of polished steel in a daring display of the transparency and relative tensile strength of glass (Figure 16.8).

Unless it is kept polished, glass—especially colorless and transparent glass—loses most of its beauty. Finger and water marks or specks of dust are more conspicuous on clear, shiny glass than on most other materials. Under some circumstances, the transparency of glass can make it a hazard to the unwary, especially in poorly designed window walls or sliding doors.

FORM IN GLASS

What was said about form in ceramics might also be repeated for glass; because, in both, an amorphous substance takes form while it is plastic or liquid; the final product is hard, usually brittle, and breakable; and process, material, and use lead naturally (although not exclusively) to rounded forms. Glass, however, adds a second major form category in flat sheets for house furnishings and architectural elements.

Two other distinctive qualities of glass should be mentioned. The first is that glass, technically speaking, always remains a liquid. Therefore, even when rigid, as it is at ordinary temperatures, it is actually a "supercooled liquid." Second, an almost perfect union of form and space can be achieved with glass. We look less *at* a transparent glass window than *through* it to the space enclosed and the space beyond.

Hand-Blown Glass. Just as the bowl is a natural shape for ceramics formed on the potter's wheel, the bubble is the natural form for hand-blown glass. The craftsman dips a hollow metal rod into molten material, blows it into a bubble and then forms the hot, soft mass into the desired configuration by rolling, twisting, or shaping with tools while it is still hot and plastic. But because hand-blowing is a time-consuming, expensive technique, most household glass derives from procedures more suited to quantity production.

Molded and Pressed Glass. In a mass-production situation, molten glass is blown or pressed by machinery into cast-iron or wooden molds. The molds can be simple or intricate in shape and leave a plain or patterned surface on the glass.

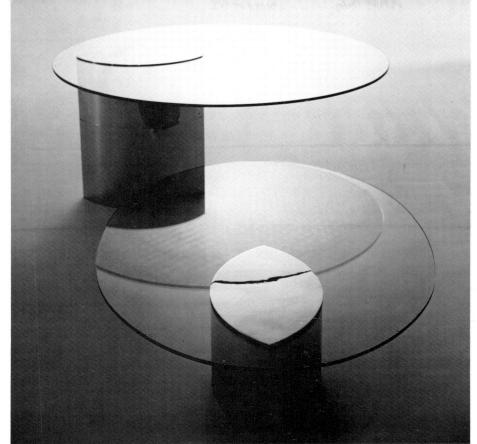

16.8 In the "Lunario" table, the transparency of glass reveals and accentuates the off-center poise of the table top on an ellipsoid base. Cini Boeri, designer. (Courtesy The Knoll Group)

16.9 (left) A free-blown clear-glass vase—an assemblage of three bubbles topping a hollow tube—strongly evokes the act of blowing glass. Willem Heesen, designer. (Courtesy Glasvormcentrum Leerdam)

Drawn, Rolled, and Floated Glass. Three processes apply to the manufacture of sheet glass. **Drawing** (the method by which inexpensive window glass is made) calls for molten glass to be drawn from furnaces in never-ending sheets, flattened between rollers, and cut into usable sizes. Although satisfactory for most purposes, drawn glass tends to be weaker, thinner, and more subject to flaws (waviness and distortion) than plate glass. In **rolling**, the method for making plate glass, both sides are ground and polished for greater clarity. **Floating**, a newer method of manufacture in which molten glass is floated over molten metal, produces glass comparable to plate glass at less expense. Sheets of plate glass more than fifty feet

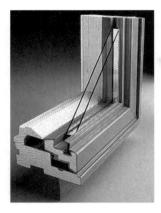

16.10 Andersen® Windows High-Performance glass is 54 percent more efficient than normal double-pane windows during the winter months and 18 percent more efficient in blocking radiant heat gain during the summer. In addition, it reduces fabric fading and deterioration from ultraviolet rays by 71 percent, yet it looks like ordinary glass. (Courtesy Andersen Windows, Inc.)

16.11 (below, left) A *latticinio* pattern of white and amethyst threads of glass embedded in clear glass accentuates the teardrop shape of a bottle designed by Archimede Seguso of Italy. (Coming Museum of Glass, Coming, New York)

16.12 (below, right) Many chandeliers derive their beauty from the sparkling play of light on faceted crystal. John White, interior designer. (Photograph: John F. Martin)

long are possible, and manufacturers can incorporate special qualities, materials, and techniques such as *laminating*, to make the glass shatterproof (even bullet-resistant) or to give sound, heat, cold, and glare control as well as reflective properties. *Low emissivity (low-E) glass* reflects heat outward in summer and back to the interior in winter while also filtering out damaging ultraviolet rays. Many energy-efficient laminated forms of glass are tinted bronze, gray, gold, silver, green, or blue to reduce glare.

ORNAMENTATION

It is not easy to draw a sharp line between form and ornament in glass. Structural ornament can be added before glass is shaped by incorporating in the material substances that give color, make the glass translucent or cloudy, or produce such visual textures as bubbles or opaque streaks. Sometimes form becomes so complex that it serves as its own decoration. An entire glass piece can be fluted, ribbed, or ringed with swirling patterns. The glassblower can also "drop on" globs of molten glass to produce almost liquid ornament on the one hand or practical appendages such as handles on the other. Molded or pressed glass takes its texture, as well as its form, from the mold in which it is processed. Beyond this, several other types of applied enrichment are possible.

Cut Glass. Although glass was beautifully cut by the Romans, the technique experienced a renaissance about A.D. 1600, when a court jeweler in Prague applied gem-cutting techniques to glass. Rich effects come when the design is cut through an outer coating of colored glass to reveal colorless glass underneath. In colorless crystal, cutting gives many facets to catch and break up light (Figure 16.12).

Engraved Glass. As with cut glass, engraving is done with wheels and abrasives, but engraving produces a shallow intaglio that by optical illusion often seems to be in relief. Finer pictorial and decorative designs are engraved rather than cut. Both mirrors and regular glass may be engraved on either the front or back. Firmness of form, sharpness of edge, and easy-flowing curves distinguish engraved glass from that which is pressed, cut, or etched.

Etched Glass. Either hydrofluoric acid or sandblasting will etch glass. The frosty etched surface can be left in that state or polished to smooth transparency. Etching is often used to imitate engraving, but the designs are not as sharp or as subtly modeled. Usually shallow and delicate, etching can be 2 inches deep, as it is in some heavy French pieces.

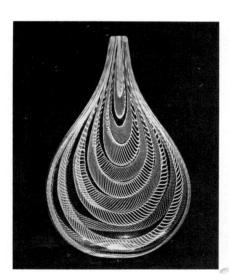

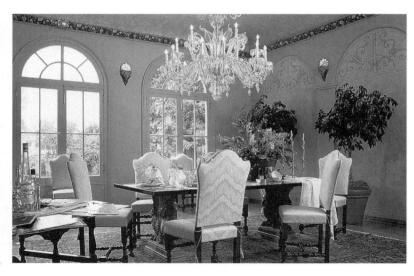

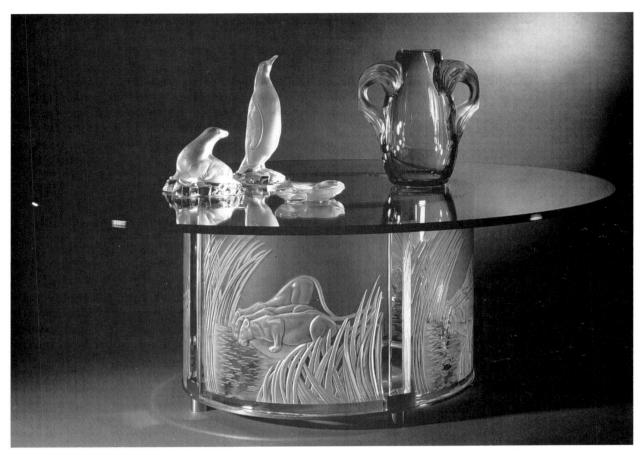

Leaded, Stained, and Beveled Glass. Composed of small pieces of glass set in a pattern and held in place by strips of lead or copper foil, leaded and stained glass have distinct capabilities as enrichment (Figure 16.14). Leaded glass usually refers to transparent glass, colored or clear, often used as a window. Stained glass—enameled, painted, or colored by pigments baked onto its surface or by metallic oxides fused into it—can serve in windows, lampshades, or wherever its translucency can be highlighted by a strong light source. Some modern techniques laminate or bond colored glass to a sheet of glass or plastic instead of piecing it together by means of lead or foil. Beveled glass has a narrow band near the edges cut on a slant and can be used for leaded glass windows, ordinary windows, mirrors, or glass panels in furniture pieces. The beveled edges create prisms when light passes through them. This play of light and color can be very effective as a design feature.

ARCHITECTURAL GLASS

Although glass for buildings is generally thought of as transparent, colorless, smooth, and flat, it can be frosted or pebbly, ribbed or corrugated, and colored to control light, heat, even vision. **Glass blocks** admit light but provide privacy and security, also creating a subtle rhythm because of their shapes and the pattern of mortar between them. Glass blocks are made up of two 37/s" pieces of pressed glass fused together with a partial vacuum between them which results in an airtight insulating barrier to noise, drafts, and dust as well as heat/cold transmission. Blocks

16.13 Marie-Claude Lalique designed the "Table of the Three Lionesses" in 1992. The three-dimensional image of three lionesses drinking from a stream is carved intaglio against curved panels of satin-finished crystal, fitted into a chrome frame to form the columnar table base. *(Courtesy Lalique®)*

16.14 (right) Stained glass, popular in Victorian houses in the late 19th century, can be just as well suited to contemporary homes. Peter Green designed this front entry of leaded, imported pastel glass for a home in Connecticut. Victor Chris-Janer, architect. (Photograph: © Karen Bussolini)

16.15 (below, left) A handsome old doorway with a clear leaded-glass fanlight and stained-glass side panels awaits recycling by an imaginative builder. (Photograph: Thomas B. Hollyman/Photo Researchers)

16.16 (below, right) Louis Comfort Tiffany (1848–1933) revived stained glass as an art form and made lamps, vases, and windows, often using sinuous plant forms in the Art Nouveau style. (The Metropolitan Museum of Art. Gift of Hugh Grant, 1974.)

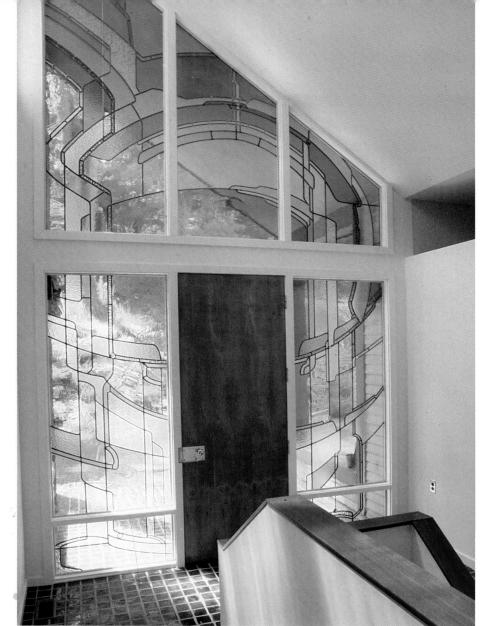

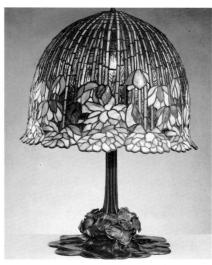

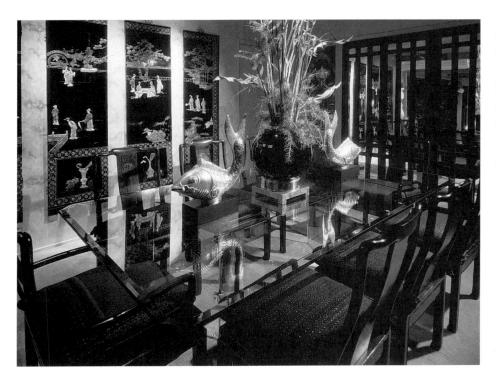

16.17 Glass-topped dining tables often have beveled edges, both for aesthetic reasons and for the comfort of users. The angled cut may extend inward as much as two inches from the edge, creating a distinct band that not only refracts light attractively but marks the edge for convenience and safety in use. Dennis Haworth, FASID, interior designer. *(Photograph: Steve Simmons)*

are 6'', 8'', and 12'' square or $4'' \times 8''$ rectangles. Glass, in either block or sheet form, can also be curved to fit specific installations.

Some architectural glass for doors and large window areas is **tempered** for safety so that, if broken by a heavy blow, it forms rounded granules rather than jagged shards; other types have a core of metal mesh or vinyl that reduces the hazard of breakage. In the past, homeowners had to choose between opaque walls and transparent windows, and then frequently cover the windows with curtains or blinds for visual protection and security. Now there is transparent and two-way **mirrored** glass that allows people to see out, but blocks the inward view with a reflection. **Insulating** glass, which has double or even triple panes welded together with a special dry gas between, makes possible large areas of glass even in cold climates. Architects have made use of these new capabilities to produce houses with walls almost totally of glass that are still comfortable, private, and secure inside.

MIRRORS

In the past mirrors were almost exclusively utilitarian in bedrooms and bathrooms, but they, too, have come into their own as a source of visual pleasure. Many metals can be given reflecting finishes, but good quality mirrors are made of float glass with a metallic backing that provides distortion-free reflections. They can be invaluable in visually expanding the size of a small room, doubling the image of an attractive feature, or reflecting all sides of a three-dimensional accessory or piece of art. They also spread light throughout a room and bring sparkle into dark corners. Although most often given a plain silvery backing, mirrors can be grayed, bronzed, veined, or antiqued, which results in a shadowy, smoked appearance; their usual flat surface can be curved to give interesting distortions, broken up by facets to create dazzling interplays of light and color, or engraved or etched with decorative designs.

16.18 Glass block can be used in nearly any space, from the bathroom to the living room, because of its insulating properties, the privacy it provides, and its aesthetic qualities. The curved glass block wall, in a two-story family room/bedroom addition, corresponds to the original architecture of a 1937 Art Deco home in Chicago. Andrew Revorie, original architect; Archimax, restoration/addition architects. (Photograph: Howard N. Kaplan)

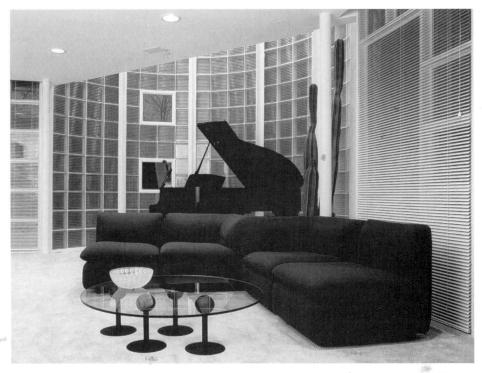

16.19 Plexiglass sheets backed with mylar produce a striated mirror-like effect in a dramatically unique guest bath. Dennis Haworth, FASID, interior designer. *(Photograph: Steve Simmons)*

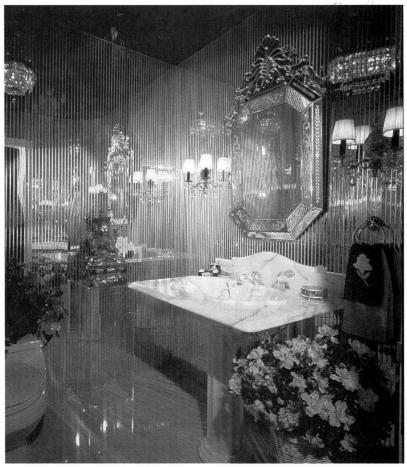

FIBERGLASS

The great versatility of glass is indicated by the fact that its ingredients can also be spun into fibers for insulation, fabrics, or rigid forms. Spun glass was used for centuries in a purely decorative way, but not until about 1893 were its utilitarian values appreciated. Today glass fibers provide insulation against extreme temperatures and sound. Another development is foam glass, made by introducing a gasproducing agent into molten glass. Filled with so many tiny air bubbles that it will float on water, it has excellent insulating properties. We are all familiar with the many types of fiberglass panels that can make lightweight, translucent fencing and roofing materials. Fiberglass also appears in molded integral bath fixtures, walls, and furniture that is so durable it can be used for public seating. It is inherently flameproof and resistant to chemicals (except alkalis), moisture, and sunlight.

METALS

Although metal was first reduced from ore about 5000 B.C., its application to domestic architecture was unimportant until recently. Today the typical "wood house" uses more than four tons of metal, but only a small portion is visible.

Metal—like masonry, ceramics, and glass—is inorganic and therefore does not burn, rot, or decay. But metal differs from these other inorganic substances in some important respects: Most metals rust or corrode when exposed to moisture and air; they have great tensile strength; their capacity to transmit heat, cold, and electricity stands unequaled. Metal surfaces are usually shiny and nonabsorbent.

With the possible exception of plastics, no other material can be shaped in so many ways. Metal can be melted and cast in simple or intricate molds; in the solid state it can be rolled, pressed, or turned on a lathe as well as hammered, bent, drilled, or cut with saws and torches; separate pieces can be welded together or joined with bolts and rivets.

This unique complex of qualities—tensile strength, meltability, ductility, malleability, conductivity, resistance to fire and decay, and potential beauty of color and surface—makes a house built today without metals hard to imagine. A partial

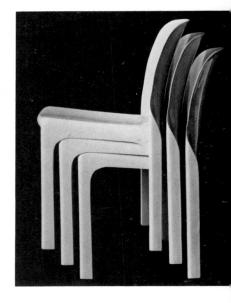

16.20 Fiberglass-reinforced plastic can be formed into light stacking chairs. (Courtesy Stendig)

16.21 A 15th century German door hinge illustrates the intricacy that can be achieved in wrought and incised iron. (*The Metropolitan Museum of Art. Gift of Henry G. Marquand, 1887.*)

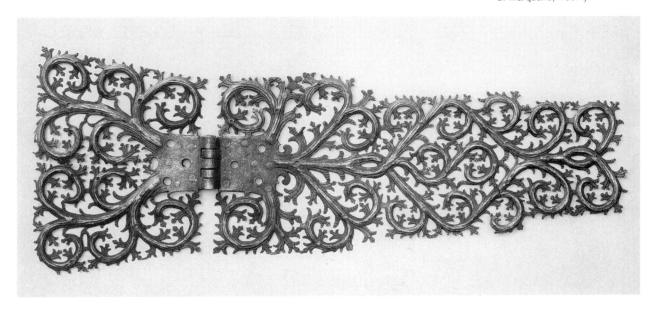

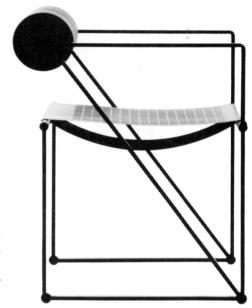

16.22 The strict geometry of the "Secondo" armchair with its pencil-thin lines is a forthright expression of the metal from which it is constructed. Mario Botto, designer. (Courtesy ICF Inc. Photograph: Peter Paige)

list would include such inconspicuous but essential elements as structural members and reinforcing in masonry; conductors of water, heat, and electricity; weatherproofing and foil insulation; and nails and screws. Metals are thinly concealed by protective coatings of enamel in stoves, refrigerators, and other appliances. They become noticeable in hinges, handles, and doorknobs; in faucets, radiators or warmair vents; and in windows and door frames. Finally, metals are treasured for their visual attractiveness in tableware, furniture, cooking utensils, lighting fixtures, tiles, ceilings, wall panels, and moldings. The metals that are most often used in the home, their qualities, and their applications are presented in Table 16.1. (Metal used in furniture design is explored in Chapter 22.)

FORM AND ORNAMENT IN METAL

Metal will take and hold any shape that can be given to wood, masonry, ceramics, or glass. Its most distinctive quality, though, is its great tensile strength, which makes possible, as well as durable, quite slender shapes. Sharp edges, as on knives,

16.23 Pierced Chinese temple carvings contrast sharply against a smooth, brushed stainless steel fireplace surround in this Sacramento, California, home designed by Dennis Haworth, FASID. (Photograph: Steve Simmons)

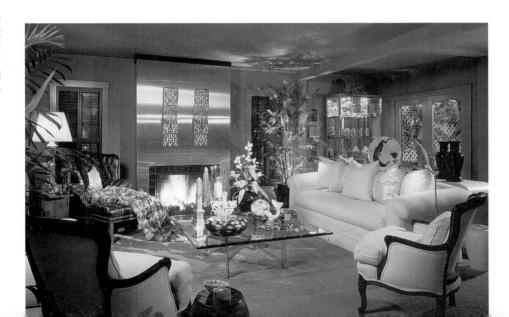

TABLE 16.1

Metals

	Color and Finish	Special Characteristics	Uses
aluminum	whitish, oxidizes to a soft gray; highly polished or brushed to silvery gray; anodizing gives satiny surface in bright metallic hues	lightweight; easily worked; does not deteriorate; impervious to water; nontarnishable	cooking utensils, pitchers, and trays; screens, sliding doors; maintenance-free indoor-out- door furniture
brass	copper alloyed with zinc; bright yellow color; takes a high pol- ish; must be polished frequently to stay bright	soft but durable; easily shaped; can be incised or inlaid with other materials; tarnishes easily; often protected by a coat of lac- quer	musical instruments, lighting fixtures, decorative door hard- ware, faucets, fireplace acces- sories
bronze	copper alloyed with tin; rich brownish-red; develops mellow, subtly colored patina over time	hard, long-lasting, durable; does not deteriorate	bells, cast sculptures, desk ac- cessories, commemorative medals and plaques
chromium	blue-white; takes and keeps high polish; can be given brushed finish	hard; resists corrosion; cold, glittery unless brushed; often used as thin plating; durable; finger and water marks	faucets; toasters and other small appliances; lighting fixtures; maintenance-free funiture
copper	orange color quickly oxidizes to dull greenish brown or lively blue-green; must be kept pol- ished to retain orange hue and lustrous surface	soft, easily shaped, but durable; good conductor of heat, elec- tricity; impervious to water; tar- nishes but does not rust; considered everlasting	water pipes; electrical wiring; eave troughs and roofs (expen- sive); cooking utensils, often displayed for beauty of finish; can be alloyed with tin or zinc to make bronze or brass
iron	grayish, galvanized with zinc coating, painted to resist rust	strong; worked easily by hand or machine	cookware, railings, decorative hardware
pewter	tin alloyed with antimony, cop- per, and lead; mellow warm gray; polishes to a satin finish	easily worked; resistant to tar- nish and hard usage	pitchers, trays, tableware, light- ing fixtures, decorative acces- sories
steel	iron alloyed with carbon, also needs painting except for special types	harder than iron but still easily formed by machine	cookware, window and door frames, painted or enameled furniture
stainless steel	addition of chromium makes pleasant blue-gray color	resistant to rust and staining; hard, durable; nontarnishable	cooking utensils, flatware, counter tops, sinks, and cook- tops
silver	whitest of metals; takes beautiful polish; reflects light; can be plated over alloy base	soft until hardened with copper (sterling silver); ductile, mal- leable; tarnishes, but easily cleaned and polished; frequently plated over an alloy base	flat and hollow tableware, decorative accessories
tin	dull silver color	very soft; easily worked; resistant to tarnish; nonrusting	lighting fixtures, ornamental frames, small accessories

are more durable in metal than in any other material. When used expressively, metal contributes a precise thinness that distinguishes it from the comparatively heavy solidity of wood, masonry, and ceramics.

The surface treatment of metal, which can give varied light-and-dark patterns and reflections, acts as a basic kind of ornament. Highly polished metal gives mirrorlike reflections, interestingly distorted when on rounded forms. By contrast, softly polished pewter or brushed steel produces more mellow and diffuse patterns. Three-dimensional textures, such as those on stamped sheet metals, can lead to myriad juxtapositions of highlights and shadows.

16.24 For the sitting room in a remodeled 1920s home located in Atlanta, Georgia, interior designer Jacquelynne P. Lanham chose a late 18th century iron table embellished with curves and early 19th century French bronze doré ornamental wall sconces to contrast with the original Classical moldings. (*Photograph: Mick Hales*)

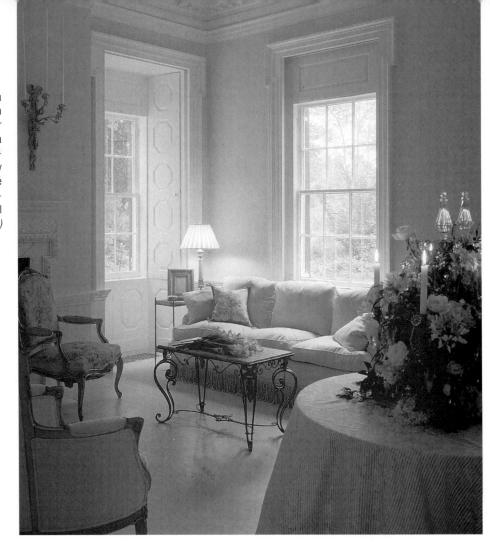

16.25 A cast bronze door knocker designed by Alessandro Vittoria during the Late Renaissance (1580) transforms a utilitarian object into a work of art with its Classical god of the sea flanked by two finned horses. *(Correr Museum, Venice)*

As with form, there are almost no physical limitations for ornament. In exploiting each material's individuality, we emphasize its most distinctive qualities. This leads to several suggestions. First, the strength of metal permits boldly projecting ornamental parts; second, the very fine grain and smoothness make delicate embellishment effective; third, the hardness of metal reconciles linear or angular decoration with the material; fourth, the long life and cost of most metals may suggest relatively formal, controlled, and precise enrichment but does not preclude other approaches.

PLASTICS

The phenomenal development of plastics in the last half of the twentieth century has affected our built environment markedly and will continue to do so. Scientists transform wood, coal, milk, petroleum, natural gas, and many other substances, including recycled materials, into new compounds tailor-made for specific purposes, and the designer must continually learn of new products and appropriate as well as environmentally safe applications.

At first, plastics were considered inexpensive substitutes for more costly materials and a rash of plastic pseudo-wood, -marble, and -metal objects flooded the market. We have since learned to appreciate this versatile material for its own unique qualities. Not only can plastics assume shapes and perform tasks that no other material can, but well-designed plastic forms can be beautiful in their own right. Plastic is lightweight and resists chipping; chairs and other furniture can be molded from transparent, translucent, or opaque plastics, or shaped from foamed plastics whose density can be controlled to vary from rigid framework to soft cushioning. Wall, floor, and ceiling panels and coverings are produced in a great variety of plastic forms; laminated countertop materials are available in a wide array of colors and patterns; nonporous acrylic or polyester composites that resemble marble or granite—or simply provide solid surfaces in diverse forms—are used for countertops and basins. There are many manufacturers and levels of quality in acrylic and polyester composites as well as most other plastics. Careful examination of specifications will assist the designer in making the best choices.

Plastic resins, principally carbon compounds in long molecular chains, come to forming machines as powders, granules, compressed tablets, or liquids, which under heat and/or pressure can be shaped as designers wish. Many techniques exist for forming plastics; the materials can be compressed in molds; extruded through dies to form continuous sheets, rods, filaments, or tubes; injected into cavities of

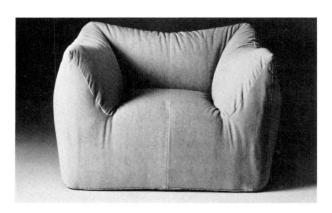

16.26 The development of foamed plastics has had a strong influence on furniture design. "Le Bambola" seating by Mario Bellini is constructed of polyurethane in varying densities embedded in a tubular steel frame, making it bulky but light-weight, extremely resilient but form-retaining. (Courtesy B & B America/Stendig International)

16.27 Acrylic panels surround the stem of the classic "City of Paris" torchère, creating a reflective column of light down its length. (Courtesy Boyd Lighting Company)

complex outline; drawn into molds by the vacuum method; blown full of gas or air to make rigid, semirigid, or flexible foams; or sprayed over forms.

Film and sheeting for shower curtains, upholstery, or laminates are made by spreading plastic solutions on wheels up to twenty-five feet in diameter, by extruding the compound through a wide die or by *calendering*—that is, by passing the compound between several rollers to get the desired thickness and surface texture. Rollers also aid in giving other materials a plastic coating. In *laminating*, layers of cloth, paper, wood, or glass fibers are impregnated with uncured resin or alternated with uncured plastic film, then pressed into a single sheet.

FAMILIES OF PLASTICS

Although innumerable plastics exist, some of those most used in homes derive from the types of resins discussed in Table 16.2. Each name refers to a family of plastics with basic shared characteristics but with considerable diversity in form and application. More and more resins are being cross-bred to produce plastics that demonstrate specific unique traits. Four terms associated with plastics explain some of their distinctions:

- The terms **plastic** and **synthetic** can be applied to the same basic material: molded nylon is called a plastic; nylon thread a synthetic. In this chapter we shall consider only the plastics (Chapter 17 deals with synthetic fibers).
- Thermoplastic substances can be softened and resoftened by heat and pressure, short of the point of decomposition. Vinyl, acrylics, and urethane are examples.
- Thermosetting plastics cannot be modified after the initial chemical change during the curing process. Melamine and laminates are thermoset plastics.

Certain qualities taken together differentiate plastics—despite their variability—from other materials. The range of color and texture, actual or simulated, seems limitless, and plastics exhibit all degrees of transparency and opacity. They feel warm and pleasant. Truly "plastic," they can be formed into almost any rigid or flexible seamless shape. Typically, plastics are tough and durable in relation to weight and thickness. Absorbing little or no moisture, they neither rot nor mildew. Their resistance to chemicals varies but is generally good; however, their strength and dimensions are, with a few exceptions, noticeably affected by extreme temperatures, and some deteriorate when exposed to ultraviolet light. Plastics cover a broad range of prices, and many have actually decreased in cost as they have increased in use.

VINYL Polyvinyl chloride, commonly called PVC or vinyl, is given specific attention here because of its widespread use as a flooring, upholstery, and wall covering material. Floor coverings may be solid vinyl with the color throughout, vinyl composition (reinforced and blended with resins, plasticizers, coloring pigments, and fillers), or a transparent vinyl sealing over real wood veneer. Either sheet or tile forms are available, offering the advantages or relatively low cost, variety of design, ease of installation and maintenance, some resilience and flexibility, and greater warmth and sound absorption than the various forms of masonry and ceramic tile. (Floor coverings are explored in greater depth in Chapter 19.)

Vinyl upholstery is often referred to as artificial leather. It offers low to medium cost and ease of cleaning, but has the disadvantages of puncturing, tearing, and melting, and it is difficult to repair successfully. It may also be used on walls.

As used in wall-covering materials, vinyl has many applications, ranging from a thin coating over paper to improve durability and washability, to laminated fabrics, to heavy vinyls for nonresidential (and some residential) use. Again, vinyl may imitate any other material or be unique in design. Vinyl wall coverings may be

TABLE 16.2

Families of Plastics

	Characteristics	Uses	
ABS (Acrylonitrile, butadiene, styrene)	tough, hard, great tensile strength; resistant to scratching, chemicals, weather; moldable; lightweight	"fitting" ability leads to every- thing from plumbing systems to modular furniture that can be assembled in various con- figurations	
ASA (Acrylonitrile, styrene, acrylic)	good integral color; cross-bred for specific applications and for plating, alloying with other plastics		
acrylics (Plexiglas, Lucite, Perspex, also acrylic yarns)	strong, rigid, light in weight, excellent color; exceptional clarity, ability to pipe light; resistant to weathering, temperature changes and extremes; may scratch but can be buffed; molded into rigid shapes, then carved	domes and skylights, furniture, tableware, sculpture, paint (much used by artists)	
FRP (fiberglass-reinforced plastics, often polyester)	stiff to flexible, hard to soft; good color range; resistant to chemicals, weather; strong	patio covers, luminous ceil- ings, light-transmitting panels, walls, skylights, molded and laminated furniture, sculpture	
melamines (Formica, Micarta, Melmac)	hard, durable, transparent to opaque; resistant to scratching, chipping, water, food stains, heat, fading; thin layer used in laminates shows material underneath; thicker molded, opaque; extensive color range; high-gloss, satiny or matte surface	high-pressure laminates for counter tops, table tops, and as wood subsitute for case goods; dinnerware	
nylon (generic term for group of plastics; also trade name and nylon yarn)	thin layer transparent, thicker opaque; relatively rigid, high tensile strength; resistant to many chemicals, but not to food stains, coffee, tea; to abrasion but not to scratches or weathering; good color range; can be frozen, boiled; not recommended for continuous outdoor exposure	tumblers, dinnerware, kitchen- ware; especially useful for long-wearing gears, bearings, rollers; furniture	
polyethylenes	flexible to rigid, often waxy surface; semitransparent to opaque, lightweight; resistant to breakage, chemicals, freezing, boiling water, but cannot be boiled; good color range	kitchen bowls, dishpans, squeeze bottles; more rigid form used for molded, nonupholstered chair shells	
polystyrenes	hard, rigid, but will break under bending, impact; resistant to household chemicals, foods (except citrus fruits, clean- ing fluids), but not to abrasion; transparent types pipe light; range of translucent, opaque colors; lustrous surface warm, pleasant to touch	kitchenware to modular furni- ture	
urethanes (cellular plastics so called because of structure, ability to foam) (also as nonwoven fabric)	can be given any density, degree of hardness, from resilient to rigid; hard can be worked, finished, repaired like wood; can be foamed in place, bonded to any surface; good insulating properties, lightweight; foams are combustible and must be covered with fire-rated material	cushioning material, covering fabric, to furniture itself; insulation	
vinyls (also as nonwoven fabric)	rigid, nonrigid, foam or cellular types; transparent, translucent, opaque; tough, strong, lightweight; resistant to foods, chemicals, normal use; cuts readily, may stiffen in cold; cellular form a wood substitute; can be embossed, printed in wide range of colors and textures	upholstery, wall coverings, lamp shades, luminous ceil- ings, counter surface; vinyl floor coverings combine most wanted characteristics in single material	

scrubbed clean, stripped from the wall intact, and even reused. Type and weight of the backing is an important factor in durability—so important that commercial vinyl wall covering is priced by the ounce. (These and other wall-covering materials are presented in Chapter 18.)

16.28 Solid surface countertop materials of 100% acrylic, such as "Gibralter" by Wilsonart, can be inlaid with a variety of colors and materials for accent or custom design coordination. This material can be refinished if marred or damaged in use and can be given softly contoured edges, making it very functional and versatile. (Photograph: Dan Ham. Courtesy Ralph Wilson Plastics Company.)

The adhesives used in installation of both flooring and wall covering should be selected with attention to potential for off-gassing and its detrimental effect on indoor air quality and occupant health. Also, plasticizers used in the formation of some vinyls present health hazards.

ENVIRONMENTAL PROBLEMS

Three environmental problems have become apparent in connection with the tremendous proliferation of plastics. In each case, research is being conducted to find answers, but the designer should be aware of these concerns and press for solutions to protect the health and safety of their clients and the public who may visit their completed works. Although environmental concerns were previously covered in Chapter 13, those associated with plastics are reiterated here to emphasize to designers their potential professional liability for the choices and applications they recommend.

Flammability and Toxicity. While many plastics are rated as slow-burning or self-extinguishing, a few types—including some acrylics, polyurethane foams, and polystyrenes—have been found not only to burn and/or melt or break down molecularly under certain conditions, but to give off lethal and possibly explosive gases in the process. The plastics industry is attempting to overcome these hazards with new flame retardants, new chemical formulas, and the issuance of consumer information about the properties and appropriate uses of the materials.

Biodegradability. The possibility of a plastic being reabsorbed into the environment is also a matter of public awareness and demand for accountability. Plastics that can be melted down presumably could be reformed and recycled. In one

16.29 An Art Deco table has a glass top cantilevered from a sculptured acrylic base like an abstract ice carving. Michael Berkowicz, designer. (Courtesy Plexability. Photograph: Paul Aresu.)

example, plastics have been ground into chips and then combined with sand to make concrete. Other such uses are being found. Chemists continue to work on formulas for plastics that would eventually break down into harmless particles and decompose in landfills.

Noxious Fumes. The chemicals contained in the many plastics used throughout the home release vapors such as formaldehyde and benzene. With the emphasis put upon energy conservation and the nearly airtight enclosures modern technology has made possible, these fumes can easily become a health hazard. Adequate fresh air ventilation and the inclusion of live plants such as chrysanthemums, azaleas, dieffenbachia, English ivy, and peace lilies prevent a toxic buildup, but designers must be aware of the continual degradation of many unstable plastics and the harmful effects that may result.

FORM AND ORNAMENT IN PLASTICS

Plastics differ from natural materials in that their basic qualities are chemically and physically determined by humans. Thus, instead of designing to suit a material, manufacturers can actually create a material to meet a specific need, real or imagined. This brings new challenges and problems. For one thing, such absolute flexibility indicates the need for close, steady cooperation among chemist, manufacturer, and designer. The designer is not only confronted with a characterless substance to mold, but has no age-old craft tradition in which to seek accumulated knowledge or inspiration. On the other hand, this absence of guidelines frees the designer from the stereotypes of past forms.

Design in plastics can be a completely liberated merger of designer, material, and machine. No longer hampered by preconceived notions of what is proper for any particular material, the imagination can soar in many directions, starting with the composition of the plastic itself and ending with new shapes and even new

16.30 Plastics can be used effectively in any part of the home, for a wide variety of surfaces and structures, as seen in this open two-level area of a British apartment, as viewed from a terrace, with the kitchen/eating space below and a home office above. R. Portchmouth & M. Russum, architects. (Photograph: Richard Bryant/Arcaid)

functions. This does not mean that shapes *must* be invented simply because the potential exists; the contours of plastic dishes and tumblers closely resemble those of clay or glass because these have been found serviceable and pleasant. But in some fields, major breakthroughs have been achieved. Furniture designers have been investigating whole new vocabularies of shape and function allowed by the properties of the new materials, while architects continue to explore the possibilities of free-form structures of intriguing shapes. And some of the simplest forms assume a completely new quality when translated into pristine plastic.

Successful ornament in plastics remains largely structural, where the inherent possibilities for varied colors, different degrees of transparency, translucency, or opacity, embedded materials, and molded form and surface texture seem to be in the nature of the materials and in the processes used to form them. The traditional materials also have these possibilities, but a plastic can combine some of these characteristics in a different way or may add other qualities that are desirable, usually those of durability and/or ease of maintenance.

Because the conventional types of applied ornament are so closely allied with the natural materials they were originally designed to enhance, they are likely to appear weak, imitative, and inappropriate when used on plastics. Perhaps this is so because, as yet, little applied ornament has been developed for plastic that intensifies its unique quality, as, for example, etching or cutting heightens the sparkle of glass or intricate ornament throws into relief the luster of polished silver. However, many consumers and manufacturers conservatively prefer that which is at least partially familiar to something wholly new. At the other extreme, the lack of restrictions imposed by the material has resulted in much poor design or, in some cases, an overexuberance of design. Increasingly effective design in plastics continually becomes available as their nature is more fully understood.

The introduction of plastics has had enormous impact on today's homes. Plastic surfaces on furniture, counters, walls, and floors lighten maintenance and reduce noise. Plastic furniture is light in weight and easy to move from place to place;

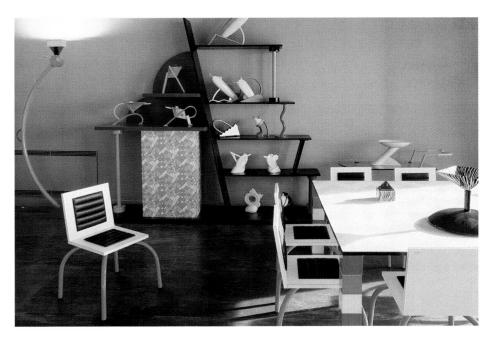

16.31 Designers and manufacturers are finding innovative new uses for the many types of plastics continually being developed. In the Monte Carlo highrise apartment of fashion designer Karl Lagerfeld, the works of the Italianbased international design collective, Memphis, exploit the versatility of plastics and metals in characteristically unexpected combinations of materials, textures, and patterns. The all-Memphis environment provides creative inspiration for Lagerfeld's work. (Photograph: Guy Bouchet)

many materials in the house may be of plastic, from plumbing to insulation to wall panels. Designers have accepted it as an exciting new medium, and are busy exploring its potentialities (Figure 16.31) while also discovering its liabilities.

Ceramics, glass, metals, and plastics make up many elements, both structural and applied, in today's interiors. They provide a wide range of natural and manmade surfaces that appeal to the senses in nearly every imaginable way. The application of each material will be further explained in Part Five, "Interior Components and Treatments."

REFERENCES FOR FURTHER READING

Almeida, Oscar. Metalworking. New York: Drake, 1971.

Bevlin, Marjorie Elliott. *Design Through Discovery*, 5th ed. New York: Holt, Rinehart and Winston, 1984, pp. 177–180.

Burton, John. Glass: Handblown, Sculptured, Colored: Philosophy and Methods. Philadelphia: Chilton, 1968.

Carron, Shirley. Modern Pewter: Design and Technique. New York: Van Nostrand Reinhold, 1973.

Charleston, Robert J. World Ceramics. New York: McGraw-Hill, 1968.

Hardner, Paul V. and James S. Plant. Steuben: Seventy Years of American Glass Blowing. New York: Praeger, 1975.

Hughes, Graham. Modern Silver Throughout the World: 1880–1967. New York: Viking, 1967. Labino, Dominick. Visual Art in Glass. Dubuque: William C. Brown, 1968.

McKearin, George and Helen S. McKearin. 200 Years of American Blown Glass, rev. ed. New York: Crown, 1966.

Nelson, Glenn C. Ceramics: A Potter's Handbook, 5th ed. New York: Holt, Rinehart and Winston, 1984.

Newman, Thelma R. Plastics as an Art Form. Philadelphia: Chilton, 1964.

Newman, Thelma R. Plastics as Sculpture. Radnor, Pa.: Chilton, 1974.

Roukes, Nicholas. Sculpture in Plastics. New York: Watson-Guptill, 1978.

Savage, George. Glass. New York: Putnam, 1965.

Textiles

FIBERS

Natural Fibers Man-Made Fibers Fiber Blends

YARNS

FABRIC CONSTRUCTION

Weaving Knitting

Other Constructions

FINISHING THE FABRIC

Functional Finishes Color Application Decorative Finishes and Enrichment

GLOSSARY OF FABRICS AND THEIR USES

Sheer Lightweight Medium Weight Heavy

Textiles make us comfortable, control light coming through windows, give privacy without solid walls, insulate against extreme temperatures, and absorb noise. They provide easily removable and cleanable coverings for tables and beds, as well as pleasant-to-touch upholstery for chairs and sofas. Beyond these service functions, fabrics bring beauty and individuality unlike that of any other material. Several distinctive characteristics of fabrics are worth noting:

- No other materials are available in such width and length and can be readily used in those dimensions.
- Uniquely pliable and easily manipulated, fabrics can be folded, draped, pleated, or stretched; and they can be cut, sewed, or glued together.
- Of all the materials in the home, fabrics are most frequently and most easily replaced.
- Textiles are noticed because they appear in quantity throughout the home, look and feel softer than other materials, and are often brightly colored or patterned.

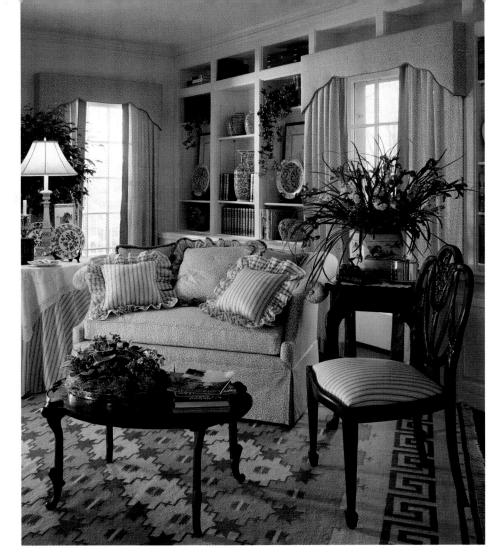

17.1 The variety of blue and white patterns throughout this room are unified by the repetition of two fabrics used as upholstery, window treatment, table cover, and pillows. (Courtesy Waverly)

• Fabrics link together people, furniture, and architecture: Carpet and other textiles attached to floors and walls adhere strictly to the "architecture" of the interior; upholstery adapts itself to the objects on which it is used and at the same time relates them to our clothing; curtains and draperies relate openings to the enclosing structure and to the furniture in the room.

Textiles serve two important functions. First, they make their own visual and tactile contributions to the home. Second, they can be strong unifying elements within a room and between rooms. Fabrics may be used for their functional qualities, to improve the appearance of functional items, or strictly for their aesthetic appeal. In addition, the use of fibers and fabric is a legitimate art form (discussed in Chapter 23, "Accessories".)

The creation of a textile product, whether commercially or by hand, involves several stages of development: the fiber-to-yarn-to-fabric construction and the application of finishes, color, and pattern. The performance and appearance of a finished fabric depend upon decisions made at each step in the process.

FIBERS

Fibers are the raw materials, the basic units that form the building blocks of textiles. They may occur naturally or be man-made. Nature provides four major fibers that have been used for centuries: cotton, flax, wool, and silk. However, many fibers used today are products of modern technology and the scientist's laboratory due

to the limited availability of natural fibers, the expense of processing them, and their limitations.

The natural fibers, with the exception of silk from cultivated silkworms, are **staple** fibers, available only in short lengths measured in centimeters or inches or fractions thereof. (Wild silkworms produce a staple fiber silk called *tussah*.) Staple fibers must be combed and carded to straighten and align them before spinning to form yarn. Man-made fibers and cultivated silk are **filaments**—long continuous fibers measured in yards or meters or even miles. They have a higher luster, are smoother, more even, and require considerably less processing than staple fibers to form yarns. Filament fibers may be cut into shorter lengths to use as staple fibers to blend with natural fibers, to imitate natural fibers, or to produce fabrics with greater insulating properties, higher bulk, or fuzzier surfaces less susceptible to snagging.

Fibers may also be characterized as **thermoplastic** if they become soft or moldable when heat is applied and can thus be heat-set to stabilize dimensions, give a permanent-press finish, or emboss designs upon their surface. All *synthetic* fibers (those manufactured fibers such as nylon that are synthesized from chemical substances in the laboratory) are thermoplastic.

Most synthetics (such as polyester, acrylic, and olefin) and man-made mineral fibers (such as glass and metallics) are **hydrophobic** or nonabsorbent, while most *natural* fibers such as cotton, linen, and wool are **hydrophilic** or absorbent, which

17.2 This indoor/outdoor furniture features weather resistant materials and finishes that withstand exposure to moisture and sunlight and are mold and mildew resistant. The fabrics are acrylic; the cushions are filled with polyester fiber and a mesh that promotes quick draining. The wicker frames are dip-coated and finished with outdoor resins. (Courtesy Lane Upholstery, Venture Collection)

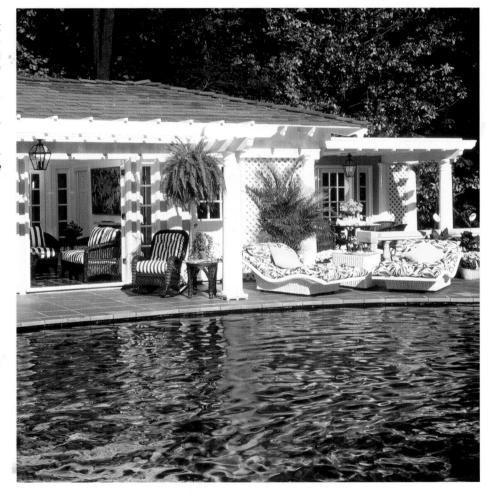

makes them comfortable and more easily dyed. *Crimp* denotes the waviness of the fiber and affects its resilience. Wool has a natural crimp; man-made fibers can be given a crimp. *Loft*, the springiness of a fiber, can also affect resiliency.

Fibers differ from one another in many ways: strength and elasticity; resistance to abrasion, stains, sun, moisture, mildew, and fire; appearance qualities; *hand* or tactile qualities, including softness, resilience, firmness, and delicacy; and maintenance. Each fiber has its strong and weak points. Although some are more versatile than others, none is ideally suited to every purpose. Moreover, important developments occur all the time—new man-made fibers are created, familiar ones are modified, and processing and finishing techniques are improved. For example, early nylon fibers were very different from the new advanced generation nylons in terms of soil and abrasion resistance. Table 17.1 provides basic facts about the performance characteristics of the more important fibers.

NATURAL FIBERS

The sources of natural fibers are plants, animals, and, to a lesser degree, minerals and natural rubber. The major textile fiber-producing plants and animals have long since been domesticated and may be considered renewable sources, although some "harvests" may be cyclical rather than continuous.

CELLULOSIC FIBERS Plant stems, stalks, leaves, seed hairs, and even barks that consist mostly of cellulose and need only be changed in physical form make up the natural vegetable fibers. The two most common are cotton and flax.

Cotton is one of the most versatile and durable fibers; it may be used in fabrics that range from sheer to heavyweight, from inexpensive to expensive, and from window coverings and linens to upholstery and floor coverings. Cotton is absorbent, dyes easily, retains color, reflects heat, is flexible, and launders easily. It can be processed and finished to overcome most of its disadvantages (wrinkling, shrinking, soiling, and burning), and it is often used in combination with other fibers to produce blends that capitalize upon the best characteristics of each. Cotton is the most important natural fiber for environmentally sensitive uses.

Linen, made from flax fibers, is the oldest fiber still used in the Western world. It is crisper and more lustrous than cotton but may also range in use from sheer and smooth to coarse. Linen is strong and wears well with good resistance to deterioration from age and, to a lesser degree, sunlight. A limitation of linen is its tendency to show wrinkles.

Other plant fibers include **jute**, **ramie**, **hemp**, **kapok**, and **sisal**. Still other plants woven into mats or used as wall coverings include various *palm*, *grass*, *husk*, and *straw* fibers. Even *bark* may be pounded into a kind of cloth.

All cellulosic fibers have low static electricity but they burn easily, a characteristic that must be taken into consideration by the designer where safety is important. Fabrics burn more quickly in an upright position, such as when used for draperies and curtains, than when used in a flat or horizontal position.

PROTEIN FIBERS Most of the protein fibers are obtained from the hair of animals, some from insect secretions. Hair fibers include the **fleece** of sheep, **goat's** hair (*mohair* and *cashmere*), **camel's hair** (including *alpaca*, *llama*, and *vicuna*), **horsehair**, and the **fur** of animals such as *mink*, *rabbit*, or *beaver*. Fibers from fibrous secretions are obtained primarily from the silkworm.

Wool, although considered a weak fiber, is very durable because of its exceptional resiliency and good elasticity and elongation properties. It makes an excellent carpet and upholstery textile. Wool dyes readily and retains color, in part because it is highly absorbent. Yet it also resists soil. Wool fibers tend to yellow

TABLE 17.1 Performance Characteristics of Common Textile Fibers

Fiber, Fiber		0	Resistances
Substance, Trade Names*	Appearance	Poor	Good
acetate (cellulose diacetate): Acele, Avisco, Celanese, Chromspun, Estron	drapes well; good color range	abrasion, aging, heat, sunlight, wrinkling	felting, fire (Acele), insects, pilling, shrinking, static electricity, stretching
acrylic (acrylonitrite and other monomers): Acrilan, Creslan, Orlon, Zefran	warm, bulky, woollike touch; good color range in some types	pilling, static electricity unless treated	abrasion, felting, fire, shrinking, stretching, sunlight, wrinkling
cotton (cellulose)	pleasant, soft, dull surface; fair drape; excellent color range	felting, fire, mildew, shrinking, wrinkling	abrasion, aging, fading, insects, stretching, sunlight
glass (silica sand, limestone, aluminum, and borax): Beta, Fiberglas, Uniglass, Pittsburgh PPG	lustrous, silky; good drape; fair color range in dyes, printed many hues	abrasion, flexing (nonelastic) but new processes increase flexibility	
linen (cellulose, from flax)	clean, fresh, lintless; fair drape; good color range	fire, shrinking, wrinkling unless treated or blended	abrasion, mildew, pilling, stretching, sunlight
modacrylic (modified acrylics): Dynel, Verel	warm, bulky, heavy, dense	heat, shrinking unless stabilized by heat-setting, sunlight (<i>Dynel</i>)	abrasion, pilling, static electricity, wrinkling
nylon (polyamide): 6, 6.6, 501, Antron, Caprolan, Cumuloft	natural luster; good drape; good color range	pilling, static electricity unless treated, sunlight	fire
olefin (ethylene, propylene, or other olefin units): <i>Herculon</i> , <i>Vectra</i>	woollike hand; fair color range	heat, shrinking, static electricity	abrasion, felting, fire, stretching, sunlight, wrinkling
polyester (dihydric alcohol and terephthalic acid): <i>Dacron, Fortel, Kodel</i>	crisp or soft, pleasant touch; good drape: fair color range	dust, soil, pilling because very electrostatic	abrasion, fire, sunlight
rayon (regenerated cellulose): Avril, Cupioni, Enka, Fortisan	bright or dull luster; drapes well; excellent color range	felting, fire, mildew, shrinking, wrinkling	abrasion, aging, insects, stretching (poor when wet), sunlight
silk (protein from silkworm cocoon)	lustrous, smooth, unique crunchy softness; drapes well; excellent color range	fire (but self-extinguishing), static electricity, sunlight	abrasion, aging, felting, insects, mildew, shrinking, stretching, wrinkling
triacetate Arnel	pleasant luster; drapes well; excellent color range		abrasion, insects, pilling, static electricity, stretching
wool (protein from sheep or goat and camel families)	soft or hard finish; dry, warm touch; drapes well; good color range	insects, felting, shrinking unless treated	abrasion, aging, fire, mildew, pilling, stretching, static electricity, sunlight

^{*}Only partial listing of trade names

6	Special Characteristics		
Excellent	and Processes	Maintenance	End Uses
	newer processes have color as integral part of fiber, increasing resistances to sunlight, cleaning	fair soil resistance; dry-clean or wash; dries quickly; iron with cool iron	bedspreads, curtains, draperies, rugs, upholstery
aging, insects, mildew, sunlight	warmth without weight; retains heat-set pleats and creases	slow to soil; easy to spot-clean; dryclean or wash; dries quickly; little ironing, under 325°	blankets, curtains, rugs, upholstery
pilling, static electricity; all resistances greatly improved by special treatments and blends	mercerizing increases luster, softness, strength, dye absorption; wash-and-wear, spot- and wrinkle- resistant finishes	soils, stains, wrinkles easily unless treated; dryclean or wash; irons easily	bed and table linen, bedspreads, draperies, rugs, towels, upholstery
aging, chemicals, felting, fire, insects, mildew, shrinking, stretching, sunlight	Beta yarn one-half size of any other fiber; can be woven into very sheer fabric; fireproof, impervious to moisture and salt air; shed fibers can cause skin rash	slow to soil; easy spot removal; hand-wash, hang with no ironing; dries quickly	bedspreads, curtains, draperies, wallpaper
aging, insects, static electricity	stronger when wet; Sanforized to reduce shrinking; can be made wrinkle-resistant	soils and wrinkles easily; washes and irons well	curtains, draperies, household linens, rugs, upholstery
aging, felting, fire, insects, mildew, sunlight (Verel)	self-extinguishing; special processes result in dense, furlike pile, textured, three-dimensional effects	similar to acrylics, but highly resistant to chemical stains; iron setting varies	blankets, draperies, rugs, upholstery
abrasion, aging, felting, insects, mildew, shrinking, stretching, wrinkling	outstanding elasticity, strength, and lightness; can be heat-set to keep permanent shape; sometimes damaged by acids; may pick up color and soil during washing	slow to soil; easy spot removal; dry-clean or wash, dries quickly; little ironing at low heat	bedspreads, rugs, upholstery
insects, mildew, pilling, aging	lightest fiber made; excellent insulator; transmits humidity well; is very cohesive (can be made into nonwoven carpets); low cost	slow to soil; spot-clean or wash; little ironing, at <i>very</i> low heat	blankets, rugs, upholstery, webbing
felting, insects, mildew, shrinking, stretching, wrinkling	lightweight; ranges from sheer, silklike to bulky, woollike; as strong wet as dry; retains heat-set pleats and creases; picks up colors in washing	soils easily; dry-clean or wash, dries quickly; very little ironing, moderate heat	bedding, curtains, draperies, upholstery
pilling, static electricity; all resistances greatly improved by blending, finishes	most versatile fiber—can resemble cotton, silk, wool; absorbs moisture and swells when wet unless specially processed; reduces static electricity in blends; low cost; wash-and-wear and spot- and wrinkle-resistant finishes	fair soil resistance; dry-clean or wash; iron like cotton or silk, depending on type, finish	blankets, curtains, draperies, rugs, table "linens," upholstery
	most desirable combination of properties of any fiber; smoothness, luster, resiliency, toughness for its weight, adaptability to temperature changes	good soil resistance; dry-clean or hand-wash; irons easily, moderate heat	draperies, rugs, upholstery
aging, felting, fire, mildew, shrinking, wrinkling, sunlight	excellent retention of heat-set pleats and creases; ability to withstand washing, ironing	slow to soil; dry-clean or wash; dries quickly; little ironing, higher setting than deacetates	draperies
wrinkling; new processes make it even more resistant to soil, stains, water, wrinkling	notable for warmth, absorbency (without feeling wet), resiliency, durability; wool-synthetic blends reduce shrinkage but have tendency to pill	good soil resistance; spot- clean, dry-clean, or wash in cold water; press over damp cloth at low heat	blankets, draperies, rugs, upholstery

with age and exposure to sunlight, to shrink and felt, and to be susceptible to insect damage (from moths and carpet beetles). Wool is naturally flame resistant, self-extinguishing after the source of ignition is removed. (Firefighters carry wool blankets with their equipment because they can be used to smother a fire.)

Other animal-hair fibers, also identified as wool, are considered specialty fibers because they are less readily available and are usually desired for their special luxurious characteristics. Animal skins (leathers) may also be considered specialty fabrics, although they are not fibrous or typically constructed as most fabrics are.

Silk has long been considered a luxury fiber, in part perhaps because of the romantic legends concerning its history. It is produced by the larva of the silkworm in spinning its cocoon, which is then unreeled by man to use in yarn manufacture. *Cultivated* silk filaments are very long, smooth, strong, and quite lustrous. The industry that cultivates the growth and production of moths for their silk is called sericulture. *Wild* or *tussah* silk has more coarse, uneven, and less lustrous staple fibers. *Spun* silk is made of short fiber lengths from the outermost layer of the cocoon. A wide variety of yarn and fabric structures are possible with a fine hand, excellent color, and durability; conversely, silk is quickly damaged by sunlight, retains creases, and is subject to damage from abrasion.

All protein fibers share the properties of moisture absorbency, which helps make them easy to dye; various degrees of resiliency and elastic recovery, which helps with wrinkle resistance/recovery; low heat conductivity, which enhances insulating capabilities; static electricity buildup; and poor resistance to alkalies.

MINERAL FIBERS **Asbestos**, a natural mineral fiber which is totally fireproof, is not used anymore due to its carcinogenic nature.

NATURAL RUBBER Natural elastomeric fibers, from the sap of the rubber tree, have been largely replaced by synthetics. However, **rubber** filaments are still used as an elastic yarn core, wrapped with cotton, rayon, or nylon. Synthetic elastomeric fibers are more resistant to sun, cold, oils, perspiration, and smog.

MAN-MADE FIBERS

Man-made fibers are not all synthetic; some are extruded from natural solutions that have been chemically altered or regenerated. True synthetics are synthesized primarily from petrochemicals. The man-made fibers have several characteristics in common: They are produced in either monofilament or multifilament form and may not require additional processes to form yarns; they resist damage from moths and insects; they are generally nonallergenic; many repel, rather than absorb, moisture and soil, making them easy to care for. Production can be controlled for uniform quality, and it is continuous, keeping costs fairly stabilized. Most importantly, man-made fibers can be specifically designed and created for particular purposes. *Generic* terms are used here to name families of man-made fibers with similar chemical composition. The Textile Fiber Products Identification Act (TFPIA), effective since 1960, established generic names to eliminate confusion over *trade* names given to fibers by textile manufacturers. This legislation also requires fiber content labels on all textile products sold at retail.

Cellulosic Fibers. These man-made fibers originate as plant fibers, primarily from soft woods, but are regenerated and modified to produce rayon, acetate, and triacetate fibers. Rayon has good flexibility, high absorbency, and good resistance to solvents and aging. Its weaknesses include low resiliency, shrinkage, gradual deterioration in sunlight, damage from mildew and bacteria, and ease of burning. Modifications in processing improve strength, dimensional stability, wrin-

kle resistance, and hand. **Acetate** has low strength, poor resiliency, low tolerance to sunlight, and poor resistance to acids, but it withstands dry cleaning solvents, resists insects, and can be treated for flame retardance. **Triacetate** withstands sun better than other man-made cellulosic fibers (and silk) and has good resiliency and

resistance to aging.

Noncellulosic (Synthetic) Fibers. The generic families, each chemically distinct, which belong in this group of invented fibers include nylon, polyester, acrylic, modacrylic, olefin, saran, aramid, and vinyl. Nylon, manufactured under hundreds of trade names with differences in characteristics, has the general characteristics of elasticity, tenacity, resiliency, low absorbency, sensitivity to sunlight (although finishes can improve resistance), and destruction by acid fumes. There are also many types of polyester which is characterized by low moisture absorbency, except for oily materials, and an excellent ability to withstand sun behind glass although direct sun weakens it. Acrylic was originally thought to be a synthetic replacement for wool because of its bulk, warm hand, softness, and resilience. It is not sensitive to sunlight, micro-organisms, or insects, but burns and retains enough heat to ignite other materials and must be treated to prevent shrinking and/or stretching. Modacrylics are similar but do not burn, making them good choices for window treatments and such. Olefin fibers are often used in carpet and upholstery fabrics. They absorb no moisture, but are cleanable with water, and, depending upon method of fabrication, resist crushing. Oil stains on olefin carpet are difficult to clean and, because of its low melting point, olefin can cause problems in areas with high heat. Saran is tough, durable, and easily maintained, especially for outdoor furniture. Aramid is resistant to fire, sun, moisture, micro-organisms, insects, aging, even bullets. Vinyl was discussed in Chapter 16.

Elastomeric Fibers. These fibers are elastic, rubberlike substances such as spandex. Used with other fibers, they give improved form-fitting qualities.

Mineral Fibers. Man-made fibers of mineral source include glass fiber and metallic fibers. Because none of these materials are fibrous in their natural state, they are considered man-made fibers. Glass fibers may produce allergic reactions in some people, perhaps due to irritation from the fiber ends. Fiberglass has low abrasion resistance. Metallic fibers may be composed of metal, plastic-coated metal, metal-coated plastic, or a core covered by metal. The metals most often used are gold, silver, aluminum, and stainless steel, which is often incorporated into carpet to reduce static buildup.

FIBER BLENDS

A textile may consist of only one fiber or may combine two or more to maximize favorable qualities and minimize disadvantages. Different fibers can be extruded as a single filament, spun together into one yarn, or yarns spun from different fibers can be combined in a single fabric. Combinations of fibers have yielded some of the most successful improvements in fabric characteristics: Adding polyester fibers to cotton, in varying proportions, produces textiles that are almost wrinkle-free and remarkably dirt-resistant; nylon increases the strength of wool; and stretch nylon combined with cotton makes slipcovers that are form-fitting and pleasant to touch. The permutations are almost endless; they permit the manufacture of fabrics that can embody the best attributes of each fiber. However, designers need to keep educating themselves on the characteristics of fibers so that their probable performance *in use* can be to some extent predetermined. For practical purposes, a textile blend of less than 5 to 10 percent of a fiber benefits very little from the characteristics of that fiber. In this sense, blends are only as strong as the weakest fiber contained therein.

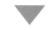

YARNS

Yarn results when fibers are twisted together to make a strand long enough and sufficiently strong for weaving or other fabric-construction processes. With natural fibers, yarn making includes cleaning the fibers, drawing them out so they are more or less even and parallel, then spinning or twisting them into yarn. Manmade fibers are clean, continuous, and parallel as soon as they have been extruded as filaments, so the process is simply one of twisting them together. Yarns vary in the kinds of fibers used either alone or in combination, in the type and tightness of twist, in the *ply* (the number of strands in the yarn), and in the size of the finished product.

Filament fibers form **filament yarns**, while staple fibers are combined to create **spun yarns**. Twisting fibers tightly or loosely is one possible variation in yarn construction. Filament yarns and yarns twisted firmly (but not so tightly as to curl back on themselves) tend to be noticeably stronger and more durable than loosely twisted and spun yarns. Increased twist adds elasticity.

Fiber strands can form single yarns, ply yarns, or cord yarns. In **single yarns**, individual fiber strands are twisted together. **Ply yarns** are made by combining two or more single yarns twisted together; **cord yarns** consist of two or more ply yarns. Yarn sizes range from spider-web single filaments to silk yarns of two hundred strands or ropelike cords. Many textiles contain only one size of yarn, but others combine several or many sizes, depending upon the desired effect.

Simple yarns are relatively smooth, even in size, and have a uniform number of twists per inch. They produce plain, smooth, flat-surface, relatively hard-finish fabrics that are usually easy to maintain and durable, although fiber content, fabric construction, coloring methods, and finishing procedures also affect use and care. Fabric pattern is achieved through woven-in or printed-on finishes.

Complex or novelty yarns are generally irregular in size, twist, and effect. They are used primarily for appearance and include *slub* yarns found in fabrics such as shantung and some linens, *flock* yarns found in tweeds, *bouclé* yarns, and *chenille* yarns. Fabrics constructed of complex yarns are relatively highly textured and tend to be more vulnerable to wear than fabrics made with simple yarns; they derive their decorative quality from the appearance of the yarn more than from fabric construction or finishing processes.

17.3 (below) A textile woven of only one fiber can have decided structural interest because of the yarn composition. In "Ticino" the yarn consists of a number of strands, almost casually laid and loosely twisted. (Courtesy Stow/ Davis Furniture Company)

17.4 (below, right) When magnified, a simple 4-ply yarn shows separation into four single yarns, one of which is further loosened by untwisting, revealing many fibers. (From Joseph's Introductory Textile Science, 6th ed., by Peyton B. Hudson, Anne C. Clapp, and Darlene Kness)

FABRIC CONSTRUCTION

Although there are endless ways of making fabrics, all of them fall generally into one of three basic categories. Each of these methods has its own special advantages, and each lends itself to certain effects and end uses.

WEAVING

Weaving is the interlacing of warp and filling yarns, usually at right angles, to make textiles. Warp yarns run lengthwise on the loom and in the fabric. Filling yarns (also called *weft* or *woof*) run crosswise to fill and hold together the warp. The apparently enormous complexity of weaves can be reduced to three general categories: plain, twill, and satin.

Plain weave is simply one filling yarn carried over one warp yarn and under one. When plain weaves utilize warp and filling yarns of identical size, a smooth-surface fabric such as organdy or percale results. The variations include *rep*, which has a definite ribbed texture produced by interweaving relatively heavy yarns with thinner ones, and *basket weaves*, a construction of two or more filling yarns crossing two or more warp yarns to produce a noticeable pattern, as in monk's cloth. Other patterns such as chambray, checks, and plaids are created by varying the colors of the yarns.

Twill weaves show a definite diagonal line or *wale* on the surface of the fabric, caused by having the filling yarns "float" across a number of warp yarns in a regular pattern. Typical fabrics include serge, gabardine, and denim. *Herringbone patterns* result from reversing the direction of the twill weave. Twill weaves resist soil and wrinkle less severely than do plain weaves of similar quality. They also tend to be the most durable fabric constructions.

Satin weaves differ from twill weaves in that the warp yarns make longer floats over the filling yarns, or the filling may float over the warp less regularly. These floats minimize the over-and-under texture. If the yarns are fine and lustrous, the fabric surface will be smooth and will shine with reflected light. Satin, sateen, damask, and chino are examples of this weave category. Satin weaves are the most vulnerable to wear of the basic fabric constructions.

Within the three basic classes of weaves, there are special variations particularly relevant to home furnishings that should be mentioned.

3, 2-ply Cord Yarn

three plies, each ply made of two single yarns

17.5 This diagram of a three, 2-ply yarn shows that it is formed from three plies, each of which consists of two single yarns. (Adapted from Joseph's Introductory Textile Science, 6th ed., by Peyton B. Hudson, Anne C. Clapp, and Darlene Kness)

17.6 (below, left) Complex yarns give this knitted cotton draperyweight fabric its interesting nubby texture. (Courtesy E.I. duPont de Nemours & Co.) (below, middle) Alternating squares of plain weave and basket weave result in a distinctive structural design in Jack Lenor Larsen's wool fabric, "Spellbound." (Courtesy Jack Lenor Larsen, Inc.) (below, right) The diagonal line characteristic of a twill weave can be emphasized by varying the angle and color of the pattern to produce a visually exciting kinetic effect. (Courtesy Stow/Davis Furniture Company)

Leno weaves result when the warp yarns (or occasionally the filling yarns) are crossed or twisted at certain points to create an open, gauzelike effect, as in marquisette. Usually, the open weave has such a small scale that the design is hardly noticed, but coarser versions produce handsome patterns. Leno weaves appear frequently in casement fabrics.

Pile weaves add a third element to the basic warp and filling: a set of yarns that protrude from the background to make a three-dimensional fabric. In commercial production, the pile generally is added with a single continuous yarn that leaves loops on one side of the fabric. When the loops are left uncut, such textiles as terry cloth and frieze result. Cutting the loops produces velvet, plush, and the like. Patterns can be formed by cutting some loops and leaving the remainder uncut, as in corduroy; by having some portions of the pile higher than others; or by employing different colored yarns. Chenille fabrics have a pile that results from

- **17.7** (right) A satin weave, with its long floating yarns on the surface, produces a shimmering, glossy fabric.
- 17.8 (below, left) "Leno Sheer," designed by Hugo Dreyfuss, has a linen warp with hemp and rayon filling crossed and locked in the typical figure-8 leno weave. Its fragile appearance masks its actual strength. (Courtesy Kagan-Dreyfuss)
- 17.9 (below, right) Pile weave upholstery fabrics reflect only a limited amount of diffused light, particularly when dark in color as in this intimate study. They contribute visual warmth and tactile comfort to an interior. (Photograph: Scott Frances/ESTO)

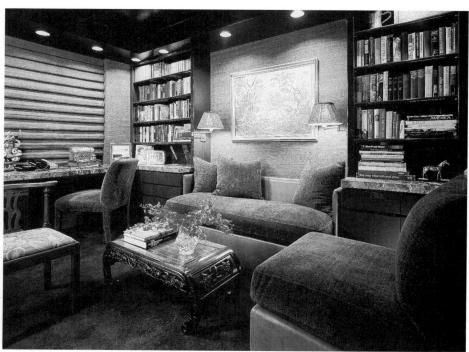

the use of chenille yarns with their soft fiber ends fluffed up like caterpillars. Certain fine rugs, including rya and Oriental rugs, are created by hand-tying individual strands of yarn onto the warp between rows of filler. This gives maximum flexibility in design. A variation on pile fabrics, *tufting* involves inserting pile yarns through previously constructed backing, which may or may not be woven. Most carpet is produced by this method. The hand version of this technique is more often called *booking*. (See Chapter 19 for more information on carpet construction.)

Jacquard weaves are pattern weaves produced on a highly complex machine—the Jacquard loom—that operates like a computer. They include flat damasks, raised brocades, complex tapestries, quilt-like matelassés, figured velvets, and woven carpet. A Jacquard pattern can be almost anything, from a simple geometric motif to a complex, irregular design.

KNITTING

Knitting is a process by which blunt rods or needles are used to interlock a single continuous yarn into a series of interlocking loops. Patterns result from a combination of *plain*, *rib*, and *purl* stitches, plus many variations. Because <u>machine knitting can be two to five times as fast as machine weaving, and therefore less expensive</u>, its possibilities have been reassessed in recent years. New fibers and techniques have produced dimensionally stable knit fabrics that have gained wide acceptance because of their stretch recovery, wrinkle resistance, and form-fitting characteristics.

Weft knits, also known as filling or circular knits, have horizontal or circular loops, resemble hand knitting in appearance, and include jersey, rib knit, double knit, and imitation fur fabrics. Horizontal stripe patterns are easily created in weft knits, and a Jacquard attachment makes a variety of patterns possible. Warp or flat knits have vertical loops and are flat. They include tricot and patterned open-structure raschel knits, laces, and drapery fabrics as well as some upholstery fabrics for foam furniture. Warp knits are usually more expensive than weft knits and do not have as much stretch.

17.10 (below, right) The Jacquard loom is capable of weaving complex figured patterns similar to handmade tapestries. This textured design is called "Kaleidoscope." (Courtesy Stroheim & Romann)

17.11 "Wave" and "Strata" are two knitted textiles designed recently by Jhane Barnes for KNOLLTextiles. Each is a fiber blend (worsted wool and polyester, and worsted wool and nylon, respectively), giving it wrinkle resistance, strength, or the best attributes of each of the fibers used. (Courtesy The Knoll Group)

OTHER CONSTRUCTIONS

Although most fabrics are produced by weaving or knitting, there are many other methods of fabrication, old and new. They may be grouped as fabric webs, knotted and twisted constructions, multicomponent fabrics, and films.

FABRIC WEBS Felt, bark cloth, and the more recent nonwoven fabrics are constructed by bonding together a **web** of fibers, with the aid of pressure, heat, moisture, and/or chemicals. Probably the earliest method of constructing fabrics, and one of the latest to be updated by new methods, **felting** is simply the matting together of fibers to form a web. Tapa cloth results from pounding together the fibers of the bark of the paper mulberry tree, often with leaves or other decorative materials added. Traditional felts are of wool, hair, or fur fibers matted by a combination of moisture, pressure, and heat, a process that induces shrinkage and increases density. The result is a continuous dense cloth—firm, slightly fuzzy, with comparatively low tensile strength, used mostly as a nonscratch protective padding or as insulation.

Needle-felts or needle-punched fabrics, constructed by a newer technique, depend upon machines pushing barbed needles through a mat of fibers to entangle them without the intervention of heat or pressure. According to the characteristics and arrangements of the fibers and needles, products with low or high strength can be produced. Padding for furniture, floors, and home insulation; indoor/outdoor carpet; and blankets are the products of needle-punched fabrics.

Nonwoven fabrics consist of layers of fibers **bonded** together by a binding agent that is set by wet or dry heat or by chemical action. *Spun-bonded* fabrics take the fibers directly from the spinnerette to the fabric without costly intermediate processes. Backings for carpet, wall coverings, and vinyls are made from various spun-bonded fabrics.

KNOTTING AND TWISTING In the processes by which nets, macrame, and laces are made, **twisting** calls for the intertwining and, sometimes, **knotting** of yarns that run in two or more directions. Machine-made lace is used for window, bed, and table coverings. Macrame is used for vertical blind vanes or louvers. Netting is also used for curtain fabrics.

MULTICOMPONENT FABRICS **Quilted, bonded, laminated,** or **foam-backed** fabrics have in common the fact that they are all comprised of at least two layers of material that are joined together with stitching, adhesive, or heat. Many upholstery fabrics use the bonding technique to provide a stable backing for loosely constructed surface fabrics, while drapery fabrics use it for insulative lining. This cuts the cost of producing a separate lining. Both tricot knits and foams are used as backings. Quilts utilize three layers and are traditionally hand-stitched, but today may also be machine-stitched or "heat-stitched."

FILMS **Films** result from processes that—by means of extrusion, casting, or calendering—produce sheets instead of filaments. Originally appearing as thin plastic sheeting or film, the new plastic fabrics come in varied thicknesses, from the thin films suitable for shower curtains to heavier weight vinyl for wall coverings. Upholstery grades are usually fused onto a knit or woven backing. Wall coverings may or may not be supported by a backing; they can also be laminated onto a layer of foam, which enhances insulating and sound-absorbing properties. Textures range from leatherlike smoothness through suedelike softness to deeply molded, three-dimensional patterns. Vinyl fabrics can also be printed, embossed, or flocked with a soft fuzz. Not surprisingly, many of the designs imitate leather or textiles, but a few exploit the unique possibilities of these products.

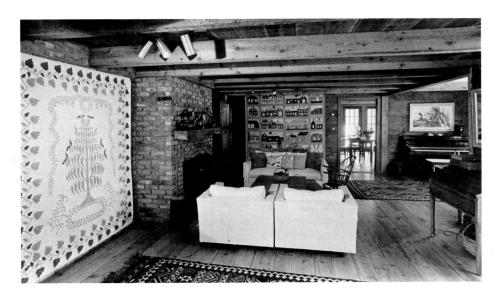

17.12 Two 19th century quilts hang in the living room of a renovated barn on Long Island, warming it physically and visually. Owners Anne and George Crawford wanted to preserve the character of the barn, so the natural materials of brick and stone remain exposed. (Photograph: Edward Hausner/NYT Pictures)

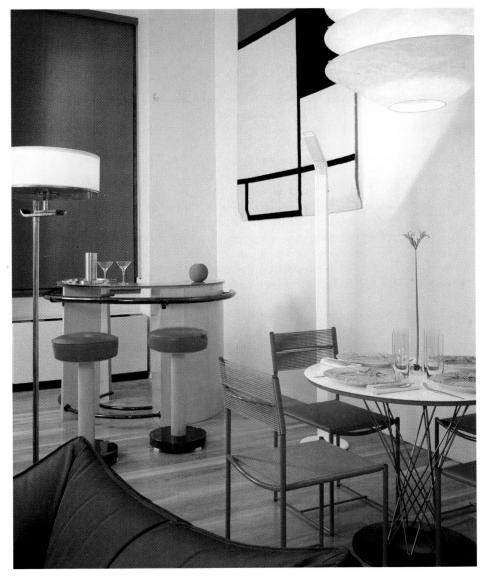

17.13 Vinyl upholstery is quite durable and requires little care, making it appropriate for casual furniture. On the bar stools in this apartment, vinyl film simulates leather; while on the dining chairs, vinyl cord is wrapped around the metal frame to give resilient support that conforms to whatever rests against it. Amie Gross Architect P.C. (Photograph: Frederick Charles)

Other techniques of fabric construction eliminate the costly cut-and-sew operations necessary to make a fabric fit a particular form. **Vacuum-formable fabrics** can be shaped into a single piece of upholstery to cover a chair in as little as two minutes. **Liquid vinyl** flows onto polyurethane foam and becomes bonded to it, resulting in a no-seams, perfect-fit, durable surface. Another method utilizes short-cut fibers that are electromagnetically **flocked** to the surface of a chair or sofa to become the upholstery.

FINISHING THE FABRIC

Various kinds of finishing give most fabrics their ultimate appearance and qualities. There are three types of finishes based on how they affect the function, the color, or the decorative qualities of the fabric.

FUNCTIONAL FINISHES

Finishes that affect the basic appearance or performance of a fabric include the following:

- Beetling, or pounding with steel and wood hammers to give luster to linens and linenlike fabrics.
- Calendering, a process by which fabrics are pressed between rollers to give smooth finishes and to tighten the weaves. It can also polish fabrics to a highly glazed sheen or emboss them with moire, crepe, or other patterns.
- Crabbing to tighten and set the weave in wool.
- Fulling to shrink, compact, and soften a wool weave.
- Gigging and napping to produce textures found in flannel and suede cloth.
- **Heat setting** to produce dimensional stability and aid in pleat retention.
- Mercerization, as applied to cellulosic fibers such as cotton, involves treatment with a solution of sodium hydroxide. If mercerized under tension, the fabric will be stronger, more lustrous, and more receptive to dyes; without tension (slack), mercerization causes the fibers and yarns to swell and contract, increasing the crimp of the yarn as well as its stretchability.
- **Shearing** and **singeing** to remove surface fibers, fuzz, and lint, and prevent pilling.
- Shrinking to lessen the tendency of most fibers to contract when exposed to moisture.
- Weighting to compensate for gum lost by silk in the cleaning process.

By such means, lifeless, flimsy textiles are transformed into usable, attractive materials. In addition, there are some special treatments that notably change the behavior of fibers and fabrics. Textiles can be treated to acquire the following characteristics:

- Antistatic, to prevent the buildup of static charges and reduce soiling.
- Bacteria-, mildew-, and moth-resistant in varying degrees of permanence.
- Fire- and flame-resistant through chemical treatments. An essential safety precaution, these processes can be durable but sometimes need to be renewed. Some treatments are *topical*, or applied to the surface, and must be repeated periodically. They may make textiles heavier and stiffer, but may also increase resistance to weathering and sometimes to insects and mildew. Specific controls have been set by federal law (the Flammable Fabrics Act) for carpet, mattresses, and

mattress covers. Degree of combustibility, flame-spread rate, and smoke density and toxicity are measured by a variety of tests such as the Steiner Tunnel Test, required by most states. This test simulates a fully developed fire to determine potential hazards of building materials and interior finishes. Interior finishes (including textiles) for commercial buildings are rated Class A, B, or C (from lowest to highest flame-spread range). Many organizations produce fire-related standards, including the American Society for Testing and Materials (ASTM) and the National Fire Protection Association (NFPA). A flame-resistant or flameretardant finish reduces flammability or tendency to burn. However, fabrics thus treated will burn, albeit slowly, in the direct path of flame. They self-extinguish when the source of flame is removed and do not propagate the fire. A fireproof fabric would not burn at all. Aramid, used in firefighters' protective clothing and space suits, is one of the most inherently fire resistant fibers. Glass fibers and modacrylics are also naturally noncombustible. Natural and man-made cellulosic fabrics ignite and burn easily if not treated with fire retardants. Plastics and synthetic fibers related to plastics present serious hazards in combustion speed and generation of intense heat and smoke, as discussed in Chapter 16. Flame-inhibiting finishes should be durable to satisfy flammability regulations. However, the care given these fabrics often determines finish durability.

- Fume-fading resistant through solution dyeing of man-made fabrics or the application of finishes to reduce damage from smog and atmospheric gases.
- Soil-resistant or soil-releasing by coating or impregnating fibers or fabrics with chemicals to make them less absorbent.
- Water-repellent by coating or impregnating the fibers with wax, metals, or resins. Such treatment makes fabrics hold their shape better as well as helps keep dirt on the surface.
- Heat-reflectant with metallic substances, usually aluminum, adhered to one side.
- **Insulating** through the application of a thin or foamed coating on the back, which keeps out the heat rays of the sun and keeps in winter warmth.
- Crease-resistant ("wash and wear," "easy care," "permanent press," and so on) by impregnating the fibers with resins or with agents that either cross-link cellulose molecules or build a "memory" into the fiber, causing it to return to its original shape. Crease-resistance gives textiles more firmness and sometimes better draping qualities; but it may also weaken fibers, reduce abrasion resistance, and wash out. Dyes become more permanent with this treatment, and shrinkage of spun rayons, light cottons and linens, and velvets diminishes. Bonding to a foam or tricot backing also enhances wrinkle-resistance.
- Elastic by including spandex fiber in the blend or by inserting stretch properties through special construction techniques, such as the twisting or crimping of yarns, slack mercerization of fabrics, or heat setting.
- **Stable**, chiefly through carefully controlled shrinking tendencies. In some processes, chemicals supplement moisture, heat, pressure, and tension.
- Glossy with resins that provide a more or less permanent smooth, lustrous surface. *Glazed* fabrics resist soil and have improved draping qualities. Glazing is usually limited to textiles meant for curtains, draperies, and slipcovers.

COLOR APPLICATION

Dyes can be introduced at several stages of the fabric-construction process. As the need demands, manufacturers dye unspun fibers, spun yarns, or woven textiles. In some synthetics and plastics, the dye is mixed with the liquid from which the fiber or film is made. Although generalizations about dyes cannot be absolute, the synthetic substances in which dye forms part of the fiber or film seem to be the most

17.14 A glazed finish gives luster to cotton chintz, adding depth to a pattern with a dark ground, particularly when shirred construction is used. (Courtesy Waverly)

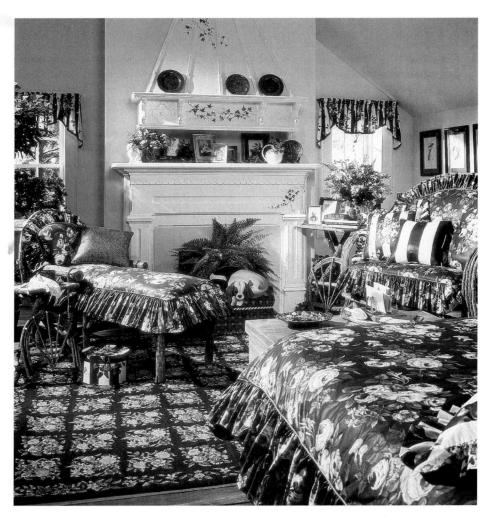

thoroughly colorfast. Next come the fibers and yarns dyed before fabric construction, and last the piece-dyed textiles. Today, however, less difference separates the latter two than was true in the past.

The kind of dye and its hue affect colorfastness, but almost all colors will fade in varying degrees when exposed to sun or polluted air, washed, or dry-cleaned. Unless fabrics are protected from sun and use at the cost of casual living, the most nearly fadeproof textiles available should be selected. Since all textiles change with time, it is sensible to select those that will mellow gracefully if they are to be kept a long while rather than those that will soon look tired and worn out. The following characteristics mitigate the results of fading:

- Colors most common in nature—grays, greens, browns, soft yellows, and oranges—retain their appearance longer than do colors of higher intensity. Mixtures, such as in tweeds, do not become as listless as faded solid colors. Dark colors may lose richness and depth with even a little fading.
- Textures, with their play of light and shade, compensate for loss of color.
- Patterns that are intricate or diffused lose less of their character than those whose interest lies chiefly in brilliant contrasts, precision, or clarity.

It is worthwhile to consider whether a little fading or wear need be so de-

plorable. Fabrics that have mellowed and that show evidence of having been lived with give some people a comfortable feeling of continuity and coziness. The softening of colors, textures, and patterns can result in a harmonious richness. Compare an antique Persian rug with a modern equivalent to realize that this is so.

Nevertheless, it should again be emphasized that one of the simplest ways to introduce color into the interior is through fabrics. Textiles contribute the brilliance and stridency of primary hues, the richness and depth of purples or chocolate browns, the subtlety of pastels. Large or small areas of solid colors or of decisive patterns can be achieved easily and inexpensively, and just as easily and inexpensively changed.

DECORATIVE FINISHES AND ENRICHMENT

PRINTING The easiest, least expensive way to add design to the surface of fabrics is by **printing**, a process known for at least four thousand years. Pigments mixed to the consistency of thick paste are applied to the finished fabric (or occasionally to the yarns before weaving) by one of the following methods:

• Roller printing involves the application of pigments from copper rollers engraved with the design. One roller is made for each color, but an effect of more colors than rollers can be achieved by engraving different parts of a roller to different depths or by printing one color over another. Sometimes the warp yarns

17.15 Monochromatic, nearly neutral, soft, and natural colors wear well with little noticeable fading over time. Accents of stronger, darker, more fade-prone color may be changed more frequently and at less expense than major pieces. Dennis Haworth, FASID, interior designer. (Photograph: Steve Simmons)

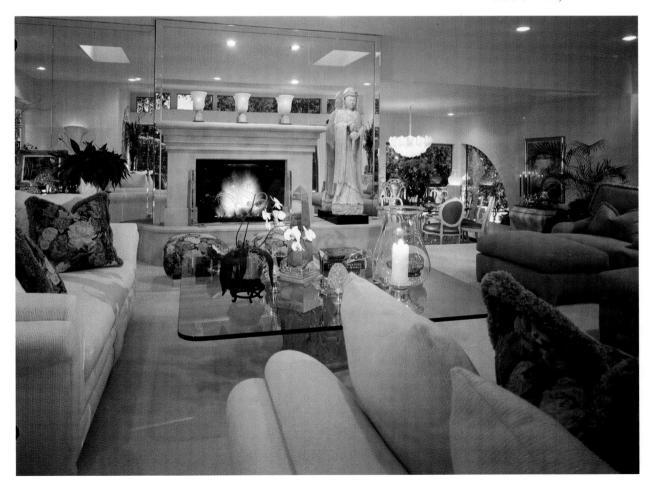

17.16 Examples of fabrics printed by different methods. (below, left) This roller-printed floral textile is an English document from the third guarter of the nineteenth century. (Courtesy Scalamandre Archives) (below, middle) Block printing is the oldest method of fabric printing. Characteristically, colors are limited, repeats are small due to manageability of block size, and the registration of designs shows some variation, a result of hand work. (Block printed fabric. Produced by Mainville and Fils, Orleans, France; about 1776. Cotton, plain weave. Height of repeat: 17 inches. Gift of Josephine Howell, 1973-51-95. Courtesy Cooper-Hewitt, National Museum of Design. Smithsonian Institution/Art Resource, N.Y. Photograph: Scott Hyde.) (below, right) Screen printing adapts well to large designs because the size of the screen (which can be quite large) determines the size of the repeat. Each color requires a separate screen. (Courtesy Brunschwig &

yarns are printed before weaving, which gives a soft, diffuse quality.

- **Block printing** is most often done by hand, although semimechanized methods exist. Wood blocks that may be surfaced with metal or linoleum transfer color to the fabric. Block-printed textiles have the slight irregularities characteristic of handcrafted designs and are expensive.
- Screen printing, often called silk screen, is a type of stencil printing which forces a thick dye through a mesh that has been coated with moisture repellant in some portions. Color passes through only the untreated areas. A number of screens may be used to add to or vary the colors. Automatic screen printing methods have greatly speeded up the process and made it economical for quantity production.
- **Resist printing** is a technique in which parts of the fabric are protected from the dye during each application. In **batik**, a dye-resisting wax or paste applied to sections of the cloth prevents dye from being absorbed in those areas. After each dye bath the wax is removed and perhaps reapplied to other parts of the fabric; the process can be repeated to form a design of more than one color. Still a much-admired hand craft, or handicraft, the technique is also being adapted to machine processes.
- **Tie-dyeing,** another resist method, requires an arrangement of pleats, knots and ties, causing portions of the fabric to resist the dye bath into which it is immersed. The resulting abstract pattern is usually diffuse, since the dye advances and recedes around the bound areas.
- **Discharge printing**, the reverse of resist dyeing, results when parts of the fabric are treated with a chemical to remove color.
- **Photographic printing** uses a process very similar to that for developing photographs. Either black-and-white or full-color prints can be made.
- **Transfer printing**, similar to ironing on a decal, transfers patterns from paper to fabric by applying heat and pressure. Although slower than roller or screen printing, transfer printing is less expensive because all colors are printed at once.
- Burn-out printing uses an acid that dissolves one of the fibers in the fabric to produce areas that are more sheer or transparent. Cotton and polyester or nylon and rayon blends are typically used; cotton and rayon are acid-degradable, leaving the polyester and nylon. Also called **etched-out printing**, these patterns are produced for window coverings.

17.17 (far left) "Sands of Time", a Jack Lenor Larsen design, illustrates the shimmering quality of a burn-out print executed in 100% silk.

17.18 (left) Crewel fabrics, even if machine embroidered, have a hand-stitched appearance that brings to mind an era gone by. Designs are typically informal, meandering florals. (Courtesy S. Harris & Co.)

STITCHERY The general trend toward increased enrichment in design has brought renewed interest in *embroidery*, *applique*, *quilting*, and other types of **needlework**. These may be done by machine in the factory, by hand in small workshops, or individually at home. Many people enjoy adding *crewel embroidery* to a pillow cover, or they may actually reconstruct the face of a fabric to be used as a seat cover by *needlepoint*. *Patchwork*—old and new, real and simulated—exemplifies the tendency for rich, complex designs.

Decisions made at every step of the textile production process are important to the final appearance and end-use appropriateness of a fabric. Although the selection of the fiber and the fabric construction are often considered the most im-

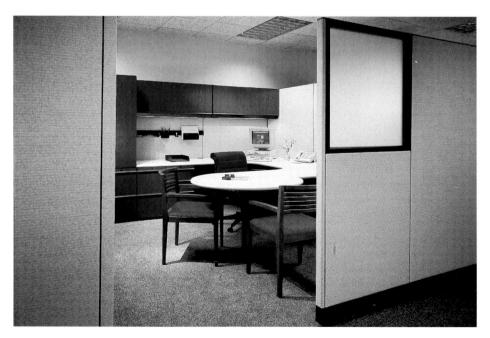

17.19 In an office environment. the choice of textile fiber, varn type, construction, and finish are all important for fabrics that must wear well, resist soiling, reduce static build-up, absorb sound, resist flames, and maintain their appearance. Jhane Barnes' "Stacked Boxes," made of a wool-cotton-polyester-rayon blend, is used for the panel fabric in the Coca-Cola headquarters in Atlanta, Georgia. (Courtesy The Knoll Group)

portant aspects, all of the selections are important factors in the performance of the finished product. For example, a fabric constructed of nylon fibers in the twill weave should be very strong and durable for a heavy-use upholstery fabric since both of these choices are considered the strongest possible. But, if a complex yarn is used, the durability of the final product is greatly diminished. In addition, a non-color-fast dye and the lack of a stain-resistant finish can in effect negate the positive effects of the strong fiber and fabric construction.

GLOSSARY OF FABRICS AND THEIR USES

Some of the fabrics most frequently used in the home are described below. They have been divided into four categories, based primarily on weight, which is an important factor in determining their applications. However, there is quite a range within each category and some overlapping between categories. Most of the fabrics can be woven from a number of different fibers, but a few are made from only one. Fabric names constitute a strange miscellany, being based on the fiber, such as *linen*, which has come to mean a special kind of linen textile; the weave, such as *satin*; the early use, such as *monk's cloth*; or a trade name, such as *Indian Head*.

SHEER

Almost transparent fabrics are suitable for glass curtains, top treatments, casements, bed hangings, table skirts, and table coverings. Most can be made from cotton, silk, synthetics, or even wool.

Bobbinet A fine and sheer to coarse open plain net with hexagonal meshes. Soft yet with character; most effective when very full; coarser types best for straight folds; sheer types well suited to tiebacks and ruffles. White, cream, ecru, pale colors; used as a base for machine-embroidered appliques.

Cheesecloth Cotton in loose, plain weaves, very low thread count. Very inexpensive; short-lived; informal. Usually off-white.

Dimity Fine, tightly twisted, usually combed cotton; plain weave with raised warp rib which gives a striped effect. Often mercerized. Fine, sheer, crisp; suited to straight folds or tiebacks. White, tints, or printed patterns.

Filet Square-mesh lace knotted at intersecting corners. Fine to coarse but usually giving a bold, heavy effect. White, cream, ecru, and plain colors.

Marquisette Leno weave in many fibers. Sheer and open; soft or crisp; fine to coarse. Serviceable; launders well. White, cream, or pale colors; sometimes printed or woven patterns.

Net Any lace with a uniform mesh, such as bobbinet or filet; fine to coarse, sheer to open; made of almost any fiber.

Niñon Plain voilelike or novelty weaves. Very thin; smooth, silky, pleasant sheen. Best in straight folds. Plain colors; self-colored stripes or shadowy figures; sometimes embroidered.

Organdy Cotton in plain weave; like sheer, crisp muslin, but crispness washes out unless specially treated. Folds keep their place. Often used without draperies; frequently tied back. Many plain colors; also printed or embroidered designs.

Point d'esprit Variation of bobbinet with dots that give it more body. White, cream, and pale colors.

Swiss muslin (dotted swiss) Cotton in plain weaves; usually embroidered or patterned in woven or flocked dots or figures. Fine, sheer, slightly crisp. Can be used alone, usually draped; effect generally informal. White and plain colors, usually light; figures may be colored.

Theatrical gauze Linen or cotton in a loose, open, crisp weave with a shimmering texture; higher thread count than cheesecloth. Often used without draperies for colorful, informal effect. Wide range of plain colors, often two-toned.

Voile Open, plain weave, sheer, and smooth. Drapes softly; gives more privacy than marquisette. Various textures; many colors, usually pale; sometimes woven patterns.

17.20 "Celestial", an antique satin handwoven in Thailand from pure silk, is a Jack Lenor Larsen design. Slub yarns are clearly visible.

LIGHT WEIGHT

Translucent fabrics are suitable for glass curtains, casements, top treatments, or draperies. They have sufficient body to be used alone and give a measure of privacy, although not at night. Light fabrics are suitable for draperies, top treatments, bedspreads, table skirts, pillows, screens, wallcoverings, table coverings, and slipcovers. They sometimes serve for upholstery in the heavier grades. Many can be made of cotton, silk, wool, or synthetics. They are available in a wide color range and can be washed.

Antique satin Variation of smooth satin, with slub filling yarns giving a dull, uneven texture. Variety of weights but usually heavier than satin. Widely used for upholstery and drapery material.

Batiste Delicate and fine, plain weave, usually cotton or polyester, often with printed or embroidered designs. Needs fullness to be effective; when embroidered, has considerable body. Light and dainty. White or pastel colors.

Broadcloth Cotton, synthetic, or silk in plain or twill weaves; spun rayon or wool in twill weaves. Varies greatly in terms of fiber and weave. Cotton and synthetic types used for draperies, bedspreads, tablecloths.

Calico Cotton in a plain weave, printed with small-figured pattern. Inexpensive and informal.

Casement cloth Almost every known fiber in plain, leno, twill, or figured weaves. Flat and lustrous. Often ecru, but can be other colors. Frequently used alone as draw curtains; some degree of transparency.

Challis Wool, synthetic, or cotton in a soft, plain, firm weave. Usually printed with small floral designs but sometimes available in solid colors. Highly drapable; often used as drapery lining.

Chambray Cotton or linen in a smooth, close, plain weave. White-frosted appearance on wide range of colors.

Chintz Cotton in a close, plain weave, usually with a printed design and often glazed. Washing removes glaze in many types.

Drill Cotton in diagonal twill weave. Firm, heavy, very durable textile. Typical color is gray, but other colors available.

Faille Plain weave with decided flat, crosswise filling ribs. Difficult to launder, but wears well if handled carefully. Varies from soft yet firm to quite stiff; used for upholstery and drapery.

Fiberglass Glass fibers in varied weaves and weights. Translucent to opaque; noncombustible; poor resistance to abrasion; abrasive hand.

Films (plastic) Nonwoven; smooth or textured, plain or printed, thin or thick vinyl or PVC. Used for shower curtains, table coverings, upholstery, or wallcoverings. Waterproof; wipes clean.

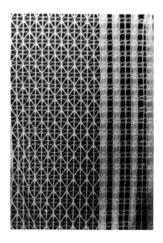

17.21 The open net-like pattern of a raschel warp knit casement fabric makes it suitable for window treatments. (From Joseph's Introductory Textile Science, 6th ed., by Peyton B. Hudson, Anne C. Clapp, and Darlene Kness.)

17.22 The irregular pattern of moiré is pleasingly contrasted with stripes in a fabric designed by Jack Lenor Larsen. (Courtesy Jack Lenor Larsen, Inc., The Graphics Collection.)

Gingham Cotton or synthetic in light to medium weight, plain weave; woven from colored yarns. Strong; launders well. Checked, striped, and plaid patterns.

Homespun Irregular yarns woven in loose, plain weave. Texture somewhat rough and irregular, suggesting hand weaving; informal character. Plain colors, dyed or woven of mixed varns.

India print Printed cotton cloth from India or Persia with characteristic intricate design in clear or dull colors. Inexpensive and durable. Fades, but pleasantly.

Indian Head Plain weave; firm and smooth. Trade name for a permanent-finish cotton, vat-dyed, color-fast, shrink-resistant. Inexpensive and durable.

Insulating Fabrics coated on one side with metallic flakes to reflect heat or with foam plastic to trap heat.

Jaspe cloth Plain weave; varied yarns give unobtrusive, irregular, blended stripes. Generally firm, hard, and durable. Can be in any color, but usually fairly neutral, medium dark, and monochromatic.

Linen Flax in a plain, firm weave. Cool to the touch, good body, launders well; wrinkles easily unless specially treated. Often has hand-blocked designs.

Moiré Ribbed, plain weave with a watermarked appearance. Most moiré finishes can be steamed or washed out—more permanent on synthetic fibers.

Muslin Cotton in a soft, plain weave; light to heavy qualities. Bleached or unbleached; also dyed and printed. Inexpensive, durable, informal; often used alone at windows or as under layer for upholstery.

Osnaburg Cotton yarns, coarse and uneven, in an open, plain weave; described as rough sheeting. Usually medium-weight, natural color, but can be light- or heavyweight, any color, printed patterns. Strong and long-lasting; rough-textured; informal; used for curtains, draperies, and slipcovers.

Oxford cloth Plain basket or twill weave, light to rather heavy weights. Durable and launders well.

Piqué Plain weave with narrow raised cords running in one direction or at right angles to each other (waffle piqué). Durable; interesting texture.

Pongee Wild silk in plain weave with broken crossbar texture caused by irregular yarns; also imitated in cotton and synthetics. Fairly heavy; often used without draperies. Shrinks unless treated. Usually pale or dark ecru, but can be dyed. Also called tussah or antique taffeta.

Poplin Cotton in plain weave with fine crosswise ribs. Firm and durable.

Rep Plain weave with prominent rounded ribs running crosswise or lengthwise.

Sateen Cotton, usually mercerized, in a satin weave; flat and glossy, with a dull back. Durable, substantial, but with a tendency to roughen. Often used for lining curtains.

Satin Silk or synthetic in satin weave; smooth, delicate fabric with a very high sheen. Somewhat slippery.

Seersucker Plain weave with woven, crinkly stripes. Durable, needs no ironing.

Shantung Plain weave with elongated irregularities. A heavy grade of pongee, but with wider color range.

Sheeting (cotton) Smooth, plain weave, light to medium weight. Inexpensive and informal. White, colors, or printed.

Silk gauze Plain weave with a slight irregularity in threads, making an interesting texture. Hangs well; is never slick. Wide range of colors.

Stretch Knit or woven of cotton, rayon, or other synthetic with special stretch properties, or of spandex. Smooth to rough textures. Valuable for slipcovers and contoured shapes.

Taffeta Close, plain weave, slightly crossribbed. Silky and crisp; sometimes weighted with chemical salts; cracks in strong sunlight. Antique taffeta has unevenly spun threads.

MEDIUM WEIGHT

Fabrics of medium weight are suitable for heavy draperies and upholstery, as well as for wall coverings and pillows. Some also adapt to slipcovers, bedspreads, screens, and table coverings. Made of heavier fibers of cotton, flax, hemp, jute, linen, silk, synthetics, or wool, they are available in a wide color range; some are washable.

17.23 (far left) Brocade fabrics have a richly textured surface and, often, a sumptuously colorful pattern such as "Baroque Floral" by Schumacher.

17.24 (left) "Delphi," a classical design executed in damask, has the figure and ground in reverse colors on the other side, a characteristic feature of all damasks. (Courtesy Jack Lenor Larsen, Inc.)

Bark cloth Cotton in a firm, plain weave with irregular texture due to uneven yarns. Plain or printed; durable.

Brocade Woven on a Jacquard loom; raised designs are produced by floating some of the filling yarns. Usually has a multicolored floral or conventional pattern.

Brocatelle A Jacquard weave similar to brocade but with a heavier design. Used mostly as upholstery on large sofas and chairs.

Burlap Loose basket weave. Heavy and coarse; interesting texture. Often fades quickly.
 Canvas Cotton in a plain, diagonal weave. Heavy, firm, and durable. Strong solid colors, as well as stripes or printed designs. Often used for awnings, outdoor curtains, and upholstery.

Crash Plain weave with a rough texture caused by uneven yarns. Often handblocked or printed.

Cretonne Cotton in a firm, plain rep or twill weave. Fairly heavy texture and bold design. Similar to chintz but heavier, dull, never glazed. Patterns are usually vigorous.

Damask Any combination of two of the three basic weaves; flat Jacquard patterns. Firm, lustrous, reversible. Similar to brocade but design is not in relief. May be referred to as figured satin. One or two colors used.

Denim Cotton in a heavy, close twill weave. Warp and filler often in contrasting colors; can have a small woven pattern. Inexpensive; washable; Sanforizing prevents shrinking; reasonably sunfast.

Duck Cotton in a close, plain or ribbed weave. Durable; often given protective finishes against fire, water, mildew. Similar to canvas.

Hopsacking Loose, plain weave of irregular yarns. Coarse and heavy. Inexpensive and durable.

Laminated Any fabric bonded to a lightweight foam backing, or two fabrics bonded together. Wrinkle-resistant; good for upholstery, slipcovers, insulating draperies, shades, wall covering.

Mohair Hair of Angora goats (now often mixed with cotton and wool) in a plain, twill or pile weave, or with a woven or printed design. Resilient and durable. Novelty weaves, sheer to very heavy.

Monk's cloth Jute, hemp, flax, usually mixed with cotton or all cotton in a loose plain or basket weave. Coarse and heavy; friar's cloth and druid's cloth similar but coarser. Not easy to sew, tendency to sag. Usually comes in natural color.

17.25 "Coquille" skillfully utilizes the puffed effect possible with cotton–nylon matelassé to raise a shell pattern above the surface. (Courtesy Boris Kroll Fabrics)

17.26 A heavy cotton tapestry, "Heriz", has a typically large pattern, inspired in this example by an antique carpet design. (Courtesy Westgate, European Passport Collection)

Sailcloth Plain weave. Heavy and strong. Similar to canvas or duck. Often used on out-door furniture.

Serge Twill weave with a pronounced diagonal rib on both face and back. Has a clear, hard finish.

Terry cloth Cotton or linen in a loose, uncut-pile weave; loops on one or both sides. Very absorbent; not always color-fast; may sag. Not suitable for upholstery, but may be used for draperies and bedspreads.

Ticking Cotton or linen in a satin or twill weave. Strong, closely woven, durable. Best known in white with colored stripes, but may have simple designs. Not always color-fast, but washable.

HEAVY WEIGHT

Heavy fabrics are perfect for upholstery because of their weight and durability; in lighter grades they make draperies, pillows, bedspreads, slipcovers, wall coverings, even table coverings. Most are available in a variety of fibers and a wide color range. Few are washable.

Bouclé Plain or twill weave. Flat, irregular surface, woven or knitted from specially twisted bouclé varns; small spaced loops on surface.

Corduroy Cotton or a synthetic in a pile weave, raised in cords of various sizes giving pronounced lines. Durable, washable, inexpensive.

Expanded vinyl Plastic upholstery fabric with an elastic knit fabric back. Stretches for contour fit.

Felt Nonwoven fabric of wool, rayon and wool, or synthetics. Nonraveling edges need no hemming. Available in intense colors; used for table coverings, wall coverings, pillows, even for draperies.

Frieze Also called *frisé*; a heavy-pile weave. Loops uncut or cut to form a pattern; sometimes yarns of different colors or with irregularities used. Usually has a heavy rib. Extremely durable.

Leather Treated animal hide used as a fabric. Top grain is most desirable. Very durable. Used for upholstery, wall covering, even floor covering.

Matelassé Double-woven fabric with quilted or puckered surface effect, caused by interweaving to form the pattern. Needs care in cleaning, but otherwise durable.

Needlepoint Originally handmade in a variety of patterns, colors, and degrees of fineness. Now imitated on Jacquard loom. At best, has pronounced character, from delicate (petit point) to robust (gros point); at worst, looks like weak imitation.

Plastic Wide variety of textures from smooth to embossed; used for upholstering and wall covering. Resists soil, wipes clean. Not for use over deep springs unless fabric-backed, which is more pliable, easier to fit, less likely to split.

Plush Cut-pile weave. Similar to velvet but with a longer pile. Sometimes pressed and brushed to give surface variations; sculptured by having design clipped or burned out of pile, leaving motif in relief. Also made to imitate animal fur.

Tapestry Weaves with two sets of warps and weft; hand- or Jacquard-woven. Heavier and rougher than damask or brocade. Patterns usually pictorial and large.

Tweed Soft, irregularly textured, plain weave. Yarns dyed before weaving; often several or many colors combined.

Velour Short, heavy, stiff cut-pile weave. Slight luster and indistinct horizontal lines. Durable.

Velvet Doublecloth construction pile weave with loops cut or uncut. Luxurious but often shows wear quickly, particularly in silk. Lustrous or dull; light to heavy grades; plain, striped, or patterned.

Velveteen Cotton or a synthetic woven with a short, dense, sheared pile. Strong, durable, launders well.

Webbing Cotton, jute, or plastic in narrow strips (1 to 4 inches) of very firm, plain weave. Plain, striped, or plaid design. Jute used to support springs; cotton or plastic interlaced for webbed seats and backs.

REFERENCES FOR FURTHER READING

American Fabrics Magazine, Encyclopedia of Textiles, 2nd ed. Englewood Cliffs, N.J.: Prentice-Hall, 1972.

Barnard, Nicholas. Living with Decorative Textiles. New York: Doubleday, 1989.

Constantine, Mildred and Jack Lenor Larsen. *Beyond Craft: The Art Fabric.* New York: Van Nostrand Reinhold, 1972.

Frings, Virginia S. Fashion: From Concept to Consumer. Englewood Cliffs, N.J.: Prentice-Hall, 1982, chap. 5.

Gaines, Patricia Ellisor. The Fabric Decoration Book. New York: Morrow, 1975.

Hatch, Kathryn L., Nancy L. Markee, Loerna Simpson, Leslie Davis, Merry Jo Dallas, Patricia Wilson, Barbara Harger, and Janet Miller. Textile Use For Health and Wellness. *Journal of Home Economics* 83(1): 17–26, 1991.

Held, Shirley E. Weaving: A Handbook for Fiber Craftsmen, 2nd ed. New York: Holt, Rinehart and Winston, 1978.

Hicks, David. David Hicks on Decoration-with Fabrics. London: World, 1971.

Jackman, Dianne R. and Mary K. Dixon. The Guide to Textiles for Interior Designers. Winnipeg: Peguis Publishers, 1984.

Joseph, Marjory L. Essentials of Textiles, 3rd ed. New York: Holt, Rinehart and Winston, 1984.

Joseph, Marjory L. Introductory Textile Science, 4th ed. New York: Holt, Rinehart and Winston, 1981.

Klapper, Marvin. Fabric Almanac II, 2nd ed. New York: Fairchild, 1971.

Larsen, Jack Lenor and Jeanne Weeks. Fabrics for Interiors: A Guide for Architects, Designers, and Consumers. New York: Van Nostrand Reinhold, 1975.

Murphy, Dennis Grant. *The Materials of Interior Design*. Burbank, Calif.: Stratford House Publishing Company, 1978.

Nielson, Karla J. Understanding Fabrics—A Definitive Guidebook to Fabrics for Interior Design and Decoration. North Palm Beach, Fla.: L. C. Clark Publishing Co., 1989.

Reznikoff, S. C. Specifications for Commercial Interiors. New York: Whitney Library of Design, 1989.

Scobey, Jean. Rugs and Wall Hangings. New York: Dial, 1974.

Textile Handbook, 4th ed. Washington, D.C.: American Home Economics Association, 1970. Tortora, Phyllis G. *Understanding Textiles*, 2nd ed. New York: Macmillan, 1982.

Wingate, Isabel B. *Textile Fabrics and Their Selection*, 7th ed. Englewood Cliffs, N.J.: Prentice-Hall, 1976.

Yeager, Jan. Textiles for Residential and Commercial Interiors. New York: Harper & Row, Publishers, 1988.

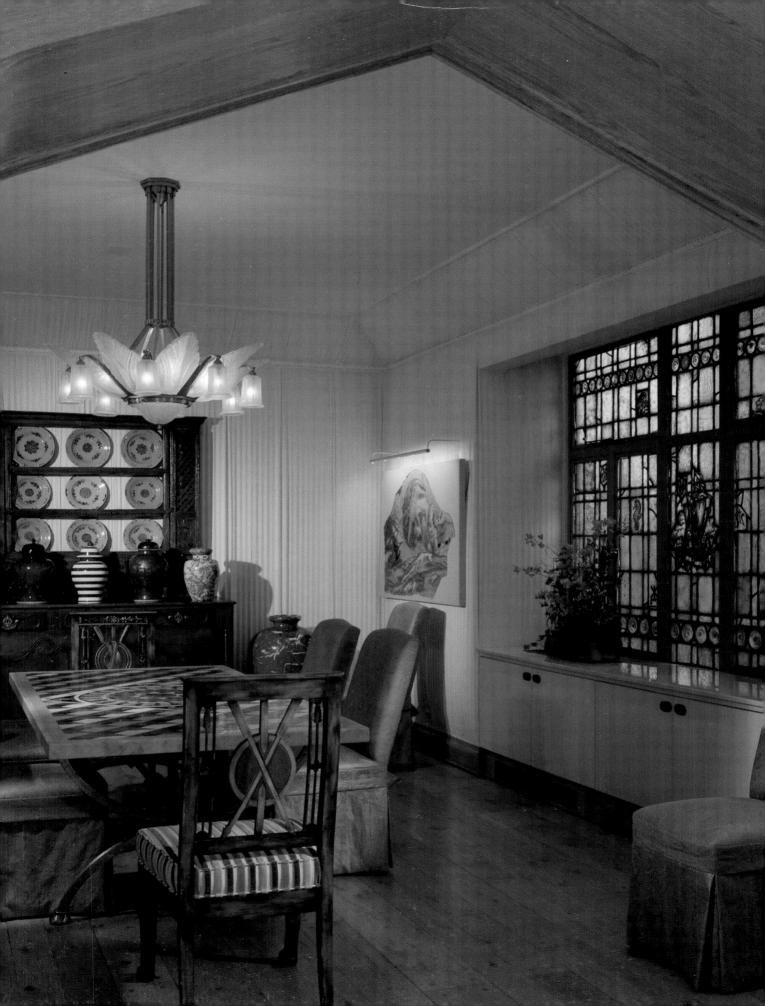

PART FIVE

Interior Components and Treatments

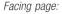

Walls and Ceilings

WALLS

Design

Construction

Materials and Surfacings

FIREPLACES

Location

Appearance

Materials

Wood-Burning Stoves

CEILINGS

Design

Materials

Color and Texture

Walls and ceilings govern the shape, size, and character of interior space; they provide protection and privacy and affect light, heat, sound, and view from within. Design, construction, materials, and finishing treatments all contribute to their dynamic role in giving space its fascinating molded quality.

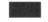

WALLS

Walls compose a stage setting for interior space and the people who lead their lives within their enclosure. The character they establish is vital in its influence on everyday living: Massive masonry provides anchorage and security; smooth plaster walls are less bulky and more passive but still protecting; and finally, glass walls—light and open—expose the outdoors, expanding space and vision. Even seemingly neutral walls of smooth plaster can be a lively mixture of flat planes, curves, angles, and cutouts. Staircase walls may have their forms dramatized, and low walls partially segregate areas but leave them within sight, having the effect of extending space. Walls may serve as open shelving, as closed, dropped cupboards in a kitchen, or as a snug backing for furniture. They create an animated, functional environment for living.

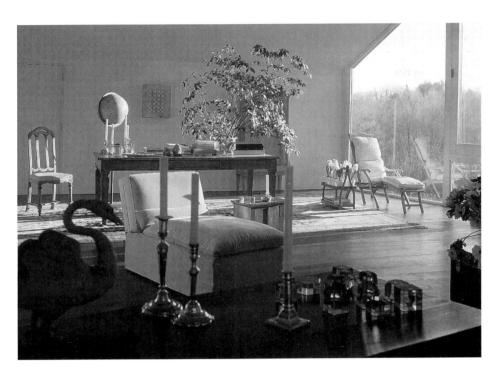

18.1 A summer home on the Connecticut River was once an 18th century barn. A floor-to-ceiling glass wall affords a scenic view and fosters a feeling of openness. James McNair, architect. *(Photograph: John T. Hill)*

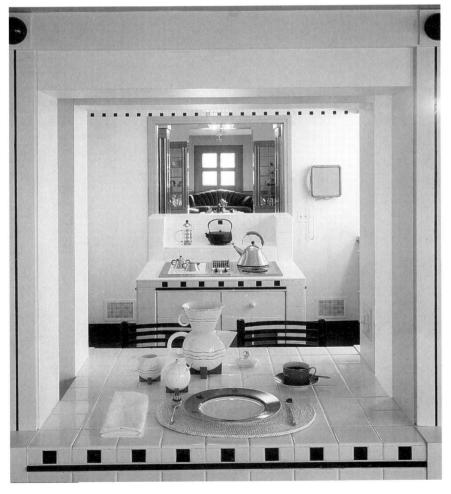

18.2 Continuity is carried throughout this Neoclassic style home with cutouts in walls that permit views of succeeding rooms. Michael Graves, architect. *(Photograph: Mick Hales)*

DESIGN

Contemporary designers enjoy a freedom far more extensive than in the past, when walls were almost always fixed, thick, opaque, and **structural** or **load-bearing** (supporting floors and roofs). Although many walls have these characteristics, the following types are also common:

- Nonstructural partition or curtain walls that hold up nothing other than themselves, acting only as space dividers and backgrounds.
- Thin, transparent, or translucent window walls of glass or glass block.
- **Movable** partition walls of all kinds that slide into pockets, fold like accordions, or consist of storage units on casters. (Offices utilize *panel systems* as movable partitions.)
- **Storage** walls that unite the enclosing functions of walls with many kinds of storage space.
- Partial walls of less than ceiling height to give visual privacy without tight, box-like enclosure.
- **Spur** or **freestanding** walls (often incorporating fireplaces) that do not join the adjacent walls at one or both ends.
- Walls that support furniture, with built-in seating or counter space.
- Walls with cutouts and open spaces giving views to adjacent rooms.

AESTHETIC CONSIDERATIONS Formality results when a room gives the feeling of a strict, firmly established, unchanging order. Symmetrical balance and pronounced regularity in the placement of doors and windows are the fundamental means to achieve this, but formality also increases when forms are stable and

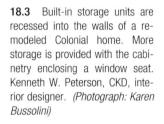

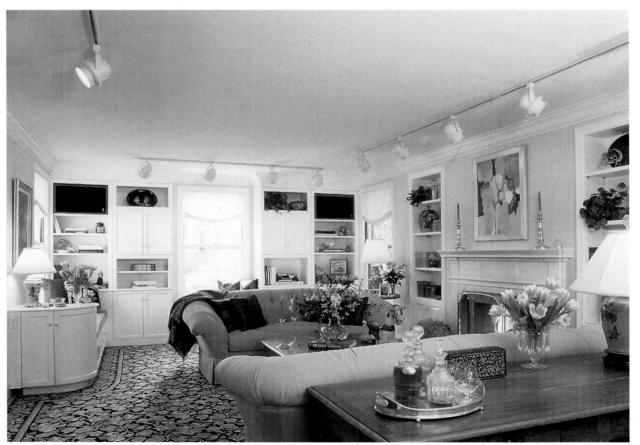

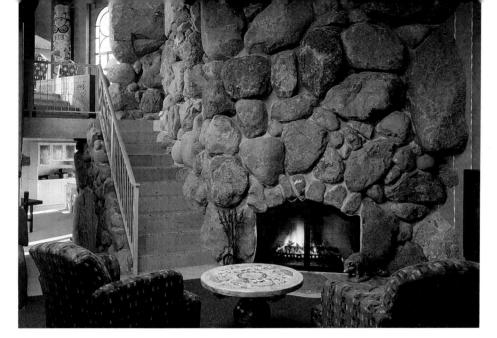

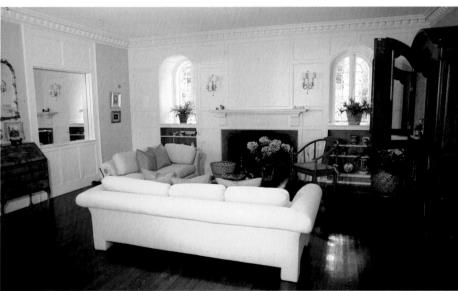

18.4 An immense three-story tower built of boulders houses the flues for four fireplaces plus a furnace and is the pivot around which major rooms are clustered on all three levels. The large scale of this "sculpture" built by Dan Yarbrough, a Chicago sculptor, is suited to the 8,500-square-foot house, which sits on 100 acres outside Racine, Wisconsin, and was inspired by Viking structures. Charles Moore, with Urban Innovations Group of Los Angeles. architects: Dennis Cannaday. interior designer. (Photograph: Mark Darlev/ESTO)

18.5 Paneled walls, a simple fireplace, and crown molding retain a touch of the past in a remodeled house. Abi Babcock, interior designer. (*Photograph:* © Karen Bussolini)

precise, surfaces are smooth, and proportions are mainly vertical. Rougher, textured materials with active patterns, open plans with an easy flow of space, partial walls or cutouts, and asymmetrical balance characterize informal rooms.

Walls become active when their design and materials arouse visual interest, especially if they suggest movement. Patterned wallcoverings or tiles, wood grain or framed panels can attract attention as can built-in furniture, fireplaces, or built-in display or storage space. Typical smoothly plastered, uniformly painted walls remain passive backgrounds for furnishings unless their color is vigorous.

Wall textures range from glassy smoothness to stony roughness, with countless intermediate steps provided by plaster, gypsum board, tile, brick, wood, and plastics. Smoothness is often associated with formality, roughness with informality. A basic pattern of companionable surface textures gives a sense of coherence, but variety and contrast are needed to awaken it.

Of tremendous importance is the scale of the walls in relation to the size of the space, the character of furnishings, and the personalities of the people using the room. A stone or concrete wall may be bold and impressive but not overpowering if the room and its furnishings are large in scale. In the living room shown in Figure 18.5 the smaller scale of the walls with the dentil molding and quiet paneling relate to the intimate character of the room.

The scale of walls can establish the scale of the room as a whole. High walls seem to expand space, as do long, unbroken expanses of wall. Too long a wall can be broken by a spur wall perpendicular to it or by variations in surface treatment that direct attention to one part at a time. Walls that are too high can also be broken into segments with a chair rail or picture molding, with a dado treatment, or with the ceiling treatment carried down onto the wall, perhaps to the picture molding.

FUNCTION AND FLEXIBILITY Walls that can be moved to create new and varied spaces as needs change make a lot of sense. Movable walls that are at the same time storage walls can be doubly efficient. The owner or tenant of a large open space, such as a loft or barn, may be reluctant to break it up into smaller cubbyholes. In place of permanent interior walls, various kinds of dividers ranging from free-standing screens to folding sections to hanging fabrics can create "rooms" within and between them with some visual privacy, yet they do not interfere with the sense of flowing space. More substantial but still movable wall partitions can be mounted on tracks in the ceiling and on the floor, in the manner of Japanese shoji screens. Depending upon their thickness, they may provide acoustical as well as visual control.

Of course, movable walls give less actual and psychological privacy than permanent ones. Some people feel insecure in the absence of permanent, fixed, floor-to-ceiling walls. On the other hand, permanent walls are often removed or opened up to enlarge space in the remodeling of older homes that typically had small, to-tally enclosed rooms. Whether the goal should be stability or fluidity will depend on many factors, including the composition of the household, the lifestyle of its inhabitants, and the particular dispositions of individuals.

18.6 (below) A small space, such as this apartment in New York City, may function best with only a minimal suggestion of walls to demarcate spaces. A sliding divider of vertical panels and changes in level achieve the effect of separation yet maintain openness. Joe D'Urso, designer. (Photograph: © Peter Aaron/ESTO)

18.7 (right) In remodeling a 19th-century Boston stable the owners were restricted by local ordinances that prohibited altering the facade. The solution came from opening up the interior with sliding glass windows around a private interior courtyard. CBT/Childs Bertman Tseckares and Cassendino, Inc., architects.

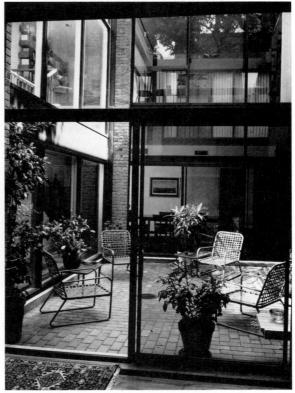

DEGREE OF ENCLOSURE Enclosure results from such things as opaque, substantial-looking walls, warm dark colors, and noticeable textures. Small, separated, framed doors and windows with small panes and heavy draperies may contribute to a feeling of protection or oppression and claustrophobia, depending upon the individual and the context.

Openness comes with a maximum of transparent, translucent, or apparently thin unobtrusive walls, with wide windows and doorways without frames, and with a minimum of partitions that block view or movement. Receding colors and inconspicuous textures also contribute to openness. Of great importance is a continuity of materials, form, and colors—not only inside a room but with the space in adjacent rooms and with the outdoors.

LIGHT QUALITIES In light absorption and reflection, color value is the most critical factor. White reflects up to 89 percent of the light striking it, black as little as 2 percent. But surface texture must also be considered, because the smoother the surface, the more light it reflects. In the past, when windows were small and artificial illumination poor, very light walls were frequently needed to make rooms bright. Light-colored walls are often considered refreshing; they increase apparent size, make rooms easier to illumine (an energy-saving consideration), and serve as an effective background because they contrast with most objects placed against them. Darker colors and heavier textures generally bring walls inward, make spaces more difficult to light effectively, and tend to absorb objects placed against them or to push light-colored objects forward in a noticeable manner. However, they may also lend a cozy, intimate atmosphere to large spaces.

DURABILITY The amount of time and money needed to maintain walls may need to be considered as well. Some materials (masonry, tile, wood, and vinyl plastics) are durable and easy to maintain. Others, including fragile but color-fast wall-papers, will endure with little care on walls that do not receive hard use. The basic questions in selection are, what kind of use will the wall receive? how easily is the material damaged? and how easily can it be cleaned or repaired?

ACOUSTICAL QUALITIES Many contemporary homes are noisy due to their small size, open plans, greater freedom for children, the prevalence of sound systems and television, labor-saving but noisy appliances, and the trend away from heavy upholstery and draperies. This problem can be effectively controlled, however, by wall construction and/or finishes. "Hard" surfaces bounce and reflect sound; if they predominate in a room, noise is bound to be magnified and distorted. Conversely, "soft" porous materials a orb sounds and can noticeably lower the decibel level in a room. In terms of wall construction and surfaces, the hardest materials are metal, plastic, masonry, and glass; wood, plaster, and wallboard are somewhat less sound-reflective; and the most sound-absorbing materials include cork, fabric, vinyl, and the various "acoustical" substances. To keep noise from leaking through walls, staggered stud construction, insulation (including double-glazed windows and wrapped pipes), sound traps in ducts, and the positioning of closets, stairways, and storage walls can all be utilized during planning and construction. Rooms that require good quality of sound within, such as music or media rooms, need a planned mix of sound-absorbing and sound-reflecting walls for balanced sound (see Chapters 9 and 11).

Imagine two extremes of noise and silence contrived by manipulating the structure and furnishings of a room. The noisiest possible environment might consist of a precisely rectangular space with walls, floor, and ceiling of smooth metal or glass, furnished with only a few rectangular, smooth metal or plastic pieces set parallel to the walls. The quietest room could have broken walls, a projecting or recessed fireplace and storage cabinets, a ceiling plane interrupted by beams, walls

surfaced with cork or fabric, a carpeted floor (the deeper the pile the better), a plaster or acoustical-tile ceiling, heavy upholstered furniture, thick draperies, large plants, and many books on open shelves. As noted, these two examples are extremes. The former would probably be so nerve-shattering as to drive occupants out of the house, but the latter could be so eerily silent that it became equally unsettling. Depending on the purpose of the room and the needs of the household, the best solution lies somewhere in between.

THERMAL QUALITIES Finally, in the interests of both comfort and conservation of energy, the design of walls with a high degree of heat and cold insulation is of the utmost importance. (Chapter 13 deals with these matters.) The designer may supplement the insulating qualities of walls with surface treatments of vinyl, fabric, carpet, cork, and the like. (Possibilities for windows are described in Chapter 20.)

CONSTRUCTION

Although we often take walls for granted, the building of efficient, protective enclosures was a notable achievement for early peoples. Recently, there have been tremendous technological advances, especially in factory-made wall units. The technology of wall construction is beyond the scope of this book, but some knowledge of how walls are constructed and how their characteristics are affected by the materials used is essential.

Walls that are fixed, opaque, and of one material (monolithic) are easiest to understand. Examples include houses built of heavy timbers—such as log cabins and chalets—and structures of solid stone or adobe brick. These are not common today because they are expensive and comparatively poor insulators. Moreover, they leave no concealed space for pipes, ducts, wiring, and insulation, and are not very amenable to the broad, unobstructed openings now in favor. Walls entirely of masonry have great appeal, however, with their comforting sense of permanence as well as their color and texture. Steel reinforcing increases their stability, and space can be left for insulation and utilities. The possibilities of concrete as a distinctive material have received relatively little attention in residential architecture, but its use in multiple-family dwellings is quite common.

Today, most walls consist of more than one material, or of the same material used in different ways. Wood-frame walls are most common in single-family homes, since they are familiar to builders and not expensive. In addition to resilient stability, they allow space for insulation and utilities. Usually, but not necessarily, they support the roof. Surface treatment, inside and out, can be varied. Although wood-frame walls may have five or more layers, they can be thought of as three-layer sandwiches:

- 1. Structural frame of wood studs (two-by-fours, or two-by-sixes where drainpipes are to be installed) from floor to ceiling. Studs typically are set 16 inches on center—a useful measurement to know when hanging decorative arts, sculpture, or paintings which need to be securely fastened to a wall surface that will bear their weight.
- 2. Exterior layers of diagonal wood sheathing and insulation or sheets of strong insulating composition board, covered with weather-resistant surfaces of wood, plastic, or metal sidings, shingles, or sheets; with lath and stucco; or with a veneer of brick or stone.
- 3. Interior layers of lath and plaster, plywood, gypsum board, or wood paneling.

Increasingly, structural framing systems of metal take the place of wood, because of their labor- and cost-saving potential. Steel studs offer improved fire resistance and are used where fireproof construction is desired or required.

Although walls of this type are still the most familiar for single-family homes, manufacturers have made great strides in the prefabrication of walls. Panels of wood, metal, or plastics—comprising in one component the layers of materials mentioned above—can be made in factories, which results in lowered construction costs without loss of individuality. Hundreds of different designs are available.

MATERIALS AND SURFACINGS

Table 18.1, a comparative list of wall materials, enables the designer to evaluate the many differences in structural materials and surfacings.

PLASTER* Used for centuries to surface and enrich walls, plaster is applied over lath (a lattice of thin strips of wood or metal grilles), special types of wallboard, or concrete block. It may be given a variety of finish textures ranging from smooth to stuccoed, or it may be cast to form intricate and beautiful moldings as seen in some old homes that have been preserved or restored. In renovation and adaptive reuse projects, designers are likely to have to repair or replace plaster. Unfortunately, there are few contemporary craftsmen who can match the skill of their ancestors; however, rag-paper moldings and other materials that imitate plaster are available at reasonable prices.

The advantages of plaster include the facts that it can cover simple or complex surfaces without visible joints and it can be textured, colored, painted, or covered with wallpaper, fabrics, or tile. Its disadvantages include cracking, chipping, and easy soiling (see Chapter 15). Plaster is also more expensive than many types of wallboard available today that provide better insulation against heat, cold, and noise.

WALLBOARD Many interior walls today are of *dry-wall* construction, consisting of one of the various types of wallboards: **gypsum plasterboard** (Sheetrock is a common brand name), **pressed wood**, or **plastic laminate**. Most of them are relatively inexpensive and easy to install. They are made in 4-by-8-foot (to 16-foot) sheets that are attached directly to the stud walls. The joints and indentations from nail heads in Sheetrock must be taped, spackled, and sanded carefully

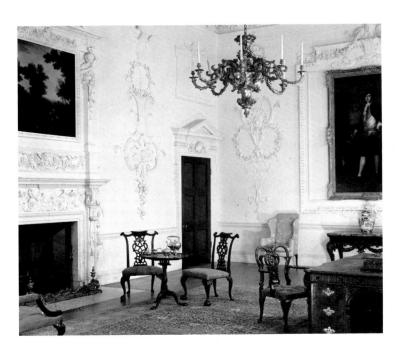

18.8 This room from Kirtlington Park in Oxfordshire, England, was completed in 1748. Rococo swags of fruit and foliage, as well as C-shaped scrolls and ribbons, appear in the marble fireplace, wood-carved door and console table, a bronze chandelier, and especially in the delicate plasterwork of the walls and ceiling. The furniture of the period includes a pair of fine Chippendale chairs. (The Metropolitan Museum of Art, New York, Fletcher Fund)

TABLE 18.1

Wall Materials and Their Costs, Characteristics, Advantages, and Disadvantages

Material	Character	Use	Finishes	Advantages	Disadvantages	
EXTERIOR AND INTERIOR						
brick (adobe) cost: varies greatly from one locality to another	earthy solidity combined with handcraft informality; large in scale; noticeable pattern of blocks and joints unless smoothly plastered	interior–exterior walls, chiefly in mild climates; heat storage mass	stucco, special paints, or transparent waterproofing	unique character; resists fire and insects; newer types stronger, weather- resistant; traps heat and releases it slowly.	older types damaged by water; walls must be thick or reinforced; sturdy foundations required; comparatively poor insulation for weight and thickness	
brick (fired clay) cost: high but less than stone	substantial and solid; small-scale regularity; many sizes, shapes, and colors; can be laid in varied patterns	interior–exterior walls, exterior surfacing or garden walls; around fireplaces; heat storage mass	none unless waterproofing necessary; interior walls can be waxed	satisfying texture and pattern; durable, easily maintained; fireproof; traps heat and releases it slowly	none other than heat-cold conduction and noise reflection	
concrete cost: moderately high	typically smooth and solid-looking, but can be highly decorative	interior–exterior walls in mild climates; heat storage mass	exterior painted or stuccoed if desired; interior painted, plastered, or surfaced with any material	permanent, durable, low maintenance; can be cast in varied shapes and surface patterned; traps heat and releases it slowly	comparatively poor insulator; requires sturdy foundations and costly forms	
concrete blocks (light- weight aggregate) cost: moderate	typically regular in shape, moderately textured, and bold in scale, many variations	interior–exterior walls in mild climates; exterior and garden walls anywhere	exterior waterproofing necessary; no interior finish needed but can be painted, plastered	durable, easily maintained; fireproof; fair insulator	none of any consequence, except perhaps lack of domestic character	
glass (clear, tinted, and patterned, blocks) cost: moderately high	open and airy; patterned glass and blocks transmit diffused light	interior–exterior window walls; blocks or patterned glass for translucency; tinted for privacy, glare; double or triple panes or blocks for insulating qualities	none (except for curtaining for privacy and control of light, heat, and cold)	clear glass creates indoor—outdoor relationships; blocks, patterned, and tinted glass combine light and varying degrees of privacy	breakable; very poor heat-cold insulation unless double or triple pane; needs frequent cleaning; blocks more durable, easily cleaned, insulating	
metal (panels, siding, shingles, and tiles) cost: moderate	varies greatly depending on size, shape, and finish; often regarded as unhomelike	sometimes used in kitchens and bathrooms; exterior house and garden walls; mobile homes	aluminum and steel available with long- lasting factory finishes in many colors	lightweight in relation to strength; resistant to fire; enameled and aluminum panels need minimum upkeep	although very durable, metal surfaces are difficult to repair if damaged	
plaster and stucco cost: moderately low	typically smooth and precise but can be varied in texture; only surfacing material that shows no joints, breaks; quiet background	plaster in any room; stucco usually for garden or exterior house walls	special weather- resistant paints; paint, paper, or fabric for interiors	moderately durable if properly finished; suited to many easy-to-change treatments; fireproof; special types absorb sound	often cracks or chips	

Material	Character	Use	Finishes	Advantages	Disadvantages
plastic (panels, siding, glazing; often reinfored with glass fibers) cost: moderate	opaque or translucent, often textured and colorful; thin and flat or corrugated; thicker with cores of varied materials	interior walls where durability, upkeep are important; partitions; interior–exterior walls; exterior siding	factory finished	similar to patterned glass except breaks less easily, lighter in weight; can be sawed and nailed	not thoroughly tested for longevity
stone cost: high	substantial, solid; impressive; natural colors and textures	around fireplaces; interior–exterior walls	none unless waterproofing is necessary	beauty and individuality; durability, ease of maintenance; fireproof; ages gracefully; traps heat and releases it slowly	reflects sound; not amenable to change
wood (boards, plywood, shingles, and thin veneers) cost: moderate to high	natural beauty and individuality of grain and color	interior and exterior walls	needs protective finish to seal it against water, stains, dirt	fairly durable, easily maintained; good insulator; adaptable; ages well inside	weather-resistant
INTERIOR C	ONLY				
cork cost: moderately high	sympathetic natural color and texture	any room; only plastic-impregnated types suitable for baths and kitchens	None needed but can be waxed	durable, easily maintained if properly sealed; sound-absorbent; good insulator	harmed by moisture, stains, and so on, unless specially treated
paint (water- base, oil-base) cost: moderately low	flat to gloss, smooth to textured; endless color range	any wall; select for specific use	none needed	inexpensive, versatile, colorful	must be chosen and applied properly
<pre>plastic (thin, rigid tiles) cost: relatively low</pre>	similar to clay tile except variety is sharply limited	kitchen and bathroom walls	no finish needed	easy to keep and apparently durable; simple to install; lightweight	similar to clay tile
plastic (resilient tiles or sheets) cost: moderately high	great variety of colors, patterns, textures	where durable, reilient walls are wanted, such as in play space or above kitchen counters	some need waxing; many now do not	very durable and resistant to cuts and stain; easy maintenance; can extend into counter tops	can be scratched

TABLE 18.1 (continued)

Material	Character	Use	Finishes	Advantages	Disadvantages
tile (clay) cost: moderately high	repeated regularity sets up pattern; great variety in size, shape, ornamentation	kitchens, bathrooms, and around fireplace; heat storage mass	no finish needed	great beauty, individuality; very durable, easily maintained; resists water, stains, fire; traps heat, releases it slowly	hard and cold to touch; reflects noise; can crack or break
wallboard (gypsum, Sheetrock) cost: moderately low	noncommittal; joints show unless very well taped and painted	any room	paint, wallpaper, or fabric	not easily cracked; fire-resistant; can be finished in many ways	visually uninteresting in itself; needs protective surface
wallboard (plastic laminates) cost: high	shiny, matte, or textured surface; varied colors and patterns	kitchens, bathrooms, or any hard-use wall	none needed	very durable, unusually resistant to moisture, stains, dirt; cleaned with damp cloth	although wear- resistant, it can be irremediably scratched or chipped; reflects noise
wallboard (pressed wood) cost: moderate	smooth, matte surface with slight visual texture; also great variety of patterns	hard-wear rooms	needs no finish but can be stained, waxed, painted	tough surface is hard to damage	none of any importance
wall covering (plastic) cost: moderately high	many patterns; pleasing textures; matte or glossy surfaces	good for hard use walls	none needed	very durable; resists mositure, dirt, stains; cleans with damp cloth	none of importance
wallpaper and textiles cost: moderately low	tremendous variety of color and pattern	any wall	usually none but can be protected with lacquer	inexpensive to costly; can give decided character; some kinds very durable and easy to keep	must be chosen and used carefully

so they do not show. Wallboard takes readily to many different finishes (which help conceal imperfections) and can be refinished. If paper or vinyl wallcoverings are planned, wallboard should be sealed prior to their application to facilitate removal at a later date.

Plastic laminate panels and some of the pressed woods are totally prefabricated, with finishes including solid colors, wood grains, fabric textures, and a variety of patterns produced by a photographic process. They are very durable.

Wallboard will not bear much weight, being light and not very dense. To hang objects of any size or weight on the wall, the underlying studs must be located or special screws (such as molly bolts) that pierce through the panel and clamp on the inner side must be used.

WOOD As **boards**, **shingles**, or **panels**, wood is available in an immense variety of grains, colors, and styles (Figure 18.9). The patterns produced by shingles or by boards laid horizontally or vertically—the joints beveled, left straight and

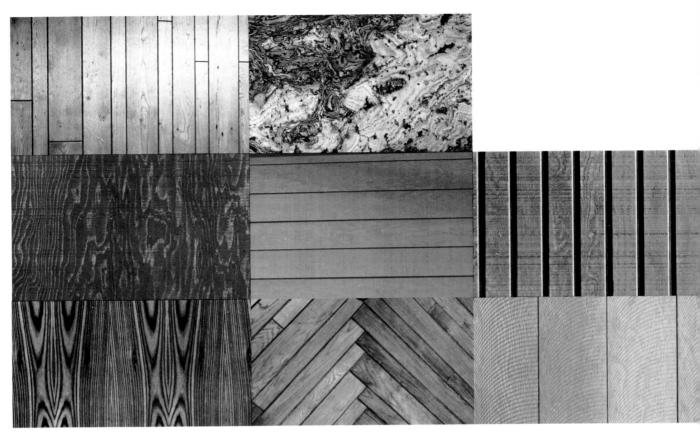

plain, or covered by battens (thin narrow strips of wood)—make up part of the architectural vocabulary that can set the character of the wall. A quite different effect results when plywood sheathes the wall. Another variable is the way in which the wood is finished, whether smooth-surfaced, resawn for a softened effect, or treated with vinyl or other substances to preserve attractiveness and reduce maintenance. (The qualities of various woods and wood finishes were described in Chapter 15.)

Wood has been popular throughout history for its warmth and richness. Distinctive wood paneling and trim—baseboards and moldings, door and window frames, mantels, and cabinets—helps establish the character of historical periods and styles.

Solid wood with good grain is expensive but is available in a wide range of colors and patterns. Redwood, cedar, knotty pine, walnut, and pecan as well as other woods are used for walls. Traditional paneling utilizes solid wood rails and panels. Boards, ranging from 4 to 12 inches wide, are usually joined with *butt*, *tongue-and-groove*, or *shiplapped* (overlapped) *joints*.

A less expensive alternative is a plywood veneer which may have various patterns determined by the type of matching between veneer pieces (see Figure 15.13, p. 357), or pressed-wood wallboard with a photo-process wood-grain pattern. Very thin veneers are also available, some so thin they are flexible and can be applied to walls like wallpaper.

Shingles, normally thought of as exterior sheathing or roofing, make a casual interior wall surface especially useful in rooms subject to much dampness—such

18.9 Wood is available in numerous variations. Shown here are some of the many different woods, grain patterns, and methods of cutting and assembly for interior use. (Photographs courtesy American Plywood Association; Bangkok Industries; Expanko Cork Co., Inc.; Potlatch Corp; and U.S. Plywood)

18.10 A Lake Tahoe vacation home fits naturally into its mountain setting with board-and-batten whitewashed fir paneling on both the walls and the coved ceiling. Kirk Hillman, architect; Alice Wiley, Kendall Potts, interior designers. *(Photograph: David Livingston)*

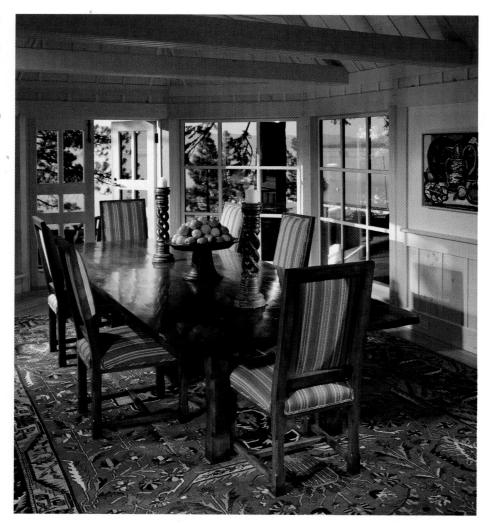

18.11 A vacation home on an island off the coast of Maine maintains its relation to the outdoors with Douglas fir plank ceilings and floors, native white cedar paneled walls, and a native granite fireplace. Walls on both sides consist of mahogany-framed sliding glass doors that offer views of the ocean and woods. Peter Forbes and Barry Dallas/Peter Forbes & Associates, architects. (Photograph: Timothy Hursley)

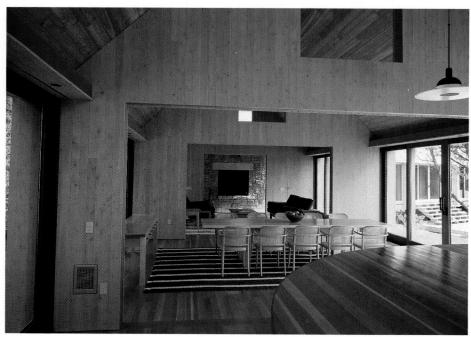

as garden rooms and saunas—because they absorb moisture. **Cork**, which is actually the thick, elastic outer bark of the cork oak, gives both sound and temperature insulation, in addition to serving (in children's spaces particularly) as tack boards (Figure 18.12).

Wood is a good insulator and can be finished in a variety of ways. It can also be refinished. However, it will fade, and is flammable unless treated to make it fire-resistant.

MASONRY Various types of masonry walls were discussed in Chapter 15. They include concrete block, exposed brick and stone, ceramic tile, and stuccoed brick.

Masonry walls in solar homes function as heat storage devices, absorbing direct heat from the sun and heat from the air itself and radiating it slowly during the night hours. The exposed masonry surfaces may be brick, concrete, clay tile, or adobe. Such surfaces also help moderate the overheating effect if constructed with sufficient mass to heat through slowly.

Concrete-block structural walls are used in buildings in moderate climates, multiple housing units, and basements. They absorb sound as a result of their construction. Drawbacks include an institutional look when painted and the difficulty concrete-block walls present to anyone trying to hang something on them.

Ceramic tiles are made in a variety of patterns and colors, from "natural" or earthlike to unique designs. (See Figure 18.13.) Tiles can be hand-set one by one, with grout; but they also come in mesh-backed sheets that, with an adhesive, can be more easily set in place. Some larger tiles have a peel-and-stick backing, making them popular with do-it-yourselfers. Tile is easily maintained since it is impervious to water, but it is noisy, hard and cold to the touch, and can crack or chip.

Stone and brick are typically associated with fireplace walls and exterior walls but need not be limited to these locations. Thin sections of stone available in panels or tiles offer the rugged durability of the material without the bulk and weight. Marble veneer can contribute elegance to a formal interior. Stone and brick have

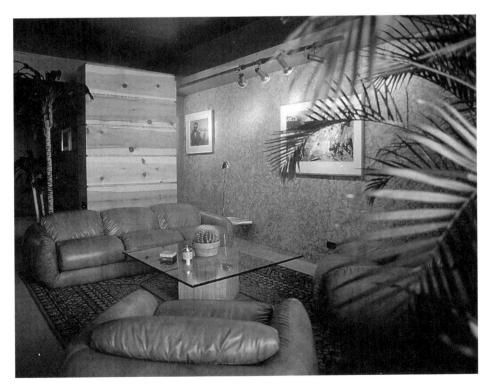

18.12 A cork wall makes a versatile art gallery surface, allowing frequent rearrangement and change without requiring constant repair. The textured and patterned surface masks nail holes. Robert Shaw, interior designer. *(Photograph: Robert Perron)*

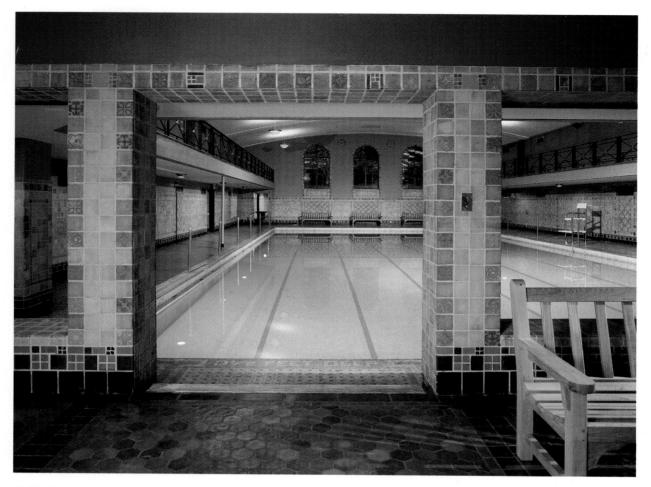

18.13 A variety of original ceramic tile, some manufactured over sixty years ago in Italy, was retained for its colorful character when this private residential health club was restored in a Manhattan building dating back to the 1930s. Kevin Thompson, restoration architect; Gregory Cilek/The lowa Group, interior designer. (Photograph: Frederick Charles)

been used since ancient times, but are well suited to contemporary as well as period styles. Their texture ranges from warm and casual to smooth and formal, but they are noisy, hard, and often cold to the touch like most other masonry surfaces. Pictures and other wall-hung accessories are difficult to mount on masonry walls. All masonry materials are fireproof.

GLASS Broad areas of glass might be seen as an expansion of traditionally small windows until they have taken over whole walls, flooding rooms with light (or glare) and heat (or cold), and expanding space into the outdoors. **Window walls** influence color schemes, may present problems in insulation and appropriate treatment, and often determine possible furniture arrangements. (Other problems and possible solutions are presented in Chapter 20.)

Another common use for glass on walls is in the form of mirrors, which expand the apparent size of a room and create brilliant patterns of reflected light (Figure 18.14). Mirror is produced in sheets or tile, and may be antiqued, goldor silver-veined, of tinted or clear glass, with etched designs and beveled edges. Mirrors can mask structural details at the same time that they add drama to the interior decor. If the wall surface is uneven, furring strips (narrow strips of wood) are placed over it and the mirror is attached to them.

Glass blocks, or glass bricks, either patterned or plain, have returned to use. They permit light to pass through but obstruct clear vision and may be used for interior or exterior walls, set in walls of other materials or by themselves, in curved or straight lines.

METAL Metal does not often appear on interior walls, being confined primarily to outside sheathing. But metal tiles of copper, stainless steel, or aluminum can provide a striking wall surface. The extreme sound- and light-reflective qualities of polished metal must be handled carefully, but brushed finishes and natural patinas have a soft, burnished quality (Figure 18.16).

A unique idea is to cover a metal-sheathed interior wall with fabric and use that wall, where pictures can be hung with magnets, for easily changed and re-

arranged picture display.

PLASTICS Rigid plastics are used on walls with increasing frequency. They masquerade as other materials or stand on their own to make superior wall surfacings for special installations, such as bathrooms, or any place where their imperviousness to water and soil as well as their ease of maintenance is an advantage. They

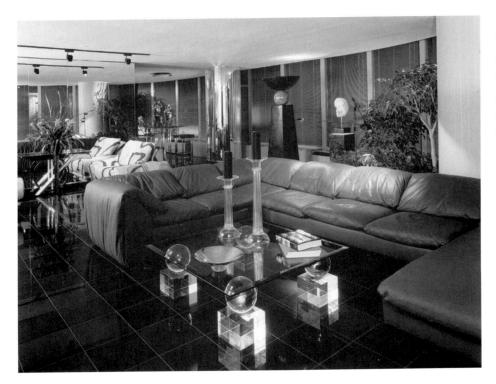

18.14 In contrast with the solid mass of the leather sofa and large obelisk, the mirrored wall adds depth and light to this Chicago Lakepoint Tower condominium interior while also carrying out the weightless effect of transparency seen in the crystal coffee table and candle holders. A highly polished black granite floor and the faceted mirror treatment on the column contribute sparkle. Norbert Young, architect; Calvin Ashford/Gilmore-Ashford-Powers Design Inc., intedesigners. (Photograph: Howard N. Kaplan)

18.15 A remodeled kitchen makes use of glass block to admit light while obscuring the view. (Photograph: © Peter Aaron/ESTO)

18.16 Brushed aluminum panels create unique walls in a New York apartment. One wall consists of movable panels mounted on tracks for maximum flexibility in the use of space. (Photograph: John T. Hill)

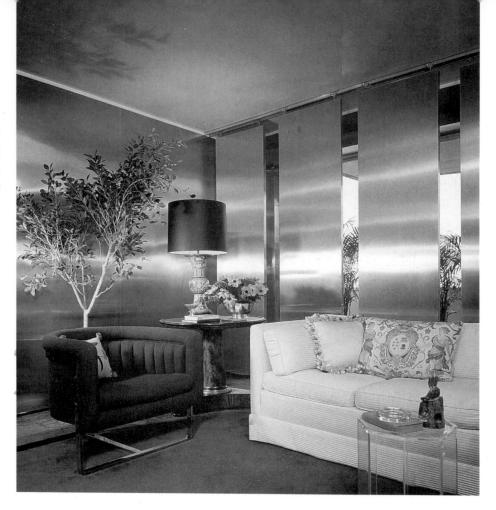

are available in sheets or tiles. Formed plastic is also used for bath and shower enclosures. Most plastics are difficult to repair or refinish if damaged and many present environmental hazards (off-gases, flammability, and deadly fumes), giving the responsible designer reason to make careful and knowledgeable selections and applications.

PAINT Paints are made from a broad range of natural and synthetic materials selected for their special attributes. Paints are the most widely used finish for walls and ceilings, for both decorative and protective purposes. Their diverse properties are impressive. They can be applied to wood, masonry, plaster, stucco, metal, or gypsum board; many resist sun, fading, and blistering; and most dry in a short time. Others are sound-absorbing, flame-retardant, or rust-inhibiting.

New ceramic-filled paints have both sound-blocking and energy-saving properties. Very fine ceramic particles mixed into the paint are extremely reflective to heat radiation and dissipate heat rapidly. (This is the same type of ceramic material used on the heat shield tiles on NASA space shuttles.) Lower emissivity prevents heat loss by radiation to outside walls in winter. More of the heat is reflected back to the interior. Ceramic-filled paint also forms a sound-insulating film. It is very durable and covers in one coat.

Synthetic resin latex paints are easier to apply than older varieties; they usually go on with a roller or pad, have little solvent odor, dry quickly, present minimal fire hazard, and can be touched up. When dry, they offer *matte* (flat), *semigloss* (satin), or *high-gloss* surfaces. These <u>water-base paints</u> are extremely easy to handle, because paint spots can be wiped up with a damp cloth and brushes cleaned with soap and water. After a short period of curing, they become impervious to water.

Alkyd-based paints (oil-modified resins) are more durable, but using solvents such as mineral spirits for clean-up is somewhat more tedious, toxic fumes and flammability are problems until the surface has dried, and some areas of the country restrict the amount of volatile organic compounds (solvents) that can be used per gallon and control their disposal.

Lacquer is a solvent-based paint that is applied with a spray gun, often in many coats, with a fine sanding between each coat. Lacquer is highly combustible and may present an environmental hazard to those who work with it. For this rea-

son, some companies no longer use it.

Primer is an undercoating used first to prepare the surface or substrate for a final finish coat. Primers seal porous substrates to prevent waste of paint. Some

finish coats are self-priming.

A flat finish paint is often used on walls and ceilings, except for woodwork and in bathrooms and kitchens, which benefit from the more durable, scrubbable semi-gloss and gloss finishes. Darker colors reflect more light if semigloss paint is used. Pastel colors reflect more light in gloss paints as well but may become washed out in appearance and lose too much color. Therefore, pale colors are often better in matte finishes. The number of different colors available has been vastly increased by automatic mixing machines, and colors from other materials can be closely matched in paint. Since the color will appear darker and more intense when applied to walls (the effect of *amplification*), paint colors slightly lighter and less saturated than desired should be selected. (See Chapter 5 for a more detailed discussion of color effects.)

Being the easiest of all finishes to apply, paint leads many people into doing their own wall finishing. Nothing so quickly and inexpensively changes the character of a room. Paint finds its place in the smallest apartment and the most elaborate mansion, in good part because it is an excellent background for furnishings, art objects, and people. In the hands of a skilled professional painter, paint finishes can take on great beauty and individuality. Figures 18.17–18.19 show quite different decorative effects that can be achieved. *Faux finishes, trompe l'oeil* effects, *antiquing, glazing*, and *texturizing* are among the many special techniques that make maximum use of paint's versatility.

Paint can also be used to add pattern and texture to a wall, as in Figure 18.18. Stenciling (painting a design through a stencil) was used to enliven the walls of the

18.17 (below, left) A San Francisco late 1800's Victorian home includes several examples of the painter's art. At the stair landing, a trompe l'oeil cat, sitting in front of an urn of flowers, gazes toward a bird painted on the wall in the niche; vines trace their way from the urn out onto adjacent walls; original moldings and balustrade have been given a faux verdigris finish; and walls have a glazed finish. Richard Banks/Design Solutions, interior designer; B. Johnny Karwan, tromple l'oeil artist. (Photograph: David Livingston)

18.18 (below, center) Hawaiian motif fabrics and a sisal floor covering inspired designer Jarrett Hedborg to have a glass block wall outlined with a stenciled pattern reminiscent of barkcloth designs. Nancy Kintisch, stencil artist. (Photograph: Tim Street-Porter)

18.19 (below, right) Painted walls can be given visual texture, either to simulate other materials or simply for greater interest and depth of color. Five different colors were worked together with sponge painting, then glazed, in this example. Cynthia Campanile/Artistic Tile, designer. (Photograph: David Livingston)

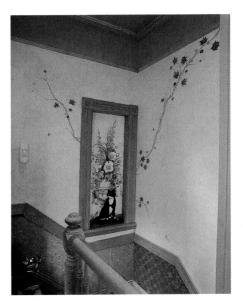

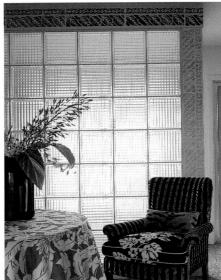

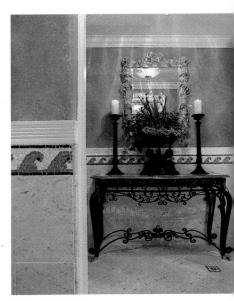

living room with floral motifs in keeping with the eclectic character of the space and furnishings. Designs that are varied in size and scale result in a much freer and personal expression than wallcovering could have achieved.

Next in importance to color is paint's ability to give a smooth uniform surface to whatever it covers. But sometimes smooth paint will not cover all blemishes, and occasionally smoothness is not wanted. In such cases paint can be *stippled* with a stiff brush to obliterate brush marks and to provide a soft, matte finish; or it can be *spattered* or *sponged* with one or more colors to give some vibrancy and minimize spots or scratches. More pronounced textures are produced with special paints which produce a sandy surface, by applying the paint with special rollers, or by going over the wet paint with a sponge, dry brush, comb, or a whisk broom. These are easy and inexpensive ways to cover plaster cracks or gypsum board joints, and they create unique surfaces.

Measuring and Estimating. To determine the amount of paint needed, measure the perimeter of the room and multiply by the height of the room. This yields the total square footage to be covered. A gallon of paint will normally cover from 400 to 500 square feet of surface (one coat of paint on the walls and ceiling of a 9-by-12-foot room with an 8-foot ceiling), depending on the surface material, its condition, and previous color. Porous materials, rough surfaces, and dark colors require more paint to cover adequately. Paint coverage per gallon is usually noted on the container label and varies with type of paint being used.

WALLPAPER Long known in the Orient, wallpaper has been used in Europe for about five centuries and in the United States since the Colonial period. "Poor man's tapestry" was a good name for it, because wallpaper came into use in humble homes as an imitation of the expensive textiles used by the wealthy. Wallpaper's advantages are many:

- It can be used in any room in the home.
- It can be tested for its effect in advance by borrowing large samples.
- It is available in an infinite variety of colors, patterns, and textures, and in varying degrees of durability.
- It is a quick and easy way to remodel with prepasted or self-adhesive (peel-and-stick) types.
- It has the most positive character of any wall surfacing in its price class and can establish the feeling of a period in history.
- It makes a room seem to shrink or expand, gain height or intimacy, become more active or subdued, more formal or less formal.
- It can minimize architectural problems by illusion or camouflage.
- It hides disfigured walls.
- It makes rooms with little furniture seem furnished.
- It distracts attention from miscellaneous or commonplace furniture.

Wallpaper seems natural for many traditional or restored rooms. The Early American bedroom in Figure 18.21 is an assemblage of authentic antique toys and furnishings. The small-scaled pattern and light color of the wallpaper join with dormer windows and exposed beams to provide a background for the mellowed furnishings and hand-stitched patchwork quilts.

Wallpaper has a few inherent disadvantages. Some people may not like its "papery" look, and it may not be very durable or easily maintained in high-use areas. However, it is possible to find papers appropriate to almost any way of living, any kind of furnishings, or any exposure or special factor.

Wallpapers are produced by roller printing, screen printing, or block printing. They range from solid colors through textured effects, from small to large patterns, from abstract to naturalistic mural or scenic designs which may create an

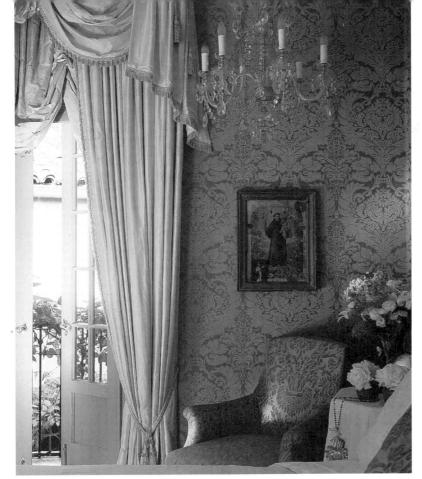

18.20 A house built in 1929 in Hollywood Hills, California, is very formal in character, with elaborate drapery, crystal chandelier, 19th century French armchair, and a historical print wallpaper by Clarence House. Annie Kelly, interior designer. (Photograph: Tim Street-Porter)

18.21 An attic can be the ideal place for a cozy room for children. Here the wallpaper reflects the traditional pattern of a handmade quilt. Snezana Grosfeld/Litchfield-Grosfeld, architect. (Photograph: © Norman McGrath)

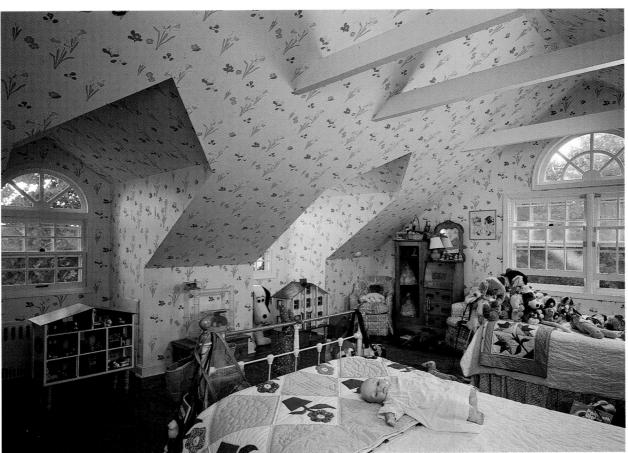

illusion of depth and enlarged space. Most have a matte finish that may or may not be washable, but some are glossy and may be vinyl-coated for washability, durability, and soil resistance. Flock papers with their raised, fuzzy nap look like textiles. Marbleized papers hint at the gloss and depth of marble, and metallic papers add luster. Available in a wide range of prices, wallpaper is quick and relatively easy to apply. Coordinating wallpapers and fabrics provides easy harmony with both unity and variety for any interior (Figure 18.22).

Selection of pattern and color presents a challenge with so many available. Wall-length samples of several patterns can be fastened up for the client to observe at different times of day and night. Wallpaper is a kind of applied ornament that may noticeably affect the apparent size, shape, and character of rooms. Strong designs set the character of a room, and other furnishings must be keyed to them. A bold pattern may make it difficult to coordinate other accessories, especially wall-hung objects that may require large, plain mountings. Consider wallpaper in the light of the criteria for ornament discussed in Chapter 3, making these more specific by keeping in mind that the wall and paper are flat and continuous, like fabrics, and that in most instances the pattern will cover very large areas. In addition, note these advantages and disadvantages:

18.22 Fabrics and wallpapers coordinate by means of repeated color in this nursery. The striped fabric clearly dominates due to its bolder scale and larger area, while the border paper and gingham lampshade add accent. An infant will focus on the red color and the patterns with strong value contrast before s/he is attracted to blue; however, the blue provides a quiet, calm, and restful effect for the parents. Pauline Boardman, Ltd., interior designer. (Photograph: Mick Hales)

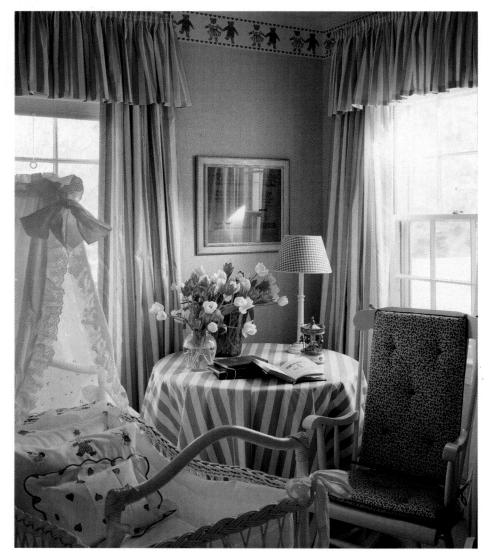

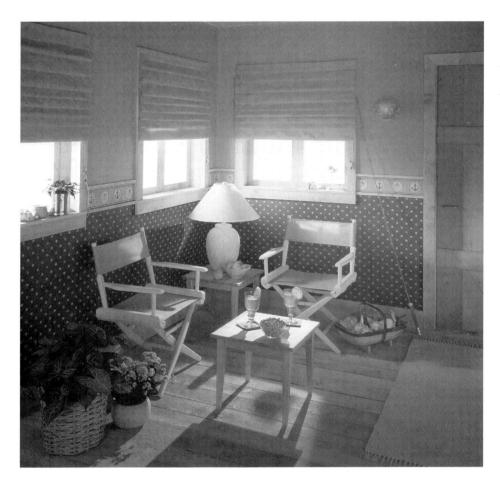

18.23 Stripes and dots share a common abstract geometric character, further unified by a nautical theme border. For variety, the stripes in the chairs are horizontal. (Courtesy Warner)

- Plain colors look much like paint but possess varied textures.
- Textural patterns are more active, more pronounced in character, and more effective in concealing minor damage than are plain colors. Very smooth, light reflecting papers, on the other hand, emphasize wall blemishes. In kitchens and utility areas, grease and lint may cling to highly textured surfaces.
- Abstract patterns such as stripes and geometrics do not go out of fashion quickly and seem especially suitable to walls.
- Scenic wallpapers are somewhat like murals, and may seem to broaden the space when they contain a predominance of horizontal lines or deepen the space with perspective.
- Repetitive, bold, conspicuous patterns may reduce the visual importance of the space, furniture, and people, but can provide a focal point.
- Conspicuous, isolated motifs often make walls look spotty.

Measuring and Estimating. Wallpaper is priced by the single roll although it is packaged in double or triple, sometimes quadruple, roll bolts, which result in less waste. A single roll contains about 30 usable square feet, allowing as much as 6 square feet for waste in cutting and matching patterns. To determine the quantity of paper needed, measure the total square feet of wall space to be covered (length times height of each wall, then add) and divide by 30, rounding fractions up to the nearest whole number. This formula will tell you the number of single rolls needed with perhaps a little excess for walls that are not "plumb" or truly square and straight. Subtract one roll for every two normal openings (doors and

windows), or subtract the area of such openings. Some large-patterned papers may require as much as 20 percent extra in order to align the pattern properly on the walls; however, many patterns are produced in modular-sized repeats that space evenly from floor to ceiling in standard-height rooms. Pattern repeats of 2, 3, 4, 8, and 12 inches, for example, divide evenly into a 96-inch wall height.

VINYL WALLCOVERINGS Nearly all the things that were said about wallpaper apply equally to vinyl wallcoverings, though certain qualities are easier to achieve. Application requires less delicate handling because the vinyl film, often backed by a fabric, doesn't stretch or tear as easily as paper. Removal is made quicker and less tedious than paper as well; many vinyls can easily be stripped from a wall in large sheets and even reused. Because vinyl presents fewer problems in application than does wallpaper—and is thus easier to match at the seams—it lends itself well to large unbroken walls and large pattern repeats. Vinyls for commercial use are available in 52-inch or greater widths which might be used in kitchens, baths, and utility rooms where fewer seams are desirable. Textured, three-dimensional effects are a particular strong point of vinyl wallcoverings.

In terms of maintenance and long life, of course, vinyl wallcoverings tend to be superior to wallpaper, but the initial cost may be higher. Vinyl is *scrubbable* with soap and a soft brush while paper is usually only *washable* with a damp sponge if it is vinyl-coated. With proper application, heavyweight, tough vinyls can hide serious wall defects, even hold cracked plaster in position. Some vinyls have special backings for sound insulation, and a number of them perform well as upholstery, thus allowing for harmony between two elements of the interior.

18.24 Plexus 54" vinyl wallcovering has a distinctly textured surface pattern. (Courtesy C&A Contract Wallcoverings, a division of Imperial Wallcoverings, Inc.)

18.25 The walls of this dining area in a Manhattan, New York, highrise apartment are upholstered with panels of silver satin. They soften the bright lights, glossy ceiling, and metallic silverpainted parquet floor, making a transition to Saladino fabriccovered chairs and a Regency rosewood table adorned with an 18th century English chandelier centerpiece. John Saladino. interior designer. (Photograph: ESTO Photographics)

WALL FABRICS AND FIBERS—Just about every fabric known has at one time or another been draped over, stretched on, or pasted to walls. Centuries ago the walls of nomadic tents were constructed of fabric and poles. In more northerly regions, heavy tapestries were hung over cold stone walls for beauty and warmth. Today, such effects still fall into two main categories: wall fabrics that surface a wall and cover at least one section completely, and those that are simply hung on walls as enrichment.

Almost any fabric can be made into a wallcovering by tacking it directly to the wall or to a wooden frame, or by using double-faced carpet tape, vinyl adhesive, or Velcro strips. Fabric can also be hung in soft folds by gathering it at top and bottom *(shirring)*, or walls can be padded and upholstered, both of which increase sound-absorbing and cold-insulating qualities. Fabrics can be vinyl-coated and paper-backed and hung like wallpaper as well.

The various kinds of grass cloth, longtime favorites for adding texture to a wall, are easy to apply, because they are glued to a tough paper backing and then handled much as wallpaper. They are hung in alternate strips, however, a technique which masks the mismatched quality inherent to these natural materials. Grass cloths range in texture from comparatively smooth to bold and may be any color, although they are often most appropriate in their natural colors. Other natural fibers and materials, such as wool, flax, leather, and cork, are also used in this manner.

Carpet has also been used on walls, providing sound and cold insulation, a soft, sensuous texture in an unexpected place, and continuity between floor covering and wall. This technique can be especially successful when it serves to tie built-in seating into the structure of the room. It is very durable in hard-use areas. However, carpet designed for flooring may not meet flammability standards required in public or commercial spaces when used on walls. Carpet designed especially for walls is available in a limited range of colors and textures.

Fabric wall hangings of many types add enrichment to an interior. Heavier woven or stitchery panels—even rugs—open up many possibilities for walls, to replace the standard paintings or prints. A textile can act as a partial wall or space

18.26 A Lake Tahoe, Nevada, vacation home makes use of many appropriately informal textures. ranging from the rough-sawn Douglas fir tongue-and-groove paneling that covers walls and ceilings to the natural river rock fireplace to a string wallcovering of natural hemp mounted on black paper. The faux finish table in the foreground is fiberboard, painted to look like a piece of stone with Indian cave painting on it. Indian drums serve as tables in front of the fireplace. Karen Kitowski, ASID, interior designer. (Photograph: David Livingston)

divider, separating but not shutting off one part of the room from another. All told, textile fabrics give variety and mobility, often with little time or effort.

Chapter 17 provides more detailed information on the soil resistance characteristics of the various fibers and finishes. Generally, rough textures catch more dust but show less soil than smooth textures. Removable fabrics can easily be washed or dry cleaned and rehung. A soil-repellant can be applied before or after hanging to reduce soiling and make cleaning easier.

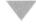

FIREPLACES

Conventional fireplaces are extravagant. A fireplace may cost as much to construct as a bathroom. Further, storing fuel takes dry space, getting it into the firebox requires labor, and the later cleanup is a chore. Many fireplaces are actually used for fires less than one percent of the time. When lit, they provide some physical and psychological warmth, perhaps heat for cooking and some light and ventilation—but all of a hard-to-control sort, and at high cost.

Still, open fires are beautiful, and fireplaces even without fires can be substantial centers of interest (Figure 18.27). A fire's warm, constantly changing, beautifully shaped and colored flames and embers produce a kind of lighting equaled only by sunrises and sunsets. Nothing perhaps lifts the spirits on a cold, cheerless day or night like a fire, warming hands and hearts. Thus, even though conventional fireplaces are hopelessly out of date in terms of utility and economy, open fires are not outdated in terms of human satisfaction.

Heat from a fireplace on a cold day may seem worth its cost, even though it creates drafts on the floor, draws warm room air up the flue, and may throw thermostatically controlled furnaces off balance. Heat output can be increased and controlled by designing the firebox to throw heat into the room, by keeping the damper open just enough so smoke doesn't enter the room, and by using a projecting or suspended hood to radiate heat. Glass doors also decrease draft and heat loss, and special grates consisting of metal pipes which draw in cool air from the room, circulate it around and over the fire to warm it, then allow it to re-enter the room improve the efficiency of conventional fireplaces markedly. Prefabricated fireplaces with vents, like small warm-air furnaces, circulate heated air effectively. An energy efficient insert can be put into a fireplace to push more heat into the room and possibly even into other rooms with additional ducts and fans. Installation of a fireplace insert is regulated by local building codes for safety.

Light is an aesthetic contribution of fireplaces, because the illumination they provide is unique. It is restfully soft and warm enough in color to make even pallid complexions come to life. The concentrated, flickering light can be hypnotically relaxing and draw people together like a magnet.

Ventilation is hardly a major function of fireplaces, but they do air rooms—violently with a good fire, moderately when they are cold and the damper is open.

The *symbolism* of "hearth and home" continues to be important. The experience of gathering around a fire unites people of all ages and interests and can make a group feel relaxed and secure. Where burning wood is regulated or prohibited due to particulate emissions that contribute to environmental problems, natural gas fireplaces are still in demand for their psychological and symbolic effect.

LOCATION

When fireplaces were used for heating, nearly every room had one. Today, few houses have more than a single fireplace, and this generally is located in the living, dining, or family social space. Occasionally, one or more additional fireplaces

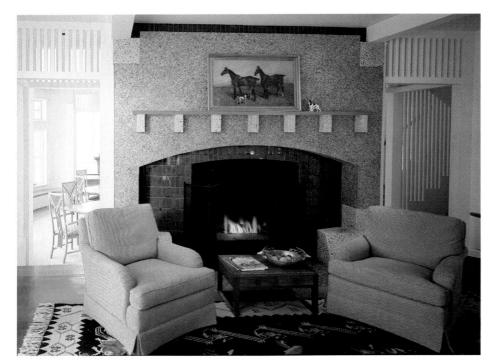

18.27 A massive granite and ceramic tile fireplace symbolizes the heart of a Chester, Pennsylvania, home and creates a warm, inviting place to sit. The solid cherry mantle rests on precast concrete supports. Harry Teague Architects. (Photograph: Timothy Hursley)

18.28 A traditional sculptured adobe fireplace fits snugly into the corner of a bedroom with a small built-in seating space adjacent. Maurice J. Nespor & Associates, architects; Diana Cunningham, interior designer. *(Photograph: Maurice Nespor)*

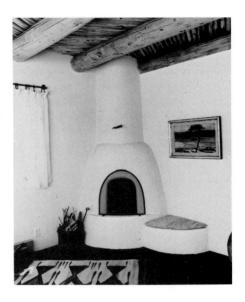

will be put in rooms in the private zone. Because of its traditional association with food preparation, the fireplace located in a family kitchen seems natural, though it is rarely used for cooking.

Fireplaces most often are large, more-or-less dominant elements. They demand considerable maintenance when a fire is burning and therefore should be accessible. Fireplaces make natural centers for furniture arrangement and usually attract as many people as space around them permits.

A typical location is the center of a long wall. While such an arrangement allows maximum visibility for large groups, it also suggests an evenly spaced furniture placement, which can lead toward static symmetry and tends to shorten the room visually. A fireplace in the center of one of the short walls can make the room seem longer, and it may inspire one furniture grouping near the fireplace and another at the opposite end. Locating a fireplace in the corner of a room also emphasizes the room's longest dimension, and it invites a diagonal furniture arrangement.

A fireplace may also be placed in a spur wall that acts as a room divider; it might be a freestanding structure that delineates continuous space into areas for different activities; or it may serve as the focus for a space specifically designed as an intimate area away from the main group space. A fireplace between two rooms can be enjoyed from both sides.

APPEARANCE

Although consistency with the room as a whole is a major consideration, fireplaces can have their own special beauty and individuality. Of all elements in the home, fireplaces lend themselves best to overscaling without seeming unpleasantly obtrusive; but very small fireplaces can have a certain refreshing charm. It is easy to increase the importance and apparent size of fireplaces by enriching them with contrasting materials, by integrating them with bookshelves, architectural niches, or built-in furniture, or by making them an integral part of large areas of masonry. Also, fireplaces seem larger on small walls.

Relationship to walls, floors, and ceilings profoundly affects the character of fireplaces. They simply can be holes, perhaps framed unobtrusively, in an unbroken wall—the least noticeable treatment. Some project from the wall a few inches or several feet, which increases their impact. The fireplace outlined by a

mantle and possibly a molding remains classic in modern as well as traditional homes. When the fireplace is freestanding, it becomes still more conspicuous.

The fireplace unit may extend to the ceiling, which accentuates its verticality. If it terminates a little or well below the ceiling, it can create a horizontal or blocky effect. The bottom of the fire pit may be either at floor level or at seat height; in the latter case, the hearth usually is extended for safety, creating additional sitting space. Or the fire pit and surrounding area may be depressed below the main floor, with space large enough for furniture around it. This arrangement tends to draw people into a convivial huddle and subdivides a room without partitions.

MATERIALS

Materials are limited to masonry and metal, since neither is damaged by fire. Brick and stone look substantial and permanent, tile can be plain or decorated, and metal not only lends itself to shaping in many ways but also transmits heat, thus using

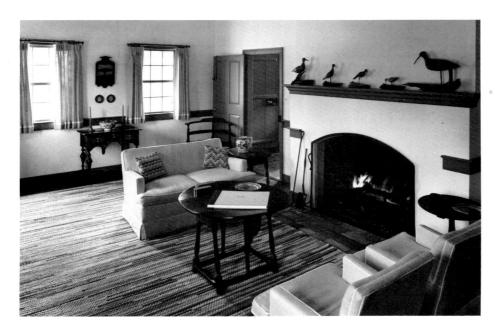

18.29 A fireplace projecting slightly from the wall and capped by a mantelpiece gains an unobtrusive prominence that sets the character of this quiet, comfortable room. Thomas A. Gray and William L. Gray, designers. (Photograph: Bill Aller/NYT Pictures)

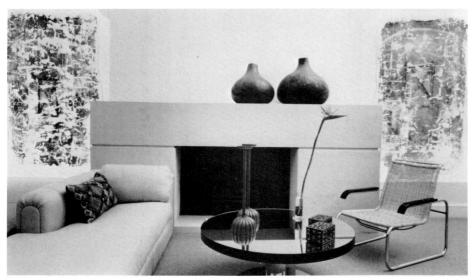

18.30 A monumental fireplace mantel and solid-slab construction make a strong design statement in a contemporary living room. Juan Montoya, designer. *(Photograph: Mark Golderman)*

all of the fire's energy potential. These materials exhibit many colors and textures: smooth tile and polished marble, shining copper and dull iron, brick and stone in all gradations of roughness. The fireplace may also be faced with other materials, including wood (Figure 18.31).

WOOD-BURNING STOVES

Concern with energy conservation and fuel shortages has led many families to consider returning to wood as a partial or emergency source of warmth. Many homes have either contemporary or old-fashioned, but highly efficient, wood-burning or pellet stoves partially inset within a fireplace or free-standing with only a heavy-duty pipe outlet through the ceiling or wall. The farmhouse living room in Figure 18.32 boasts such a piece—a splendid example of ironcraft enriched with touches of brass. It is set on a brick pad a safe distance from a brick wall, in accordance with fire codes. Given the superior efficiency of freestanding metal stoves, this unit could keep such a small room comfortable on all but the coldest nights. Even if it could not, it earns its place in the room by the charm of its design and embellishment. Unfortunately, some localities are finding that too many such wood-burning stoves and fireplaces are resulting in a serious air quality problem because of all the smoke, an environmental concern that affects everyone.

18.31 Mark and Nancy Jordan completely rehabilitated a derelict 1896 Queen Anne Victorian town house in Chicago, saving what they could, including the oak fireplace mantel. The marble tile is new, coordinated handsomely with the modern classic Josef Hoffmann reproduction chairs. (Photograph: Hedrich-Blessing)

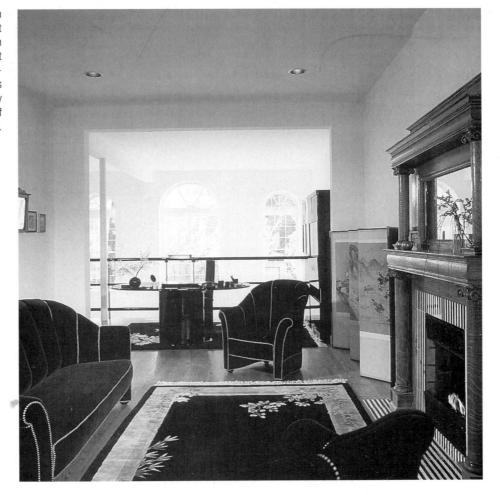

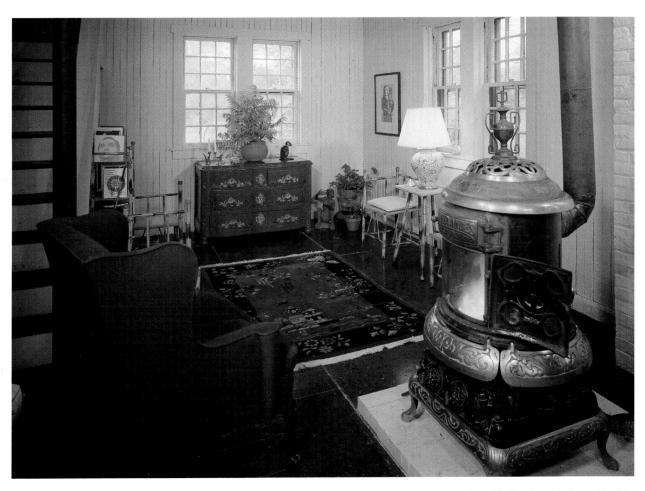

CEILINGS

Although they are rarely *used* in the same sense that other major elements of the house can be, ceilings do have important effects, other than shelter, illumination, acoustics, heating, cooling, and character; yet they are often neglected. Typical ceilings are the same size and shape as the floors they parallel, surfaced with plaster or gypsum board, and painted white or some very pale hue. There are several reasons for this stereotype. A flat, neutral ceiling is inexpensive to build and maintain; it gives unobtrusive spaciousness; and it reflects light well. Perhaps it is just as well in a busy world to retain one large undecorated surface in every room for visual respite. Nevertheless, ceilings play an important role in the architectural background of a room and should not be forgotten.

DESIGN

Ceilings during the time of the Renaissance were coordinated with wall designs and were executed in molded or carved plaster. These backgrounds set the mood of the room, stating its character and even dictating furnishings and accessories. Decorative treatment of ceilings continued into the eighteenth century, when plain ceilings came into vogue. In the second half of the twentieth century, however, there has been a renewed interest in ceilings, especially high or slanted ones. In

some cases, the overhead plane has been elevated so high as to be practically unnoticeable. Rather than the ceiling itself, it is the dramatic volume of open space that dominates.

HEIGHT Ceiling heights are determined by reconciling our needs for head room, air, and economy with our desire for space pleasantly proportioned and in character with our lifestyles. Minimum human heights are 7 feet for basements, 8 feet for the main level and for upper stories. Heights beyond these may well be justified for aesthetic reasons, and lowered ceilings, especially in part of a room, may seem cozy and sheltering.

There are notable differences in the effects of low and high ceilings. Space seems to expand under high ceilings, while low spaces are more intimate. The *appearance* of increased or decreased ceiling height can also affect the character of the room. To make a ceiling seem higher, use a light color on it, light it or place a skylight in it, run the wall color onto the ceiling a short distance, or use vertical lines on the walls to lead the eye upward. To create the appearance of a lower ceiling, use a dark color (but not a glossy finish), a pattern, or contrasting horizontal beams on the ceiling, drop the ceiling color onto the wall (where it can end with a picture molding), or use horizontal lines on the wall to lead the eye along its length rather than its height.

Ceilings of different heights can energize space and differentiate one area from another. For example, dining rooms can be set apart by lowering the ceiling or raising the floor, and quiet conversation spaces can be demarcated by ceilings appropriately lower than those in the rest of the group space.

In remodeling older buildings, which often have high ceilings, the designer can make use of that verticality to provide more floor area and the contrast of varied ceiling heights with balconies and lofts.

Low ceilings reduce winter heating costs but make rooms warmer in summer, because the rising hot air has nowhere to go. A ceiling fan can provide some relief. High ceilings bring in cooler air at floor level, so they are more comfortable

18.33 Contemporary homes, with their open plans, often modulate interior spaces with changes in ceiling height. Here the dining area is made more intimate by a lowered ceiling with a skylight while the living area is opened up with clerestory windows near the raised ceiling. Carol J. Weissmann Kurth and Peter C. Kurth, architects. (Photograph: Peter Mauss/ESTO)

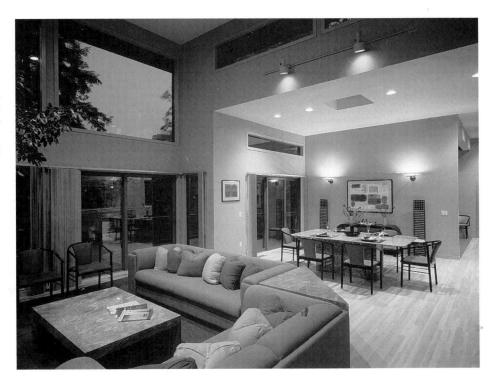

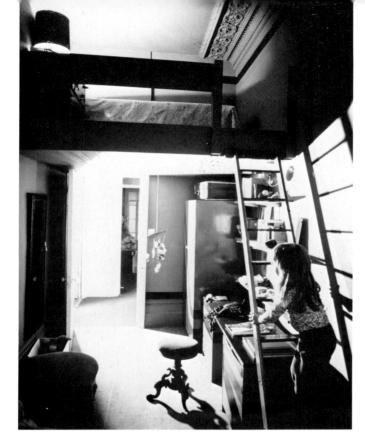

18.34 A sleeping loft greatly expands usable space in small but high-ceilinged apartments. *(Photograph: Michael Boys)*

in summer, but much more energy is required to keep the lower part of the room warm in winter. The warm air that rises, however, can be directed downward by means of fans or recaptured and recirculated at floor level.

SHAPE AND DIRECTION While it is often suitable to have ceilings that are nothing more than uninterrupted horizontal planes, some other possibilities offer more interest.

Dropped ceilings can enliven the overhead plane even on the first floor of a two-story house, where horizontal ceilings are almost mandatory. They can demarcate certain areas and provide a handy recess for indirect lighting that will softly illuminate a room. A dropped ceiling over a hallway will emphasize the sudden, exhilarating elevation of ceiling over the larger living space. The effect of transition is magnified.

Integrated ceilings combine lighting and ceiling as a total, unified system. (Lighting is discussed further in Chapter 21.)

Coved ceilings, in which walls and ceiling are joined with curved or angled surfaces rather than right angles, make space seem more plastic and flexible. A variation provides a recessed space for cove lighting around the perimeter of the room, washing the ceiling with light from an unseen source.

If carried to their logical conclusion, coved ceilings become **domed** or **vaulted ceilings**. Contrasting materials add visual as well as actual weight to enhance the sense of enclosure in a room.

Coffered ceilings are generally wood-paneled with ornamental sunken panels between closely spaced beams running at right angles to each other (Figure 18.35). Height is necessary to prevent such a ceiling from seeming oppressive.

Shed, lean-to, or **single-slope ceilings** provide excellent acoustics and call attention to the highest part of the room, often in a quite dramatic manner.

Gabled or double-pitched or cathedral ceilings encourage one to look up, and they activate and increase the apparent volume of a space. If the beams are exposed, the eye tends to follow their direction. For example, a gently sloping ceiling with beams running longitudinally from one end of the room to the other will

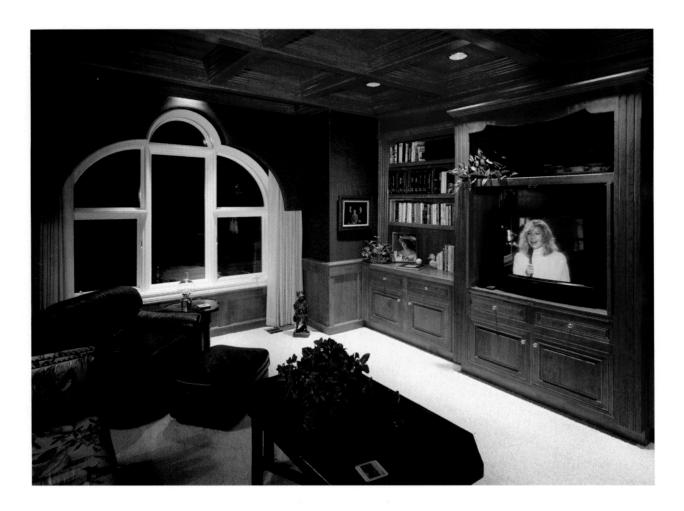

18.35 (above) A coffered ceiling and matching cherry cabinetry enhance the comfortable atmosphere of a study. The interesting window shape is repeated in the lines of the pelmet. Keith Yates/AudioVideo, cabinet designer. (Photograph: Ed Asmus)

18.36 (right) A cathedral ceiling with exposed beams helps balance a broad corner fireplace with long, low structural lines. Ceiling beams and fireplace are painted nearly white to keep their visual weight in harmony with furnishings yet allow their mass and volume to contribute to the scale of the space. Bruce Benning, Allied Member ASID, interior designer. (Photograph: Bob Van Noy)

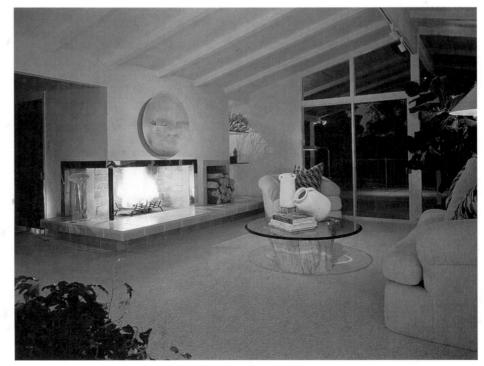

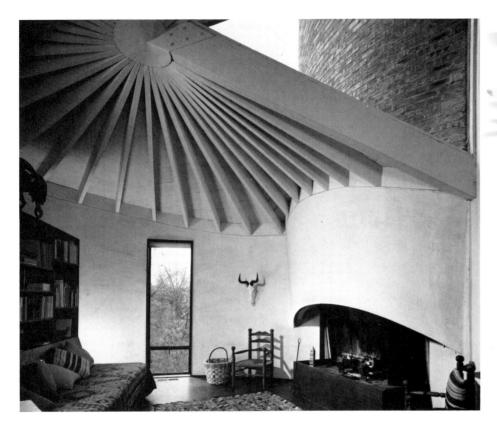

18.37 In this house of curves and planes, heavy wood beams and steel reinforcement flaunt their structural role and transform utility into a thing of beauty. The striking radial pattern of the ceiling, cut by a large triangular window, becomes the focal point of the room. (Photograph: © Ezra Stoller/ESTO)

accentuate the room's length and lower the ceiling's apparent height. When large beams follow the direction of steeply pitched ceilings, they emphasize the room's height dramatically. Ceiling planes can also slope in four directions when under a hip or mansard roof. A-frame houses have double-pitched ceilings that descend almost to floor level for an unusually strong architectural statement.

Sculptured ceilings defy classification because they are uniquely themselves. The ceiling shown in Figure 18.37 exposes structural members to create a striking radial pattern that is interrupted by the curving fireplace and the plane of the adjacent space cutting across it. This ceiling is clearly not a neutral backdrop but the focus of the whole room.

MATERIALS

Plaster and wallboard are the most common ceiling materials, since they are inexpensive and easy to apply. But these conventions by no means exhaust the possibilities for ceiling embellishment.

Plaster provides an uninterrupted surface that can meet plastered walls without joints, thereby passively unifying the sides and top of a room. It can be smooth or textured, plain, painted, or papered. In the days of more leisurely craftsmanship, plaster often was embellished with designs, a refinement preserved with care in many remodeled homes. *Acoustical plaster* is sprayed on, resulting in a rough texture that helps reduce ambient noise. Low in cost, it is often used.

Gypsum board resembles plaster, except that it leaves joints that must be concealed with tape or with wood battens. The latter provides lines of emphasis.

Ceiling tiles and panels are available in many sizes and patterns; they can contribute a ready-made texture. Some are easy to apply by the householder to cover a less-than-attractive surface; many are acoustical and offer the very obvious

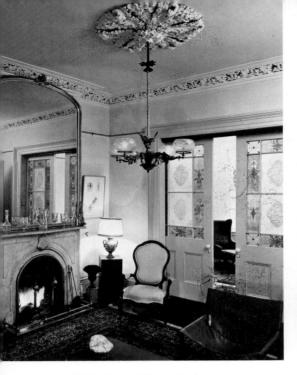

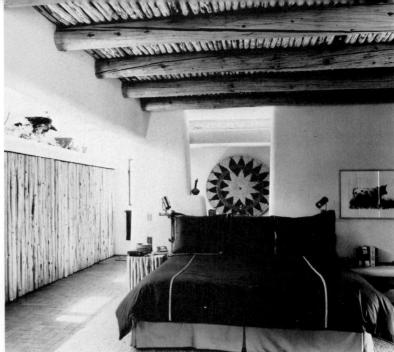

18.38 (above, left) An intricate plaster molding highlights this formal turn-of-the-century Brooklyn living room. *(Photograph: John T. Hill)*

18.39 (above. right) Small saplings called latias span the spaces between large supporting logs called vigas, traditional in Spanish pueblo-style architecture, creating an unusually emphatic ceiling in an adobe house. The saplings, peeled but left unfinished, are also used to front a wall of closets in the master bedroom. Maurice J. Nespor & Associates, architects; Diana Cunningham, indesigner. (Photograph: terior Maurice Nespor)

advantage of reducing noise at its source. There are also tiles with foil backing that cut down on air-conditioning costs. The framework for ceiling panels establishes a repetitive grid pattern. Translucent panels can be integrated with lighting behind them. Such panels can also be used to drop a ceiling.

Wood—in the form of strips, planks, or panels—is both handsome and homelike. It can be left in its natural state (in which case it will need minimum care over the years), stained, or perhaps painted to brighten the room. Wood is not often used for the entire ceiling today, but beams, as part of the structure, are exposed to give character.

Metal tiles, sheets, or strips can provide historic or contemporary effects. Tin, steel, copper, and others can be stamped with three-dimensional designs or left flat—polished, brushed, matte finished, or painted. Metal efficiently reflects sound, however, and may not be appropriate where noise is detrimental to the uses of the space.

Transparent, translucent, or **reflective materials** like plastics and glass admit natural daylight, or artificial light from fixtures concealed above them, to provide all-over illumination to the room and allow glimpses of the sky. **Mirrored** ceilings reflect light; they also give an illusion of height, an effect that is useful in small spaces.

Fabrics are rarely used on ceilings, but they can add warmth and softness to a room in unexpected ways (Figure 18.40). In addition to lending its drapability, fabric also diffuses and softens light.

Besides the surface materials that finish a ceiling, of the utmost importance are insulating materials placed between ceiling and roof or, in a multistory building, under the floor of the level above.

COLOR AND TEXTURE

Heaviness overhead is usually unpleasant unless the weight is clearly supported from above and balanced from below. This fact, together with the advantage of having ceilings that reflect and spread light, explains the frequency of light colors and fine textures on overhead surfaces. Certainly this characterizes most apartments, in which ceilings tend to be low and daylight enters through windows on only one exterior wall.

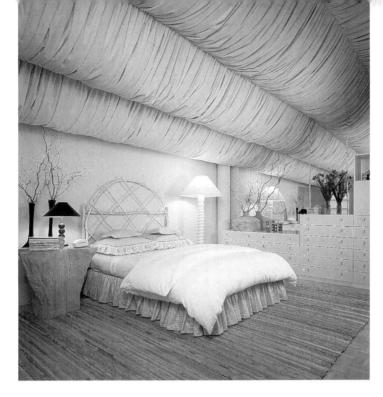

18.40 Shirred cotton duck draped over PVC pipe creates a cloud-like ceiling further emphasized by reflection in a mirrored wall above the stepped storage units. A willow headboard, rag rug, cedar tree stump table, and matching bed ruffle balance the unique ceiling treatment. Roger Scott, architect; Bruce Benning, Allied Member ASID, interior designer. (Photograph: Steve Simmons)

It should be remembered that ceilings, especially at night if much light is directed toward them, bathe everything below with their reflected color. A yellow ceiling, for example, would enliven yellows, oranges, or yellow-greens beneath it, but would gray any blues or violets. Special effects of considerable impact, however, can be achieved with ceilings painted in strong colors or made of a dark wood. Glossy color should generally be avoided on ceilings (because of glare), and additional lighting will be needed to compensate for the lack of reflected light from above.

Of the three elements discussed in this chapter, only two could be considered essential: the walls and ceilings that surround and cover our enclosures. Yet just as walls and ceilings give protection and privacy, fireplaces contribute both actual and psychological warmth. When handled with skill and imagination, each of these three elements can bring its own design integrity into the home.

REFERENCES FOR FURTHER READING

Baillie, Sheila and Mabel R. Skjelver. Graphics for Interior Space. Lincoln: University of Nebraska Press, 1979, pp. 162–164.

Faulkner, Sarah. *Planning a Home*. New York: Holt, Rinehart and Winston, 1979, pp. 167–172, 174–189.

Friedmann, Arnold, John F. Pile, and Forrest Wilson. Interior Design: An Introduction to Architectural Interiors, 3rd ed. New York: Elsevier Science Publishing Co., 1982, pp. 357–408.

Gilliatt, Mary. The Complete Book of Home Design, rev. ed. Boston: Little, Brown and Company, 1989.

Hornbostel, Caleb and William J. Hornung. *Materials and Methods for Contemporary Construction*, 2nd ed. Englewood Cliffs, N.J.: Prentice-Hall, 1982.

Radford, Penny. Designer's Guide to Surfaces and Finishes. New York: Whitney Library of Design, 1984.

Riggs, J. Rosemary. *Materials and Components of Interior Design*. Reston, Va.: Reston Publishing Company, Inc., 1985, chaps. 3 and 4.

Whiton, Sherrill. *Interior Design and Decoration*, 4th ed. Philadelphia: Lippincott Company, 1974, pp. 419–436 and 505–521.

Floors and Stairways

FLOORS
Finish Flooring Materials
Selection
STAIRWAYS
Design and Construction

For many years floors were considered relatively innocuous blank surfaces serving utilitarian purposes only, but many homes now treat them as strong interior components with decisive influence on the character of the space. Instead of a flat, horizontal plane, floors now often bridge many levels: a few steps up or down to define different areas of the main group space; balconies overlooking other parts of the house; even two or three stories flowing into one another. At the same time, interest in floor coverings has revived. We see greater variety in hard-surface and resilient flooring, and more conspicuous colors and textures in carpet. Area rugs once again function as strong accents in the interior design vocabulary.

Stairs, of course, permit us to move from one level of an enclosure to another. By their nature—as an efficient system for changing levels in minimum space—stairs usually cut a diagonal line or sometimes spiral upward. This feature introduces a diversion from the predominantly rectilinear quality of most homes. Unless they are completely buried behind walls, stairs attract (and deserve) much attention.

In a house built on a hillside bordering a lake (Figures 19.1 and 19.2), the stepped-down configuration of the plan takes on vivid definition because of the treatment of floors and ceilings. Entering at the top of the hill, one is immediately aware of the ceiling that swoops down over the living room. The dark slate floor balances the visual weight of the ceiling and heightens the effect of protective white walls alongside the stairs. The floor also halts, at intervals, the downward plunge of the stairway.

An area rug in the living room bears an abstract pattern echoing the rectangular floor tiles. This defines the generous conversation group which assumes warmth and intimacy because it is under the lowest part of the ceiling in the living room and because the hard floor has been softened by the deep pile rug. At this level, the floor extends beyond the living room to a terrace on the roof of the

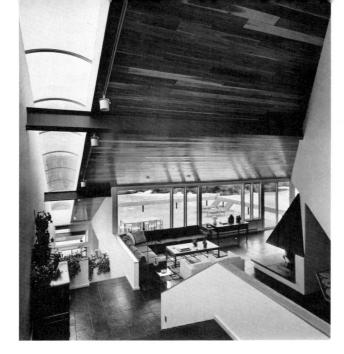

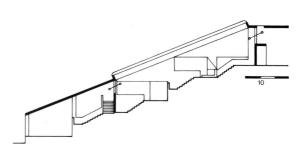

19.1 (left) Stairways interrupted by successive levels of living space draw the eye continuously downward in a Vermont house built to correspond to a steep hillside. Peter L. Gluck, architect. See also Figure 19.2. (Photograph: © Norman McGrath)

19.2 (above) A section of the house illustrates the way in which the stairway ceiling ties together the various terraced levels. The placement of large pivoting windows at top and bottom creates a natural air-conditioning effect. Peter L. Gluck, architect.

next lower level. Floors and ceilings have been used in opposition to each other to state the theme of the steep site yet anchor the house firmly on its foundations in the hillside. A skylight parallels and emphasizes the descent from level to level down the stairs.

FLOORS

Floors are flat, horizontal surfaces meant to be walked on, sometimes to be sat on; they take a limited amount of wheel traffic such as vacuum cleaners, service carts, children's toys, and occasionally wheelchairs; they support people and furniture and provide insulation against cold and dampness. Floors get the greatest wear and the most dirt of any part of the house. But floor design and materials are not as completely mundane as these factors imply. As components of interiors, they contribute to the expressive character of the whole house. Floors can define and separate areas without benefit of walls, suggest traffic patterns, and be as dominant or subordinate as desired.

Floors may be on three grade levels (Figure 19.4). Basement floors are concrete slabs poured **below grade** where the presence of moisture is a problem. A polyethylene sheet beneath the concrete is essential for a moisture-free surface. Floors **on grade** (in contact with the ground) are also concrete, poured over a moisture barrier plastic film. A moisture-free subsurface is very important for the installation of any floor. Those **above grade** (above the ground or on a second or third floor, if any) usually consist of supporting floor *joists* or linear beams, a *sub-floor* sheathing layer of inexpensive wood planks or plywood for strength, topped by a *finish flooring* of hardwood, masonry, tiles, sheet vinyl, or carpet. Moisture is not a problem above grade. (Moisture is the primary cause of wood shrinking, swelling, or warping.)

In ground-hugging, basementless houses and precast concrete slab high-rise apartments, all floors may be concrete slabs basically like those on grade. In a high-rise building, intermediate floors may have much thinner slabs, with the *plenum* space between them and the ceilings underneath used for HVAC, sprinkler systems, and sound and temperature insulation. Concrete surfaces can be integrally colored or patterned through the use of various materials in the concrete mix or with wood or metal grids, which also allow for expansion. By heating concrete

19.3 Raising the piano onto a platform gives it prominence and allows the musician to look out at a beautiful lake while playing. The maple platform is accented with mahogany to coordinate with other wood trim and to visually alert everyone to the change in level. Cathy Nason, ASID, interior designer. (Photograph: Jay Graham)

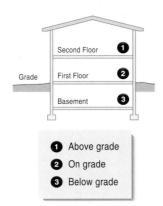

19.4 Grade level may affect the construction and materials used in subflooring and the installation method for finish flooring.

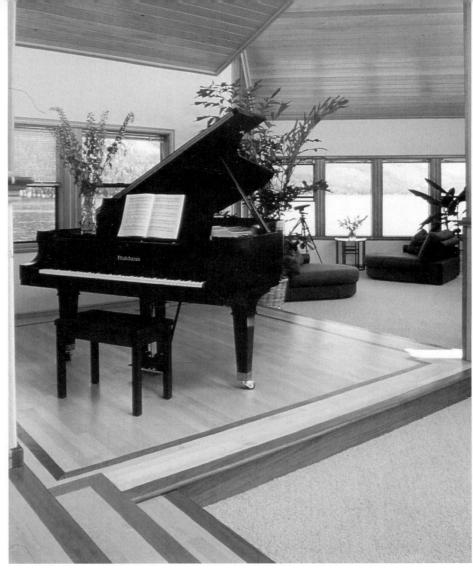

floors or covering them with resilient or soft floor coverings, the designer can lessen one unfortunate side effect—cold, tired feet. It appears that combined coldness and hardness, rather than hardness alone, results in fatigue. In summer, however, the coolness of concrete floors is refreshing.

FINISH FLOORING MATERIALS

The rock ledges of caves and earth beaten down by use were probably the first hard-surface floors. Stones smoothed and set into place represented an improvement; constructed floors of brick, tile, and wood, yet further refinements. Until a century or so ago these were the only possibilities for permanent flooring. Today, carpet, vinyl, and other materials supplement these traditional materials. Table 19.1 summarizes briefly the characteristics of finish flooring materials commonly found in contemporary homes. Compared with carpet, almost all are durable, cool, either hard or moderately resilient, more or less stain-resistant, and easy to clean with water. But these general similarities should not obscure the equally important differences in appearance and behavior among them.

HARD FLOORS Hard-surface flooring materials are remarkably durable and ageless in their versatility; high initial cost and lack of resilience are their chief drawbacks. Hard floors of masonry materials and wood are used throughout today's home.

Masonry. Stone, brick, and ceramic tile have high original costs but last for generations, indoors or outdoors. Stone floors of slate, marble, or other composition can produce almost any effect, from the very rugged to the elegantly formal, depending upon how the stones are cut, set, and finished. Irregularly cut and unpolished stones, such as flagstone, placed in random patterns tend to be more casual than smoothly honed stones, such as marble, set close together in an even configuration. Terrazzo (a composite mixture of marble chips and binder or matrix) can be poured in place with other materials (brass, zinc, plastic) used to separate colors or form a design, or tiles can be precast, usually 12 by 12 inches. Unglazed brick and tile seem especially suited to kitchens, bathrooms, and sunspaces because of their natural, earthy quality; however, unless sealed, masonry floors will absorb grease and stains that are difficult to remove. Polished or glossyfinished stone should not be used for floors for safety reasons and because the reflective gloss and color will dull with wear. Honed or rubbed finishes produce more appropriate smooth surfaces with little or no gloss.

The popularity of ceramic tiles for flooring has persisted through many centuries and remains high today, despite the introduction of newer materials. In fact, many types of vinyl tile and sheet vinyl imitate clay-tile flooring as well as stone and brick. Classic terra cotta red quarry tiles and hand-formed Mexican tiles create a warm rustic effect (page 476, Figure 19.7). Their rugged durability permits the same tiles to surface and unite indoor and outdoor spaces. On the other hand, tiles can be as elegant as the most sumptuous marble floor. Ceramic tiles are available in many sizes, shapes, and textures: from mosaic-sized pieces to 8-inch to even 24-inch tiles, ranging in shape from square to oblong, hexagonal, octagonal, or round, with smooth or grooved and abrasive surfaces for slip resistance. Glazing provides an impervious finish that resists stains, but also makes dust and soil more noticeable. Smooth-surfaced, highly-glazed tiles are unsuitable for floors subjected to moisture and heavy traffic because they are extremely slippery when wet and the shiny glaze will scratch and show wear.

Concrete, as mentioned previously, is usually used as an outdoor or subflooring material, to be covered with a finish flooring that will provide resilience, sound

19.5 (below, left) Irregular pieces of flagstone, bevel-edged cedar paneling, a sisal rug, and wicker and metal furnishings combine to establish a casual entertainment atmosphere in a mountain home in Telluride, Colorado. Solomon Architects; Terry Hunziker, designer. (Photograph: Mark Darley/ESTO)

19.6 (below, right) In an unusual combination, polished pink and green marble are used with slate tiles of equal size. Both materials extend from the bedroom out onto the small terrace of a San Francisco condominium. David Weingarten/Ace Architects. (Photograph: Alan Weintraub)

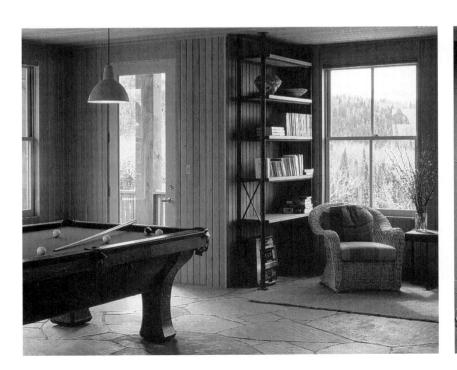

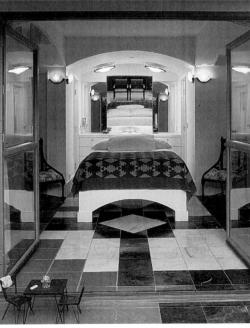

Finish Flooring Materials and Their Costs, Uses, and Characteristics

Material	Source or Composition	Use	Size and Shape	Patterns
HARD			•	
concrete cost: least expensive flooring; can be base or finish flooring	cement, sand, aggregates, and water; can be integrally colored	can be left bare; a base for clay, tile, brick, and stone; coverable with wood, resilient flooring, carpet; heat- storage mass	usually poured in slabs but tiles available; at times marked off in rectangles by screeds	exposing aggregates gives surface interest; terrazzo has mosaiclike patterns from marble chips
stone cost: very expensive	slate, flagstone, marble, and so on	chiefly entrances and near fireplaces, but can be used in any room; heat-storage mass	usually not more than 2' square; rectangular or irregular	natural veining, shapes of stones, and patterns in which they are laid
tile and brick (clay) cost: expensive	heat-hardened clay; tile is usually glazed	areas getting hard wear, moisture, dirt; entrances, hallways, bathrooms, any place where effect wanted; heat-storage mass	tiles are ½" to 12 " square or rectangular, hexagonal, and so on; standard bricks are 2" × 4" × 8"	tile has varied designs; typical brick patterns come from the way in which the bricks are laid
wood (hard) cost: moderately expensive	oak, birch, beech, maple, pecan, teak, walnut; sealable with liquid plastics, finished with synthetics	any room; often covered by carpet	strips 1 ¹ / ₂ " to 3 ¹ / ₂ " wide; planks 2" to 8" wide; parquet blocks 9" × 9"	color and grain of wood; usually laid in parallel strips; also blocks of varied parquetry patterns
RESILIENT				
asphalt tiles cost: least expensive composition flooring	asbestos or cotton fibers, plasticizers, pigments, and resin binders	recommended for laying over concrete directly on ground, especially in much- used areas	standard is $12'' \times 12''$ but others available	tiles are plain or marbleized; laying creates typical tile patterns
cork tiles cost: moderately expensive	cork shavings, granules compressed and baked to liquefy natural resins	floors not subject to hard wear, water, grease, stains, or dirt	squares $9" \times 9"$ or $12" \times 12"$; also rectangles	chunks of cork of different colors give fine to coarse textural patterns
rubber tiles cost: moderately expensive	pure or synthetic rubber and pigments vulcanized under pressure	can be laid directly over on-grade concrete floors	$9'' \times 9''$ to $18'' \times 36''$	usually plain or marbleized
vinyl-asbestos tiles cost: inexpensive	similar to asphalt but with vinyl plastic resins	any indoor floor including on-grade and below-grade concrete floors	$12'' \times 12''$ tiles are typical	wide range of patterns, printed or embossed
vinyl-cork tiles cost: moderately expensive	same as cork but with vinyl added as a protective sealer	any floor where heavy- duty durability is not important	same as cork	same as cork
vinyl sheets and tiles cost: moderately expensive	vinyl resins, plasticizers, pigments, perhaps cheaper-grade fillers, heat-formed under pressure; sheet vinyl laid on alkali- resistant backing	any indoor floor; special types available for basement floors; also counter tops, wall covering; foam backed for greater resiliency	usually 12" × 12" tiles; also by the roll, 6' to 15' wide; can be poured on floor for completely seamless installation	great variety, new designs frequent; marbled, flecked, mosaic, sculptured, embossed, veined, and striated
SOFT				
carpet and rugs cost: wide range	almost all natural and manufactured fibers	recommended over any flooring that is moisture-proof	almost unlimited	plain to ornate, structural to applied

Colors	Durability	Maintenance	Comments
Colors	Duruomey		
limited range of low- intensity colors, but can be painted, color-waxed, and so on	very high except that it often cracks and can be chipped; serious damage difficult to repair	markedly easy if sealed against stains and grease; waxing deepens color and gives lustrous surface but is not necessary	hard and noisy; cold (welcome in summer) unless radiantly heated; absorbs and releases heat slowly
usually black, grays, and tans; variation in each piece and from one piece to another; marble in wide range of colors	very high but chipping and cracking difficult to repair	easy—minimum sweeping and mopping	solid, permanent, earthy in appearance; usually bold in scale; hard, noisy; cold if floor is not heated; absorbs and releases heat slowly
glazed tiles in all colors; bricks usually red	generally high but depends on hardness of body, glaze; may chip or crack, fairly easy to replace	easy—dusting and washing; unglazed types can be waxed; porous types absorb grease and stains	satisfyingly permanent and architectural in appearance; can relate indoor to outdoor areas; noisy and cold; absorbs and releases heat slowly
light red, yellow, tan, or brown; can be painted any color	high but shows wear; irradiated types very durable	medium high—must be sealed, then usually waxed and polished; irradiated need minimum care	natural beauty, warmth; moderately permanent; easy to refinish; but fairly hard, noisy
full range of hues, but colors are neutralized; becoming available in lighter, clearer colors	excellent but can be cracked by impact and dented by furniture; some types not grease-proof	moderately easy—mopping and waxing with water- emulsion wax	eight times as hard as rubber tile; noisy; slippery when waxed
light to dark brown	moderately high; dented by furniture	not easy; porous surface absorbs dirt, which is hard to dislodge; sweep, wash, and wax	luxurious in appearance; resilient and quiet
unlimited range; often brighter and clearer than in asphalt	moderately high, resistant to denting; some types damaged by grease	average—washing, wax or rubber polish	similar to asphalt, but more resilient
almost unlimited	high general durability, resistant to grease, alkali, and moisture; can be dented by furniture	among the easiest; resilient underlay retards imbedding of dirt	somewhat hard and noisy but more easily kept than asphalt
same as cork	same as cork, but more resistant to denting, dirt, grease	very easy—sweep, wash, and wax as needed	vinyl makes colors richer; less resilient and not so quiet as cork
wide range including light, bright colors; in some, translucency gives depth in color similar to marble	excellent; cuts tend to be self-sealing; resists almost everything including household acids, alkalies, or grease, denting, chipping, and so on	very easy; built-in luster lasts long; foreign matter stays on surface; can be waxed but not always necessary, especially for some types; dirt collects in depressions of embossed types	pleasant satiny surface; quiet and resilient, some types have cushioned inner core; patterns developed from material itself seem better than those imitating other materials
infinite range of hues, tints, shades alone or in rich designs	depends on fiber (see Table 17.1); surface texture and density	daily spot cleaning, weekly vacuuming, sweeping for Orientals; occasional deep cleaning	appreciated for possible beauty, as well as insulation, comfort, safety, ease of care

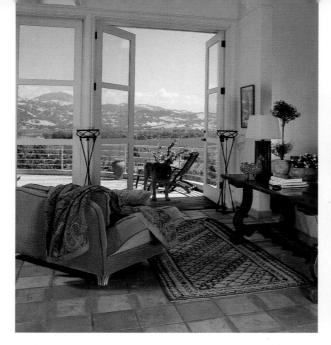

19.7 (above) Mexican paver floor tiles bring the varied earth tones of the California wine country into the great room of a new home. Roland Miller, architect; Arnelle Kase/Barbara Scavullo Designs, interior designer. (Photograph: David Livingston)

19.8 (above, right) The varied shapes possible with clay tiles and the many patterns they can assume help to explain their long and continued history. (Courtesy Country Floors, Inc.)

insulation, warmth, and greater aesthetic appeal. But concrete may take on a completely different quality when colored or textured aggregates are added to the mix (Figure 19.9). A clear polyurethane finish brings out the color of exposed aggregate and facilitates maintenance of concrete floors.

In spite of the warm or cool appearance of color and texture, all masonry floors are hard and cold unless radiantly heated. In warmer climates, this quality can be an advantage, keeping the house cool even in uncomfortable outdoor temperatures. Masonry materials that are dark and unglazed for maximum heat absorbency use a reverse heat lag to advantage in passive solar homes.

Wood. The most popular of the hard flooring materials, wood varies in cost with the type, the method of cutting (whether solid or veneered), and the method of placement. It may require a good deal of day-to-day maintenance, depending upon finish, but is fairly easy to repair and refinish. Some wood floors must be waxed, but if the wood has been irradiated or impregnated with polyurethane or

19.9 Exposed aggregate concrete is suited to a variety of applications, indoors and out, including at poolside, where its texture may remind one of a pebbled beach. (Courtesy J.B. Sandlin Homes)

acrylic, it can be cleaned with a damp mop. This type of flooring is high in initial cost but low in maintenance. Less expensive alternatives include surface applications of paint, stain, or clear urethane. Plain-sawed wood is the least expensive, but quarter-sawn lumber is more resistant to shrinkage and warping. Laminated blocks expand and contract least with changes in moisture. End-grain blocks (cut across the growth rings) from 1 to 4 inches thick have excellent durability and insulating qualities, absorbing noise and vibration very effectively.

Wood floors (most often oak, maple, teak, or birch) generally take one of three forms: narrow (2½ inches or less), regularly spaced **strips** of similar-grained wood joined with tongue-and-groove joints; random-width **planks** (3 to 8 inches) typical of barns and country houses; and inlaid squares of alternating grain known as **parquet** (see Figures 19.10–19.12). Strip flooring may be laid either parallel or diagonal to the wall. Random plank flooring may have a square or beveled edge and decorative pegs or plugs of contrasting woods or brass. Usually three sizes of planks are used, with sizes selected in scale with the space. Most often highly polished, parquet floors follow many different designs and configurations, possibly with woods of contrasting colors. Pieces are most often preset into squares, but may be custom designed. Great flexibility in design makes wood flooring very appealing.

Wood is the least hard, the quietest, and the warmest of all hard surface flooring, making it more comfortable than the others. In kitchens and baths, it is susceptible to excessive moisture and may dent if hard objects are dropped on it. Protective coats of polyurethane make possible the use of wood floors in these areas.

19.10 While the diagonal fireplace wall and area rugs partially separate activities in this open plan residence in Chicago, Illinois, the wood strip flooring unifies the space and provides continuity throughout. (Photograph: Howard N. Kaplan)

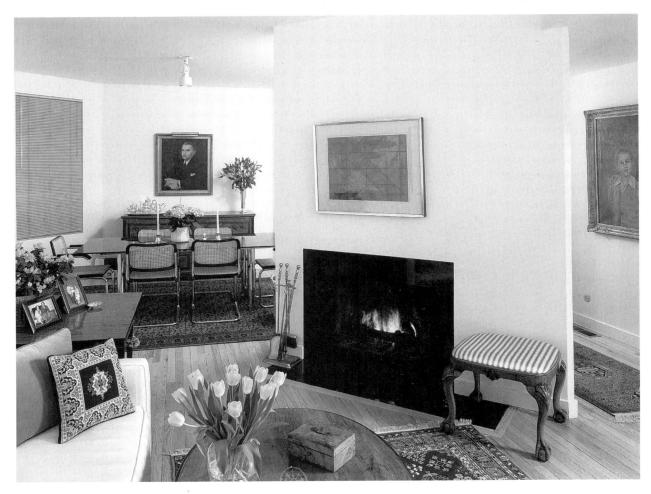

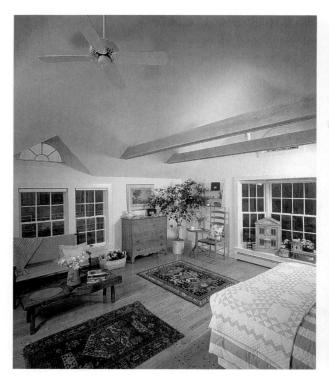

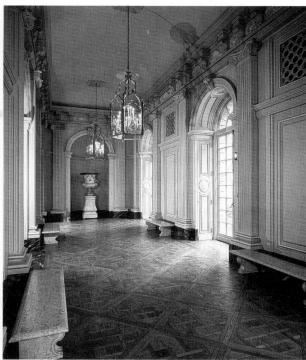

19.11 (above, left) An oak plank floor with pegs extends the character of a six-room Connecticut farmhouse, built in the 1850s, into a new addition. James Schettino, architect. *(Photograph: Robert Perron)*

19.12 (above, right) Parquet flooring is shown in the Reception Hall of The Frick Collection. Parquet floors, with their rich patterns, are once again in favor now that they are available in block form for easy installation. (Copyright The Frick Collection, New York)

RESILIENT FLOORING Once confined to work spaces and baths, resilient flooring now may be seen in all areas of the home, offering a wide range of visual effects, greater comfort underfoot and less noise reverberation.

An endless variety of resilient flooring materials—sheet flooring and tiles, most synthetic but some of natural composition—are now available. Cork, solid vinyl, and rubber are much more resilient than asphalt or vinyl composition tile, while some of the cushioned sheet vinyls have an inner core of foam or foam backing to increase springiness, warmth, and quietness. Color and pattern choices abound.

Sheet vinyl is produced in rolls 6, 9, or 12 feet wide. It has fewer dirt-catching seams than do tiles of the same material, but usually requires professional installation and is more expensive than tile. Sheet vinyl is flexible and may be *coved* to form its own seamless base. The design (color and pattern) in sheet vinyl is either printed in a rotogravure process or inlaid with layers of tiny granules of vinyl fused together. The inlaid design is more durable, with color and pattern going all the way through. Rotovinyls have the printed layer protected by a wear layer of vinyl resin, sometimes combined with urethane for a high gloss surface.

Vinyl can be bonded to fabric for a custom floor design either in sheet or tile form. Also, *liquid vinyl*, *urethane*, *epoxy*, or *polyester* flooring can be formed-in-place or poured at the site, useful where a nonskid and easily-cleaned surface is needed.

Tiles can be installed with less waste than sheet flooring if the floor is irregular in outline. They also permit replacement of an area that is subjected to unusual wear. Most tiles are *vinyl composition* (vinyl, resin, plasticizer, pigment, and filler) or *solid vinyl* (polyvinyl chloride, plasticizer, pigment, stabilizer, and filler). Solid vinyl is less porous and more noise absorbing.

Tile is also available with real wood veneer sandwiched between layers of PVC. Asphalt tile has largely been replaced with vinyl. *Rubber* tiles are very sound absorbent, resilient, and moisture-resistant. (Sheet rubber with raised discs is popular where water and dirt are prevalent. The discs or studs keep water and dirt below

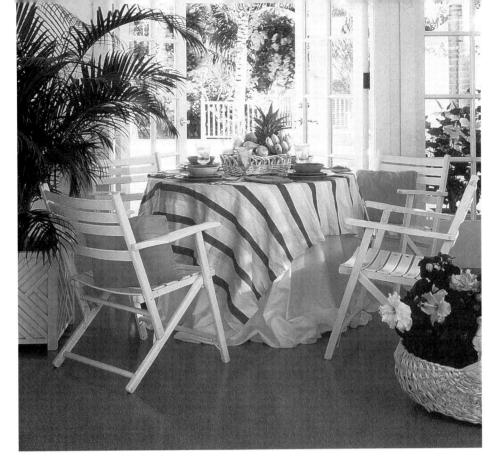

19.13 Sheet vinyl provides an easy-care, durable floor surface with few, if any, seams. It can be used in any room, adding color and pattern at less expense than many other materials. (Courtesy Armstrong World Industries)

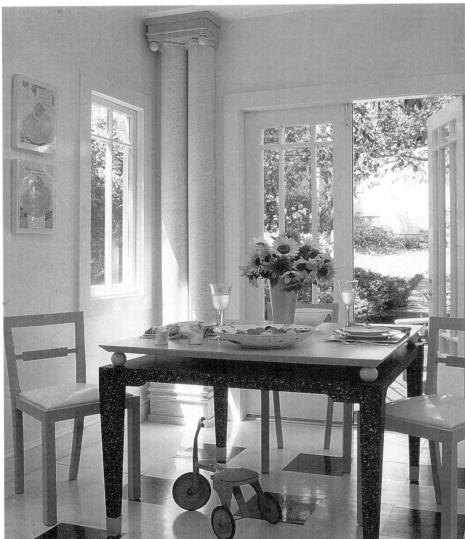

19.14 Vinyl tile in a classic black and white marble pattern is well-suited to a casual dining area with access to a garden such as this remodeled 1906 home in San Francisco, California. Arnelle Kase/Barbara Scavullo Designs, interior designer. (Photograph: David Livingston)

the traffic surface and have aesthetic appeal as well. Sheet rubber flooring has been used successfully for many years in restaurants and airplanes.) *Cork* tiles (usually cork combined with vinyl) are very resilient, have good sound absorbency, and are excellent insulators. *Leather* is also available in tiles for the floor. It is very expensive, quiet, and normally used only in low traffic areas. Embossing may add texture to the natural grain. Tiles are commonly available in 9- and 12-inch squares. Vinyl is also used for coved wall base to trim resilient floor installations, and is available in $2\frac{1}{4}$ - and 4-inch heights.

Resilient flooring offers many choices. *Cushioned vinyls* are easy on the feet and legs, but they can dent under heavy loads and often have an embossed surface that

19.15 Studded rubber flooring can be used even on countertops and walls, as in this North London apartment kitchen, for the same qualities that make it practical and appealing on the floor. Eva Jiricna, architect. (*Photograph: Richard Bryant/Arcaid*)

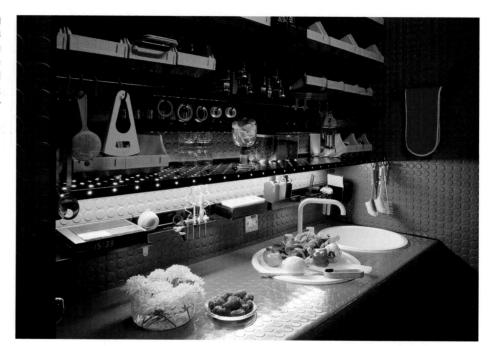

19.16 In the game room of a 25,000 square foot house in Atlanta, Georgia, red leather tiles are used as flooring and then continued onto the wall. Robert Frank McAlpine, architects; John F. Saladino, interior designer. (From HG Magazine. Photograph: Michael Mundy)

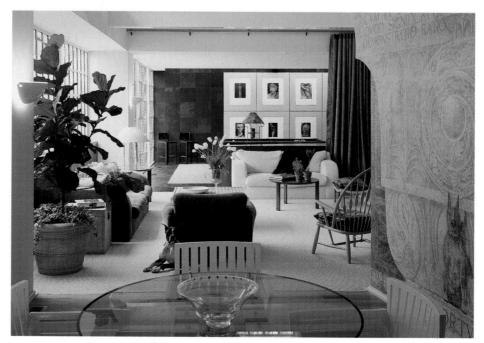

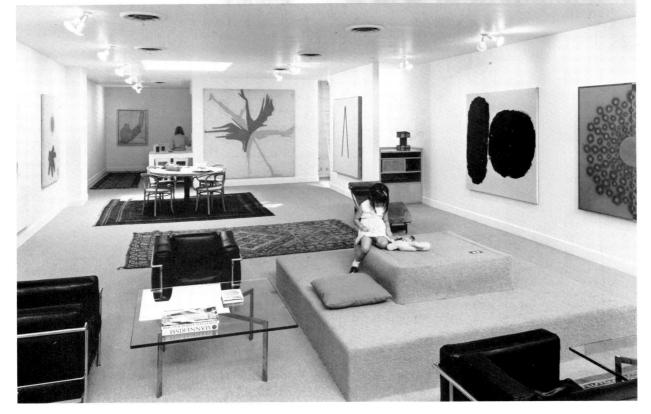

can require extra scrubbing to remove soil from the depressed areas. Most vinyls are available with a no-wax surface and a high-gloss or matte finish. Even a no-wax finish will dull in high-traffic areas, however. Scratches and stains will show more on a high-gloss finish than on a duller matte finish.

A smooth, level, clean subfloor is necessary beneath resilient flooring because the finish surface will reveal any bumps, cracks, or holes. A moisture barrier may also be needed to prevent mildew if installed in basements or places where moisture is a problem. If the flooring is laid over an older existing flooring material, it must also be smooth, level, clean, and securely attached. Resilient flooring is glued down.

SOFT FLOOR COVERINGS Soft floor coverings add maximum warmth, texture, resilience, and quietness, as well as visual appeal to floors. As with wallpaper, soft floor coverings give rooms a more intimate, "furnished" look, even with little furniture. Floor textiles explicitly relate the floor to the softness of upholstered furniture, curtained windows, and the clothing of the occupants. With their color, texture, and pattern, they contribute markedly to the character of homes. Like hard materials, they can alter the apparent size and shape of rooms. Since the early 1960s, carpet has been economically produced and available for widespread use. It is used to modulate acoustics and insulate floors as well as provide finish flooring, comfort, and aesthetic interest.

Types. A few definitions will help classify the broad range of soft floor coverings. Rugs are made in or cut to standard sizes, have finished or bound edges, and are seldom fastened to the floor, making them ideal for clients who rent or move frequently. Carpet is sold by the yard from a roll 27 inches to 18 feet or wider (usually 12 feet wide), must be cut (and pieced if necessary) to cover all the floor, and is fastened down. Broadloom refers to floor textiles woven on looms more than 36 inches wide. The term does not describe the weave, fiber, color, pattern, or any quality other than width. When the broadloom was invented, fabrication of carpet in wider widths encouraged the use of wall-to-wall carpet rather than area rugs in residences. Rugs, carpet, or a combination of both can be appropriate for many different situations. (Carpet, not carpeting or carpets, is the correct term for textile floor covering(s) securely attached to the floor.)

19.17 In painter Frank Stella's huge living loft wall-to-wall carpeting unifies the space, moving up to cover a central seating platform. Oriental rugs create internal spaces to break up the expanse. *(Photograph: John T. Hill)*

19.18 Hand-woven Tibetan area rugs placed over oak flooring add warmth and character while defining conversation areas and traffic paths in a renovated summer home on Long Island. David Hannaford Mitchell, architect. (Photograph: Frederick Charles)

Sizes. Wall-to-wall carpet is one of the best means of unifying a room or of relating several adjacent spaces. Because it does not define special areas within a room, it simplifies arranging furniture. If the pattern is quiet and the color muted, it lends an aura of spaciousness. Because it fits a room exactly and is fastened to the floor, carpet gives a sense of security and permanency as well as warmth and comfort. Covering a larger area than a typical rug, a carpet is more expensive (except for handwoven rugs), but it is a finished floor covering, eliminating the need for expensive flooring underneath. Maintenance costs and bacterial counts are lower than for resilient flooring that needs constant washing and waxing; but wallto-wall carpet must be vacuumed regularly and thoroughly cleaned about once a year to remove embedded soil and stains, which can harm fibers. (Too frequent cleaning can also break down the fibers; spot cleaning is recommended as needed.) For people who are allergic to dust, carpet may not be the best choice of floor covering. Carpet cannot be moved to another room or house or turned to equalize wear. Once thought appropriate only for the more formal areas of the home, carpet now appears in all rooms because of the variety of materials and qualities available. An antimicrobial treatment is even obtainable for carpet used in areas where the growth of microorganisms can be a problem.

Rugs can be purchased in many sizes and shapes. If they cover the entire floor or most of it, the effect is similar to that of a carpet except that rugs are loose-laid and most have a definite pattern that makes them more emphatic. Room-size rugs cover all but about 12 inches of floor around the perimeter of the room. They are produced in standard sizes such as 9 by 12 feet or 12 by 15 feet. Area rugs cover a lesser part of the floor and often hold together a grouping of furniture, defining the space without enclosing walls in homes with open plans. Area rugs can also be small accents calling attention to a special part of the home and may be of any shape, construction, fiber, texture, or color, placed over hard floors or carpet. When placed over carpet, a special pad between the two reduces slippage and prevents wear on the carpet. The edges of area rugs may present a hazard to anyone with vision or mobility limitations. Small rugs protect sections of the floor subject to hard use and soiling and are called scatter or throw rugs. Runners are long, narrow rugs (usually 27 inches wide) designed for hallways or stairs. On stairs, they are often anchored with brass rods fastened at the back of the treads (Figure 19.19).

Rugs can be used on top of hard, resilient, or soft flooring materials. Their mobility and cleanability make them particularly useful; they can easily be moved from one room—or even one home—to another since they are not attached to the floor, and they can be adjusted to spread wear and soil. They are usually (though

19.19 A commercially-produced runner and coordinating room size rug over the parquet floor unify living space, stariway, and traffic way in this home. Hand woven rugs are sometimes used as runners also; anchor rods hold the rug firmly in place. (Courtesy Karastan Bigelow)

19.20 A large Oriental rug defines an open area at one end of the open living space in photographer Morley Baer's home. Its handsome, decided design can thus be fully appreciated, much as if it were hanging on a wall. Wurster, Bernardi, and Emmons, architects. (Photograph: © Morley Baer)

19.21 Comfortable traditional furnishings and an Indian dhurrie rug lend warmth and accent to the modern interior of a Greenwich Village penthouse. Shelton, Stortz, Mindel & Associates, architects. (Photograph: Bo Parker)

19.22 A huge braided rug with concentric bands of color provides the classic floor covering for this Colonial-style bedroom. The canopy bed and other antique furnishings, traditional wallpaper, exposed beams, and rough-hewn wood paneling are all in character. Mr. and Mrs. James Tyson, designers. (Photograph: John T. Hill)

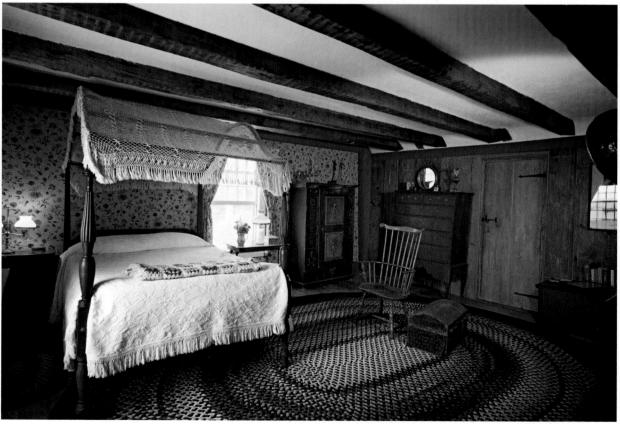

19.23 Carpet tiles permit flexibility in design and pattern combinations. Surface textures range from cut pile to level loop pile to multilevel loop and combinations of cut and uncut pile. (Courtesy Milliken & Co.)

not necessarily) striking in color, pattern, or texture. Oriental, Indian, Scandinavian, rya, hooked, or braided (Figures 19.20–19.22), and an infinite variety of handwoven rugs add particular character to a room and play a more prominent role in the total room design than a plain floor material.

Carpet tiles or squares may have a self-stick backing, can be glued down, or may be loose-laid. They function best when installed wall-to-wall since the edges are not bound, and the tiles are easy to cut to follow the contours of a room. Carpet tiles can be uniform in color and texture; if the pile is sufficiently long, the seams will not show. On the other hand, the 12- to 24-inch-square tiles readily lend themselves to combination for making patterns. Tiles can be replaced individually when worn or soiled. Seams may separate and lose some adhesive capability if too much water is used in cleaning. Access to wiring under the floor (primarily in office buildings) is an added convenience.

Methods of Construction. Typical carpet-construction processes fall into several categories:

Tufting accounts for over 90 percent of soft floor coverings. In this process, pile yarns are punched through a preconstructed *primary backing* by multineedled machines. A latex coating, a *secondary backing* of jute or polypropylene, or a rubber backing secures the tufts and adds dimensional stability.

Weaving and knitting interlock the surface yarns and backing simultaneously. Very little carpet is produced by knitting. Axminster, velvet, and Wilton are types of machine-woven rugs. Axminster and Wilton carpet were first made in English cities of those names. They are both woven on Jacquard looms. Wiltons are very heavy and made of wool; Axminsters are either wool or nylon and have a heavily ribbed backing; both are patterned, very expensive, and used mostly in nonresidential design. Velvet weave carpet typically has no design or is limited to stripes or checks, and is usually wool or a wool-nylon blend. Velvet carpet is the least expensive woven carpet to produce. Most Oriental and Indian rugs are hand-woven, as are Navajo and similar tapestry (free-woven) designs and floor cloths.

19.24 Woven carpet need not necessarily have traditional floral patterns, as demonstrated by this contemporary abstract geometric design in a Wilton carpet. *(Courtesy Larsen Carpet)*

19.25 Needle-bonded carpet is commonly available in $12" \times 12"$ tile form. This stain-resistant solution-dyed olefin example is very durable for spaces such as sunrooms, playrooms, basements, or any other room. (Courtesy Bretlin®)

Needlepunched or needlebonded carpet has a dense web of short fibers punched into a backing, resulting in a durable but not very resilient, often feltlike surface (Figure 19.25). Originally confined to kitchen and indoor-outdoor use—because the polypropylene fibers used resisted liquids and did not dye well—needlepunched carpet, with newer dye and printing techniques, has moved into every part of the house. It is available in tiles, is usually made of nylon or olefin (polypropylene), and is inexpensive.

Flocked carpet is made of short, chopped nylon fibers electrostatically embedded in an upright position on a backing fabric to make a very dense, short plush,

velvet-like surface. It does not wear well.

Hooking, a hand process related to tufting and needlepunching, calls for pile yarns to be forced through a woven backing. Hooked rugs generally exploit their potential for free use of color and intricate, nonrepetitive designs.

Braiding, too, originated as a hand process. In Colonial times, braiding was one method of providing a second life for used garments, sewing remnants, and other fabric scraps. These were braided together (like hair) in strips and the strips sewn together, thus the name *rag rug*. Today, commercial braided rugs are available; they give a particular warm, homey quality to traditional rooms (Figure 19.22). Not all rag rugs are braided; some are woven.

Carpet backings, as distinguished from separate padding or cushions, are also important in the life of a carpet and can affect the way it lies on the floor. In many processes, the backing (which is the foundation on which the carpet is constructed) is coated with latex or a similar product to hold the surface yarns securely; other methods will add an extra layer of backing of jute, polypropylene, or latex for greater strength and shape retention. Both techniques help in keeping the carpet flat, prevent it from skidding, and aid in noise control. Woven carpet needs no secondary backing.

Pattern. The pattern in a carpet can result from structure (the size and type of yarn, method of construction, and resulting texture) or from the colors of the fibers and the way they are fabricated, ranging from a tiny, almost imperceptible figure to a striking one-of-a-kind design. Commercially manufactured carpet most often has repetitive designs, because of the exigencies of industrial looming; but this very uniformity can serve as an asset in the room where the floor covering functions as a subdominant feature. Almost invariably a fine handwoven rug calls attention to itself, becoming the focus of a room.

One special characteristic of rich patterned rugs deserves mention: their tendency to migrate to the walls. *Rya rugs*, for example, which are universally marketed as floor coverings in the United States, would never have been used for this purpose in the Scandinavian countries of their origin. So ornate are the patterns—and so intricate the process of weaving them—that the rugs earned a place of honor on the wall. Such is also the case with some beautiful old Navajo rugs.

In recent years great innovations have been made in dyeing and texturizing techniques, so that pattern has become easier to create in industrial carpet. Printing, similar to fabric printing or rotary news printing, is now possible over pile textures with deep penetration of colors. Programmed processes drip and jet dyes onto the face of carpet to give a brindled effect or draw washes of color. Fibers themselves can be constructed with multiple sides to reflect a shimmering light. Combinations of colors, as many as twenty per carpet—in high or low pile, cut or uncut—result in distinctive patterns. Pattern, whether textured or printed, helps the carpet hide soil, adds interest, and contributes to the character of a room.

Texture. Carpet can generally be classified in texture as either **cut pile** or uncut **loop pile**, although great variety in effect is achieved by the length of pile as well. Most carpet made today has some type of pile (the visible surface fibers), from the very low plush of flocking, through uncut loops of varying heights, to

A remodeled 1920s Santa Monica bungalow captures the Spanish-influenced early California style in architecture. furnishings, and accessories. Beamed wood ceilings, thick plaster walls with rounded corners, a leather club chair, and old wood doors and windows are complemented by Navajo blankets, an Acoma pot, antique candlestick lamps, and a Mexican wall shelf. The chaise is covered with a kilim. Thomas Callaway. interior designer. (Photograph: Tim Street-Porter)

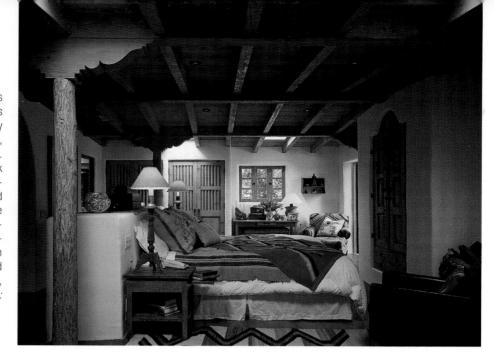

19.27 Cut pile plush carpet has a velvety appearance, appropriate for spaces where a smooth, uniform texture such as velvet would be used. (Courtesy Savnik & Co.)

the cut pile loops of velvets and the deep pile of shags. The size of the yarn and spacing between yarns or *density* of the pile also affects texture. There are several basic carpet textures: (See Appendix B for diagrams)

- **Plush** or **velvet** carpet has a dense pile with cut loops of uniform, relatively low height. It has a luxurious, smooth surface appropriate for more formal rooms and wears well in moderate traffic areas.
- Saxony also has a uniform-height cut loop pile, but it is deeper and less dense, often with thicker yarns that have been twisted for extra body. The resulting appearance is nubbier than velvet pile with yarns that seem to flow to the touch.
- **Frieze** is a rough, grainy textured carpet resulting from tightly twisted yarns in a cut pile (Figure 19.28). It is very good for heavy traffic areas because the tight twist makes the pile very resilient, hiding the footprints that show on plush carpet. If the yarn is overtwisted it can adversely affect wearability.
- Shag carpet has a cut loop or sometimes a twisted loop pile with a height of more than 1 inch and low density. It is designed to bear the weight of traffic on the sides of the fibers rather than the ends. The longer pile gives shag carpet a feel similar to plush but it is "shaggy" and very informal in appearance.
- **Tip-sheared** carpet is similar to plush, but not all the loops are cut, creating a subtle pattern of color and texture (Figure 19.29). Also called *cut and uncut loop* or *random sheared*.
- Level loop carpet has a low uncut loop pile that can stand the heavy wear of a kitchen, bathroom, or activity area. Foam backing gives added resilience and comfort. Level loop construction combined with high density produces the highest grade of commercial carpet.
- Berber carpet has a large loop pile which produces a distinctive popcorn-like texture.
- Multilevel loop or sculptured carpet is produced by combining varied heights of looped pile in a seemingly random or controlled pattern. Some sculptured carpet is tip sheared in addition to having different lengths of pile. Significant differences in pile height tend to crush and mat.
- Tweed is both a texture and a pattern. It is similar to level loop but with larger loops and lower density, making it generally less expensive and less resilient. Tweed carpet is normally cross-dyed, resulting in tufts of different colors or a "tweed" pattern.

Deep pile carpet offers the potential for complete self-indulgence as few other materials in the home do. It also contributes a feeling of warmth and informality.

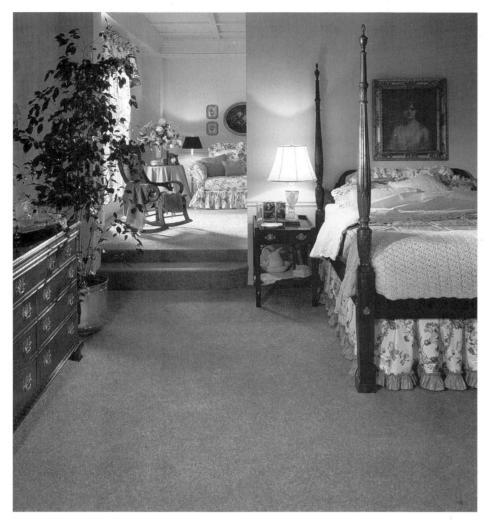

19.28 The curly texture of a frieze carpet does not mark with footprints, making it a good choice for casual, high-use, and multipurpose rooms. *(Courtesy Milliken & Co.)*

19.29 (below, left) Tip-sheared carpet gives the appearance of a tone-on-tone pattern, a result of the difference in light reflectance from the cut yarn ends and the sides of yarn loops. (Courtesy Karastan Bigelow)

19.30 (below) Level loop carpet varies in appearance, depending on the height of the pile, the size of the yarn, and the tightness of the yarn loop. The small loops in this example look almost like needlepoint, while others may be much coarser in texture, with shorter pile, thicker yarn, and larger, looser loops. (Courtesy Savnik & Co.)

Flat-surface carpet generally is confined to the needle-punched indoor-outdoor types or to braided and other handcrafted rugs. Whatever the texture, it strongly affects light reflection, sound absorption, and both visual and tactile sensations of comfort and luxury.

Fibers. Many changes have taken place in the manufacture of carpet during the past decades. Above all, there has been a great increase in the use of man-made fibers. Fibers affect the cost, cleaning time, and appearance of carpet; much of the synthetic fiber carpet is durable, dirt-resistant, and easy to clean. Moreover, it is less expensive than natural fibers and comes in almost any color or texture.

- Wool is the traditional carpet fiber and retains its popularity today because it has so many good qualities and because it appeals to our love of natural materials. It is extremely resilient and long-lasting, takes dyes beautifully, and is resistant to burns (whereas many synthetics will melt if touched by a flame and retain a permanent scar). A blend of 70 percent wool and 30 percent nylon is often used in areas such as hotels with very hard, continuous wear. Wool needs mothproofing and some people are allergic to it, but it remains the standard by which all man-made fibers are judged for appearance and hand. Wool is the only natural fiber used to any extent in mass-produced carpet. It is still the preferred carpet fiber in most countries other than the United States. Costs vary tremendously, but all are quite expensive. Many handmade rugs, such as kilims from Turkey, use wool as well. Antique Oriental rugs of wool are regarded as art objects and financial investments. (Oriental rug colors and patterns are now imitated by factories in many countries and may be made from fibers other than wool. True Oriental rugs are handmade in the East and Mid-East, using either a pile weave with hand-tied knots or a flat tapestry weave. Wool, goat, or camel hair and sometimes silk are used, with some cotton, for the backing through which the knots are tied.)
- Nylon or nylon blends account for over 90 percent of carpet sales in the United States. Nylon is the most popular synthetic fiber for its endurance, abrasion resistance, easy maintenance, and resistance to insects. It is also very resilient and nonallergenic. New treatments counteract its tendency to pilling and static electricity, while fiber modifications have improved soil resistance markedly. Common brand names are Antron, Cumuloft, Caprolan, Enkaloft, 501, Anso, or often just Nylon.
- Polyester is less expensive and softer than nylon. It wears well, except in heavy traffic areas, cleans easily, resists soiling, and dyes well. However, polyester is resilient only when the pile is dense and the yarn twist is heat set. Appearance may not be as good after cleaning, and polyester carpet retains odors, due to the static electricity it generates, making it unsuited to some applications. Labels range from Dacron, Fortrel, Encron, Mylar, Trevira, and Kodel to various generic names.
- Acrylic is the most wool-like in appearance and hand of the man-made fibers. It is soft and nonallergenic, wears well, dyes well (takes brighter, truer color than wool), and is color-fast and nonabsorbent, but has low resiliency, crushes, and mats. It also fuzzes and pills and is prone to static buildup which attracts dirt. Life span is increased when combined with wool or nylon. It is often used to imitate wool, particularly in berber carpet. Yarns must meet flammability standards, particularly for commercial use. Trade names include Orlon, Creslen, Zefran, and Acrilan.
- Modacrylic is inherently flame resistant, soft, and bulky, but it also mats easily, fuzzes, and pills. It is usually blended with other fibers.
- Olefin (or polypropylene) is growing in popularity because of its low cost and near-indestructibility. It wears and cleans exceptionally well, does not fade, has low static-electricity buildup, and will not absorb moisture. It has little re-

silience and a plastic feel, but is often found in indoor-outdoor types of needlepunched carpet and tiles as well as in indoor pile carpet. Herculon, Vectra, and Marvess are common brand names, but the fibers may be offered as generic names.

- Cellulosic fibers sometimes used as floor coverings include jute, sisal, hemp, and various grasses. Available in both pile and woven designs, they make cool and inexpensive floor coverings well suited to today's natural look. They usually have an unobtrusive pattern resulting from the weave and the way the sections are assembled, although they can be quite fanciful in design. They are flammable, can harbor insects, and are not very durable. Nonetheless, in some parts of the world, particularly tropical regions, grassy materials are basic for floor coverings. *Tatami* or grass mats take the place of carpet in traditional Japanese homes, for example.
- **Cotton** and **linen** frequently appear in flat-weave rugs. While not as durable as wool, these natural materials can contribute special qualities, such as intense color and a soft, hand-loomed effect. Cotton or linen carpet is also less expensive than wool and easier to clean. Cotton carpet has little resilience and sheds (lints) excessively, however. Cotton *dhurries* from India (Figure 19.21), rag rugs, and floor cloths with handpainted designs have been popular as area rugs in recent years.

New fibers and combinations of fibers, new techniques, and new finishes are constantly appearing, so it is important to find out as much as possible about a carpet's specific fiber and processing before deciding on a purchase. The carpet industry continues efforts in the research and development of environmentally sound products, including carpet that helps deter the spread of fire.

Installation. Carpet may be professionally installed by one of two methods. Either it is **stretched** between pretacked strips that have been attached at the perimeter of the room, or it is **glued** directly to the floor. In the first method, a **pad** or cushion is also installed beneath the carpet for comfort, extension of carpet life (over 50 percent longer), and insulation. Carpet padding is made from natural fibers such as jute and hair felted together, or from foam or sponge rubber. Natural fibers will mildew and mat down while rubber will disintegrate in time; but rubber is initially more resilient and resists moisture better. The pad can be too thick, causing installation problems, breakdown of the carpet backing, track marks, and fatigue from the *trampoline effect* of walking on it. Generally, rubber pads should not exceed ½ inch in thickness and, if the pad is dense, ¼ inch may suffice. If measured by ounces per square yard, a 40-ounce pad is recommended for most residential use. Twice the padding may be needed on stair treads because of the tremendous wear on the edges. For glue-down installations, foam-backed carpet provides some cushion.

Measuring and Estimating. Measuring the floor to determine the amount of any finish flooring material needed is a job for a professional. However, a rough estimate can be obtained by figuring the area of the space, dividing by 9 to convert square feet to square yards, and adding up to 10 percent if carpet must be pieced or patterns must be matched. This method will result in more waste when a plain design or a very small pattern is chosen than when a larger pattern is used, but will allow for the excess needed to piece with carpet nap all flowing in the same direction. A more accurate method involves using graph paper to plot the exact location of all seams and pattern repeats. The area that can utilize the largest single piece of carpet is determined using the rule that the largest piece is placed in the heaviest traffic paths to avoid seams in these areas. Additional yardage is then figured to piece in the remaining area, with each piece laid in the same direction as the largest piece; the two (or more) are added together, multiplied by the carpet width, and divided by 9 (see Figure 19.32). Computer programs aid designers in making quick and accurate measurements.

19.31 This maize floor covering has a dark-and-light checkerboard pattern. Although stitched together, the small pieces are individually constructed so that they may be cut apart, replaced, and generally treated like tile. (Courtesy Stark Carpet Corporation)

19.32 Primarily, carpet seams should be parallel with the nap and with doorways, but they should be perpendicular to windows wherever possible to minimize visibility of the seam due to cross lighting.

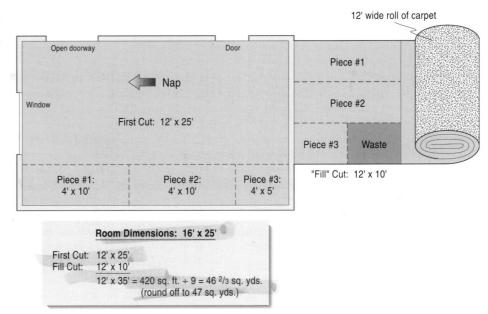

SELECTION

The matter of choosing suitable floor materials deserves careful planning, especially in view of the size of the areas involved, the probable cost, the long-term consequences, and the numerous possibilities. Some important factors to consider are these:

- **Durability** is of primary importance, because floors take severe punishment from the abrasion of feet and the weight and possible movement of furniture. Durable floors have a surface sufficiently tough to prevent wearing through. They do not crack, splinter, or disintegrate, nor do they become permanently indented or otherwise make noticeable the hard use they get. In pile carpet, *density* of pile is of primary importance: the more tufts per square inch, the longer the life of the carpet. Length of pile is also important, because carpet with high pile lasts longer than carpet with short pile. The backing should be strong and flexible, tightly woven, and capable of holding the tufts securely. In flat-weave rugs, the fibers and thickness plus tightness of yarn and weave prolong usefulness. Knots per square inch denote quality in Oriental rugs, with as many as 800 per square inch in a fine rug.
- Economy of upkeep allows us to enjoy the attractiveness of flooring materials. Upkeep is lessened when floor materials resist stains and bleaches, and do not absorb liquids or dirt. Camouflage patterns and neutralized colors near middle value reduce labor, regardless of the material or surface texture. Floor areas without jogs or crevices are easier to sweep, vacuum, or mop than those of complicated shape. And, somewhat surprisingly, tests indicate that carpet takes less labor to maintain than hard surfaces. Densely constructed cut pile carpet is the easiest to clean because dirt is not trapped within loops of yarn and tends to remain close to the surface.
- Resilience cushions impact, thereby reducing foot fatigue, breakage, and the noise produced when we move around.
- Warmth, actual and apparent, is welcome in all but excessively hot climates. There are four ways to make floors *actually* warm: putting the heating elements in the floor, having the heat in the ceiling so that the floor will be warmed by

- radiation, insulating the floor, and using carpet or large rugs with underlays (padding). There are also three characteristics that make floors *look* warm: warm hues, middle to dark values, and soft textures.
- **Light reflection** is generally associated with ceilings and walls, but much light hits floors both day and night. The more light floors reflect, the brighter the home will be and the less artificial light needed. Part of the reason a room seems bright and open may be the degree of light reflectance from the flooring.
- Sound absorption, as differentiated from the noise reduction that comes from resilience, relates to muffling of sounds at the point of origin. Especially in large apartment buildings, the use of sufficient sound-insulating material between the floor of one apartment and the ceiling of the next beneath is desired. Within each home, flooring of soft, porous materials helps absorb the impact and surface noise of footsteps and of furniture being moved across the floor. Carpet, the thicker the better, makes the most efficient kind of sound insulator. In some instances, this has led to the use of carpet on walls which further reduces the almost constant airborne noises of the city and perhaps of the neighbors or the household itself.
- Flammability safety standards are regulated by federal, state, and municipal agencies. All textile floor coverings sold in the U.S. must be tested by the methenamine tablet (pill) test (ASTM D 2859) to confirm that they conform to the performance standards enforced by the Consumer Product Safety Commission. The test simulates a situation in which a carpet or rug is exposed to a small source of ignition, measuring the extent of burn within a controlled time or until it ceases, whichever occurs first. The "pill" of methenamine is likened to a burning match, a cigarette, or a glowing ember. Commercial carpet must conform with additional regulations to reduce the threat to life and safety in public places.
- **Appearance** depends on appropriateness to specific situations and on the individual tastes of the household. Many people overlook the strategic potential of

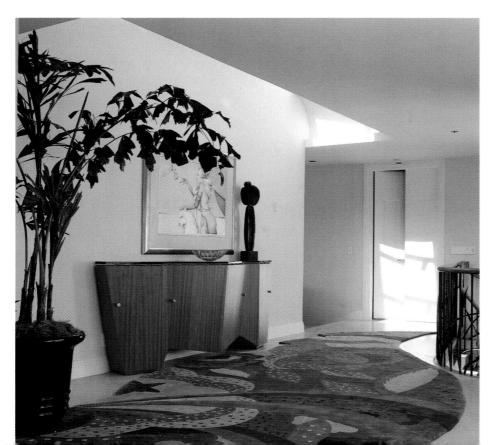

19.33 Sharon Campbell, ASID, custom designed this entry hall rug to follow the lines of the stairwell in a remodeled Art Deco home in Tiburon, California. It makes an emphatic statement of personal style. (Photograph: David Livingston)

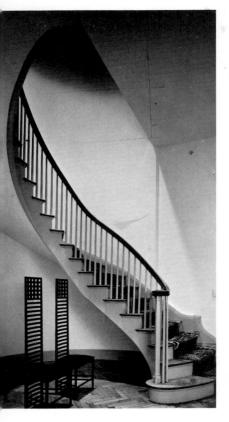

19.34 The "snail" staircase in a town house restored by Henry Smith-Miller provides the perfect setting for a pair of high-backed Mackintosh chairs. (Photograph: © Norman McGrath)

floors as sources of personalized aesthetic expression and satisfaction. Floors can be keyed up or subordinated; can alter drastically the apparent size, shape, and character of a room; or can suggest division of space without walls, unifying or demarcating various sections of the home.

Obviously, these are broad generalizations to which we could point out many exceptions. For example, durability and economy of upkeep are vastly more critical in a kitchen or a family room than in a study, where appearance might be more significant. These factors also set up conflicts, for there is as yet no one flooring material that is perfect in every respect. Thus, once again, the designer must decide what is most important and make such compromises as are necessary.

STAIRWAYS

If we think of stairs as physical entities, they are a series of steadily rising small pieces of flooring. Visually, stairs belong to walls; they become part of the wall if set against it, or act as dividers—a wall function—if they are free-standing. The basic stair consists of a straight set of risers (vertical increments), attached to a wall on one side and supported by another wall opposite; the latter may extend all the way to the ceiling or be a simple railing or balustrade for protection.

Some of the delight possible in a free-standing staircase is apparent in Figure 19.34. Here a wood stairway, reduced to its simple elements—treads, risers, stringer, and protective balustrade—curves down in a dramatic spiral from the upper floor.

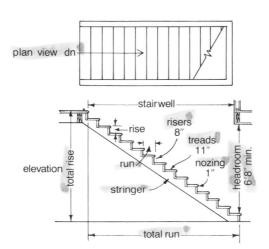

19.35 The sizes of risers and treads are important in planning safe and comfortable stairs. Building codes control riser-to-tread ratios and dimensions, stair widths, and landing requirements.

DESIGN AND CONSTRUCTION

Stairs cannot be considered only from the point of view of visual impact. The physical dimensions and their comparative proportions are of the utmost importance for the comfort and safety of those negotiating the stairs (Figure 19.35). These points should be considered in appraising stairs for use:

- A tread deep enough to take the entire sole of the shoe feels most secure; 10 inches is comfortable. In commercial construction, 11 inches is the minimum.
- A rise (the vertical measurement between each tread) of close to 7 inches seems easiest for most people. Some rules of thumb recommend that the sum of the tread and rise be between 17 and 17½ inches, or that riser-to-tread ratio be determined by the multiplication of the two resulting in a product of 70 to 75.
- Bare treads can be slippery; carpet provides firmer footage.

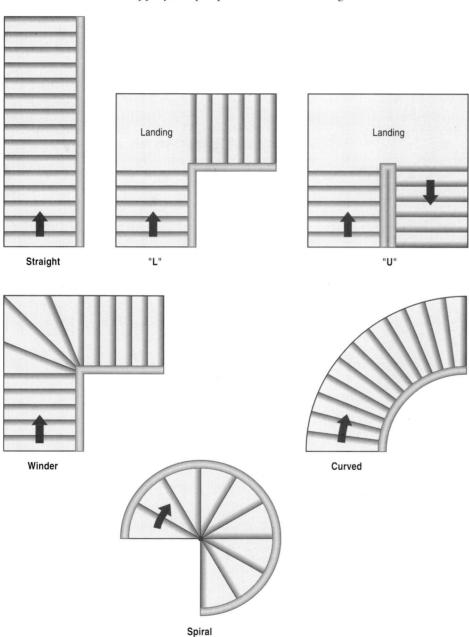

19.36 Common types of stair plans for residential design include some with wedge-shaped treads, which are not permitted as fire exits in commercial spaces because they are difficult to use, particularly in an emergency.

- A landing offers a welcome breathing space on long stairs. For straight runs of stairs, a landing is required at each 12 feet of vertical rise; in places of public assembly, the maximum vertical rise between landings is 8 feet.
- Ample **headroom** (84 inches) at the top of the staircase is a self-evident safety precaution which also affects psychological comfort. (HUD permits a minimum of 80 inches.)
- Variation in the size or spacing of steps (except for well-defined landings) can be a trip hazard.
- Minimum width for comfort is 36 inches; for two people side-by-side or furniture moving, 42 inches; for means-of-egress in public or commercial buildings, 44 inches.
- Winding stairs may be perilous, especially if the inner edge of the tread is too narrow to accept a firm footstep. A minimum diameter of 48 inches is needed for a spiral stair. Even then, a spiral stair presents difficulty in transporting furniture up or down. Many building departments allow winding stairs only as a secondary staircase; a traditional staircase must exist, too.
- Some kind of handrail running the length of the stairs is essential for safety. When the household includes a person whose limited eyesight or other physical condition makes stair-climbing precarious, there should be an easily gripped rail on *both* sides of the stairway. Codes require a handrail 30 to 34 inches above the floor (24 inches for children) on at least one side where there are three or more risers. The handrail should be 1½ to 1½ inches in diameter with a 1½-inch clearance between the wall surface and handrail. It must also

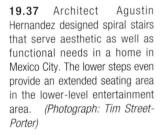

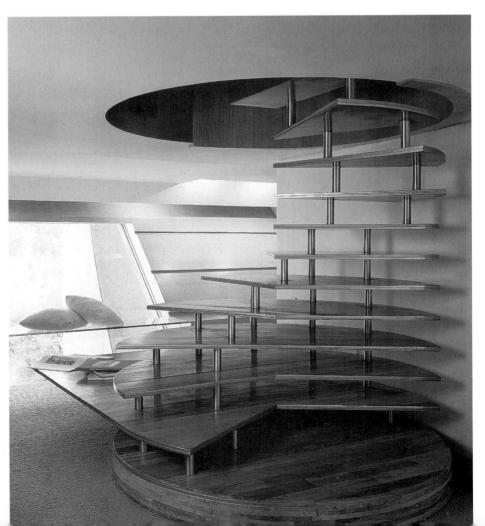

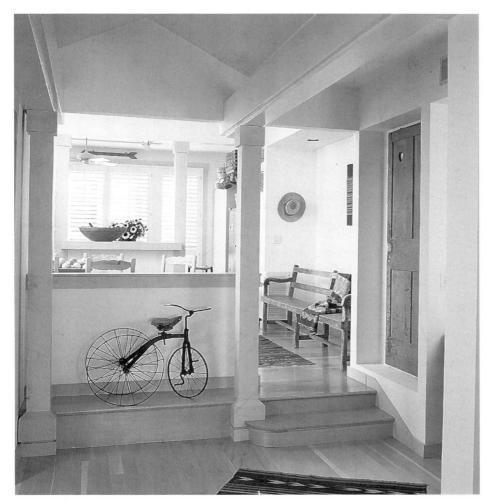

19.38 Columns and a low wall clearly mark the change in floor level in an early 1900s San Francisco duplex remodeled to become a single family home. Wilkinson & Hartman, architects. (Photograph: David Livingston)

extend beyond the last tread for ease of use; building codes dictate how much. In an open railing, the upright supports (balusters) can be no more than 9 inches apart.

This list of utilitarian considerations may seem confining, but it need not be considered binding for every flight of stairs. When planning a secondary staircase or one that leads to a hideaway area of the house—not to the essential rooms—imagination can have freer rein. In Figure 19.37 the spiral stair rising up to the level above brings a delightful, sculptural accent.

In one-story dwellings stairs usually are not a consideration, except for an occasional two- or three-step drop or rise in floor level to define different areas of a larger space. Nevertheless, consideration must be given to making these steps both evident and safe for the unwary. Clear definition by furniture arrangement, a low wall, railing, or the placement of large plants and other accents can prevent a twisted ankle or even a broken leg.

Among the most telling aspects of interior design are the treatment of floors, floor coverings, and stairways. Together with walls and ceilings, they give a room or an entire dwelling its basic character and, once established, begin to channel decisions about other steps in interior design. A sympathetic integration of these elements constitutes a major step in creating a comfortable home.

REFERENCES FOR FURTHER READING

Barnard, Nicholas. *Living with Decorative Textiles*. New York: Doubleday, 1989, chaps. 3, 6. Ching, Francis D. K. *Building Construction Illustrated*. New York: Van Nostrand Reinhold, 1975.

Con, J. M. Carpet from the Orient. New York: Universe, 1966.

De Chiara, Joseph, Julius Panero, and Martin Zelnik. *Time-Saver Standards for Interior Design and Space Planning*. New York: McGraw-Hill, 1991, pp. 516–565, 660–723, 1122–1129.

Eiland, Murray L. Oriental Rugs: A Comprehensive Study. Greenwich, Conn.: New York Graphic Society, 1973.

Faulkner, Sarah. *Planning a Home*. New York: Holt, Rinehart and Winston, 1979, chap. 7, pp. 149–167.

Formenton, Fabio. Oriental Rugs and Carpets. New York: McGraw-Hill, 1972.

Hollister, Uriah S. The Navajo and His Blanket. Glorieta, N.M.: Rio Grande, 1974 reprint. Hull, Alastair, and Nicholas Barnard. Living with Kilims. New York: Clarkson N. Potter, Inc., 1988.

Jackman, Dianne R., and Mary K. Dixon. *The Guide to Textiles for Interior Designers*. Winnipeg, Canada: Peguis Publishers Limited, 1983.

James, George Wharton. Indian Blankets and Their Makers. New York: Dover, 1974 reprint. Kahlenberg, Mary Hunt, and Anthony Berlant. The Navajo Blanket. New York: Praeger, 1972.

Keough, James G. Carpeting: The Soft Touch. Home, December 1983, pp. 68-74.

Keough, James G. The Easy Care Option: Vinyl. Home, November 1983, pp. 40-45.

Minimum Guidelines and Requirements for Accessible Design. Washington, D.C.: U.S. Architectural and Transportation Barriers Compliance Board, 1982.

Morgan, Jim. Building Stone Endures. Residential Interiors, July-August 1980, pp. 68–69. Radford, Penny. Designer's Guide to Surfaces and Finishes. New York: Whitney Library of Design, 1984.

Riggs, J. Rosemary. *Materials and Components of Interior Design*. Reston, Va.: Reston Publishing Company, Inc., 1985, chap. 2.

Scobey, Jean. Rugs and Wall Hangings. New York: Dial, 1974.

Whiton, Sherrill. *Interior Design and Decoration*, 4th ed. Philadelphia: Lippincott, 1974, chap. 15.

Winitz, Jan David and the Breema Rug Study Society. *The Guide to Purchasing an Oriental Rug*. Oakland, Calif.: The Breema Rug Study Society and Dennis Anderson Photo-Publishing, 1984.

Yaeger, Jan. *Textiles for Residential and Commercial Interiors*. New York: Harper & Row, Publishers, 1988, chaps. 23–31.

Windows and Doors

WINDOWS

Types

Design and Location Architectural Composition

Window Walls

WINDOW TREATMENTS

Exterior

Interior

DOORS

Types

Functional Aspects

Design

Windows and doors relate spaces to one another both visually and physically. The "wind's eye" of old was a narrow opening to let out some of the fire's smoke and let in a little fresh air, to help light the room, and to permit peephole glimpses of what was going on outside. Today we think of different kinds of spaces, carved by walls, penetrated by windows and doors. The types of window treatments we adopt—curtains, draperies, shutters, shades, blinds, or nothing whatsoever—govern the amount of interrelationship two adjacent spaces will have.

WINDOWS

Of the three functions performed by windows—ventilation, light admission, and visual communication—only the last is unique. Ventilation can be handled through louvered and shuttered openings, air conditioning, exhaust fans, and other mechanical devices. Electric light is sometimes more convenient and is capable of more precise control than natural light. But only through transparent windows, doors, and walls can we enjoy a view of the outdoors from protected enclosures. When windows expand to fill large areas of a wall, interior and exterior spaces become closely united. In the house shown in Figure 20.1 a window wall at one end of the space serves as a natural magnet for an intimate seating group. At night, the window can be closed off and the focus turned inward.

20.1 Built within the walls and structural wood joists of a house from the early part of the century, this five-story residence overlooks the East River in New York. The curved bay echoes a four-story semicircular glass stair tower, with an everchanging view of boat movement on the River. At night, draperies can be drawn for greater privacy. Richard Blinder/Beyer Blinder Belle, architect; Janet LeRoy, interior designer. (Photograph: Frederick Charles)

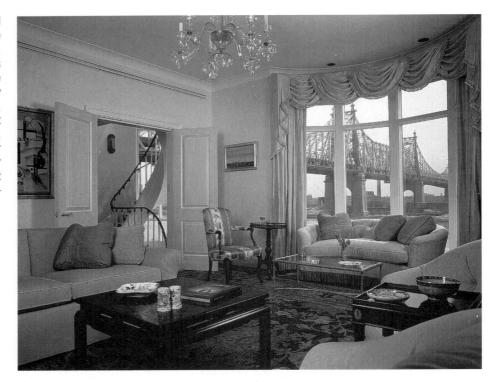

TYPES

Despite immense variation in the appearance of windows, all can be classified in one of two general categories: **fixed** windows meant essentially for light and views, and **operable** windows that open for ventilation. In this century operable windows have predominated, although the use of air conditioning and solar design concepts have caused a rise in the use of fixed glass.

Rather than a strict reliance on either form of window, a combination of operable and fixed windows—and of various types of glass—often provides the best solution to climate control in the home from both an aesthetic and an environmental point of view. Fixed and operable windows are manufactured in many standard sizes and prefabricated units, which have lowered the cost of acquisition and installation.

Wood and metal are the materials typically used to hold the glass in windows and walls. Metal is stronger (which makes thinner structures possible), does not shrink or swell noticeably, and has a uniform texture harmonious with glass. With the exception of aluminum and stainless steel, metals in windows must be protected by paint; and because all metals conduct heat and cold readily, moisture may condense on the inside of metal sashes in cold weather. Better-quality aluminum windows now utilize a vinyl heat-loss block in the aluminum frame. Wood shrinks, swells, and requires a protective finish, but it does not encourage condensation. Vinyl cladding may protect wood frames from the effects of moisture. The use of plastic as a material for framing windows is also rising because of the relative stability of many plastics, their imperviousness to heat and cold, and their integral finishes.

Various types of windows are illustrated in Table 20.1 (page 502). Each type has certain advantages and disadvantages that influence its location, treatment, and also the furniture arrangement nearby.

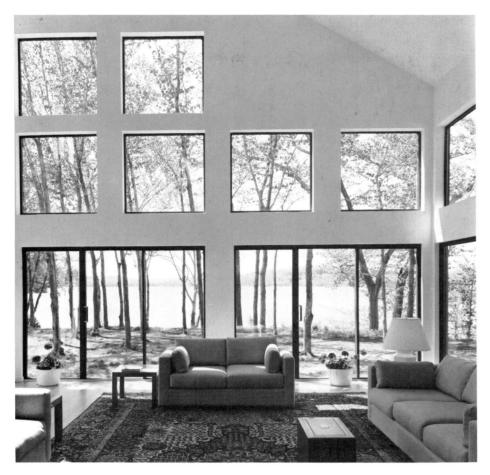

20.2 A view of the Connecticut River and an adjacent stand of trees prompted architects Alfredo De Vido Associates to design a high sloped-ceiling living space with a progression of fixed and movable glass openings. (Photograph: Otto Baitz, Inc.)

DESIGN AND LOCATION

Heat and cold, light and ventilation, views and privacy, and furniture arrangement are among the major factors determining window design and placement. Accessibility for cleaning and security may also be considered. Interwoven with these is the larger concern of architectural composition—the relationship of windows to the mass and space of the whole structure and its site. Because windows reduce thermal qualities of the structure, the size and location of window areas is often regulated by building codes.

THERMAL TRANSMISSION Most colorless, transparent materials are poor insulators. Hence, extreme temperatures will be important factors in window design and placement. By reducing costs for heating and air conditioning, special types of glass, such as double and triple insulating glass and low-emissivity glass that reflects excess solar heat, usually pay for themselves in a few years. Orientation of windows, however, is more important in achieving equable temperatures indoors at the least cost (see Chapter 13):

- Glass facing south brings welcome winter sun but, with a properly designed overhang, can exclude hot summer sun.
- Glass facing east admits the morning sun, cheering in winter and seldom too hot in summer.
- Glass on the west side lets hot afternoon heat deep into the house.
- Glass on the north admits winter cold.

20.3 The parts of a double-hung window.

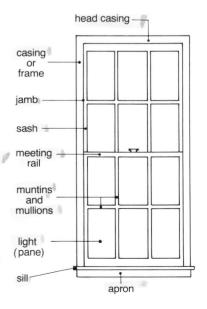

TABLE 20.1

Types of Windows and Their Advantages and Disadvantages

Туре	Advantages	Disadvantages
double hung single hung vertical sliding	Sashes slide up and down so they can be opened top and/ or bottom for ventilation; weatherproofing is effective; do not get in way of people or curtains; usually taller than wide; seldom warp or sag	Only half can be opened at one time; little protection from rain; difficult to clean from inside, unless sash can be removed or pivoted; inconvenient to operate with furniture under them; horizontal meeting rail may interfere with view
horizontal sliding	Advantages and disadvantages similar to above, except for horizontal slide; vertical divisions interfere less with view than horizontal	
	Often combined with fixed glass for broader horizontal proportions; furniture can be placed under fixed portion	
casement	Panels hinged at one side, swing in or out; whole area can be opened; panels direct breezes, reduce drafts; crank- operated hardware easy to use over furniture	Usually fairly small panels, larger may warp; in-swinging interfere with furniture; outswinging hazardous if at ground level; little protection from rain
awning projected	Similar to casement but hinged at top and occasionally at bottom; give precise, draft-free ventilation, block rain or snow	Similar to casement, but collect dust when open; look institutional; normally direct air flow above occupied area of room; horizontal divisions interfere with view; hopper (bottom hinged, inward swinging) must be placed low in wall for effective ventilation but interferes with window treatment, furniture, and traffic inward swinging top hinged window must be placed high in wall
jalousie	Similar to awning type but with narrow, unframed slats of glass, plastic, even wood that operate in unison; take little space, and can be made to fit odd shapes; excellent, precise control of ventilation	Many small panes difficult to clean and weatherproof; may interfere somewhat with view
fixed glass	Design free from constraints of standardized shapes and sizes; need no screens or hardware; easy to wash if accessible; furniture usually stands away from wall, lessening usable space, increasing visual space; unified with wall	Hard to control light and heat, and to clean inaccessible areas; attention must be called to glass in some way to prevent collisions
skylight and clerestory	Bring light/air into center of house; balance light, remove air efficiently; introduce light from unexpected source to give new dimensions to form and space	Difficult to control light and heat; difficult to clean; special hardware needed if operable

Undesirably oriented windows necessitate relying on special types of glass, insulating window treatments, or something outside, such as nearby shade trees, vine-covered arbors, very wide overhanging roofs, or awnings to mitigate negative effects. Generally speaking, in terms of thermal transmission—and in most parts of the United States—glass on the south is best, followed by that on the east.

LIGHT Natural light is cheerful and healthful. But it is unfortunately easy to design rooms that seem unpleasantly bright, with strong contrasts of light and dark that lead to **glare**. Oddly enough, glare generally comes not from too much light but from too little light in the wrong places. More light can mean less glare if the windows are well planned. Until recently, most windows were holes cut out of the wall, and the first thoughts were of hanging curtains to "soften" the light. In the best contemporary design, however, large areas of glass seldom cause excessive brightness. Major factors in planning include the following:

- Light coming from more than one direction minimizes heavy shadows and makes occupants feel enveloped by light, rather than being caught in a spotlight.
- Light entering near the top of a room illumines the ceiling and spreads throughout a room more than does light penetrating the lower levels.
- Overhangs projecting beyond windows reduce the glare of the sky and mellow the light entering a room.
- Windows to the floor will admit less glare if the surfacing material outside does not reflect light unduly. Light-absorbing materials or the shade from trees or trellises help solve this problem.
- In extreme situations it may be necessary to use nonglare glass, which can be clear, smoked, or tinted. Some types are also sound- and heatproof, even reflecting.

The lightest elements of a room by day, windows are very dark—almost ominous—at night unless they are lighted or curtained, or unless the immediate view outside is illuminated.

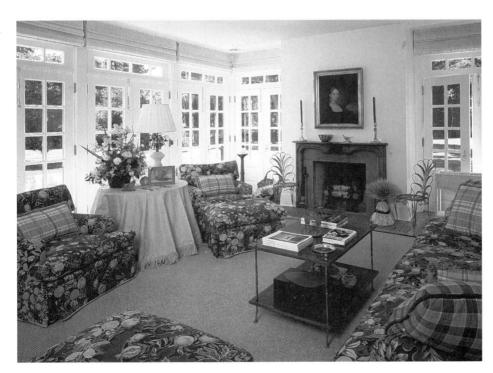

20.4 A new wing addition to a 1930s Georgian home in Princeton, New Jersey, matches an existing wing on the opposite side. French doors with transom windows above allow an abundance of light to enter, balanced from multiple directions and from both high and low. Roman shades can be pulled if the light is excessive. Harry Williams, builder; Hedl Brick and Jim Hamilton, designers. (Photograph: Norman McGrath)

VENTILATION The most comfortable ventilation inconspicuously lets stale air out from near the top of a room and draftless fresh air in from the floor level. High windows, openable skylights, exhaust fans, or louvered openings above windows accomplish the first, while low windows or ventilators do the second. There are times, though, when a breeze sweeping through the house from wide-open doors and windows is desired. Rooms are most quickly aired if openings are on opposite sides, with one facing the prevailing winds. Cross ventilation reduces the need for air conditioning, an important energy conservation measure.

VIEWS, PRIVACY, AND SECURITY Large windows often face the best outlook: a view out over a city, into a private garden, or toward a range of mountains or body of water. When such a vista does not occur naturally, perhaps when a solar orientation takes precedence, it is possible to create one with landscaping, interior courtyards, or atriums.

Windows facing the street or nearby neighbors offer less privacy both day and night and often are smaller, higher in the wall, or of less transparent materials than those with more desirable views. Otherwise privacy can be achieved by building fences or planting hedges outdoors, by creating an indoor greenhouse window area and, as a last resort, by closing off the window with view-blocking fabrics, grilles, or shutters. Nighttime privacy can also be increased somewhat with outdoor lighting, which lessens the contrast between indoors and out, making forms and shadows less noticeable.

Security concerns are heightened as the number, size, and accessibility of windows increases. Windows are an easy target for unlawful entry. Preventive measures include exterior lighting, inaccessible placement, installation of metal grilles,

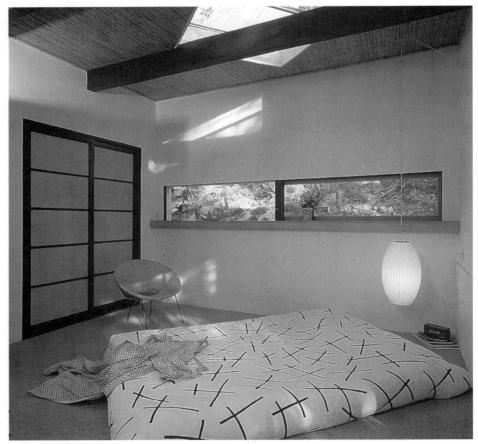

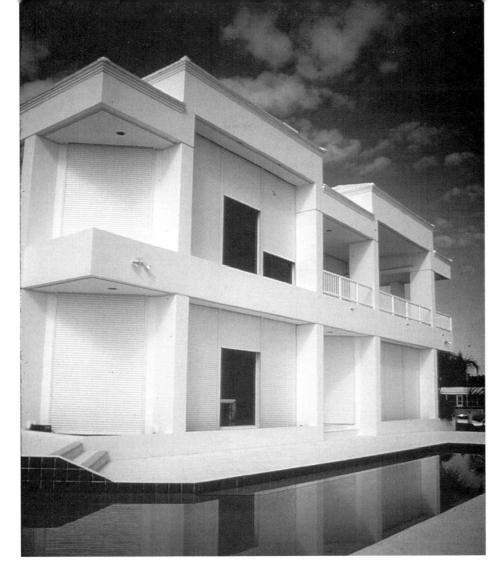

20.6 Exterior aluminum rolling shutters offer a number of benefits: storm protection, security against vandalism and burglary, as much as 40% energy savings and 75% noise control, and protection from the sun's heat and harmful ultraviolet rays. (Photograph: Julio Castro. Courtesy Euroll Shutter Design.)

and various alarm or surveillance systems. Landscaping can also aid in preventing access, and high-density living areas may provide additional protection with gated or security entrances and design of the building(s).

FURNITURE ARRANGEMENT The location and design of windows and doors largely determines how furniture can be arranged. The more openings walls have, the harder it is to place furniture. This situation is aggravated if the openings are separated from one another or if windows extend below the ordinary table height of 27 to 30 inches. Windows grouped in bands high enough to allow the placement of tables, desks, or sofas beneath them facilitate flexibility, making possible furniture arrangements that leave a maximum of usable space open in the center of a room. Skylights and clerestories (windows located very high on the wall) present fewer problems, but the strong light and heat they admit may cause fading and sun damage to furniture placed below. In larger rooms or open spaces, the tendency is to group furnishings away from the walls, thus minimizing the influence of windows except when they provide a view. Windows that extend to the floor make indoor and outdoor space seem continuous, but they lose most of their value if heavy furniture must be put in front of them. In other words, window walls increase visual space but may reduce usable space.

CLEANING All glass needs cleaning occasionally, especially in dusty or sooty locations or where it can be reached by small children and pets. It is easiest to clean when the panes are large, when they can be reached without excessive stoop-

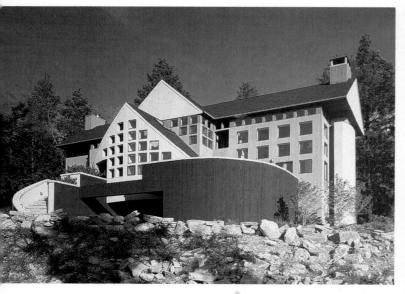

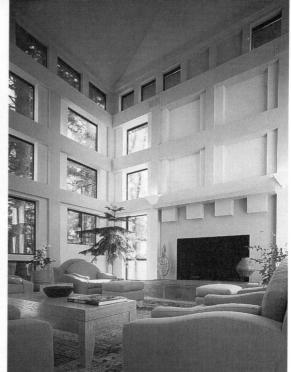

20.7 (left) A residence in Guilford, Connecticut, designed by Alfredo De Vido Associates, emphasizes the geometry of its fenestration with the use of color on both the exterior and the interior. A band of recessed windows just below the roof and gable end contrasts in color with the walls below. (right) The same windows are encased by another band of contrasting color on the interior while the neatly ordered windows below are overlaid by a gray layered grid on a yellow background. (Photograph: Frederick Charles)

ing or climbing, and when they are accessible from outside as well as inside. Clerestories and skylights bring special cleaning problems, often lessened with translucent glass. Paned windows may have muntins (the grid-like structure dividing the glass into small panes) sandwiched between two layers of glazing so the glass is more easily cleaned. In other types, the muntins snap out so the glass can be washed as a single sheet, with fewer difficult corners. By design, many windows are either removable for cleaning or designed so that both interior and exterior can be washed from inside the house. Indoor access to windows is often controlled by furniture arrangement.

ARCHITECTURAL COMPOSITION

Openings today, as in the past, are a vital factor in architectural design. Contemporary trends can be summarized as follows:

- **Fenestration**, the arrangement and design of windows and doors, is considered an integral part of the architectural shell.
- Windows typically are grouped in bands, usually horizontal, but vertical as well
 when compatible with architectural design. When feasible, windows and doors
 are combined in harmonious units.
- Large areas of glass are placed where they serve best; small windows are strategically located for balanced lighting and ventilation, with privacy.
- Unity and simplicity of effect result from using as few shapes, sizes, and types as possible, with the tops of windows and doors aligned. Variety may be introduced to add character and individuality.
- A less formalized attitude toward the design and placement of windows is also evident, with odd-shaped windows sometimes being set in unusual locations for a forceful design impact.

From an architectural point of view, the design of openings is at least as important as the design of walls, ceilings, and floors. Windows are conspicuous day and night, inside and out. Their thin, smooth, light-transmitting material contrasts strikingly with what is around it. Beyond these physical characteristics, the fact that enclosed and unenclosed spaces interpenetrate one another through windows and doors endows them with a unique psychological importance.

WINDOW WALLS

The act of audaciously opening the home to its surroundings is, in some respects, as significant as the age-old struggle to secure dwellings against the environment (Figure 20.9). Box-tight enclosure has never been completely satisfying, and the urge to combine the paradoxical goals of security and openness has a long, varied history. Walled gardens allowed the early Egyptians, Greeks, and Romans to open part of their homes to the outdoors. In the medieval period, areas of glass large enough to be called "window walls" were introduced. Many houses built fifty or more years ago had sizable "picture windows." Though seemingly revolutionary, window walls represent an evolutionary step toward broader expanses of glass.

Window walls are now standard features even in tract houses, but many designers and builders fail to understand them completely. A window wall should be thought of not as merely a bigger window but as a different way of planning the house and garden. The space in Figure 20.10 gives the illusion of being in a tree-house, because it is almost completely walled in glass. Indoors and outdoors are thoroughly integrated, yet the occupants remain protected from the elements.

At best, window walls flood rooms with healthful, invigorating light; at worst, they admit glare, heat, or cold. By visually uniting house and landscape, they affect furniture arrangements and color harmonies as well as the design of the exterior. It should be remembered that some interior treatments may be generally

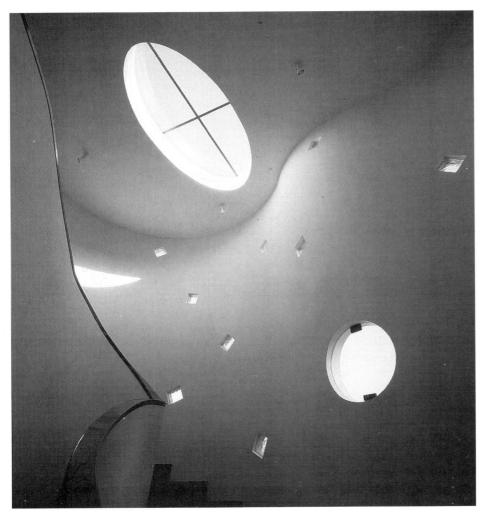

20.8 A home in Lima, Peru, employs geometric shapes and forms in an unconventional manner. The free-form walls and ceiling surrounding a curved stairway are scattered with squares and circles of window openings which illuminate the space. Arquitectonica, architects. (Photograph: Timothy Hursley)

20.9 A window wall is given definition with a stepped placement of tiered panes and mullions. Partial solid walls give a feeling of security and enclosure to balance the openess of the expanse of glass. Steven David Ehrlich, architect. (Photograph: Tim Street-Porter)

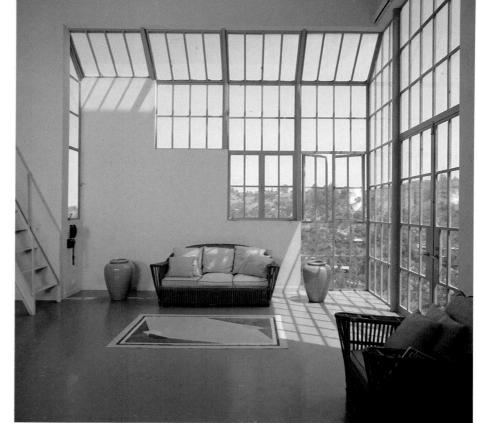

20.10 A three-level house, built on a hillside in Pasedena, California, makes use of full length floor-to-ceiling walls of glass to give the second-level living room and balcony the effect of being part of the forested landscape. Conrad Buff, architect. (Photograph: Mark Darley/ESTO)

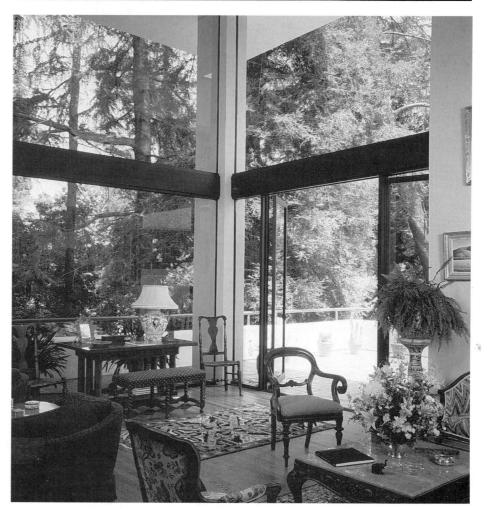

TABLE 20.2

Special Considerations for Window Walls

Problem	Solution (
loss of privacy	Choose window wall facing toward private part of property or above sight lines. Build fences or plant hedges. Use curtains and draperies, and potted plants indoors and out.	
glare of light	Light should be balanced with windows in other walls or with skylights. Overhanging roof or trellis will help. Plant suitable shade trees nearby. Use glass curtains and hanging plants.	
excessive heat or cold	Look for orientation toward south or southeast, insulating glass, overhead protection or trees. Use insulating draperies that can be drawn when necessary.	
more glass to clean	No easy solution; use professional window-washer's techniques.	
greater quantity of curtaining	Look for window wall placed so that curtains are not essential.	
furniture arrangement	Plan room so that major furniture group is related both to window wall and another dominant unit, such as a fireplace.	
color schemes	Take account of relationship between colors inside and those seen through the glass.	
danger of being mistaken for an open door	Use proper design—a raised sill, obvious supports, or colorful stick- on designs—to indicate physical presence of a window wall. Arrange furniture and/or floor materials indoors and out to steer traffic to a door, not a window.	
fading of colors	Choose colors that do not fade or that fade pleasantly. Exclude sun with projecting roof, planting, or curtains; use low-emissivity glass.	
black and cold at night	Illumine window with lighting trough above it. Light terrace, balcony, or garden outside. Use draperies or reflective glass.	
design and maintenance of landscape	Plan at least the immediate landscape architecturally to harmonize with interior; use paving, fixed outdoor furniture, sculpture, and plants that will remain attractive all year with little care.	

unsatisfactory solutions to the problems presented by window walls, since they defeat the primary purpose by limiting the feeling of openness. Table 20.2 lists difficulties created by window walls and suggests ways of dealing with them.

There are innumerable ways of designing window walls. When they fill an entire wall from floor to ceiling, a minimum break remains between indoors and outdoors. Greenhouse or sun-room windows may constitute both walls and ceiling; they are relatively easy to install and are often included in or added to homes for their solar capabilities. They must be judiciously located to avoid excessive sun and heat penetration into the house. If windows begin above the floor, they leave room for furniture beneath them and give a more secure sense of enclosure. Window walls may have few divisions or a strong pattern of *muntins* and/or *mullions* (horizontal divisions and/or vertical piers between sections of glass). They can join a room with an extensive view or focus attention on a small enclosed court. Although typically associated with living or dining areas, glass walls can make kitchens or hallways expansive. If well planned, they are quite feasible in bedrooms—even bathrooms—in almost any part of the United States.

Large windows add to the cost of a home. Glass is expensive to buy and replace, and difficult to make weathertight around the edges. It must be cleaned often and is likely to increase heating and cooling bills. Strong sunlight and heat fades and damages interior materials and furnishings. Operable windows need

20.11 In a solar home in New Jersey, the large expanse of angled glass forms both wall and ceiling in an emphatic diagonal line. Alfredo De Vido Associates, architects. (Photograph: © Peter Aaron/ESTO)

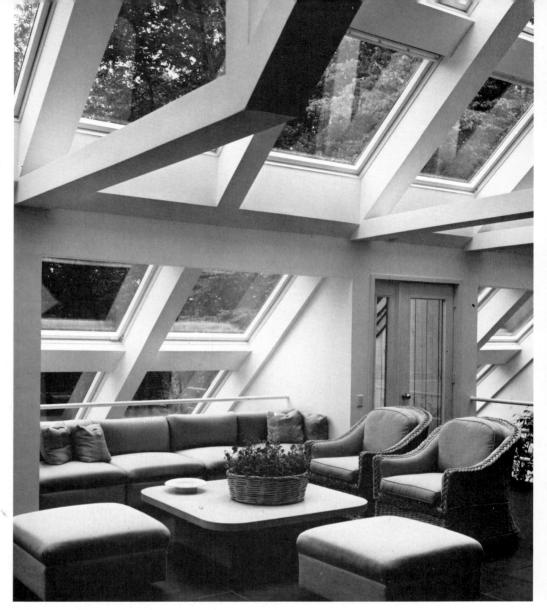

20.12 The hallway to the bedroom wing of a vacation home, located on an island off the coast of Maine, gives the feeling of an outdoor passage with its wall of wood-framed windows and sliding glass doors and wood floor, ceiling, and walls. The inclusion of bookcases doubles the function of the space. Peter Forbes and Barry Dallas/Peter Forbes & Associates, architects. (Photograph: Timothy Hursley)

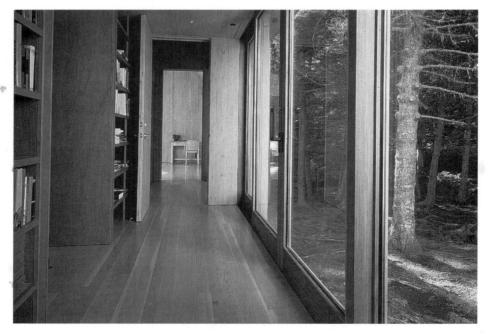

screens and window hardware. Many windows bring the added expense of curtains, draperies, or blinds. But sensibly large, well-placed windows are worth their cost in aesthetic delight and energy savings.

WINDOW TREATMENTS

It is tempting to say that perfectly planned windows need no "treatment," but we would then ignore the great changes in outdoor light and heat and the varying needs of the people inside. Thus, for the sake of *utility*, curtains, draperies, blinds, or shades may be needed to control privacy and safety, the amount and kind of light that enters, and the transmission of heat and cold. These needs should be noted when the design program is being completed. From the point of view of *economy*, efficient window treatment can reduce heating and cooling bills, keeping in mind that whatever is put on the window should be durable, resistant to the ravages of sun, moisture, and insects, and easily maintained. *Beauty* comes from the inherent attractiveness of the materials chosen and from the way in which they relate windows to the whole room. *Character*, here as elsewhere, is less a matter of being "different" than of solving problems well. The architectural design of windows can be changed by remodeling; window replacements are one of the most popular home improvements. But often we use what is there and modify it by way of window treatments that act as *controls* on windows.

EXTERIOR

Too often overlooked, exterior window treatments have one overriding advantage: they provide the most effective climate control without interfering with furniture or taking wall space within the room. Exterior treatments are used quite extensively in Europe.

Awnings. Awnings made of weather-resistant fabrics can be adjusted as the weather varies to protect windows from sun, rain, and dirt while casting a soft, pleasant light inside. They are available in many designs and colors, which must be selected with the knowledge that they are subject to fading, soiling, and wind damage. However, awnings can reduce solar heat gain as much as 65 to 75 percent. Metal awnings, usually aluminum, can either be stationary or roll up. They are higher in initial cost than fabric types but pay for themselves with a longer life. The major design problem with awnings is making them look like integral parts of the structure rather than afterthoughts.

Shutters. Increasing in popularity today, true shutters temper light, heat, and cold. They also serve to secure houses against marauders or windows against violent storms. More common are the dummy shutters employed to make small windows look larger on Colonial-style houses.

Cutouts and Projecting Elements. Overhanging roofs and trellises are popular exterior shading devices. In addition, they can shelter outdoor living areas, visually relate a house to its site, and also control the quantity and quality of light entering windows. Cutouts are semi-open spaces, missing a wall or two or perhaps a roof, that nevertheless seem an integral part of the structure.

Grilles and Fences. Masonry, wood, plastic, or metal grilles and fences—placed close to windows or some feet away—control privacy, sun, and wind in any degree desired, depending on their design and location. They also add security against invaders when attached to window frames.

Louvers. Ventilating panels of wood, metal, or plastic can be especially effective as sunshades and for weather protection. Normally used over windows, they can take the place of glass completely in very temperate climates (Figure 20.14).

20.13 Broad overhangs provide a cool walkway, shelter an outdoor entertainment area, and shade the windows of a home from the heat and glare of the high desert sun in Reno, Nevada. Maurice J. Nespor & Associates, architects.

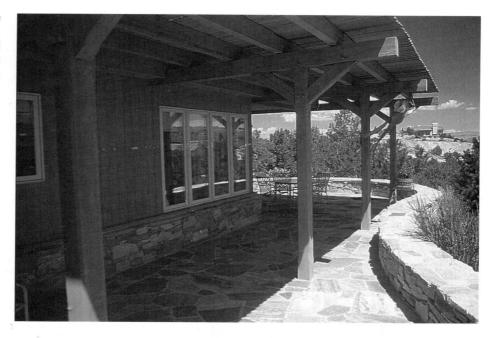

20.14 Adjustable wooden louvers shield the three-story window walls of a Florida house to permit flexible control of the semitropical climatic conditions of bright sun tempered by daily breezes, sometimes heavy rainfall, and high winds. Dwight E. Holmes, architect.

If security is a concern, louvers are not an effective choice because the narrow slats are easy to remove from the exterior of the structure.

INTERIOR

Besides the traditional curtains and draperies, interior window treatments include many other kinds of controls such as shades, blinds, screens, and shutters. (For illustrations of both types, see Appendix C.) These treatments can move sideways or up and down, the latter having the definite advantage of being completely out of the way when not wanted. They are more rigid and architectural by nature, and may be better for certain situations than the traditional "soft" window treatments.

HARD TREATMENTS

Shades. Roller shades pull up and down, and are mounted on rollers. They may be mounted at either the top or bottom of the window, unwinding either downward or upward. Shades reduce light and give privacy in direct relationship to their thickness and translucency or opaqueness. They may be constructed of vinyl or fabric and may be reflective to reduce heat gain. A fabric used elsewhere in the room can be laminated onto a plain shade to give unity and individuality. Roller shades are inexpensive. Gather shades, while performing in the same manner as roller shades, have a very different mechanism for raising and lowering them: Roman and Austrian shades are attached to tapes that, respectively, pleat or shirr the fabric when drawn by cords similar to those used for blinds. Roman shades pleat in definite horizontal lines as they are raised. They may unfold flat or in cascading loops, depending upon construction techniques. Austrian shades fall in lengthwise bands of soft, scalloped, horizontally draped folds. They are vertically shirred in very lightweight, often sheer fabric. Balloon or pouf shades, of fabric vertically shirred or pleated, create balloon-like poufs at the bottom. With inverted pleats, the panels hang nearly flat until raised, giving a more tailored effect. Shirring produces a more billowy effect.

Bamboo, or **matchstick**, and **woven-wood** shades function much like those made of fabric, either rolling or folding as they are raised. They differ in that they

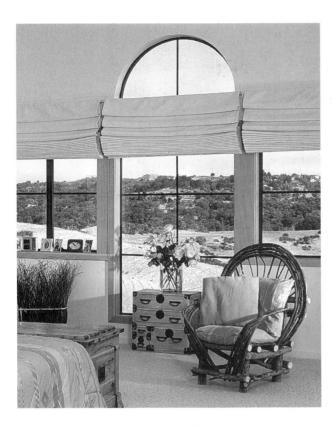

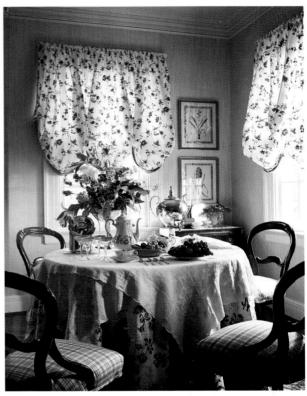

usually let more light through, give a better view of the outside, and have pleasantly natural textures and colors. They have a linear quality with horizontal strips of wood or split bamboo held in place with natural or colored cord.

Pleated shades, made of a polyester web or mesh material, filter or block sunlight while remaining visually unobtrusive. They are generally very narrow accordion-pleated shades and are excellent for tempering strong sunlight and excess heat in greenhouses and sunrooms, especially when they have an aluminum backing (which also increases privacy). Honeycomb pleated shades are paired, creating an insulating air pocket between them. The outerside is white to reflect heat and unify exterior appearance, but the inside may be any color. Pleated shades take up very little space when raised; when lowered, the pleats open but retain a slight fold, giving them a three-dimensional effect.

Thermal shades or window quilts constructed of multiple layers of insulating fabric, often surrounding a reflective Mylar sheet, are used effectively to control heat loss or gain. They can also either roll or pleat, but require more space at the top of the window when opened because of their high bulk. Thermal shades are mounted in tracks or otherwise attached along the sides of the window frame to prevent air leakage. They can reduce heat loss/gain by up to nearly 80 percent. Even ordinary shades, if they are made of an impermeable material like vinyl-coated cloth, can cut heat loss through windows by 30 to 35 percent if mounted inside the window casings with a few adjustments to seal the top and bottom of the shade when drawn. Some shades offer a reflective backing that prevents excessive heat gain as well.

The drawbacks of shades include the fact that, when pulled down, most cut out the light from the top of the window first—and that is the best light, offering the most privacy. Some shades roll from the bottom up, but these may interfere

20.15 (above, left) Roman shades provide privacy at night, block sunlight when desired during the day, and, if properly constructed, can contribute added window insulation as well. (Photograph: David Livingston)

20.16 (above right) Shirred balloon shades have a light, billowy, cloud-like appearance. (Courtesy Waverly)

20.17 Pleated shades filter sunlight through their accordian folds and leave generous space for more decorative over treatments. They can be pulled up, completely hidden from view behind the draped festoon. (Courtesy Hunter Douglas)

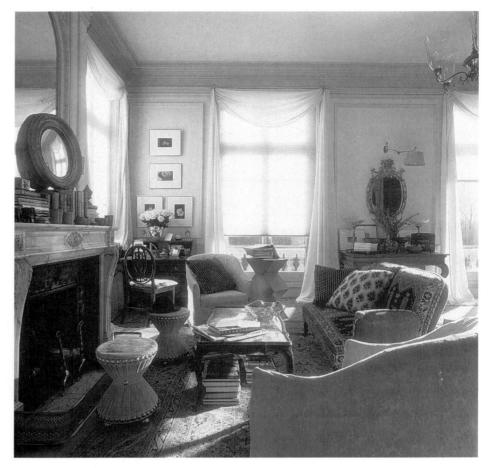

20.18 Window quilts are used for their insulating (and privacy) value more than to temper light. When raised, their bulk forms a large bundle that may be concealed behind a cornice but that covers a portion of the window area. (Courtesy Appropriate Technology)

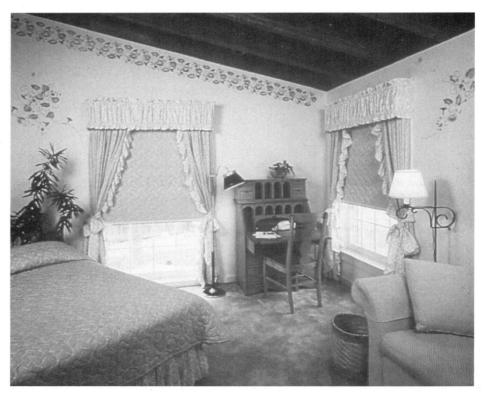

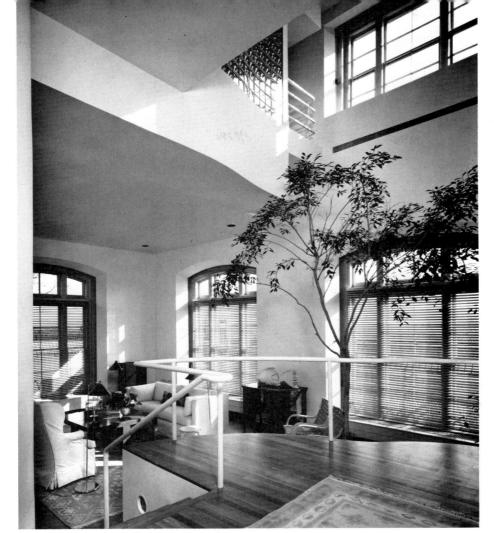

20.19 Miniblinds give privacy and light control while relating strongly to architectural design. Henry Smith-Miller, architect. (*Photograph: Norman McGrath*)

with the operation of the window. Shades also block the breeze and may whip around noisily.

available now in metal and plastic as well. Their special advantages include almost complete light and air control—directed straight into the room, down toward the floor, or up toward the ceiling—as well as complete disappearance behind a valance or other treatment, if desired. Blinds are durable and not expensive, unless made of wood. They create pleasing horizontal lines. Venetian blinds have 2-inch slats held with fabric tape. Miniblinds are constructed with narrow slats (1 inch in width), held by thin cords, causing minimal interference with the view. Microblinds have even narrower slats, only ½ inch wide. Blinds can have different colors on each side of the slats; some are available with a heat-reflective surface on one side. They do, however, collect dust and dirt and are somewhat difficult to clean. They may also be awkward to raise and lower, depending upon window size and height, the presence of additional window coverings, and furniture placement.

Vertical blinds of metal, wood, PVC, or fabric can be shaped easily to fit and unify odd-size openings and can hold inserts of fabrics or wallpapers that coordinate with other materials in the room. Their louvers control light from side to side, rather than from up or down, and emphasize the height of windows and walls. Most vertical blinds afford a view directly in front of but not at the ends of a long window area. Newer materials are perforated for transparent effects. Of importance for household maintenance is the fact that the vertical surfaces collect less dust than do horizontal blinds. Vertical blinds may hang loosely from the top like a drapery, slide in tracks, or be joined by a chain at the bottom (and for long runs,

20.20 In a Piedmont, California, home overlooking San Francisco Bay and the Golden Gate Bridge, vertical blind vanes are faced with grasscloth to blend uniformly with the grasscloth-covered walls when they are closed. Dennis Giacovelli, architect; Bob Rogers, ASID, interior designer. (Photo-graph: David Livingston)

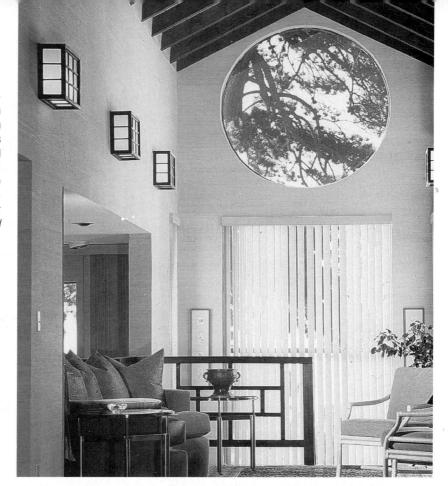

20.21 Lattice wood screens lend a Middle Eastern atmosphere to a condominium in Westwood, California. They allow filtered light to enter, yet offer some privacy. Steve Chase, interior designer. (Photograph: Tim Street-Porter)

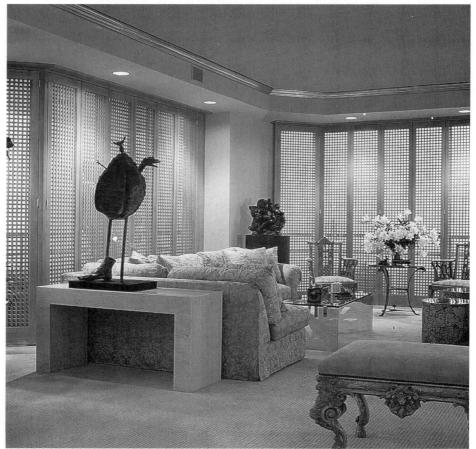

they may even be motorized). They afford complete privacy when closed (the louvers overlap) and can be energy efficient. A disadvantage is that they are rather easily damaged, especially by children.

Grilles, Screens, and Panels. Under certain circumstances—when windows are not well designed, when there is no view, or when privacy is necessary—grilles or screens of wood or other materials pierced with various patterns deserve consideration. With a translucent backing added, they are called *shoji* by the Japanese and they mask windows but allow diffused light to enter. Screens may slide, fold, or be stationary. Stained, etched, beveled, and leaded glass panels may also be hung in place of standard window glass or in front of it. They add color, sparkle, and varying degrees of privacy. Wood or vinyl lattice screens are used by contemporary designers on both the interior and exterior of windows.

Shutters. The old-fashioned indoor type of shutters have become popular again. They consist of fixed or movable panels or wood slats or louvers on a framework hinged to the window frame or wall. Most louvers are an inch wide, but plantation shutters have at least 2-inch louvers (Figure 20.22). An architectural wall treatment, shutters serve as a unified part of a wall. Because they are usually in hinged sections, shutters open and close off the windows as desired, providing flexible amounts of privacy and light control. Shutters collect dust, but the wood (pine or oak, normally) is usually stained or painted to seal against soil. Although their initial cost is rather high, they last almost indefinitely. When viewed in terms of life-cycle costing, shutters are actually less expensive than fabric treatments which must be replaced periodically.

20.22 Plantation shutters are appropriate in scale and materal for a large living room with hardwood floors, a copper fireplace,10' black glass screen, honed travertine table, and exotic African and Asian accessories. Roger Scott, architect; Bruce Benning, Allied Member ASID, interior designer. (Photograph: Steve Simmons)

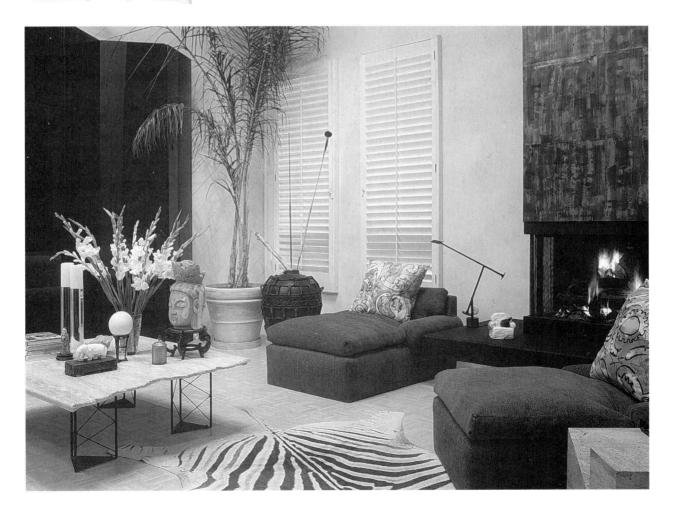

Bare Windows. When window design itself or the outward view is truly striking, any added "treatment" becomes superfluous and could even detract from the effect. Such is the case in Figure 20.23. Sometimes clients and designers make a conscious choice between privacy and openness and opt for the latter. Any curtaining would destroy the drama. In these circumstances, consideration should be given to double and triple paned windows to control heat loss/gain if building codes do not initially require them.

Plants. Plants placed in front of windows filter, but do not shut out, light and also give some degree of privacy. A screen of live plants in a greenhouse window may very nearly block visual communication in and out. Plants are more a

20.23 Stately arched windows at one end of the living room of an ocean-side villa are left bare to flood the interior with light and allow an unfettered view. Robert A.M. Stern Architects. (Photograph: Timothy Hursley)

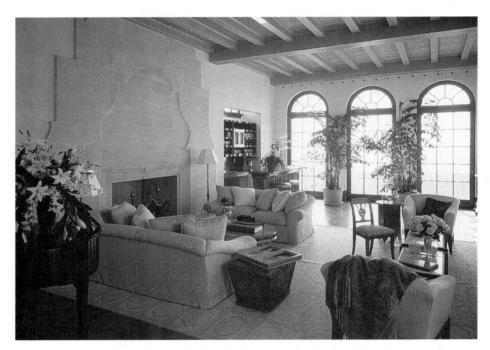

20.24 A solarium filled with plants brings the outdoors into a family room, brightens the interior, and provides fresh, clean air. Dennis Haworth, FASID, interior designer. (Photograph: Steve Simmons)

soft than hard kind of window treatment, but they have been considered here because they leave the glass itself essentially bare.

SOFT TREATMENTS: CURTAINS AND DRAPERIES In addition to flexibly controlling privacy, light, and heat, curtains and draperies soak up noise in proportion to the area they cover, the thickness of the fabric, and the depth of the folds. They make rooms homey and effectively cover up the bareness of those not completely furnished—a point worth remembering. Curtains and draperies can change the apparent size, shape, and character of a room (Figures 20.25 and 20.26), or conceal architectural awkwardness. Small rooms look larger if curtains and draperies blend with and extend the length of the walls; low rooms look higher if draperies go from ceiling to floor. Gloomy rooms seem brighter when cheerful colors or invigorating patterns are used on windows. Walls chopped up with windows or jogs can be unified by generous glass curtains and draperies, and some eyesores can be completely concealed.

Almost any degree of attention can be directed toward windows by the fabrics selected and the way they are hung. Unpatterned materials similar to the wall color, acting as inconspicuous transitions between opaque walls and clear glass, encourage us to look through windows. Moderate color contrasts and patterns direct attention toward windows. Bold or unusual colors and designs usually cause us to look at the draperies rather than the windows. A few definitions will help clarify the terminology of "soft" treatments for windows:

- **Curtains** are usually of lightweight, unlined fabric that filters and diffuses light. Curtains are used either alone or under drapery, hung next to the glass.
- Glass curtains, often called sheers, are of thin, often sheer or semisheer fabrics and hang closest to the glass.

20.25 Heavy silk draperies amply clothe the wall of a renovated New York apartment, adding luxurious softness. Machado-Silvetti, architects. (Photograph: Norman McGrath)

20.26 Coordinated fabric and wall coverings and an elaborately draped window treatment, combined with cafe curtains, establish the character of a comfortable room in which to relax. (Courtesy Warner)

- Sash curtains are a type of glass curtain hung on the window sash. They can be stretched taut between rods at the top and bottom of window sashes or hung in loose folds. They are often used on doors that contain windows.
- **Draw curtains**, usually of translucent or lightweight opaque fabrics, are mounted on *traverse rods* which provide a pulley mechanism that allows the curtain to be drawn or pulled open and closed. In the past, draw curtains were hung between glass curtains and draperies; today they are more often used alone.
- Casement curtains are of open-weave fabric usually more opaque than a sheer or glass curtain. They may be used alone or under drapery and may also be mounted on traverse rods.
- **Draperies** are *any* loosely hung (not stretched) fabric. Thus, the term really includes all curtains. Generally, though, draperies are thought of as heavy, opaque fabrics that can be drawn or that stand idly at the sides of windows purely for decoration. Most draperies should be lined if not used with sheers; they are hung from either stationary or traverse rods. (Drapery is the correct term; drape refers to the way a fabric hangs or the act of draping or arranging it in flowing lines.)
- Cornices are rigid horizontal bands several inches deep placed at the window top (or the ceiling) to conceal curtain tops and the rods from which they hang. Constructed of wood, they are somewhat architectural in feeling and relate window treatment to walls and ceiling. Cornices are often used as part of an energy-efficient window treatment because they are closed at the top, stopping the air flow over the top of the treatment. Upholstered cornices are padded and covered with fabric (Figure 20.27).
- Lambrequins or cantonnieres are similar to cornices but, in addition to the horizontal member across the window top, they have rigid vertical members on

either side of the window. They are very effective in preventing heat loss around windows when used with draperies but they can also be used without curtains or draperies. Lambrequins accent the vertical dimension of the windows and may be full length or short and covered with fabric or painted. Lambrequins have the potential of unifying windows, sometimes altering apparent size, shape, and location when used in conjunction with draperies.

- Valances are made of fabric draped across or covering a rod or shaped form at the tops of the windows. They are allied more closely with the drapery than with the wall and are decorative in nature. Valances are open at the top and do not serve the energy conservation function of cornices. Different styles of valances (festoons or swags and cascades; pelmets; pouf, shirred, or pleated) may help establish the character of various historical periods during which they were popular (Figure 20.28 and Appendix C).
- **Portieres** are curtains or draperies hung in open doorways or arches between interior spaces, often tied back or let down for privacy or insulation. They were frequently used during the Victorian era.

Glass Curtains. Softening and diffusing light, glass curtains temper the hard glitter of window panes and relate them to the rest of the room, as well as giving partial privacy. Thin curtains are used when the view is unattractive or when some privacy is desired during the day. Any fabric that hangs well and withstands sun, washing, or cleaning is suitable. Lightweight, sheer fabrics are most often used.

20.27 Upholstered cornices can take any shape and often repeat shapes found elsewhere in the room. They may be used in conjunction with many other window treatments. (Photograph: Ed Asmus)

20.28 In a Philadelphia house built in 1840, Empire-style swagged valances draw the eye upward and add a crowning touch. Jean-Patrice Courtaud, designer. (Photograph: Robert Levin)

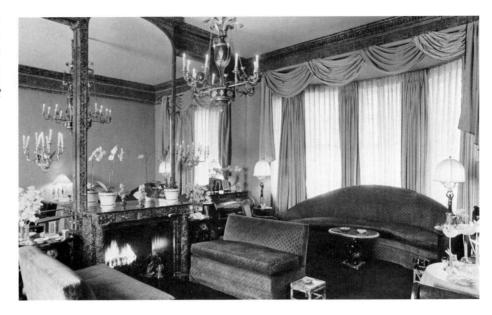

20.29 Sheer curtains soften the light filtering through their diaphanous folds. Pattern, texture, or color affect the light transmitted, in this example, reiterating the leafy texture of the exterior landscape and the lacy bed linens. (Courtesy Waverly)

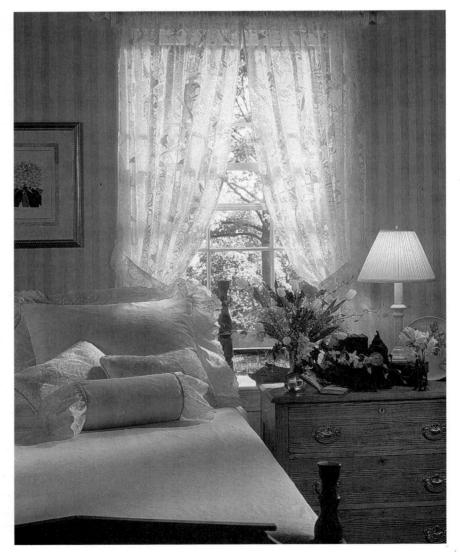

Glass curtains make one somewhat unique visual contribution: They bring light into the room *through* color and pattern. *Color* is especially important, because the light filtering through glass curtains will take on their color, thus tinting the whole room. Also, glass curtains are conspicuous from the outside. Therefore, they are usually a neutral light color and, for exterior harmony, identical or very similar in all rooms. They can, however, be pink or yellow to warm a cool room, or pale green, blue, or lavender to cool a hot one. Although customarily plain, suitable fabrics are available with woven or printed patterns, which are useful in rooms that need interest at the windows without adding heavier draw curtains or draperies. Lace curtains create interesting patterns of light while casements, which are semisheer, add textural interest.

If combined with draperies, glass curtains usually hang inside the window frame, close to it and the glass. Used alone, they can be hung outside the frame and cover two or more grouped windows with a unifying film. Sometimes two or more sets of glass curtains are hung in the **cafe** or **tier** manner to emphasize horizontality or give privacy without always reducing light from the window tops.

Draw Curtains and Draperies. Flexible control of light, temperature, and privacy are the primary functional purposes of curtains and draperies that slide on traverse rods. Often they are used alone, and then they take over all the aesthetic functions of window treatment as well. Draw curtains and draperies differ from glass curtains in that they do not veil the view; they either block or expose it completely.

Fabrics used for draw curtains need sufficient strength, durability, and flexibility to withstand being pulled back and forth and to hang gracefully when stretched or pulled together. The choice of material is wide, ranging from bedding through dress and upholstery fabrics to bamboo and woven wood. (Fabrics to avoid in strong sunlight are described in Chapter 17). Noncellulosic synthetics (nylon, polyester, acrylic, olefin, and saran) and cottons are used far more than other fibers in window treatments.

Appropriateness to the home and its occupants is the primary criterion for *color* and *pattern*. Draw curtains are least noticeable when related to the walls. They become more conspicuous if they repeat or echo the color and character of such large units as furniture or floor, but make emphatic statements when they contrast strongly with the rest of the room. If a variety of colors and patterns are used throughout the house, all curtains and draperies should be lined with the same color to unify their appearance from the exterior. Linings also prevent fading, provide extra insulation, absorb dust coming through the windows, protect from sun deterioration, and add fullness and weight that contribute to the appearance of the curtain or drapery. Insulated and reflective linings provide even greater temperature control.

Color, chiefly color value, is typically the most noticeable quality of curtains; very dark curtains against a light wall (or vice versa) stand out sharply. Scale and character come next: large-scale patterns with vivid contrasts or those that differ from other large areas in the room become dominant. It is a matter of deciding what degree of dominance or subordination, harmony or contrast will be most appropriate.

Draw or **traverse curtains** are almost invariably most effective and serviceable when they hang in straight folds that at least cover all the window frame and begin and stop at sensible points. They fit their setting best when they begin either slightly above the top of the frame (at least 4 inches to conceal the backside of the heading; 6 inches if a *decorator rod*—one which is exposed with the fabric hung beneath—is used) or at the ceiling and when they end at the sill, the apron, or the floor. One-half inch of clearance at the floor reduces dragging and soiling; one-quarter inch at the ceiling is sufficient clearance for treatments which extend to that height. However, some treatments are deliberately "puddled" onto the floor

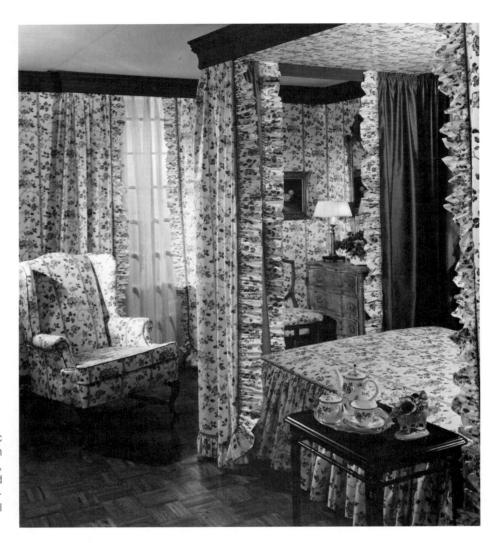

20.30 A glazed cotton fabric with a sprightly naturalistic design has been used as wall covering, chair upholstery, bedspread, and bed and window draperies, turning a bedroom into a delightful bower. (Courtesy Schumacher)

for energy efficiency or aesthetic effect. Stationary treatments are less subject to wear when touching the floor. Usually, longer draw curtains are more pleasing, but sometimes there is a good reason for stopping them short. Also, fuller curtains (from two to three times the width of the space they cover) hang more gracefully. When pulled open, curtains should stack at the side of the window, covering the frame and wall rather than the glass. Stacking space, called the *stackoff*, will lengthen the rod needed by as much as one-third. A partial stackoff leaves some of the treatment in front of the glass, saving expense in extra yardage. Pleating or shirring takes care of fullness at the top and a generous bottom hem, often weighted for a proper hang, helps them drape well. Exposed decorative rods may be used if they contribute to the total design.

Draperies began their life in the heavy textile tapestries that physically and visually warmed the cold stone walls of medieval homes and then migrated from the walls to beds and windows. Today they are still found at windows, and sometimes on four-poster beds or secluding a bed alcove. Occasionally they serve as wall hangings. Draperies differ from draw curtains only in that they tend to be heavier and do not necessarily pull across the opening they guard. They often have a valance, either tailored or draped, and sometimes are tied back, evoking an earlier, more romantic era.

Measuring and Estimating. To compute a rough estimate of the fabric yardage needed for soft window treatments, first measure the width of the window in inches, including any wall space to be covered. Multiply this figure by 2 or 3 to provide adequate fullness (the lighter-weight the fabric, the fuller it should be; unless very heavy, multiply by 3). Divide by the width of the fabric that is to be used and round the answer to the next larger whole number. (Common widths of drapery fabric are 45 and 50 inches.) The result is the number of panels of fabric needed.

Next, measure the height of the window in inches, including the wall space above and below that will be covered. Add 16 to 18 inches to allow for generous hems (a double 4-inch heading at the top and a double 4-inch hem for weight at the bottom).

The yardage required for the window is the product of the number of panels needed multiplied by the total length needed. Divide by 36 to convert inches to yards. (For step-by-step instructions and a sample problem/solution, see Appendix D.)

If the fabric chosen is patterned, divide the total length by the vertical repeat dimension and round the answer to the next highest whole number if a fraction results. This yields the number of pattern repeats in a panel. Multiply the number of repeats by the size of one motif to obtain the total length for one panel. The correct number of repeats is more important than the exact yardage because repeats must be precisely matched across all panels of the drapery.

Specific types of treatment chosen will alter methods of measurement considerably; this is meant to be a *general* guide for pleated or shirred treatments.

20.31 Draperies may play an important aesthetic role in a room in addition to their functional purpose. The fabric, length, and style chosen determine whether the window will be a dominant visual element or one of unassuming subordinance. In this unique London master bedroom, full-length draperies, casually puddled on the floor, emphasize height and visually unify the walls, with the post office trollevbed, placed in the center of the maple floor. CZWG Architects, London. (Photograph: Tim Street-Porter)

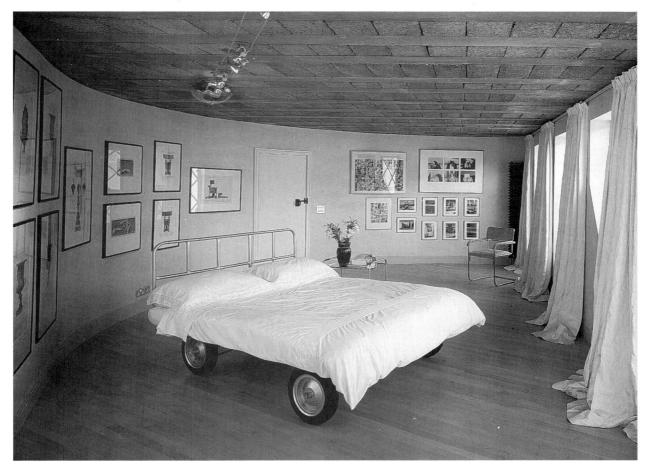

HARDWARE, TRIMMINGS, AND INSTALLATION A variety of hinges, handles, pulls, tracks, curtain and traverse rods—whether concealed or exposed and decorative—and tieback holders comprise the hardware utilized to hang or install both hard and soft window treatments. The designer must be knowledgeable of the hardware appropriate to the functioning of each treatment. Hardware, when exposed, can also bring additional character to window treatments.

Trimmings are added to fabric treatments for decorative enrichment. Braid or gimp, fringe, tassels, even beads are called *passementerie*. Other trimmings include ruffles, piping or welting, and banding. Most trimmings are available in a diversity of manufactured styles, but many may also be custom-fabricated by the drapery workroom. Also, many gift items and ornaments can be used in creative ways.

The installation of window treatments plays a critical role in the professional quality of the finished product. The designer must understand the installation process in order to select the correct hardware and, in some cases, even an appropriate treatment. It is also important in communicating with the installer and checking on the quality of his workmanship. Professional installers should always be used; they will have the proper tools, be mindful of the client's furnishings, and clean up after themselves when the job is completed.

A major element of the architectural shell, windows have gone through many developmental phases, from a slit in the wall to becoming the wall itself. Each stage has brought with it the need for window "treatment," modifications that will make this hole in the wall comfortable as well as appealing. Many such modifications—shutters, curtains, and the like—can be dispensed with if the building has been well designed or if the location, size, shape, and type of windows make them unnecessary. The design factor has become even more important as we have entered an era where we can no longer depend entirely on artificial means of lighting, heating, and cooling our homes. Here we have another example of the great need to think about *all* factors in advance of construction and to solve as many problems as possible architecturally.

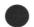

DOORS

Doorways allow us and our vision (as well as light, sounds, smells, breezes, warmth, and cold) to travel in and out of the home and from one room to another. Doors control this travel in varying degrees depending on their location, design, and material. Contemporary doors run the gamut from stout, opaque barriers of wood or metal that shut everything in or out, through sheets of translucent glass or plastic, to transparent glass. Folding doors of wood, bamboo, or fabrics offer additional possibilities. Further, doors can be designed so that only part of them opens, such as Dutch or barn doors, in which the top can be open but the bottom closed. The sliding shoji panels—at once walls and doors—of traditional Japanese houses allow a flexibility in design that has had a marked influence on contemporary American architecture.

In rented quarters or in a home already built, less can be done about doors than about windows, but the following are possibilities:

- Remove unneeded doors to create greater openness.
- Seal up or cover doors that are unnecessary for traffic.
- Refinish doors and their frames so that they blend with the walls.
- Paint some or all doors in contrasting colors so that they become dominant features
- Change older doors that lack character for newer ones, perhaps with glass or panels, which may be more appealing.

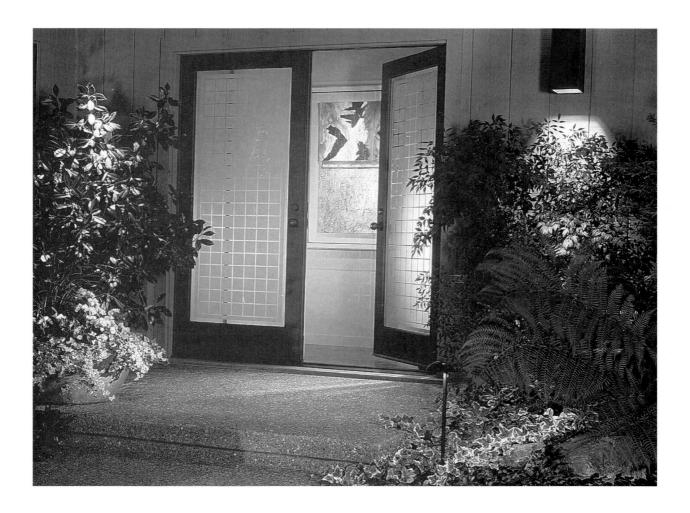

TYPES

As with windows, doors can swing or slide; they, however, can also fold. The architectural symbols that represent the various types of doors are illustrated in Appendix A.

Swinging Doors. By far the most common type, swinging doors are hinged at one side, like casement windows. They are widely used because they are easy to operate, have simple hardware, can be made to close automatically with closing devices, and lend themselves to effective weatherproofing, soundproofing, and burglar proofing. Their major disadvantage is that the arc through which they swing must be left free of furniture. Dutch doors are divided in half so that the top or bottom half can be opened independently; French doors are a pair of wood-framed doors with glass panels.

Sliding Doors. Sliding doors need not take otherwise usable room or wall space when opened and can disappear completely to give a great sense of openness. They do, of course, have to go someplace, often into a wall (pocket doors). Or they can slide in front of a wall, which is often done when door and wall are of glass. Although sliding doors can be suspended entirely from overhead tracks, they usually perform better if they also slide along tracks in the floor (which are hard-to-clean dirt-catchers). On the debit side, the movements required to open and close them are not as easy to make as for swinging doors, and there is no inexpensive way to make a sliding door, especially a screen door, close itself. Exterior sliding doors present problems in both security and insulation. Many sliding

20.32 French doors with the glass sandblasted in a grid pattern create an interesting entrance to a contemporary home in the San Francisco Bay area. Werner Design Associates, interior designers. (Photograph: David Livingston)

doors do not glide as quietly or smoothly as one would wish, and the backs cannot have narrow shelves or hooks, which are especially convenient on closet doors. The fact that they can be much wider than swinging doors emphasizes horizontality and spaciousness. Sliding doors in multiple sections are often used to pro-

vide flexibility to convention or meeting rooms.

Folding Doors. Sliding along tracks, usually at the top, folding doors open and close like an accordion. They take little space when collapsed and come in diverse colors and textures. In general, they are not as soundproof as other types, but they are excellent for those situations in which one wants to be able to open or close a large opening inexpensively. *Bifold* doors are sometimes used for closets because, when opened, they allow full access to interior contents without taking up much floor space.

Fire-Rated Doors. Although residential structures are less regulated than public buildings, the designer should be aware that specially constructed walls, floors, ceilings, and doors help slow the spread of fire. Doors and other materials are given a fire rating of one or more hours, depending upon the length of time they can contain a fire, thus allowing occupants to escape. The National Fire Protection Association (NFPA), building codes, and other standards govern these safety features. Solid-core and hollow-core doors covered with metal or hollow metal doors are the most fire-resistant.

FUNCTIONAL ASPECTS

Because doors and windows have so many points in common, almost everything said about locating windows applies to doors, but there are two important differences. Doors govern traffic paths, and they are often opaque, blocking any view beyond.

Traffic paths, like highways, are usually best when short and direct and when they disturb areas for work or quiet relaxation as little as possible. From this point of view a room should have as few doors as is feasible, with necessary ones kept

close together if other factors permit, as outlined in Chapter 8.

Furniture arrangement is in part determined by the location of doors, because a traffic path should be left between each pair of doors, and space must be allowed for those that swing. Major furniture groupings should be located away from main entrances and exits but should have two or three access paths into them.

Privacy is controlled by door location and material. In a bedroom, for example, a well-placed door, even when open, should not bring the bed or dressing area into full view. Doors between cooking and dining areas function best when they do not direct attention toward the major kitchen work areas. Opaque materials are typically used where view is nonexistent and privacy always needed. At the entrance, an opaque door ensures maximum privacy and provides greater security. Installing a peephole allows occupants to see out without visitors seeing in. Translucent materials serve well where there is neither view nor the need for absolute privacy. Transparent materials allow two-way vision.

Light can come through doors as well as windows, and transparent doors are frequently combined with windows as a means to architectural unity. Glass doors give a special pleasure in that they permit one both to *look* out and to *go* out. Sidelights and transom windows are often used beside and above doors to admit light

and permit vision even when the door itself is opaque.

Ventilation can be accomplished quickly by opening doors, especially in opposite walls. There is nothing like opening doors to "air out the house," but ordinary doors are not suited to gentle, controlled venting. In Mediterranean countries, a heavy fabric is hung outside the doorway as a sunscreen and the door

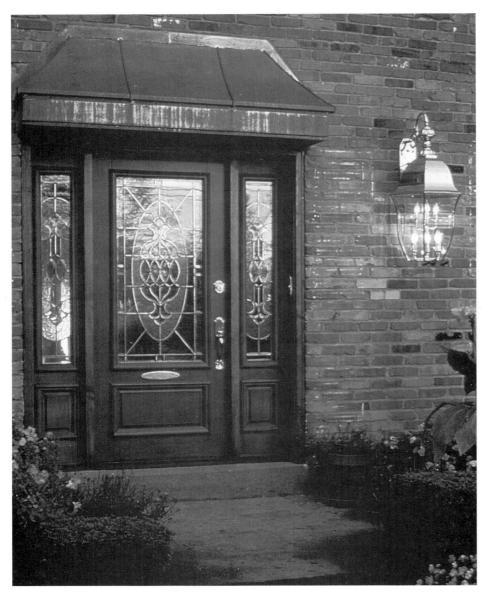

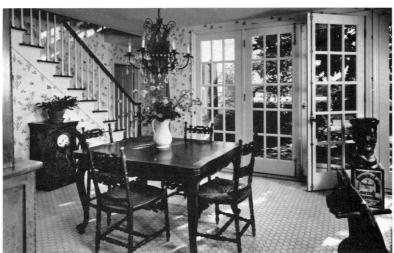

20.33 The interest in old doors with character has led many companies to provide new versions of traditional doors and windows, such as this one with wood panels, leaded glass, and brass hardware. (Courtesy Peachtree Vintage Insulated Entry Doors)

20.34 Traditional French doors, combined with matching windows on either side, create a bright, cheerful space for dining in a country garden atmosphere. Snezana Grosfeld of Litchfield-Grosfeld, architect. (Photograph: Norman McGrath)

is left open for ventilation. Screen doors allow the luxury of cool breezes without the nuisance of insects.

Heat or cold coming through light-transmitting doors has the same characteristics as that coming through windows, and thus the same comments apply. Opaque exterior doors stand somewhere between windows and walls: They do an adequate job of climate control if well weatherproofed and concentrated on the side away from winter winds. Exterior doors must be of solid core construction. Storm doors and two sets of doors, as in the air chamber entry, also help conserve heat.

Cleaning a glass door is like cleaning a window, except that finger marks are more frequent, and it is easier to get at both sides. Opaque doors, too, get their full share of finger marks, particularly around handles. Metal or plastic plates help a little and offer a logical place for ornament. Kick plates may also be used, particularly to protect swinging doors.

Curtaining for glass doors is usually accomplished with draw curtains or vertical blinds that can cover or expose the entire area of glass. The best solution locates glass doors where they need never be curtained, but this is not always easy. Sash curtains are sometimes used on doors with glass panels, especially French doors. Attached pleated shades are very simple, effective, and easy to raise up out of the way.

DESIGN

Doors are often as visually simple as possible. This style includes plain wood doors in which plywood sheathes a strong but light core, as well as doors of metal, glass, or plastic framed unobtrusively with metal, plastic, or wood. Many units that are little more than sheets of glass function as both windows and doors, calling attention not to themselves but to what they reveal. Thus, large transparent doors should be made from safety glass and must be so designed or marked that a closed door is obvious from both sides. Folding doors with louvers or fabric-covered frames and mirrored doors provide visual interest with their textures, patterns, and reflections.

Paralleling this taste for simplicity is the concept of doors as accents. Even without unusual shape, size, or scale a door can serve as a point of emphasis and visual enrichment in the home. French doors composed of fairly small rectangular panels of glass have returned to popularity. The classic wood-paneled door seems just as comfortable in many contemporary homes as it did in the nineteenth-century manor house, and salvage companies do a thriving business in selling old doors to be recycled for new applications. Hardware adds additional visual and tactile elements that give character as well as serve a function. Hinges, handles, pulls, backplates, and knockers are available in a wide range of materials, designs, and finishes.

Location and design of windows and doors are fundamentals in home planning. In many historic houses these elements gave designers and craftsmen a unique opportunity to use their inventiveness in enriching interiors and exteriors. This principle still applies today.

REFERENCES FOR FURTHER READING

Baillie, Sheila, and Mabel R. Skjelver. Graphics for Interior Space. Lincoln: University of Nebraska Press, 1979, pp. 164–165.

Bedell, Ben. Wrapping Up Windows. Interiors, September 1979, pp. 107-108, 128.

Breskend, Jean Spiro. New Windows and Doors Are Energy Savers. *House and Garden*, September 1981, pp. 74–78.

Energy-Saving Shades. Better Homes and Gardens, November 1981, p. 104.

Helsel, Marjorie B. (ed.). The Interior Designer's Drapery Sketchfile. New York: Watson-Guptill, 1969.

Ingersoll, John H. (ed.). Windows: Return to Romantic. *House Beautiful*, September 1982, pp. 51–73.

Marks, Charles, and Jack Whedbee. *Drapery Manual, A Designer's Guide to Decorative Window Treatments*, 2nd ed. Augusta, Ga.: Carole Fabrics, 1978.

Nielson, Karla J. Window Treatments. New York: Van Nostrand Reinhold, 1990.

Nolan, William L. Bump-Outs: Bonus Space for Less. *Better Homes and Gardens*, September 1982, pp. 68–71.

Oddo, Sandra. Energy Answers: How to Save Energy with Window Insulation. *House and Garden*, February 1981, pp. 86–88.

Riggs, J. Rosemary. *Materials and Components of Interior Design*. Reston, Va.: Reston Publishing Company, Inc., 1985, chap. 5.

Selecting Windows. University of Illinois at Urbana–Champaign: Small Homes Council-Building Research Council, Circular F11.1, rev. 1984.

Speaking of Windows. University of Illinois at Urbana-Champaign: Small Homes Council-Building Research Council, TN #16, 1984.

Viladas, Pilar. Through a Glass, Brightly. *Progressive Architecture*, November 1981, pp. 138–143.

Whiton, Sherrill. *Interior Design and Decoration*, 4th ed. Philadelphia: Lippincott, 1974, pp. 568–585.

Urbana-Champaign: Small Homes Council-Building Research Council, Circular F11.0, rev. 1984.

Yaeger, Jan. Textiles for Residential and Commercial Interiors. New York: Harper & Row, Publishers, 1988, chaps. 17–21.

Lighting

NATURAL LIGHT ARTIFICIAL LIGHTING

Sources
Types and Uses
Technical Factors
Psychological Aspects
Lighting Fixtures
Economic Aspects
Lighting Specific Areas and Activities

The definition and character of objects and spaces is largely determined by the kind of lighting that makes them visible to us. Strong contrasts of light and dark result when an object is illuminated by small, sharp light sources, less contrast when the light source is broad and diffuse, and almost no contrast when an object is evenly lighted from all sides. When small beams light an object, it will cast hard, sharp, dark shadows; and light coming from more than one direction will cause an object's shadows to be multiple and overlapping. The shape and form of objects and spaces can be emphasized, subordinated, or changed completely in appearance according to the strength, placement, and direction of the light source.

Light is a vital element of design and building that affects not only our perception but also our response to the environment. Contrasts of brightness and darkness can create drama and emphasis but may cause eyestrain; uniform lighting is good for many kinds of work but may be monotonous if used throughout a room. Bright light can be stimulating, low levels of illumination quieting. Warm-colored light tends to be cheerful, cooler light more restful. Working with lighting, the interior designer can influence the mood and atmosphere as well as the aesthetics of a space while providing functional illumination for the activities that will take place there.

Control of the luminous environment divides into two categories: natural daylight and artificial illumination.

NATURAL LIGHT

The sun is, of course, our primary source of natural light. It represents wakefulness and warmth, and is vital to the health of the human organism, both as our principal source of vitamin D and of **full spectrum light**. Sunlight contains all visible wavelengths of radiant energy plus invisible infrared (felt as heat) and ultraviolet wavelengths at either end of the band. Current research indicates that a wide variety of health problems may result from lack of full spectrum light and the absence of ultraviolet light in some artificial light sources.

Both energy costs and health concerns have led to renewed interest in natural lighting. The direct radiant energy of the sun, daylight, is a determining factor in the design of homes, especially when large wall areas have been devoted to glass to capture solar heat, light, or a view. Large window areas provide more even, glareless light distribution than small windows oriented toward bright sunlight. However, strong light emanating from a single side of a room creates harsh shadows if not balanced by light from other directions, and may blank out the faces of people or the details of objects facing into the room. To distribute light more evenly throughout the space, careful window design and placement are important. Although discussed in Chapter 20, some reiteration is warranted. More light reflection throughout a room with less glare is gained from windows located high in the wall than from those in lower positions. At the same time, high windows do not sacrifice wall space or privacy. Natural light can be admitted to interior rooms and private spaces perhaps otherwise inaccessible when clerestory windows, skylights, and inner courtyards or atriums are planned. Room size and shape should be designed so that no floor area is more than one and one half times the ceiling height away from the window wall. Glass partitions between inner spaces, light reflective colors (especially on walls opposite windows), and mirrors all increase the availability of natural lighting as well.

In many cases, the designer's task is not to maximize the effects of natural lighting but to modify, regulate, and redirect or otherwise control it. Direct sunlight can produce discomfort: too much heat or glare because of excessive contrast with an otherwise dim interior. It can also cause fabrics to deteriorate and colors

21.1 Before and after photographs of a 1930s shingled cottage transformed into a more high-style vacation home on the New England coast clearly illustrate the effect of window size and placement. Charles A. Farrel-/Shortand Ford, architect. (below left) Originally the living room was dark and restricted, and the second floor contained undefined loft space. The single small window in the west-facing door was a source of glare. (Photograph: Charles A. Farrell) (below, right). The renovation extended the west wall of the living room into an existing porch and removed the second floor, extending the space up to the existing roof structure. The new light-filled room has more even natural light with less glare. (Photograph: © Sam Sweezy)

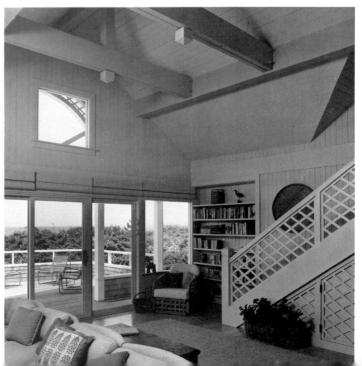

21.2 A second-story room, open to the living space below, gains light and a view from an unusual skylight and a window placed high on the opposite wall. William Turnbull, Jr., FAIA, architect. (Photograph: David Livington)

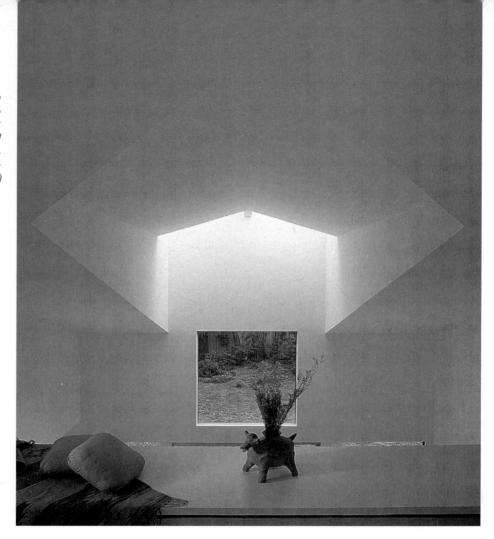

to fade. (Many ways to temper and diffuse natural lighting entering the home were examined in detail in Chapter 20.)

Natural light is a calendar of passing time; its qualities change throughout the day and are affected by the direction from which it is admitted into the home. North light is cool and steady, with few shifting shadows, making it desirable for artists' studios and workrooms. Its revealing harshness may be mellowed with warm colors. East light signals the first approach of a new day with light that is initially tinged with reddish orange like a pale sunrise. It then progresses from bright to neutral as the day continues. It may be cheery, warm, and desirable to early risers in the household, while others may want to block its admittance. South light seems warm and constantly shifts direction throughout the day. It may need to be tempered, especially during the summer months. Its flat brightness may be counteracted with cool colors, and deciduous trees help diffuse the light and reduce heat gain in summer. West light may be very warm and rich, particularly in the late afternoon, making control necessary from the exterior (trees, shrubs, awnings, or trellises) or the interior (blinds, curtains, shades, or shutters), or the glass itself may be tinted to filter the light. Cool colors in the interior will help also.

Figure 21.3 shows one way in which natural light can be brought into a house without overwhelming it. Located near the beach, where glare can be a problem one day and fog the next, the house has been sited among trees that temper but do not obstruct the ample light coming through large windows and skylights. Another kind of natural light, that from burning logs, flickers in the fireplace.

21.3 (facing page) Skylights extending a wall of glass bring the warmth and joy of sunlight deep into the living room of a house built on a wooded slope. Although the room faces south, the surrounding trees protect it from too much sun. Smith and Larsen, architects. (Photograph © Morley Baer)

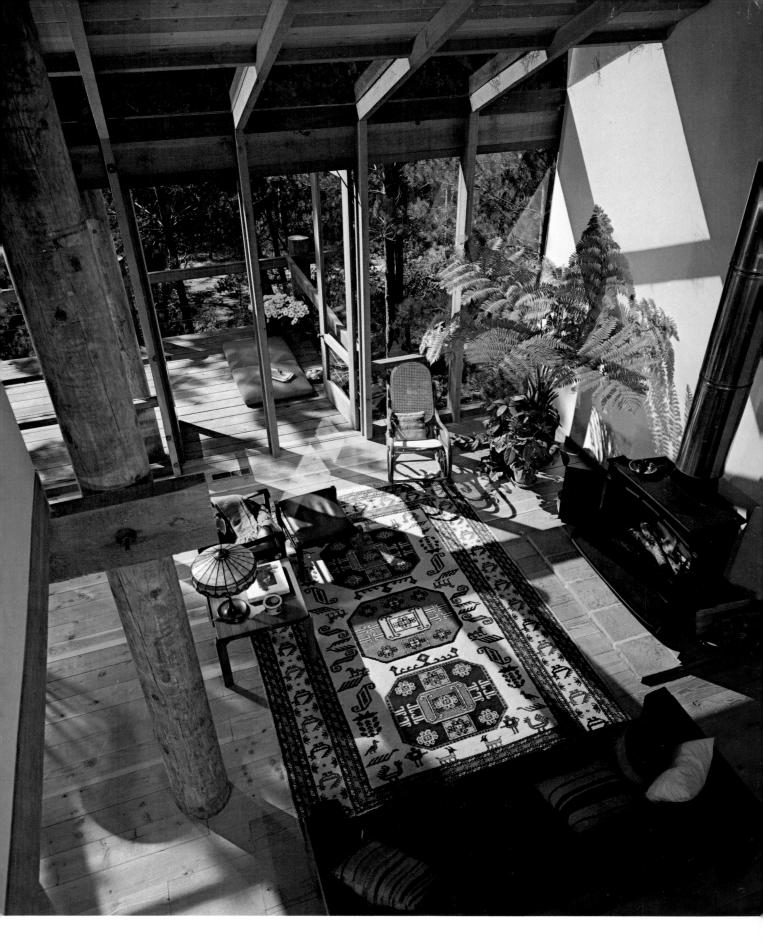

For untold ages people depended on the flames of fireplaces, candles, or lamps to illuminate their homes at night. Today we seldom limit ourselves to light from combustion, except occasionally from candles and fireplaces indoors, barbecues and torches outdoors. Although inefficient, all give a warm, flickering, flattering light that seems hospitable, even festive, and draws us into its embracing circle.

ARTIFICIAL LIGHTING

Well-planned artificial illumination enables us to see without strain and helps prevent accidents. Above all, it makes a vital contribution to the aesthetic quality of

21.4 Varied levels of indoor lighting can change the mood of a room dramatically Marlene Rothkin Vine and David Vine, designers. (Photographs: David Vine) (right) Natural daylight streams in through windows and a skylight for an overall cheerful effect. (below left) General artificial illumination brightens every corner of the room to produce a mood suitable for group entertainment. (below right) Subdued night lighting from lamps and the fireplace creates intimate "pockets" of light while leaving the corners in shadows.

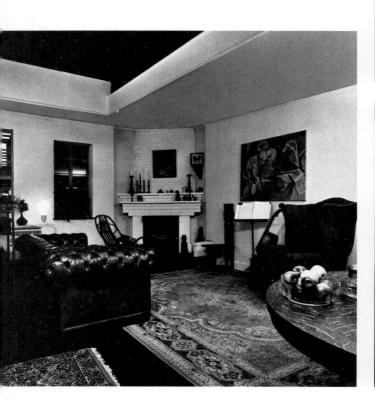

537

interiors. At night, much of a room's character is determined by its illumination. Even more than color, varying light can make rooms seem to shrink or expand, become intimate or formal. Important objects can be spotlighted, those of lesser interest deemphasized. And with the equipment available today, all this can be changed instantly by flicking switches, turning dimmers, or programming a computer. When planned in relation to architecture, furnishings, and people, lighting can do far more than merely enable us to see. It is one of the most versatile aspects of interior design and powerfully affects us, both physiologically and psychologically.

In lighting homes, designers can learn much from theaters, aquariums, museums, stores, factories, and restaurants. Theaters have long exploited lighting as a vital part of dramatic production. Houselights lower, footlights come on as the curtains part, and from then on lights of all colors, brightnesses, degrees of sharpness, and diffusion focus attention where it is wanted and underscore the mood of the play. Aquariums concentrate light on the fish, leaving spectators just enough lighting to let them see around, a practice sometimes also followed in museums to rivet attention on a few things. At the opposite extreme are factories and laboratories, traditionally flooded with bright illumination to benefit production. Offices today locate lighting at each work station with less general illumination throughout, as a result of research regarding visual fatigue and strain. Restaurant lighting ranges from floodlighted lunchrooms to elegant formal dining rooms with discrete table lighting and dramatic, sparkling accents to dark caverns with a candle on each table.

The source of energy for artificial illumination is electricity, which must be changed into another form of energy—visible light. The rate of change is expressed as **wattage**, the amount of power delivered to an electric light fixture or an appliance as a result of **volts** (pressure or potential energy available) times **amps** (rate of flow of electric current). The standard supply of energy for home lighting is 120 volts. The total wattage, or power, consumed by a group of appliances and/or light fixtures cannot exceed volts times amps without blowing a fuse or tripping a circuit breaker, which, as a safety measure, stops the excessive flow of electricity.

SOURCES

Lamps (or light bulbs, as they are commonly called) are available in a wide range of types, sizes, colors, and shapes designed for an equal variety of purposes and effects. Selection may be made based upon energy consumption, efficiency, length of life/hours of expected service, quantity of light produced, or its qualities—color, shape, brightness, and functional, decorative, or psychological effects. The method of producing the light itself also varies.

(*Note added in proof:*) The national Energy Policy Act of 1992 sets mandatory energy efficiency standards for lamps and fixtures. This legislation makes obsolete certian lamps now commonly used, including all R lamps (reflector lamps, including ER and PAR spot and flood lights) of 40 watts or larger and the following fluorescent lamps: 4-foot straight and 2-foot U-shaped lamps at or above 28 watts, and all rapid start 8-foot high-output lamps and 8-foot instant start lamps over 52 watts. Manufacture of new lamps in these categories has ceased; remaining stock is still available at this printing. Most existing incandescent recessed light fixtures will have to be retrofitted with more energy efficient lamps such as MR-16s and CFLs (compact fluorescents). New lighting installations should not specify lamps that do not meet new standards.

21.5 Incandescent lamps are avalible in many sizes and shapes for a variety of uses.

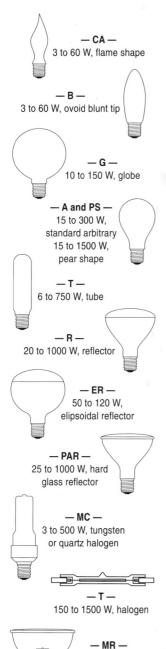

20 to 75 W. low

voltage halogen

INCANDESCENT SOURCES Incandescent light is produced by heating any material (but usually metal) to a temperature at which it glows. Typical incandescent lamps have a tungsten filament in a sealed glass bulb. These lamps are available in many varieties and offer several advantages:

- Fixtures and lamps are less expensive than other types.
- There is no flicker or hum and less likelihood of interference with radio or television reception.
- Textures and forms are emphasized because the light comes from a relatively small "point" source.
- The light is warm in color and flattering to skin tones.
- Control over quantity is made easy by the great variety of wattages available and by the use of dimmer switches.

The **tungsten filament lamp** has been the most common source of light for residential interiors since it was first produced at the beginning of the twentieth century. However, it has several disadvantages:

- It has a low *efficacy* or efficiency in terms of producing light in relation to the amount of energy consumed (approximately 20 lumens per watt). Efficacy also declines over the life of standard incandescent lamps. Low-wattage lamps are less efficient than those of higher wattages.
- A considerable amount of heat is generated at the same time light is produced.
- The warm-colored light grays cool colors.
- Lamps have a short life expectancy (750–1000 hours). "Long-life" lamps last up to 2500 hours but at the cost of much lower efficacy.
- Exposed lamps can be an uncomfortable source of glare.

There are many classes of incandescent lamps designed for specific uses and features. A few warrant mentioning. The **standard**, most-used are the **A** and **PS** shapes (arbitrary and pear-shape). There are also a variety of **decorative** shapes: **G** (globe), **C** (conical), **T** (tubular), **F** (flame). These letters are used to identify and order lamps. Sizes are indicated by diameter, in eighths of an inch; a T-10 lamp is a 1½-inch-diameter tubular lamp. When specifying and ordering lamps, designers use the letter-number designation that manufacturers use in their product catalog.

Reflector lamps have built-in reflectors. There are two types: the **R** (reflector) lamp is less expensive and lighter in weight than the **PAR** (parabolic aluminized reflector), which can be more accurately focused as a spotlight because of its lens. Either can supply flood light. PAR lamps can be used outdoors.

Multiple-filament or three-way lamps have the built-in flexibility of three light intensities. They contain two filaments; either or both can be burned at one time for varied levels of light without the need for a dimmer switch.

Low-voltage lamps are designed to operate at 6 to 75 volts rather than at the standard 120 V. The most popular ones operate at either 6 or 12 volts. They require a transformer to step down standard voltage. Low-voltage PAR lamps are very small and can project a brilliant, precise *pin spot* of light a great distance without "spilling" onto surrounding surfaces. They are excellent where space is limited and for highlighting special accessories. Low-voltage lamps also generate less heat than standard sources.

Tungsten-halogen lamps produce up to 20 percent more light than standard lamps because the halogen gases inside regenerate the filament and keep the lamp clean. The bulb is less blackened over time and the lamp has a longer life. They can also be quite small because the very hard, often quartz, glass used for the bulb will not crack when placed close to the hot filament. They are made in bulb, tube, and reflector shapes which require protective shielding because of high operating

temperatures. They also require a specially designed fixture and are not interchangeable with standard lamps.

ELECTRIC DISCHARGE SOURCES The family of electric or gaseous discharge lamps produce light by passing an electric current or arc through a gas vapor sealed inside a glass tube or bulb. They are filled with different gases, some kept at low pressure and others at high pressure. The spectral distribution of electric discharge lamps tends to be uneven or discontinuous, which affects their ability to produce certain reflected colors and may be detrimental to good health unless balanced with other continuous-spectrum light sources. All of these lamps require that a *ballast* be installed between the power line and the lamp to regulate the amount of electric current used in their operation and provide the proper starting voltage. Some lamps have an integral ballast, doing away with the necessity of a bulky separate ballast and boxy metal housing. The entire assembly can then be easily replaced. The light produced by electric discharge lamps is "cold" or *luminescent* (not produced by heat).

Low-Pressure Electric Discharge Lamps. Fluorescent lamps, introduced in 1939, are the most commonly used luminescent light source in homes. The glass tube is filled with vaporized mercury and argon under low pressure. When electric current activates the gases, invisible ultraviolet light rays are produced. The inside of the tube is coated with phosphors that "fluoresce" or transform the ultraviolet rays into visible light. Although fluorescent lamps vary less in size, shape, and wattage than do incandescent lamps, they have a considerable diversity. The most commonly used are the T-12 lamps—tubular, approximately 1½ inches in diameter, ranging in length from 2 to 8 feet with the 2- and 4-foot lengths most used in homes. (The longer tubes are more efficient.) The newest design is a low-wattage, self-ballasted compact fluorescent with a screw socket that can be used as a replacement for an incandescent lamp. These are some significant advantages to fluorescent lighting:

- Tubes last ten to fifteen times longer than incandescent lamps (three to six years) and produce about four times as much light per watt (60 to 80 lumens), conserving energy.
- Almost no heat is produced.
- The light source is considerably larger (*linear* when used singly, *planar* in multiples), which spreads the light more and produces less glare.

The *deluxe* colors (cool white deluxe and warm white deluxe) are more spectrally balanced than other colors. The color of the light is controlled by the chemical mix of the phosphors coating the tube. Deluxe colors are also warmer in tone, with warm white deluxe being closest to incandescent light. Although they have a lower efficacy, their better *color rendition* makes them desirable. *Full spectrum* lamps that approximate sunlight are also available. These lamps are desirable where people spend many hours away from the healthful benefits of sunlight. Their color rendition is much better than the deluxe colors.

Fluorescent lamps are classified by one of three starting methods. *Preheat* lamps are the oldest types; they are the slowest to start. *Instant-start* lamps are the quickest; they start without any delay, but are slightly more expensive to operate. The most recently developed and the most widely used type is the *rapid-start* lamp. It is a compromise in starting speed but uses a smaller, more efficient ballast than a comparable instant-start lamp and is the only fluorescent lamp that can be electrically dimmed.

The following are some of the disadvantages of fluorescent light:

Efficacy declines about 10 percent over the life of the tube.

21.6 Although avalible in less variety than incandescents, fluorescent and high intensity discharge lamps are more energy efficient.

FLUORESCENT T — 4 to 75 W, tubular U — 5 to 40 W FC — 6 to 27 W, circline

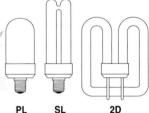

5 to 38 W, compact fluorescents

HIGH INTENSITY DISCHARGE

Types:

Mercury vapor, 40 to 1500 W (250 and 400 W most common)

Metal halide, 50 to 1500 W (compact 50 to 400 W)

High pressure sodium, 50 to 1000 W

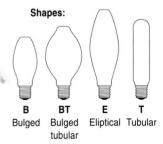

- Lamps may flicker and/or hum, particularly near the end of their lifespan or if the ballast is deficient.
- The cool colors are not complimentary to skin tones.
- The flat, diffuse light can be monotonous and tiring.
- The spectrally deficient lamps can cause health problems if they are the sole source of light.
- Ballasts are required and they generate heat.
- Dimmers are expensive and limited to one type of lamp.

Neon lamps (an incorrect but popular name for **cold cathode** lamps) are another kind of low-pressure electric discharge lamp. Neon itself, as the gas inside the tube, produces red light. Other colors often referred to as neon are actually produced by other gases within the tube and different phosphors used to coat the tube, or even by painted or colored-glass tubing. Neon lamps are used primarily as decorative lighting and are often custom-designed (Figure 21.7). The thin tubing is easily bent into interesting shapes and may be mounted on walls or ceilings, or installed behind coves, baseboards, or anywhere lighting that follows the contour of a structure is desired. Cold cathode lights have a very long life, are low energy consumers, and can be dimmed and flashed; they, however, are quite fragile, require a large ballast, are expensive to replace, and often buzz.

High-Intensity Discharge (HID) Lamps. High-pressure electric discharge lamps are commonly available in three types, each with different characteristics, depending upon the gas vapor inside and the phosphor coating. In general, their advantages include

- high efficacy (up to twice the output of fluorescents, ten times that of incandescents);
- long life (15,000 to 24,000 hours); and
- lamp shape similar to incandescents (slightly larger).

HID lamps have been used primarily for industrial applications and outdoor lighting because of their poor color rendition (due to a discontinuous spectral composition), but new developments are improving them rapidly and they are now being used in interiors. Their traditional drawbacks have been

- lack of a well-balanced spectral distribution of light, resulting in both health and color-perception problems;
- noisier ballasts than fluorescent lamps;
- sensitivity to current variations (they shut down when the flow of electricity to them varies);
- slow start-up time (up to 9 minutes) and dimming response; and
- intense glare and uneven light patterns.

One of the first HIDs developed was the **mercury vapor** lamp. Its blue-green color is vastly improved with a phosphor coating. It is inexpensive, has a high efficacy, and the longest life of any lamp. **Metal halide** lamps offer better color rendition, higher light output, and smaller size for more precise control compared to mercury vapor lamps. However, they also have a shorter life with more decrease in light output over their lifetime, and they produce a bluish-white light that varies in hue from lamp to lamp. The newest HID is the **high-pressure sodium (HPS)** lamp, which is very efficient and provides excellent optical control because it is very thin. Its drawbacks include a shorter life than other HIDs and a discontinuous spectrum light output. However, one new HPS lamp produces a feeling similar to incandescence. HID lamps are often installed in uplight fixtures for indirect general lighting, and in portable lamps. Other lamps, including a **metal chloride** source that produces a more even spectrum, are being developed.

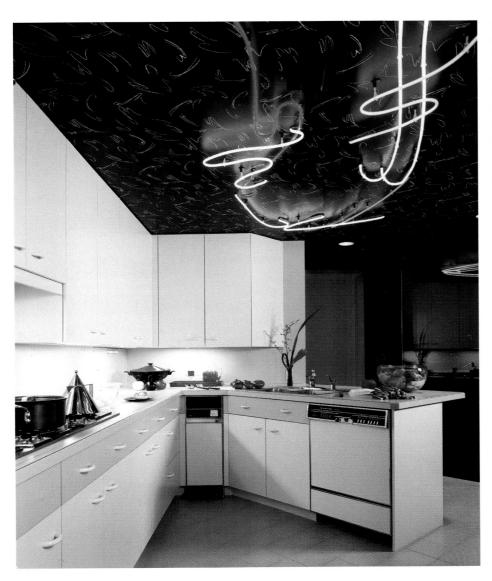

21.7 Neon lamps are frequently used in non-residential design because they can be customized to suit the theme or character of a space. The same feature makes them applicable to residential spaces. Neon provides accent on the kitchen ceiling in a Houston, Texas, highrise condominium. Ray Zukatis, architect; Marlis Tokerud, ASID, interior designer. (Photograph: Peter Paige)

TYPES AND USES

In terms of purpose and effect, there are three major types of artificial lighting.

AMBIENT/GENERAL LIGHTING Ambient lighting, or general lighting, illuminates a room more or less uniformly, as the sun illumines the earth. It lets us see every corner of a room in a safe, reassuring way and brings to equal attention the design and color of the whole space. At best, it minimizes the bulkiness of furniture, the darkness of shadows, and the often harsh contrasts of local lighting. General lighting very often emanates from ceiling fixtures or from lamps having reflector bowls and translucent shades. It is more truly general when lights concealed in coves evenly illuminate the ceiling or when troughs "wash" large wall areas or curtained windows with light. Finally, the entire ceiling or large sections of

21.8 Recessed ceiling fixtures provide direct general illumination. Hank Bruce, architect. (Photograph: Philip L. Molten)

it can bring light through translucent plastics or glass. It is low-level background lighting, unobtrusive and restful, and often contributes to a sense of space.

General lighting can be either **direct** (with light shining downward full on objects to be illuminated) or **indirect** (when light is thrown against a surface, usually the ceiling, from which much of it is reflected into the room). For general illumination, indirect light usually produces a softer effect than direct light, but it costs more to install and operate and may overemphasize the reflecting ceilings or walls. Ambient lighting is seldom bright enough for reading or close work; it must be combined with local or task lighting for these activities.

TASK AND LIGHTING The kind and amount of direct, functional illumination needed at specific places for specific activities, such as reading, cooking, sewing, eating, or grooming, is provided by **task** or **local lighting**. The light source can be high or low, but eye comfort suggests that it be shielded. Except in kitchens and bathrooms, local/task lighting fixtures consist mainly of movable floor, desk, or table lamps, but fixtures attached to the wall, ceiling, or major pieces of furniture are also used (Figure 21.12). Some furnishings even have lighting built in.

Local lighting also creates interesting *pools* of light that attract attention and draw people toward a circle of activity and warmth. It can be used to help direct traffic, set a mood, break a large room into "islands," or make a small room appear to have several distinct areas, thus visually enlarging its space.

ACCENT/DECORATIVE LIGHTING The play of *brilliants* seen on Christmas trees or in fireworks, crystal chandeliers, and candelabra makes up the third type of lighting: **accent** or **decorative lighting**. It is produced by fixtures that break light into many small, bright spots or focus it onto art or other possessions. Typical sources include candles, fixtures with many small lamps, those in which light passes through many small openings, pin spots, framing projectors, even tiny Christmas lights and flexible strips of miniature lights that can be bent to conform

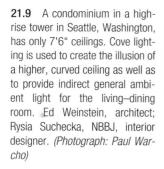

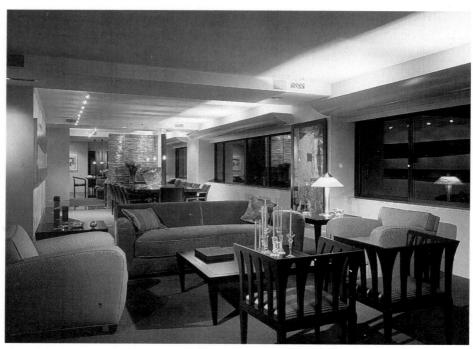

21.10 A custom-designed kitchen in Des Moines, lowa, has a dropped lumious ceiling that provides uniform lighting over the U-shaped island. Flexible control can adjust the level of illumination for different needs. Jack Bloodgood, FAIA, architect. (Photograph: Hedrich-Blessing)

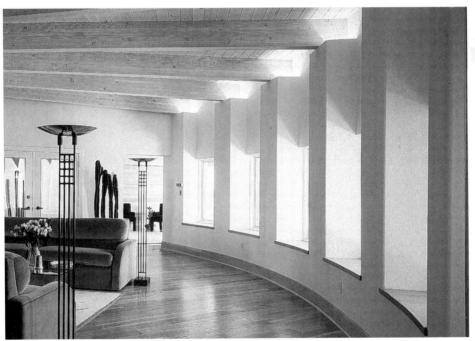

21.11 The living room of a house built in Scottsdale, Arizona, has deep-set windows and subdued indirect lighting to counter the glare of the desert sun. Antoine Predock, architect. (Photograph: Timothy Hursley)

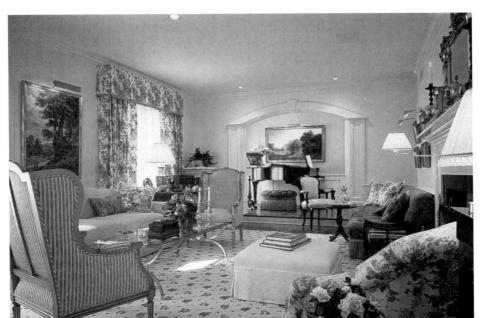

21.12 Local lighting in the living room is most often derived from portable lamps. Where surfaces for table lamps are limited, floor lamps and wall-mounted fixtures, such as the swing-arm lamp shown here, can provide task light for reading or other pursuits. (Photograph: Scott Frances/ESTO)

21.13 A Sun Valley, Idaho, home has an atmosphere of rustic comfort, made more intimate by ambient cove lighting and soft pools of local light near seating. Stan Aicker, architect; Frank Pennino & Associates, interior designers. (Photograph: Norman McGrath)

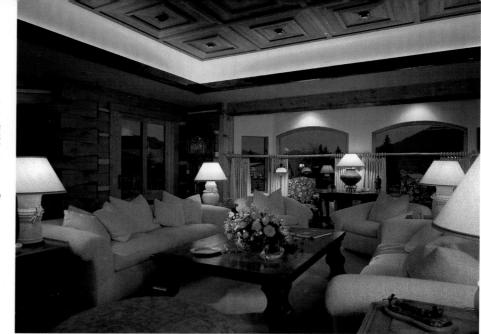

21.14 A chandelier, small wall sconces, and picture lights serve primarily as decorative lighting, adding brilliant sparkle and accent, while recessed downlights supply the uniform distribution of light necessary throughout this dining space. Paul Holt, architect. (Courtesy Luminae Souter Lighting Design. Photograph: James R. Benya.)

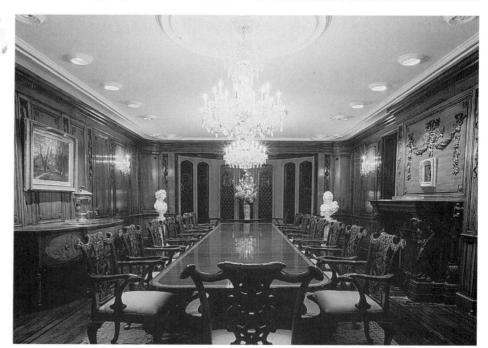

21.15 Recessed accent lighting illuminates art work used to accessorize this dining space while a suspended fixture and two additional down lights provide light for dining. (Courtesy Luminae Souter Lighting Design. Photograph: Doug Salin.)

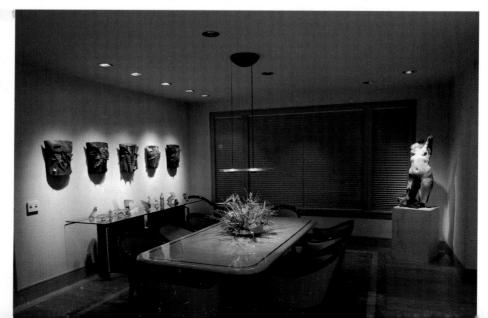

545

to any shape. Acrylic tubes or sheets with etched designs and laser lights add decorative light as an art form in itself. The special contribution made by accent lighting can be experienced immediately when one enters a room filled with sparkling light. It is stimulating, accentuates focal points, and provides the personal touch that highlights a room.

TECHNICAL FACTORS

Planned lighting demands attention to measures of quantity and quality, control of reflection, placement and size of light sources, direction of light, and color of light together with its effect on colors.

MEASURES OF LIGHT There are four units of measure for light: lumen, candela, footcandle, and footlambert. The light output, called light *flux* or flow, is the amount of light produced by a lamp, and is measured in **lumens**. This is the measurement used on manufacturers' packages and in lamp catalogs. A lamp's *efficacy* is equal to the number of lumens of light produced per watt of electricity consumed. Fluorescent lamps produce much more light than incandescent lamps of the same wattage. The **candela** is a measure of the candlepower or luminous intensity of a light source in a specific direction; it aids in describing the directional kind of light produced by a PAR lamp, for example.

The amount of light that reaches a surface (incident illumination) is measured in **footcandles (fc)** or illuminances. The standard light meter can be used to measure this quantity of light. One footcandle is equal to the amount of light falling on one square foot of surface one foot away from a candle flame. Surface illuminance levels vary inversely as the square of distance from the light source: At two feet, only one-fourth as much light would reach the surface as at one foot; at five feet, the light would be only ½5 as intense.

Experiments have shown that people generally will select as most desirable the middle of almost any range of incident illumination. For example, if the range is from 10 to 30 footcandles, the typical individual will prefer 20. When, without the observer's knowledge, the range is stepped up from 30 to 100 footcandles, the middle will again be chosen. A great difference separates 20 and 65 footcandles, but over short periods of time our eyes do not tell us which is better. They automatically adjust to different levels of light like fantastic miniature cameras. (Perhaps their greatest defect is that they do not warn us quickly when they are being strained by ineffective light.)

The Illuminating Engineering Society (IES) has prepared minimum recommended footcandles of illumination needed for many standard seeing tasks and activities and for the general illumination of rooms. Table 21.1 lists some of this information. More complete data are available in IES handbooks. The lumens necessary to obtain the desired footcandles of light will vary with the distance between light source and surface; the design of lighting equipment; the amount of reflection from ceilings, floors, and furnishings; and whether incandescent or fluorescent lamps are used.

Lighting technology is in the process of changing to the metric system, converting footcandles to *lux*, the amount of illuminance reaching a one square meter surface one meter distant from the source. One lux is equal to 0.0929 footcandles. Footcandles can be changed to lux by multiplying by 10.76.

The light we see reflected or transmitted by a surface is called *luminance* and is measured in **footlamberts (fL)**. The quantity of light leaving any surface is a product of the footcandles reaching it multiplied by the percentage of light reflected or transmitted by it ($fL = fc \times \%$ reflectance or transmittance). *Brightness* is a subjective evaluation of differences in luminance. Impressions of brightness

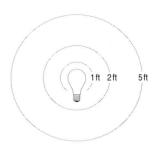

21.16 Surface illumination levels diminish inversely to the square of distance from the light source. If available illumination 1' from the source is 400 fc (footcandles), at 2' it's only a quarter of that (100 fc); at 5' it's 1/25th (8 fc) of that; and at 10', only 1/100th (4 fc) of the light at the source reaches a surface.

TABLE 21.1

Minimum Recommended Light for Certain Activities

	Foot- candles
General Lighting	
most rooms	5-10
kitchen, laundry	10-20
passage areas	5-10
Local Lighting for Activities	6
card playing	10-20
casual reading, easy sewing, makeup, easy musical scores	20–30
kitchen, laundry	30-50
prolonged reading, study, average and machine sewing, difficult musical scores,	
shaving, benchwork	40-70
fine sewing, any small detail work	100–200

TABLE 21.2

Seeing Zones and Luminance Ratios for Visual Tasks

Zone	Luminance (footlamberts)	
2—Area adjacent to the visual taska) Desirable ratiob) Minimum acceptable ratio	½ to equal to task† ½ to equal to task†	
3—General surroundinga) Desirable ratiob) Minimum acceptable ratio	½ to 5 times task† ½ to 10 times task†	

[†]Typical task luminance range is 40 to 120 candelas per square meter [12 to 35 footlamberts] (seldom exceeds 200 candelas per square meter [60 footlamberts]). Reprinted with permission from *Design Criteria for Lighting Interior Living Spaces*. Publication #RP-11 (New York: Illuminating Engineering Society of North America, 1980), p. 5.

is demonstrated with Zone 1 being the task (reading material or gameboard); Zone 2 the surface immediately adjacent to the visual task; and Zone 2 the general surroundings, and the viewer's visual acuity.

Luminance ratios or brightness relationships in the visual field of a person performing a task are important for comfort, efficiency, and safety. The visual field consists of three zones: The first zone is the precise area in focus or the task itself; zone two is the area immediately surrounding the task (such as a kitchen countertop); and zone three is the general surrounding area (the walls and floor of the room). There are optimum contrast relationships between these three zones: For tasks requiring close vision, zone two should be no brighter than zone one (as a maximum) and no less than one-third of it (desired ratio); zone three should be no more than five times the luminance of zone one or less than one-fifth of it. The longer the task takes to complete, the more critical the brightness relationships of the three zones. In areas where critical visual tasks are never performed, higher luminance ratios are acceptable (see Table 21.2). The reflectance levels of major surfaces in a room are important in achieving desirable luminance ratios. Recommended reflectances are listed in Table 21.3.

CONTROL OF LIGHT When light strikes an object in its path, it may be reflected, absorbed, or transmitted, depending on the degree of transparency or opacity in the material and on its surface qualities. The eye responds to reflected light,

21.17 (below left) The light source re-

lation to the three zones in the visual field

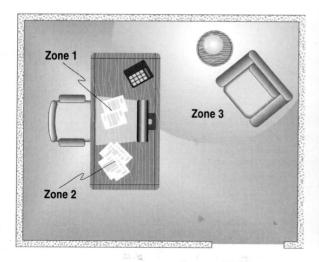

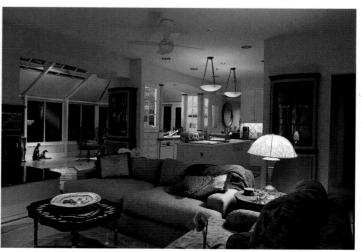

which must be controlled for optimum visual conditions. Comfortable light has sufficient but not extreme contrasts for easy viewing without strain or fatigue.

When the intensity or brightness of light causes discomfort or interferes with vision, the effect is called glare. Glare from abrupt changes in light intensity is a particular problem for the elderly. Veiling glare results when excessive light is reflected from a shiny surface such as a glossy magazine page, creating a reflection of the light source as a blind spot on the task surface and preventing discernment of the task. Specular reflection is reflected glare or bright, sharp light reflected from a highly polished or mirrored surface. Reflected glare is not always disabling but is uncomfortable and distracting nonetheless. The angle of reflected light is equal to the angle of incident light. Thus, if a painting hung at eye level is illuminated from above at an angle of 30 degrees, the light reflected from its glass should not strike the viewer in the eyes (Figure 21.18). A wider angle of illumination may cause reflected glare from the surface of the painting, which would wash out the detail and be a source of glare to others in the room. The viewer may also come between the light source and painting, casting a shadow upon it. Dull or matte surfaces exhibit diffuse reflection; they appear equal in brightness from all viewing angles, without the "hot spots" associated with glare. Direct glare results from bright light in the direct line of vision. Unshielded lamps and bright windows, especially if surrounded by dark walls, are sources of direct glare, the latter producing glare by contrast.

Light may be transmitted by or pass through a material that is either transparent or translucent. A translucent shielding material over a light source spreads the light distribution and diffuses or softens its brightness. Some materials refract or bend the light rays as they pass through them. A lens has such an effect, either concentrating or scattering the light rays passing through it.

When no light is transmitted or reflected, it is absorbed by a material. Some materials absorb nearly all the light falling on them, resulting in a dark gray or black appearance; others selectively absorb some light rays while reflecting others, resulting in our perception of individual hues. The percent of light reflected by certain colors is listed in Table 21.4 (next page). Lighter colors reflect more light, darker colors absorb more light. The relation of Munsell value to reflectance (see page 101, Table 5.1) is roughly the square root of reflectance.

Blandness of light, with every part of a room equally bright, is also fatiguing—to both the muscles of the eyes and the spirits of the occupants. If we remember that natural light modifies constantly—from dawn through midday to moonlight, filtered by trees and clouds, varying with the time of year—we will realize that change is normal and even beneficial. The designer's aim should be moderation, in both quantity and contrast of light.

Selective switches allow us to turn on or off different fixtures at will. With rheostatic dimmers, brightness of light from most fixtures can be smoothly adjusted to any point between candlelike glow and full brightness. The small cost of these dimmers could, in many instances, be more than compensated by reducing the number of separate fixtures that would otherwise be needed to achieve varied levels of brightness.

LOCATION AND DIRECTION OF LIGHT Accustomed as we are to the sun being more or less overhead, lighting from above seems normal, and that from other directions surprising. The following observations apply generally to location of potential light sources in the home:

- Location of both the light source and any surface from which light is reflected will be important in the total effect.
- Light high in a room is at the same time serene and revealing. It can be efficient to the point of boredom or a striking revelation of an architectural highpoint.

TABLE 21.3

Recommended Reflectances for Residences

Surface	Reflectance (%)
ceiling	60 to 90
fabric treatment on large wall area	45 to 85
walls	*35 to 60
floor	*15 to 35

In areas where lighting for specific visual tasks takes precedence over lighting for environment, minimum reflectances should be 40% for walls, 25% for floors.

Reprinted with permission from Design Criteria for Lighting Interior Living Spaces. Publication #RP-11 (New York: Illuminating Engineering Society of North America, 1980), p. 6.

avoiding glare

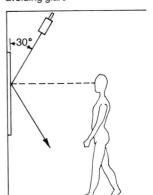

21.18 In lighting reflective vertical surfaces, to avoid glare the angle of incident light should not exceed 30 degrees from the vertical.

TABLE 21.4

Light Reflectance of Various Colors and Finishes

Color	Reflect- ance (%)
Dull or Flat White	75–90
Tints	
Ivory	75
pink or yellow	75–80
light green, blue, orchid	70-75
biege or gray	70-73
Medium Tones	
tan, yellow-	
gold	55
gray	35-50
turquoise, blue	
chartreuse	45
gold, pumpkin	34
rose	29
Deep Tones	
cocoa brown,	
mauve	24
green and blue	21
gray	20
olive green	12
navy, forest	
green	5-10
Wood	
birch	35 - 50
maple, oak	25 - 35
cherry	10-15
black walnut,	
mahogany	5-15

Adapted from *Planning Your Home Lighting*, House and Garden Bulletin 138 (Washington, D.C.: U.S.G.P.O., 1968), p. 4. Reprinted with permission of Macmillan Publishing Company from Marjorie Branin Keiser, *Housing: An Environment for Living* (New York: Macmillan, 1978), p. 245.

• Light below eye level seems friendly and draws groups together. It is also useful while watching television.

• Light coming from near the floor flatters people's appearance in the same manner as do theater footlights, and also contrasts pleasantly with more conventional lighting. Low light is a good safety device near steps and in hallways.

• Light from a number of sources, or well-diffused light, makes a room seem luminous rather than merely lighted, tends to spread interest throughout the area, and is comfortably undemanding. However, entirely diffused light that casts no shadows is monotonous and perhaps unsafe because shadows are necessary to reveal depth and form.

• Strongly directed light, for example that coming from one or two spotlights, may be dramatic, but it can seem harsh if not handled carefully. Our attention tends to follow its path—up, down, sideways, or at an angle—much as it does a solid form. Directional light casts highlights and shadows on surfaces which change with the position of the observer, adding interest and variety. *Downlights* over people create unflattering shadows under the eyes, nose, and chin.

• Light positioned near and parallel to a textured surface *grazes* the surface, highlighting its irregularities dramatically. However, grazing is an inefficient method of lighting a wall because the units must be placed as close as one foot from the wall and one foot apart, so they do not provide light for anything hung on or sitting in front of the wall.

Lights positioned 3 to 4 feet from the wall and the same distance apart wash the surface with an even, shadowless light.

• *Perimeter* lighting expands apparent space. A dark perimeter makes space seem to contract.

• Light for working should illumine the task without forming distracting shadows and should not shine in the worker's eyes. Task lighting should follow the recommended levels in the three visual zones to avoid glare and gloom contrasts.

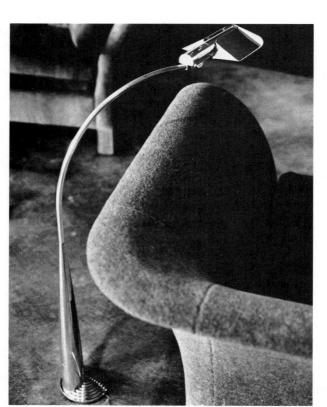

21.19 Cedric Hartman's floor lamp with its shallow pyramid reflector of brass or nickel is infinitely adjustable and provides a very wide beam spread at just below seated-eye-level height. In addition to being an excellent reading (or other task) light, it does not create a reflection of itself on the television screen. (Courtesy Cedric Hartman. Photograph: Vera Mercer, Paris)

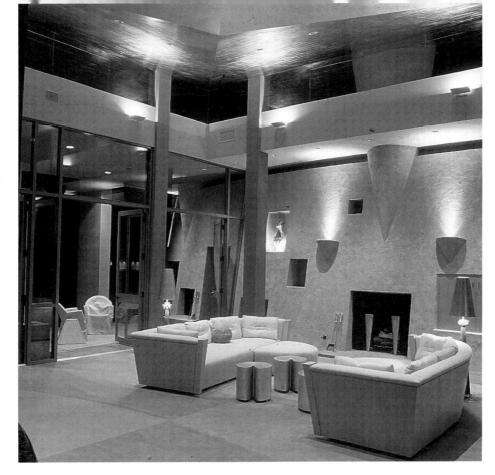

21.20 Directional light leads the eye in whatever direction it follows. In this Palm Springs, California, house, it reinforces the height of the space, leading visual focus upward. The sconces also graze the wall surface, emphasizing its texture. Exterior lighting illumines the covered terrace with the effect of expanding interior space. Leonard Salvatto, architect. (Courtesy Luminae Souter Lighting Design. Photograph: Cynthia Bolton-Karasik, Tom Skradski.)

21.21 Wall-washing light and color both contribute to the luminous quality of this lively study in a home in Memphis, Tennessee. Blass Chilcote Carter Gaskin Bogart & Norcross, architects; Eleanor Baer, designer/owner. (Photograph:Timothy Hursley)

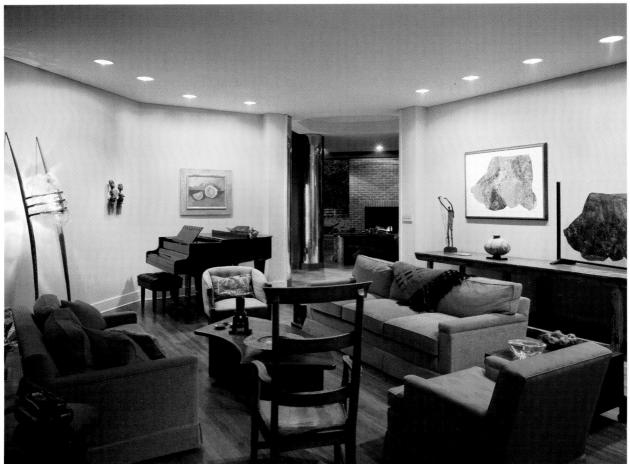

Taking these variables into consideration, lighting engineers have made some general recommendations about the placement of light fixtures and the wattage that will provide an adequate amount of light for both general illumination and concentrated light for reading, sewing, and other close work. Table 21.5 lists these recommendations. More precise formulas are used to calculate illumination in offices, manufacturing facilities, classrooms, and other contract interiors. For residential design a light meter suffices to measure incident, reflected, and transmitted light.

SIZE AND SHAPE OF LIGHT SOURCE Much depends on the size of a light source. To understand this, we need only compare the luminous vault of the sky by day with its myriad play of brilliants at night.

- Broad sources or **planes** of light—the sky, a skylight, an illuminated ceiling, a window wall—give flat, glareless, uneventful light excellent for general vision, health, and safety, because they minimize contrasts and shadows. In decorative terms, however, they can be monotonous.
- Smaller light sources that diffuse light broadly through lenses, translucent shades, or reflectors approximate this effect. Because of their resulting amorphous shape, these lights are sometimes referred to as **glob** sources.
- Very small light sources, especially bright ones, have high accent value, emphasize parts of rooms, and make polished metal and glass sparkle. But such lights must be used with care, for they can be visually fatiguing and may cause a spotty effect. These lights are called **point** sources.
- Line sources are typically fluorescent or neon lamps, but they may also include strips of incandescent lamps, either exposed or concealed behind valances, brackets, cornices, or coves. They are usually general perimeter light sources, subdued and space-expanding except for neon lights, which are decorative and stimulating.

COLOR OF LIGHT Artificial light seems to be most pleasing if it simulates natural light that varies by time of day and direction. Incandescent lighting has traditionally been favored for residential illumination because of its full-spectrum distribution of wavelengths and, because incandescent light has existed longer than fluorescent and other sources, we are more accustomed to its color and effects. However, other types of light are also being developed with a more even spectral distribution and are gaining favor for the home.

The color of light is determined by three factors: the light source, the diffusing or reflecting shade, and the room surfaces.

- White light shows colors as they are and has no pronounced emotional effect other than the important sense of normal well-being.
- Warm light flatters people, dispels the chill associated with darkness, and brightens warm colors, but deadens blues and purples.
- Cool light makes rooms seem more spacious, separates objects from one another—and may make people look cadaverous.
- A combination of warm and cool light adds variety but needs to be planned with care.
- Light reflected from one colored surface to another is modified by each and affects each in turn. **Amplification** of color is a result of this selective reflection and absorption of different wavelengths or "colors" of light. (More of the effects of color on light were explored in Chapter 5.)
- Colors look different under different lights, a phenomenon known as
 metamerism. The colors in a textile vary quite remarkably under incandescent, fluorescent, or natural light. That is why it is best to select and coordinate colors under the light conditions in which they will be used. Low levels

TABLE 21.5

Recommended Placement and Wattage of Light Fixtures

Туре	Placement	Range of Wattage
wall fixtures (incandescent)	at least 66" above floor	60–100w every 8' for general lighting
wall fixtures (fluorescent)	faceboards at least 6" out from wall, and as high in inches as they are in feet from floor, to shield fluorescent tubes	general lighting—approximately 1' of channel (10w) for each 15 sq. ft. of floor area special lighting—approximate width of area to be lighted
cornice	at edge of ceiling, sheds light down	
valance	at least 10" down from ceiling, sheds light up, down, or both	
wall bracket	50–65" above floor, sheds light up, down, or both	
ceiling fixtures		
shallow	centered, symmetrically placed, or placed to illumine special areas	120–200w in multiple bulbs; 60–80w in multiple tubes
recessed	as above	30–150w bulbs
pendant	as above; see below when used for reading	120–180w in multiple bulbs
floor lamps (for reading)	stem of lamp 10" behind shoulder, near rear corner of chair; bottom of shade 45–48" above floor	50/150w-100/300w bulbs; 60–180w in multiple bulbs
table lamps (for reading)	base in line with shoulder, 20" to left or right of book center; bottom of shade at eye level when seated, about 40" above floor	as above
wall lamps (for reading)	42–48" above floor, 15" to left or right of book center	as above

of light render colors more grayed in intensity; higher levels, if not too harsh, tend to brighten colors.

Until recently, most people have been rather timid about using colored illumination in residential interiors. But the last few years have seen more experimentation with different colored lamps or lenses, even with patterns of colored light, either stationary or moving, thrown on walls.

PSYCHOLOGICAL ASPECTS OF LIGHT

Light is a psychological communicator of mood or atmosphere. The skilled designer can use it to establish the character of a space just as lighting designers for the theater use it to establish the mood of a play.

• **Bright light** is stimulating, calls forth energy, and makes us feel as though we should be up and about, but, if overused, may ultimately be boring and visually tiring. Bright light casts strong shadows.

21.22 A lighting showroom exhibits a variety of contemporary luminaries. Bruce Benning, Allied Member ASID, interior designer. (Photograph: Steve Simmons)

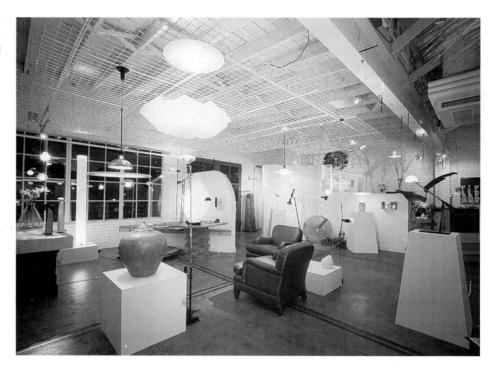

- **Subdued light** may seem relaxing, restful, and intimately romantic, or dingy, depressing, even frightening—depending on the context. Soft light minimizes shadows and textural differences.
- Too brilliant light often causes us to retreat in physical and emotional distress. A bright, focused light makes us feel the center of attention and may boost our ego or make us very uncomfortable. Small hard lights add brilliance and sparkle.
- Moderately bright light brings no pronounced feeling other than general wellbeing.
- **Flickering light**, as from a fireplace or candles, nearly always draws attention and physically draws people toward it. Warm, flattering light is emitted by fire.
- An appropriate distribution of light quantities results in an impression of balance and rhythm, of emphasis and moderation similar to those produced by nature. It allows the eyes to adjust easily and provides visual comfort.
- Warm-colored light seems cheerful and welcoming.
- Cool light is often more restful than warm light.

LIGHTING FIXTURES

Ideal lighting fixtures, called **luminaires**, give the kind and amount of light suitable to a particular purpose, thus fulfilling the principle of *utility*. They represent sound *economy* in balancing their original cost with the electricity they use, in the ease with which they are cleaned and the lamps are replaced, and in the space they take. They contribute to the *beauty* of our homes, and they underline or create the distinctive *character* we seek. Almost inevitably lighting fixtures contrast with other furnishings, because they fill quite a different purpose. This suggests that some of them be deliberately chosen as accents. In general, though, most fixtures should be appropriate in size, scale, and character to the rest of the interior. Lighting devices can set up their own pattern of design running through the entire home, supplying a connective theme.

ARCHITECTURAL AND BUILT-IN LIGHTING Architectural lighting is planned at the same time the structure is designed and wired during construction. (Existing structures can also be retrofitted.) Built-in lighting accounts for about half of all artificial lighting. It contributes to the total unity of a lifespace and can produce unique effects, usually reflecting off walls, ceilings, and furnishings. It can—and should—enhance the architectural outlines and forms of the space.

Ceiling Luminaires. Fixtures attached to or mounted in the ceiling are available in many varieties (see Appendix E for illustrations):

- Luminous panels may cover all or most of the ceiling, illuminating large areas evenly and softly through diffusing materials.
- Recessed and adjustable downlights (highhats, eyeballs, and wall-washers) may direct a flood or a narrow beam of light downward or angle it toward an activity area or accessory, creating pools, scallops, or a wash of light (Figure 21.23).
- **Cornices** are mounted at the juncture of ceiling and wall, washing the wall in light, providing reflected ambient light to the rest of the room (Figure 21.24).
- Soffit lights are most often used in the bathroom, laundry, or kitchen over the sink. The underside of the soffit is covered with a diffusing panel with lamps above it. Soffit fixtures are effective task lights (Figure 21.25).
- Flush-mounted and surface-mounted fixtures, some dropped only a few inches, are often centered in the ceiling to provide direct or direct/indirect ambient lighting. Some can reflect light from the ceiling, diffuse it through

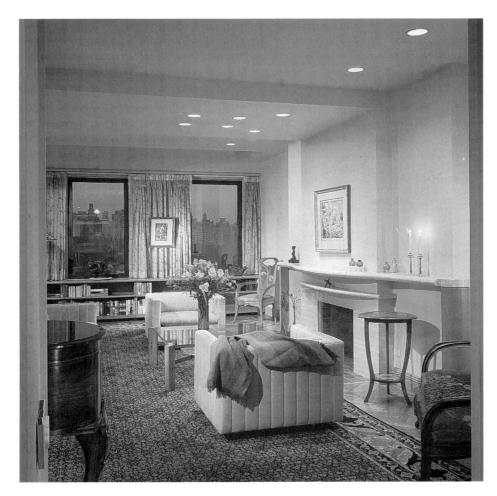

21.23 Recessed downlights distribute uniform illumination along the fireplace wall, with additional cannisters over the seating area in a Manhattan, New York, apartment. lan J. Cohn/Diversity: Architecture & Design. (Photograph: Paul Warchol)

21.24 This dramatic dining room is punctuated by cornice lighting around its perimeter and cove lighting above the columns in the foreground. Randall Whitehead, Catherine Ng, of Light Source, lighting designers; Helen C. Reuter, interior designer. (Photograph: Douglas Salin)

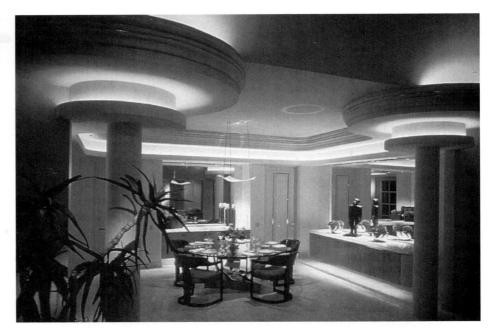

the bowl, and direct a pool of light downward, making them an inexpensive three-in-one way to light space for eating, hobbies, or homework. Others are similar to recessed luminaires except that they are surface-mounted (cans, eyeballs, and wall-washers). Although some of these fixtures may be removable (and not truly built-in), their wiring is permanent, making them architectural in nature.

• **Suspended luminaires** may be dropped well below the ceiling and may be adjustable in height and position for greater flexibility and ease of maintenance (Figure 21.26). A large suspended fixture may form a *canopy* overhead.

• Track lighting may be architectural if the wiring is concealed or the track is recessed into the ceiling. Tracks allow flexibility; many sizes and shapes of fixtures, even pendants, can be mounted on a single track to serve a multitude of purposes (Figure 21.27).

Wall Luminaires. Wall-mounted fixtures are popular because they keep table and desk surfaces free for other things, they remain out of the way, and they provide direct light where it is needed or supply general overall illumination balanced throughout the room. However, they are attached to the wall and fixed in location, which may interfere with hanging pictures or changing furniture arrangements. (See Appendix E for illustrations.)

- Valances are located directly above windows. They supply both direct and indirect light, emphasizing the texture of window treatments and bouncing light off the ceiling into the rest of the room.
- **Brackets** are similar to valances but are not located over windows. They may be positioned high or low on the wall and used for ambient or ambient *and* task light, depending on height and the shape of the *face board*. (An angled face board, as opposed to a straight face board, directs more light in the direction that it is angled away from the wall; or, with two equal angles in a broad V shape, it distributes light further away from the walls). Brackets are often used over beds or to balance valance lighting on the opposite side of a room.
- Coves provide a trough to conceal lighting that is directed upward only, toward the ceiling. They may be used to add a feeling of height to a space or to emphasize a vaulted or cathedral ceiling.

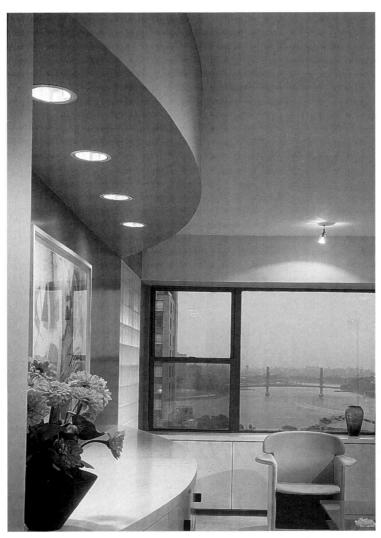

21.25 A soffit containing recessed downlights echoes the curve of cabinets which, in turn, reflect the curve of the river seen from a Manhattan apartment window. Stamberg Aferiat Architects. (Photograph: Paul Warchol)

21.26 (below left) A suspended halogen light fixture over a custom-designed desk emits both direct and indirect light through a frosted glass diffuser. A companion floor lamp does the same. The study opens into a spa area at the far end. Peter Kurt Woerner, FAIA, architect. (Photograph: Karen Bussolini)

21.27 (below right) Track lighting can serve a variety of needs. In this San Francisco residence, it washes a wall of art with light. Robert A.M. Stern Architects; Randolph Arczynski, interior designer. (Courtesy Cline Bettridge Bernstein Lighting Design Inc.)

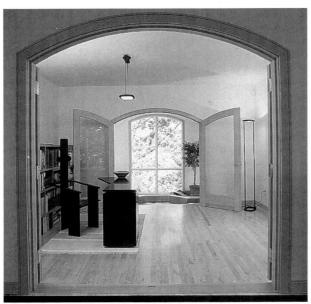

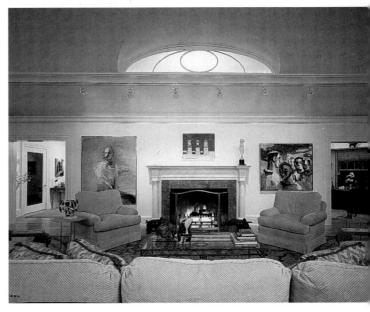

- **Sconces** and luminaires mounted directly on the wall are available in many shapes and sizes, for use as direct and indirect lighting, or purely for decorative effects (Figure 21.28).
- Luminous wall panels are lighting panels placed in the wall surface. In confined spaces, luminous wall panels can create an ambience of natural light. The panels may be treated as windows with draperies, shutters, or milky diffusers.

NONARCHITECTURAL LIGHTING AND PORTABLE LUMINAIRES Track lights and pinup fixtures of all kinds can also be *nonarchitectural*, with surface wiring and exposed cords, allowing them to be moved or removed at will.

Floor and table lamps can be moved when and where they are needed. Moreover, they perform as lively decorative accessories. In some instances, lamps that are unornamented and inconspicuous seem best, but genuinely handsome, decorative lamps can greatly enrich a room at the same time that they provide light. A beautiful ceramic or glass piece or a richly modeled work of metal profits from light above or in it. Some lamps could be described as art forms. The light is captured in a sculptural form that in turn spreads the ambience of its glow in the immediate vicinity. Other types enclose the light source in an opaque base and emit light in one direction only. In still others, clear or frosted bulbs themselves become the lamp, while providing light.

Portable luminaires are often chosen as much (or more) for their aesthetic qualities—balance, proportion, scale, color, texture, form, and use of materials—as for the kind or amount of light they supply. There are several types: direct light, indirect light, a combination of direct and indirect light, luminous, structural-type, and accent.

Direct-light fixtures include *gooseneck* and *apothecary* types, *bullet* shades and *high-intensity* luminaires. Because they concentrate light in one direction only, they are often used as task lighting, but may also provide accent light for other accessories or even indirect light if aimed toward a wall or ceiling. Direct-light fixtures should not be used without sufficient general illumination, or they produce eye fatigue from the glare resulting from an extreme contrast in light and shadow.

21.28 Built-in wall luminaires bring a soft glow to a narrow hall; a ceiling fixture illuminates the sculpture on the end wall. Michael Graves, architect. (Photograph: © Peter Aaron ESTO)

21.29 The arm of an asymmetrically balanced halogen desk lamp called "Tizio" can be pivoted to cast high intensity light where needed. Richard Sapper, designer. (Photograph: Artemide, Inc.)

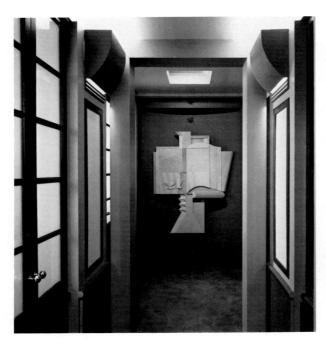

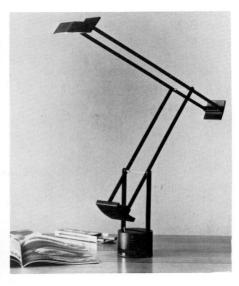

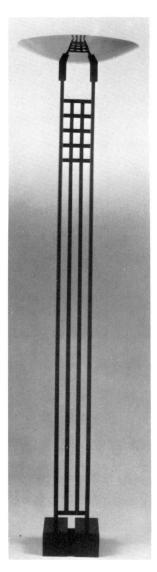

21.30 (left) An indirect luminaire of polished brass with black stem and base, designed by Robert Sonneman, has a halogen bulb and a full-range dimmer. (*Courtesy George Kovacs Lighting, Inc.*)

21.31 (below) A canister lamp with the bulb in the base directs light up to be reflected by the shade over the table or desk top. George Nelson, designer. (Courtesy Koch & Lowy Inc.)

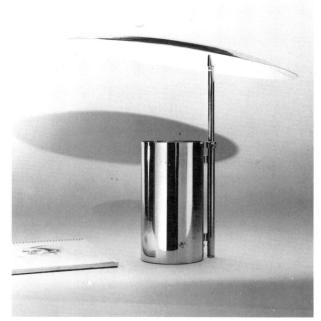

Indirect luminaires include various *torchere* and *urn* types that aim light upward to be reflected from walls and ceilings. They are based upon the use of torches of flame to light interiors centuries ago and have enjoyed a modern resurgence of popularity as ambient lighting.

The customary **table** or **floor fixture** provides a combination of direct and indirect light, for general room illumination as well as task performance. The shape of a fixture ought to grow from its function: The base supports the lamp bulb and shade; the lamp sends out light; the shade protects our eyes from glare and directs and diffuses light. The simplest base of a traditional table luminaire is a cylinder with a foot large enough for stability. The breadth-to-weight ratio is important in keeping a fixture upright, but materials also play a determining role; a support of metal, plastic, or wood can be more slender than a clay or glass one. Bases, lamps, and shades, although different in function and usually in material, comprise a unit when organized into a luminaire. This suggests a basic agreement among them—some qualities in common but seldom exact repetition.

21.32 The proportions of a portable lamp often determine whether it can be used for task performance or serve as ambient light and contribute to the aesthetic qualities of the room. A truncated cone shade distributes more direct than indirect light, spreading it to cover the surface below and nearby seating. The coral-like stone lamp bases complement furniture of giant bamboo hand tied with leather in this multipurpose room. Dennis Buchner, interior designer. (Photograph: John F. Martim)

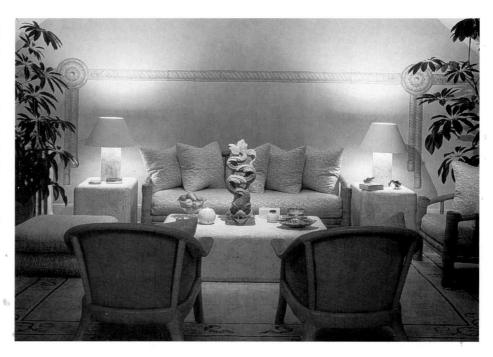

21.33 A floor lamp called "Chimera" diffuses light through a sculptured translucent column, providing a soft ambient glow. Vico Magistretti, designer. (Courtesy Artemide, Inc.)

Luminous fixtures might sometimes be described as art forms. Light emanates from materials that may be transparent, translucent, or pierced. Neon is an example. Such fixtures are primarily decorative although they may supply some ambient light as well. They must use low-wattage lamps in order to avoid annoying harshness.

Structural-type portable fixtures appear much like built-in brackets, *strip* lights, *shelf* lights, and tracks, but they are surface-mounted and plug into an outlet. They may be either decorative or functional, and allow the flexibility and ease of installation often needed in rented living spaces.

Accent lighting uses exposed lamps to add sparkle and glitter to a room. It includes some *chandeliers*, *strips*, *sconces*, *clusters*, and *candles*. Clear or tinted-glass lamps and chimneys may be used on these fixtures. They are purely decorative and use low wattages (up to 25-watt lamps). The cumulative wattage of several lamps in a chandelier may be much higher. Also, if a chandelier is used for general lighting in a room, it must be balanced with additional light sources, such as wall sconces, to avoid glare.

SHADES Traditional shades generally take the form of *drums*, *domes*, or *truncated cones* to spread the light downward and sometimes upward as well. A tall, steep shade gives concentrated light, a low, wide one dispersed light. A 16-inch bottom diameter is recommended to spread light sufficiently and a 10-inch shade depth is needed for a single socket in a vertical position (6 to 8 inches for a multiple socket in a horizontal position with a top shield and diffusing disk below) to shield the lamp from view. Minimum top diameter is 8½ inches. If the lamp is positioned just above the lower edge of the shade, a wide downward spread of light results for reading and other tasks. Of course, shades can be square, triangular or any other shape, but rounded forms seem more congenial to light, and their curves provide variety in predominantly rectilinear homes.

Light transmittance is of importance in choosing shades. Generally, shades produce soft, ambient light. A translucent shade diffuses the light and provides attractive cross lighting, but if too transmittant "hot spots" revealing the lamp inside produce annoying glare. Opaque shades, however, create heavy pools of light

above and below and allow little light to reach vertical surfaces. When used for television viewing or working at a desk, lamps with dense shades (low transmittance) are best.

Color is important, especially in translucent shades but also in the whole ensemble, because lighted lamps are very conspicuous. A preference for warm, flattering incandescent light would tend to rule out translucent shades of blue, green, or violet. Opaque or near-opaque shades in colors may be used in rooms with the same colors in backgrounds; dark shades will be less conspicuous than light ones against dark walls or brilliantly-colored walls. Translucent shades are mostly white or off-white; if colored, the light transmitted distorts the other colors in the room.

Shade linings should always be white or nearly white to provide high reflectance. Medium-value colors have only 40 to 50 percent reflectance, meaning that much light is absorbed inside the shade, never reaching nearby surfaces.

SIZE The optimum size of a luminaire will be determined by illumination requirements and by the scale of the room and its furnishings. High fixtures with large spreading shades illumine broad areas and are compatible with large-scale furniture. Deliberately overscaled fixtures can create dramatic focal points, but unless they are sensitively used, they may crowd small spaces. The more fixtures a room has, the smaller each can be, though too many small luminaires may give the appearance of clutter. When several fixtures are used, they should be coordinated to give unity and order: pairs of fixtures with similar styling; shades of about the same brightness and color; and shade bottoms at the same approximate height throughout the room. Usually the bottom edge of the shade is kept at about the eye level of a seated person (38 to 42 inches) so the lamp is never visible.

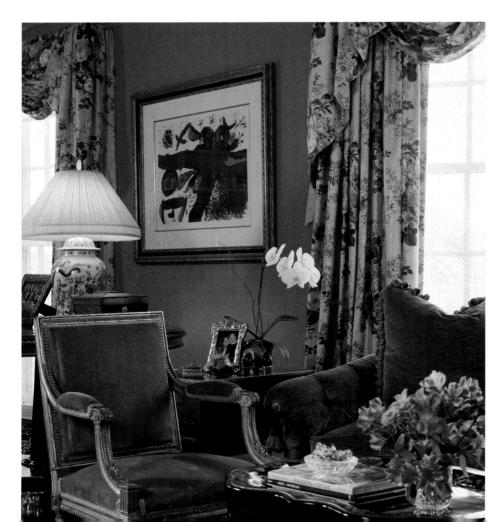

21.34 A pleated silk lamp shade over a base converted from an Oriental porcelain vase emits softly diffused ambient light in a San Francisco, California, home designed to resemble an English townhouse. Diane Chapman Interiors. (Photograph: David Livingston)

AESTHETICS When selecting portable and nonarchitectural (even architectural) luminaires, all the elements and principles of design and criteria for design judgment come into play (see Chapters 3–6), in addition to the more technical issues outlined in this chapter.

ECONOMIC ASPECTS

To conserve energy, windows should be planned and placed to admit as much natural light as possible during daylight hours. When artificial light is necessary, maximum control (allowing flexibility of use) will help reduce waste. This may mean adding a few more switches, installing dimmers, changing lamps or luminaires, or installing a computer-controlled system that automatically adjusts lighting levels to preset standards throughout the day. Multiple manual switches allow as much or as little light as is needed to be used. Dimmers lower the voltage needed by incandescent lamps and prolong their life up to three times longer when used. (They also change the color of light emitted; as the lamp is dimmed, the light becomes more yellow.) A higher-wattage lamp is more efficient than several lower-wattage lamps totaling the same number, and three-way lamps offer greater versatility of use than standard single-filament lamps. Reflector floodlights provide more light with less wattage than standard lamps. And low-voltage lamps have proved a highly successful method of dealing with state energy codes that limit the number of watts per square foot that can be used on lighting. These codes were established as part of a national effort to save energy. Energy consumption per square foot can be figured by simply dividing the total wattage of all lighting planned by square feet of space.

Wherever possible, low-voltage fluorescent, HID, and tungsten-halogen lamps can be used instead of regular incandescent lamps (Figure 21.35). Fluorescents consume less energy, produce more light, and have a longer lifespan than incandescents; HIDs have even higher efficacy and longer life than fluorescents. Longer fluorescent tubes are more efficient, and HIDs are more efficient at higher wattages. Tungsten-halogen sources also produce more light with less decline over time and have a longer life than ordinary incandescent lamps.

Finally, light-reflective colors used on ceilings, walls, floors, and furnishings will help maximize the effects of all light while dark surfaces will demand additional illumination. Refer to the reflectancy of various colors when planning an interior. (See Table 21.4. Chapter 5 also provided more information on the light reflectancy of color.)

LIGHTING SPECIFIC AREAS AND ACTIVITIES

In designing a home or revising the furnishings of a room, the designer draws a floor plan with furniture arrangements. Once the furniture has been placed, lighting requirements can be assessed—where local illumination is needed, what kinds of general and accent lighting will best complement the character of the room, its colors, textures, and surfaces. Lighting can be indicated on the furniture plan or on a separate electrical plan. Plans do not relay information about the effects of lighting, however. Only the designer's knowledge of lighting, experience, analysis of client needs, and thorough planning can produce the effects desired. Some computer programs can simulate the lighting planned for a space—a valuable tool for helping the client see what the designer visualizes (Figure 21.36). In nonresidential design, a *reflected ceiling plan* is prepared (see Figure 21.37). This is a working drawing showing the placement of architectural lighting and types of luminaires located on the ceiling. It is called a reflected ceiling plan because it is drawn as though the floor plan were mirrored, reflecting an image of the ceiling where much

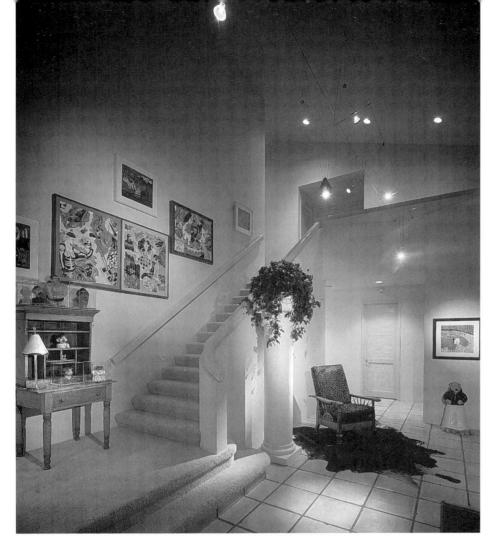

21.35 In this two-story area of a residence in Gold River, California, the lighting system is of low-voltage halogen powered by a remote transformer directly through the visible cables. Lighting manufacured by Neidhardt Lighting. Graber & Rasmussen, architects; Bruce R. Benning, Allied Member ASID, interior designer. (Photograph: Steve Simmons)

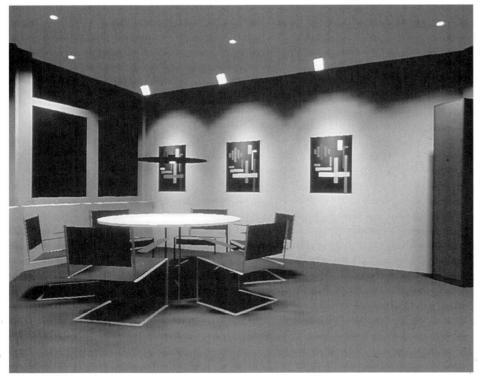

21.36 Computer software has made it possible to produce a three-dimensional graphic that simulates lighting effects during design, affording clients a much more accurate idea of what they can expect in the finished project. (Courtesy Zumtobell Lighting, Inc.)

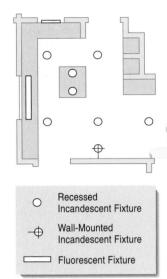

21.37 In this diagram of the reflected ceiling plan of a kitchen, placement and types of fluorescent and incandescent fixtures are suggested.

of the lighting in nonresidential spaces is located. An *electrical plan* indicates switches, convenience receptacles, and hookups for various appliances. (See Figure 14.18, and electrical symbols in Appendix A.)

Entrance areas benefit from friendly, welcome illumination as a transition from the dark outside to the brightness of the interior or vice versa during daytime. Guests and hosts should see one another in a pleasant light, which provides a graceful introduction to the home. Diffused light from ceiling or wall fixtures, perhaps supplemented by more concentrated, sparkling light, creates a balanced effect. Less than 75 square feet can be lighted by a single luminaire with incandescent lamps totaling 100 to 120 watts. Larger areas need 150 to 180 watts. Adequate light outside also provides safety from unwanted intruders, since many people will not open their door to a stranger.

Living rooms and family rooms need general illumination, preferably both direct and indirect, to bring walls and furniture, floors and ceilings into soft perspective. Flexibly controlled direct light is requisite where people read, sew, play the piano or games, or do homework. A touch of scintillating light adds interest. Dimmer switches provide versatility.

Conversation benefits from a moderate level of lighting, neither too stimulating nor too bland. Intimacy is encouraged by keeping the general background lighting low and by using fixtures placed low. High fixtures seem more conducive to formal exchanges. Warm-colored lighting draws people together at the same time that it flatters their complexions.

Television viewing requires well-balanced light with no sharp contrasts or glare reflected from the screen. A relatively low level of lighting may be sufficient since the television screen itself is a light source. Fixtures should be shielded or positioned to prevent reflection from the screen. Video display terminals for home computers require much the same kind of lighting conditions.

21.38 Downlights carefully positioned over a dining table highlight table appointments, establishing the focal point of the room. John F. Saladino, Inc., architects and interior designers. (Photograph: © Peter Aaron/ESTO)

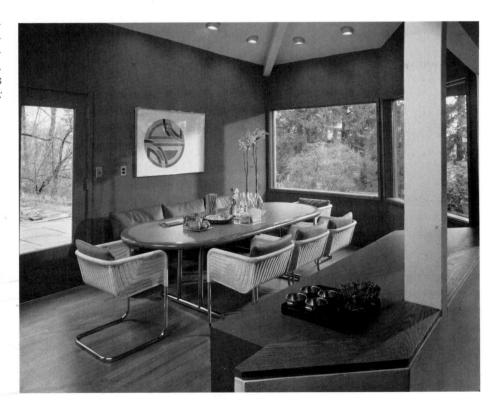

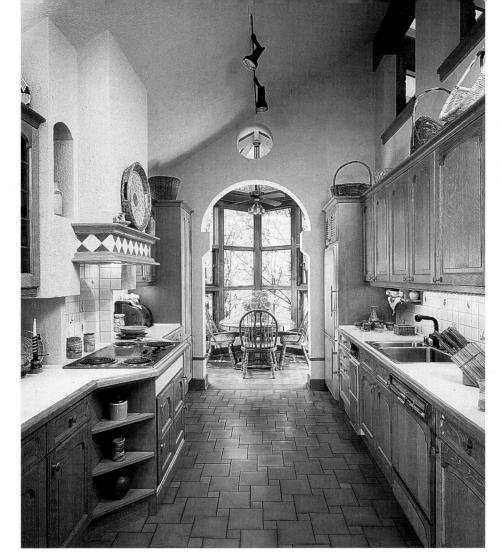

21.39 While track lights provide direct general illumination, undercabinet fluorescent lamps assure abundant countertop task light in the kitchen. Clerestory windows add daylight to the mix. (Photograph: Hedrich-Blessing)

Reading of a casual nature can be done in moderate light, but more sustained reading or study needs direct light balanced by some general lighting to avoid excessive contrasts. Placement of the lamp for light without shadows is illustrated in Appendix F; other visual tasks, such as sewing, playing the piano, and personal grooming also have specific requirements for the best placement of fixtures as indicated.

Active play, dancing, ping-pong, billiards, or other physical games usually benefit from high levels of general light. Table games need direct overhead light, positioned high enough to be out of the line of vision.

Dining spaces deserve primary emphasis on what is most important—the table and the people around it. Light directed downward makes silver, glass, and china sparkle, enhances the appetizing qualities of food and beverages, and, if carefully positioned, reflects back up onto diners' faces without casting harsh shadows under prominent features. However, some indirectly diffused light lessens glare and diminishes unbecoming shadows on the diners' faces. Pendant fixtures (chandeliers or luminaires) should be at least 12" smaller in diameter than the table is wide (to avoid bumping into them while setting the table, etc.). They must be centered at least 30 inches above the table top so they do not interfere with conversation and visual contact across the table. (With each foot of ceiling height above 8 feet, the light fixture should be raised 3 inches.) Candles on the table should be either above or below eye level for the same reason, and should be supplemented with ambient light. Only the table itself needs a moderately high level of light; the re-

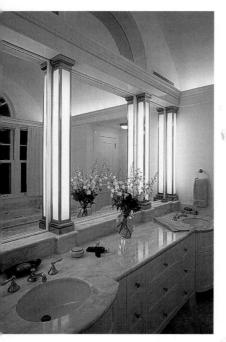

21.40 Columns of diffused light flank either side of dual lavatories for a shadow-free grooming area in a bathroom. Cove lights illuminate the vaulted ceiling and provide uniform indirect general lighting. Robert A.M. Stern Architects. (Courtesy Cline Bettridge Bernstein Lighting Design Inc.)

mainder of the room can have lighting of a reduced level. A dimmer switch allows flexibility. Incandescent sources tend to render both food and faces more appealing than fluorescents. Hanging fixtures are more practical if adjustable in height for multiple use in the dining area in smaller homes (for instance, for card-playing, studying, or sewing).

Kitchens demand good light, especially over the work centers. The eating table and the rest of the room should have a fairly high level of general illumination. Ceiling lights are almost indispensable, as are bands of task lighting placed at strategic points along work counters, especially under the front edge of wall cabinets to dispel shadows on the work surface. Multiply counter length by 8 watts to determine how much light is needed. The range, sink, and mix centers must also have adequate shadow-free task lighting. Over the sink two recessed or surface mounted downlights spaced 15 to 18 inches apart with 75-watt R flood lamps or a soffit light are recommended. Warm white or warm white deluxe fluorescent lamps are pleasant. Luminous ceilings are often used in kitchens, utility rooms, and hobby rooms. In California, the Energy Commission has passed legislation requiring fluorescent lamps as the primary source of lighting in all new kitchens and renovations consisting of fifty percent or more new work. This represents a substantial savings of energy.

Bathrooms require lights near the mirror to give shadowless illumination to the face. Light on both sides of the mirror and overhead is best. If placed above the mirror only, lighting causes shadows on the lower part of the face, making shaving and makeup application difficult. If just two wall lights are used on either side of the mirror, they should be 30 inches apart and mounted at eye level, with translucent shades or diffusers. Warm-colored lighting flatters skin tones. Strip lights or theatrical lights surrounding the sides and top of the mirror should be of low wattage and frosted. A dimmer switch is also effective in controlling glare from

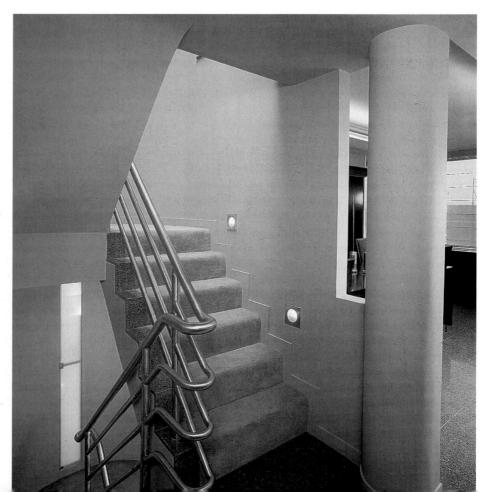

21.41 Low-voltage incandescent step lights and a vertical panel with continuous incandescent low-voltage light strips at the stair landing contribute design as well as safety in a tri-level Manhattan apartment. Sandblasted glass lenses and diffusers soften the light, which is positioned low enough to clearly light stair treads and landing surface. Steven Forman, architect. (Photograph: Paul Warchol)

strip lights. A bathroom also needs general illumination from a ceiling fixture or two, lighting over the tub and in the shower stall, and a night light.

Bedrooms should have lighting for dressing, reading in bed, and perhaps such activities as desk work, reading, sewing, or watching television. Direct-indirect lights over the beds, chairs, desks, and chests of drawers—as well as direct lights near mirrors—may be sufficient, but some general lighting, closet lighting, and a night light (particularly in children's rooms) is usually advisable. For reading, the light fixture should be 30 inches above the surface of the bed when located behind the bed, or 20 inches above when placed at the side, to provide sufficient illumination on the reading material. Switches near the bed allow control without maneuvering in the dark. Lighting should be comfortable, cheerful, restful, and glareless.

Hallways need some overall lighting for safety; its source might be ceiling or wall fixtures that send glare-free light downward, but lighting near the floor, as in theaters, not only focuses on the area we need most to see in hallways but offers a readymade opportunity for variety in lighting effects as well. Sources should be spaced about every 10 feet. Ornamental, colorful fixtures or lighting directed toward art work or family photos can dispel the dullness typical of most halls. A night light in bedroom hallways is a good safety precaution.

Stairways are hazardous. Light that clearly differentiates the treads from the risers—such as ceiling or wall fixtures that send even, glare-free light downward—can lessen accidents. Spotty or distracting light is dangerous and best reserved for

21.42 Lighting can extend interior space into the landscape and bring outdoor art into the home, even at night. It also eliminates the reflection seen on glass that is dark on one side. (Also see Figure 21.20.) Dennis Haworth, FASID, interior designer. (Photograph: Steve Simmons)

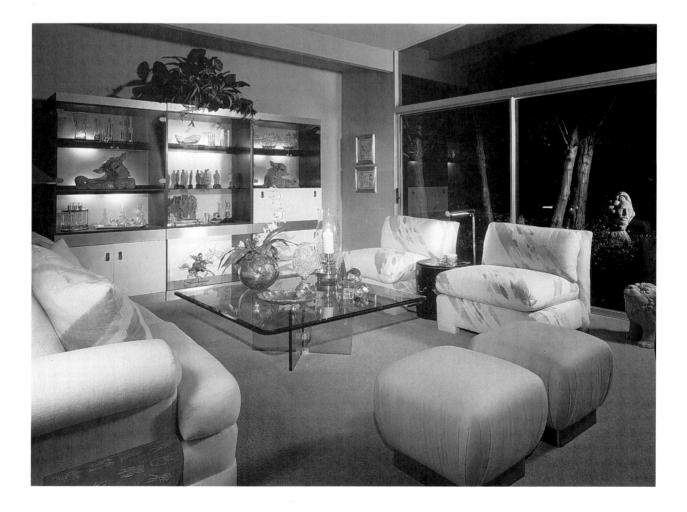

some other part of the house. Illuminate the first and last steps clearly—most falls occur there. Lighting should always be in front of the person using the stairs so that shadows do not obscure clear vision. Switches should be placed at both the top and bottom of the stair run. Portable lamps at the foot of a stairway should be placed so that the bulb is not visible to anyone descending the stairs, momentarily blinding the person.

* Exterior lighting seldom gets the attention it deserves. The minimum—seldom met—would call for illuminating the entrance of a house so that it can be recognized and the house number read from the street. Visitor and host should be able to see each other clearly in a good light at the doorway. Walkways to the street and garage should also be illuminated for safe, secure passage. Light sources should be kept out of the direct line of sight, either above or below eye level.

Terraces, patios, and gardens can be enjoyed at night, even from inside, if they are lighted. This effect has become especially important with window walls and landscape design that is integrated with the house. Seen from inside, lighted outdoor areas greatly expand the apparent size of the interior and bring some illumination into the house. Also, light outdoors eliminates the rather menacing black windows or mirror effect that results in the absence of balanced illumination. Typical solutions are weatherproof fixtures mounted on exterior walls or overhanging roofs. More elaborate installations have spotlights and floodlights concealed in the landscape. However, outdoor lighting must be handled with discretion, for high levels of illumination may seem unnatural and staged and may annoy neighbors nearby. A low glow will suffice to dispel the unwanted blackness.

It is relatively easy to focus sufficient light on work surfaces and to provide for some kind of general illumination. But a balanced combination of natural and artificial light throughout the home requires knowledge of lighting methods, techniques, and effects, careful design, and thoughtful planning for the needs of the occupants. Like other components of design, much information is needed before a systematic and effective solution can be developed.

NOTE TO THE TEXT

 Marjorie Branin Keiser, Housing: An Environment for Living (New York: Macmillan, 1978), p. 246.

REFERENCES FOR FURTHER READING

Bedell, Ben. Lighting: Watts the Matter. Interiors, April 1980, pp. 84-85, 102.

Birren, Faber. Light, Color and Environment, rev. ed. New York: Van Nostrand Reinhold, 1982.

Caringer, Denise L. and Robert E. Dittmer. Lighting: New Techniques, New Fixtures, New Looks. *Better Homes and Gardens*, September 1981, pp. 88–95.

Choosing and Using Track Lighting. Better Homes and Gardens, October 1979, pp. 54, 56. Design Criteria for Lighting Interior Living Spaces. New York: Illuminating Engineering Society of North America, 1980.

DuCrest, Robin. The Language of Lighting. *Interiors and Sources*, 6(18):66–69, November/December 1991.

Eng, Rick. Effective Lighting, Room by Room. Home, February 1991, pp. 99–101.

Faulkner, Sarah. *Planning a Home*. New York: Holt, Rinehart and Winston, 1979, pp. 101–128.

567

LIGHTING

Furnival, Lawrence. Scattering Light. Residential Interiors, August 1980, pp. 54-57, 90.

Gilliatt, Mary and Douglas Baker. Lighting Your Home: A Practical Guide. New York: Pantheon, 1979.

Guide to Portable Lamps and Lighting. Washington, D.C.: Member Services Division, National Rural Electric Cooperative Association, April–May 1968.

Hopkinson, R. G. and J. D. Kay *The Lighting of Buildings*. London: Faber and Faber, 1972.Horn, Richard. Task Lighting: Useful Hints for Lighting Up the Written Word. *Residential Interiors*, September-October 1979, pp. 114–115.

Kaufmann, John E. and Jack F. Christensen (Eds.). *IES Lighting Handbook*, 5th ed. New York: Illuminating Engineering Society, 1972.

Keiser, Marjorie Branin. *Housing: An Environment for Living*. New York: Macmillan, 1978, pp. 244–257.

Light and Color. Cleveland, Ohio: General Electric Company, 1974.

Light for Living: Guidelines to Good Lighting. Chicago: American Home Lighting Institute, 1979.

Lighting 1. Vertical Surfaces. ASID Industry Foundation Bulletin. New York: American Society of Interior Designers.

Mahnke, Frank H. and Rudolf H. Mahnke. Color and Light in Man-Made Environments. New York: Van Nostrand Reinhold, 1987.

Marshall Editions Limited (ed.). Color. Los Angeles: Knapp Press, 1980, pp. 10-23.

McDermott, Jeanne. Closeup on an Energy Specialist. *Interiors*, October 1982, pp. 94, 112, 114.

Morgan, Jim. Energy-Conscious Interior Design. *Residential Interiors*, August-September 1978, p. 30.

Nuckolls, James L. Glare-Free Workstation. *Interiors*, August 1982, pp. 74–75.

Nuckolls, James L. Interior Lighting for Environmental Designers. New York: Wiley, 1976.

Phillips, Derek. Planning Your Lighting. London: Design Centre, 1976.

Pickett, Mary S., Mildred G. Arnold, and Linda S. Ketterer. *Household Equipment in Residential Design*, 9th ed. New York: John Wiley & Sons, 1986, chap. 18.

Pile, John. Getting on With the Task. Interiors, April 1980, pp. 86-87.

Pile, John. The Lighting Direction for Health. Interiors, August 1982, pp. 34, 102.

Raymond, Betty. Interiors Report on Lighting: Making Every Lumen Count. *Interiors*, October 1979, pp. 14, 18, 22, 30.

Shapiro, Cecile, David Ulrich, and Neal DeLeo. *Better Kitchens*. Passaic, N.J.: Creative Homeowner Press, 1980, pp. 114–140.

Shemitz, Sylvan R. with Gladys Walker. Designing with Light: Tools of the Trade. *Interior Design*, September 1982, pp. 224–227.

Sorcar, Prafulla C. Architectural Lighting for Commercial Interiors. New York: John Wiley & Sons, 1987.

Furniture

SELECTING FURNITURE

Utility and Economy Beauty and Character

FURNITURE TYPES

Built-In and Modular

Beds

Seating

Tables and Desks

Storage Units

Outdoor Furniture

MATERIALS AND CONSTRUCTION

Wood

Metal

Synthetics

Upholstered Furniture

Furniture provides the major transition between architecture and people. It exists to provide comfort and function in the things we do: working, eating, sleeping, and relaxing. An easy chair and an office chair, for instance, while meant basically for sitting, differ in design because they serve different functions. Furniture also performs as an architectural element by organizing the space within a room, defining conversation areas and traffic paths, or suggesting separation of areas. Finally, furniture enables us to express individuality and personal tastes even when our homes are architecturally the same as those of our neighbors. The character of the furnishings and their arrangement are manipulated to define the types of activities and lifestyles we expect a room to foster.

Furniture has been discussed and illustrated on many of the preceding pages. Design quality, evaluation, and human factors have been addressed; furniture arrangement was considered as a factor in group and private spaces; and materials have been considered for their impact on design and use. Keeping these earlier discussions in mind, we now approach the selection of furniture with emphasis on personal values of the end-user and information regarding the various types of furniture, materials, and construction.

SELECTING FURNITURE

The vast array of furnishings currently available testifies to a wide divergence in the ways people live. There is unique furniture designed by craftsmen or designers; mass-produced and modular furniture; and antique, collectible, and reproduction furniture from which to choose. Some people find satisfaction in constructing their own furnishings and in rehabilitating furniture others have discarded or no longer need. Some existing furnishings will undoubtedly be retained when new living quarters are designed. The designer must inventory and measure all pieces that will be reused—some may need to be refinished or recovered.

In order to sort through the many types of furniture and find what will best fulfill the job, the designer should develop a scale of values that will allow evaluation of furniture as it relates to the particular necessities and aesthetics of the client. Deciding on physical requirements is the first step. Considerable thought should be given to how and in what situations the furniture will be used and who will use it. The single-person household will obviously have quite different needs than the family that includes several children and a dog.

Before selecting furniture, consideration should be given to how much space is available, what scale of furniture will relate well to the room, and possible arrangements. Alternatives should be compared and contrasted, with the strengths and weaknesses of each noted. When the opportunity presents itself, furniture

22.1 Avant-garde furniture designs explore new ideas and techniques. *Escargot* (ottoman) and *Cher Chez la Chaise* (sofa) reinterpret traditional furniture materials and construction into whimsical new forms. Jerry Goodman and Steven Charlton, designers. *(Photograph: Jeremy Samuelson)*

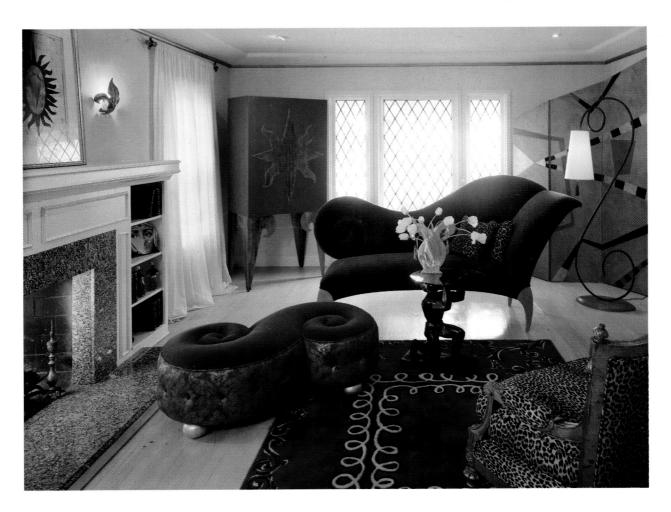

22.2 An eclectic collection of furnishings from a variety of countries, mostly dating from the 1930s, along with a new coffee table designed by Arnelle Kase, distinguish a remodeled home built in 1906 in San Francisco, California. Arnelle Kase/Barbara Scavullo Design, interior designer. (Photograph: David Livingston)

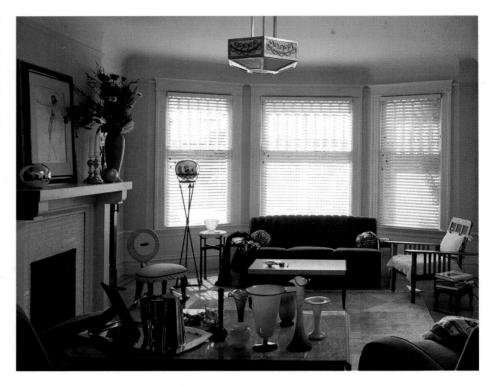

should be sat on, looked at, and felt by both designer and client to enable the designer to find out what looks good and is comfortable to the people who will be using it.

The designer looks, thinks, and compares, continually sharpening the ability to see and evaluate differences while also deciding which aspects are most important for the client's needs and personal scale of values. With some clients, comfort or beauty may transcend all other considerations, although most people seek a balance.

UTILITY AND ECONOMY

Whether furniture is for sleeping, sitting, eating, working, or playing, practical considerations should not be minimized. Important factors for function and economy are the following:

Convenience applies to efficient storage and to the ease with which oftenmoved furniture (such as dining chairs or beds that must be pulled out from the wall for making up) can be handled. Almost all furniture is moved from time to time, so it should be no heavier than necessary for use, strength, and appearance. Large pieces, especially if they are heavy, should be on casters or gliders. Mobility is a fact of life in our society, and many households must cope with packing, shipping, and resettling at frequent intervals. While this may make it more difficult to personalize a space, it does offer many individuals and designers the challenge of designing a new environment every few years.

Comfort relates to pieces on which we sit or sleep, as well as to the height of tables and desks and to the leg room under them; in other words, to design based on anthropometric data. Sometimes comfortable support overrides every other factor in choosing a particular item of furniture (the classic example is the easy chair, but the office task chair has been the subject of much research in recent years). The age of household members becomes important here, for elderly and young people have definite but quite different requirements for comfort.

Flexibility pertains to furniture that can be used in more than one room or for more than one purpose. Multipurpose and flexible furnishings permit greater freedom in adapting to new uses as needs or locations change. Built-in furniture, unless composed of modular units, cannot easily be moved or rearranged.

Space required has become increasingly important as homes have grown smaller. Accordingly, designers may eliminate protruding moldings and curved legs so pieces can be fitted together snugly; extend storage units to the floor or hang

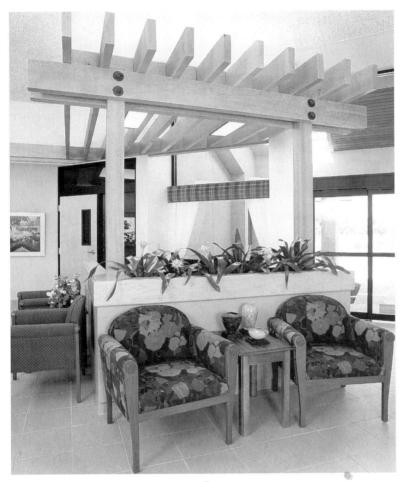

22.3 Chairs designed for the elderly must provide easily grasped arm supports for use in sitting and rising, a firm and not-too-deep seat cushion, space beneath the seat to allow use of feet and legs to assist in rising, and stable footing so that the chair does not move away while sitting or rising. Chairs in the lobby of the San Joaquin Gardens retirement community in Fresno, California, were chosen to meet these requirements and to visually contrast with the surroundings. Temple Anderson Moore, architects; Pat Hennings, ASID, and Laura Watkins, ASID, interior designers. *(Photograph: Scott Zimmerman)*

22.4 (below) Console tables, hinged so that they can be folded flat against the wall, are designed to look like pieces of abstract geometric art when not in use. Bruce R. Benning, ASID, interior designer. (Photograph: Cathy Kelly)

22.5 Space-saving storage and work surfaces are often built in or attached to walls to eliminate bulky free-standing case pieces. Wine storage can be conveniently tucked away under a cantilevered serving counter which does not appear to take any space because it has no supporting legs to occupy the floor area beneath it in a small apartment in Greenwich Village, New York. (Photograph: Paul Warchol)

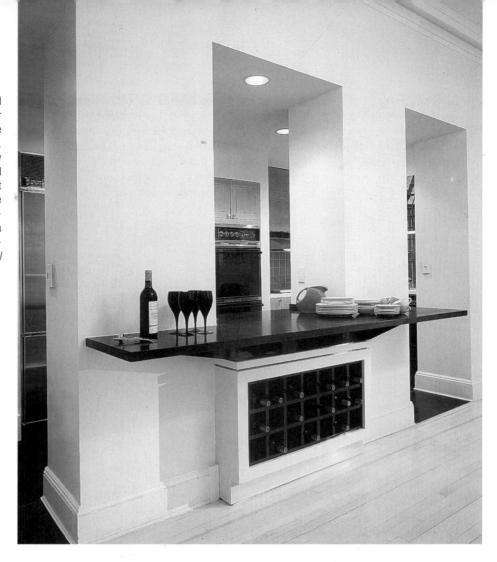

22.6 "Peacock," a chair designed by Hans J. Wegner in 1950, has become a modern classic and is still in production today. (Courtesy Design Selections International, New York)

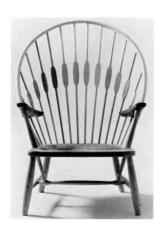

them on walls; design closets, cupboards, and drawers to fit their contents flexibly; employ materials—metal, plywood, foam—that reduce size; develop folding, stacking, and nesting tables and chairs; and, in some cases, reduce size, weight, and scale to a minimum.

The concept of modular and built-in furnishings has had great impact on the space in homes. By eliminating the separate piece of furniture that must stand alone, designers utilize the in-between spaces, so that *more* furniture requires *less* floor area is also freed when furniture is attached to walls.

Length of service depends on both physical and psychological durability. The physical life of furnishings, of course, is determined by materials, construction, finish, and use. Psychological longevity, while equally critical, can be harder to appraise. A fine piece of furniture may last for generations, but the homeowners may grow weary of it within a year or two. The length of service each article is capable of giving should depend somewhat on the length of service that will be required. An inexpensive bit of whimsy can occasionally brighten the home, but when investing in basic articles of furniture, it is far better to choose well-made, well-proportioned items in which the materials have been honestly and suitably used. Designs which have an exceptional capacity for standing the test of time are called classics—their beauty and character are as much appreciated today as when they were first designed, perhaps even more.

Cost of maintenance includes cleaning, repairing, refinishing, and reupholstering. The choice of appropriate materials can lighten cleaning burdens, while strong materials and firm construction lessen the need for repairs. Durability of finish and ease of refinishing are important: Painted furniture, whether wood or metal, needs new paint every few years; transparent finishes on wood, supplemented by wax or polish, last a long time, and some of the new synthetic finishes reportedly are almost indestructible. Such materials as aluminum and chromium can last indefinitely without being refinished. Upholstery fabrics may serve from one to twenty years or more depending on the material and the wear it is subjected to. Several factors govern the cost of reupholstering: the price of the fabric, the amount of fabric needed, and the labor involved. The use of zippered covers facilitates both cleaning and recovering.

BEAUTY AND CHARACTER

Whether furnishings have beauty and character depends on an entirely subjective appraisal, because individuals vary so markedly in their tastes. The concept of different standards of beauty has already been discussed. Insofar as furniture is concerned, some people consider beautiful only the most streamlined, ultramodern designs, while others prefer the grace and charm of antiques (Figure 22.7). There are also many good contemporary reproductions of classic pieces. Beyond style, other alternatives exist: the beauty of natural or man-made materials; the clarity of primary colors (Figure 22.8) or the subtlety of neutrals; the precision of geometric order or the opulence of flowing curves. There are, indeed, many contrasting styles and tastes. At a time when more and more people live in architecturally similar spaces, it is more important than ever for the designer to

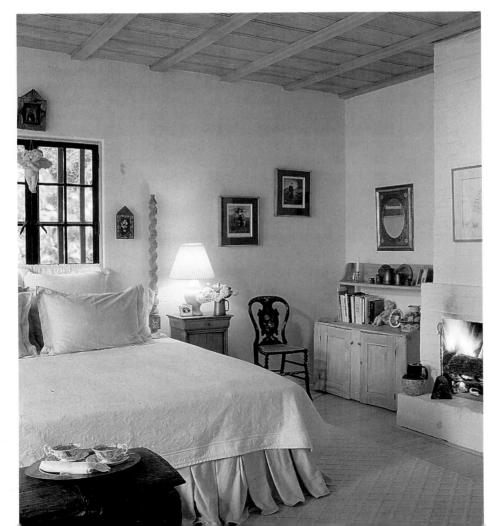

22.7 A rural home in Woodside, California, has been remodeled but with its 1920s Spanish Colonial Revival style and charm intact, making it a perfect match for the homeowner's collection of antique furnishings and folk art from Mexico, South America, and elsewhere. Timothy Pflueger, original architect; Marie Fisher, interior designer. (Photograph: David Livingston)

22.8 Easy chairs designed by Michael Graves in the 1980s seem quite companionable in a setting from an earlier age. (Photograph: Bill Kontzias. Courtesy Domore/DO³)

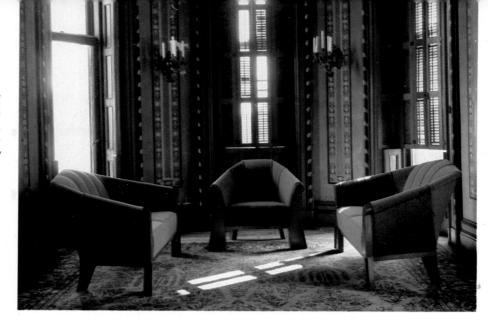

work closely with clients to choose furnishings that will individualize a space and make them feel they are coming home—not to an impersonal and indifferent environment but to their own personal retreat, which gives them the freedom to expand mentally, psychologically, and spiritually.

Aesthetic aspects of furniture can be evaluated more objectively using the criteria presented in Chapter 3 and the time-tested principles of design: balance, proportion, scale, rhythm, emphasis, and harmony.

FURNITURE TYPES

The first furniture probably consisted of a natural rock ledge found in a protected spot and used for sitting or sleeping. In effect, this was "built-in" furniture, the prototype of units integrated with the architectural shell that we are accustomed to today. Historians theorize that the earliest individual pieces of furniture were hammocks and mats for sleeping, which in colder climates would have been made of skins, in warmer climates of grasses and reeds. During the seventeenth and eighteenth centuries, comfort became important, with the result that human scale, form, and activities were reflected in furniture design and that many new furniture pieces were developed to meet specific needs. From these ancestors the myriad of furniture articles we know today evolved.

BUILT-IN AND MODULAR

Once established, the preference for isolated furniture prevailed well into the nine-teenth century. Even clothes closets were unknown, and people stored their garments in bulky wardrobes or chests. (Chests were very important furniture articles because people were accustomed, from medieval times, to fleeing from their enemies with all their belongings in tow, and, once relocated, the chest could serve as table, chair, and storage piece, all in one.) Then, in the late 1800s; designers began to use walls more intensively, and by the early twentieth century built-in furniture had staged a revival that is still vigorous today. Combined with the interest in furniture that is at one with the architecture is the development of modular *unit* or *component* pieces, which in a sense offer a compromise between built-in and individual furnishings. Unit furniture organizes a variety of furniture elements into a cohesive structure.

Built-in furniture promotes flexible living, although this may seem like a contradiction. Because the furnishings take less room than movable pieces, they leave a maximum amount of free space around and between them. Built-in furniture can also give a feeling of permanence and security and break up the boxiness of typical rooms. At the same time, it reduces the visual clutter of many isolated separate pieces of furniture. Many people trace the current interest in built-in furniture to Frank Lloyd Wright, who early in his career began thinking of the house as a unified whole, with storage, seating, and tables forming an integral part of the architecture (see Chapter 2). Built-in furniture may make it difficult to tell where architecture leaves off, so thoroughly may the two be integrated. This concept of total, unified design appeals to our sense of harmony and order.

Like built-in furniture, modular or *systems* furniture answers a desire for coherence and spaciousness. Modular furniture, however, offers the added advantage of mobility and flexibility. The component pieces may be assembled into varying units, changed at will, and used wherever needed. Built-in and component furniture will be referred to again in relation to specific types of pieces.

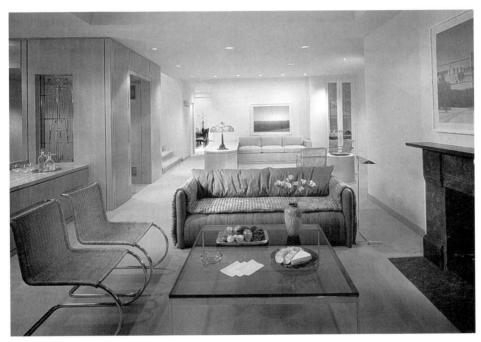

22.9 A Chicago, Illinois, brownstone was remodeled for large group entertainment with two seating areas, one of which is built in with a storage unit at its side that also serves as a boundary for the traffic corridor. A buffet/storage area is also built in opposite the fireplace. Vintage Frank Lloyd Wright leaded glass, a Tiffany lamp, a Dunbar sofa designed by John Saladino, Miës chairs, and a Cedric Hartman reading lamp comprise the classic furnishings. Hancock & Hancock, Inc., interior designers. (Photograph: Hedrich-Blessing)

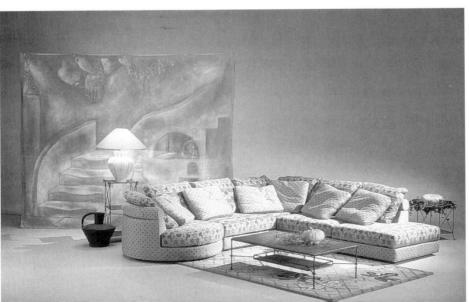

22.10 Modular furniture pieces can be combined to form a single cohesive unit, used individually, or grouped into different configurations of two or three as needs and preferences change. (Courtesy Roche Bobois)

22.11 •A custom-designed bed with posts of Lucite and brass refracts light from the setting sun to project rainbows on the walls of a South Lake Tahoe, Nevada, master bedroom. Rae Designs, interior designer. (*Photograph: Ed Asmus*)

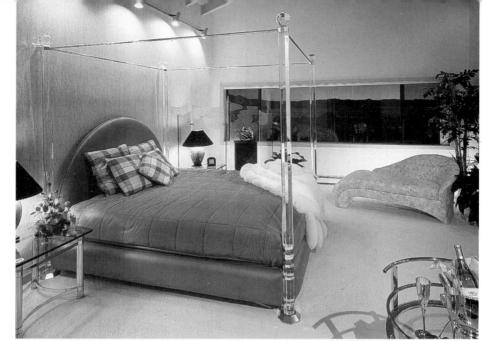

22.12 A built-in platform bed can provide numerous amenities, including seating, storage, and various security, communication, media, and lighting controls, in addition to making an aesthetic statement. Carol J. Weissmann Kurth and Peter C. Kurth, architects and designers. (Photograph: Peter Mauss/ESTO)

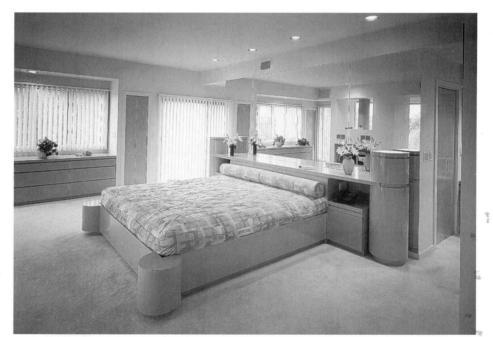

22.13 A Murphy bed can be excellent in a home office that doubles as an occasional guest room. When not needed, it folds completely out of the way. (Courtesy Murphey Bed Co., Inc.)

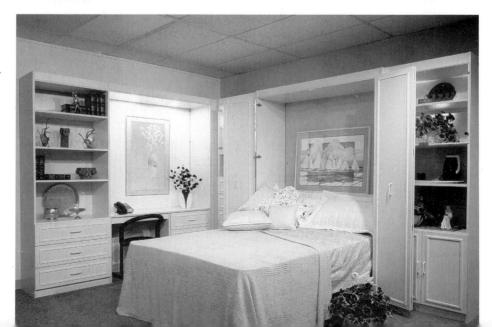

BEDS

Reducing physical strain to a minimum is the major purpose of beds. Individuals vary in their specific ideas about sleeping comfort, so the only real way to find out whether a bed is right for the intended user is to try it. The typical foundation consists of a spring unit on a simple metal or wood frame, but a platform foundation can also be comfortable and some elaborate bedsteads may have traditional head and footboards, posts, canopies, or testers (wood or fabric canopies suspended from the ceiling or attached to a fourposter bed) while contemporary designs may include storage, lighting, mirrors, and bedside table surfaces.

Built-in and **platform beds** offer a certain reassuring protectiveness and may bring many conveniences close to hand—lighting, possibly a slanted end for reading in bed, bookcases, media controls, surfaces on which to place things (Figure 22.12). Difficulties lie in moving the bed and in making it. In small quarters or for occasional guests, **sofabeds** or even **futons** make a sensible economy. Also, various types of **bunk beds, fold-down beds** (Murphy beds), and **trundle beds** can be excellent space-savers.

SEATING

The greater part of most people's waking hours is spent sitting down. We work, study, relax, eat, and travel in a seated position. Leading such sedentary lives, we should be expert sitters; but we are not, and seating is rarely custom-designed to fit the size and shape of just one person although some pieces are adjustable, allowing the user to make accommodations to individual stature. Manufacturers of office seating have conducted a considerable amount of research into seating and working at the computer, resulting in the development of furniture that is ergonomically designed. We know from anthropometric data that maximum comfort results when weight and pressure are distributed and tension eased by having

- the height of the seat somewhat less than the length of the sitter's lower legs, so that the feet rest on the floor and the legs can be relaxed;
- the depth of the seat a bit less than the length of the upper leg to avoid putting a pressure point under the knee;
- the width of the seat ample enough to permit some movement;
- the seat shaped or resilient, so that pressure is not concentrated on the small weight-bearing edge of the pelvis;
- both seat and back tilted backward slightly to buttress the weight;
- the angle between seat and back 95 degrees or more;
- the chair back in a position to provide lumbar support;
- the position of the seat and back adjustable for different people (as in ergonomically designed office chairs) or for different ways of relaxing (as in the early Morris chairs and many new reclining chairs); and
- a place to rest the head and relax the neck, plus supports for arms.

The wing chair was one of the first types of seating devised for comfort. Over the years many variations have appeared. A contemporary design by Charles Eames (Figure 22.15) resulted from a thorough exploration of new and old materials and techniques and a detailed study of sitting comfort, which showed that flexibility is essential. The Eames version has been so successful and has achieved such wide popularity that innumerable copies have appeared over the years.

Chairs serve a number of purposes, and their forms should mirror their functions. In the group space, in a study, and in bedrooms if possible, it is desirable to have seating that allows each person who regularly uses the room to relax completely for reading or simply for a brief "quiet time." The Eames chair and other

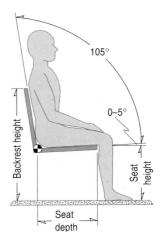

22.14 Even a chair intended only for brief periods of use should accommodate the human form comfortably. A seat 17" high will accommodate most adults; 16" or lower would be more comfortable for smaller users. The seat width should be about the same (16"–17"); the seat depth, 15.5"–16". The top of the backrest should be 31"–33" high. (From Human Dimension & Interior Space by Julius Panero and Martin Zelnik)

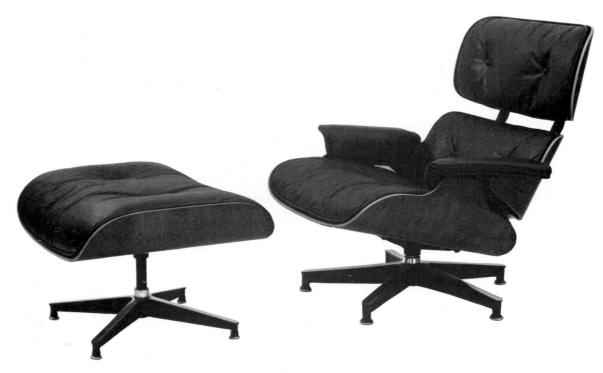

22.15 (above) Charles Eames' swivel lounge chair (c. 1957) of molded rosewood with cushioned leather upholstery adjusts to many positions; with the ottoman, it promises complete semi-reclining luxury. (Molded plywood shells of rosewood on cast aluminum swivel bases; seat and back cushions of feather, down, and foam rubber, covered with black leather. Chair: 33 ½ " × 32"; ottoman: 15½" × 26" × 21". Manufacturer: The Herman Miller Furniture Company, Zeeland, Michigan. Collection, The Museum of Modern Art, New York. Gift of the manufacturer.)

22.16 (left) A conversation area should contain enough comfortable seating for household members plus the number of guests most frequently entertained. Smaller side chairs may be pulled into the group when additional seating is needed. Michael Graves, architect. (Photograph: Mick Hales)

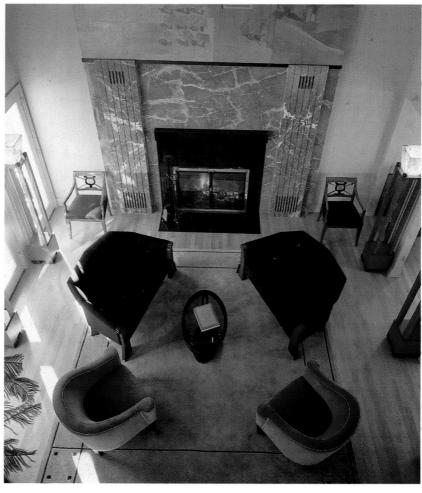

22.17 "Champs," a post-modern sofa, is bulky but not heavy in weight because of foam cushioning materials. (Courtesy Donghia Furniture)

types of reclining furniture meet this specification, as do many sofas and well-cushioned chairs, which adjust to varying individuals and are comfortable over long periods. Padded upholstered chairs and rocking chairs have long remained favorites for relaxing, but new designs expand the range of flexibility for "supercomfortable" chairs. Also, new types of springs and foams have greatly decreased weight, making possible pieces that are trim and neat, or even bulky but still movable.

Talking, listening to music, watching television, and similar pursuits can be enjoyed in the kinds of seating described above, but smaller side chairs that are fairly easy to move and give good support make helpful adjuncts. Such chairs can have shaped seats of wood, metal, or plastic, or they might be lightly upholstered, webbed, canvas-covered, or caned. Whatever the material, these chairs should be easy to grasp, light to lift, and strong enough to withstand frequent moving.

Dining, working, and games require sturdy, easily moved chairs with relatively upright backs to keep the sitters alert; seats and backs that are shaped or lightly padded to lessen pressure; and upholstery that resists abrasion and soil. The most frequently used group dining space should have enough chairs or built-in seating always ready to accommodate the entire household, but it is helpful to have pull-up chairs to bring out for larger gatherings.

The inclusive term *sofa* refers to a seat for two or more people, but many other names are or have been applied to such pieces of furniture. Some are used interchangeably, but the various terms may convey different shades of meaning:

- Chesterfield refers to an overstuffed sofa with upholstered ends.
- Couch originally meant a long upholstered piece with a low back and one raised end for reclining.
- Davenport is used in the United States to describe an upholstered sofa often convertible into a bed, but originally the word designated a small writing desk named after its maker.
- **Divan** is a Turkish term for a large, low couch for reclining without arms or back that developed from piles of pillows placed on a bed-like mattress covered with rugs.
- Lounge once referred to a type of couch with no back but with one high end for reclining. Today the term indicates either a flat, padded surface on which to stretch out or any supercomfortable seating unit that invites relaxation.
- Love seat means a small sofa or "double chair" for two people.
- **Settee** refers to a light double seat with a back and sometimes with arms, often lightly upholstered.
- Settles are all-wood settees, used in Colonial days before a fire to trap heat with their high backs.

22.18 A favorite since its conception in 1925 by designer Josef Hoffmann, the *Prague* bentwood armchair is a comfortable and handsome pull-up chair for many uses. (*Courtesy Stendig, Inc.*)

- **Sofa** comes from an Arabic word; in the United States it describes any long upholstered seat for more than one person. A **tuxedo** sofa has arms and back of the same height; a **Lawson** has arms lower than the back.
- Convertible sofa, sofa-bed, sleeper, or studio couch refers to a dual-purpose unit used for both sitting and sleeping.
- Sectional units or modular sofas have separate pieces easily assembled into various and changeable sizes and shapes or separated into individual chair units.
- Seating platforms often look built-in because they merge with the floor and wall.
- **Floor pads** are mattresses placed directly on the floor, often heaped with cushions, for relaxed lounging. If they can be folded over or rolled up to form seating units, they may be called **futons** after the traditional Japanese sleeping pads.

The variety of sofas is legion: straight, curved, or angled to fit a room; with or without arms; in one piece or sectional modules; long enough for a tall person to stretch out on or more modest in scale; heavy and massive, delicate and graceful, or light and simple. The functions the sofa is expected to perform will guide selection. In different situations individuals will need a sofa

22.19 Sofas are available in many varieties to suit most needs and styles of design.

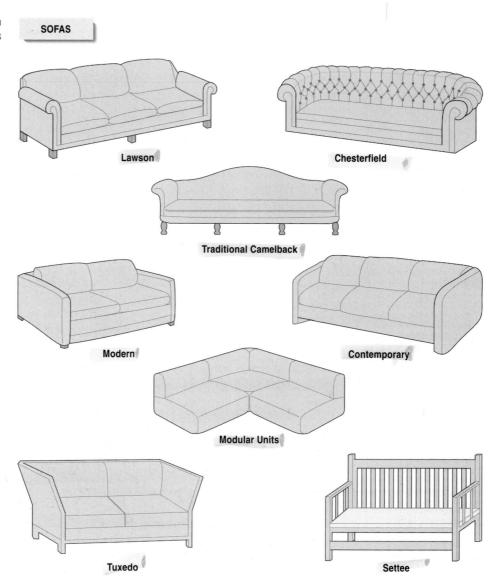

- long enough to stretch out on—6 feet or longer for most people (standard sofas are 84 inches long; full-sized sofas are 72 inches; loveseats 60 inches);
- low and deep enough for relaxation, but high and firm enough so that most people can get up under their own power;
- fitted with arms for comfort;
- convertible into a bed if extra sleeping space is required;
- modular if flexibility or mobility is a necessity; and
- upholstered for comfort in a material that combines beauty and durability.

TABLES AND DESKS

The essence of table design calls for supporting a flat surface at a convenient level above the floor. There are problems, however, in all table design, and these include providing for

- necessary strength and stability;
- supports out of the way of feet and legs;
- the right height, size, and shape for intended use; and
- durable materials.

As with chairs, each home needs a variety of tables that differ in function and therefore in size, shape, height, and materials. Sit-down meals require a table that is sturdy enough not to be jarred by the unpredictable movements of children or the force of someone carving meat, with a top large enough to give each person at least 2 feet of elbow room and high enough to allow leg room between the chair and the table apron, with supports out of the way of sitters' feet and knees, and with expansion capabilities, if necessary. Rather than extending a table, more than one can be used for a larger group if space is available.

The surface of a dining table will be an important feature in its selection; consider the durability, ease of maintenance, and beauty of the top surface (Figure 22.20). Wood, plastic, and glass are commonly used materials. Choice depends on use, effect desired, and price.

22.20 A glass table top lightens a dining space, adding sparkle and the weightlessness of transparency. For safety and durability, tempered glass with polished edges is recommended. (*Photograph: Esto Photographics Inc.*)

22.21 An extension table can expand to accommodate additional guests when necessary without being permanently too large for more frequent, smaller groups. (Courtesy Baker Furniture, Historic Charleston Collection. Photograph: Aves Advertising, Inc.)

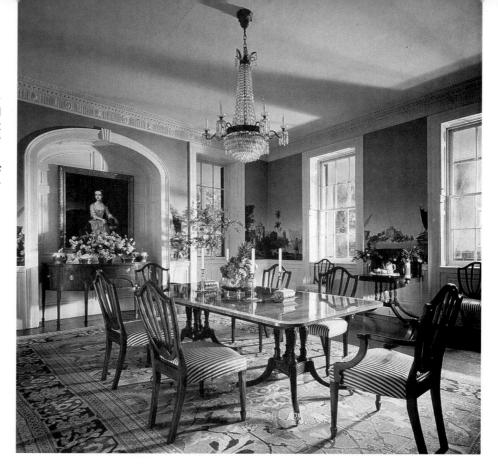

Shape is the other major consideration in choosing a dining table. Most are rectangular, because a basically squared shape harmonizes with rectangular rooms and can be pushed snugly against a wall or into a corner. In the right place, however, a round or oval table will give an inimitable friendly feeling. A polygonal or odd-shape table makes a refreshing change. Table shape also influences communication between those seated around it; round tables promote interaction among all parties unless they are too large for easy interaction (King Arthur's legendary round table was fabled to encourage all to interact with equal status, having no "head"). At square and rectangular tables, again depending upon size and proportion, communication tends to be across the table. When these typical patterns do not occur, people converse with those adjacent (corner to corner) or next to them.

Many kinds of rectangular, round, or oval tables can be extended with leaves—the round thus becoming an oval. *Drop-leaf tables*, in use since Elizabethan days, expand or contract with ease. Some contemporary *folding tables* can be compacted to 9 inches or stretched to 110 inches, the latter dimension providing space for fourteen people. *Extension tables* should be checked for ease of manipulation and stability when extended.

It is important to check proposed dining chairs and tables together because their legs often interfere with each other, the heights of the two may not be coordinated, or the space between seat and apron may be insufficient.

Convenience seems to demand a horizontal surface, however small, within reach of seating. Coffee tables placed in front of seating need to allow access and give foot room in front of chairs or sofas (18"), and be in scale with them. Occasional tables seldom interfere with the legs of sitters and may provide shelves or drawers for supplementary storage. They look better if they are of the same height as the arms of upholstered sofas and chairs, but a slightly lower or higher level makes for greater convenience and diminishes spillage of beverages. Occasional tables often hold lamps. Nests of tables, the top one acting as an end or coffee table, simplify flexible entertaining, as do stacking tables. Console or sofa tables are higher, longer, and designed to fit against a wall or sofa back.

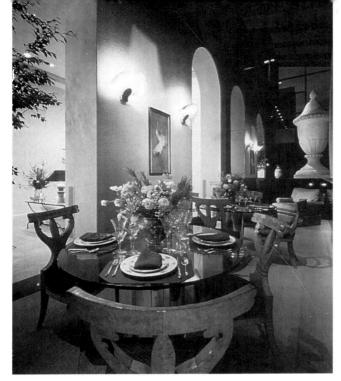

22.22 (left) Dining chairs need not match the table, or each other, if heights, legs, and styles are compatible and interesting together like these contemporary glass tables and antigue Biedermeier chairs, combined in a New York duplex apartment by Arnold Syrop, architect, and Joanne Syrop, interior designer. (*Photograph: Peter Paige*)

22.23 (below, left) Tables in a conversation area provide convenient surface on which to place books, refreshments, and accessories. A coffee table should allow ample leg room and be appropriately scaled for the seating group. Robert A.M. Stern, architect. (Photograph: Timothy Hursley)

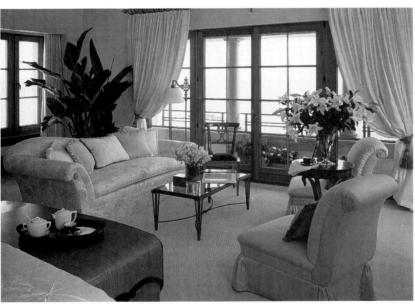

22.24 (below, left) A sewing table with functionally planned drawers and drop leaves can double as an occasional table almost anywhere in the house. Hans J. Wegner, designer. (Courtesy Design Selections International, Inc.)

22.25 (below, right) Nesting tables are especially useful in small quarters where they can be pulled out as a serving surface or separated as individual tables to accommodate several guests. Josef Hoffmann, designer. (Courtesy ICF Inc. Photograph: Peter Paige)

Most people find it more comfortable to play cards and other games at tables several inches lower than those meant for eating. Collapsible card tables are ideal for occasional games, bridge luncheons, buffet suppers, and supplementary serving at festive dinners. Space permitting, a permanent card table with at least two chairs always handy could be a fixture in any household where games or casual eating occur frequently.

An efficient desk has two essential properties: a suitable surface for writing and/or typing and computer use, and convenient and accessible storage for papers and supplies. It should be obvious that every household needs at least one good writing place, but the size, complexity, and location of the unit will depend on individual design program requirements. A desk can be a table with only one or two drawers, a compartment in a modular unit, or a piece of furniture designed for serious work such as a computer workstation or drafting table. It may be located in the kitchen, study, bedroom, or any other room that provides the privacy and space needed. The surface should be steadily supported at a convenient height for the person who uses it most often and for the kind of use it receives. (Various work surface heights were detailed in Chapter 11.)

STORAGE UNITS

Storage is a design need for most clients. Living quarters have steadily become smaller, while attics, spare rooms, and basements are no longer taken for granted as bonus storage space. More people have more things to put away and less time in which to do it. Having the proverbial "place for everything" simplifies house-keeping, conveys a sense of order, and makes the most of limited space.

A total concept of household storage goes beyond furniture, because efficient storage is part of the architectural design. As much thought should be given to storage in all parts of the home as is typically devoted to the kitchen. Convenience, visibility, accessibility, flexibility, and maintenance are just as important in group spaces and bedrooms.

22.26 A desk or work surface in a home office can be fitted to whatever space is available as long as it meets the needs of activities to be completed. Architect Annig C. Sarian uses a corridor for a study library in his Milan, Italy, apartment. (*Photograph: Alberto Piovano/Arcáid*)

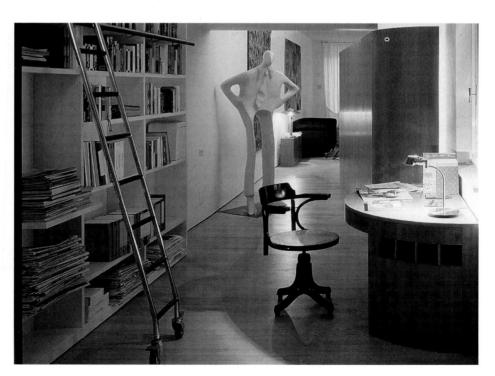

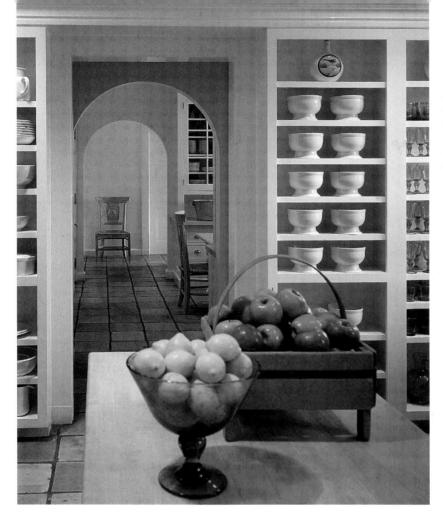

22.27 Simple, open shelves reveal artfully arranged serving dishes and glassware at a glance in a remodeled home from the 1920s in Atlanta, Georgia. A butler's pantry in the adjoining space contains more conventional closed cabinets and drawers. Jacquellynne P. Lanham, interior designer. (*Photograph: Mick Hales*)

The simplest pieces of storage furniture are shelves. Despite the fact that books, stereo components, televisions, art objects, and miscellaneous items to be housed come in many different sizes and shapes, easily adjustable shelves can store them efficiently. Items on open shelves do collect dust, but they can make a handsome display, absorb noise, and some, such as books, even add insulation on exterior walls. Stability and flexibility are the critical factors in shelving. Home entertainment centers are available in ready-made units or modular systems, or they can be custom-designed to the client's needs.

Nearly every room can profit by some book and magazine storage. In the kitchen a single shelf may store cookbooks, while a bookcase or a few shelves in the living areas and bedrooms may suffice to hold current reading materials. The principal center for the household's collection of books could be the living room, dining area, study, family room, or even a separate library or gallery. Low bookcases can double as table surfaces and, if sufficiently long and well planned, can unify a wall. A bookcase that reaches to the ceiling often becomes a forceful architectural element. Shelves can frame and relate doors and windows or serve as free-standing partial or complete dividers between two rooms or parts of a single room.

Although they appear infrequently outside kitchens, dining spaces, and bathrooms, closed storage cabinets are welcome in every room. Doors on cabinets present the same problems as doors between rooms. Swinging doors operate easily and accept shallow storage racks on the back, but they get in the way when open. Sliding doors open only part of the cabinet at a time, sometimes jam, collect dust in tracks, and allow for no door-back storage. When space in front of cabinets is at a premium—or when doors are left open while people move about—sliding

22.28 A fireplace set into a fanciful arabesque-sculpture chimney breast is an eye-catching focal point in a room lined with bookshelves. Jefferson B. Riley of Centerbrook, architect. (Photograph: © Norman McGrath)

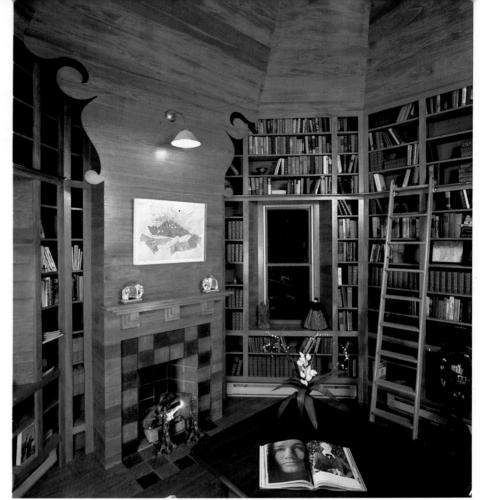

doors offer a good solution, but in other places swinging doors have distinct advantages. In some cases, doors can swing open, then slide out of the way into a pocket along the edge of the cabinet. These work especially well for cabinets which house a television or sound system (Figure 22.29). Audio-visual equipment is often integrated with cabinets and bookshelves or built into the wall.

The chest was the original piece of storage furniture, a simple multipurpose box that could be moved with relative ease. (Sliding drawers were not widely used until the seventeenth century.) Chests of drawers work best when they have strongly joined, dustproof drawers that slide easily on center guides, drawer stops to prevent them from falling out, and handles that can be grasped without difficulty. Shallow drawers with flexible dividers at the top of chests are a great convenience.

Relatively small storage components that fit together increase flexibility of placement. Drawers combined with shelves and/or cabinets and compartments of different sizes can store a multitude of variously shaped items as can be seen in the many storage systems now on the market.

OUTDOOR FURNITURE

Interest in outdoor living has led to many kinds of weather-resistant furniture in a surprisingly wide range of materials. Redwood, cedar, and cypress are long-lasting and attractive. Aluminum never rusts, stays cool in the sun, and is light in weight. Wicker and rattan bring the charm of natural materials to an outdoor living area and are often used indoors as well. Newer plastics and resins withstand weathering very well.

Tables present no special problems, nor do the frames of chairs and chaises, but it is not easy to make upholstery both weatherproof and resilient. Few springs, cushions, and pads remain unharmed by an excess of water, although some plastic materials can take moderate amounts.

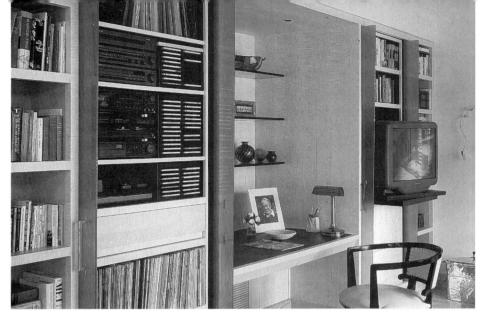

22.29 Television and stereo equipment, located in a library/study, can be fully visible and accessible or kept behind doors that pull out of narrow pockets. When opened, as shown, the doors are out of the way of slide-out shelves. Scott Johnson and Margot Alofsin/Johnson, Fain & Pereira Associates, architects and designers. (Photograph: Tim Street-Porter)

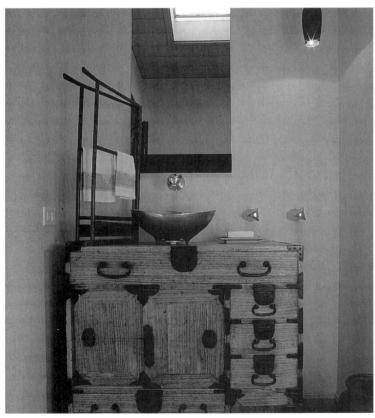

22.30 A chest is a versatile piece of furniture that can function anywhere in the home as shown by this unusual use of a Japanese Meiji period tansu as a washstand. The towel bar is a Japanese obi rack. Chadine Flood Gong, interior designer. (Photograph: David Livingston)

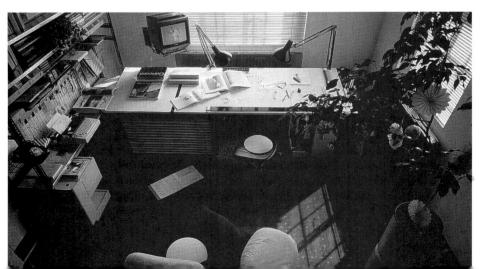

22.31 A free-standing metal storage unit offers flexibility and a variety of attachments to house a miscellany of supplies and equipment in the home office of architect Eva Jiricna's North London apartment. (*Photograph: Richard Bryant /Arcaid*)

22.32 Powder-coated extruded aluminum frames and contour mesh padding with channel quilting and a layered backrest make *Legend* an award-winning design in outdoor casual furniture. (Courtesy Brown Jordan)

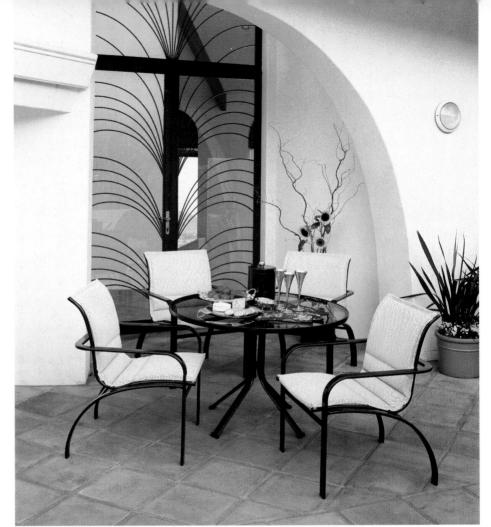

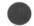

MATERIALS AND CONSTRUCTION

When buying new furniture the manufacturer's specifications and guarantees should be reviewed to verify quality. It is also advisable to look at every piece of furniture from literally every angle; to get all possible information from the salesperson; and to purchase only from manufacturers, wholesalers, or retailers who stand behind their merchandise. Furniture can be no better than the materials, the joinings and the finishes that go into its makeup. Some preliminary test questions include the following:

- Does the piece stand firmly on the floor and resist efforts to make it wobble? This is particularly important in tables (even more so in expandable ones), as well as in desks and chairs.
- Do all movable parts, such as drawers and drop leaves, operate easily and steadily?
- Are all joints tightly and smoothly fitted together with some type of interlocking construction?
- Is the finish durable, smooth, and evenly applied? Is it composed of one or many coats properly applied or of one or two coats that look thick and gummy in any crevice or indentation?

Having answered these questions, the points of greatest wear and stress should be examined.

Flat surfaces—tops of tables, desks, counters, bookcases, cabinets, and chests—should resist scratching, denting, breaking, staining, and wetting. Properly finished hardwoods generally prove satisfactory if kept reasonably free from liquids. Plastic finishes on wood are durable, some exceedingly so; however, the problems of refinishing such surfaces have not been solved completely. Vinyl tiles or sheets provide quiet surfaces and good resistance to stains and cuts, while plastic laminates are even more durable but noisier. We have not yet come to the point of considering wear on plastics as a plus factor, as we may on wood that shows its age but has been lovingly cared for or restored. Glass is light and airy but presents a breakage hazard; it also requires almost constant cleaning. Acrylic is less subject to breakage but may scratch more easily. Marble and other stone, although rich, are exceedingly heavy and make a noisy surface that can break and stain. Their weight must be taken into consideration in the construction of both furniture pieces and, if large, the floor on which they rest.

Edges of tables, doors, and drawers are the points most easily nicked and marred. All but the most durable materials will show wear, but hardwood or replaceable metal or plastic strips help. Bullnose edges soften the harshness of standard 90-degree-edge angles and, when made of solid wood, are more durable for vulnerable edges.

Runners of drawers should be made from hardwood, plastics, or noncorrosive metals since they receive the wear from sliding open and shut. Large or heavy drawers are best suspended on rollers and tracks.

Hardware—drawer pulls and handles—should be easily grasped and hinges should operate smoothly, closing securely with little effort. Hardwoods and mattefinish metals are still the most serviceable materials, but plastics now have taken over a portion of the field. Hinges should be of the best possible quality and securely fastened into a base material hard enough to hold screws under strain. Plastics have one important advantage in furniture manufacture in that functional devices can be part of the unit itself, rather than being applied, which makes them much more durable. Of course, if self-handles and hinges should be broken, repair might be difficult or impossible.

Legs and bases can suffer less damage from normal use and housekeeping by minimizing the number of parts that touch the floor and using medium-dark wood, plastic, or metal, with finishes that do not scratch or chip readily.

The following sections list the virtues and drawbacks of various materials for furniture and the ways in which these materials are fabricated.

WOOD

The standard furniture material, wood should be thoroughly dry and of a variety that is stable in size and shape to minimize shrinking, swelling, and warping. Each wood has its own qualities, and the knowing craftsman may combine several kinds in one piece. Structural parts need not take a good finish but are best when of strong kiln-dried hardwood such as ash or birch. Exposed surfaces ought to wear well, be hard enough to resist scratching and denting, have a pleasant finish, and be beautiful in themselves; walnut, oak, maple, birch, beech, pecan, cherry, teak, and mahogany display these qualities and are the most commonly used hardwoods for visible parts. Redwood has a pleasant color and withstands weather, but it is soft and splintery. Other softwoods, including pine and cedar, are sometimes used in simple country pieces or utility furniture. (The qualities of various woods and finishes are presented in Tables 15.1 and 15.2, pp. 354 and 369.)

The term *solid* means that the furniture (at least all exposed parts of it) is made of whole wood, having no veneer. *Genuine* means that all exposed parts are made from a single kind of wood, with veneer on flat surfaces and solid wood structural.

22.33 The way in which wood is join critically affects the durability and appearance of furniture. The most typical joints are shown.

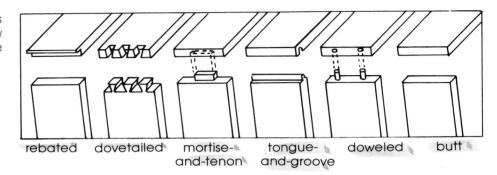

supports such as legs. *Veneer* refers to a thin slice of finishing wood that is adhered to a body of less refined wood, perhaps even of several layers of wood, known as *plywood*. (The characteristics and advantages of the various forms of wood are discussed in Chapter 15.) Hard-pressed *composition board* or *particleboard*, manufactured from wood fibers and covered with laminates, veneers, or resins, is frequently used for table tops and the flat sides of case pieces. Backs of chests and parts of drawers use particleboard without any surface material over it. The major drawbacks to composition board are its limitations in repair and refinishing and its toxicity. The Federal Trade Commission prohibits misleading labeling regarding both construction and composition of furniture.

Wood in furniture can be joined in a number of ways (see Figure 22.33):

- Rabbeted or rebated joints have a groove cut from the edge of one piece to receive the other member.
- **Dovetailed** joints have flaring tenons (or tongues) on one piece and mortises (or grooves) on the other. They are used in good drawer construction.
- Mortise-and-tenon joints have a mortise (a hole or cavity) in one piece of wood into which a tenon (projecting piece) cut in the end of the other fits securely. They are usually stronger than doweled joints.
- **Tongue-and-groove** joints resemble mortise-and-tenon joints except that the tongue and groove extend the width of the boards.
- **Doweled** joints have wooden pegs (or dowels) inserted into holes in the two pieces of wood to be joined.
- Miter joints have edges cut to meet at a 45-degree angle and must have reinforcement such as screws or metal *splines* straddling the joint.
- **Butt** joints are the simplest and the weakest; they have no place in furniture unless reinforced with *corner blocks*.

Most joints need glue to reinforce them, and synthetic resins have joined the older vegetable and casein glues for this purpose. Frames of chairs, sofas, and case goods also require triangular wood or metal corner blocks tightly screwed and cemented in place for reinforcing. Screws strengthen joints much more than nails do.

Until a few decades ago wood joints were among the highlights of a fine piece of furniture—the sign of a master craftsman. After a period in which joinings declined in both interest and quality, we are now beginning to see again the emphasis on wood joints as things of beauty and structural design. Some of the newer knockdown furniture does away with rigid joints so that the pieces can be easily disassembled for moving.

Most case goods, including chests, bookcases, cabinets, desks, tables, and chairs with no upholstered parts are made of wood. However, other materials are becoming increasingly popular.

METAL

Mass-produced metal furniture is relatively inexpensive, which is a factor in its popularity. Designers exploit metal for its inherent structural properties, finding it uniquely suitable for pieces that are strong and durable but not bulky. Steel is widely used for legs and frames of chairs, tables, and storage units. Rods, tubes, and sheets of steel can be coated with any color, and some metallic enamels have a soft but rich glow. Chromium plating gives lasting protection and surfaces that range visually from glittering hardness to pewterlike mellowness. Stainless steel requires no finish and can be left natural.

Notably different from the earlier "pipe and angle-iron" designs are those based on the sculptural potential of metal. In the hands of a sensitive designer steel wire becomes an inspirational, responsive medium for chairs that are both graceful and comfortable. Lightweight, rustproof, and cool to the touch, aluminum is particularly suitable for outdoor furniture. Some of the sculptured pieces are elegant far beyond their cost. Aluminum must be anodized or can be permanently treated with a wide range of hues.

Metal can be joined by welding, riveting, bolting, or just shaping. Welding gives smooth, strong joints, but bolts and rivets suffice if seeing what holds the

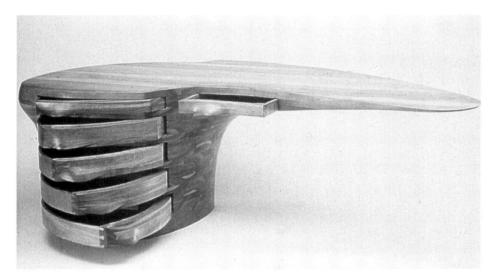

22.34 Dovetail joints are a featured aspect of structural design on Wendell Castle's organic cantilevered cherry desk. (Photograph: Dirk Bakker)

22.35 Metals were used for furniture construction before the Roman Empire. Their versatility, strength, and lasting appeal is evidenced in a continuation of historically inspired pieces of furniture as well as many new designs being produced today, such as in this contemporary steel bed in the guest bedroom of a Great Falls, Virginia, residence designed by Ronn Jaffe, ASID, IBD, and Marlene Jaffe, ASID. (Photograph: Peter Paige)

22.36 Furniture for both residential and non-residential use is quite commonly fabricated, at least in part, from various synthetic materials. (Courtesy Herman Miller)

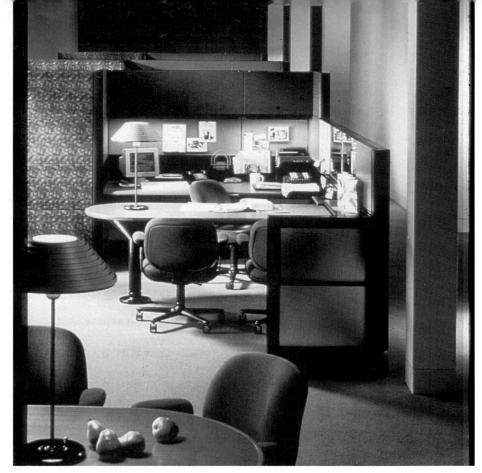

pieces together is not objectionable. Most metal furniture is so much stronger than normal household use demands that construction generally presents less of a problem than it does with furniture made of wood. Repairs, however, are much more difficult.

SYNTHETICS

Synthetic materials have affected furniture design and maintenance in three markedly different ways. Most obvious are the durable, easy-to-clean surfaces—vinyl and laminated melamine sheets for table and counter tops, vinyl upholstery for chairs and sofas. More striking is the use of molded plastics for chairs and tables. Thin and lightweight, amazingly strong yet slightly resilient, polyester resin reinforced with fiberglass, polypropylene, or acrylic can be molded so that the seat, back, and arms of the chair are one continuous piece, thus eliminating the need for joining. The plastic shell, much warmer and more pleasant to touch than metal, can be left as is, coated with vinyl, or upholstered with foam rubber and fabric. Finally, transparent or translucent plastics, such as Plexiglas or Lucite, offer designers opportunities for a new vocabulary in furniture design.

Foamed plastics represent an even newer development—one that has made possible a new type of furniture construction. Foams have revived the bulky look in furniture, although in this instance it is bulk without weight. These cellular plastics are quite versatile, since the density can be controlled to produce either rigid structural parts or soft cushioning. Certain foamed plastic units need no joining; they are simply blocks of the material, perhaps enclosed within a rigid frame. Others are built up of shaped slabs of foam in different densities held in place by contact cement with no rigid skeletal frame. Integral-skin foams can even eliminate the need for separate upholstery.

Exciting as these developments are, the possibility exists for eventual dulling or discoloration, pitting or scratching, even breakage or breakdown of the material. Repair or refinishing capabilities have improved, especially with polyester resin

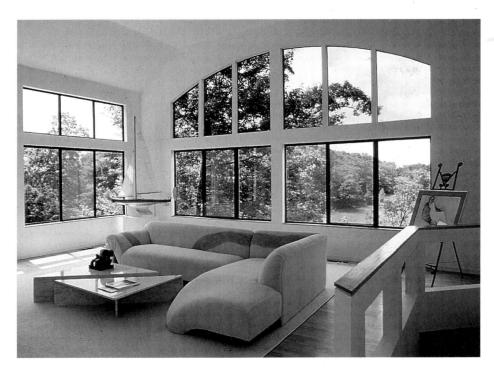

22.37 Foam can be sculpted into shapes that would be difficult to produce in more traditional furniture-building materials. Peter Kurt Woerner, FAIA, architect. (Photograph: Karen Bussolini)

finishes. Problems of flammability, including the release of toxic fumes, the instability of the chemical compounds, the emission of gases, and ultimate solid-waste disposal have still to be worked out. Of course, there are problems with wood and metal also, but the natural materials have been around longer, so their dangers, environmental problems, and recycling possibilities are fairly well known. With plastics, it becomes a matter of learning as we go along, and insisting on more thorough testing and disclosure. The designer bears responsibility for the conscious design of interiors that protect health, safety and the environment as well as meet the needs of clients.

UPHOLSTERED FURNITURE

Until the Renaissance, upholstery consisted chiefly of textiles, rushes, or leather stretched over frames and often supplemented by loose cushions. Furniture with backs and seats of leather or fabric is still common today and provides lightweight, inexpensive resilience. The use of cane, rush, wicker, or rattan for furniture parts or whole pieces also prevails; in cost and extent it ranges from the cane seats familiar in bentwood and other occasional chairs to elegant rattan pieces that would be at home in the most formal setting. The latter often have upholstered cushions for greater comfort. (*Rattan* is a hard wood, solid core vine in the palm family which grows to tremendous lengths. It is not affected by dryness, direct sunlight, or even rain and is shaped only by steam. *Wicker* is made from the inner core of the rattan pole or a very young rattan vine and is usually woven into furniture.) In any event, the frame on which fabric is stretched should be strong as well as attractive, the upholstery durable and securely fastened to the frame but easily removable.

The next step in comfortable seating would be a padding made from thin layers of resilient materials covered with fabric and secured to a frame. Since the seventeenth century this has been the standard method of making frequently moved chairs comfortable. Until recently, long curled hair was the best and most costly padding, with kapok, moss, and cotton relegated to less expensive pieces. Today,

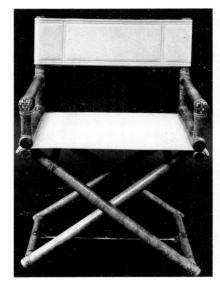

22.38 Stretched leather seat and back on an X-frame folding chair of rattan is a modern version of a centuries-old design. Leonard Linden, designer. (Courtesy The McGuire Company)

various types of foam padding are common. As a rule this arrangement takes the form of a foam cushion on a plywood base, on webbing, or on a sling of resilient material. Thicker foam pads have taken the place of springs and stuffing for many seating pieces. Sometimes foam pads become furniture themselves, consisting of one piece or several held together by buckles or straps. Removable covers make cleaning easy, and in some cases the foam may have a plastic fabric laminated to it or an integral skin, which means it can be wiped clean with a damp sponge.

Although furniture designers began to place springs under stuffing during the eighteenth century, it was not until about 1914 that massively overstuffed pieces came into fashion. The materials and steps of this complicated process may include the following (see also Figures 22.39 and 22.40)

- Frame of strong hardwood (often elm, poplar, gumwood, birch, ash, or oak) with secure joinings.
- Webbing woven in a simple basket weave and tacked to the frame.
- **Springs**, *coiled* for the seat, tied to the webbing and frame, and spaced closely enough to prevent sagging but not so closely that they rub against one another (twelve springs are needed in a good chair). *Flat sinuous wire* springs are used for the chair back. They should be of tempered and insulated wire to maintain spacing and prevent noise.
- Burlap covering the springs to protect the padding.
- **Padding** or stuffing (similar to simple padding) evenly distributed and stitched in place to give smooth, soft contours.
- Muslin to cover the padding (only on better furniture).
- Cover fabric hiding all of the above and presenting a finished appearance. The bottom of the piece should also be covered, with a lightweight material, to give a finished quality.

Once most upholstery was fastened directly to the frame of the piece of furniture. Now separate cushions for the seat and pillows for the back and even the arms make furniture still more comfortable and adjustable to the human body.

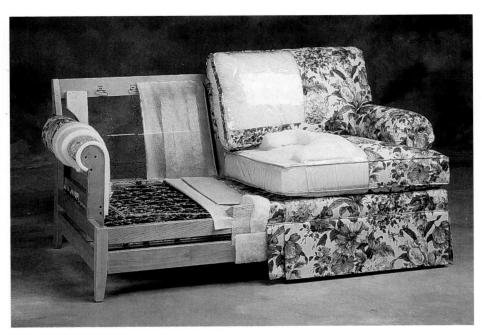

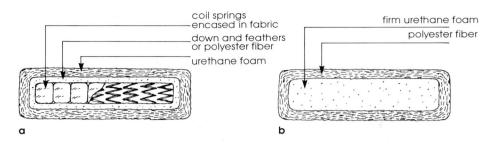

22.40 Seat and back furniture cushions can be made of springs encased in fabric, and covered with foam, down, and/or other stuffing (a). Less expensive pillows are made of firm foam between two layers of soft foam (b), or dense foam with polyester fiberfill (c). Back pillows may be downand feather-filled or filled with polyester fiber or bits of foam (d).

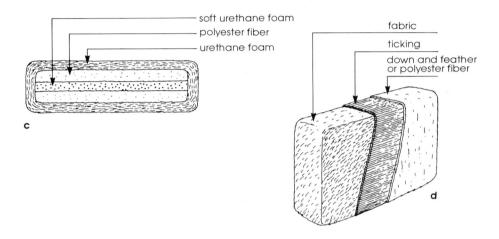

Down (and feathers) remains the most luxurious stuffing, but lacks resilience and must be fluffed after each use. (*Down* is the undercoating of feathers from waterfowl, a very soft, fluffy fiber without the quill shaft of feathers. It is used for expensive furniture or may be combined with feathers for less costly cushions and comforters.) Newer types of cushions may have a core of coil springs or firm urethane foam covered by softer layers of foam and perhaps a wrap of polyester or even a layer of down encased in ticking. Different versions and densities may be used for sitting and support cushions. Core density should be at least 1.8 pounds per cubic foot for greatest comfort and durability. Back and arm pillows are often softer and perhaps filled with polyester fiberfill. (One of the main benefits of man-made materials is that they spring back to their original contours.) Sofa and chair arms should be adequately cushioned so that the wooden forms beneath cannot be felt.

UPHOLSTERY FABRICS Fabrics become almost an integral part—and the most conspicuous part—of the furniture to which they are fastened, appealing to both visual and tactile sensations. The least to expect is that they look comfortable to sit on, feel good to hands and arms, and resist abrasion and soil. Visual relationship to the shape they cover and the setting in which they are placed serves the principles of scale, proportion, and harmony. Upholstery is sewn onto loose or integral cushions and also stapled to the frame underneath seating pieces. At least a two-year warranty should be provided by the manufacturer.

Seeing identical pieces of furniture covered with varied fabrics reminds us of the forcefulness of color and design in altering the apparent shape, size, and character of any form (Figure 22.41). In rooms with several or many upholstered items, the whole effect can be changed with different furniture covers. Slipcovers can pro-

22.41 (right) The same piece of furniture can take on very different characteristics, depending on the upholstery fabric used. A wing chair upholstered in leather. (far right) The same chair upholstered in a patterned fabric. (Courtesy Drexel Heritage Furnishings, Inc.)

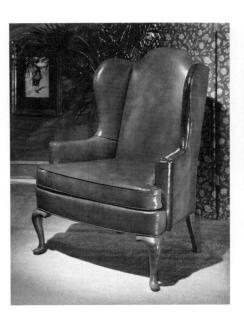

vide such a change, perhaps for different seasons. All that the designer knows about the psychological effects of hue and value, emphasis and scale can be brought to bear in selecting upholstery.

Deciding on the fabric itself involves a knowledge of fibers and weaves (as discussed in Chapter 17). Then it is a matter of searching for a textile that is aesthetically pleasing, assessing it for its intended use and cost. Tightly woven fabrics are more durable than loose, satin, or novelty weaves. Very dark and very light colors show lint and soil readily. Stain-resistant finishes are more durable when applied by the manufacturer than when sprayed on by a retailer.

The International Fabricare Institute has devised a voluntary code to be adopted by manufacturers to guide consumers in cleaning and caring for upholstered pieces. It suggests that a tag attached to each piece label the fabric as to type of cleaning product that should be used on it. All upholstered pieces should carry this information: manufacturer, fiber content, composition of fiberfill and cushioning, care instructions, colorfastness, shrinkage, and spot-stain resistance.

The Upholstered Furniture Action Council (UFAC) Voluntary Action Program was formed to improve the ability of upholstered furniture to resist catching fire from a burning cigarette, the most common cause of fire in upholstered furniture. Fabrics are classified by their ability to resist ignition, and specific construction criteria must be met for manufacturers to participate in the program. Labeling consists of a hangtag that identifies furniture meeting UFAC criteria. These pieces are safer, but not fireproof. In addition, commercial-grade fabrics (used more and more frequently in residential applications) must provide information on flammability, resistance to abrasion or "rubs," and durability (wearability), and meet rigorous standards set by legislation. The American Society for Testing and Materials (ASTM) is one of many scientific associations involved in establishing performance standards. The Department of Transportation strictly regulates the flammability of all upholstery and textile components used in transportation applications (motor vehicles and airplanes) to provide more time for occupants to escape from fires.

The basic goal in all furniture selection (and arrangement) is a personal environment that works for its occupants rather than the other way around.

REFERENCES FOR FURTHER READING

Abercrombie, Stanley. Ergonomics—It's Not a New Exercise, It's the New Science of Comfort. *House and Garden*, February 1980, pp. 78–80.

Hennessey, James and Victor Papanek. *Nomadic Furniture*. New York: Random House, 1973. Murphy, Dennis Grant. *The Materials of Interior Design*. Burbank, Calif.: Stratford House Publishing Company, 1978, chaps. 7–9.

Pinzler, Arlene. Guide to Grasses: How to Buy Wicker, Rattan and Bamboo. *American Home*, November 1976, p. 58.

Rymer, Jeanne S. and George Nakashima. Master Woodworker: Integrated Philosophy and Process. *Journal of Interior Design Education and Research*, 17(2):35–46, 1991.

Shopping for Upholstered Furniture. Better Homes and Gardens, October 1981, pp. 86–89. Stem, Seth. Designing Furniture from Concept to Shop Drawing: A Practical Guide. Newtown, Conn.: The Taunton Press, 1989.

Walkling, Gillian. Upholstery Styles. New York: Van Nostrand Reinhold, 1989.

Whiton, Sherrill. *Interior Design and Decoration*, 4th ed. Philadelphia: Lippincott, 1974, pp. 585–592, 634–640.

Why Comfort? House and Garden, February 1980, p. 75.

Yaeger, Jan. Textiles for Residential and Commercial Interiors. New York: Harper and Row, Publishers, 1988, chaps. 12–16.

Accessories

BACKGROUND ENRICHMENT
FUNCTIONAL ACCESSORIES
DECORATIVE ACCESSORIES
Plants and Flowers
Art
Crafts
Mass-Produced Accessories
LOCATION AND BACKGROUND FOR ACCESSORIES

Human beings have an inherent desire for aesthetic enrichment. Almost as soon as primitive peoples learned to build shelters, to fabricate tools and useful objects, they began to add purely decorative touches. This, of course, is ornament, but, in a sense, enrichment means ornament—something that heightens the visual or textual interest of a piece, possibly a piece of furniture. In the context of home design, accessories are usually considered from another point of view. Our homes abound with objects that are either purely decorative and serve no functional purpose or, if they are utilitarian, have been designed in such a way that they provide enrichment against a contrasting or simpler background (Figure 23.1). These are the elements of primary concern in this chapter: the designs, arrangements, embellishments, and accessory objects that contribute a quality of richness to daily lives and personal environments.

Accessories can be approached in at least two ways: Objects may serve as enhancement of the total design in architecture and furnishings, or they may constitute the focus of the design, with other elements subordinated to them. In the latter treatment, accessories dominate totally, coming to the foreground in the hierarchy of space. The architectural elements, including wall, floor, and ceiling design, may be extremely simple and straightforward, acting as background to cast the accessory collection in a central role. This technique may be employed when clients are collectors of art or objects of interest to themselves (and perhaps others as well). Upon entering such a room, the visitor's eye would be drawn immediately to the display of objects for its overall impact. Next, one could spend a pleasant time absorbing details, studying each individual piece as it competes for attention. The richness of interest and visual design may be so complex that each

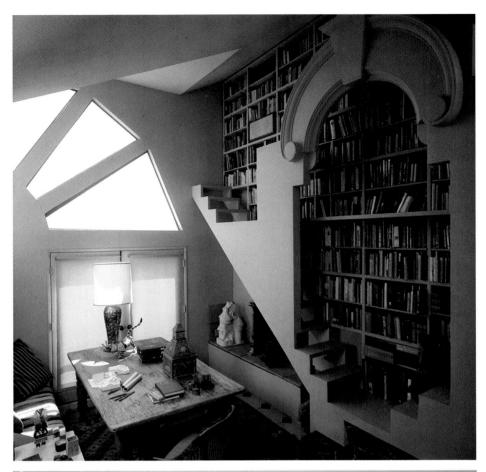

23.1 A huge 19th-century pediment, rescued from a wrecker's ball, dominates the library of architect Charles Moore's house and holds in place the two-story wall of books behind it. (Photograph: Tim Street-Porter)

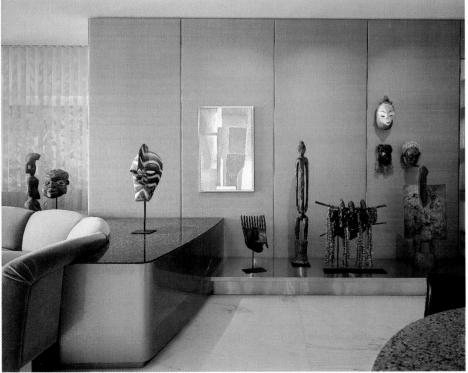

23.2 This Chicago apartment was renovated to allow emphasis on the client's art collection. Neutral surfaces in a variety of textures—silk-wrapped wall panels, marble floor, granite-topped stainless steel cabinets, wool mohair sofa—provide contrast without drawing attention from hand-carved African masks and figures. Ronald Krueck/Krueck & Olsen, architect. (Photograph: Timothy Hursley)

subsequent visit to such a home would be a new adventure, as previously undiscovered subtleties became apparent. If all the objects of enrichment were removed from the space—or a completely new set substituted—the room would take on a dramatically different character.

The same approach might be followed using a work of art. One concept may be to subordinate everything else to the art. A subtler method of focusing attention on a painting is to repeat or recall its colors elsewhere in the room, so that the eye is inevitably drawn back to the source of the color. In this case, the repeated color from the work of art serves as a kind of middleground, relating and unifying the elements of the space for an unmistakable overall harmony.

Thoughtful use of accessories can also enhance the design of a home to bring out certain architectural or historical features. The accessories may play a background role, complementing the total composition without dominating or directing attention to other features. Three very different examples will illustrate this point.

The house shown in Figure 23.4 takes its character from the rustic architecture: thick masonry walls, deeply recessed windows, exposed rough-hewn beams. To emphasize the quality of an old country farmhouse, the owners have added several integral touches: a soft-hued painting in an antique frame, folk pottery and wood carvings, a wooden light fixture hanging from the ceiling, touches of wrought iron, an old butcher's block, and so on. The overall impression is one of harmony, warmth, and coziness, of lives enriched by the past through accessories.

Figure 23.5 shows another traditional home, in this case a very formal one. The aura of nineteenth-century elegance is established by graceful paneled walls, an ornate carpet, and antique furnishings; but this effect would be incomplete without the enrichment provided by the crystal chandelier and candelabrum, the elaborate gold mirror frame, and porcelain ware on the table and sideboard. Period authenticity (or simply authenticity of feeling) is only one aspect of accessorizing, but it can be a very important one. Good accessorizing distinguishes a home from a showroom or furniture store with objects that reflect the individual lifestyles, tastes, experiences, and personalities of the people who dwell there.

The points to be emphasized in a particular home may have no clear relation

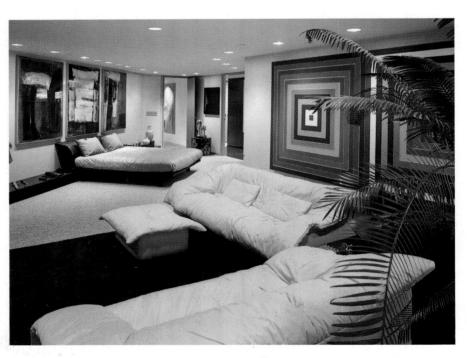

to any style or period or type of design, but rather be a distinctive aspect of the architecture. One of the most striking features of the house illustrated in Figure 23.6 is its soaring height. To focus attention on the raised ceiling, the designer has added a display shelf at the base of the cathedral ceiling, with accessories spotlighted from above. They naturally draw the eye upward, but they also refer back to pottery and glassware throughout the room to bring the eye down to ground level again.

These examples not only demonstrate how accessories can either carry a design or support it, but also reveal a spectrum of tastes. We know much about the occupants of each of these homes without having met or seen them. Some people might empathize with the collector of charming native handicrafts, others with the

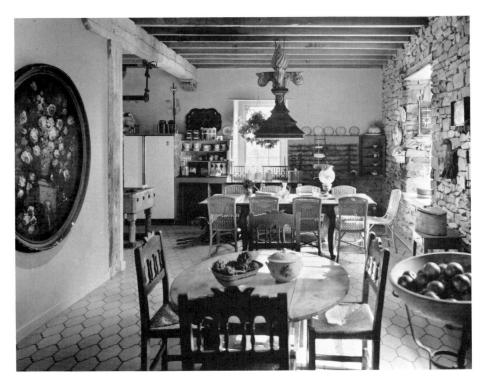

23.4 Old artifacts, including an oval painting in an antique frame, seem appropriate enrichment for a renovated mill in Pennsylvania's Bucks County. Lilias Barger and Raymond Barger, designers. (Photograph: John T. Hill)

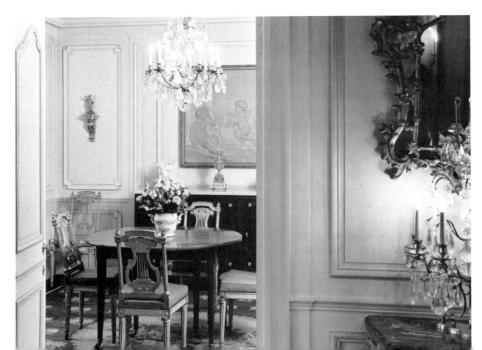

23.5 Heavy crystal, fine porcelain, and an antique mirror in a gold-leaf frame enrich this formal, traditionally paneled dining room and foyer. (*Photograph: John T. Hill*)

23.6 Accessories can draw attention to an architectural feature, such as a high ceiling, through placement, form, and lighting. Lewis & Bristou, architects; Dennis Haworth, FASID, interior designer. (Photograph: Steve Simmons)

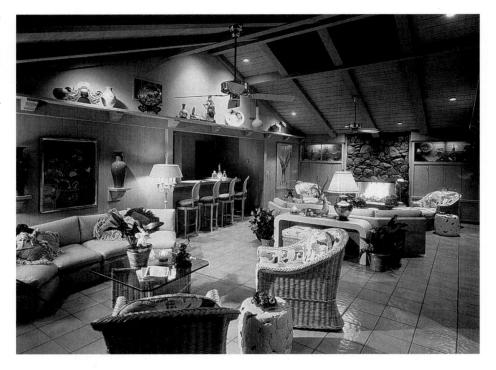

person who cherishes classic or Oriental accessories. This emphasizes an important aspect of home enrichment: A collection of objects without personal significance to those who live with them will never blend comfortably into a home. Accessories should express the unique individuality of the occupant, not the taste of the designer or the latest fashion.

So far accessories have been treated as something deliberately added with the conscious desire to "enrich." In so doing we overlook a very basic form of accessorizing—the kind that develops spontaneously or as a side effect from some other element. Because it is so fundamental, such incidental embellishment should be considered first.

BACKGROUND ENRICHMENT

The most obvious enrichment in any home is the one most likely forgotten about—people. Their varying personalities, changing moods, and different activities all affect the background against which they move. Like actors bringing to life a stage setting, people enrich the spaces they inhabit.

Another basic form of enrichment is provided by the architecture of the home itself. The patterns of ceiling beams, door and window frames, supporting columns, and wall panels often enrich otherwise unadorned surfaces.

Patterns and textures in draperies and upholstery, in floor coverings and wall treatments, in furnishings and lighting fixtures all provide a measure of enrichment. So too might the implements and materials of a profession or hobby, especially when they involve the visual arts. No space could be visually richer than the inside of a weaving studio, with its profusion of multicolored yarns, the form of the loom, and works in progress scattered about; a painting, sculpture, or ceramic studio creates the same kind of delightful image.

Books and magazines are not normally chosen for their physical appearance

on a shelf, but it cannot be denied that a wall of books brings enrichment to any room. Personal involvement with certain books may add an emotional enrichment to bolster the visual, but even without this attachment satisfaction can be taken in the rows of similarly shaped objects with their colorful bindings and dust jackets.

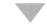

FUNCTIONAL ACCESSORIES

The typical household, over the years, will accumulate many utilitarian objects. All have a very specific functional purpose, but all come in a vast range of designs, so individuals can exercise a great deal of personal taste in selection.

With a venerable history as ornamental space dividers, **screens** are especially welcome in open-plan homes or in multipurpose rooms. Screens can be moved or adjusted to divide areas into comfortable units without completely shutting out

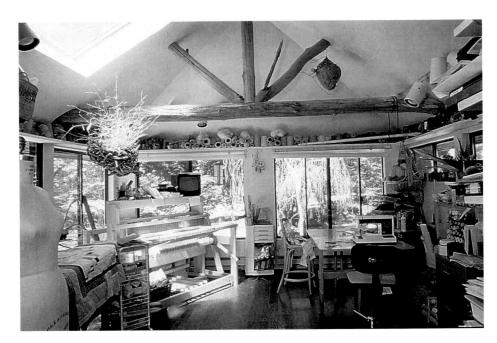

23.7 The studio addition to fiber artist and weaver Florence Suerig's home in Greenwich, Connecticut, is rich with the tools and materials of her craft. An aged oak log, plank floors, ample daylight, and the nest of another fiber artist, the paper wasp, along with baskets and shelves full of yarn provide an environment for creative inspiration. Karl C. Suerig, architect. (Photograph: Karen Bussolini)

23.8 A 1919 Georgian brick country house is an excellent setting for an antique collector. Two hand-carved and lacquered Coromandel screens grace the living room along with a small Oriental chest and ceramic pieces. Jean P. Simmers, Ltd., interior designer. (Photograph: Karen Bussolini)

23.9 Laura Ashley's *Bramble* design for bed linens gives aesthetic focus to a bedroom. (Courtesy Laura Ashley Inc.)

what is beyond; or they can be folded inconspicuously against walls. There are no limits to the possible materials: sheer silk and rice paper, clear or translucent glass and plastics, tapestry, brocades, leather, shutters and bamboo poles, curved or flat plywood, wallpaper, or fabrics. Some screens are almost as heavy and substantial as walls, others are light and free-standing. Screens can be plain or ornamented, identical or different on the two sides, and harmonious or contrasting with their surroundings.

Bed and **bath accessories** are very flexible, since they are relatively inexpensive and easy to change. Until little over a quarter-century ago colored and patterned sheets and towels were almost unknown; pure white was standard. The extent of this revolution in design can be realized when we see world-famous textile and clothing designers applying their talents to bed coverings and bath accessories (Figure 23.9).

Since the bed will nearly always be the focus of any bedroom, the bed coverings that dominate the surface strongly affect the room's overall design. Bedspreads, quilts, and comforters allow an immediate kind of personal expression, and they are often the products of widely popular crafts and hobbies. Bed coverings can also act to unify a room.

Functional bath accessories such as hardware, towels, shower curtains, hampers, and bath mats also provide a variety of colors and designs to enliven the bathroom. Most can be changed easily and inexpensively, some even daily if desired.

The myriad of other functional accessories include such things as mirrors and lamps (which may also be purely decorative), clocks, fire tools, umbrella and hat stands, and the many kinds of hardware used on doors, furniture pieces, and plumbing fixtures which have a great deal of potential for enhancing spaces and providing personal expression. (Lighting and lamps were discussed in Chapter 21.)

Pillows and cushions covered in bright colors and patterns represent one of the most pervasive and versatile forms of enrichment. They are easy to make, lending themselves to all kinds of fabric arts. While nominally useful in providing comfort, pillows of this sort often take on a primarily decorative role, especially when intricately worked or heavily ornamented. This leads to consideration of objects that have no function except just to be—for the sensuous delight they give.

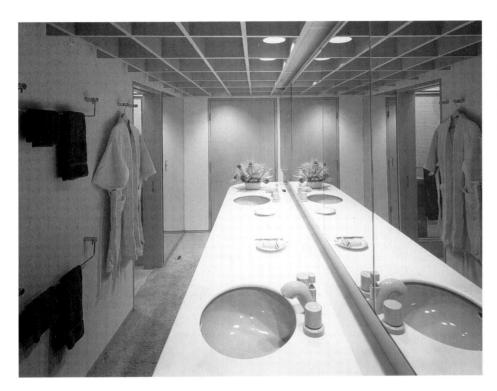

23.10 Distinctive hardware makes an aesthetic as well as a functional contribution to bathroom design, as in this vacation home located at the foot of the Grande Teton Mountains in Jackson Hole, Wyoming. (Photograph: Howard N. Kaplan)

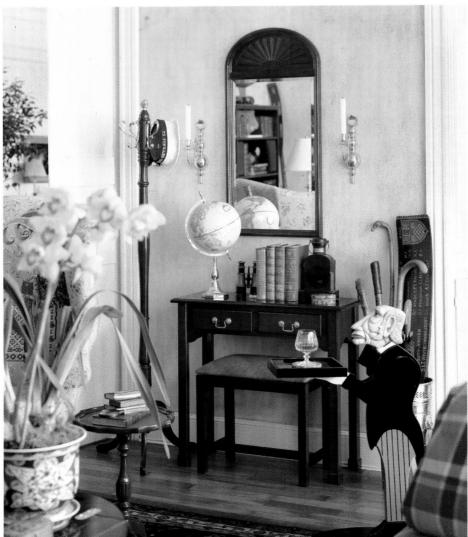

23.11 Functional accessory items—coat trees, umbrella stands, framed mirrors, ceramic pots for plants, even a "butler" table—can express individuality and add character to any space. (Courtesy The Bombay Company)

DECORATIVE ACCESSORIES

In saying that the objects discussed here—plants and flowers, art work, handcrafted items, and other accessories—serve no useful purpose, the definition of "useful" is severely limited to a rigid, almost Puritan standard. Works of art, whether fabricated by nature or by human beings, enrich the very essence of our selves: our minds, our spirits, our sensibilities. A world—or a home—devoid of objects that exist purely for the joy of existing would be almost like a world without sounds.

PLANTS AND FLOWERS

Plants are so much a fixture in today's homes that it seems difficult to imagine doing without them. A glance through the pages of this book will show that few rooms banish plants altogether and many enlist them as important design elements. Several factors explain this penchant for bringing part of the healthy outdoors inside. The first is, of course, the widespread desire to introduce a natural touch in a controlled environment; this could be considered a psychological goal—to maintain touch with what has traditionally been an agrarian culture. Plants also serve a healthful function by cleaning indoor air of pollutants and keeping it fresh. In purely visual terms, plants contribute colors, textures, and ungoverned forms that contrast pleasantly with the human-controlled parts of an interior environment. Lastly, there remains the emotional satisfaction of watching something grow and change and develop. With reasonable care, plants grow and change, and in some cases may bloom (thus altering their physical appearances), which distinguishes them from any other element of home design.

As visual design, plants can play many roles. A single, strategically placed plant may be a dramatic, almost abstract, outline, whereas masses of plants filling a garden room or cascading from a balcony might create the effect of a soft visual screen.

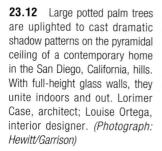

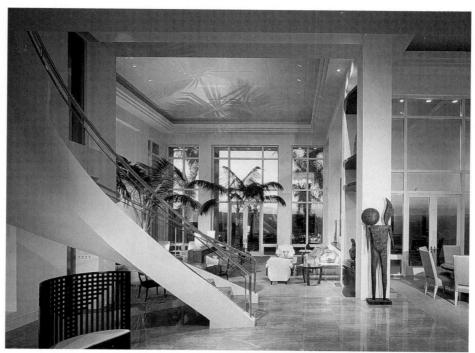

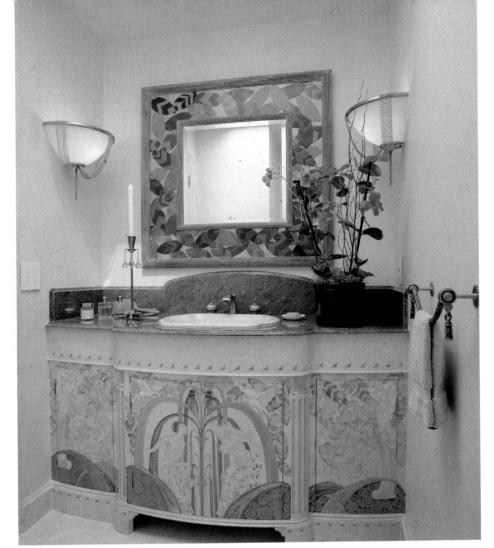

23.13 A flowering plant brightens a small bathroom with a unique hand-painted vanity and mirror designed by Sharon Campbell, ASID. Victoria Bohlman, artist. (*Photograph: David Livingston*)

Big, bold plants are good for major effects or to fill a space where furniture does not fit; small ones, whose interesting foliage merits close study, could occupy a place of prominence on a table or window ledge.

Acquiring plants for their purely visual appeal can be a perilous adventure. If no one in the household has the slightest interest in gardening, the carefully chosen specimen that precisely fits design needs will inevitably wither and die, destroying the effect as well as the plant. Some plants, including cactus, philodendron, and certain members of the Dracaena family, seem to flourish with little care, while others demand the most meticulous care merely to survive. In addition, some plants are poisonous, as indicated in Table 23.1. Selection and placement of these plants must be considered, particularly if the household includes unwary children or pets.

Flowering plants are a relatively inexpensive way of bringing color into the home. If chosen carefully and when the flowers are in bud or freshly open, many types will last far longer than cut flowers while giving more accent value than foliage plants.

The containers in which plants are kept have much to do with both their ornamental value and their physical health. However, once the requirements for proper drainage, root spread, and soil aeration have been met, almost no container can be ruled out, the materials ranging from the classic unglazed pottery through glazed ceramics, metals, glass, and plastics. These materials can also provide liners for more decorative, less water-resistant containers such as wood or wicker.

Raised to the level of an eloquent art by the nature-loving Japanese and assiduously practiced by many others, flower arrangement can mean anything from

TABLE 23.1

Poisonous Plants

Plant Name	Toxic Part	Symptoms	
Amaryllis	Bulb	Nausea, diarrhea, and vomiting	
Anthurium, Flamingo flower	Leaves and stem	Burning of lips, mouth, tongue and throat, with occasional blistering	
Calla Lily (from same family as philodendron and dieffenbachia, which are also poisonous)	Leaves	Intense burning of the lips and mouth usually prevents swallowing of significant amounts	
Clivia, Kaffir lily	All plant parts	Ingestion of large quantities may cause nausea, vomiting, and diarrhea	
Dumbcane (dieffenbachia species)	Leaf	Intense burning and irritation of the mouth and tongue; death can occur if base of the tongue swells enough to block air passage of the throat	
Elephant ear, Caladium	Leaf and stem All parts— Caladium	Burns lips, mouth, tongue, and throat; difficulty with speech due to rapid onset of pain; rarely swallowed	
English Ivy	Leaves and berries	Burning sensation in the throat, vomiting, and diarrhea	
Foxglove	All parts	Pain in the mouth, nausea, vomiting, abdominal pain, cramping, diarrhea; in large amounts may cause irregular heart beat and pulse, mental confusion; may be fatal	
Hyacinth, Narcissus, Daffodil, Galanthus	Bulbs	Contact with bulb can cause skin irritation; nausea, vomiting, diarrhea; may be fatal	
Iris	Underground stems	Severe, but not usually serious, digestive upset, vomiting, and diarrhea	
Jerusalem cherry	Immature fruit	Scratchy throat, fever, vomiting, and diarrhea	
Larkspur, Delphinium	Young plant, seeds	Digestive upset, nervous excitement, depression; may be fatal	
Lily-of-the-Valley	All parts, and water in which flowers have been kept	Pain in mouth, nausea, vomiting, abdominal pain, cramping, and diarrhea; irregular heart beat and pulse, mental confusion	
Mistletoe	Leaves and stems	Berries toxic if consumed in large quantities; vomiting, abdominal cramps, and diarrhea; rarely fatal	
Pasque flower, Anemone	All parts	Intense pain and inflammation of the mouth; bloody vomiting and diarrhea with severe abdominal cramps; sap causes skin irritations	
Ranunculus or Buttercup	Sap and bulb	Same as Pasque flower	
Rhododendron, Azalea	All parts	Causes serious intoxication in children who chew leaves; temporary burning in the mouth; several hours later, salivation, vomiting, and diarrhea; prickling sensation in the skin; headaches, muscular weakness, dimness of vision, difficult breathing, coma, and convulsions	
Tomato	Vines and suckers, green fruit	Dullness of perception and understanding, loss of sensations; contact with leaves can cause skin irritation	
Yellow Jessamine, Carolina Jessamine	Flowers, foliage, and branches	Headache, dizziness, visual disturbances, dry mouth; difficult swallowing and state of feeling unwell or unhappy	

Sources: Kingsbury, John M. *Poisonous Plants of the United States and Canada* (Englewood Cliffs, N.J.: Prentice-Hall, 1964); Lampe, Kenneth F., and Mary Ann McCann. AMA Handbook of Poisonous and Injurious Plants (Chicago: Chicago Review Press, 1985).

putting some fresh blossoms in a vase to a fascinating art. The effects that can be produced are limitless and include dried arrangements and artificial plants and flowers as well as fresh cut flowers.

ART

Works of art—paintings, drawings, prints, photographs, and sculpture—are as personal and emotionally charged as the books we read, the music we enjoy, or the types of entertainment we pursue. Most people either have some objects of visual art that give them particular pleasure or are eager to seek them out. In terms of home enrichment, then, three factors must be considered: choosing works that evoke a special response; framing them appropriately; and deciding where and how to display them to their best advantage.

TWO-DIMENSIONAL ART The several categories of art differ substantially in medium, effect, content, and cost.

Paintings are original, one-of-a-kind works done in oil, tempera, watercolor, acrylic, or other pigment bases on canvas or similar backing. Along with original sculptures, they are the most expensive works of art one can buy. Few people are in a position to purchase masterworks of a caliber visible in museums, but it must be remembered that the vast majority of paintings initially were sold to discerning collectors for a tiny fraction of their current value. Local art shows and galleries, art schools, even auctions can be the source of treasures that awaken particular responses and may, incidentally, have intrinsic value. A painting may suggest a general theme or color harmony, but should provide an aesthetic appreciation on the part of the viewer rather than simply fill a void or coordinate with other furnishings (Figure 23.16).

Drawings—in pencil, crayon, charcoal, or ink on paper—tend to be much less expensive than paintings, even when done by recognized artists. Because they are often preliminary sketches for other works, drawings may be more relaxed than paintings, a more direct revelation of the artist's concept; but they can also be precise delineations or full-bodied statements, as developed as a painting.

Prints, often known as multiples, are impressions on paper resulting from such processes as *woodcut*, *etching*, *drypoint*, *lithography*, and *silk screen*. They are considered original works of art when struck directly from plates made or supervised by the artist, numbered according to which impression in sequence each is from the initial print, and signed or authorized by the artist. Prints are much less expensive

23.14 (above, left) Fresh flowers bring a cheerful note into the home, heightened by their delicacy and short life. Cesar Pelli & Associates, architects; Julie Meyers, interior designer. (Photograph: Timothy Hursley)

23.15 (above, right) Dried plants and flowers and topiary add both color and texture to a room with many neutral colors in a Philadelphia townhouse. Marguerite Rodgers, Ltd., interior designer. (Photograph: Matt Wargo)

23.16 Falling Day, a large painting by Norman Bluhm, dominates the manorial living room of a Los Angeles home, contrasting starkly with the sand-colored hand-troweled stucco walls. The homeowners collect works by second-generation abstract expressionists and California artists. Ricardo Legorreta, architect. (Photograph: Timothy Hursley)

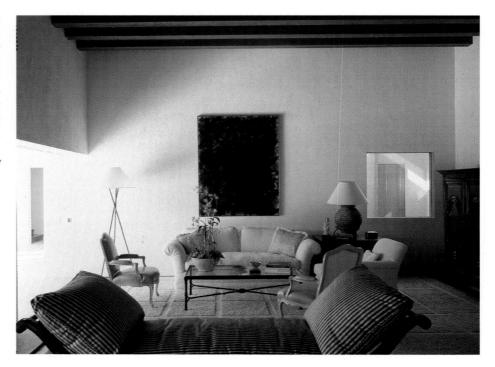

than paintings or drawings; even works by established artists are usually within the range of average collectors and could represent a sound investment.

Photographs are another medium of decorative expression. The content of a photograph can vary from the "art" subject—indistinguishable from that of paintings, drawings, or prints—to the picture that has only personal significance such as a snapshot of family and friends. Either is valid as an image for home accessories as long as it has meaning to the individual.

Reproductions of art works have no direct connection with the artist. They are reasonably priced impressions on paper made photographically or by a commercial printing process. Such reproductions do not give the total impact of original works, for they lack the full range and brilliance of color and the special interests of texture and materials. Still, if one has particular empathy with a certain painting or drawing, reproductions can successfully complete an interior space and give it personality, especially for someone with a limited budget. High-quality reproductions, especially of drawings, are sometimes quite faithful to the originals. New techniques to capture color and even the texture of original works are continually being developed.

Posters are a form of reproduction, often of works by well-known artists, that are frankly temporary. Brilliant or subtle in color, available in varying sizes, framed or unframed, they are an inexpensive and useful means of adding the personal touch, particularly for children's rooms or spaces that invite periodic change.

FRAMING AND HANGING ART **Frames** visually enclose pictures and contribute to their importance and effectiveness. Also, they form a boundary or transition between the free, intense expressiveness of pictures and architectural backgrounds. Lastly, frames safeguard the edges, may hold protective glass, and facilitate moving and hanging. Their first duty is to enhance the art, their second to establish some kind of relationship with the setting. Generally this means that frames should either complement the size, scale, character, and color of what they enclose without overpowering it or simply be unobtrusive bands. Occasionally,

marked contrast can accentuate the qualities of a painting. Only exceptionally should the frame dominate the picture. The wide, heavily carved and gilded frames of the past or any that project at the outer edges "set off" pictures from their backgrounds. Those of moderate width and simple design, harmonious in color with the walls, and either flat or stepped back, relate to the walls, focusing attention on the individual art works rather than the total composition. Today, much art is hung without frames, the impact of the boundary of a painting against its background being part of the total concept. These works may be supported by stretchers, the framework over which canvas, fabric, or even a photograph can be tautly attached. Some works may also be simply adhered to a rigid backing or encased in frameless sheets of glass or acrylic.

Mats and glass are typical accompaniments of watercolors, photographs, and graphic prints. Mats enlarge small pictures and surround them with rest space as a foil, especially important if the picture is delicate or if the background is competitive (Figure 23.17). They may also unify a group of pictures of various sizes. In color, mats are usually of white or pale-hued paper, because these tones concentrate attention on the picture, but they can be of textiles, patterned paper, cork, or even metal, and have pronounced color.

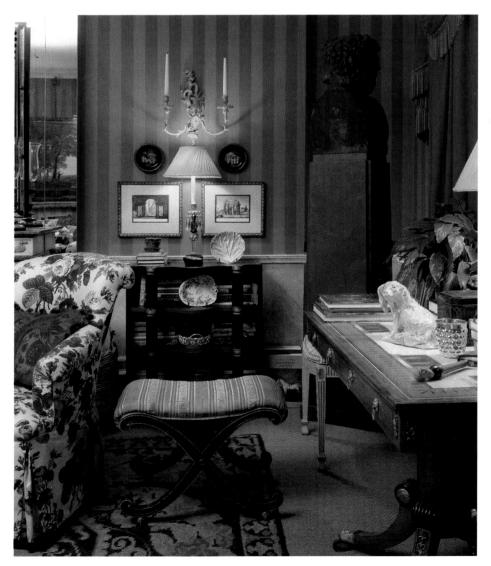

23.17 English Regency furnishings prevail in a Manhattan brownstone. Small photos have generous mats to draw attention against the bold claret-colored striped wallpaper. David Easton, interior designer. (*Photograph: Mick Hales*)

In size, mats vary with the size and character of the picture as well as with the frame and the location. Heavy frames lessen the need for generous mats, while large or important locations increase it. To correct optical illusions and give satisfying up-and-down equilibrium, the width of the top, sides, and bottom of mats may be different. In matting a picture, as in creating one, the elusive interaction of form, line, and space—not a set formula—should determine the result.

Glass is necessary for pictures that need to be protected from surface dirt, moisture, and abrasion. It also seems to intensify colors. But glass also produces annoying reflections, a problem partially alleviated with nonreflective glass, as well as with Lucite, Plexiglas, and other plastics. Nonreflective coverings should be approached with care, however, for they tend to gray and soften what is underneath. Mats and glass generally go together on watercolors, prints, pastels, and photographs. Oil and acrylic paintings seldom have or need either.

Both aesthetic and prosaically physical considerations come into play in hanging art. Once the latter are dealt with and mastered, the former can be given free rein. In general, pictures should be hung flat against the wall, with no wires or hooks showing, although sometimes the wires are decorative. In older homes, a picture molding, placed near the ceiling, may provide a method of hanging art in which case the wires are revealed in order to bring the work to viewing level (see Figure 23.15).

Locating paintings, drawings, photographs, and prints so that they interact pleasingly with each other, their setting, and their viewers involves using design principles. Since pictures help unify furniture and walls, they are often placed over something—a sofa or group of chairs, a desk, a table, a bookcase, a piano, or a fire-place; they should relate in scale and be regarded as part of the total composition so that art and furniture are seen as a single unit. Keeping art at eye level allows comfortable viewing, relates it to furnishings beneath it, and emphasizes the room's horizontality. Eye levels may vary, depending upon viewing position (seated or standing), age and stature of the viewer, even cultural background.

From time to time, though, it is refreshing to have a painting stand for what it is worth on an otherwise blank wall. Large, dominant paintings, by their forceful presence, almost demand this kind of treatment. Smaller, more modest works can be grouped successfully for greater impact if they are in scale with each other and provided each is in a position to invite leisurely study. Tight spacing emphasizes the total composition of a group of works, while more generous spacing allows each work to be focused upon in turn. An odd number of works forms the most pleasing composition. Large bold works need space for the viewer to step back while smaller, more subtle, or detailed works need to be viewed at close range.

Art should be hung in pleasing proportion to furnishings and walls and can be used to help create balance, rhythm, emphasis, and unity in interiors. Lighting, addressed in Chapter 21, is important for the full appreciation of color, texture, and detail. Original art should be hung where it will not be subjected to color fading or other damage from direct rays of sunlight.

SCULPTURE Bringing into three dimensions the intensity and expressiveness found in painting adds textural experience to art. An important piece of sculpture, regardless of its size, commands a place of importance and becomes the focus of attention (Figure 23.19). Large pieces that are free-standing can—from a purely organizational point of view—be treated as articles of furniture. Whether or not they will gather an aura of distinction about them depends as much on their visual integrity as on their placement. Smaller pieces may occupy prominent positions on a shelf, pedestal, or table, on the wall, in a niche, or possibly suspended from the ceiling. The collector who is fortunate or diligent enough to amass many pieces of related sculpture will certainly want display areas created particularly for them, with appropriate lighting.

23.18 Small and delicate engravings and drawings gain importance when arranged together on a wall over an 18th-century table. (*Photograph: Charles M. Nes IV*)

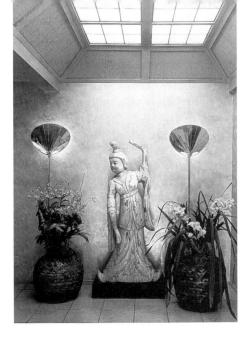

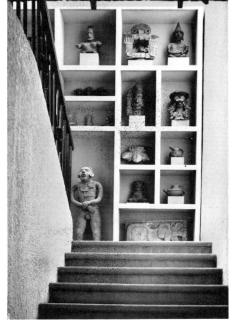

23.19 (far left) Oriental sculpture, fans shielding light sources, and plants establish the character of a Sacramento, California, home from first introduction in the entry hall. Lewis & Bristou, architects; Dennis Haworth, FASID, interior designer. (Photograph: Steve Simmons)

23.20 (left) Rufino Tamayo, an artist who designed his own house, made one wall into a honeycomb of display spaces for his collection of pre-Columbian art. (*Photograph: Julius Shulman*)

CRAFTS

As collectors have increasingly turned their attention toward an appreciation of applied arts, crafts have begun to throw off their "homey" image and assume their rightful place as serious expressive works. A beautiful ceramic object may be no less significant than a piece of sculpture, a handwoven tapestry no less important than an oil painting. Happily, craft objects are still much less expensive and much more readily accessible than paintings and sculpture. In many homes such precious articles have begun to replace the traditional picture-on-the-wall as prized objects of enrichment. The uniqueness of handcrafted artifacts from other cultures makes them appealing accessories as well as reminders of our travels.

Throughout this book many examples have been shown of the potter's and glass and fiber artist's work enriching contemporary interiors. Glass, whether stained or blown, combines color and light in a unique way. Although the glass itself is colored, it may depend upon the transmittance of light for its beauty and must then be hung or placed with natural or artificial light penetrating it. Baskets, when their design is sensitive and closely adapted to the materials, take the place of sculpture and make an aesthetic statement. While often divorced from their original utilitarian functions, such objects retain the suggestion of sturdy serviceability that relates them to the basic activities of everyday living.

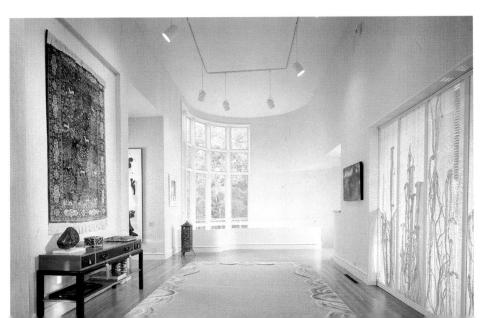

23.21 In the gallery/entry of a home in Des Moines, Iowa, artist Lane Hartman handcrafted door panels from wool and silk with small touches of cotton and mohair. The panels were fabricated by a combination of knitting and weaving. Other textile products shown include an antique Oriental silk rug (on the wall) and a custom-made rug by Edward Fields. Bloodgood Sharp Buster, architects; Rosalie Gallagher. ASID, interior designer. (Photograph: Hedrich-Blessing)

23.22 Stained glass makes an excellent bathroom window and accessory. It resolves the question of privacy and incorporates color into an environment often dominated by neutrality. Joanna van Heynigen, designer. (*Photograph: Lucinda Lambton/Arcaid*)

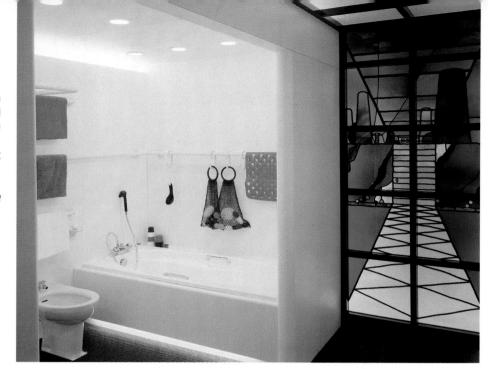

23.23 Baskets serve many useful purposes and make charming accessories, particularly in a country kitchen or dining alcove. *(Courtesy Warner)*

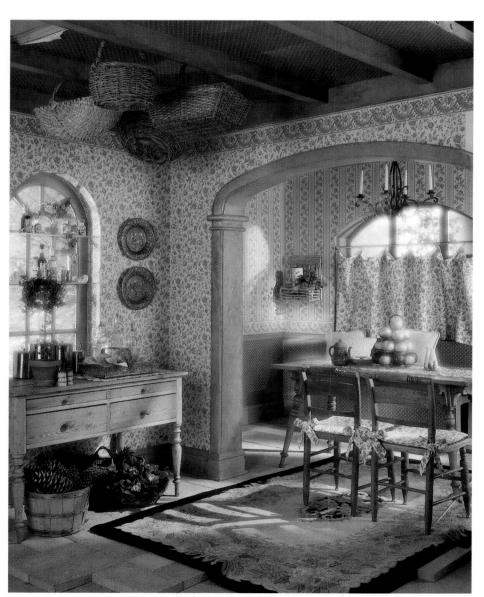

MASS-PRODUCED ACCESSORIES

One major category has not yet been mentioned: objects that are not quite works of art or craft (since they are mass-produced) and not quite utilitarian (although they may perform some marginal task), but are simply kept about because they delight the eye or hand or intellect. A collection of such articles might include brass candlesticks, glass paperweights, a whimsical ceramic figure, a globe, a collection of tools and implements pertaining to a trade, or mementos of travel to other parts of the world. If we try to imagine a room stripped of these little islands of enrichment, it seems very dull indeed. That is because they delineate the very character of a room. Without them, a space would be impersonal and bland. In a sense, this sums up the underlying nature of accessorizing—that which personalizes a home, gives it its particular quality, and makes it peculiarly one's own.

LOCATION AND BACKGROUND FOR ACCESSORIES

There are two logical types of location for accessories: those places where people normally look, and those places where we want them to look with interest and pleasure.

People tend to look more or less straight ahead; through doors, windows, or wherever distance invites exploration; and at anything that is large, different, or well illumined. Thus it is reasonable to think about putting aesthetic interest opposite the home's entrance door, somewhere in the first view of the major group space, more or less opposite seating for conversation and dining, on the wall op-

23.24 A collection of interesting accessories need not be one-of-a-kind unique works of art to have appeal. Many mass-produced items, both decorative and functional, add interest and variety to interiors. (*Courtesy The Bombay Company*)

posite a bed, in the space above a desk, and at the end of a hall. Outdoors, the major views from inside the house or from the terrace, as well as the ends or turning points of garden paths, are logical places on which to concentrate attention.

Entrance areas are introductions to the home. Usually they are small, which suggests something best seen at close range in a short period of time. A good table or chest with flowers, plants, or a small sculpture below a mirror is one possibility, if space permits. Or the accessory can be on the wall—a distinctive lighting fixture or mirror, an uncomplicated painting or print, an art fabric, a unique item such as a silk Oriental rug.

The first view into the living room is another matter, for the opposite wall or window may be some distance away. In many contemporary homes this first view carries attention through the room out into the garden, which then becomes the place for interesting planting or fences, decorative urns, or sculpture. In other houses, the fireplace wall is the first thing seen, and it may or may not need more than the architect has given in its design and materials. If the fireplace is small and simple, the wall above may hold a painting or textile large enough and strong enough to balance the opening below and to make itself understood from across the room—and also with sufficient interest to be worth looking at over long periods of time. In still other quarters the initial view may end with a wall against which a group of furniture and accessories is seen. Whatever the situation, it is gratifying to have something of interest greet the eyes.

23.25 The end of a hallway can be a delightful nook for a brief pause, perhaps to write a note. It can also be visually alluring, such as this space, with interesting framed prints on the fabric-covered wall, a plant, baskets woven from twigs, and warm lighting. Saunders & Walsh, interior designers. (Photograph: Tim Street-Porter)

23.26 An unusual centerpiece contains two large squash of interesting shape and texture accompanied by small blossoming branches and votive candles. (*Photograph: Karen Bussolini*)

Changing the placement of accessories renews their appeal and freshens their impact. Most are quite easily moved and should be tried in a variety of locations and arrangements. Generally, accessories chosen for group spaces should have aesthetic appeal beyond personal sentimental value. The selection of accessories should reinforce the atmosphere of each room: Bedrooms are intended as restful places, living rooms and family rooms can be dramatic or subtle depending upon individual taste, and kitchens and baths may be light-hearted and cheerful. Storage space throughout the home is important for rotating accessories so that they remain fresh in appeal.

Then there are the spots in most homes where attention must be enticed, such as uninteresting corners, long hallways, or small wall spaces that must be used (Figure 23.25). A small, separate furniture group can be reinforced with congenial illumination; by having prints, paintings, or textiles on the wall; and by placing interesting objects on the table. Then, what was an unused corner becomes inhabited space, chiefly through appropriate furniture but also, to a surprising degree, through distinctive accessories.

The relation of a decorative centerpiece to the size of the table or other surface on which it rests and its surroundings is all-important. A centerpiece is a deliberate focus of attention, emphasized by its placement, often in the center of a symmetrically balanced composition within the room or against a wall. If people sit or walk around it, a centerpiece should be attractive from all angles. It is also desirable that a centerpiece be low enough to permit those seated around it to hold a conversation without interference. Centerpieces may underscore the theme of an interior or contrast sharply, and they may be selected from a broad range of arts, crafts, family heirlooms, personal mementos, individual interests, or intriguing, unusual, and aesthetically pleasing objects.

"Tablescaping", selecting and arranging tabletop objects, is an art in itself, one of many accessorizing techniques which may characterize a designer's work. One of Billy Baldwin's trademarks was his meticulously chosen table vignettes—still-life assemblies composed with an eye for texture, scale, juxtaposition, and detail—as seen in Figure 23.27.

23.27 A table vignette by the late Billy Baldwin reveals the care with which he selected and arranged even the most casual-appearing collection of objects. (Photograph: Horst)

Another approach is exemplified by Ward Bennett and other Minimalists whose museum-like placement of objects, whether on tabletop or wall, gives each one visual emphasis in their sparse, elemental interiors.² Yet another tactic is to either coordinate or contrast style, subject matter, or time period of accessory items with architecture and interior furnishings. A hallmark of the English designer David Hicks is to freshen a room filled with eighteenth-century furniture by hanging in it unframed contemporary abstract paintings.³ (He has written several books on design, one of which is listed in the References for Further Reading at the end of this chapter.)

The most important consideration in the selection of accessories, however, remains the client. The designer should always keep in mind that the space s/he designs and accessorizes must satisfy the program requirements and desires set forth through the process of interviewing those for whom the space will be a central part of life. Accessories, as well as other aspects of interior design, should bring pleasure to those who interact most intimately with them, reflect their interests, and involve them in their selection and placement.

The effectiveness of any accessory can be increased or decreased markedly by its setting. Large, significant objects can proclaim their presence by being put in important positions, by being given backgrounds against which they can be readily seen, and by being built up with smaller objects. At the other extreme, some accessories can take their place unobtrusively, a little murmur in a harmonious setting (Figure 23.29). Thus varying degrees of emphasis and subordination are achieved; balance and rhythm, scale, proportion, and harmony come into play, and accessories become important elements in the total home design.

NOTES TO THE TEXT

- 1. C. Ray Smith. *Interior Design in 20th Century America: A History* (New York: Harper & Row), 1987, pp. 236–237.
- 2. Ibid, pp. 229-230.
- **3.** Ibid, p. 317.

23.28 David Hicks often contrasts contemporary art with traditional furnishings to lighten and relax the formality of sometimes imposing antiques, as in the guest suite sitting room of his London apartment. (Photograph: Derry Moore)

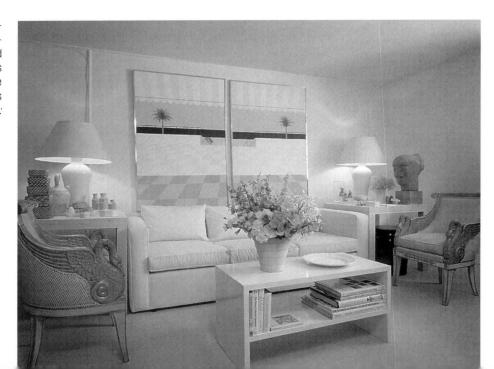

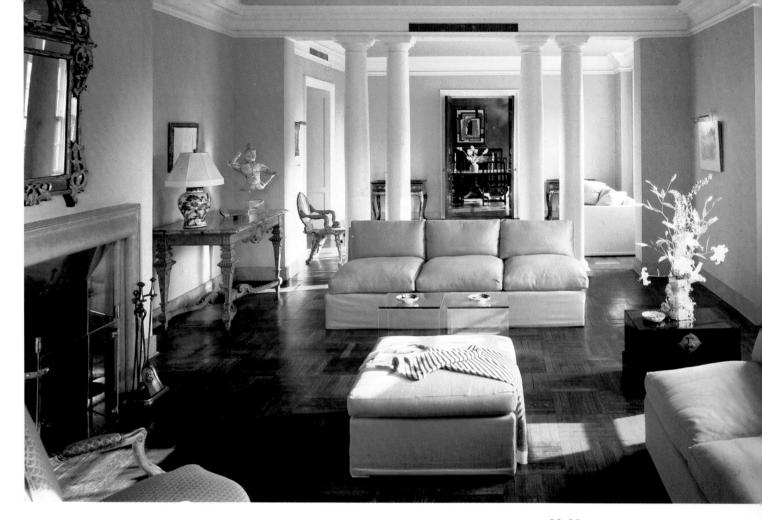

REFERENCES FOR FURTHER READING

Arnason, H. H. History of Modern Art: Painting, Sculpture, Architecture, Photography. New York: Harry N. Abrams, 1986.

Barnard, Nicholas. *Living with Decorative Textiles*. New York: Doubleday, 1989, chaps 4–6. Bernstein, Jack. *Stained Glass Craft*. New York: Macmillan, 1973.

Castleman, Riva. American Impressions: Prints Since Pollock. New York: Alfred A. Knopf, 1985.
 Clarke, Carl D. Metal Casting of Sculpture and Ornament. Butler, Md.: Standard Arts, 1980.
 Constantine, Mildred and Jack Lenor Larsen. Beyond Craft: The Art Fabric. New York: Van Nostrand Reinhold, 1972.

Davidson, William, ed. *The Illustrated Encyclopedia of House Plants*. New York: Exeter Books/Simon & Schuster, Inc., 1984.

Faulkner, Ray and Edwin Ziegfeld. Art Today: An Introduction to the Visual Arts, 5th ed. New York: Holt, Rinehart and Winston, 1974.

Gardner, Helen. Art Through the Ages, 6th ed. New York: Harcourt Brace Jovanovich, 1986.Held, Shirley. Weaving: A Handbook of the Fiber Arts, 2nd ed. New York: Holt, Rinehart and Winston, 1976.

Hicks, David. On Living-With Taste. London: Frewin, 1968.

Knobler, Nathan. The Visual Dialogue. New York: Holt, Rinehart and Winston, 1971.

Korwin, Laurence. Textiles As Art. Chicago: Laurence Korwin, 1990.

Krauss, Rosalind E. Passages in Modern Sculpture. New York: Viking Press, 1977.

Nelson, Glenn C. Ceramics: A Potter's Handbook, 5th ed. New York: Holt, Rinehart and Winston, 1984.

Scarf, Aaron. Art and Photography. New York: Penguin Books, 1986.

Smith, Paul J. and Edward Lucie-Smith. American Craft Today. New York: American Craft Museum/Wiedenfeld and Nicolson, 1986.

Whiton, Sherrill. *Interior Design and Decoration*, 4th ed. New York: J. B. Lippincott Company, 1974, chaps 8, 9, and 15–20.

23.29 A restrained use of accessories allows each object to be appreciated individually yet blend into a coherent whole. Ronald and Victoria Borus, designers. (Photograph: © Peter Aaron ESTO)

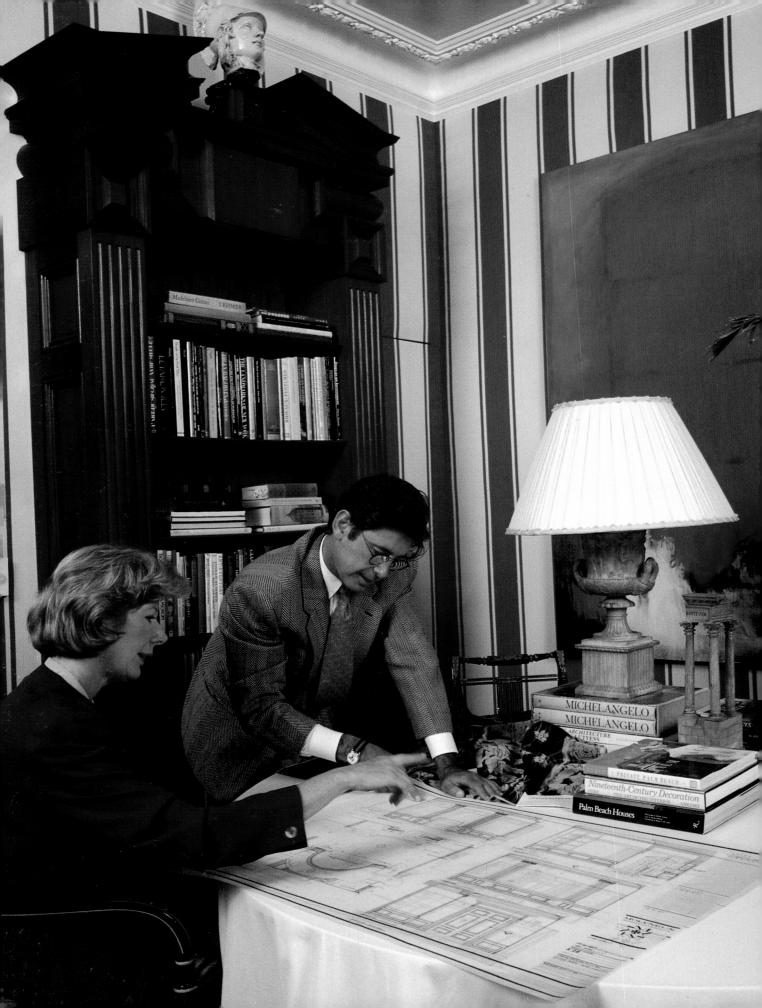

Professionalism in Interior Design Practice

Business Matters and Professional Issues

PREPARATION FOR THE PROFESSION
PROFESSIONAL ORGANIZATIONS
NCIDQ EXAMINATION
ETHICS
LICENSING
FUTURE OF THE PROFESSION

The business of interior design has become more and more complex. The scope of practice today encompasses not only the decorative effects of color, furnishings, and materials, but also the definition and analysis of functional, aesthetic, and behavioral needs within the built environment; the planning of space to function as a supportive environment as well as to please the aesthetic senses; the provision of accurate budgets and design costs; the production of design and construction drawings; the preparation of written documents such as agreements, specifications, and correspondence; the coordination, scheduling, and expediting of workmen, deliveries, and installations; and the maintenance of financial accounts, time records, and project files.

Project management has become an important role for the interior designer. The ability to effectively, efficiently, and profitably manage the *business* of interior design is as important to a successful career as technical knowledge, creative ability, and interpersonal skills. Seeing a project through from initial client contact to installation and post-occupancy evaluation requires management of a considerable amount of detailed information and the logistical planning of many activities.

It is important to remember that no project is completed without the cooperative efforts of many people. An interior designer does not work alone. Obviously, clients play an important role in a design project: The designer must develop rapport with them, secure their confidence, skillfully draw information relative to the project from them, and, ultimately, measure the success of the design by their response.

In the planning stages, many projects require an interdisciplinary exchange of information, consultation, and collaboration with architects, engineers, and specialists with technological expertise in lighting, acoustics, sound and/or video systems, electronic security mechanisms, computerized "smart house" energy management systems, and so forth. Some projects are, from their inception, joint efforts; several designers work together cooperatively as a *design team*.

24.1 A designer should keep a file of all the notes, sketches, and materials that accumulate during the course of a project to keep necessary information together and available for ease of reference. Juan Pablo Molyneux, interior designer. (*Photograph: Ted Spiegel*)

24.2 The team approach, as at Kohn Pedersen Fox, Interior Architects, New York, has become more prevalent as environmental and regulatory concerns have become more complex. At left, the architect works with computer-aided design to input a drapery motif that can then be overlaid onto the floor plan as a carpet pattern. At right, from left to right: The project manager, who selects staff, determines fees, executes contracts with clients and consultants, and oversees schedule and budget; the architect, who oversees drawings and construction, building and fire codes, and coordination of structural, mechanical, and electrical engineers: the resources designer, who serves as materials expert (colors, strengths, acoustic and fire ratings); the project designer, who designs the overall project, creating spaces and patterns. (Photograph: Ted Spiegel)

24.3 Manufacturers' representatives visit design offices to keep designers up to date on new products and their applications. They can also assist designers with current projects when their products may provide solutions to problems. Rochelle Cohen of Shelley Tiles. *(Photograph: Ted Spiegel)*

24.4 Carpenter making a custom wooden window frame. (*Photograph: Alvis Upitis/TIB*)

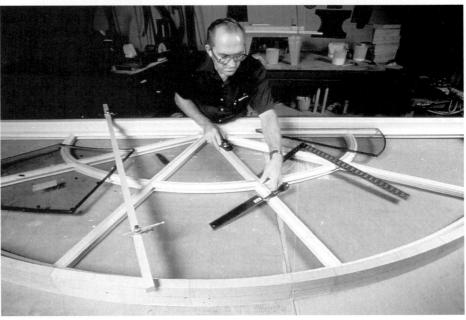

During the building process, the designer works with contractors and sub-contractors, including electricians, plumbers, carpenters, painters, wallpaper hangers, tile and carpet layers, and even landscape architects. The designer must also communicate with manufacturers and their representatives, trade sources, vendors, and dealers to purchase furniture, fixtures, and equipment (FF&E). Craftsmen, workroom personnel, and cabinetmakers are needed for the fabrication of products which may be custom designed for the project. Delivery people and installers are also essential to complete the project. All of these individuals become members of a kind of extended design team with whom the designer must establish good working relationships.

The working methods of a professional interior designer reflect a systematic and logical approach to problem solving, as in other professions. For review, the **sequence of activities in the design process**, as defined and described in detail in Chapters 1 and 8, is

- 1. Programming
- 2. Conceptualization
- 3. Design Development
- 4. Presentation
- 5. Construction Drawings and Specifications
- 6. Estimates and Bids

- 7. Scheduling
- 8. Purchasing
- 9. Supervision
- 10. Installation
- 11. Post Occupancy Evaluation

Unlike the decorator who may rely on a moment of inspiration or one decorative element to act as the focus of an interior, the truly professional designer thoroughly analyzes the problem and pursues the design process step by step, synthesizing relevant research, training, and experience with the objectives and constraints of the problem to provide a design solution unique to client and program needs. Creativity is certainly valued, but application of knowledge, thoroughness, organization, sensitivity to client needs, accuracy, attention to detail, and follow-up are also necessary. These characteristics are especially applicable to space planning, securing estimates and bids for a project, scheduling sequential aspects of work to be completed, purchasing, observing work in progress, making sure all details of the final installation are completed, and assessing the success of a project after the client has had the opportunity to experience it for a period of time.

PREPARATION FOR THE PROFESSION

As stated in the definition of interior design (see Chapter 1), the professional interior designer is qualified by education, experience, and examination. This three-fold qualification standard begins with a formal education which combines broad

24.5 Educational programs inform and prepare interior design students for the profession with a wide variety of knowledge and skills. L. Dorcus Roehrs, Instructor, at Parsons School of Design, New York City (Photograph: Ted Spiegel)

cultural aspects, specialized technical skills, and practical content specific to the profession. Accessibility, ergonomics, building and fire codes, and the physical attributes of materials are among considerations for the health, safety, and welfare of the public emphasized in educational programs.

The minimum educational standards which meet the needs of the profession and adequately prepare students for entry are set by the Foundation for Interior Design Education Research (FIDER), the agency, founded in 1971, which accredits post-secondary professional interior design programs in the United States and Canada. Three types of interior design programs are eligible for accreditation by FIDER: pre-professional assistant level programs, typically of two year duration; first professional degree level programs of four to five years; and post-professional master's degree programs. Two year certificate or diploma programs prepare students for design assistant positions, while four or five year baccalaureate degree programs provide a common body of knowledge that prepares students to become professional interior designers. Graduate degree programs direct students in research or advanced creative design work. In assessing standards of quality, FIDER evaluates programs for three levels of student achievement: awareness, understanding, and competency. The first level entails basic familiarity with concepts; the second involves a deeper comprehension and more specific and detailed knowledge; the third encompasses a well developed ability to apply concepts and information to specific tasks.

A common body of knowledge in interior design education is required for program accreditation. Eight categories are specified, as outlined in Table 24.1, with specific content units and achievement levels in each. Educational curricula may vary in emphasis and particular specialties; however, the common body of knowledge provides a standard foundation content to prepare graduates for entry-level positions in the profession. Programs which meet FIDER standards of quality may be granted accreditation for periods of three or six years. The FIDER office can provide a current list of accredited schools and programs. (Table 24.2 provides addresses for FIDER and other professional organizations.)

24.6 Membership certificates and awards displayed in designers' offices denote professional status. (*Photograph: Ted Spiegel*)

TABLE 24.1

Body of Knowledge for First Professional Degree Level Programs. Letters at right indicate minimum achievement required for each content unit: A = Awareness, U = Understanding, C = Competence

Content Units	Level
•	
•	
	\mathbf{A}
	C
•	U
Special purposes, i.e., historic preservation, adaptive use, etc.	U
Design attributes of materials, lighting, furniture, textiles, color, etc.	
	С
	C
	C
•	U
	C
Structure and construction	
Building systems, i.e., HVAC, lighting, electrical, plumbing, acoustics, etc.	U
	U
	C
	C
	C
	С
	C
	C
	C
	A
	U
	U
	U
	U
	U
	A
Experimental, survey, literature search, observation, etc.	A
	Studio: two-dimensional design fundamentals Studio: three-dimensional design fundamentals Drawing, painting, sculpture, ceramics, weaving, photography, etc. Theory: elements of design and composition Theory: color Theory: human environment, i.e., proxemics, behavior, etc. Design theories Spatial composition Human factors, i.e., anthropometrics, ergonomics, etc. Design for special concerns, i.e., environmental, ecological, etc. Design process, i.e., programming, conceptualizing, problem solving, evaluation, etc. Space planning Furniture layout and selection Special populations, i.e., disabled, elderly, children, low income, etc. Special purposes, i.e., historic preservation, adaptive use, etc. Design attributes of materials, lighting, furniture, textiles, color, etc. Design process, i.e., programming, conceptualizing, problem solving, evaluation, etc. Space planning Furniture layout and selection Special populations, i.e., disabled, elderly, children, low income, etc. Special purposes, i.e., historic preservation, adaptive use, etc. Design attributes of materials, lighting, furniture, textiles, color, etc. Structure and construction Building systems, i.e., htyloc, lighting, electrical, plumbing, acoustics, etc. Energy conservation, i.e., passive solar energy, etc. Detailing, i.e., furniture, cabinetry, interiors, etc. Materials, i.e., surface and structural materials, soft goods, textiles, etc. Laws, building codes and ordinances, life safety, fire, etc. Presentation, i.e., oral, written Graphics, signage, lettering, etc. Drafting, working drawings, etc. Computer systems, i.e., word processors, CADD, etc. Interior design profession and organization, ethics, related professions Business practice, specifications, industry product safety standards, estimating Business management: relationship to industry Art, architecture, and interiors Furniture, textiles, and accessories Theories and methodologies of research

TABLE 24.2

Professional Organizations for Interior Design

Organization	Address	Description/Background Information
American Society of Interior Designers (ASID)	608 Massachusetts Ave., N.E. Washington, D.C. 20002 (202) 546-3480 FAX (202) 546-3240	The largest professional organization in the world (over 31,000 members); formed in 1975 by merger of AID (American Institute of Interior Designers) and NSID (National Society of Interior Designers), origins dating back to 1931 when AID was founded. Includes both residential and non-residential designers, and educators, industry members, and others associated with the profession.
Council of Federal Interior Designers (CFID)	P.O. Box 27565 Washington, D.C. 20038	An organization for professional interior designers and space planners employed by the U.S. government; founded in 1986.
Foundation for Interior Design Education Research (FIDER)	60 Monroe Center, N.W. Grand Rapids, MI 49503 (616) 458-0400	An international agency formed in 1970 to accredit interior design programs in post-secondary institutions in the U.S. and Canada to ensure consistently high quality education.
Institute of Store Planners (ISP)	25 N. Broadway Tarrytown, NY 10591 (914) 322-1806	Formed in 1961 for persons active in store planning and design, visual merchandisers, students and educators, contractors, and suppliers to the industry; provides a forum for debate and discussion by store experts, retailers, and public figures; 1,200 members.
Institute of Business Designers (IBD)	341 Merchandise Mart Chicago, IL 60654 (312) 467-1950	Formed in 1969 for designers who specialize in non-residential or contract design; over 3,500 members.
Interior Designers of Canada (IDC)	Ontario Design Center 260 King Street East, #506 Toronto, Ontario M5A 1K3 CANADA	An umbrella organization encompassing the autonomous provincial associations; founded in 1972 to create a unified voice for the profession and provide a national forum for the exchange of information throughout Canada.
Interior Design Educators Council (IDEC)	14252 Culver Dr., Suite A-331 Irvine, CA 92714 (714) 551-1622	International organization founded in 1967 to aid interaction among educational programs; dedicated to advancing education and research in interior design. Publishes research in <i>The Journal of Interior Design</i> , formerly <i>Journal of Interior Design Education and Research</i> .
International Federation of Interior Architects/Interior Designers (IFI)	Waterlooplein 219 Postbus 19126 NL-1000 GC Amsterdam The Netherlands 31-20-6276820 FAX 31-20-6237146	Comprised of national interior design associations from around the world; over 20 member countries; founded in 1963.
International Furnishings & Design Association (IFDA)	107 World Trade Center P.O. Box 58045 Dallas, TX 75258 (214) 747-2406	An organization for interior design professionals involved in retailing and executives who deal with furnishings; formerly the National Home Fashions League (NHFL).
International Society of Interior Designers (ISID)	ISID International Office 1933 South Broadway, Suite 138 Los Angeles, CA 90007 (213) 744-1313	Worldwide membership promotes networking between designers, students, industry, and related fields; founded in 1979.
National Council for Interior Design Qualification (NCIDQ)	50 Main Street White Plains, NY 10606-1920 (914) 948-9100 FAX (914) 948-9198	Incorporated in 1974 to establish standards for the qualification of professional designers and to administer a competency exam; membership is comprised of other professional organizations rather than individuals.

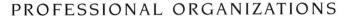

A number of professional design organizations exist in the United States, in Canada, and internationally. Although each has its own specific qualifications and categories of membership, all work to advance the profession through continuing education for members, promoting design excellence, adhering to a code of ethics, and supporting licensing, title registration, or certification. Generally, major design organizations require education, experience, and examination for full professional membership. Many educational programs include entry-level internships which provide students an opportunity to receive on-the-job training in professional design firms. Beyond that, work experience and education together must total six years before an individual is eligible to take a qualifying examination, the final component for full membership. Most organizations have additional membership categories for those wishing to belong prior to completion of requirements for full professional membership. Association with professional organizations provides the designer with a valuable network for continued professional growth. Membership also indicates to the public that the designer has met the criteria of the organization and confers the status of professionalism. Active involvement in such organizations facilitates the exchange and pursuit of knowledge for the individual while also strengthening the profession as a whole. The major organizations for practitioners, design educators, accreditation of educational programs, or examination are listed in Table 24.2. For more information, contact the organizations directly.

A recent development related to design associations is the discussion of unifying into one large body, eliminating all or many of the separate organizations. Some of the benefits of such a "unified voice" include greater influence and power through larger numbers, increased communication and information sharing among designers, and the simplification of belonging to only one professional design organization. Drawbacks include possible lack of identity for areas of specialization in design and increased expense to manage such a large organization encompassing all existing associations throughout the world. Discussions are ongoing and many issues need to be addressed before this concept takes form. It represents the current state of the profession and reflects awareness of our global potential.

24.7 Computer programs have simplified the process of writing specifications with complete product information accessible at the touch of a finger. New York Design Collaborative, Inc. (Photograph: © Norman McGarth)

NCIDO EXAMINATION

The National Council for Interior Design Qualification (NCIDQ) was formed to establish minimum standards of competence for professional practice. The NCIDQ administers an examination twice a year at locations throughout the U.S. and Canada to qualify design practitioners as professionals. The exam must be passed for professional membership in ASID, IBD, ISP, IDC, and ISID. Eligibility requirements, as stated above, are six years of combined education and practical experience (with a minimum of two years of experience). The NCIDQ exam has a twelve-hour format, extending over a two-day period. Candidates may take all of the exam or selected sections at one sitting. The exam was recently revised, and not everyone applauds the new format. (The following information describes the exam currently being administered at this writing of this text.) There are six sections, ranging in length from one and one-half to three hours each. Different levels of questions measure awareness (recall of information, recognition, and discrimination), understanding (comparison/contrast and application of principles, concepts, or skills), and *competency* (integration of principles or concepts to make judgments and provide solutions to problems and complex situations).

The first section of the NCIDQ exam addresses building and barrier-free codes and includes working drawings and construction as well as codes/standards knowledge pertaining to life safety, testing standards, and barrier-free design. Second is identification and application of design theory and human factors, programming techniques, contract documents, furniture/fixtures/equipment/finishes, building and interior systems (materials, installation methods, lighting, electrical, plumbing, mechanical, acoustics, security, and window treatments), communication methods, business and professional practices, project coordination, and history. A problem solving section presents questions based on drawings related to the work of an interior designer and tests the candidate's ability to read and interpret graphic information. The final three sections make up the practicum portion of the exam which measures competency in programming, three-dimensional design (spatial volume, building systems, and lighting) and the design of a scenario, selected by the candidate from five project types: corporate, residential, retail, institutional, or hospitality. This allows the candidate to work in his/her area of practice. Passage of the exam provides certification of professional competency to practice interior design.

An underlying purpose of the NCIDQ is to contribute to public acceptance and awareness of the interior design professional and both professional and legal recognition. The profession's concern for public health, safety, and welfare are clearly reflected in the content of the NCIDQ exam, which may be used as a universal standard of minimum competency to enable designers to practice as professionals and have reciprocal registration throughout the U.S. and Canada. The NCIDQ also provides guidelines for codes of conduct and recommended practices.

As recognition of interior design as a profession is increased, the public will benefit by becoming more aware of the qualifications of professional practitioners and more protected from incompetence. The expertise of the licensed professional interior designer will bring not only greater responsibility but also greater reward.

ETHICS

A profession is characterized by standards of behavior and practice to which its members adhere. Standards of professional conduct are important to maintain the trust placed in designers by their clients, the general public, other design colleagues, and members of other professions with whom they interact. In addition to design competence (certified by passage of the NCIDQ exam), the professional designer must possess honesty, integrity, and objectivity. The major professional organizations have defined *codes of ethics* as models of conduct for their members. Both moral principles and business practices are addressed; the organizations enforce minimum acceptable standards through judicial councils and ethics committees which review charges brought against members and may publicly revoke membership or level other sanctions against violators. Being a professional means acceptance of responsibility to the public and requires unswerving commitment to honorable conduct.

Responsibility to the environment has become an issue in professional practice in recent years. More and more designers are joining the "green" movement to preserve and protect a healthful environment for us and for generations to follow. This is a far-reaching concern and an area of current research in which the conscientious professional designer must be informed and responsive. It involves issues that range from depletion of natural energy resources and deforestation, to the sick building syndrome resulting from indoor air pollution.

LICENSING

Since the early 1950s, the interior design profession has been working to pass licensing, title acts, practice acts, certification, or registration in the states and provinces of the U.S. and Canada. Licensing in its various forms addresses three issues: legal recognition of the interior design profession as having expertise distinct from other professions; interior designers' contribution to and protection of the health, safety, and welfare of the public; and public assurance of the professional qualifications of practitioners. In recent years, a number of licensing acts have been passed. Many more are being considered and will undoubtedly gain acceptance soon. Most are not meant to limit who may practice the profession, but rather to inform and protect the public through certification or registration of professionals. Minimum requirements are established for education and experience, usually those already stated for major professional organizations and the NCIDQ. The NCIDQ exam or its equal is specified to qualify professional competence. A code of practice guidelines in licensing acts describes and enforces ethical conduct. Requirements for continuing education are stated as well. The NCIDQ definition of interior design (see Chapter 1) is also included in licensing bills. Provisions for reciprocity between states still need to be established in many states.

Licensing brings with it both legal and ethical responsibilities which the designer must be prepared to accept. Designers work to enhance the quality of life and to protect the health, safety, and welfare of the public when they engage in space planning, interior construction and detailing, specification of FF&E (furniture, fixtures, and equipment), project management, and many other daily activities. They must act in a competent and objective professional manner and fully accept the liabilities of their actions. They may also be subject to liability with other professionals who form an interdisciplinary design team having joint responsibility for built environments utilized by the public.

FUTURE OF THE PROFESSION

Future directions in interior design will be influenced by technological advances as well as an increasing emphasis on professionalism. The computer, already an

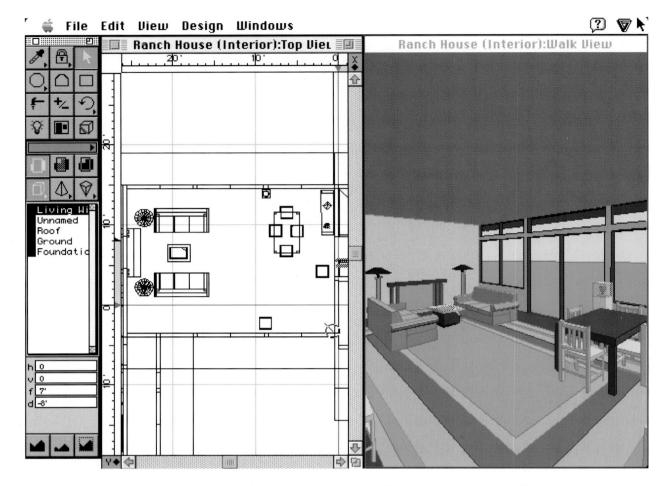

24.8 (above) Many new computer programs offer clients a "walk through" their newly designed space while it is still in the planning process, enabling them to accurately envision what the designer proposes with photo realism. (Courtesy Virtus Corporation)

24.9 (right) Computer-generated perspective drawings allow the designer to explore various color, texture, and lighting options. Jim Lennon, designer. (Courtesy StrataVision 3D)

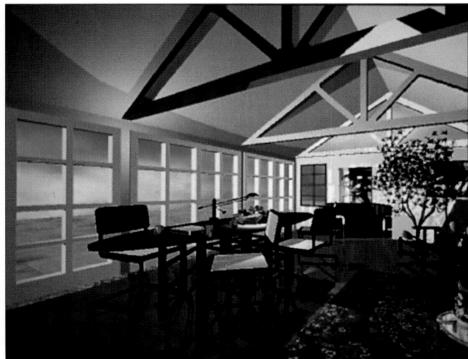

important design tool, will continue to play a stronger role in analysis of client needs, project coordination, graphic communication, and information retrieval. Both time and space are saved if a design office is fully computerized. Errors in computations and specifications can be reduced with computer programs that automatically figure yardage and contain complete product information from manufacturer's catalogs. Some programs can give clients a "walk through" tour of proposed plans or realistic views of spaces complete with lighting to help them visualize what is being designed for them. Figures 24.7–24.9 illustrate some of the capabilities of the computer for both business functions and design graphics.

As we progress toward the twenty-first century, designers will be called upon to have more technical knowledge in specialized areas such as interiors for special populations, energy efficiency, adaptive reuse of buildings, and environmental safety. They will also find themselves collaborating with others to a greater extent as members of design teams. And, as the practice of interior design becomes more complex and the technical aspects more demanding, there will continue to be pressure from both within and from outside the profession for the legal recognition of interior designers throughout North America. Designers of the future must be prepared to accept greater responsibility and accountability for the environments they shape.¹

NOTE TO THE TEXT

1. "Interior Design as a Profession." (Richmond, Va.: Interior Design Educators Council, 1982.)

REFERENCES FOR FURTHER READING

Abercrombie, Stanley. A Philosophy of Interior Design. New York: Harper & Row, 1990.

Alderman, Robert L. How to Make More Money at Interior Design. New York: Whitney Communications Corporation, 1982.

Ballast, Kenneth R. Interior Design Reference Manual. Belmont, Calif.: Professional Publications, Inc., 1992.

Jones, Gerre L. How to Market Professional Design Services, 2nd. ed. New York: McGraw-Hill, 1983.

Kliment, Stephen A. Creative Communications for a Successful Design Practice. New York: Whitney Library of Design, 1977.

Knackstedt, Mary V. Interior Design for Profit. New York: Kobro Publications, Inc., 1980. Knackstedt, Mary V. with Laura J. Haney. The Interior Design Business Handbook. New York:

Whitney Library of Design, 1988.

Murphy, Dennis Grant. *The Business Management of Interior Design*. North Hollywood, Calif.: Stratford House, 1988.

Piotrowski, Christine. Professional Practice for Interior Designers. New York: Van Nostrand Reinhold, 1989.

Siegel, Harry with Alan Siegel. A Guide to Business Principles and Practices for Interior Designers, new rev. ed. New York: Whitney Library of Design, 1982.

Veitch, Ronald M., Dianne R. Jackman, and Mary K. Dixon. *Professional Practice*. Winnipeg, Canada: Peguis Publishers, 1990.

APPENDIX A: DESIGNER SYMBOLS

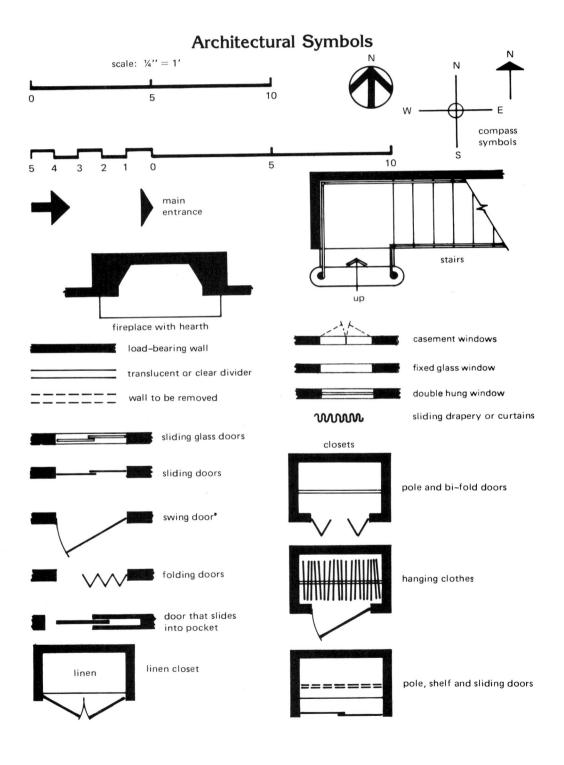

Architectural Symbols

cabinets

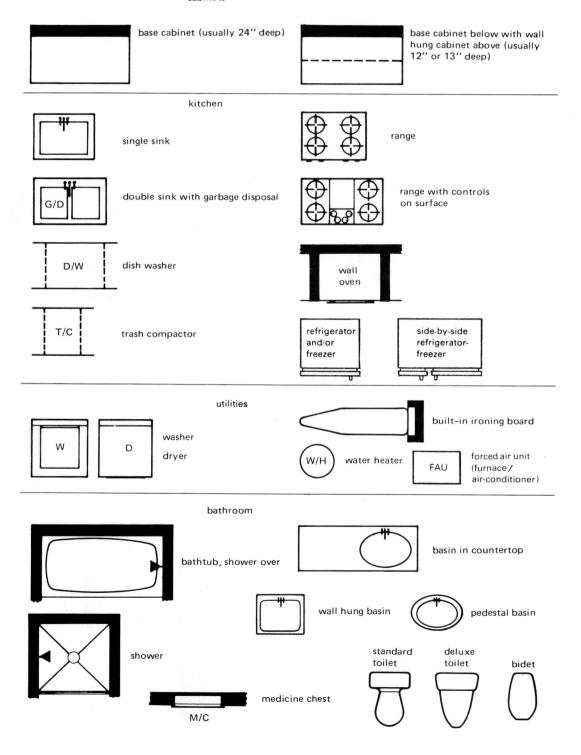

Electrical Symbols

Ю <u>-</u>	wall light	\Diamond	ceiling light		
⊢ Ç	pull chain wall light	\bigcirc	recessed ceiling light		
Ιω	switch	-(H) -	heat light		
⊦w³	3-way switch	-(F)-	ceiling fan		
HT	thermostat	∀	pull chain		
\mapsto	110 volt outlet		ceiling light		
₩	220 volt outlet		track lighting		
⊯	special outlet (air-conditioner)	0	surface individual fluorescent		
₩ _{20 A} .	20 amps	OR	recessed individual fluorescent		
FG	clock outlet	0	surface continuous row fluorescent		
\odot	floor electric outlet		recessed continuous		
\blacksquare	telephone outlet	OR	row fluorescent		
	floor telephone outlet	\oplus	floor and table lamps		
HTV	television antennae outlet	-			
\Box	door bell				
to	controls one fixture	ω ₃	two 3-way switches control two lights		
	controls one fixture and one outlet	w ₃			

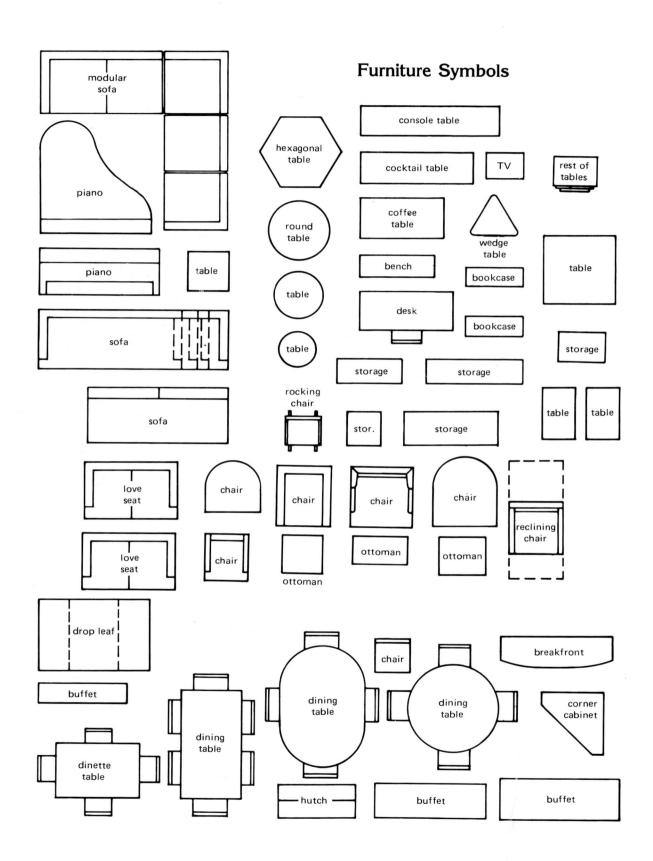

Furniture Symbols twin queen size double bed king size bed with with with headboard with headboard headboard headboard bench bench table stool night night stool table table corner TV table dressing night sofa table table rocking chair bedside round twin twin table table bed bed chair chaise longue double ottoman dresser chair chair storage stor. storage desk storage chest storage chest chest hamper chair chair table play table toy dressing chest feeding table table

APPENDIX B: CARPET PILE STYLES AND SELECTION GUIDE

×		Halls & Stairs ¹	Living Room ²	Dining Room ³	Family Room ⁴	Bed- room ⁵	Kid's Room ⁶	Kit- chen ⁷	Bath- room ⁸
	Saxony Plush: A dense level- cut pile of about one-half inch or less. Yarn tufts are closely packed, presenting a smooth, luxurious surface. Generally for formal settings.		√	V		√			
MM	Textured Plush: Also a level- cut pile but with pile heights of more than one-half inch and not as dense as saxony plush. Appropriate for informal room schemes.	$\sqrt{}$	√	V	V	√	V		√
<u> Maranara</u>	Frieze Twist/Trackless: Curled or twisted tufts make for a textured plush that masks foot-prints. Especially suitable for less formal decors.	V	V		V		V		
	Cut-Loop: Yarns are tufted into islands of high cut tufts and lower loop tufts to form a sculptured pattern. Suits more informal settings.		V	V		V			
000000	Level-Loop: A simple loop pile with tufts of equal height. Durable construction makes it appropriate for high-traffic areas and informal rooms.	V			√ 		V	V	
	Multi-Level Loop: A loop pile carpet with two or three levels of tufts forming a random sculptured surface. Broad application, including semi-formal schemes.	√			√		√	√	√
	Random Shear/Tip Shear: Features a mixture of cut and uncut loops, creating a highly textured appearance. Suitable for both formal and informal settings.	√			V		V		√

¹High traffic requires densely tufted carpet with low pile height. Consider medium colors with soil-hiding texture or pattern.

²If client entertains frequently, stain resistance and cleanability are important.

³Stain resistance and cleanability are important.

⁴Multipurpose rooms require dense carpet with stain resistance. Consider patterns and multicolor tweeds.

⁵Durability may not be critical in low-traffic areas; delicate textures and colors are appropriate.

⁶Active kids need tough, easy-to-clean carpet. Consider medium colors and soil-hiding texture or pattern.

Soil and stain resistance and cleanability are very important. Moisture, mildew, and stain resistance are important.

APPENDIX C: INTERIOR WINDOW TREATMENTS

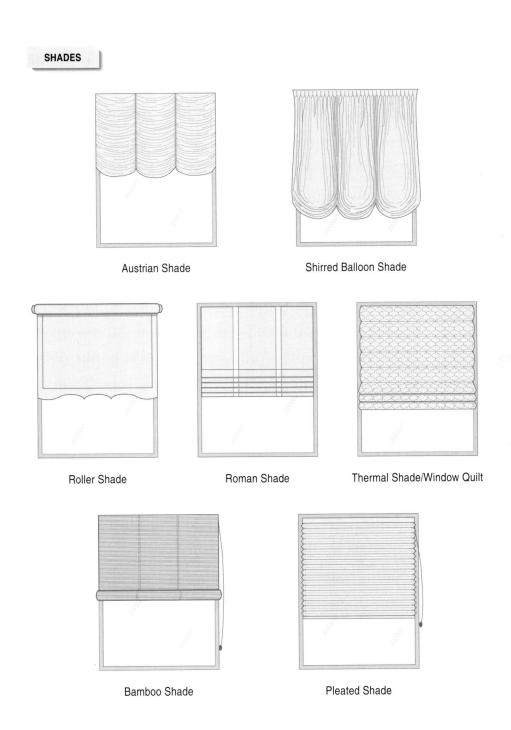

BLINDS, SCREENS, AND SHUTTERS

Venetian Blind (2" slats)

Miniblind (1" slats)

Vertical Blinds (4" slats)

Shoji Screen

Latticework Screen

Raised-Panel Shutters

Louvered Shutters (1" blades)

Plantation Shutters (2" to 4" blades)

CURTAINS AND DRAPERIES

Sheers/Glass Curtains

Two-way Draw Draperies

Tieback Draperies with Sheers

Sash Curtains

Crisscross Priscilla Curtains

Café Curtains

Tiered Curtains

Bishop's Sleeve Curtains

TOP TREATMENTS

Shirred Valance

Shirred Valance on an Extra-wide Rod

Valance Shirred Top and Bottom

Shirred Pouf Valance

Pleated Valance

Box Pleated Valance

Box Pleated Balloon Valance

Flat/Pelmet Valance

Festoon, or Swag, and Jabot, or Cascades

Shaped Cornice

Architectural Cornice

Lambrequin, or Cantoniere

APPENDIX D: EXAMPLE OF MEASURING FOR DRAPERIES

Given:

- · 8'0" ceiling height
- · 4'6" X 6'0" window
- · Two-way conventional traverse rod
- · Floor length pleated drapery
- · 60" wide fabric

Scale: $\frac{1}{4}$ " = 1'0"

 Measure the window width, or the width of the area to be covered if more than just the window opening (see #2).

Calculation: Window width = 72".

2. Add **stackoff** space (the area needed by opened draperies to stack off the glass) by extending the width by, in most cases, one-third. (A lightweight or sheer fabric may require only one-fifth the window width, depending on fullness.) For a two-way draw drapery, the stackoff dimension is divided equally on each side of the window opening. One-way draw drapery utilizes the entire stackoff on one side; on the other side the drapery should extend 4–6" beyond the glass to eliminate *light strike* (a narrow shaft of light leaking into the room) and to insure privacy.

Calculation: Add stackoff $(72'' \div 3) 24'' + 72'' = 96''$.

3. Add overlaps and returns. A two-way traverse rod provides a 2" overlap on each side where it meets in the center, or a total of 4" for one pair of draperies. The overlap prevents light strike, provides privacy, increases insulating properties, and presents a nice appearance when the draperies are closed. The return is the distance the drapery rod projects from the wall and the corresponding distance the end of the drapery heading wraps around it to the wall, covering the hardware. Returns vary according to the number of layers of drapery, with single-layer draperies normally needing a 4" return on each side while overdraperies require 6" on each side for a second layer and 9" for a third layer. (Underdraperies do not require returns)

Calculation: Add overlaps and returns (4'' + 8'') 12'' + 96'' = 108''.

4. Determine the number of widths of fabric required to make up the finished pleated panels of drapery. First, multiply the finished width by the desired fullness, usually 2, 2½, or 3. Generally, the lighter the weight of the fabric selected, the larger the multiplier. Next, divide the product by the width of the particular fabric used. If the

result is a fraction, round up to the next whole number. (Rounding down will result in less generous fullness, appropriate if space is limited or a slender effect is desired, and for some styles of curtains.)

Calculation: Multiply for fullness $(2.5 \times \text{width}) = 270''$. Number of widths needed $(270 \div 60) = 4.5$ rounded up to 5.

5. Measure the finished length of the drapery after determining whether sill, apron, or floor length and whether hung from the ceiling, a decorator rod, or a conventional rod. If the drapery is installed floor to ceiling, this dimension has ½" taken from the top and bottom (1" total) to prevent wear from abrasion against the floor and ceiling. For underdraperies, deduct 1½" so they do not show below the overdrapery. Conventional drapery rods are installed 4" above the window casing, decorator rods 6" above, so that the back side of the drapery heading is not visible from outside the window.

Calculation: Finished length (4" above window to $\frac{1}{2}$ " above floor) = $87\frac{1}{2}$ ".

6. Add hems and headings required to finish the draperies and stiffen the pleats. An allowance of 16–18" is sufficient for a 4" hem turned twice (requiring 8") and a 4" double wrapped heading. Individual workrooms construct headings differently so it is wise to communicate with the particular fabricator before the additional length is figured.

Calculation: Add hems and headings to determine cut length (8'' + 8'') 16'' + 87.5'' = 103.5''.

7. Calculate total yardage by multiplying cut length (determined in #6) by the number of widths (found in #4) for total linear inches, then dividing by 36 to convert to yards. Round up to the next whole yard.

Calculation: Multiply cut lengths by number of widths $(103.5" \times 5) = 517.5$ ". Convert to yards $(517.5" \div 36) = 14.375$ rounded up to 15 yards.

If a patterned fabric is selected, matching the pattern repeats horizontally across the panels will undoubtedly require additional fabric and result in some waste. The cut length of the fabric must be determined by calculating the number of complete pattern repeats per panel. The size of the pattern repeat is divided into the *unpatterned* cut length, with the resulting number rounded up to the nearest whole number. For example, a 15" repeat divided into a 100" plain cut length (finished length plus hems and headings) yields 7 complete pattern repeats per panel, requiring 105" per cut rather than 100", with some waste. This increases the necessary yardage. The larger cut length required for complete pattern repeats is multiplied by the number of widths, then converted to yards.

Placement of the pattern repeat requires attention as well. Generally, in a floor to ceiling drapery, any partial repeat should be placed at the bottom hem where it will be least noticeable and furniture may obscure it. The full pattern repeat is placed where it is most noticeable. In shorter draperies, the bottom hemline may be more in view, requiring the partial repeat at the heading.

Calculation: If a 20" repeat pattern fabric is used, each panel would be 120" long rather than 103.5" and would include six complete repeats $(103.5" \div 20" = 5.175$ rounded up tro 6; $6 \times 20 = 120$ "). Then follow the remaining steps: $120 \times 5 = 600$; $600 \div 36 = 16.66$ rounded up to 17 yards.

APPENDIX E: LUMINAIRES

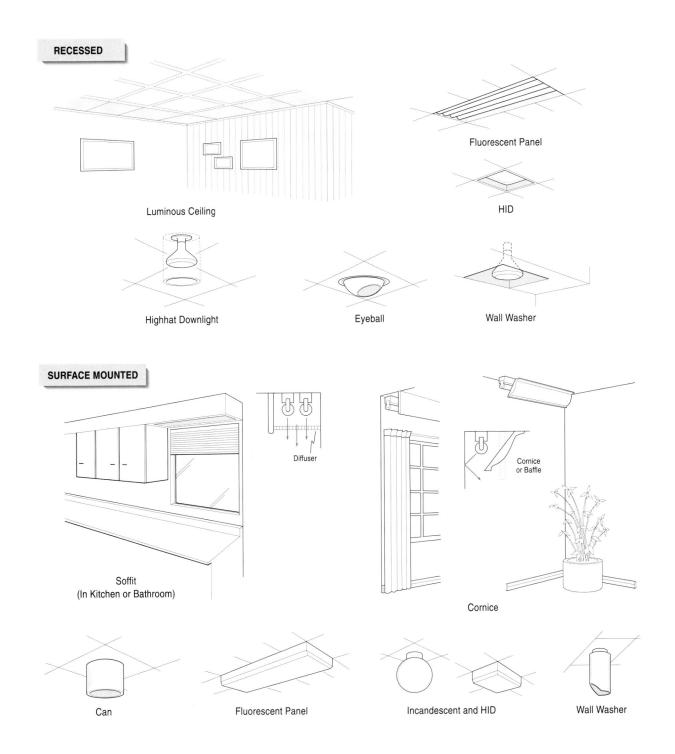

TRACK Fluorescent SUSPENDED General Diffusing Direct / Indirect Downlight Exposed Lamp Canopy (In Kitchen or Bathroom)

WALL MOUNTED LUMINAIRES

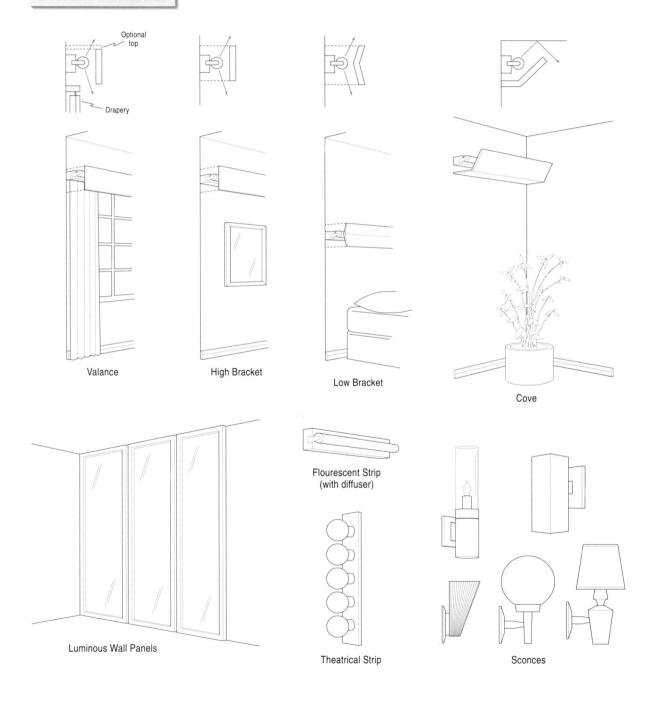

APPENDIX F: OPTIMUM LAMP POSITIONS AND LAMPSHADE HEIGHTS

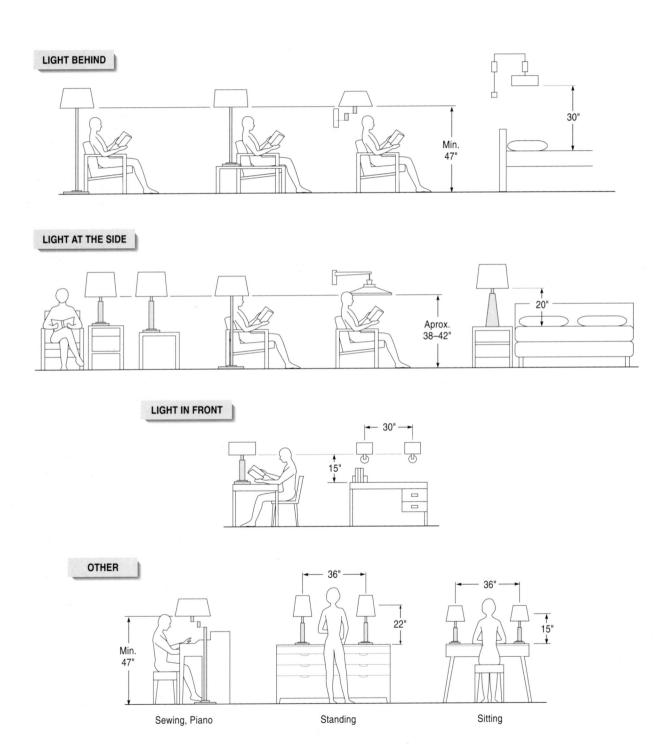

GLOSSARY

Terms italicized within definitions are also defined separately in the glossary.

ABS (acrylonitrile, butadiene, styrene) A tough, lightweight, highly moldable plastic compound especially suited to fitted parts and interlocking components; major uses include modular furniture, luggage, and plumbing systems.

accent To enhance the decoration by using, in moderate quantities, an intense color to differentiate a scheme.

accent lighting Directional lighting to emphasize a particular object or draw attention to a part of the field of view.

achromatic Neutral color, lacking in chroma or intensity: black, white, or gray.

acoustical tile/plaster Wall and ceiling tiles and plaster that help subdue noise.

acoustics The science of the production, control, and transmission of sound. It often refers specifically to the optimum quality of musical sounds.

acrylics Rigid, durable plastics that are very clear and transparent and have the unique ability to "pipe" light. Common trade names include Lucite, Plexiglas, and Perspex.

active solar system A system of specially designed equipment that requires additional energy to collect, store, and especially to distribute solar heat.

adaptive reuse Recycling of older and historic buildings. adobe brick Brick composed of sun-dried clay with a cement or asphalt stabilizer; a traditional building material in the southwestern United States and other hot, dry cli-

aerial perspective The effect of the atmosphere on distant colors, diminishing contrasts, lowering intensities, and lightening values.

afterimage A visual sensation that occurs after exposure to the external stimulus has ceased; often the appearance of a complementary hue after intense visual stimulation by strong color.

ambient light General illumination.

American Society of Interior Designers (ASID) The largest national professional interior design organization in the world. Membership is based on educational and practical experience as well as a competency exam. The organization focuses on professionalism in design.

amplification The effect of color intensification due to the interreflection of light from one colored surface to another; also an increase in the volume of sound.

anthropometrics The measurement of the size and proportions of the human body and its application to the design of furnishings, equipment, and spaces.

antimicrobial treatment A treatment that prevents the growth of mold, mildew, or bacteria in carpet.

area The two-dimensional measure of a surface; in home design, usually the square measure of large planar elements—walls, floor, or the whole enclosure.

ASA (acrylonitrile, styrene, acrylic elastomer) A plastic compound with properties similar to those of ABS.

ashlar Masonry construction in rectangular stones or bricks.

ASTM The American Society for Testing and Materials. **atrium plan** An architectural *plan* in which all major rooms open directly upon an atrium or central courtyard, which may be glass-enclosed.

awning windows Windows hinged at the top or occasionally at the bottom that swing in or out to open.

Axminster carpet A patterned, woven *carpet* originating in the 1700s in Axminster, England. Almost all of the pile yarns appear on the surface, and they are usually at one height.

axonometric projection A drawing showing an object or building in three dimensions; the *plan* is placed at an angle and all dimensions on the horizontal and vertical planes are to scale, but diagonals and curves on the vertical plane are distorted.

ballast An auxillary device used with fluorescent and high intensity discharge (HID) lamps to provide the necessary starting voltage and to limit the current during opera-

balloon frame See *skeletal frame construction*.

baluster One of a set of small pillars that supports a handrail (or balustrade) on a stairway; also used as a decoration on furniture.

balustrade A series of turned vertical supports (balusters) for a stair rail.

banquette An upholstered bench-type seat.

barrel vault See vaulted ceiling.

barrier-free design Design for the disabled which presents no physical obstacles or barriers to access and free movement in the environment.

baseboard A board skirting the lower edge of a wall.

batten A thin narrow strip of wood used to cover a joint. Bauhaus A school of design begun in Germany in 1919 advocating the union of art and technology that led to the development of the International Style.

bay window A window set in a frame projecting outward from a wall to create an interior recess, usually of fixed glass but may have movable sections.

beam The horizontal member of a structure's support skeleton resting on vertical posts; usually a heavy timber or metal bar.

berber A *carpet* texture characterized by broad, short loops which give a popcorn-like appearance.

bevel The divergence of one part of face from the *plane* of another, or from a perpendicular to that plane.

bidet A bathroom fixture designed for water-cleansing of the perineal area of both males and females after using the toilet.

bifold door A door with vertical double panels that folds back against itself; frequently used for closet doors.

binuclear plan An architectural plan that divides a structure into two separated wings. In home design, such a plan often sets aside one wing for group living, the other for bedrooms.

biodegradable Capable of being broken down into innocuous products by the action of living beings.

blister (1) A bulge in a veneered surface; (2) an irregular-

shaped growth ring in wood.

board-and-batten construction A type of wall surfacing in which wide vertical boards are sealed at their junctures by narrow strips of wood, the battens.

bolt A roll containing wall covering or textile yardage.

bonded fabric A fabric formed by combining an outer face fabric with a backing fabric using an adhesive or thin foam lamination.

bow window A bay window in the form of an unbroken curve

braced frame See skeletal frame construction.

bracket lighting A light placed on a wall behind a bracket board that directs light upward and downward.

brainstorming The generation of ideas without imposing judgment as to their quality.

brick A clay block hardened by heat, often used as a building material. See also adobe brick, firebrick.

brilliants Several pinpoints of light that produce a glitter

broadloom Floor textiles woven on looms more than 36 inches wide.

bubble diagram The first step of planning in which bubbles represent activity zones and are placed in proximity relationships.

burl A wartlike growth on a tree that is the source of a veneer with a mottled pattern.

cabriole A furniture leg of double curvature, tapering gradually to an ornamental foot, often in the form of an animal's paw.

calendering A process of turning thermoplastics into film and sheeting by passing the plastic between heated rollers; a process of giving cloth or paper a glossy finish by smoothing it between heated rollers.

can/cannister A luminaire shaped like a can that contains a lamp at the top or bottom.

candela The unit of measure of candlepower.

candlepower The luminous intensity of a light source in a specific direction.

cantilever In architecture, any horizontal member—a beam, floor, or other surface—projecting beyond its support.

carpet A soft-surface floor covering available by the yard and blanketing the entire floor. Increasingly, the term is used to embrace partial floor coverings or rugs.

carpet The general term for a soft floor covering fastened to the entire floor from wall to wall.

casement A loosely woven or knit sheer contemporary drapery fabric.

casement window A window hinged at the side and swinging open like a door, usually used in pairs.

cast To mold a substance while it is in a malleable, usually liquid state, allowing it afterward to set or harden. Also, the result of such a process.

cathedral ceiling A high, open, gabled ceiling.

cavity-wall construction A building technique that provides hollow space within a wall to afford room for pipe and wiring as well as insulation in the form of thermal materials or simply trapped air.

cellulosic fiber A fiber from a plant source; cellulose is used as a basic raw material in making rayon, acetate, and tri-

cement A finely powdered composition of alumina, silica,

lime, iron oxide, and magnesia that, when combined with water, sets to a hard, durable mass; the binding agent for concrete.

ceramics Objects shaped from clay and heated (fired) in a kiln to make them hard and durable.

chair rail A horizontal band or strip, generally of wood, secured to the sides of a room at a height from the floor equivalent to the visual height of the backs of chairs in order to prevent them from injuring the face of the wall.

chaise longue An elongated seat for reclining with a raised backrest and sometimes arms.

china Fine white ceramic ware fired at a very high temperature; used for figurines and much expensive dinnerware.

chroma See intensity.

clapboard A wood siding composed of narrow boards each with one thinner edge to facilitate horizontal overlapping; also, an individual board of this type.

clerestory A window or bank of windows inserted between two roof levels to bring light high into a room.

closed plan An architectural plan that divides the internal space of a structure into separate, discrete rooms.

coffered ceiling Ceiling with ornamental sunken panels between beams that are closely spaced and placed at right angles to one another.

commode A low chest of two or more drawers resting on legs.

concrete A material consisting of cement mixed in varying proportions with sand and gravel or other aggregates. With the addition of water, the mixture becomes moldable, capable of assuming almost any shape. Concrete dries to a heavy, stonelike mass of great strength. Precast blocks and slabs offer particular convenience for building. See also reinforced concrete.

concrete blocks Large, generally hollow, bricklike blocks composed of concrete, widely used in building, especially

for walls.

condominium A multiunit living complex—usually of the apartment-house type but sometimes organized as a group of separate dwellings-in which residents own their individual units. Services and maintenance are provided by a management company, which charges a fee to residents.

conduction The direct transfer of heat through a solid ma-

terial, such as glass or metal.

conduction heater A heating system whereby radiators circulating hot water or steam warm the air in an enclo-

console table A table placed against, or whose top is affixed to, a wall.

construction/working drawings The final mechanical drawings that are used to obtain bids and construct a de-

contract A legally binding written agreement between an interior designer and a client outlining services to be ren-

dered, time schedule, and responsibilities.

contract design Nonresidential interior design, including offices, institutions (health care, medical, and geriatric facilities; schools, colleges, and universities), hospitality and industrial facilities, retail businesses, and model homes.

convection The transfer of heat through air circulation. convection heater A heating system whereby air warmed in a furnace is blown out through registers; a forced-air

corner block A block used to strengthen chair rails or cab-

GLOSSARY 653

- **cornice** The topmost horizontal member of any structure. In interior design, a horizontal band at a window top or ceiling that conceals curtain or *drapery* tops and rods, or a *luminaire* which directs light downward.
- cove A trough or other recess, often part of a ceiling design, or sometimes built into a wall, concealing an indirect light source (cove lighting); a concave molding, particularly one placed where the wall meets the ceiling or floor.
- **coved ceiling** A ceiling that curves into the supporting walls rather than meets them at right angles.
- critical path The time frame and overlapping order of steps in the building and finishing process.
- crotch The junction of a tree trunk and limb that produces a V-shaped figure in veneers.
- **crown molding** Topmost *molding*. **cruciform** In the shape of a cross.
- crystal In common usage, glass of superior quality containing lead.
- **curtain/partition wall** A thin subordinate wall between two piers or other supporting members.
- **cut pile** A *fabric* or *carpet*, the face of which is composed of cut ends of *pile yarn*.
- **dado** The specially finished lower portion of an interior wall defined by a continuous horizontal *molding* that is normally waist-high; also, the molding itself.
- **daybed** An elongated chair or *chaise longue*; more generally, a convertible couch in which the mattresses serve as the seating surface.
- **dead storage** Holding space either beyond unaided human reach or otherwise inconveniently situated.
- **decibel** A unit for expressing the relative intensity of sounds on a scale from zero for the least perceptible sound to about 130 for the average pain level.
- **decorative design** The arrangement, shaping, coloring, or addition of ornament to make an object or space beautiful or interesting to the eye.
- **decorator rod** Decorative large-scale hardware meant to be visible; usually made of brass, chrome, wood, or wrought iron.
- **density** A factor used to judge the quality of *carpet*; the amount of surface *yarns* compressed into a given area: the closer the *pile* tufts are to each other, and the higher and heavier the *pile yarn*, the more durable the carpet within the same *fiber* category.
- **design** The process of planning a building, furnishings, or composite interiors; the scheme that makes an end product possible in its executed form, material(s), and size.
- **design concept** An idea for the solution to a design problem.
- **design/problem statement** A brief statement identifying a design project according to its purpose, location, and client.
- **design process** The sequence of steps in creating and executing a design project.
- **detail drawing** A drawing, commonly of full size or on a scale two to three times greater than the general drawings, showing the details of a composition or object to be built, or part of it.
- **dhurrie** A *rug* that is manufactured in India; originally cotton, now also made from wool.
- diaphonous sheer See glass curtain sheer.
- diffuse reflection Scattered, soft reflection of light.

- **direct lighting** Lighting that shines directly on the area or task being lit.
- **dome** A hemispherical roof or vault. In theory, the result of rotating an arch about its vertical axis.
- **dormer** A window structure projecting outward from a sloped roof.
- **double-glazed window** A window with two glass panes, having a dead-air space between them to provide insulation and prevent condensation on the inside pane.
- **double-glazing** The process of providing windows with two thin sheets of *glass* hermetically sealed together and trapping air between them; often used for window walls because of the superior cold insulation.
- **double-hung windows** Windows having two vertically movable *sashes*.
- down Soft, fine feathers used as a filling in some upholstered cushions.
- **downlight** Lighting directed downward from *luminaires* attached to or recessed in the ceiling.
- draperies Loosely hung, often heavy fabric curtains.
- **drapery panel** A *drapery* length made of one or more widths of *fabric* that travels in one direction on the rod.
- **draw curtain/drapery** A *fabric panel* that can be opened and closed on a *traverse rod*.
- **drop-leaf table** A table whose top has one or more hinged "leaves" that can be folded down.
- **dropped ceiling** That portion of a ceiling lowered below the actual functional level or below other sections of the ceiling within the same space. Often, a dropped ceiling serves to articulate specific segments of a room, such as a dining area.
- **drywall** A technique for building interior partitions, using large panels of wallboard, *gypsum board*, plasterboard, or sheetrock in place of *plaster* to cover studs or other wall-support materials.
- **duct** An air passage, usually made of sheet metal; in *HVAC* systems, ducts carry heated or cooled air to inlet grilles.
- **Dutch door** A door split in half, allowing top and bottom to open separately.
- earth berm A mound of earth used to partially cover and insulate exterior walls.
- earthenware A relatively coarse red or brown ceramic ware fired at a low temperature; typically brittle and fragile, porous if unglazed.
- egress The way out or exit.
- electric discharge lamp A lamp that contains a gas or mixture of gases such as mercury, sodium, or neon and produces light by either a high-pressure or low-pressure arc.
- elevation A drawing which represents a vertical right line projection of one side of an object, room, or building.ell A right-angled building extension.
- ergofit The relationship between people and their environment.
- **ergonomics** The science that seeks to adapt the environment to its users.
- eyeball An incandescent lighting fixture, usually recessed into a ceiling with a lamp installed in a pivoting, spherical element that permits direct light to be focused as desired.
- **fabric** Cloth; more specifically, a construction of *fibers*, not necessarily woven.
- **facade** The face or front of a building or article, frequently applied rather than natural.

654

face yarn See pile yarn.

faux finish A French term for an imitation of a material such as simulated wood or marble.

felting The joining of fibers into a fabric through the application of heat, agitation, and moisture, or by mechanical treatment.

fenestration The arrangement and design of windows and

other openings in a building

festoon/swag and jabot/cascade A formal framing window top treatment with a semicircular draped fabric and folded fabric falling vertically between or at the ends.

FF&E Furniture, fixtures, and equipment.

fiber A material of natural or synthetic derivation capable of forming a continuous filament such as yarn or thread.

fiberglass Any number of plastic resins, such as polyesters, polypropylene, or nylon reinforced with segments of glass fibers.

figure As applied to wood, the overall pattern and character, including all irregularities of grain, burls, knots, and

filament A single continous strand of natural or synthetic

filling/weft/woof The yarns which run crosswise in a woven cloth or carpet, interlacing with the various warp yarns threaded onto a loom.

film As applied to textiles, an extremely thin sheet of plastic produced by extrusion, casting, or calendering. Films are used as fabrics or as bonding laminates.

finish flooring The final visible flooring material.

finish plumbing The installation of sinks, toilets, and faucet hardware.

firebrick Very hard brick capable of withstanding the intense heat of a kiln or fireplace interior.

flame-resistant fabric A fabric whose fiber content or topical finish makes it difficult to ingnite, slow to burn, and often self-extinguishing.

flame-retardant finish A chemical finish that renders a fabric made of a flammable fiber resistant to fire ignition

flat/plain slicing A method of cutting a log parallel to a line through its center producing a vaulted or cathedrallike grain.

flatware The implements of eating and serving foodknives, forks, and spoons.

flitch A lengthwise cut from a tree trunk.

flocking The process of adhering short, chopped fibers to a base fabric to produce a short pile material with a velvety texture.

floor plan A drawing that represents the horizontal design or arrangement of building parts and possible interior

fluorescent lighting Artificial lighting that results when electrical current activates a gaseous mixture of mercury and argon within a sealed glass tube to create invisible radiation which is then absorbed by the tube's interior surface coating of fluorescent material to yield visible luminescence.

focal point A center of interest or emphasis.

footlambert The unit of measure of reflected light.

footcandle A measure of incident illumination.

Foundation for Interior Design Education Research (FIDER) The national accrediting body for interior design educational programs.

French door A hinged swinging door typically with two

rows of rectangular panes of glass divided by wood grids; usually used in pairs.

fretwork Ornamental openwork or relief arranged as a network of small, usually straight bars; often carved.

frieze A tightly twisted saxony cut pile carpet with a crisp texture

FRP Fiberglass-reinforced plastics in thin, translucent sheets; often used for patio roofs, light-transmitting walls and ceilings, and furniture.

full spectrum light Light that contains the complete range of wavelengths present in daylight, including the invisible

radiation at each end of the spectrum.

gabled roof A double-pitched roof; a roof that comes to a point and forms a triangle; also describes the interior ceil-

galvanized iron Iron coated with zinc or paint to retard

gateleg table A drop-leaf table with legs that rotate outward to support collapsible leaves.

generic A general term or name not protected by a trade-

geodesic dome Developed by R. Buckminster Fuller, a self-supporting rigid network of steel or paper rods joined in triangular patterns and covered with a membrane of glass, plastic, or other material.

glare Uncomfortably brilliant light.

glass A mixture of silicates, alkalies, and lime that is extremely moldable when heated to high temperaturepermitting blown, molded, pressed, and stretched forms-and cools to a rigid, nonabsorbent, transparent or translucent substance.

glass blocks Hollow, bricklike forms of glass available in a variety of shapes and sizes. They can be set together or

joined to other materials with mortar.

glass curtain/sheer A transparent or translucent, lightweight fabric used for daytime privacy or to diffuse glare next to the glass of a window, or as an underdrapery; also called diaphanous sheer.

glaze A protective and/or decorative glassy coating bonded

to a ceramic piece by firing.

golden section A classical proportion that yields pleasing size and shape relationships in the ratio of 2:3:5:8:13 :21 :34 and so on; a line cut in such a way that the smaller section is to the greater as the greater is to the whole.

grain Disposition of the vertical fibers and pores in a piece of wood. More generally, texture, from fine to coarse, resulting from the particle composition of the material. See also hardwood, softwood.

grazing Light directed at a very steep angle or parallel and close to a surface, emphasizing its texture.

groin vault See vaulted ceiling.

gypsum board Also known as wallboard or plasterboard, an interior wall surfacing consisting of thin panels of a plaster-like material. The boards are not decorative, so they must be painted, wallpapered, or covered with another material.

half-timbered Constructed of exposed wood beams and posts with remaining spaces filled by masonry, brick, or wattle and daub (woven rods and twigs plastered with clay).

hardwood Finely grained wood types from broadleaf deciduous trees such as maple, oak, and walnut. Hardwoods are for the most part (although not always) harder than softwoods; they are also more expensive and accept fine finishes and intricate shapes more readily.

herringbone pattern A zigzag or chevron pattern formed in a twill weave by alternating the direction of the twill.

highboy A tall chest of drawers, usually divided to simulate a chest-on-chest, with the lower section most often resting on short legs.

highhat A *luminaire* recessed very deep into the ceiling with

the lamp high inside the fixture.

high intensity discharge lamp (HID) Electric discharge lamp which produces light when a high-pressure electric arc passes through a gas vapor.

high pressure sodium (HPS) lamp High intensity discharge (HID) lamp in which light is produced by radiation from sodium vapor.

historic preservation The saving of architecturally significant buildings from destruction.

holistic Emphasizing the relationship between the whole and its parts and that the whole is greater than the mere sum of its parts.

hue The distinctive characteristics of color described by a basic color name and a particular position in the visible spectrum.

HVAC Heating, ventilation, and air conditioning systems.

IBD The Institute of Business Designers.

IDC The Interior Designers of Canada.

IDEC The International Design Educators Council.

IDS The Interior Design Society.

IES The Illuminating Engineering Society

IFDA The International Furnishings and Design Association (formerly NHFL, the National Home Fashions League).

IFI The International Federation of Interior Architects/ Designers.

incandescent lighting Artificial radiant lighting created by heating a filament—usually of tungsten—to a temperature at which it glows.

incident illumination The amount of light that reaches a surface.

indirect lighting Lighting directed against a reflecting surface, most often a ceiling, to generate diffuse ambient lighting.

ingress The way in or entrance.

inlay A general term for techniques of decoration whereby pieces of wood, metal, ivory, or shell combine in patterns of contrasting color and/or texture, either as insertions in a background material or applications to a solid backing, to result in a continuous surface. See also intarsia, marquetry, parquetry.

insulation The prevention, by means of certain materials, of an excessive transfer of electricity, cold, heat, or sound between the inside and the outside of a structure or between portions of a structure; also, the materials them-

selves.

intarsia A type of inlay in which shaped pieces (usually of wood) are fitted and glued into a flat surface of solid wood.

intensity (chroma) The purity or saturation of color as contrasted with grayness or neutrality.

interior architect An *interior designer* who practices in Europe; an interior designer who is also trained in structural building as an architect.

interior designer An individual qualified by education, ex-

perience, and examination to enhance the function and quality of interior spaces.

International Style Twentieth-century style of architecture and design emphasizing function, structure, and material, and lacking a specific national identity.

ISID The International Society of Interior Designers. **isometric projection** A drawing showing an object or interior in three dimensions; a *plan* is placed at an angle to the horizontal, usually 30 degrees, all lines are drawn to scale, vertical lines remain vertical, but diagonals and curves are distorted.

Jacquard weave A *fabric* of complex *pattern*, such as tapestry or brocade, produced on the Jacquard loom.

jalousie windows Louvered window units of narrow, adjustable *glass*, *plastic*, or wood slats, most often arranged horizontally.

JID The Journal of Interior Design (formerly JIDER, the Journal of Interior Design Education and Research).

joining The method of assembling furniture by fitting together pieces of wood.

joist A horizontal framing member of a floor or roof that supports a bearing surface and generally frames into a beam or other members.

kilim A handwoven flat tapestry rug made of wool, reversible flat-woven.

kiln An oven or furnace used to fire *ceramic* ware.

knitting The continuous looping of one or more *yarns*. **knot** A round or oval figure interrupting the regular *grain*

in wood; caused by the growth of a branch.

lacquer Properly, a substance (for cover or finish) made of lac, or shellac; by extension, also a *varnish* made in Oriental countries from the sap of certain plants.

lambrequin/cantonniere An upholstered wood *cornice* with sides that extend to the floor.

lamination The process of bonding together, generally with glue, thin sheets or small pieces of material to create a substance having properties the material would not otherwise possess, such as strength, durability, or intricate form.

lamp An artificial light source consisting of bulb and base.
lamp efficacy The ratio of *lumens* produced by a lamp to the *watts* (power) consumed, expressed as lumens per watt.

laminated The layer construction of lumber; may be either horizontal or vertical layers securely glued together.

landing The platform of a stair where it begins, ends, or turns.

lath A framework of thin wood or metal ribs integral with a building skeleton for the support of tiles, plaster, reinforced concrete, plastic foams, or the like.

lathe A machine on which wood or metal is turned to shape and carve it.

law of chromatic distribution The traditional use of predominantly neutralized hues with intensity increasing as the size of areas decreases.

leaded glass Windows made of small pieces of *glass* held together with lead caming to form a *pattern*.

leno An open, gauzelike *fabric* woven with paired warp *yarns* twined between insertions of the filling yarn which prevents the filling yarns from slipping.

leno weave An open weave used for casements.

letter of agreement The legal contractual arrangement between a design firm and client that describes the services and responsibilities of both parties.

level loop A carpet style having all tufts in a loop form and

of identical height; may be woven or tufted.

life-cycle costing The initial cost of a product (including installation) plus the cost of maintenance, divided by the expected number of years of service, yielding cost per year, useful in computing annual budgets.

line Technically, the extension of a point in a single dimension. More generally, the outline of a form or shape. In the language of design, the general disposition and

dominant direction of elements.

load-bearing wall A wall that provides structural support for a floor or roof.

loft An upper floor, normally of a commercial building or warehouse, converted into a home or studio. Also, a raised platform or projecting balcony used for sleeping.

loop pile A carpet style having a *pile* surface consisting of uncut loops of *yarn*; may be woven or tufted.

lowboy A low chest of drawers resting on short legs; the Colonial American term for a *commode*.

low-voltage lamp An *incandescent* lamp that typically operates at 6 to 12 volts, consuming little energy.

lumen A measure of light output or quantity of light produced by a lamp.

luminaire Light fixture.

luminance The amount of light reflected or transmitted by an object.

luminescence Visible light produced by friction or by electrical or chemical action, as opposed to incandescence produced by heat.

mansard roof A roof sloped in two planes, the lower slope being the steeper. A mansard roof provides more attic space than a conventional pitched or *gabled* roof.

marquetry An elaborate *inlay* technique in which pieces of wood, shell, and ivory are set in a wood *veneer* that is then

glued to a firm backing.

masonry Architectural construction of stones, bricks, tiles, concrete blocks, or glass blocks joined together with mortar. In broader usage, construction, as of a wall, from plaster or concrete.

mat A border of mat board or other material, used as a frame or part of a frame for a picture.

matte A flat, nonshiny finish.

medullary rays Lines radiating from the heart of a tree trunk.

melamines High-melting, transparent-to-translucent plastics noted for the exceptional durability they bring to laminated counters and table tops and molded dinnerware. Common trade names are Formica, Micarta, and Melmac.

melon bulb A large bulbous turned support typical of English Elizabethan and Jacobean furniture.

metamerism The visual matching of colors under one kind

of illumination but not under another.

Methenamine Tablet Test (ASTM D 2859) A carpet flammability test which measures flammability as a function of burn produced by a timed burning tablet (Methenamine pill). All carpet sold in the United States must pass this test. Described in federal regulations CPSC 1-70 and CPSC 2-70.

mezzanine A low-ceilinged story between two main floor

levels, usually placed over the ground floor; an intermediate story that projects as a balcony.

microblinds Horizontal blinds with 1/2" slats; also called micro-miniblinds.

miniblinds Horizontal blinds with 1" metal or plastic slats held together with nylon cord; have both lift and tilt control.

mobile home Originally, a small, compact dwelling capable of being towed by an automobile or truck. Today the term applies to any *prefabricated* home equipped with axles. The basic *module* can be no more than 12 feet wide, although frequently two sections are bolted together.

modular Built of modules or according to standardized sets

of measurements.

module One of a series of units designed and scaled to integrate with each other in many different combinations to form, for example, a set of furnishings, a system of construction, or whole buildings. In current usage, the term is most often applied to mass-produced prefabricated units.

molding An ornamental strip of wood or plaster that pro-

trudes from a ceiling or wall surface.

monolithic construction A building system in which the major part of the structure consists of a single, self-supporting mass, usually of *reinforced concrete*, *plastic*, or *fiber-glass*.

mortar *Cement*, lime, or *plaster* combined with sand and water. When wet, the substance is moldable; it hardens to form the binding agent of *masonry* construction.

motif The main or dominant idea used in a work of art, furniture, or architecture.

mottle A dappled or blotched color or grain.

mullions Wood strips holding panes of glass in a door or window.

muntins Slender wood strips between panes of glass in doors or windows.

National Council of Interior Design Qualification (NCIDQ) The organization responsible for testing minimum professional competencies and establishing guidelines for legal licensing of interior designers.

needle-punched fabric/needle felt A *nonwoven fabric* in which webs of *fibers* are closely entangled by hundreds of

barbed needles.

nonwoven fabric A *fabric* which is either fibrous, but not made into *yarn* form, or non-fibrous, made directly from a solution.

nosing The projection of the tread of a stair beyond the

riser, usually 11/8".

nylon The generic term (as well as trade name) for a family of plastics exhibiting high tensile strength in fiber or sheet form.

open plan An architectural *plan* organized with few fixed partitions to provide maximum flexibility in the use of interior space.

orientation Arrangement, alignment, or position in relation to other factors or elements.

orthographic projection The projection of perpendicular lines to the *plane* of projection.

paneling Thin, flat wood boards or other similarly rectangular pieces of construction material joined side by side

GLOSSARY 657

to form the interior and usually decorative surface for walls or ceilings.

panelized housing Dwelling structures assembled from modular, prefabricated panels or sheets that serve as walls,

floors, and ceilings.

PAR lamp A parabolic aluminized reflector lamp with good beam control: made of heavy glass that can be used outside.

- parquetry *Inlay* of wood that takes the form of geometric patterns; used primarily for floors and sometimes for table tops.
- particleboard/hardboard A mat-formed flat panel consisting of particles of wood bonded together with a synthetic resin or other suitable binder.

passementerie Window treatment trimmings, including braid, gimp, fringe, tassels, and small glass beads.

passive solar system A technique of solar heating that uses parts of the building structure to collect, store, and distribute solar heat without pumps or fans.

patina The sheen, color, and texture on furniture, produced by age, use, waxing, and/or polishing. On metal, patina is the film that develops from long exposure to the atmosphere.

pattern An artistic decorative design.

pelmet A flat, stiffened, and shaped *fabric valence*; also can refer to an upholstered, shaped wood *cornice*.

pendant/suspended luminaire A light fixture hung on a cord or chain from the ceiling.

perimeter lighting Lighting around the outside of a room or an area, having the effect of visually expanding space.

perspective The system of realistic pictorial drawing representing objects and spaces in relative distance or depth using converging lines and vanishing points.

pile The visible wear surface of *carpet*, consisting of *yarn* tufts in loop and/or cut configuration; also called face or nap.

pile weave A *fabric* construction in which cut or uncut loops protrude from the ground cloth.

pile yarn The yarn which forms the tufts of carpet; also called face yarn.

pitched roof A sloped roof.

plan The configuration of spaces and rooms, walls and openings in an architectural structure; also, the graphic representation of such an arrangement.

plane A two-dimensional expanse; a flat surface.

plantation shutters Movable wood *louvered* shutters with very wide blades (3 "-4").

plaster A paste, usually of lime, sand, and water, which hardens as it dries. Often used as a finish for interior wall and ceiling surfaces.

plastic Describing a malleable, ductile material. More specifically, a member of any of the several families of synthetic polymer substances.

plate glass Ground and polished glass sheets formed by spreading molten material on an iron table mold with rollers.

plenum A concealed space below the floor or above the ceiling used for mechanical and electrical equipment or operations.

plugmold strips Long tracks with numerous electrical outlets that permit flexible spacing of lighting fixtures and bulbs.

plush/velvet carpet A smooth *carpet* surface texture in which individual tufts are minimally visible and the overall effect is that of a single level of *fiber* ends.

plywood A composite sheet of *laminated veneers*, some or all made of wood, with the *grain* of adjacent strata arranged at different angles to each other for increased strength.

pocket door A door that slides into a pocket recessed in

the wall.

polyethylenes A group of lightweight, flexible *plastics* characterized by a waxy surface and resistance to chemicals and moisture but not high temperatures; popular for household containers.

polystyrenes A family of rigid, transparent-to-opaque plastics that are durable, capable of accepting varied finishes, and possessed of good insulation properties.

polyurethanes See urethanes.

porcelain High-grade, translucent white ceramic ware fired at extremely high temperatures; most familiar in fine dishes and ornaments, but with many industrial applications, such as plumbing fixtures and electrical insulators.

portieres Straight or tieback curtains that frame a doorway and provide privacy.

post In architecture, a vertical member that supports horizontal *beams* to create a structure framework.

post-occupancy evaluation (POE) The formal process of examining a *design* once it is in use to determine how well it is functioning.

prefabricate To mass-produce standardized construction parts or *modules* for later assembly and/or combination.

primary backing A component of tufted *carpet* consisting of woven or *nonwoven fabric* into which *pile weave* tufts are inserted by the *tufting* needles.

primer A coating that is applied before any other finish treatment to seal the pores in the surface to be treated.

printing As applied to *textiles*, the application of dyes according to a selective pattern to create a design by such methods as woodcut, silk screen, and tie-dye.

product design The design of furniture, accessories, or other components that are marketed in the design field.

programming The research phase of design which determines the objectives and requirements of a design project.

proportion The relation in terms of magnitude, quantity, or degree of parts to each other or to the whole. See also *scale*.

proxemics The study of human interaction with space and of personal and cultural spatial needs.

punch list A checklist of items to be completed before final building inspection and occupation.

quarter slicing A method of cutting lumber in which the blade meets the *grain* at right angles to the growth rings producing a straight, striped grain.

quartz-iodine lamp See tungsten-halogen lamp.

radiation A type of heating in which the heat is transmitted by radiant panels—installed in the architectural shell and warmed by air or water heated in a furnace or by electrical current—to solid masses within the area.

rag rug A plain weave *rug* woven with strips of *fabric*, historically rags or recycled clothing remnants.

ranch style Descriptive of a single-story dwelling often of *open plan* and having a low-pitched roof.

random-sheared carpet A *carpet* texture created by shearing either *level loop* or high-low loop carpet lightly so that only the higher loops are sheared.

rattan Furniture made from the Asian palm tree. The thin, tough stems are woven into wicker baskets and furniture.

reflectance The amount of incident light falling upon a surface that is reflected, expressed as a percentage.

reflected glare Glare resulting from *specular reflections* of the light source in polished or glossy surfaces in the field of view.

refraction The bending or deflection of light rays from their original path as they pass through different media.

rehabilitate To restore to usefulness.

reinforced concrete *Concrete* embedded before hardening with steel rods that lend the material a *tensile strength* far beyond its original capacity.

rendering A pictorial representation of a proposed *design*, usually in *perspective* and full color.

renovate To restore to a better previous condition by re-

building, repairing, or cleaning.

rep Plain, woven fabric characterized by distinct ribs running crosswise, produced by running large filling yarns through the warp yarns.

restore To renew or return to an original state or condition.

retrofit To fit with new parts or equipment not available at the time of initial construction or production.

reverberation A sound effect that resembles an echo.

ribbed vault See valuted ceiling.

riser The vertical distance from one *tread* top to another in a flight of stairs.

R lamp A reflector lamp that directs a beam of light; usually restricted to interior use.

Rococo A style of eighteenth-century French decoration using profuse asymmetrical ornamentation based on natural forms.

roof monitor A cupola, *skylight*, or *clerestory* window that catches warmth from the sun and allows ventilation for excess heat.

rotary cutting A method of shaving a continuous layer of wood from a log mounted on a *lathe* producing a broad, open *grain*.

rough plumbing The installation of pipes to carry water, sewage, and central vacuum.

row house See townhouse.

rubble masonry Masonry construction of rough, irregularly shaped stones joined with mortar.

rug A heavy fabric floor covering made or cut to standard sizes; also, a floor covering that covers only a portion of the surface. See also carpet.

rug A soft floor covering not fastened to the floor and usually not covering the entire floor.

run The total horizontal distance of the entire stairway (tread minus nosing).

R value The thermal resistance of a material.

rya rug A deep pile shaglike rug handknotted with abstract, contemporary pattern, from Scandinavia.

saltbox A skeletal-frame, two-story dwelling with a doublepitched roof whose rear slope is continued over a onestory extension at the rear.

sash A window frame holding panes of glass; the movable part of the window.

sash curtain A semisheer fabric gathered or shirred onto rods at top and bottom and hung onto a window sash.

saxony A cut-pile carpet texture consisting of heat-set plied yarns in a relatively dense, erect configuration with well defined individual tuft tips; denser and with more erect tufts than shag. scale Size relative to a standard or to a familiar size.

schedule A chart that indicates the finish material used on floors, walls, and ceiling, and lists types of doors and windows.

schematic design/drawings Quick drawings used to generate or show ideas.

sconce A wall-mounted lighting fixture which generally directs light upward.

secondary backing A woven or *nonwoven fabric* reinforcement *laminated* to the back of *tufted carpet*.

secretary A tall writing desk with drawers for storage below and a set of shelves enclosed by doors above a hinged writing surface.

sgraffito A decorative technique of exposing an undercoat of paint on pottery; plaster decorated with incised patterns cut through the top coat to reveal a different colored undercoat.

shade A low-value or dark color produced by adding black to a bue

shag A carpet texture characterized by long pile tufts laid over in random directions in such a manner that the sides of the yarns form the traffic surface; made from plied heat-set yarns which may be either cut pile or cut-andloop styles.

shape The measurable, identifiable contours of an object.

shed ceiling A single-slope, lean-to ceiling.

shingle A thin slab of wood or other material, slightly thinner at one end. Laid in overlapping rows, shingles form a building's *siding* or roof covering.

shirring The gathering of fabric onto a curtain rod.
shoji screen Oriental paper affixed to a wood frame with a wood grid to form translucent sliding or stationary panels; used in traditional Japanese homes and in contem-

porary Western residential and nonresidential interiors. siding The exterior surfacing of a building, boards, metal slabs, *shingles*, or other materials providing protective covering for the exposed outer walls of frame buildings.

simultaneous contrast The accentuation of differences between the *bue*, *value*, and *intensity* of colors due to adjacent or background colors.

site The actual groundspace on which a house is constructed.

skeletal frame construction A building system consisting of a supporting framework of *posts* and *beams*, to which walls and roof are attached as a shell of skin. If junctures

of the support skeleton are strengthened by diagonal crosspieces, the arrangement is termed a braced frame or, in small wooden-frame homes, a balloon frame.

skylight A window in a roof admitting natural light through reinforced *glass* or some other transparent or translucent

soffit The underside of a projecting structural part of a ceil-

ing, cornice, or beam.

softwood Coarse-grained, fibrous wood primarily from trees with needle-type leaves that they do not shed, such as pine, cedar, and redwood. Although they may actually

pensive and cannot be given as high a finish.

space planning The functional planning of interior space;
a design specialty which concentrates on establishing
space needs and utilization in the early stages of design.

be harder than some hardwoods, softwoods are less ex-

specifications A written list of materials and furnishings, itemized according to company, stock number, color, and other pertient ordering information, and the location where the goods will be installed; in nonresidential de-

659

sign, the criteria of minimum durability, cost, and safety requirements of finish materials; all the information necessary for the construction of custom-made items.

spectral distribution The level of energy at each wave-

length of a light source.

specular reflection The reflection of bright light from a

mirror or other highly polished surface.

spline A thin, narrow strip, usually of *plywood*, inserted into matching grooves in abutting edges of panels or lumber to insure a flush alignment and secure joints; customarily runs the entire length of the joint.

split-level Descriptive of a house in which the floor level of one portion lies approximately midway between floors

of the adjoining two-story section.

spun-bonded fabric A man-made fabric made from thermoplastic filaments formed in a directionless mass and bonded with heat.

spur wall A free-standing wall projecting from an adjoining wall at one end.

stackoff/stackback The wall area on either side or the top of a window where a window treatment will fit when

stain A coloring liquid or dye for application to any material, usually wood. It is readily absorbed by the pores of the material so that grain and texture are not concealed.

stainless steel Durable, blue-gray steel made rust- and stain-resistant by the inclusion of chromium.

staple fiber Short lengths of fiber in its natural state before it is spun into yarns.

Steiner Tunnel Test A stringent flammability test for tex-

stoneware A relatively fine, durable, and waterproof ceramic ware made from gray or light brown clays fired at medium temperatures, often used for medium-price dinnerware.

strike-off A sample of a paper or fabric design.

structural design A basic category of design in which the design is intrinsic to the structure—one cannot be separated without destroying the other.

stucco A weather-resistant *plaster* for exterior use.

studio A one-room apartment; a combined living/working

stump or **butt wood** The lowest part or root end of a log of wood, the source of crinkly or rippling-patterned decorative veneers.

subflooring A rough base for a *finished floor* which rests on

suspension A variation of skeletal-frame construction in which horizontal beams, floors, or roofs are hung from the supporting vertical posts.

synthetic fiber A man-made fiber synthesized from chemical substances in the laboratory; nylon, polyester, acrylic,

modacrylic, olefin, and saran.

systems furniture Furniture that is designed to combine with other elements; component pieces can be chosen and assembled to suit the needs of the user.

task light The light needed for the performance of a specific activity.

tempered glass Glass toughened by heating and rapid cool-

tensile strength Capacity to resist breaking or tearing apart under longitudinal stress.

terra cotta Fired clay, usually low-fire earthenware; also, the reddish-brown color associated with this ware.

terrazzo A polished concrete flooring made of crushed marble and cement.

textile A *fiber* construction; technically, a woven *fabric*.

texture Tactile surface quality, perceived directly through touch or indirectly through vision.

thermoplastic A material that softens with heat and hardens again when cooled.

thermoset An irreversible property of a substance that is attained by heat softening to change the chemistry of the substance, making it firm.

tile Stone, concrete, or ceramic pieces, flattened, and/or curved, used for roofing and as wall and floor covering. Also, thin *modules* of cork, *vinyl*, or other resilient material used primarily to protect and enhance interior walls, floors, and ceilings.

tint A high-value or light color produced by adding white

to the hue.

tone The intensity of a color.

topography The configuration of physical features of the surface of the land, including position and elevation.

total rise The vertical distance from one finished floor to the next.

townhouse Once termed a "row house," a structure two to five stories high that directly abuts the buildings adjacent on either side. Interior space tends to be long and narrow, with doors and windows only at the front and back.

track light A movable luminaire mounted on a recessed or surface-mounted electrical raceway (track).

tract development A residential community planned with detached single-family dwellings, each on its own plot of land. Lots and houses typically are arranged in a tight grid pattern.

trade name A name that is given by a manufacturer to a product to distinguish it as made or sold by him/her and that may be used and protected as a trademark.

traverse rod A rod that uses carriers, pulleys, and cords to draw curtains or draperies open when the cord at the end is pulled.

tread Run or the horizontal distance from the face of one riser to the next in a flight of stairs. There will always be one less tread than riser.

trombe wall A glass-covered, dark-painted masonry wall which provides the three-fold functions of collection, storage, and distribution of heat in a passive solar system.

trompe-l'oeil ""Deceive the eye" in French; skillful rendering of objects or scenes in three-dimensional effect through the use of perspective, foreshortening, and shad-

tufting A method of carpet construction which utilizes hundreds of needles to push pile yarns through a previously constructed primary backing sheet, forming loops or tufts of yarn which may be left uncut, cut, selectively sheared to form a variety of surface textures, or high-low loops and sculptured effects can be created.

tungsten-halogen lamp A small, long-life incandescent light source (also called quartz or quartz-iodine lamp).

turning The art of shaping decorative wooden cylindrical forms—furniture parts, columns, utensils—through the cutting action of a fixed tool upon a piece of wood as it rotates rapidly on a lathe. Also, the result of this tech-

twisting The winding of two or more strands of *fiber* or yarn together to make a single multiple-ply yarn.

underglaze The paint that is applied to porcelain before

the glaze.

Uniform Building Code A set of specifications regulating materials and methods used in construction and maintaining consistent standards to assure healthy, safe, and sanitary conditions.

universal design Design that is usable by people of all ages,

abilities, and sizes.

upholstery A soft covering of *fabric* on seating units, sometimes but not necessarily over padding, stuffing, and pos-

sibly springs.

urethanes Lightweight, cellular plastics capable of assuming nearly any density and thus any hardness from resilient to rigid. Urethane foams can be sprayed as surface coating or preformed as cushioning and insulation.

utility core A central space or a unit, sometimes prefabricated, that contains all a home's service elements, including bathrooms, heating, air conditioning, and the like.

vacuum-formed A plastic formed in a mold in which all the air is drawn out to form a vacuum that forces the plastic around the mold.

valance A decorative fabric heading at the top of a window that may conceal lighting.

value The relative lightness or darkness of color.

varnish A substance (for cover or finish) made from a resinous material and dissolved in linseed oil.

vaulted ceiling A ceiling constructed as an extended arch, often semicylindrical in form (a barrel vault). Intersecting arches produce a groin vault; a ribbed vault reveals the framework of arched ribs.

veiling reflection Reflection of light sources in a task, reducing the contrast between detail and background, thus imposing a veil and decreasing task visibility.

velvet carpet Woven *carpet* made on a loom similar to a *Wilton* loom but lacking the *Jacquard* mechanism.

veneer A thin facing of decorative or protective material attached to another material that is usually of inferior quality.

ventilator A mechanism such as a louver designed to admit fresh air to the interior.

vernacular architecture The characteristic design of buildings that is sensitive to and makes use of daily and seasonal temperature fluctuations in a given place.

vinyls A versatile family of strong, lightweight plastics avail-

able in flexible and rigid, molded and film, foam and cellular forms.

visible spectrum The small segment of visible light energy that enables us to see; the wavelengths of light that contain visible color.

vista View through an opening or along an avenue.

visual weight The effect of visual impact regardless of actual weight, determined in part by color, texture, and pattern.

volume Mass or space expressed in cubic units (length × width × height = cubic volume).

wainscot A lower interior wall surface that contrasts with the wall above it.

wallboard See gypsum board.

wall washer Luminaire used to illumine a wall for ambient

lighting.

warp The lengthwise *yarns* in a *fabric*, running vertically through the loom parallel to the selvages (the edges on either side).

watt A current of one ampere under one volt of pressure

(equal to about 1/746 of one hoursepower).

wavelength The distance between corresponding points on successive waves (of light); colors at the red end of the spectrum have long wavelengths while the violet end of the spectrum has short wavelengths.

weaving The process of interlacing two or more sets of yarns, usually set at right angles to each other, to make

textiles.

Wilton carpet A type of patterned or multilevel *carpet* woven on a loom with a *Jacquard* device which raises one predetermined *pile yarn* at a time to the surface, leaving the remaining *yarns* embedded in the center and back of the carpet in the *warp* direction.

wing A bulding portion that extends from or is subordinate

to the major central area.

work triangle The path formed by connecting the three major appliances (refrigerator, sink, and range) in the kitchen; used for efficient design.

yarn A long strand, either of *fibers* twisted together or of extruded synthetic material, used in *fabric* construction.

zoning The designation of space and allowance for specific types of uses and activities.

Index

Page numbers in italics refer to illustrations or to pages with both illustrations and text concerning the topic.

Aalto, Alvar, 38, 43, 362				
Aarnio, Eero, 39				
above grade floors, 471				
ABS, 401				
abstract design, 86				
accent, 104				
accent/decorative lighting, 542, 544, 545,				
558				
access: for dining needs, 223				
accessibility. See architectural barriers				
accessories: art, 609-613, 610-613; and				
background enrichment, 602-603;				
crafts, 383, 613-614; decorative acces-				
sories, 606–607, 606–615, 609–615;				
functional accessories, 385, 603-605;				
location and background for,				
615-618, 616-619; mass-produced ac-				
cessories, 615; plants and flowers,				
606–609; uses of, 598–602, 599–602				
acetate, 410-411, 413				
achromatic, 104				
acoustical ceiling tiles, 341				
acoustical plaster, 467				
acoustics: and floors, 493; for music,				
214–217; of space, 68; technical re-				
quirements for, 338–343, 340–343; for visual media, 217; and walls,				
439–440				
acrylics, 401, 402, 410–411, 413, 490				
active balance, 118–119				
adaptive reuse, 317–322				
adjacency studies, 189–191, 190				
adjustable downlights, 553				
adobe brick, 375				
adobe houses, 14, 182, 208, 374, 468				
advancing hues, 95				
aerial perspective, 109				
aesthetics: of furniture, 573-574; of light-				
ing fixtures, 560; in programming, 13,				
<i>14</i> , 15				
afterimage, 95				
air. See ventilation				
air conditioning, 306, 333-334, 335				
air infiltration, 308				
air pollution, indoor, 315-317, 332-333				
alkyd-based paints, 451				
alpaca hair, 409				
alternation, 121				
alternative energy sources, 314–315				
Altman, Irwin, 145				
ambient/general lighting, 541, 542				
American Society for Testing and Mate-				
rials (ASTM), 421, 596				
American Society of Interior Designers				
(ASID), 628, 631 Americans with Disabilities Act, 152				
amplification, 108, 550				
amps, 537				
analogous color harmonies, 104–105				
analogous hues, 94				
analysis, for residential spaces, 184–109,				
202–203				
Andersen Windows High-Performance				
glass, 390				

```
angular forms, 77-78
animal fur, 409
animal-hair fibers, 409-412
annual rings, of wood, 350
anthropometrics, for kitchens, 233, 234,
   235, 236
antiqued finishes, 368
antiques, 174, 264, 348, 573, 601, 603, 618
antiquing, 451
antistatic, 420
apartments, 15, 27, 40, 42, 72, 83, 125,
   175, 284, 336, 364, 368, 405, 419,
   438, 450, 457, 465, 519, 599
apothecary lamps, 556
appliances, standard sizes of, 4, 234
applied ornament, 86
applique, 425
approach behavior, 228
aramid, 413, 421
architectural barriers: bathrooms,
    154-155; in residential spaces,
   152-156; stairs, 152, 153, 154
architectural glass, 391, 393
Area, definition of, 73
area rugs, 482-484
Aronson, Joseph, 73
art: as accessory, 124, 127, 174, 364, 573,
    599–601, 609–613, 610–613; framing
   and hanging art, 447, 610, 611, 612;
   lighting for, 544; sculpture, 612, 613;
   two-dimensional art, 609, 610, 611
Art Deco, 36, 37, 46
Art Deco table, 403
Art Moderne, 34
Art Nouveau, 24-25, 26, 27, 46
artificial lighting. See lighting
artist's studio, 13, 603
Arts and Crafts Movement, 20, 21-23, 46
ASA, 401
asbestos, 412
ashlar masonry, 370
associations. See professional organiza-
    tions; and names of specific organizations
asymmetrical balance, 118-119
Atrium rain forest, 14
attached housing, 289, 290, 291
attic, 117, 453
audio-visuals, 213-217, 214-218, 344,
    586, 587
auditory sense of space, 68
Austrian shades, 512
avoidance behavior, 228
awnings, 511
 axial systems, 69
 Axminster carpet and rugs, 485
 axonometric views, 197, 198
 bacteria-resistant, 420
 balance: asymmetrical balance, 118-119;
```

```
pacteria-resistant, 420 palance: asymmetrical balance, 118–119; definition of, 115–116; as design principle, 115–121; perpendicular balance, 119; radial balance, 118, 120; symmetrical balance, 117–118; vertical balance, 119; and visual weights, 116
```

```
balcony, 212
Baldwin, Billy, 39, 40, 128, 617, 618
balloon shades, 512, 513
bamboo shades, 512-513
bands, of windows, 506
Barcelona chair, 34
bare windows, 518
barn, conversion of, 228, 229, 369, 419,
   435
Barnes, Jhane, 425
barriers. See architectural barriers
Barrow, Stanley, 150
Barrows, Stanley, 131
Basculant armchair, 35
baseboard heater, 329-330
baseboard moldings, 362, 363
basements, laundry facilities in, 250-251
basket weaves, 415
baskets, 614
bath accessories, 604, 605
bathrooms: accessibility for disabled,
    154-155; accessories for, 604, 605,
    614; Art Deco modernism in, 37; de-
    sign of, 266-273; door in, 269; elec-
    trical outlets in, 337, 339; ergonomic
    considerations for, 266, 268; indus-
    trial utilitarian design of, 40; layout
    of, 268, 269-273; lighting for,
    270-273, 554, 564, 565; location of,
    262, 268-269; number of, 266; plants
    in, 607; plexiglass used in, 394; safety
    for, 154-155; shower in, 266, 268,
    269, 378; sink in, 384; size of, 269;
    sizes and clearances of standard fix-
    tures, 269; tile in, 376, 377-378; tubs
    in, 267, 268, 269; windows in, 269
bathtub, 267, 268, 269
batik, 424
Bauer, Leopold, 364
Bauhaus, 30-32, 33, 42, 59-60
bean-bag chair, 39
beauty. See aesthetics
Beaux-Arts, 29
bed accessories, 604
bed curtains, 257
Bedin, Martin, 41
bedrooms: accessories for, 604; braided
    rug in, 484; built-in upholstered
    headboard, 61; ceiling of, 469; cotton
    chintz used in, 422; design of,
    257-265; doors in, 261, 262; dressing
    areas in, 258, 259; electrical outlets
    in, 337, 339; fabrics in, 342, 469; fur-
    niture sizes and clearances, 259; indi-
    vidual needs in, 263-265; layout of,
    261, 262; lighting in, 258, 264, 565;
    location of, 261; mattress sizes, 258;
    multipurpose uses of, 260–261, 265;
    from 1990s, 60, 61; number of, 261;
    requisites for sleeping, 257-258;
    safety for, 156; Saladino's design of,
    42; Shaker tradition in, 25; size of,
    260; Spanish Colonial Revival style
```

of, 573; storage in, 262, 263, 265;

bedrooms (continued) television viewing in, 337; Victorian bedroom, 60, 61; window treatments for, 513, 514, 521, 522, 524, 525; windows in, 261, 262, 504. See also children's rooms beds: built-in beds, 576, 577; built-in upholstered headboard for, 61; mattress sizes, 258; of metal, 591; Murphy bed, 278, 576, 577; platform bed, 366, 576, 577; sizes of, 259; types of, 577 bedside table, 258 Beecher, Catherine, 54, 55 beetling, 420 behavioral basis of design: cultural influences, 142, 143, 144; ergonomics, 141, 142; psychological and social needs, 144–152 Bellini, Mario, 74, 399 below grade floors, 471 Bennett, Ward, 40, 41, 618 bentwood chair, 24, 25, 57 benzene, 316 berber carpet, 488 Bertoia, Harry, 39 beveled edges, 360, 361, 362 beveled glass, 391 bids, 17 bifold doors, 528 big upward curves, 82 binary hues, 93 binuclear plan, 187 biodegradability, 322, 402-403 bisymmetrical balance, 117-118 blandness, 547 bleached finishes, 368 blinds, 515, 516, 517 block materials, 369-378 block printing, 424 boards, 444, 445 Boeri, Cini, 388 Bohannan, Paul, 170 bolts, of wallpaper, 455 bonded fabrics, 418 bookcases, 39, 44, 342, 585, 586 book-matched veneers, 356, 357 bouclé yarns, 414 bowls, 64, 385, 387 brackets, 554 braided rugs, 484, 487 braiding, 417, 484, 487 brainstorming, 16, 191 breakfront, 365 Breuer, Marcel, 32, 33, 39, 42, 43, 60, 187 brick: as construction material, 374-375; for floors, 473, 474; for walls, 442, 447-448 brick bonds, 375 bright light, 551 brightness, 545-546 broadloom, 481 Brown, Denise Scott, 46 brownstone houses, 73, 85, 575, 611 bubble diagrams, 16, 190, 191 budget, for residential spaces, 183-184 buffet meals, 226, 227 built-in furniture, 61, 574, 575-576, 577 built-in ovens, 239-240 bullet shades, 556 bungalow, 488 bunk beds, 577 burn-out printing, 424, 425 Burne-Jones, Edward, 21

Burr, Andrus, 15 butcher block countertop, 358 butt joints, 445, 590 butt-matched veneers, 356, 357 cabinets: base cabinets in kitchen, 241, 253; in kitchen, 234, 237, 238, 240-246, 253; need for, in every room, 585-586, 587; standard sizes of kitchen cabinets, 234; wall cabinets in kitchen, 237, 240, 241. See also storage cafe curtains, 520 calendering, 400, 420 Cama, Rosalyn: office of, 5 camel's hair, 409 candela, 545 candles, 558 Cannaregio modular seating, 56 cantilever construction, 346, 347 cantonnieres, 520-521 Cape Cod House, 286-287 carpet backings, 487 carpet pad, 491 carpet squares, 485 carpet tiles, 485 carpets: characteristics of, 474-475; construction methods of, 485, 486, 487; definition of, 481; fibers for, 490-491; installation of, 491; measuring and estimating, 491, 492; pattern in, 487; sizes of, 482; texture of, 487-490, 488, 489; as wall covering, 457; wallto-wall carpet, 482 carving: in ceramics, 386; in wood, 363, 364, 365 Casa Battló, 25, 26 casement curtains, 520 cashmere, 409 Castle, Wendell, 41, 57 cathedral ceilings, 466, 467 ceiling fan, 306, 330 ceiling luminaires, 553-554 ceiling tiles and panels, 468 ceilings: acoustical ceiling tiles, 341; color of, 108, 468-469; curved forms in, 79; design of, 463, 464-467; height of, 464-465; high ceiling, 602; in house built on hillside, 470, 471; materials for, 467, 468; shape and direction of, 465, 466-467; texture of, 468-469 cellulosic fibers, 409, 412-413, 491 centerpiece, 617 ceramic tiles, 447, 448, 473 ceramic-filled paints, 450 ceramics: clay bodies, 383-384; colored pigments in, 386; definition of, 382; form in, 384-385; glazes of, 385-386; hand construction of, 385; mass production of, 385; modeling and carving of, 386; ornamentation in, 385-387; steps in formation of, 382-383 chair rail, 363 chairs: Aalto's lounge chair, 38; arrangement of, for conversation areas, 208-210, 211, 212; Barcelona chair, 34; Basculant armchair, 35; bean-bag chair, 39; Bellini's easy chair, 74; bentwood chair, 24, 25, 57; Breuer's side chair, 60; for dining needs,

223-226; Eames's side chair, 38; easy

chair, 39; for elderly, 571; ergonomic

design for comfort, 577; Grand Com-

chairs by Michael Gray, 574; Egg

fort cube chair, 35, 36; Gyro chair, 39; Hoffmann's chair with contrasting piping, 64; Jefferson lounge chair, 141; Kirkpatrick folding chair, 78; Le Bombola seating, 399; lounge chair, 577, 578; maple chair, 9; MR lounge chair, 75; number of, for conversation area, 578; Pantonic chair, 350; "Peacock" chair, 572; plastic stacking chairs, 56, 57, 395; Post-Modernism, 45; Prague bentwood armchair, 579; Red-Blue Chair, 32; Rietveld's side chair, 56, 57; Saarinen's singlepedestal chair, 39; Sacco chair, 39; Secondo armchair, 396; Shaker ladderback rocking chairs, 23; sizes and clearance spaces, 209; and space, 149-152; Swan chairs, 39; tubular steel chair, 32, 33; Tugendhat chairs, 34; types of, 577-579; Utrecht armchair, 55; Venturi's chairs, 75; webbed chair, 181; wing chair, 577. See also seating chandeliers, 293, 390, 441, 453, 558 character: in programming, 12, 13; in residential spaces, 178-179, 202-203 chenille yarns, 414 chest, 586, 587 chesterfield, 579 chests of drawers, 586 children: child's nook, 151; design considerations for, 158-159; design for activities of, 221-222; meals of, 227 children's rooms: computer in, 219; design of, as social zone, 219, 221, 222; individual needs in, 263, 264; nursery, 454; scale in, 130, 131; size of, 260; storage in, 262; wallpaper for, 453 china, 384 chopping block, 57 chroma, 100 chromatic distribution, law of, 99 circles, 78, 79 circuit-breaker panels, 338 circular knits, 417 circulation, 187, 188, 189, 293 Citrohan house, 34-35 clay. See ceramics clay bodies, 383-384 clay bricks, 374 cleaning: equipment and supplies for, 242; of kitchen, 248 clerestories, 506 client profile, 12, 170-176, 202 closed plans, 282, 283 closets: adjustable closet systems for accessibility, 157; in bedrooms, 262, 263; child's closet, 159; planning of, 189; in social zone for greeting guests, 207. See also storage clusters, 558 codes of ethics, 630 coffee tables, 570, 582, 583 coffered ceilings, 465, 466 cold cathode lamps, 540 collectors, in active solar systems, 310 color: of artificial light, 550-551; in bathrooms, 270; of ceilings, 108, 468-469; in ceramics, 386; color systems, 99-102; color theory, 92-99; as conservation measure, 300, 301; considerations on, 90-91; of draw curtains, 523; economies of, 112-113; effects of hue, value, and intensity,

663

cornices, 520, 521, 553, 554 108-112; of fabrics, 421-422, 423; factors in selecting, 106-108, 107; of corporate office design, 39 glass curtains, 523; in home office, corridor arrangement, of kitchens, 244, 279; hue of, 93, 94, 95, 108-112; intensity of, 98, 99, 108-112; of lamp cost estimates, for residential spaces, shades, 559; law of chromatic distrib-183-184 ution, 99; and light, 91-92; Munsell cotton, 409, 410-411, 491 couch, 579. See also sofas system of, 99, 100, 101; Ostwald system of, 101; of paints, 451; planning Council of Federal Interior Designers color harmonies, 102-106; primary (CFID), 628 colors, 92; relativity of, 94; in remodcounters: acrylic countertop, 402; in bedeling project, 204; value of, 95-98, room, 258; butcher block countertop, 108–112; in visible spectrum, 91; 358; heat-resistant counter, 239; in kitchen, 236, 237, 238, 240-244, 372; walls and light qualities, 439; of wood, 352–354, 360, 361 for snacks and quick meals, 227 color conditioning, 90 courtyard plan, 282 color wheel, 93, 96-97 courtyards, 73, 438 common bricks, 374 cove lighting, 542, 544 communications, 344-345 cove molding, 362 tails, 195-197 compact florescent, 539 coved ceilings, 465 coves, 554 complementary color harmonies, 104, crabbing, 420 complementary hues, 94-95 craft revival, 41 complex yarns, 414 crafts, 613-614 crease-resistant, 421 composition board, 590 computers: entertainment uses of, 218, crewel embroidery, 425 219; in home office, 276, 277; in intecrimp, 409 rior design, 560, 561, 631, 632, 633; critical path, in design process, 10, technical requirements for, 344, 345 11, 17 crowding, 150-152, 151 Con Edison's Conservation House, 314 crown molding, 362 concept development: concept statement, 193; in design process, 10, 16; crystal, 387 ideation, 191; for residential spaces, cultivated silk, 412 cultural influences, on residential spaces, 191-193; schematics, 191, 192 concept statement, 10, 16, 193 142, 143, 144 details, 197 culture, definition of, 142-143 concepts, 16 diagonal lines, 82 concrete: as construction material, 379, Cunningham, Diana, 14 442; for floors, 473, 474-475, 476 cupboard, 26 concrete blocks, 378, 442, 447 cupboards, 26, 122 concrete floors, 471-472 curtain walls, 436 dimmers, 338, 560 curtains: bed curtains, 257; definition of, conduction, of heat, 326 cones, 80 519; for doors, 529; draw curtains, 523-524; glass curtains, 521, 522, cones, of eyes, 98 Conservation House (Con Edison), 314 523; measuring and estimating for, 525; types of, 519-521 conservation measures: air infiltration, 307-308; behavioral adaptations, 300; curved forms, 78, 79-81 design features, 300, 301-306; earthcurves, 78, 79-81, 82 cushioned vinyls, 480-481 sheltered housing, 308, 309; insulation, 306, 307; retrofitting, 309. See cushions, 595, 604 also energy conservation and efficut and uncut loop carpet, 488 cut glass, 390 ciency cut pile carpets, 487 console table, 582 construction drawings, 17, 195 cutouts: in walls, 435; in window treat-Consumer Product Safety Commission, ments, 511 Cutten, Betty, 202 cylinders, 80 Contemporary furniture, 41 continuous related movement, 121, 122 davenport, 579 contract, 17, 198, 202 contract design, 6-9 Davis, Sam, 310 De Long, Alton J., 147–148 contrast, in rhythm, 124 De Stijl, 32 contrasting color schemes, 103 De Vido, Alfredo, 340, 368 convection, of heat, 326 De Wolfe, Elsie, 2, 3, 28-29 convection oven, 240 conversation areas, 208-209, 210-212, decibels, 338 deck, 334 562, 578 581-583 decorative accessories, 606-607, 606-615, convertible sofa, 580 cook center, 239-240 609-615 direct glare, 547 cool hues, 95, 109-110, 113 decorative design, 64-65. See also ornacool light, 552 mentation cord yarns, 414 decorative lighting, 542, 544, 545 cork: for floors, 474-475, 478, 480; for decorator rod, 523 walls, 443, 447 Delamarre, Jacques, 37 design: balance in, 115-121; color as elecorner blocks, 590 ment of, 92-113; as conscious 160-161; kitchens for, 156, cornice molding, 362

process, 52-53; decorative design, 64-65; definition of, 52; determinants of, 53-62; discrimination in, 66; emphasis in, 125–127; form and shape as elements of, 71-81; and function, 53-55; harmony in, 132-136; light as element of, 91-92; line as element of, 82-83; and materials, 55-58; rhythm in, 121-125; scale and proportion in, 128-131; space as element of, 67-73; structural design, 62-64; and style, 60-62; and technology, 58-60; texture as element of, 83-89; types of, 62-65. See also interior design design concepts, 193 design drawings: axonometric views and perspectives, 197, 198; floor plans, 193, 194-195; for residential spaces, 193-204; sections, elevations, and dedesign process: critical path in, 10, 11, 17; CUBE in, 11-16; evaluation in, 10, 16; final design development and documentation in, 10, 16, 193-204; implementation in, 10, 16; presentation in, 10, 16; problem statement in, 10, 11; programming in, 10, 11–16, 170–190; schematic design and concept development in, 10, 16, 191-193; steps in, 9-18, 625 design statement, 11 design team, 622, 623 desk lamp, 556 desks, 22, 23, 80, 584, 591 Diffrient, Niels, 141 diffuse reflection, 547 dining patterns: buffet meals, 226, 227; children's meals, 227; kitchen eating area, 242, 243; quick meals, 227; sitdown meals, 224, 225, 226; snacks, dining rooms: accessories in, 385, 614; in apartments, 15, 457; Arts and Crafts influence on, 46; of Casa Battló, 26; ceilings in, 464; De Wolfe's designs for, 28, 29; design of, as social zone, 222, 223-227; from 18th century, 379; electrical outlets in, 337, 339; Elkins's design of, 3; floor of, 348, 479; flowers in, 609; furniture for, 209, 223-226, 365, 393, 581-583; furniture sizes and clearance spaces, 209, 581; lighting in, 8, 233, 390, 541, 542, 544, 562, 563-564; masonry used in, 369; Merier's design of, 8; multipurpose functions of, 227; plastics used in, 405; vinyl upholstery used in, 419; walls of, 457; window treatments in, 513; wood used in, 348, 361, 365, dining tables, 209, 223-226, 365, 393, direct lighting, 542 direct-light fixtures, 556 disabled: bathrooms for, 154-155, 160-161; door openings for, 156, 157, 162; floor plans, 154-156, 162; guidelines for adaptive housing,

disabled (continued)

160-161, 163-166, 164, 165, 236;

residential spaces for, 154-157,

160-166, 162, 163; traffic paths for, 156, 157 discharge printing, 424 discord, 97 252 dishwasher, 238 distressed finishes, 368 distribution of light quantities, 552 divan, 579 documentation, in design process, 10, 16 elevations, 197 domed ceilings, 465 dominant emphasis, 125, 126 Donghia, Angelo, 39-40 door knocker, 398 doors: and air infiltration, 308; in bathrooms, 269; in bedrooms, 261, 262; changing, in existing spaces, 526; cleaning of, 529; curtaining for, 529; design of, 530; and disabled, 156, 157, 162; and energy conservation, 328; functional aspects of, 528-529; and furniture arrangement, 528; in kitchen, 247; and light, 528; and privacy, 528; safety for, 156, 157; and temperature control, 529; and traffic paths, 528; types of, 527, 528; and ventilation, 528–529 501, 503 double complementaries, 104, 106 double-hung window, 501 double-pitched ceilings, 467 dovetailed joints, 590, 591 doweled joints, 590 down, 595 downlights, 548, 553, 562 draperies, 520, 524, 525. See also curtains draw curtains, 520, 523-524 drawing rooms, in Art Nouveau style, 27 drawings, 609 drawn glass, 389 dressing areas, 258-259 613, 616 drop-leaf tables, 582 dropped ceilings, 465 drying clothes. See laundry facilities drypoint, 609 dry-wall construction, 441 ducts, for heat conduction, 327, 329 Dunbar Furniture Company, 41 D'Urso, Joseph Paul, 41, 128 Dutch doors, 526, 527 dyes, 421-422 Eames, Charles, 38, 39, 577, 578 earth berm, 180 earthenware, 383, 384, 386 earth-sheltered housing, 308, 309 east light, 534 Eastlake, Charles Locke, 21 eating. See dining patterns; dining rooms 177 economy: of color, 112–113; evaluation of, concerning floor plans, 294; of ergofit, 17, 171 floor upkeep, 492; in furniture, 570-573, 571, 572; of lighting, 560, ing, 577 561; in programming, 15; in programming for residential spaces, 183-184 etching, 609 Egg chair, 39 ethics, 630 Egyptian wall painting, 380 elastic, 421 elastomeric fibers, 413 elderly: chairs for, 571; design considerations for, 159-162; guidelines for adaptive housing, 160-161; kitchens exterior window treatments, 152,

511-512 for, 163-166, 164, 165 electric discharge lamps, 539, 540 eyeballs, 553 electrical outlets, 337, 337-338, 339; for fabric webs, 418 audio-visual systems, 344; in bathrooms, 337, 339; in bedrooms, 337, 339; in dining rooms, 337, 339; in kitchen, 241, 337, 339; for workshops, electrical plan. See wiring plan electrical switches, 338, 339 electrical systems, 204, 337-339 electronic video games, 218 Elkins, Frances, 3 embroidery, 425 emphasis, as design principle, 125, 126, emphatic emphasis, 126 endangered species, 322 end-matched veneers, 356, 357 energy conservation and efficiency: air face board, 554 infiltration, 307-308; alternative enface bricks, 374 ergy sources, 314-315; and ceiling heights, 465; conservation measures, 300-310, 301-309, 390, 393; earthsheltered housing, 308, 309; insulation, 306-307; and lighting, 560, 561; 328, 562 retrofitting, 309; sustainable energy resources, 310-315; and windows, Energy Policy Act, 537 faux finishes, 451 felting, 418 engraved glass, 390 entertainment areas: active indoor enterfences, 511 tainment, 218, 219; audio-visual enfiber blends, 413 tertainment, 213-217, 214-218; electronic video games, 218; floor in, fiberglass, 395 480; lighting for, 563; outdoor entertainment, 220, 512; quiet games, 213; seating for, 55; with sliding glass doors to patio, 172; tables for, 584 entrance areas, 207-208, 208, 493, 562, environmental design, 42, 144-145 environmental issues: conservation measures, 300-310, 301-309; endangered species, 322; energy conservation and efficiency, 300-315; and ethics, 630; global impact of design decisions, 322-323; health consequences of indoor air pollution, 315-316; imporfilament yarns, 414 tance of, 298-300; indoor air filaments, 408 pollution, 315–317; plastics, 402–403; preservation, 317–322; restoration/ filling knits, 417 filling yarns, 415 adaptive reuse/remodeling, 317-322; sick building syndrome, 315; sustainable energy resources, 310-314, finish flooring, 471 environmental psychology, 144-145 equipment needs, in residential spaces, ergonomics: of bathrooms, 266, 268; and design, 62, 63; of home office, 277; of residential spaces, 141, 142; for seatfirebricks, 375 etched glass, 390 etched-out printing, 424 evaluation, in design process, 10, 16, 17 exercise room, 219, 268 extension tables, 582 way fireplace, 172 exterior lighting, 566

fabrics: for ceilings, 468, 469; color application for, 421-422, 423; construction of, 415-420; coordination with wallpaper, 454; decorative finishes and enrichment, 423-426, 424, 425; of draw curtains, 523; fabric webs, 418; films, 418; finishes for, 420-426, 422-425; functional finishes for, 420-421; glossary of, 426-430; heavy weight, 430; knitting, 417, 417; knotting and twisting, 418; light weight, 427-428; medium weight, 428-430, 429; multicomponent fabrics, 418, 419; printing on, 423, 424-425; sheer, 426; stitchery for, 425; upholstery fabrics, 595, 596; as wall coverings, 457-458; weaving, 415-417 facsimile machines, 344, 345 factory, conversion of, 13, 318, 321 Falling Water home, 31 family rooms, 150, 151, 221, 229, 230, farmhouse, 463, 478 faucet, single-lever-control, 158 fenestration, 506. See also doors; windows fibers: for carpet, 490-491; cellulosic fibers, 409, 412-413; characteristics and types of, 408-409; definition of, 407; elastomeric fibers, 413; fiber blends, 413; man-made fibers, 412-413; mineral fibers, 412, 413; natural fibers, 409, 412; natural rubber, 412; noncellulosic (synthetics) fibers, 413; performance characteristics of, 410-411; protein fibers, 409, 412; as wall coverings, 457-458 Fibonacci sequence, 129 figure, of wood, 350 films, for fabrics, 418 final design development, in design process, 10, 16 finish plumbing, 336 finishes: for fabrics, 420-426, 422-425; for wood, 366, 367, 368 fire extinguishers, 343 fire-rated doors, 528 fire-resistant, 420-421 fire safety, 343, 493, 528 fireplaces: appearance of, 460-461; design considerations, 458-462; examples of, 81, 127, 133, 230, 329, 347, 348, 362-364, 371, 381, 396, 423, 437, 441, 458-462, 466, 477, 553, 555; heat output from, 459; location of, 459-460; materials for, 461-462; two-

fireproof fabric, 421

665

Fitch, James M., 298, 309 formaldehyde, 315, 316 Foundation for Interior Design Eduation fixed windows, 500, 501 fixtures: for bathrooms, 269; for chil-Research (FIDER), 626, 628 frames for art, 610, 611, 612 dren's activities, 221. See also lighting Frankl, Eve, 215, 216 freestanding walls, 436 flame-resistant, 420-421 flame-retardant, 421 freezer, 237 flammability safety standards, for floors, French doors, 527, 529 493 French secretary, 64 frieze carpet, 488, 489 Flammable Fabrics Act, 420 FRP, 401 flat knits, 417 flat slicing, of wood, 350, 351 full spectrum lamps, 539 full spectrum light, 533 fleece, 409 flickering light, 552 fulling, 420 floated glass, 389-390 fume-fading resistant, 421 function: and design, 53-55; form follows flock yarns, 414 function, 54-55 flocked carpet, 487 flocked fibers, 420 functional color, 90 floor lamps, 556-558 functional goals, 177 functional needs. See utility floor pads, 580 floor plans: by Beechers in 19th century, fur, 409 54; closed plans, 282, 283; definition furniture: beauty and character of, of, 194; developed from schematic 573-574; bedroom furniture sizes and clearances, 259; built-in, 574, drawings, 192; for disabled, 154-156, 162; evaluation of, 291-295; flexible 575-576; and comfort, 570; and conspace in, 71; of home in German venience, 570; cost of maintenance Pavilion, 34; horizontal and vertical for, 572-573; desks, 584, 591; and plans, 284, 285-288; multifamily doors, 528; edges of, 589; evaluation housing, 289; multilevel plans, 285, of floor plan concerning, 293; flat surfaces of, 589; and flexibility, 571; 286-288; one-story plans, 285; open hardware for, 589; indoor/outdoor plans, 283-284; open space subdivided by furnishings, 73; remodeling of furniture, 408; legs and bases of, 589; townhouse, 203; for residential spaces, length of service for, 572; materials 193, 194–195; single-family detached and construction of, 588-589, housing, 291; types of, 281-288; of 590-596; of metal, 591, 592; in Modern period, 38-42; modular, 575-576; Wright's Robie house, 30 outdoor furniture, 408, 586, 588; runfloor tiles, 376 ners of drawers, 589; seating, 577–581; selection of, 569–574; sizes flooring bricks, 375 floors: appearance of, 493-494; in bathrooms, 270; bluestone floor, 373; of, and clearance spaces, 209; space required for, 571-572; storage units, brick floors, 374, 375; color of, 108; durability of, 492; economy of up-584, 585-587; of synthetics, 592-593; types of, 574-586, 575-587; upholkeep, 492; for elderly and disabled, stered furniture, 593-596; utility and 159, 160; and energy conservation, economy in, 570-573, 571, 572; and 313; finish flooring materials, 472-492; flammability of, 493; grade windows, 505; of wood, 349, 350, 589, 590, 591; and zones in residenlevels of, 471, 472; hard floors 472-477; importance of, 470, 471; tial spaces, 185. See also beds; chairs; marble floors, 372; masonry for, 473, sofas; tables; and other specific pieces of 476, 476; for noise control, 342, 343; resilient flooring, 159, 160, 474-475, futons, 577 478-481; safety for, 156; selection criteria for, 492-494; in social zone for gabled ceilings, 467 greeting guests, 207; soft floor covergallery, 63 ings, 474-475, 481-491; tile floors, game room. See entertainment areas 376, 377; vinyl for, 474, 478, 479, games: electronic video games, 218; 480; warmth of, 492-493; wood floorlighting for, 563; social zone for quiet ing, 348, 365, 381; wood for, 474, 476, 477, 478 games, 213; tables for, 584 garage, laundry facilities in, 250-251 fluorescent lamps, 539, 540 garbage, 238 garden apartments, 289-291, 290 flowers, 606-609 garden rooms, 252 flush-mounted fixtures, 553-554 foam-backed fabrics, 418 gardens, lighting for, 566 gather shades, 512 focal points, 125 Gaudi, Antonio, 25, 26 fold-down beds, 577 folding doors, 528 general lighting, 541, 542 folding tables, 582 generic versus trade names, 412 footcandles (fc), 545 geodesic dome, 302 geometric design, 86 footlamberts (fL), 545 form and shape: angular, 77-78; curved, Georges Pompidou National Center for 78, 79-81; definitions of, 73-75; form Art and Culture, 43, 44 follows function, 54-55; rectilinear, German Pavilion, 33, 34 75, 76, 77 GFIC. See ground fault interrupter circuit (GFIC) formal balance, 117-118

gigging, 420 glare, 503, 547 glare by contrast, 547 glass: architectural glass, 391, 393; for art framing, 611; characteristics of, 388; fiberglass, 395; form in, 388–390; making of, 387–388; mirrors, 393 448, 449; ornamentation in, 390-392; plexiglass, 394; for table tops, 13, 394, 581; walls of, 43, 79, 320, 381, 435, 436, 448, 449 glass blocks, 270, 378, 391, 393, 394, 442, 448, 449 glass bricks, 378 glass curtains, 519, 521, 522, 523 glass fibers, 410-411, 413, 421 Glass House, 43 glazed bricks, 375 glazed fabrics, 421, 422 glazes, 385-386 glazing, 451 glob sources, of light, 550 glossy, 421 glossy finishes, 366 goals, in programming, 177 goat's hair, 409 golden rectangle, 128 golden section, 128, 129 gooseneck lamps, 556 gradation, 122 grade levels, of floors, 471, 472 grain, of wood, 350 grand scale, 129, 130 granite, 372, 373 grass fibers, 409, 491 Graves, Michael, 45 Gray, Eileen, 37 Gray, Michael, 574 gray scale, 95, 96-97 grazing, 548 great rooms, 172, 229, 318, 476 green" design, 42 Greene and Greene, 23 greenhouse, 252, 312, 509 greenhouse blinds, 305 Greenough, Horatio, 54 grid systems, 69, 70 grilles, 511, 517 Gropius, Walter, 32, 42 ground fault interrupter circuit (GFIC), guest houses, 178, 273-275, 356, 376, guests, greeting of, 207, 208 Guimard, Hector, 25, 26 Gwathmey, Charles, 45 gypsum board, 468 gypsum plasterboard, 441 Gyro chair, 39 Hall, Edward T., 146, 188 hallways: accessories in, 616; electrical switches in, 338; lighting for, 565; width of, 188; window wall in, 510 halogen lamps. See tungsten-halogen lamps hand-blown glass, 388, 389 handrail, 496-497 hard floors, 472-477 hard wood, 350-351 hardboard, 350

harmony: definition of, 132; as design

principle, 132-135, 136; and unity, 132,

133, 135; and variety, 134, 135, 136

Hartman, Cedric, 548 Hartman, Lane, 613 Haworth, Dennis, 211, 228 headroom, at top of stairs, 496 health club, 448 health consequences, of indoor air pollution, 315-316 heat setting, 420 heating, 269, 326-330, 331, 458-462, 465, 492-493. See also fireplaces; wood-burning stoves heat-reflectant, 421 heat-resistant counter, in kitchen, 239 hemp, 409, 491 Herman Miller Company, 39 Hernandez, Agustin, 496 herringbone patterns, 415 Hicks, David, 618 HID lamps. See high-intensity discharge (HID) lamps highhats, 553 high-intensity discharge (HID) lamps, 540, 560 high-intensity luminaires, 556 high-pressure sodium (HPS) lamps, 540 High-Tech syle, 40, 41, 43 Hillman, Kirk, 12 Hoffmann, Josef, 22, 64, 579 home offices, 5, 275, 276-279, 277-279, home security, 343, 344 homes. See residential spaces honeycomb pleated shades, 513 hooked rugs, 417, 487 hooking, 417, 487 horizontal curves, 82 horizontal lines, 82, 83 horizontal plans, 284, 285-288 horsehair, 409 Horta, Victor, 24-25, 26 hospitality design, 8 hot tub, 267, 268 hot water heater, 238 hotels, 8 house plans. See floor plans household, definition of, 170-171 HPS lamps. See high-pressure sodium (HPS) lamps hue, 93, 94, 95, 108-112 human factors: behavioral basis of design of residential spaces, 141-152; importance of, 140-141; physiological requirements for residential spaces, 141; safety and architectural barriers in residential spaces, 152-156; special needs populations, 157-166 human factors engineering, 142. See also ergonomics human scale, 130 humidity, 330-331 husk fibers, 409 HVAC systems, 325-334 hydrophilic, 408 hydrophobic, 408 hygiene areas. See bathrooms

ideation, 191
Illuminating Engineering Society (IES), 545
illusion. See spatial illusion
illusionary texture, 83–84
implementation, in design process, 10, 16
incandescent lamps, 538, 539
incident illumination, 545

Indian rugs, 484, 485 indirect lighting, 542 indiret luminaires, 557 indoor air pollution, 315-317, 332-333 indoor/outdoor furniture, 408 industrial design, 37 industrial designers, 9 informal balance, 118-119 inherent ornament, 85, 86 inlay, 365 instant-start lamps, 539 Institute of Business Designers (IBD), 628, 631 Institute of Store Planners (ISP), 628, 631 insulating glass, 393 insulation: for energy conservation, 306, 307; and fabrics, 421; for noise control, 341-342; and walls, 440 intarsia, 365 integrated ceilings, 465 integrity, in materials use, 56-57 intensity, of color, 98, 99, 108-112 intercom systems, 344 interior architects, 2 interior decorators, 2-4 interior design: activities in, 5; areas of specialization in, 6–9; Art Deco, 36, 37; Art Nouveau, 24–27, 26, 27; Arts and Crafts Movement, 20, 21-23; Bauhaus, 32, 33; body of knowledge in, 626–627; business of, 622, 623-624, 625; careers in, 6-9; computer used in, 631, 632, 633; contract design, 6-9; De Stijl, 32; De Wolfe as first professional decorator, 28-29; definition of, 4-6; education for, 625-627; ethics in, 630; future of, 631, 632, 633; history of, 19-47; industrial designers, 9; Le Corbusier's contribution to, 34, 35-36; licensing/ registration in, 6, 630-631; for machine age (1900-1930), 31-37; Mies van der Rohe's contribution to, 33-34; modern design, 37-43; NCIDQ exam in, 630, 631; in nineteenth century, 20-24; Post-Modernism and preservation movement, 45-47; product design, 7, 9; as profession, 4-9, 17-18, 622-633; professional organizations for, 628-629; residential design, 6, 8; Shakers, 23, 23-24; versus interior decorating, 2-4; Wright's contribution to, 29-31. See also design Interior Design Educators Council (IDEC), 628 Interior Designers of Canada (IDC), 628 interior window treatments, 512-526, 513-522, 524-525 intermediary hues, 93 International Federation of Interior Architects/Interior Designers (IFI), 628 International Furnishings & Design Association (IFDA), 628 International Society of Interior Designers (ISID), 628, 631 International Style, 31, 33, 34, 42, 46, 47 interpersonal distances, 146-148 intimate distance, 146, 148 ironing, 250, 251 island, in kitchen, 245 isometric drawing, 197

Jacobsen, Arne, 39 jacquard weaves, 417, 417 Japanese art and architecture, 21, 23, 143–144, 517, 526
Jeanneret, Pierre, 35
Jeanneret-Gris, Charles Edouard. See Le Corbusier jiggering, 385
Johns, Jasper, 74
Johnson, Philip, 43, 43, 45
joining methods, for wood, 360, 362, 445, 446, 590, 591
joists, 471
Jordan, Mark and Nancy, 462
Juhl, Finn, 38
jute, 409, 491
kapok, 409

Kase, Arnelle, 44, 570

kilims, 490 Kim, C. W., 79, 126 kinesthetic experience of space, 68 kinetic, 63-64 Kira, Alexander, 256, 266, 268, 270 Kirkpatrick folding chair, 78 kitchen design, 4 kitchens: accessories in, 614; anthropometrics of, 233, 234, 235, 236; Beecher's ideal kitchen, 55; book shelves in, 585; cabinets in, 234, 237, 238, 240-246, 253; as center of activity, 232, 233; circular elements in, 126; cook center in, 239-240; counters in, 236, 237, 238, 240-244, 372; country kitchen, 614; design of, 4, 243, 244-249, 332; for disabled, 156, 160-161, 163-166, 164, 165, 236; doors in, 247; eating areas in, 242, 243, 334, 402; for elderly, 163-166, 164, 165; electrical outlets and switches in, 241, 337, 338, 339; floor of, 480; functional planning for, 233-234; island in, 245; laundry facilities in, 250; lighting in, 238, 240, 241, 248, 543, 563, 564; location of, 246, 247; maintenance of, 248; minimalist's approach to, 177; mix center in, 240-241; peninsula in, 245; planning center in, 242; quick-cook center in, 240; refrigerator/storage center in, 236, 237; safety for, 133, 155, 156; serve center in, 241, 242; shape of, 247; single-lever-control faucet for, 158; sink/clean-up center, 237-238; size of, 247; standard arrangements of work centers in, 244, 245; standard kitchen appliances and cabinet sizes, 4, 234; of Star House, 120; storage in, 233, 242-243; subtraction method in planning, 245-246; tile in, 377; traffic routes in, 244; unity in, 133, 135; ventilation in, 240, 332, 333, 334; windows in, 120, 247, 248; wood used in, 358-360; work centers in, 233, 236-242, 237-241, 243-246, 244, 245, 254; work triangle in,

knee space, in sink/clean-up center, 238 knitting: of carpets, 485; of fabrics, 417, 417 Knoll, Florence, 39 knotting, 418 Kohler's Master Shower, 266

L-shape kitchens, 244, 245 lacquer, 366, 367, 451

667

Lagerfeld, Karl, 405 Lalique, Marie-Claude, 391 lambrequins, 520-521 laminated fabrics, 418 laminated glass, 390 laminated wood, 349, 358 laminating, 400 lamps, 537. See also lighting landing, 496 Lanham, Jacquelynne P., 398 large downward curves, 82 Larsen, Jack Lenor, 58 laundry facilities, 249-251, 250 law of chromatic distribution, 99 Lawson sofa, 580 Le Bombola seating, 399 Le Corbusier, 34, 35–36, 42, 47, 76 lead-based paints, 315 leaded glass, 391, 392 lean-to ceilings, 465 leather tiles, for floors, 480 Lechman, Patti, 84 Legionnaire's Disease, 315 leno weaves, 416 level loop carpet, 488, 489 library, 44, 81, 189, 227, 227 licensing, of interior designers, 6, 630-631 life-cycle costing, 184 lifestyle, definition of, 171 light: and color, 91-92; and doors, 528; east light, 534; importance of, 91, 532; measures of, 545-546; natural light, 116, 533-535, 536; north light, 534; south light, 534; visible spectrum of, 91; walls and light qualities, 439; wavelengths of, 91; west light, 534; and windows, 499, 503, 533-535 light transmittance, 558-559 lighting: accent/decorative lighting, 542, 544, 545; ambient/general lighting, 541, 542; artificial lighting, 536-566; and balance, 116; in bathrooms, 270-273, 564, 565; in bedrooms, 258, 264, 565; for children's activities, 221; color of light, 550-551; computer software to illustrate, 560, 561; control of light, 546-547; for conversation areas, 210; daylight and balance, 116; in dining rooms, 223, 390, 544, 562, 563-564; direct versus indirect, 542; for disabled and elderly, 161; economic aspects of, 560, 561; electric discharge sources of, 539, 540; and energy conservation, 306; of entrance areas, 562; exterior lighting, 566; from fireplaces, 459; fixtures for, 552-559, 560; and floors, 493; fluorescent lamps, 539, 540; high-intensity discharge (HID) lamps, 540; in home office, 276, 277-279; importance of, 532; incandescent sources of, 538-539; in kitchens, 238, 240, 241, 248, 563, 564; in living rooms, 84, 543, 549, 553, 555, 558, 562, 565; local/task lighting, 542, 543; location and direction of light, 547-550, 548, 549; measures of light, 545-546; mood produced by, 536, 537; and natural light, 116, 533-535, 536; neon lamps, 540, 541; plant lights, 252; psychological aspects of light, 551-552; for reading areas, 213; in remodeling project, 204; and safety,

155-156; for sculpture, 612, 613; for security, 343, 344; size and shape of light source, 550; skylights, 331, 506, 534-535; in social zone for greeting guests, 207; sources of, 537-540; for specific areas and activities, 560-566, 562-565; for stairways, 153, 564, 565-566; technical factors in, 545-551, 546-549; and texture, 84, 85; types and uses of, 541-545 542-544; for visual media, 217, 218; for workshops, 252. See also windows lighting fixtures: aesthetics of, 560; architectural and built-in lighting, 553-556; ceiling luminaires, 553-554; characteristics of, 552; nonarchitectural lighting and portable luminaires, 556-558; shades, 558, 559; size of, 559; wall luminaires, 554, 556 limestone, 373 line, 82-83 line sources, of light, 550 linear systems, 69 linen, 409, 410-411, 491 liquid vinyl, 420 lithography, 609 living rooms: accessories in, 383, 616, 618; antiques in, 174; in apartments, 40, 72, 83, 125, 175, 176, 284, 364, 368, 450; art in, 124, 127, 174, 364, 610, 611; Bennett's design of, 40; ceilings in, 79, 464; color in, 96, 103, 105, 110, 111, 113, 121, 123, 423; conversation areas in, 149-151, 210; in converted factory, 13; design of, as social zone, 208-212, 210-212; eclectic mixture of old and new in, 135; furniture sizes and clearance spaces, 209; with glass slides open to terrace, 43; in Gothic revival style, 83; Le Corbusier's design of, 35; lighting for, 76, 84, 542, 543, 549, 553, 555, 558, 562, 565; as main social area of home, 229; masonry used in, 371; metal used in, 396; minimalist's approach to, 177; monotony due to excessive unity, 134; open plans for, 70, 72; plants and flowers in, 287, 609; plaster molding in, 468; in restored mill, 88; scale and proportion used in small area, 131; seating in, 149-152; tables in, 582, 583; textiles used in, 407, 419; in vacation homes, 76, 118, 129, 133; in Victorian homes, 81, 301; window treatments in, 514, 516, 517; windows in, 76, 80, 96, 127, 146, 306, 318, 381, 464, 503, 518; wood used in, 287, 348, 362-364, 368; of Wright's Taliesin East, 30; of Wright's Taliesin West, 3. See also chairs; sofas llama's hair, 409 load-bearing walls, 318 local/task lighting, 542, 543 lofts, 70, 144, 147, 153, 175, 176, 317, 383, 409, 465, 581, 600 longitudinal sections, 195, 197 loop pile carpets, 487 Loos, Adolph, 31-32 lounge, 579 lounge chair, 577, 578 louvers, 511-512, 513 love seat, 579 low emissivity (low-E) glass, 390

low-pressure electric discharge lamps, 539 540 low-voltage lamps, 538, 560, 561 lumber-core plywood, 357 lumens, 545 luminaires, 552-559, 560. See also lighting fixtures luminance, 545 luminance ratios, 546 luminous fixtures, 558 luminous panels, 553 luminous wall panels, 556 Lunario table, 388, 389 Lyons, Susan, 58 Machine-Age Modernism, 34 Macintosh, Charles Rennie, 25, 27 macrame, 418 maintenance: costs for residential spaces, 184; of kitchen, 248 man-made fibers, 412-413 mantel, 174, 328, 371, 461, 462 marble, 372, 373 marquetry, 364, 365 Maslow, Abraham, 140 masonry: advantages of, 369; ashlar masonry, 370; block materials, 369-378; brick, 374-375; concrete, 379; concrete blocks, 378; definition of, 368-369; for floors, 473, 476; glass blocks, 378; limitations of, 370; moldable materials, 378, 379-381; plaster and stucco, 379, 380; random ashlar masonry, 370; recycling of, 381; rubble masonry, 370; stone, 370, 371-373; tile, 375-378, 376-377; for walls, 447, 448 mass-produced accessories, 615 matchstick shades, 512-513 materials: for audio-visual entertainment, 215; for carpets, 490-491; for ceilings, 467, 468; as conservation measure, 300, 301; and design, 55-58; finish flooring materials, 472-492; for fireplaces, 461-462; for furniture 588–596, 590–596; for walls, 441, 441-458, 445-458. See also specific materials, such as textiles; wood Mathsson, Karl Bruno, 38 matrixes, 16 mats for art, 611, 612 mattress sizes, 258 McClelland, Nancy, 28-29 McMillen, Eleanor, 29 meals. See dining patterns media rooms, 229 medullary rays, of wood, 350 Mehrabian, 228 Meier, Richard, 8, 9, 39, 45, 349 Memphis furniture, 41 mercerization, 420 mercury vapor lamps, 540 metal chloride lamps, 540 metal halide lamps, 540 metallic fibers, 413 metals: charateristics of, 395-396, 397; form and ornament in, 26, 395-396, 396-399, 398; for furniture, 591, 592; as material, 57, 58; as wall covering, 442, 449, 450; for windows, metameric pair, 108 metamerism, 108, 550

Mexican tiles, 377

needlepoint, 425

needlepunched carpet, 487

needle-punched fabrics, 418

microblinds, 515 needlework, 425 passementerie, 526 microwave oven, 240 Nelson, George, 39 passive balance, 117-118 Mïes van der Rohe, Ludwig, 33-34, 39, neon lamps, 540, 541, 558 patchwork, 425 42, 43, 75 Nespor, Maurice J., & Associates, 14 patina, 368 mildew-resistant, 420 nesting tables, 582, 583 patios, 172, 566 mill, conversion of, 370 netting, 418 pattern, 86-88, 89 mineral fibers, 412, 413 Neumann, Kenneth, 365 patterns, of fabrics, 422 Neutra, Richard, 42-43, 43 pavers, 375 miniblinds, 515 Minimalism, 41 neutrals, 96, 103, 104, 423 paving bricks, 375 mirrored ceilings, 468 Noguchi, Isamu, 39 "Peacock" chair, 572 mirrored glass, 393 noise. See acoustics penetrating finishes, 366 mirrors: in bathrooms, 270-273; in bednonbiodegradable, 322 peninsula: in kitchen, 245 rooms, 258; glass for, 393; in social noncellulosic (synthetics) fibers, 413 perception. See sensory perception zone for greeting guests, 207; as wall nonwoven fabrics, 418 perimeter lighting, 548 covering, 448, 449 normal value, 96-97 perimeter protectors, 344 Mission Style, 23 north light, 534 perpendicular balance, 119 novelty yarns, 414 Null, Roberta, 163 miter joints, 590 personal distance, 146-147, 148 mix center, in kitchen, 240-241 personal space, in residential spaces, 146-148, 147, 149 mobility, of clients, 171, 173, 175 nursery, 454 nylon, 401, 410-411, 413, 490 modacrylics, 410-411, 413, 421, 490 perspectives, 198 modeling, in ceramics, 386 Pesce, Gaetano, 575 moderately bright light, 552 obsidian, 388 phases, in residential design, 184 Modern movement, 2, 3, 31-32, 32, occult balance, 118-119 photographic printing, 424 37 - 43photographs, 610, 611 offices. See home offices modular furniture, 221, 575-576 offices: of interior designers, 5 physiological requirements, in residential modular sofas, 580 olefin, 410-411, 413, 490-491 spaces, 141 mohair, 409 olfactory experience of space, 69 piano, 214, 215, 216, 394, 472 molded glass, 388 on grade floors, 471 Piano, Renzo, 43, 44 moldings, 362-363 one-story plans, 285 pictorial projections, 197 Mondrian, Piet, 32 one-wall kitchens, 244, 245 picture moldings, 363 monochromatic, 94, 96, 103, 104 opaque finish, 366 pile weaves, 416, 417 Moore, Charles, 45, 122, 599 open plans, 283-284 pillows, 604 Morris, William, 20, 21, 46 operable windows, 500, 501 pilotis, 34, 35 mortise-and-tenon joints, 590 ordering systems, of space, 69, 70 pin spot, 538 mosaic tiles, 376 organic nature of archtiecture, 29-30 plain slicing, of wood, 350, 351 Moser, Koloman, 22 organizations. See professional organizaplain weave, 415 moth-resistant, 420 tions; and names of specific organizations planes of light, 550 motif, 86, 87 Oriental rugs, 12, 481, 483, 485, 490 planks, of wood, 477 motion detectors, 344 orientation, for residential spaces, 179–182 planning. See programming movable partition walls, 436 planning center, in kitchen, 242 movable walls, 438 ornament, 85-86 plantation shutters, 211, 517 MR lounge chair, 75 ornamentation: in ceramics, 385-387; in plants, 113, 287, 518, 519, 606-609 mullions, 509 glass, 390-392; in metals, 395-396, plaster: for ceilings, 467, 468; as conmulticomponent fabrics, 418, 419 396-399, 398; in plastics, 403-405; struction material, 379, 380; as wall multifamily housing, 289 wood, 359-365 covering, 441, 442 multilevel loop carpet, 488 Ostwald system, 101 plastic-impregnated finishes, 366 multilevel plans, 285, 286-288 outdoor entertainment areas, 220, 512 plastic laminate, 441, 444 multiple-filament lamps, 538 outdoor furniture, 408, 586, 588 plastic stacking chair, 56, 57, 395 multipurpose rooms, 229 oven, 239, 240, 241 plasticizers, 315-316 Munsell system, 99, 100, 101 overglaze, 386 plastics: and biodegradability, 402-403; muntins, 509 characteristics of, 399-400; environ-Murphy bed, 278, 576, 577 paintings, 609, 610 mental problems of, 402-403; families music, 214-217 paints: decorative effects of, 451, 452; of, 400-402; flammability and toxicmeasuring and estimating, 452; texity of, 402; form and ornament in, ture provided by, 451, 452; types of, 403-405; as material, 56, 57; as nonnapping, 420 Nason, Cathy, 267 450-451; for walls, 443, 450-452; for biodegradable, 322; noxious fumes of, National Association of Home Builders wood, 366, 367, 368 403; vinyl, 400-402; as wall covering, (NAHB), 306 443, 449-450 palace, 120 National Council for Interior Design palm fibers, 409 platform bed, 576, 577 Qualification (NCIDQ), 628, 630, panels, 444, 445, 446, 517 Platner, Warren, 58, 59 Panton, Verner, 56, 57, 350 playrooms, 229, 563 PANTONE Professional Color System, National Fire Protection Association pleated shades, 513, 514 (NFPA), 421, 528 101-102 plenum space, 471 natural fibers, 409, 412 Pantonic chair, 350 plexiglass, 394 natural light. See light pantry, 242, 243 plumbing, 334-337, 335, 336 PAR lamps, 538 natural resources, 322 plush carpets, 488 natural rubber, 412 Parish, Mrs Henry "Sister", 46, 47 ply, 414 naturalistic design, 86 parlor, 210 ply yarns, 414 Navajo rugs, 485, 487 parquet floors, 477, 478 plywood, 350, 357, 357-359, 445, 590 needlebonded carpet, 486, 487 parquetry, 365 pocket doors, 527 needle-felts, 418 partial walls, 436 POE. See post-occupancy evaluation

particleboard, 350, 590

partition walls, 436

particleboard plywood, 357

(POE)

point sources, of light, 550

poisonous plants, 608

669

pollution, indoor air, 315-317, 332-333 polyester, 410-411, 413, 490 polyethylenes, 401 polypropylenes, 490-491 polystyrenes, 401 polyvinyl chloride (PVC), 400 porcelain, 384 porcelain tiles, 377 pores, of wood, 350 portieres, 521 positive-negative reversal silhouette, 74 posters, 610 Post-Modernism, 44-47 post-occupancy evaluation (POE), 10, 17 Potts, Kendall, 12 pouf shades, 512 Poulsen, Tage, 355 Pozzi, Marcello, 72 Prague bentwood armchair, 579 prairie houses, 23, 29, 30 preheat lamps, 539 preliminary schematic design, in design process, 10, 16 presentation, in design process, 10, 16 presentation drawings, 197 preservation, 46, 317–322. See also barn; factory; mill; restoration pressed glass, 388 pressed wood, 441 primary hues, 93 primer, 451 printing, on fabrics, 423, 424-425 prints, 609-610 privacy: for conversation areas, 210; and doors, 528; in residential spaces, 145-146, 256; and windows, 504 private zone: definition of, 187-188; for guest accommodations, 274-275; for home office, 276-279; for hygiene, 266-274; in residential spaces 256-279; for sleeping and dressing, 257-265; for studio space, 276-278. See also bathrooms; bedrooms; home problem statement, in design process, 10, product design, 7, 9 professional organizations, 628-629. See also names of specific organizations program, in design process, 11 programming: adjacency studies, 189-191; analysis, 184-109; beauty, 13, 14, 15; case study of, 202-204; character, 12, 13, 178-179; circulation, storage and efficiency, 187, 188, 188-190; client profile, 170-176; cost estimates and budget, 183-184; in design process, 10, 11-16; economy, 15; equipment needs, 177; functional goals, 177 maintenance costs, 184; for residential spaces, 170-190; site and orientation, 179-182; space requirements, 178; utility, 13; zoning, 185–187, 188 progression, 122-123 project management, 622 projecting elements, in window treatments, 511, 512 proportion, as design principle, 128, 128 - 131proposal, 16 protein fibers, 409, 412 PS incandescent lamp, 538 psychology: of light, 551-552; of residential spaces, 144-152

public distance, 147, 148 punch list, 17 PVC. See polyvinyl chloride (PVC) pyramids, 77–78

quarry tiles, 376, 377 quarter slicing, of wood, 350, 351 quick-cook center, 240 quilting, 425 quilts, 418, 419

R lamps, 538 R value, 307 rabbeted joints, 590 radial balance, 118, 120 radial systems, 69, 70 radiant panels, 330 radiation, 122 radiation, of heat, 326 radiator, 329, 330 radon, 315 rag rug, 487 ranch-style homes, 31 random ashlar masonry, 370 random-matched veneers, 357 random sheared carpet, 488 rapid-start lamps, 539 Rapoport, Amos, 143 rattan, 593 rayon, 410-413 reading areas, 212-213, 563 rebated joints, 590 receding hues, 95 recessed downlights, 553 recreation rooms, 229 rectangularity, 75-77 rectilinear forms, 75-77, 76 recycling: in the home, 238; of masonry, 381; recycled materials, 15, 46 Red-Blue Chair, 32 reflected ceiling plan, 560, 562 reflected glare, 547 reflective materials, 468 reflector lamps, 538 refrigerator/storage center, 236, 237 registers, for heat conduction, 327, 329 related color schemes, 103 remodeling, 317-322 rep, 415 repetition, 121-122 reproductions of art works, 610 residential design, 6, 8 residential spaces: active indoor entertainment areas in, 218, 219; analysis for, 184-109; attached housing, 289-291, 290; audio-visual entertainment in, 213-217, 218; bathrooms in, 266-274; bedrooms in, 257-265; behavioral basis of design, 141-152; case studies on, 163-166, 202-204; character of, 178-179; and children, 158-159, 221-222; circulation, storage and efficiency, 187, 188, 189-190; client profile for, 170-176; concept development for, 191-193; conversa-

tion in, 208-212, 210-212; cost esti-

crowding in, 150, 151, 152; cultural influences on, 142, 143, 144; design

159-162; equipment needs for, 177;

ergonomics of, 141, 142; evaluation of

drawings for, 193, 194–198; dining areas in, 222, 223–227; and disabled,

mates and budget for, 183-184;

154-157, 160-166; and elderly,

floor plans, 291-295; floor plan selection for, 281-295; functional goals for, 177; greeting guests in, 207, 208; guest accommodations in, 274-275; home office in, 276-279; human factors in, 140-156; importance of, 140-141; Japanese versus Western houses, 143-144; kitchens in, 232-249; laundry facilities in, 249-251, 250; maintenance costs for, 184; multifamily housing, 289; outdoor entertainment in, 220; personal space in, 146-148, 147, 149; physiological requirements for, 141; planning social zones in, 228-231; privacy in, 145-146, 256; private spaces in, 256-279; programming for, 170-190; psychological and social needs for, 144-152; quiet games in, 213; reading areas in, 212-213; remodeling of, 202, 203, 204; safety and architectural barriers, 152-156; sewing areas, 251-252; single-family detached housing, 291; site and orientation of, 179-182; space requirements for, 178; special needs populations, 157–166; specifications and schedules for, 198-202; territoriality in, 150, 151; usable space in, 189-190; utility spaces in, 249-254; workshops and garden rooms, 252; zoning in, 185-187, 188 resilient flooring, 159, 160, 474-475, 478-481 resist printing, 424 restaurants, 14 restoration, 88, 105, 117, 120, 293, 317-322. See also barn; factory retrofitting, 309 revivals, 39, 41 rhythm: and continuity, 125; contrast in, 124; definition of, 121; as design principle, 121-125; progression, 122-123; repetition, 121-122; transition, 124 Richardson, Henry Hobson, 22, 23, 29 Rietveld, Gerrit, 32, 55, 56, 57 Rodin, Auguste, 73 rods, of eyes, 98 Rogers, Richard, 43, 44, 177 rolled glass, 389 roller printing, 423, 424 roller shades, 512 Roman bowl, 387 Roman shades, 512, 513 roof monitors, in passive solar system, 312 roofs, and energy conservation, 303-305 room-size rugs, 482 room sizes, 193 Rose, Peter, 15 Rossl, Aldo, 58 rotary cutting, of wood, 350, 351 rough plumbing, 336 row houses, 289-291, 290 rubber, 412 rubber tiles, 474-475, 478, 480 rubble masonry, 370 Rudolph, Paul, 77 rugs: characteristics of, 474-475; definition of, 481; Indian rugs, 484, 485; Oriental rugs, 12, 481, 483, 485, 490;

sizes of, 482-484, 485

Russota, Rhoda: office of, 5

runners, 482, 483

rya rugs, 487

Saarinen, Eero, 38, 39 shirring, 457 solar energy, 303, 309, 310-313, 314, 510 Sacco chair, 39 shoji, 517, 526 safety: for bathrooms, 154-155; for bedshower, 266, 268, 269, 378 rooms, 156; for children, 158-159; shrinking, 420 fire safety, 343, 493, 528; guidelines shutters, 211, 511, 517 for adaptive housing, 160-161; home sick building syndrome, 315 security, 343, 344; for kitchens, 133, silk, 408, 410-411, 412 (SOM) 155, 156; and lighting, 155-156; in silk screen, 424, 609 residential spaces, 152-156; for stairs, simple yarns, 414 152, 153, 154, 495, 495-497; of temsimulated texture, 83-84 pered glass, 393; for traffic paths, 156, simultaneous contrast, 94 singeing, 420 Saladino, John, 41, 42 single-family detached housing, 291 sand-struck bricks, 374 single ovens, 239 saran, 413 single-slope ceilings, 465 sash curtains, 520 single varns, 414 satin weaves, 415, 416 sinks: in bathrooms, 384; in greenhouse, sauna, 268 252; in kitchens, 237-238; for worksaxony carpet, 488 shops, 252 scale: as design principle, 128, 129-131; sisal, 409, 491 of floor plans, 194; of walls, 437, 438 site, for residential spaces, 179-182, 294 Scandinavian Modern, 38 site analysis, 179, 181 scatter rugs, 482 sitting rooms, 398 schedules, 17, 198, 200, 201 Skidmore, Owings & Merrill (SOM), 39 schematic drawings, 16, 191, 192 skylights, 271, 331, 506, 534-536 Schroeder, Kenneth, 13 skyscrapers, 33, 34 Schwartz, Warren, 381 slate, 373 sconces, 556, 558 sleeper, 580 sleeping and dressing areas. See bedrooms screen printing, 424 slide viewing, 218 screens: room screens, 211, 603-604; for visual media, 217, 218; as window sliding doors, 527-528 treatment, 516, 517 slip, 385 sculpture, 612, 613 slip-matched veneers, 356, 357 sculptured carpet, 488 slub varns, 414 sculptured ceilings, 467 small curves, 82 Smart House, 306, 338, 345 seating: for audio-visual entertainment, 215, 217, 218; for conversation areas, smell. See olfactory experience of space 208-210, 578; design characteristics Smith-Miller, Henry, 494 for comfort, 577; for dining needs, smoke detectors, 343 snacks, 227 "snail" staircase, 494 223; for dressing in bedroom, 258; in home office, 276, 277-279; modular, 575; for reading areas, 213; in social social distance, 147, 148 stable, 421 zone for greeting guests, 207; types social needs, for residential spaces, of, 577-581. See also chairs; sofas 144-152 seating platforms, 580 social zones: for active indoor entertainsecondary hues, 93 ment, 218, 219; audio-visual entertainment, 213-217, 218; for children's Secondo armchair, 396 activities, 221-222; for conversation, sectional units, 580 security: home security, 343, 344; for 208-212, 210-212; definition of, 186, 206–207; for dining, 222, 223–227; for greeting guests, 207, 208; location reading areas, 213; and windows, 504-505, 505 of, 228-230; for outdoor entertainsensory perception, of space, 68-69 ment, 220; planning of, 228-231; for serve center, in kitchen, 241, 242 settee, 355, 579 quiet games, 213; for reading, settles, 579 212-213; room shapes and sizes in, sewing areas, 251-252 230-231. See also dining rooms; ensewing machine, 251 trance areas; living rooms sofa tables, 582 sofabed, 274, 275, 577, 580 sewing table, 583 sgraffito, 386 shade linings, 559 sofas: arrangement of, for conversation shades: for lamps, 558, 559; for windows, areas, 208-210, 211, 212; Bauer sofa 97, 512-515, 513, 514 with marquetry pattern, 364; and crowding, 151, 152; definition of, shag carpet, 488 Shakers, 23, 24, 25 579, 580; measurements and characshape, definition of, 73. See also form and teristics of, for comfort, 581; modular, shape 575; sizes and clearance spaces, 209; shearing, 420 types of, 579-580; unified conversashed ceilings, 465 tion area, 133; Venturi's overstuffed sheers, 519 sofa, 129, 130 sheet vinyl, 474, 478 soffit lights, 553, 555 sheetrock, 441 soft floor coverings, 474-475, 481-491 shelves, 585, 586 softwood, 350 shingles, 444, 445, 447 soil-releasing, 421 shiplapped joints, 445, 446 soil-resistant, 421

solar orientation, 179 solarium, 312, 518 Soleil unit, 27 solid wood, 355, 445, 446 SOM. See Skidmore, Owings & Merrill Sommer, Robert, 144 Sonneman, Robert, 557 Sottsass, Ettore, 39 sound. See acoustics sound barriers, 215 south light, 534 Sowden, George J., 41 space: for audio-visual entertainment, 215, 218; for children's activities, 221; considerations on, 67-68; for conversation areas, 208, 209; for dining needs, 223-224; for dressing in bedroom, 258; for laundry facilities, 251; ordering systems of, 69, 70; requirements of, for residential spaces, 178; in residential spaces, 178, 291-293; sensory perception of, 68-69; in social zone for greeting guests, 207; space-time continuum, 68; spatial illusion, 70-72 spandex, 413 spatial illusion, 70-72 specifications, 17, 198, 199 specular reflection, 108, 547 spheres, 78, 79 spiral stairs, 496 splines, 590 split complementary, 106 split-level plan, 288 sprinkler systems, 336, 337 spun-bonded fabrics, 418 spun silk, 412 spun yarns, 414 spur walls, 436 stables, conversion of, 438 stacking chairs, 56, 57, 395 stacking tables, 582 stackoff, 524 stained glass, 27, 391, 392, 614 stains, for wood, 361, 366, 367 stairways: design and construction of, 495-497; for disabled and elderly, 161; in house built on hillside, 470, 471; lighting for, 153, 564, 565-566; newel post and balustrade for, 364; from 19th century, 22, 26; purpose of, 470; safety for, 152, 153, 154, 494, 495-497, 565-566; sizes of risers and treads, 494, 495; "snail" staircase, 494; spiral stairs, 496; stair tower, 356, 500; width of, 188, 494, 496; winding stairs, 153 staple fibers, 408 Star House, 120 Starck, Phillippe, 58 steel-wire furniture, 58, 59 Steiner Tunnel Test, 421 stemware: crystal goblets, 87, 88 stenciling, 451, 451-452 stereo speakers, 216, 217 Stern, Robert A. M., 45, 371 Stickley, Gustav, 23 stone: as construction material, 370, 371-373; for floors, 473, 474; for walls, 447-448 stoneware, 384

671

stools, 227, 238, 362, 419 storage: adjustable closet systems for accessibility, 157; in bathrooms, 270; in bedrooms, 258, 259, 262, 263, 265; built-in storage, 572; child's closet, 159; for disabled and elderly, 161; ergonomics of, 142; evaluation of floor plan concerning, 293-294; general storage, 253, 254; in greenhouse, 252; in home office, 276, 277-279; in kitchens, 233, 242-243; planning of, 189; for sewing areas, 251; types of storage units, 134, 584, 585-587; for workshops, 252. See also cabinets; closets storage walls, 436, 436 storm windows, 307 stoves, in kitchen, 239-240, 241 Stowe, Harriet Beecher, 54, 55 straw fibers, 409 Streamline Style, 37 Strengell, Marianne, 63 strike-offs, 107 strip lights, 558 strips (lighting), 558 strips, of wood, 477 structural design, 62-64 structural-type portable fixtures, 558 stucco, 379, 380 studio couch, 580 studio space, 276-278. See also artist's studio study, 145, 146, 149, 189, 227, 275, 277, 278, 466 style, and design, 12, 60-62 stylized design, 86 subdominant emphasis, 126 subdued light, 552 subfloor, 471 subordinate emphasis, 125, 126 subtraction method, in kitchen planning, 245-246 Suerig, Florence, 603 Sullivan, Louis, 27, 29, 54 summer homes. See vacation and summer homes sunroom, 307, 373, 377, 509 surface-mounted fixtures, 553-554 surface units, in range, 239 surfaces: for children's activities, 221; for conversation areas, 210; for dining needs, 223; in greenhouse, 252; in social zone for greeting guests, 207. See also counters suspended luminaires, 554, 555 sustainable energy resources, 310-314, 315 Swan chairs, 39 swimming pools, 222, 476 swinging doors, 527 switches, 338, 339 symbols, of floor plans, 194-195 symmetrical balance, 117-118 synthetic, 400. See also specific synthetics synthetic fibers, 408-409, 413 synthetic resin latex paints, 450 synthetics, for furniture, 592-593 table lamps, 556-558

table lamps, 556–558 tables: arrangement of, for conversation areas, 208–210, 211, 212; Art Deco table, 403; bedside table, 258; coffee table, 119, 570, 582, 583; console table, 571; dining tables, 223–226, 365, 393, 581–583; drop-leaf table,

41; fan-legged table-stool, 362; glass table tops, 13, 394, 581; glass tables, 391; hall table, 347; Lunario table, 388, 389; Machine Age Modernism in, 37; nesting tables, 582, 583; shape of, 582; sizes and clearance spaces. 209, 581; Tippy Jackson folding table, 58; tubular steel and glass table, 37; types of, 581-583, 584 tablescaping, 617, 618 tactile experience of space, 69 tactile textures, 83, 84 Tamayo, Rufino, 613 task lighting, 542, 543 Tassel House, 24-25, 26 taste, of clients, 174-177 tatami, 491 technology: and design, 58-60 telephones, 344, 345 television viewing: in bedrooms, 337; large-screen television, 217, 218; lighting for, 548, 562 temperature control: air conditioning, 306, 333-334, 335; comfortable temperature ranges, 300; and doors, 529; heating, 326-330, 331, 458-462, 465, 492-493; and walls, 440; and windows, 501, 503. See also energy conservation and efficiency tempered glass, 393 tensile strength, of wood, 346 terraces, 43, 566 terrazzo, 473 territoriality, 150, 151 tertiary hues, 93 tetrad color harmony, 106 Textile Fiber Products Identification Act textiles: characteristics and functions of, 406-407; color application for fabrics, 421-423, 423; fabric construction, 415-420; fabric finishing, 420-426, 422-425; fabric webs, 418; fibers. 407-413; films, 418; glossary of fabrics and their uses, 426-430; knitting, 417; knotting and twisting, 418; multicomponent fabrics, 418, 419; performance characteristics of textile fibers, 410-411; weaving, 415-417; yarns, 414, 414 texture: of carpets, 487-490, 488, 489; of ceilings, 468-469; as conservation

texture: of carpets, 487–490, 488, 489; of ceilings, 468–469; as conservation measure, 300, 301; considerations on, 83–85; definition of, 83; of fabrics, 422; and lighting, 84, 85; ornament, 85–86; paints used for, 451, 452; tactile textures, 83, 84; visual textures, 83, 84; of walls, 437; of wood, 360 texturizing, 451

textures, 83, 84; of walls, 437; of wood, 360
texturizing, 451
thermal experience of space, 69
thermal shades, 513
thermoplastic, 400
thermoplastic fibers, 408
thermosetting plastics, 400
think tank, 191
Thonet, Michael, 24, 25, 57
throw rugs, 482
tie-dyeing, 424
Tiffany, Louis Comfort, 27, 392
tile: ceiling tiles and panels, 468; as construction material, 375–378, 376–377; for floors, 473, 474–475, 476, 478,

480; for walls, 444, 447, 448

time, 68 tints, 97 tip sheared carpet, 488, 489 Tizio lamp, 556 tobacco smoke, 316 Toffler, Alvin, 171 tone, of color, 98 tongue-and-groove joints, 445, 590 too brilliant light, 552 topographical orientation, 179 Torrice, Antonio, 130, 131, 159 townhouses, 289–291, 290, 302 toxic chemicals, 315 track lighting, 554, 555 trade versus generic names, 412 traffic paths: for disabled, 156, 157; and doors, 528; in kitchen work centers, 244; planning of, 187, 188, 189; safety for, 156, 157 trampoline effect, 491 transfer printing, 424 transition, 124 translucent materials, 468 transparent finishes, 366 transparent materials, 468 transverse sections, 195 trash compactor, 238 traverse curtains, 523-524 triacetate, 410-411 triad color harmonies, 106 triangles, 77-78 trichloroethylene, 316 trompe l'oeil, 71, 451 trundle beds, 57 tub. See bathtub; hot tub tufting, 417, 485 Tugendhat chairs, 34 tungsten filament lamp, 538 tungsten-halogen lamps, 538-539, 560 turning, 363, 364, 365 tussah, 408, 412 tuxedo sofa, 580 tweed carpet, 488 twill weaves, 415 twisting, 418

U-shape kitchens, 244, 245 UFAC. See Upholstered Furniture Action Council (UFAC) underglaze, 386 unity, as design principle, 132, 133, 135 upholstered furniture, 61, 593-596 Upholstered Furniture Action Council (UFAC), 596 upholstered walls, 342 urethanes, 401 utility: functional accessories, 603-605; of furniture, 570-573, 571, 572; in programming, 13 utility core, 187 utility spaces: general storage, 253, 254; laundry facilities, 249-251, 250; sewing areas, 251-252; workshops and garden rooms, 252 Utrecht armchair, 55

vacation and summer homes, 12, 76, 118, 129, 133, 275, 381, 435, 446, 458, 482, 533
vacuum-formable fabrics, 420
valances, 521, 522, 554
value, of color, 95–98, 108–112
Vanderbilt, Gloria, 79
variety, as design principle, 134, 135, 136

varnish, for wood, 366, 367 vases, 65, 389 vaulted ceilings, 465 veiling glare, 547 velvet carpet and rugs, 485, 488 veneer-core plywood, 357, 358 veneers, 350, 355-359, 356, 357, 590 Venetian blinds, 515 ventilation: in bedrooms, 258, 332; for dining needs, 223, 332, 334; and doors, 528-529; for energy conservation, 306; and fireplaces, 459; in kitchens, 240, 332, 333, 334; in living rooms, 332; technical requirements of, 331-333; and windows, 499, 504 ventilators, 332 Venturi, Robert, 39, 45, 46, 75, 129 vernacular style, 41 vertical balance, 119 vertical blinds, 515, 516, 517 vertical fibers, of wood, 350 vertical lines, 82, 82 vertical plans, 284, 285-288 vibration, 111 Victorian houses, 81, 301, 358, 364, 451, 462 vicuna, 409 video games, 218 view orientation, 179 Villa Savoye, 34, 35 vinyl: as fabric, 413, 418, 419; for floors, 474-475, 478, 479, 480; as plastic, 400-402; for upholstery, 400, 418, 419; for wallcoverings, 400-401, 444, 456 visible spectrum, 91 visual experience of space, 68 visual media, 217, 218 visual textures, 83, 84 visual weights, 116 Vittoria, Alessandro, 398 volts, 537 volumes, 285 Voysey, Charles F. A., 22 Walburg, Gerald, 13 wale, 415 wall cabinets in kitchen, 237, 240

wall finishes, in bathrooms, 270 wall luminaires, 554, 556 wall tiles, 376 wall-to-wall carpet, 482 wall-washers, 553 wallboard, 441, 444 wallpaper, 444, 452-456, 453-455 walls: and acoustical qualities, 439-440; aesthetic considerations, 436-438, 437; in apartment, 438; color of, 108, 109; construction of, 440-441; cutouts in, 435; degree of enclosure, 439; design of, 436-438, 436-440; for disabled and elderly, 161; durability of, 439; exterior layers of, 440; function and flexibility of, 438; of glass, 43, 79, 320, 381, 435, 436, 448, 449; insulation of, for noise control, 341-342; interior layers of, 440; and light qualities, 439; load-bearing

walls, 318; masonry for, 447, 448; materials and surfacings for, 441, 441-458, 445-458; metal as wall covering, 449, 450; paint for, 450-452; plaster for, 441, 442; plastics as wall covering, 449-450; purposes of, 434, 435; scale of, 437, 438; of stone, 371; structural frame of, 440; textures of, 437; and thermal qualities, 440; tile for, 376; types of, 436; vinyl wallcoverings, 400–401, 444, 456; wall fabrics and fibers for, 457–458; wallboard for, 441, 444; wallpaper, 452-456, 453-455; wood as wall covering, 444-447, 445, 446 warehouse, conversion of, 336 warm-colored light, 552 warm hues, 95, 109-110, 113 warp knits, 417 warp yarns, 415 washing clothes. See laundry facilities water-repellent, 421 water softener, 238 water supply. See plumbing wattage, 537 wavelengths, 91 weaving: of carpets, 485, 486; of fabrics, 415-417 web of fibers, 418 Webb, Philip, 20, 21 webbed chair, 181 weft, 415 weft knits, 417 Wegner, Hans, 38 Weidhaas, Ernest, 230 weighting, 420 Weingarten, David, 63 Wells, Malcolm, 308 west light, 534 Wheeler, Candace, 28 whirlpool, 268 Whirlpool Corporation, 236 White House, 47 wicker, 593 wild silk, 412 Wiley, Alice, 12 Wilton carpet and rugs, 485 wind orientation, 179 window quilts, 513, 514 window treatments: bare windows, 518; blinds, 515, 516, 517; characteristics of, 511; curtains and draperies,

window treatments: bare windows, 518; blinds, 515, 516, 517; characteristics of, 511; curtains and draperies, 519–522, 519–526, 524–525; exterior, 152, 511–512; grilles, screens, and panels, 516, 517; hard treatments, 512–519, 513–518; hardware, trimmings, and installation, 526; interior, 512–526, 513–522, 524–525; measuring and estimating for, 525; plants, 518, 519; shades, 512–515, 513, 514; shutters, 517 window walls, 435, 436, 448, 499, 500,

window walls, 435, 436, 448, 499, 500, 507, 508, 509, 510, 511

windows: and air infiltration, 307–308; Andersen Windows High-Performance glass, 390; architectural composition of, 506; in bathrooms, 269; bay window, 321; in bedrooms, 261,

262, 504; cleaning of, 505-506; and color, 111-112; design and location of, 501, 503-506; for disabled and elderly, 161; double-hung window, 501; and energy conservation, 303-305, 311, 390, 393; fixed windows, 500, 501; functions of, 499; and furniture arrangement, 505; greenhouse blinds for, 305; and insulation, 306, 307; in kitchen, 247, 248; and light, 499, 503, 533–535; in living rooms, 76, 80, 96, 146, 306, 318, 381, 503, 518; operable windows, 500, 501; and privacy, 504; and security, 504, 505; in social zone for greeting guests, 207; storm windows, 307; thermal transmission, 501, 503; transom windows, 306; types of, 500, 502; and ventilation, 504; and views, 146, 381, 500, 501, 504

wing chair, 577 wiring plan, 338, 339, 562 wood: carving and turning, 363, 364, 365; for ceilings, 468; characteristics and uses of, 346-349, 347, 348; color of, 360; finishes for, 366, 367, 368; for floors, 477, 478; forms of, 349-359; for furniture, 589, 590, 591; genuine wood, 589-590; hard versus soft, 350-351; joining methods for, 360, 362, 445, 446, 590, 591; laminated wood, 349, 358; layered wood, 355-359, 356-358; limitations of, 349; moldings, 362-363; ornamentation with, 359-365; pieced design in, 365; plywood, 350, 357, 358-359, 590; qualities of selected woods, 352-354; recycling of, 322; solid wood, 355, 589; stains for, 361, 366, 367; structure of, 350, 351; tensile strength of, 346; texture of, 360; variety of, 444, 445; veneers, 350, 355-359, 356, 357, 590; as wall covering, 443, 444-447, 445, 446; for windows, 500

woof, 415
wool, 409–412, 490
work areas. See kitchens; utility spaces
work centers, in kitchen, 233, 236–242,
237–241, 243–246, 244, 245, 254
work triangle, 244
work zone, 186–187
working drawings, 195
workshops, 252
Wormley, Edward, 41
woven-wood shades, 512–513
Wright, Frank Lloyd, 3, 23, 29, 30–31,
42, 47, 120

wood-burning stoves, 328, 329, 462, 463

yarns, 414 Yudell, Buzz, 220

woodcut, 609

Zanini, Marco, 41 zoning, 185–187, 188. See also private zone; social zones